APOLLO & VULCAN

APOLLO & VULCAN

The Art Markets in Italy, 1400–1700

Guido Guerzoni

Michigan State University Press

East Lansing

 Michigan State University Press
East Lansing, Michigan 48823-5245

Printed and bound in the United States of America.

17 16 15 14 13 12 11 1 2 3 4 5 6 7 8 9 10

LIBRARY OF CONGRESS CATALOGING-IN-PUBLICATION DATA

Guerzoni, Guido.
 [Apollo e Vulcano. English]
 Apollo & Vulcan : the art markets in Italy, 1400–1700 / Guido Guerzoni.
 p. cm.
 Includes bibliographical references and index.
 ISBN 978-1-61186-006-1 (cloth : alk. paper)
 1. Art—Economic aspects—Italy—History. 2. Art—Marketing. I. Title. II. Title: Apollo and Vulcan.

 N8600.G8413 2011
 338.4'770945—dc22 2011008818

Cover design by David Drummond, Salamander Hill Design (www.salamanderhill.com)

Book design by Scribe Inc. (www.scribenet.com)

Cover art: Jacopo da Empoli, *Michelangelo shows his project for Saint Peter to Pope Leo X,* Italy, Florence, Casa Buonarroti. Courtesy of PhotoserviceElecta/Leemage.

green press INITIATIVE Michigan State University Press is a member of the Green Press Initiative and is committed to developing and encouraging ecologically responsible publishing practices. For more information about the Green Press Initiative and the use of recycled paper in book publishing, please visit www.greenpressinitiative.org.

In memory of my mother Renata and my father Sergio

Contents

Tables

Foreword

ENRICO STUMPO

OVER THE LAST COUPLE OF DECADES, THE THEME OF THE ART MARKET HAS BECOME one of the most frequently studied *topoi* of Italian and international art history. And perhaps precisely because of this, it has become a sort of affirmation of a principle on which both the art historians and economic (there are few in Italy) historians agree, even if in a vague and unspecific way. Studies on patrons, collectors, account books of this or that painter have multiplied, but there has been no attempt to connect the interests that motivate art and economic historians or the general picture of the art markets. But it is not in the multiplication of the "art markets" in Florence, Venice, Ferrara, Mantua, Rome, or Naples that we will come to an understanding of the history of each of them. Guido Guerzoni's book fills a serious gap, especially for Italian history. In a series of essays, different in research area but united by clear professional capacity, the author has used the instruments of the modernist, of the economic historian, the art historian, and sometimes a bit of humor to provide that which will in the coming years be considered an indispensable premise for scholars in this complex field. In fact, what emerges is a dialogue of many voices, where the author changes observation points while maintaining the central theme of the extraordinary experience of many Italian artists and artisans over the course of three centuries. In trying to offer examples, to bring alive complex historical sources, to explain his point of view and the path of his research, the author offers the reader the possibility of verifying his method and of finding a better one.

In the first two chapters, he completely and carefully reconstructs the very complex history of the theme and gives the reader a key to interpretation. Taking patrons, artists, and artisans out of their isolation in monographs and projecting them into their historic setting, he restores the fabric of daily life in which economic factors can be fully seen. In this way, the social setting where the courts, patrons, and workshops operated is restored and replaces works and workers in their spaces and their world. For example, the splendid essay on liberality, magnificence and splendor is part of that extraordinary sector of study on *Memoria dell'antico nell'arte italiana*, which Salvatore Settis has reconstructed in the three volumes of the *Biblioteca di storia dell'arte* published by Einaudi. This book should be required reading for all early modern historians, as they are too often convinced of having found in the Cinque and Seicento ideas and precursors of the scientific or industrial and sometimes, rather ingeniously, of French revolutions. In reality, Italian society in the Cinque and Seicento lived projected towards the past—a past that moved grand political projects like that of Charles V, and offered at the same time models of civic virtue, juridical wisdom, artistic and military know-how. Every antique fragment could be treasured to become, like Mantegna's Roman portrait "*la mia cara Faustina de marmo anticha*," the focal point of a private collection.

The two dense and full essays on the Este courts, in dealing with demand and the labor market that was formed between Quattro and Cinquecento, offer a picture that is, of its kind, uniquely complete. There are no similar studies for any Italian court of the period: not for Rome, Mantua, Florence, or Milan—and especially as regards the dimensions of a labor market analyzed using a wealth of data and extraordinary amount of archival sources. And it is not by chance that the author, in the light of more recent studies, asks whether the case of Ferrara is an anomaly. Rightly the author reconstructs a cultural fabric that in that period and for at least two centuries would be based more on the practical than the theoretical. It was practice, concrete experience that made a great architect, artisan, ship builder, or artillery expert. They were capable, without particular schooling, of building ships and galleys, castles, churches, and palaces that still dominate our squares and hillsides; of making bullets and efficient, functional cannons. And further, the author reminds us of a theme well known to historians of art but ignored by economic historians, which is that of the court or popular *feste* (feasts) and the triumphs of ephemera. These artisans were capable of building complex machines and mechanisms which have not been improved upon even today. This practical know-how was passed from father to son and mother to daughter: like the art of blowing glass at Murano or that of embroidery and lace-making. And at the same time through apprenticeship and experience every painter, goldsmith, engraver, sculptor, and *battiloro* (gold-beater) transmitted his knowledge and ability. Giuseppe Maria Mitelli, famous Bolognese painter and engraver, in his dedication to the collection of illustrated proverbs in honor of Prince Francesco Maria de' Medici in 1678 wrote his praise of experience in the frontispiece: "*Così al mondo tramando i documenti / e le regole certe altrui prescrivo / noto sul paragone ogni sentenza / sono, Maestra all'uomo,* l'esperienza."

"Thus I give the documents to the world / and write some other rules / I note every judgment by comparison / I am EXPERIENCE, Master to man."

The Cinquecento was the century in which Emanuele Filiberto of Savoy, Alfonso d'Este, Francesco I de' Medici, and Ferrante Gonzaga withdrew into their laboratories, foundries, and *studioli* (studios) to discuss, converse, work and experiment along with workers, artists, artisans, chemists and foundrymen for days on end. And this is the world that the author reconstructs and keeps in view. Even as the author shows his ability to move with great historical sense and undoubted capacity in that other world, analyzing the values, desires, needs, expectations, and relationships in that society, the chapter dedicated to the formation of prices and functioning of the markets is just as extraordinary a reconstruction, unique in the panorama of international economic history. This is the area in which too many have moved without caution, with misleading comparisons, forgetting or ignoring the difficult mechanisms of the different monies, of the relationship between unity of account and real coin, or overlooking the well-known fact that just the relationship between gold and silver went from 1/10 to 1/15 between early Cinquecento and early Settecento. But the prices of work and artists' remunerations were not merely economic, and the author notes this carefully as he reconstructs the costs of materials, of transactions, of semi-finished pieces up to the final product. This is a chapter which every scholar of this subject will have to read, essential to the understanding of the market as well as the socio-economic conditions of the artisans, the taxes and rents they paid, their professional rankings and economic possibilities—that is, the success factors that in turn determined the areas in which they worked. There is also careful attention to the increasingly recognized phenomenon of the production of copies and replicas, and the existence of hundreds and hundreds of artists—unknown to us, but who once worked

and earned as much as or more than more noted colleagues, as Lionello Puppi has recently reminded us.

The author's work thus gives us a wealth of extraordinary starting points, the fruit of the examination of a sometimes astonishing quantity of archival material, synthesized in some cases, like the Este court, in comparative tables containing surprising information about top-ranking artists and artisans, as well as "serial" manufactures, about which there was scarce prior information. And this is true particularly in the case of the so-called "minor arts" of a certain historical tradition—which, however, were not considered thus, as we learn from the archival sources.

In now-distant 1938, Martin Wackernagel concluded his great work on *The World of the Florentine Renaissance Artist,* published in Italian only in 1994: "If, however, as the works that have come down to us testify, those personal living conditions existing for the Florentine Renaissance artist obstructed his creative calling as little as did his contemporaries' pertinent evaluation of him as peculiar, then we may be able to recognize the system of preconditions and factors of Florentine artistic life recorded in this book almost as an ideal picture of desirable artistic conditions in general. With reference to this picture, we may perhaps also accordingly consider whether at least a few of those foundations, so enviable in a material as well as theoretical sense, might not once again be regained for the artist of today or tomorrow."

Guido Guerzoni has succeeded in this book in partially filling a serious gap in modern Italian economic history by taking to heart a desire expressed by Fernand Braudel: "Faced with so much different activity, how can one not turn to economic and social history, 'revolutionary'? . . . History may not be condemned to study only gardens well enclosed by walls. . . . Can there be a humanism in this year 1946 if there is no ambitious history conscious of its duty and of its great power? 'Fear of great history has killed great history,' wrote Edmond Faral in 1942. May it be revived!"

Preface

The roots of this book go back to May 1989, when, having finished my third year of university, I began to look for an advisor for my thesis in business administration. I had already found a subject: the relations between the art world and the economic world, from a historic and economic perspective.

My first interview, with an economist and well-known collector, was in vain. He very politely insisted that the theme would have no future, and did not have enough past to justify a proper thesis. Disappointed but not dissuaded, a few days later I knocked on the door of the Institute of Economic History and was received by Professor Marzio Romani, who listened for an hour. Apparently he was convinced, and over the following months we set out a research plan with Raoul Nacamulli, professor of organization studies. Thus, in July of 1992, I arrived at my defense carrying a volume entitled *Il "gran gioco" dell'arte. Il sistema artistico tra storia ed economia* (The "great art game": The art system between history and economy).

Twenty years later, I have to attribute to that "great game" my most important choices of the following years, beginning with my research doctorate in economic and social history, which I finished in 1996 with a thesis on the economic and social aspects of the Este courts between Quattro and Cinquecento.

I hope that the reader will bear with my autobiographical introduction. More than twenty years have passed since that morning in which my "professional" relationship began with the themes treated here. Many things have occurred since then, and that eccentric question has entered solidly into the agendas of various scholars, even become one of the more fashionable themes in the academic, museum, and publishing worlds.

It is, however, due neither to the fault nor the favor of that success that only now I have decided to write a book about the themes that have occupied me for two decades. My slowness depends on the caution that I believed necessary in approaching arguments lying at the cross-roads of tradition and different disciplines, and approached by social sciences using different languages and methods, given that the art markets have been and are studied by a plethora of specialists: economists, sociologists, museologists, historians of economy, mentalities, economic thought, art, collecting, culture, and so on.

Aware as I was of the breadth of the field and my inadequate formative baggage, I decided to wait, to discuss with various interlocutors and try to understand their reasoning, working methods, and lexicons. It was slow going, driven by fear of missing the moment of proper comparison in an interlocutory phase in which there were temptations towards hegemony, since interdisciplinarity easily turns to controversy.

On the other hand, between the end of the 80s and the first half of the 90s, the distances between the relative positions of the economists and art historians, antagonists in the early phases of the debate, were still too great for there to be dialogue. There was—and it is right to recognize it—a reciprocal curiosity, but the linguistic misunderstandings and opposing

extremes did not encourage any attempts at integration. I realized thus that economic history, especially as it is practiced in Italy, could become an excellent tool of mediation, as it is traditionally sensitive to the demands of other fields of history while maintaining its ability to communicate with economists.

Thus, the objectives of an undeniably ambitious research project were clarified in the light of some guiding principles: to note the changes and continuities over the long run, attempt a dialogue with the other social sciences, compare the different historiographic traditions, set out a comparative model, pose questions that could demonstrate national primacy, while at the same time continuing with the lively international debate.

Introduction

LEXICONS AND GRAMMARS

At the beginning of my research, there was not yet any historical-economical literature on the "art markets," but my early analyses of the primary sources—especially those concerning the courts—and exploration in the more specialized art-historical literature convinced me that the production and consumption of artwork, luxury items, and services were really the backbone of pre-industrial economies and far from being just accessories. On the contrary, in observing the Italian situation, I persuaded myself that that backbone had already supported the industrial takeoff—today we may say it—by mitigating the backlash of the violent postindustrial landing, from the moment that the recession of the last decade seemed not to have hurt the creative industries, heirs of a tradition that is older than usually thought, and that rigid and noncommunicative disciplinary divisions have in fact obliterated.

To my eyes, as a young scholar, it seemed obvious that the Italy of fabrics, shoes, leather goods, fashion, architecture, furnishings, majolica, ceramics, goldsmithery, furs, car designers, builders, design, musical-instrument makers, makers of specialty papers and of high quality foods and wines, of Riva and Ferrari, had its economic, social, and cultural roots deep in the somewhat overlooked terrain of the *art markets*.

This hypothesis gained consensus over time. Enrico Stumpo has confirmed that the "endless production of art objects and the antique trade that existed in Italy between Quattro and Settecento, and extended through the Ottocento and early Novecento, involving many Italian cities and a large number of artisans, painters, and sculptors" has "instigated a complex commercial movement, not just between Italy and Europe, of imported raw materials and exported objects that no scholar has, for obvious reasons, even tried to calculate. It probably allowed the integration of the manufacturing economies of famous centers like Florence, Venice, Genoa, Rome, or Milan, with diversified production of not only artistic but also certainly luxury objects, arms, jewelry, silverware, musical instruments, decoration, furniture, ceramics and majolica, paintings, statues, stuccos, and the art markets' coins, medals, prints, engravings, mirrors, lighting fixtures."[1] Similarly, Marco Belfanti and Giovanni Luigi Fontana, in an article titled *Rinascimento e made in Italy*, have observed that between the Quattro and Cinquecento, Italian taste had become the "reference point, the touchstone, not to say model, for a large part of Europe."[2] Nevertheless, in contradiction to the interpretations of the crisis that in the Seicento assailed our "traditional artisan luxury" business, the same authors have determined that "numerous studies on modern and contemporary history have shown that, even though in a very different context, diverse typically Italian products (textiles, ceramics, publishing, glass, etc.) were not subject to sudden interruptions, nor did they show signs of a definitive decline. This network of territorial specializations would be the basis for the development of the districts of *made in Italy* of the later nineteenth century."[3]

In tune with this sort of opinion, which has stressed continuity and durability over the long run, I realized that the analysis of the structures and dynamics of these markets in modern and contemporary periods would require a healing of the twentieth-century fracture between the interests in the history of economy, techniques, art, and architecture. The time, on the other hand, seemed to be ripe for healing the wounds suffered from the Sette- and Ottocentesque break between art and craft, between useful and not-useful arts, the practical and nonproductive, and at last to return by other paths to the origins of Italy's twentieth-century industrial success. These breaks had unfortunately provoked a lengthy schism that caused the activities involved in the art markets, presided over since the early 1930s by the so-called artistic industries, to be considered too industrial to merit the attention of art history and too artistic for the economic historians, causing a gap of equidistant disinterest at this crossroad.

Surely this was a missed occasion, since looking closely at the recomposition allows us to reconstruct the genealogies of important sectors of the Italian economy; the forms of transmission and migration of knowledge, know-how, and intangible assets; the mechanisms of development of organizational capacities; and more. If Marazzi is heir to the Este manufacturers, so is Beretta of the Sforza armorers, and many other players in contemporary industry are in a similar relation to the past.

Besides historiographical interests, my curiosity was piqued by other phenomena, and even though I had begun my archival research, I continued to read economic literature for teaching and scholarly reasons and found it in some ways surprising.[4]

The economic disciplines, after decades of silence and omissions, were recognizing the relevance of cultural and symbolic goods, of intangible assets, of the role played by art and culture in the spread of innovation and in the creation of human capital, the growing economic weight of creativity, and the centrality of conspicuous consumption in postmodern and postindustrial societies. Following these indications, the historical study of these markets allows us to review some fundamental stages of the development of Italian economy and industry, but it also enables us to examine the mechanisms and the functional logic of today's markets of goods and services.

The end of mass production and beginning of mass customization have in fact brought a reevaluation of the typical characteristics of goods and services that in the past were produced, distributed, and consumed in the art markets. Aesthetic property vies with services, consumption constructs and reveals individual identities and group physiognomies. As the distances between rich and poor increase, the distinction is an imperative of the mass, while consumers become patrons whose behavioral logic evokes that of earlier collectors.[5]

On this playing field—and it is only apparently narrow—a decisive game is being played out, and few fields of study can supply equally precious indications for the understanding of what will be the future of many economic approaches. The study of art markets thus does not mean the cultivation of a new little garden so much as an innovative way of reviewing *ab antiquo* the stages of the process that over the course of centuries has brought the artistic-sumptuary sectors to be the incarnation of the brightest face of our industrial economy, the successful brand *made in Italy*.

It is not necessary to start new disciplines: rather we need to ignore the presumed eccentricity and encourage their inclusion among the themes *normally* treated by economic and social history, so that they can be considered equally among peers. I do not feel the need for an "economic history of art" or of an "economic history of architecture," because these, without making second-hand historical materialism, are historiographical themes *tout court* with no distinctions,

which in this case would not sound like convinced annexations, but rather sub judice aggregations. The premise behind this analysis is the extraordinary normality of the artistic presence in Italy, its lengthy and capillary diffusion and economic relevance. These elements do not justify a diminishing status, but call for a careful examination of the origins of these phenomena and the influence that they have had on the constitution of a specific productive system, on the perception of our identity in foreign countries, on the formation of tastes, talents, styles and sensibilities that are today recognized as factors of competitive advantage.

I think it is a fascinating prospect whose themes are arguable on the basis of documentary proof, and will provoke less uneven reactions than it might have a few years ago. Nevertheless, to be able to support it unequivocally, I have to explain the significance that I have attributed to two terms in the book's title; explain my choice, the meanings attributed, and the reasons for using the plural.

PARADOXES AND RECONCILIATIONS

For about thirty years now, the word pair "art market/s" has appeared in a great number of writings, even if only a few of these question the correctness, propriety, and implications of the coupling.[6] A casual and often confused application of the term "market" has followed, since economists and economic historians tend to take the meaning for granted—considering any exercise in definition to be banal—while art historians abuse it or use it indifferently to mean sector, commerce, place, or traffic. The commonness of these words could be redeemed by the use of a more impersonal root, which would at the same time identify a mechanism and an entity with a given power, personality, and rules.

Two conceptions that are different in type and degree live side by side. In its broader sense, "art market" subsumes all the types of economically relevant exchanges, goods, services, actors, and actions, ending as a functioning and better-known synonym for the terms "field," "sector," or "arena." In the narrower sense, the combination becomes instead a residual category into which fall the transitional categories not immediately classifiable as patronage/matronage relationships and direct patronage, or: the sale of articles not commissioned by a client; the business of professional or casual intermediaries, agents and fiduciaries, auctioneers, and experts who interrupt and depersonalize the relations between producers and consumers; and lastly the acquisition of works by dead artists—passages that reflect the success or failure of collections and often involve classes of objects that are subject to revival, reproduction, and falsification, but to which was forbidden the introduction of freshly made originals, as happened in the antiques market with archaeological finds.

To simplify: in the art-historical interpretations concerning high-quality products, the market has been perceived as a form of governing of transactions more suited to the mobilization of the historically sedimented artistic patrimony (the stock of cultural heritage existing at a given time) than to the generation of new *streams* of production. Thus it is closer to collecting practices that look prevalently to acquire works from the past than to patronage that, tautologically, aims to support contemporary production. Two modes and two different worlds whose analytic implications are frequently overlooked, even while separating the destinies of the more sophisticated products from the second-rate, for which the "markets" represented a more practical outlet.

Noting these differences, one can see how in the writings of many historians of art and culture, the "market" identifies differing modes of exchange, which have in common the impersonality of relationships and the concurrence of mechanisms of mediation that can interrupt the direct relationship between maker and purchaser, conditions that are not considered necessary and sufficient, but only sufficient, to use a term that is less anachronistic than "trade" and more modern than "commerce."

The imprecision is widespread, since even a historian attentive to economic dimensions like Peter Burke has included the market among the five main systems adopted by patronage, defining it as the system "in which the artist or writer produces something 'ready-made' and seeks to sell it, either directly to the public or through a dealer" and "where clients do not commission works at all, but buy them 'ready-made,' possibly through a middleman."[7] Burke brings together in support of his argument the buying and selling of antiques, illuminated manuscripts, chessboards, mirrors, printed reproductions, ceramics, pitchers and plates from Bologna, Urbino, and Faenza, and books with woodcut illustrations[8]—in sum, very different categories.

Despite this generous semantic vagueness, which goes back to the conventional use of a term that each appropriates according to his need, in economic usage the "market" is instead a specific form of regulation of transactions, a self-sufficient and self-regulating institution whose presence is determined only by the satisfaction of certain preconditions.

For neoclassical economic historians and economists, it is not a fixed place or a synonym for commerce or sector, but rather an allocative mechanism operating by means of the forces of supply and demand, in an abstract space in which free and equal buyers and sellers, lacking taste and interpersonal relations, with no assessment distinctions, and exempt from sociocultural conditioning, are in possession of all the necessary information to complete transactions, and may interrupt the antagonistic buy/sell relation at any moment without incurring moral or pecuniary sanctions.

In this anonymous regime, the opposing parties trade fungible goods and services either bi- or plurilaterally with no constrictions or limits, using money as a means of exchange, and recognizing in the price the measure of the value of the equivalents sold, quantifiable and cumulative in virtue of the sameness of their distinguishing characteristics.

The "market" is thus a *conventio ad excludendum*. In accepting the original principles and embracing the interpretative grid, one does not feel the need to understand how prices are formed and how they evolve over the short term, or their impact on social, gender, religious, and political profiles of the participants; how the class, individual, and institutional strategies differ; or how to explain the geographical arbitrages, justify the permanence of atypical and apparently irrational behavior, or the evolution of taste.

And yet anyone interested in the themes examined in this volume knows that the above questions are decisive for an understanding of the logic and dynamics of exchanges that have occurred in the "art field," a sociological term that has a more neutral and less binding profile even if the specification as artistic gives it identifying properties and functional modalities that are far from those current in the "pure markets." In fact I will go further. Even though it may seem paradoxical, the interest in these circuits, actors, and objects of exchange comes out of establishing that in this environment there remain rules, rationalities, and behaviors that are the mirror image of those that existed in the neoclassical markets.

This sense of otherness foreshadowed misunderstandings that have induced Joseph Koerner and Lisbet Rausing (the former a historian of art, the latter of science) to note:

"Neoclassical economics black-boxes human intentions and beliefs by assuming that people are autonomous, self-interested maximizers of utility. Value is thus equated to price. Cultural anthropology in turn opens that black-box and encounters a person's or a culture's own narrative of meaning (what Clifford Geertz calls 'thick description'). Value is thus taken to be a relative and culturally specific category of thought particular to the observed subject. Anthropological studies of marginal or non-Western people often set out to prove there exists no transcultural value of art."[9]

The anthropologists' criticisms may in principle be shared by historians as well,[10] even if those who have complained of the gap that separates the abstractness of the models from the evidence of the primary sources have only denounced the lack without invoking or proposing alternative plans that are indeed available. On the other hand, various economists have held that the "anomalies" could not be ascribed to the nature of the field of study and the goods and services to be found there, but that instead they were derived from the theoretical imprecision and methodological weaknesses of their interlocutors.

Out of this has come an asynchronic movement, since the avant-garde of art-historical studies has let itself be seduced and abandoned by the rear guard of economic historians. While the more heterodox economists elaborated innovative schemes, concepts, and instruments, the historians tested themselves against, and did not find themselves in, obsolete theoretic structures tied to old industrial concepts of mass-market and standard products and reined in by the oaths of obedience exacted by the more conservative schools. In similar conditions, the study of these "arenas," to use another expression dear to sociologists, has posed the questions that every time have shown the limits and doubts about the more traditional models already subjected to heavy criticism by the pioneering studies of Karl Polanyi,[11] by archaeologists and classicists who enlivened the debate following the publication of the works of Finley or Sahlins,[12] by the cultivators of neoinstitutionalism, and by those who have gone back to look at the history of consumption and of standards of living.[13]

These studies, and perforce those concerned with works of art, luxury items, unique and rare objects, collectable items, second-hand goods, or those with symbolic, relational, and positional content, have in any case been forced to face the formation of prices, space-time variations, relativity of values, coincidence of diverse economic rationales, the permanence of attitudes, practices, and strategies that according to the most traditionalistic economic theories seem anomalous. A widespread sense of discomfort has followed, coming sometimes from undeniable lack of competence, and more often from the lack of a literature that would have aided the understanding of phenomena that at first glance seem off-key. On the other hand, there are similar questions in the uneasy domain of the "economies of symbolic goods" studied by Pierre Bourdieu and Jean-Joseph Goux,[14] in the economy of *dépense* theorized by Georges Bataille,[15] in the "libidinal economy" analyzed by Jean-François Lyotard,[16] or the "political economy of the sign" investigated by Jean Baudrillard,[17] who is significantly also the author of admirable pages on the economic foundations of collecting.[18] Caution is necessary, because there are profound differences in respect to the *things*, as anthropological research on consumption has been demonstrating for some time now.[19]

At this point in the discussion, one could criticize me for having chosen the term "markets" for base commercial reasons, since I have in part denied their heuristic capacities. But the case is really more complex than that, since in this instance there are diverse elements that denote the inadequacy of retro-application of neoclassic models. In the first place, very frequently the acquisitions took place—and still take place—outside of the "markets," by

way of gift, countergift, exchange, barter, inheritance, recovery of pawned goods, remission of debts, confiscation, requisitioning, redemption, war booty, theft, forced sales, acquisition *en bloc*, auctions, raffles and lotteries, contests, competitions, contracts, prizes, commissions paid as piecework for the job, or not paid for single acts, subcommissions, and suballocations. The outcome of the negotiations were different if princes or princesses, aristocrats or bourgeois, popes or cardinals, ecclesiastical establishments or monastic orders, merchants or financiers, men or women, Christians or non-Christians, local or international clientele, etc., were involved, where it is difficult to find in collectors the utilitarian, rational, and maximizing characteristics of "modern" consumers.

In the presence of a very questionable concept of "utility," in the artistic field many behavioral theories held by economic theory do not hold up, because the value of the goods often originate from their being parts of series that the collectors tried in vain to complete and conclude. But the missing piece was—and often remains—more important than the latest acquisition, and as Muensterberger observed, "Whatever the motivation, there is little question that collecting is much more than the simple experience of pleasure. If that was the case, one butterfly, or one painting, would be enough. Instead, repetition is mandatory"[20]—or as Jean Baudrillard repeats, "Whether denied, forgotten, destroyed or virtual, the series always remains operative . . . it is the indispensable nourishment of ownership and the passionate game of possession"[21]—marginalistic principles are called upon, and serious doubts advanced as to the rationality of individuals afflicted by manias that had little to do with current forms of positive addiction.

These affirmations do not postulate the historical absence of "art markets." There was, and I admit it with no hesitation, production aimed at them: just remember the success of serial paintings and so-called "paintings as furniture,"[22] and of the numerous items intended to satisfy the demand for originals and often mediocre copies through channels of distribution that are highly impersonal. The studies of workshops, intermediaries, and "ordinary" collectors in Italy between the end of the Quattrocento and mid-Settecento[23] have proven the existence of vast serial productions of standardized objects of low and middling quality, made in lots of a discreet size and meant to satisfy the needs of an ample and rather heterogeneous demand. This phenomenon, at least at the end of the Cinquecento, also touched the production of paintings: in 1667 the painter Francesco Raspantini, modest student of Domenichino, kept 1,778 paintings[24] ready for sale in his shop, and according to the inventory of Pellegrino Peri's shop, there were "2,941 pieces of paintings on canvas or copper of various sizes, separated as to originals and copies, drawings, models 'to be traced.'"[25] Nor were the stocks kept at hand by the semiprofessional intermediaries less imposing, if at mid-Settecento Giuseppe Sardi, master mason by trade, had "half a thousand paintings"[26] hanging on the walls of three large rooms on the ground floor of his house. This was certainly not the *crème*, but there is no doubt that these goods were an appreciable part of the production, even if produced on an almost industrial scale by artists more interested in income than in glory, and very like what happened in the Dutch market.[27] At any rate, there was no lack of economic satisfaction. Rita Maria Comanducci has discovered that according to the Florentine *catasto* (register of landed property) of 1480, the wealthiest painter in town was Neri di Bicci, whose fortunes did not come from altarpieces, but rather from the sale of "little chamber tabernacles containing a painted plaster sacred image (made with a mold), and in an 'antique style' wooden frame,"[28] while the second wealthiest painter was Giusto di Andrea di Giusto Manzini, not one of the best-known to art historians, but former student of Neri di Bicci and also "painter of plaster

statues."[29] These were not isolated exceptions: almost two centuries later, in the Venetian tax rolls of 1661 analyzed by Isabella Cecchini, there are painters listed for rather consistent sums whose names and works are completely unknown to present-day critics.[30]

Evidence of this kind invites us to keep critical and financial success separate, as there were not a few artists who, ignored as they may be by scholars, profited from the broadening client base—not necessarily collectors—and the increase in travelers and pilgrims wanting souvenirs of Italy, as one can deduce from Giada Conti's study on the Florentine Export Office for the last twenty years of the nineteenth century. Between the beginning of January 1891 and the end of December 1900, this office authorized the exportation of 33,637 "modern" paintings (created after 1815). Some 95 percent of the works in the period 1883–1888 were by unknown[31] artists. This is an important fact, as this figure does not include the permissions granted in 1896.

Even having recognized the existence, beginning in the late Quattrocento, of systems of production, intermediation, and consumption similar to modern markets, the studies carried out on institutional, aristocratic, princely, and ecclesiastic demand have instead demonstrated that the quota of items treated by artists, merchants, or occasional mediators was minor, as other kinds of supply (legal, paralegal, illegal, free, or forced) were more common. Even in the presence of payment in cash, the exchange of goods thus signified from a symbolic and relational point of view almost never involved anonymous and unknown parties. These had a title, a name, a surname, a face, a reputation, a gender, a religion, a profession, an institution to represent or a principal to conceal, earlier behavior more or less honest. But the identity of the protagonists and the circumstances in which the deals were conducted counted as much as the characteristics of the objects to be exchanged, originating in different solutions from time to time that for analytic ease or intellectual laziness can not be ascribed in a mechanical way to the opposing market vs. patronage, with the client as the third man out. It would be good to get away from the simplicity of this antithesis that sometimes unconsciously influences many studies and concentrates, not by accident, on Venice and Genoa, Spanish Milan, and Naples under the viceroy, Florence before the principality, and Bologna during the seventeenth century, in the apparent conviction that the markets would develop in the contexts in which patronage, especially that of the courts, was weaker or absent.[32] The basic problem lies in the fact that even the term "patronage" has become overused in time to identify heterogeneous practices and subjects, as noted by Francis Haskell: "the modern meaning of the term patronage . . . implies by necessity a concept of art as autonomous field, with intrinsic values and processes, usually associated with a peculiar and affectionate attitude of munificence. The true, authentic patronage should imply a personal relationship between the patron and the artist and the development of a sense of respect and protection, which is not related to the interest in obtaining this or that single artwork."[33]

Historical research has, however, found proof of the frequent absence of disinterest that patronage in its more pure forms should possess, given the remarkable variety of diversity in patronage, as Meyer Shapiro and David Chambers[34] have pointed out.

These models and the infinite variations on the theme included in the broad spectrum of modes and solutions existing between the two extremes of market and patronage coexisted peacefully, perhaps involving different producers, products, and publics according to the culture, economic possibilities and expectations, and above all registered continuous changes over the course of modern history. The attempt to encapsulate the apparently confused *florilegium* of these forms of exchange and appropriation in the name of a misunderstood theoretical rigor

is misleading, as it empties the research of its most challenging characteristics. We need to see in the near future a patient job of recognition and mapping of the very ample cases of ways of selling, negotiating tactics, contractual forms, and commercial customs without letting ourselves be swept away by the desire to solidify schemes that would only take us back into the trap of making models for their own sakes. The list of practices, dealings, and solutions in the preceding pages is so vast and heterogeneous as to argue against strict categorizations or reductions to binomial contrasts: there are differences between the forced sale of a collection to a prince and a post mortem auction that must not be silenced or diminished.

Equally, one must deny the explicit or implicit teleology of development that more often than one might think recognizes in clientelage and patronage the condition of a primitive, imperfect, and underdeveloped stage of markets. It is true that there were informative asymmetries, contractual limits, assessment mismatchings, behavioral etiquettes, negotiating strategies, and sanctioning mechanisms that, in a historical vision attentive to the long term, were substantially different. Nevertheless, before dismissing them as atavistic and imperfect, these specifics should be related to social contexts and cultures that are radically different from today's. Clientelage and the articulated forms of patronage/matronage were not the congenital vices of immature markets, but rather alternatives to these and blessed with their own logic, rationality, and rules[35] that should not be rejected but understood, given that they still inform the behavior of players in the arts today.

Prudence is necessary: otherwise almost all the phenomena that do not run on the double binary of economic and art-historic orthodoxy could be declassed as insignificant variants, an anachronistic flunking that arrives too late. In recent times, various economists have in fact contested neoclassic dogmatism, defending the genesis of a pantheon of dissenting theories that have defined a broad variety of "forms of market" and of "forms of regulation of transactions." Thus, beginning after World War II and in concomitance with the relaunching of neo-institutionalism, organization studies, and the theory of transaction costs, many scholars have theorized alternative forms that in the colorful language of their more-or-less fine speakers refer to hierarchies, bureaucracies, clans, fiefs, market A, market B, semi-hierarchies, mafia, networks, etc. Instead of forcing the mechanical transposition of a single model onto a multiplicity of historically determined situations, some preferred to ascertain the characteristics of the sector, the circumstances of the negotiation, and the protagonists of the events, singling out only afterwards the best interpretative paradigm and allowing it equal heuristic dignity, as has happened in the brilliant investigations on reputation and trust,[36] on the theory of the principal agent[37] or on signaling,[38] which have often seen the collaboration of economists and art historians.

For these reasons, one can today speak of art "markets" without falling into dangerous ambiguities, since "markets" in the plural has by now become a *conventio ad includendum*, capable of including heterogeneous phenomena, analyzable by methods that accept the distinctive elements of the differing forms of regulation of transactions.

FROM ART TO THE ARTS: THERE AND BACK

My use of the double plural "arts markets" was not motivated just by a desire to recognize the existence of multiple interpretative models, but also by a decision to extend the perimeter of research to types of goods and services that go beyond the borders of the triad of Vasari's *arte*

del disegno (painting, sculpture, architecture), which economists and some economic historians have accepted tacitly, affirming that they are not qualified to define what is "art." I do not believe that this devotion should remain unjustified, but contest its basis. This attitude prejudices the possibility of putting our knowledge and competence to work to verify some art-historical theses and to suggest rereadings closer to historical evidence. I do not arrogate to myself the right to supply a reasonable answer to this question that has been debated for centuries by brains more refined than mine, but I cannot evade my duty to explain what I have included in the area of study and my motives for the inclusions, since I do not think that the study of art markets should limit itself to a couple of Titianesque masterpieces or a bronze by Giambologna. The artistic presence, broadly speaking, has permeated Italian society and culture in forms so diffuse as to require a broader reading that attempts to account for the articulation, extension, and superimposition of these relationships. This methodological choice has necessarily determined the inclusion of genres that for a long time were considered extraneous to the art world and relegated to the peripheral domains of luxury or sumptuary, minor, applied, useful, sister, or decorative arts when the phenomenon has been perceived from the consumers' point of view, or in artisan limbo when the producers' interest was prevalent. These are terms that I too have used to facilitate argument, but they remain for the most part elusive since "luxury is every expense that exceeds the necessary,"[39] but the "concept is clearly one of relations and acquires a tangible content when one knows what is meant by "necessary." Since beyond comfort there are degrees of wealth considered licit, one defines luxury as that which is beyond this accepted limit: the entire problem lies in the nature of the limit between what is proper and what is excessive."[40] The relativistic nature of the concept of luxury, charged with moral weight, can allow us to forget that in some social *couches* the possession of mirrors and musical instruments, statues and antiques, medals and cameos, paintings and engravings, jewels and crystal, majolica and bronzes, stucco and inlay, tapestries and rugs, silver and ceramics, richly worked leather and precious furnishings, arms and books answered to a categorical imperative. These were necessary for the preservation of honor, and indispensable in maintaining precise models of self-representation, which one could not avoid without being censured by one's peers, and the same considerations held for the great range of "services" such as festivals, banquets, concerts, theater spectacles, etc. Equally, the "sumptuary arts" or "precious arts," terms still widely in use, do not mean anything specific, as they do not connote any specific thing or identify classes of objects or hierarchies of value, but instead a heterogeneous group of things having in common their being "very costly" or having "great cost": an oil painting by Van Eyck or a diamond necklace, a sculpture by Michelangelo or a blanket for a cardinal's mule, a cameo from the Hellenistic era or a *faïence* viola.

To try to put an end to these doubts, I have decided to retrace the stages of the debate that came of the coeval hierarchization of artistic forms, and from the actual conceptions of what the state of art was. A necessary passage, since these acquisitions represent the tormented results of centuries of discussion that were often held in eras later than those contemplated in my text. The rigid opposition between *liberal* and *mechanical, major* and *minor* arts, the *mind* and the *body, useful* and *not useful,* as indeed the borders of the domain of the figurative arts, *fine* or *visual,* are the contributions of later aesthetic theorizing in which one can perceive history and verify a chronology, avoiding the error of ascribing to earlier eras categorizations and methodologies conditioned by our sensations that are still post-Romantic, permeated with idealism and influenced by nineteenth-century currents.

This is neither an exercise in style nor a historical overview, but a necessary step in proving that the actual separation, clearly subordinating, between art and craftsmanship is the result,

even controversial, of a red-hot argument marked by opposing positions and an irregular progression. The question was posed by Paul Oskar Kristeller in two articles published in 1951 and 1952 in the *Journal of the History of Ideas* in which, with his usual elegance, the German thinker recognized: "It is known that the very term 'Aesthetics' was coined at that time [the eighteenth century], and, at least in the opinion of some historians the subject matter itself, 'the philosophy of art,' was invented in that comparatively recent period and can be applied to earlier phases of Western thought only with reservations."[41] This invitation to caution on the part of the scholar from Berlin underlines the fact that the dominant concepts in modern aesthetics of taste, sentiment, genius, originality, and creative imagination did not take on their modern meanings before the eighteenth century, the same period in which the fundamental distinction was made between "The term 'Art,' with a capital A . . . in its modern sense and the related term 'Fine Arts' (Beaux-Arts)."[42] Only in that moment: "With the aim of distinguishing them from the more practical arts that produced useful objects . . . the *belle arti* (*les beaux-arts, the fine arts, der schöne Künste* including painting, sculpture, architecture, music, and poetry) were subtracted from the general 'arts.'"[43] Despite this dating, the idea that the five fine arts have always constituted a closed and affinitive group, clearly distinguished from the crafts, from the sciences, and from other human activity, "has been taken for granted by most writers on aesthetics from Kant to the present day,"[44] notwithstanding that it was clear that only at the end of the Seicento "'Art' and 'artisan' had become opposite; 'art' now meant the creator of works of fine art whereas 'artisan' or 'craftman' meant the mere maker of something useful or entertaining."[45]

The frequent misunderstandings come from the polysemous nature of the word art (Latin *ars*, Greek τέχνη). It conserved up to the end of the seventeenth century the possibility of variously identifying an ability, a job, a profession, a theory, a treatise, a method,[46] a collection, etc. Multiple signifiers only partially related, but in any case broader than what would be later attributed. In particular, in the most common sense, the term designated an *ability*: manual (and hence the sense of *craft*) intellectual or spiritual, that as such could be learned, refined, and taught. For these reasons, art was normally contrasted to *ingegno* (*ingenium*), which was not yet identified with the proto- and post-Romantic "genius,"[47] but with innate talent, tied to inventive abilities and to fantasy, gifts that instead could not be assimilated or transmitted: "As ars was the skill or competence that was learnt by rule and imitation, so ingenium was the innate talent that could not be learnt."[48] And thus follows the constant presence of the binary, so that "By 1400 to praise a man for his *ars*, simply, was not much short of suggesting that he had no *ingenium*, and so the binary *ars et ingenium* or some subsuming word like *scientia* is almost always the thing that is praised"[49]: In the greater part of Quattro-Cinquecentesque texts, the combination "*Ars et ingenium*, or ars et natura or artificium and ingenium or manus et ingenium"[50] became one of the more recurrent motifs. According to these dictates, at least until the end of the seventeenth century, "art" could be manifested in various forms, not necessarily "figurative" or "visual" (we must not forget the relatively recent origin of these terms), and in various contexts such as crafts, learning, sciences, or techniques.

Nevertheless, still identifying manual ability, the term remained connected to productive sectors in which "the Arts" operated (as a synonym of corporation or guild), institutions that united and represented, identifying their bearers of capabilities, called *artefici* (artificers; from *artifex*) or *artieri* (artisans). These, through manual labor (*opus*) produced "artifacts" and "works," and these nouns denote the executive/operative matrix of the processes, so much so that the vernacular form of the Latin *opus*, work, was still used in Italy in the Ottocento to

refer to the workday of the *operai* (workers). Given these premises, one may intuit how painters, sculptors, and architects, the modern "artists," could be referred to in this way in rare cases, as the more common term was "artificers," the same term that qualified, or disqualified (according to one's point of view), the artisans, the lowly "mechanics."

This could be surprising, since in our contemporary imagination the word "artist" is inseparable from the coeval concept of "art," two notions that are presupposed to be an eternal constant, translating backwards from more modern ideals and expectations that have made us forget that in the early modern era, the "artist" was considered an artisan, and that up to the late Quattrocento goldsmiths, glassblowers, embroiderers, and illuminators were valued more highly than painters and sculptors. As late as 1681, in his *Vocabolario toscano dell'arte del disegno*, Filippo Baldinucci attributed the senses of "artificer, craftsman, artisan, maker of art"[51] to the word "artist." This evidence has often been forgotten, for such is the force of the artistic myth—sometimes mythomania—despite the fact that serious scholars[52] have explained the forces and dynamics that informed the construction of a heroic magic and legendary artistic identity whose anecdotal nature—genius-like, off-putting, melancholy, wild, saturnine—has been the artificial fruit, re-elaborated over time, of partial reconstructions and prejudiced invention.

Unfortunately, having before our eyes the damned faces and furious stares of many twentieth-century artists caressed by critics who have long since lost their subversive credibility and are even sympathetic in their revolutionary claims, it can be difficult to believe that the artist as recently as the nineteenth century could be a satisfied bourgeois or honest craftsman, as modest as some artisans or as wild as others: de facto, with all necessary distinctions and more often than one might suppose, a craftsman.

If this contestation is valid for periods so close in time, it is no wonder that the first title suggested by Giovio to Vasari was *Vite degli Artefici*, and that the polymath Aretine mind, in the Torrentini and Giunti editions of his *urtext*, used the term "artist" only in citing the first two lines of a sonnet by Michelangelo, who, parenthetically, was called greater "artificer" by the Florentine Academy of Design, established in 1562.

Similarly, in the tables of the "names of the artificers" and the "names of some moderns excellent in their arts," attached to the late Cinquecentesque treatises of Lomazzo,[53] one finds, beside painters, sculptors, and architects, "mathematicians, engravers of prints, and wood and copper and iron, goldsmiths, coiners of medals, turners in the round and statuary, machinists, embroiderers (male and female), modelers, illuminators, masters of filing, inventors of burnishing of iron, carvers of iron bas-relief, experts in the art of duplication, carvers of cameos and crystal, clockmakers, stone-carvers, inventors of hydraulic organs, burnishers of stones, founders, stucco workers and tapestry makers," underlining the proximity, and even close family relation, that united the "artists" of today to the "artisans" of yesterday.[54]

THE ARTIST: "LIBERAL" OR "MECHANIC"?

The rare appearances of the term "artist" can also be attributed to other causes. At the beginning of the fifteenth century, the word still expressed the meanings recognized in medieval and ancient sources, identifying both the artisans and university students in whose *curriculum studiorum* was included the study of the seven "liberal arts" (the Latin *artes liberales*, the Greek ἐγκύκλια), codified by Marcianus Capella in the fifth century.

In early Trecento, the Capella canon underwent some revisions, and the scholastics added the teaching of perspective to the *quadrivium* (this was not yet the scientific kind or *perspectiva artificialis*, but *perspectiva naturalis* or *communis*, the equivalent of Greek optics and thus a branch of the natural sciences that had no immediate relationship to pictorial representation), while in the following century the *Studia humanitatis* increased the number of disciplines and contents of its programs, with the addition of history, Greek, eloquence, moral philosophy, and *poesia* (the ability to write verse in Latin and understand ancient texts).

In this program, there is no trace of painting, sculpture, or architecture, while music was a theoretical subject and poetry was not easily separable from grammar and rhetoric, even if the absence may not be ascribed to an uncontested disdain as some historians have insisted.

In truth, in virtue of the proofs adopted, it is difficult to disregard Emma Simi Varanelli's arguments demonstrating that "Already in the early Middle Ages there is in play a complete rehabilitation of mechanics, like that in the twelfth-century writings of Guglielmo of Conches and Bernardo Silvestre, of the followers of Ugo of San Vittore and the Arabic philosophers, effecting a real and true theoretical reevaluation of the *artes mechanicae* as arts or *scientiae ingegnosae* having as their end the usefulness and well-being of humanity, have transmitted this doctrine to the Dugento—the era of Scholastic splendor—and how finally this century, heir to the positive appreciation of the working world and human industry, was also its perfecter, restoring dignity to the fine arts."[55]

From the beginning of the twelfth century, the *artes mechanicae* had in fact made notable strides forward after the attempt in the first half of the century by Ugo of San Vittore, who counterposed seven *mechanical* arts (lanificium-making wool, armatura-armaments, navigatio-navigation, agricoltura-agriculture, venatio-hunting, medicina-medicine, theatrica-theatrics) to the equal number of *liberal* arts, attributed to them the classification of *scientiae*, and placed them side by side with the theoretical (philosophy, physics) and practical arts (politics and ethics). Under this arrangement, architecture, painting, and sculpture were part of "armatura-armaments," along with other crafts that in the earlier Vittorian classification were more pejoratively called sordid or vulgar arts (artes sordidae or vulgares).

In Ugo's wake, Goffredo di San Vittore also took up the reevaluation, followed by Onorio of Autun, who brought physics, economy, and mechanics up to stand beside the seven "liberal" arts, the same *mechanica* that Vincenzo of Beauvais had promoted in his tripartition of knowledge to stand beside theoretic philosophy (*theorica*) and moral philosophy (*practica*) while other more daring proposals were not lacking. Thus Robert Kilwardby and Domenico Gundisalvi suggested placing architecture and medicine among the liberal arts, while *theatrica* was defended by Bonaventure, Thomas of Aquinas, and Remigio.[56]

In light of these precedents, one can see why, as Simi Varanelli notes, "In enlightened medieval theory, like Aquinas,' there is no perceptible disdain towards manual work and there is no proposal for distinctions of rank. In these there is instead a tendency to demonstrate exactly the opposite, that is: that the mechanical arts have their *architectores* and that the inventive or creative work of these learned *artificers* is to be recognized and be valued equally with that undertaken by the masters of the liberal arts."[57]

However, the theological proofs of rehabilitation were opposed by the more orthodox interpretations of Aristotelian writing that considered work that was recompensed, manual, or productive of "useful" objects to be degrading (specifications that in theory should not have touched on painting, sculpture, and architecture, whose *pulchritudine* had already been recognized) and had persuaded St. Thomas of Aquinas to follow the Stagirite and affirm that the arts producing useful objects by manual labor remained mechanical or servile.[58]

This judgment was coherent with the classical tradition,[59] given that Plato and Aristotle had established a ranking of human activities that was based on the progressive degrees of detachment that distinguished the jobs that caused *mental fatigue* from those resulting in *bodily fatigue*, typical of those who are servants or slaves. In this framework, painting and sculpture could not escape from demonstrably negative judgment, since, as noted by Wladyslaw Tatarkiewicz, "The historian is tempted to believe that the ancients faced all reasonable possibilities of classifying the arts except the division into fine art and handicrafts."[60] Thus the lowliness of manual labor and commerce, not held in great esteem either by the later *auctoritates*, as one may see in passages from the *Lives* of Plutarch and others, such as Cicero and Seneca and on up to St. Augustine.

When the ancient sources were discovered and translated as early as the Trecento, these theses found convinced elements among the laity who were interested, for easily understood motives, in proving the social inferiority of artisans and criticizing those who practiced merchandising and exchange, the columns on which rested the fortunes, and not just economic, of many ordinary Italians.

In light of this evidence, it is easier to understand why the concept of the relationships between the *Arts* and the *arts*—interpreted according to the late Seicentesque scheme of the *Fine arts* and with an obvious misinterpretation of the original meanings[61]—require recontextualization. Faced with these testimonies, it is difficult to deny that "When we consider the visual arts of painting, sculpture, and architecture, it appears that their social and intellectual prestige in antiquity was much lower than one might expect from their actual achievements or from occasional enthusiastic remarks which date for the most part from the later centuries."[62]

PASSED, FAILED, AND REPEATED

The condemnations of the late Middle Ages were, however, impugned from mid-Trecento even by the laity (consider Boccaccio's praise of Giotto, or that of Petrarch for Simone Martini), who encouraged the emancipation of painting, sculpture, and architecture from the mechanical arts, invoking a recognition of the desired qualification of "liberality" that would have legitimated the intellectual and social claims of their practitioners. After praise by Dante, Petrarch, and Boccaccio, one can find further perorations in the late Trecentesque and Quattrocentesque writings of Filippo Villani, Leon Battista Alberti, Lorenzo Valla, Bartolomeo Fazio, or Poliziano, who stretched his exegesis of the less hostile classical sources such as Pliny, Galen, or Philostratus and overlooked contrasting opinions, suggesting the promotion of painting in virtue of its affinity to poetry—with a convenient distortion of Aristotelian, Oratian, and Plutarchian sayings, synthesized in the motto *ut pictura poesis*—and backing himself up with a line of argumentation followed since the end of the sixteenth century by treatise writers such as Bernardino Daniello, Paolo Pino, and Ludovico Dolce.

Equally, and in parallel, there was the road that led to "liberality" by way of recognition of the scientific character of artistic activity, backed by the ties that united painting to "perspective" (pointed out in the *Paragone* with which Leonardo's[63] students asserted its superiority over poetry, music, and sculpture) and architecture over arithmetic and geometry (with still traceable arguments from the translation that Daniele Barbaro did in 1556 of Vitruvio's *Ten Books on Architecture*). Given the resistance, later Cinquecento demands for emancipation based their claims on the intellectual character of the ideational process, creating a break

between the nobility of *inventio* and the ignominy of making, which reflected the more ideological than social mismatch between ideation and doing, thought and practice.

This is obviously a summary reconstruction that pales beside the works of Paola Barocchi,[64] but in any case serves to show the pertinacity with which the end synthesized by Robert Williams is pursued: "Art ceases to be a well defined technique or set of techniques, a *techne*, and becomes instead a master technique, a *metatechne*. Its scope and power grow, but it also becomes more problematic—vastly, indeed, essentially problematic."[65]

Tenacity did not always pay, and the above-mentioned pseudo-Leonardesque[66] *Paragone*, far from pacifying spirits and determining a serene acceptance of paintings' candidature, stirred up old diatribes aimed at weakening other pretenders; the promotion of painting that the Maestro from Vinci hoped for in fact presupposed the failure of sculpture ("work derived from physical force but weak in intellect"), since the sculptor "produces his work by very mechanical labor, often accompanied by sweating which mixes with the dust and turns into mud, so that his face becomes white and he looks like a baker,"[67] a judgment that echoes in the denial of Michelangelo: "I was never either painter or sculptor like those who set up shop for that purpose. I always refrained from doing so out of respect for my father and brothers."[68]

Similar arguments recur in other works of a broadly similar nature, from the *Maggioranza delle Arti* by Benedetto Varchi, 1546 (which, of the three, places architecture at the top given its "nobility of purpose"), to the *Dialogo di Pittura* by Paolo Pino of 1548 (where the palm of victory is assigned to painting), up to the edition of Vasari's *Vite* of 1568, which tried to solve the question by proposing a shared, noble ancestor in drawing. Nevertheless this attribution of paternity left the flanks unprotected against other attacks (the birth of goldsmithery from the same loins), and did not dissolve the tensions between excellent artists who, according to Lomazzo in 1584, deserved admission to the circles frequented, *ça va sans dire*, by lords and gentlemen, and the desperate ones who "pushed by poverty, and with the sole objective of earning their bread, do no more than muck up the walls, temples and panels all day long, shaming this noble art and disdaining the knowledgeable men who see and consider such painting."[69]

The aftermath of these polemics did not die out with the end of the Cinquecento, but carried over into the following centuries, during which the defining distances between art and craftsmanship, between historic courses and recourses, become shorter and broaden into more significant terms. Ferdinando Bologna has written exemplary lines on the subject, confirming the cyclical return "the making, that Croce had re-depreciated as an extrinsity of the accessory"[70] of the primacy of the *idea*, and underlining the conditioning that Italian scholars were subject to "fomented by the aesthetics and history of Benedetto Croce, neo-idealist in formation but DeSanctisian in his concern to avoid overly rigid generalizations; and on the other hand not without open contrasts with Crocian aesthetic itself, especially where this insisted on the "idealistic" mode in the ever theoretic reduction of productive processes to purely accessory events."[71]

In reality, in the centuries preceding Croce's sentences, idealism did not always have the best part, or at least not in Italy. From time to time it met contrasting ideas, from the polemics of the late Cinquecento on the dignity of alchemy (celebrant of the virtues of technique and mechanics) to the Caravaggesque break, from the functionalistic doctrines of early Settecento to the encyclopedic reevaluation of the "useful" arts and manufacture, in a stormy climate in which the position of the most highly considered was challenged by the appeal of techniques that ennobled the most common of everyday objects, from cabinetwork to goldsmithery, silver to porcelain. Thus, under the heading *Fine arts/Arts*, Diderot judged the mechanical arts

to be subordinate to the liberal: "A prejudice that tended to fill the city with proud thinkers and useless contemplators, and the countryside with little ignorant, lazy, disdainful tyrants . . . Place on one side of the scales the real advantages of the most sublime sciences and revered arts, and on the other the mechanical arts, and you will see that the respect for the one and the other has not been distributed in proportion to the advantages."[72]

But praise for manual skills and attempts to restore dignity to craftsmanship and crafts continued even after the sunset of the large manufactures of the century of the *Porzellankrankheit*, through the reforms promoted in England by Cole, Jones, and Redgrave, or the Arts and Crafts Movement inspired by Ruskin and led by Morris.

These tendencies demonstrate that the acceptance of the "artistic craftsman" is quite recent, since as one of the world's greatest experts, Alvar González Palacios, has noted, "The custom of calling all these artistic creations applied arts began only in the middle of the last century [the nineteenth], that is, in the time when the great national museums were being created and in Europe enormous international exhibits of ancient and modern art works from every country were being organized. In French, using good common sense, the *applied arts* were called *arts décoratifs*—decorative arts—while in Italy, where academic preconceptions have always prevailed, an almost denigrating expression was chosen, *minor arts*. The Germans, symptomatically, preferred to use the term *Kunstgewerbe*: industrial arts . . . all these terms are mutually contradictory."[73]

Observing these tensions, George Kubler was led to affirm in 1961: "The seventeenth-century academic separation between fine and useful arts first fell out of fashion nearly a century ago. From about 1880 the conception of 'fine art' was called a bourgeois label. After 1900 folk arts, provincial styles, and rustic crafts were thought to deserve equal ranking with court styles and metropolitan schools under the democratic valuation of twentieth-century political thought. By another line of attack, 'fine art' was driven out of use about 1920 by the exponents of industrial design, who preached the requirement of universal good design, and opposed a double standard of judgment for works of art and for useful objects. Thus an idea of aesthetic unity came to embrace all artifacts, instead of ennobling some at the expense of others."[74]

These last lines of Kubler's evoke the Bauhaus-like attempt to recompose, under the sign of architecture, the separate destinies of art and craft in a total work of art and overcome the class distinctions that, according to Walter Gropius in 1919, still erected arrogant barriers between the artist and the craftsman. The opinion was used by the movements asking for increased integration after the Second World War, and today is more than ever at the center of debates on aesthetics and artistic quality.

THE PITFALLS OF GENERALIZATION

In my reconstruction, I have emphasized disagreements and discords for methodological, not ideological, reasons. In fact I do not intend to contest that "Just as Italian society (in some regions) had gone further towards the social acceptance of the merchant than most of Europe had, so it was in Italy that the status of the artist seems to rise furthest,"[75] or minimize the testimony of respect and great honors, noble titles, and sumptuous gifts received by the top ranks on the artistic scene.[76] I am, however, in disagreement with the encomiastic tendencies of certain historians who have exhausted us with their praise of the elevated social status and intellectual prestige of Italian artists,[77] which bases itself mostly on literature and treatises and

uses sleight of hand on a single miniscule group of examples. In fact, while some of these artists came from families of a certain standing (Brunelleschi, Masaccio, and Leonardo were sons of notaries, Michelangelo of a magistrate), there are contrasting signs that should not be ignored that denounce, even in the golden proto-Cinquecentesque phase, the difficulties, poverty, and competition that negatively influenced the evolution of artistic careers, and that were exacerbated between the seventeenth and eighteenth centuries.[78]

These apparently counter-rhetorical notes fed the twentieth-century mythography that hungered for creative desperation (the black misery of Perin del Vaga, the hunger of Vasari and Salviati, Taddeo Zuccari who ruined his health by sleeping on the ground, etc.) and recommended not raising the fortunes of the few to a common level, given the indigence suffered by a multitude of painters and sculptors. Even in 1564 Giovanni Andrea Gilio lamented the decadence of painting "today reduced into the hands of poor and ignorant folk . . . that a nobleman would be ashamed to practice that art for a living."[79]

The greater dangers are not in overestimating the fortunate destinies of dozens of painters, sculptors, and architects, but in the lack of consideration for the artisans and small interest in the lives of tens of thousands of honest wielders of brush and chisel. We must not be careless of the artisans who—for talent, relationships, wealth, reputation, and number of dependents—did not cut a fine figure when compared with the "celebrities" of the fine arts.[80] In respect to this second danger I confess I am more interested in the part of the iceberg that is submerged than in its shining pinnacle. Whoever wishes to study social history or intends to use the models of sociology of professions must not trust or be content with using meager or distorted samples selected by critics known to be partial. The 313 painters and sculptors from 1420 to 1540 studied by Peter Burke, extracted from the chapter "Italian Art" in the *Encyclopedia for World Art*, are too few to let us infer generalized conclusions.

Sources familiar to economic historians and historic demographers provide useful information for contrasting pseudoscientific waywardness. If we look only at painters in Padua between 1441 and 1465, there were more than 50[81] registered in the statutes of the guild; in Milan around 1500, there were more than 100[82] active in contrast to 240 counted between 1565 and 1631;[83] in Brescia between 1517 and 1548 there were 91 individuals[84] inscribed in tax rolls as painters. In Florence between 1480 and 1561 there has been found a presence of 101 illuminators, 441 painters, more than 300 goldsmiths and 50 sculptors,[85] with 36 professions connected with artistic production;[86] in Verona there were 36 members of the Arte in 1616;[87] in Piacenza there were seven in 1647;[88] in Venice between 1530 and 1657 there were 1,415 members of the painters' guild,[89] and no fewer than 350 were active in the Settecento,[90] while in 1762 the members of the so-called artistic guilds were 3,161.[91] In Rome in 1708 the Accademia of San Luca had 32 members and there were 127 gilders and painters.[92] From the list drawn up around 1675 of painter's workshops, sellers of paintings, second-hand shops, *coronari* (rosary makers) and gilders who sold paintings in Rome, there were also 178 intermediaries,[93] who were flanked in the Seicento by sellers of canvases and colors, mercers, barbers, and tailors,[94] and in the following century by bankers, hosts, innkeepers, excavators, porters, apothecaries, embroiderers, plaque engravers, stone carvers, carpenters, framers, and stucco workers.[95]

These numbers are partial and purely indicative, and understate the true quantity of workers active because of corporate emancipation, professional mobility, court privileges, and the large number of foreigners and irregular workers. Nonetheless these figures urge us to refrain from drawing general conclusions from the affairs of the few, usual, known. In the first forty

volumes of the *Allgemeines Künstler Lexicon*,[96] the most prestigious biographical dictionary of artists, from the first six letters (from A to Fitzner), to the entry *Maler* (painter), there are more than 13,500 Italian names, and the final estimate exceeds 50,000.

Equally, if in some cases the painters possessed autonomous representative organs as at Padua, they were more often included in other guilds: until 1569 in Bologna they belonged to the same corporation as the sword makers, the makers of *bombazine*, paper and saddle makers; in Florence until 1572 they were with the doctors and apothecaries, while sculptors and architects clung to the builders' groups; in Naples until mid-Seicento they coexisted with gilders, decorators of playing cards, illuminators, and *rotellari* (wheel makers),[97] underlining the condition of the majority of artisans. The *Motu proprio* with which Paul III satisfied Michelangelo's request to emancipate the sculptors from the obligation of inscription in the corporations is from 1540, and the same privilege was granted to Florentine painters, sculptors, and architects members of the *Accademia del disegno* by Cosimo de' Medici in 1570—while in Venice only on 31 December 1682 did the Senate permit the painters to establish their own college. Until that time, the art they belonged to was divided into various subgroups, including painters (also called figure painters); the painters who worked with furniture and on wood; those specialized in working on shields, arms, and signs; the decorators and builders of *cassoni* (chests); the draftsmen who created motifs for embroidery and fabrics; the leather gilders who worked the famous enameled, gilt, silvered, punctured, and painted leathers; the illuminators and calcographers who produced colored molds; the gilders; the mask makers; and the paper makers who made colored playing cards.[98]

Further proofs emerge from contracts, apropos of which Francis Haskell observed that "Even if tastes and patrons changed, the system overall remained unchanged until about mid-Settecento, in respect to the century before. Above all in Italy, one does not see a notable difference between one written in the Middle Ages and one from 1750."[99]

ECONOMIC COUNTER-DEDUCTIONS

The rationale of the discrimination that divided the arts into greater and lesser has not been confirmed by the economic evidence that, to the contrary, gives it the lie: painting and sculpture, while monopolizing 95 percent of studies on art markets, only accounted for a very small part of the related expenditures. I know of the booby traps and pitfalls hiding in inventory sources, but nonetheless I find that in the inventories of Piero di Cosimo (1456, 1463–64, and 1465) and of Lorenzo di Giovanni de' Medici (1479) published and annotated by Marco Spallanzani,[100] the pictorial and sculptural works were not included, even though the evaluation concerned *panni lini* (linen cloths), drapes, clothing, sheets, silver, jewels and the like, covers, fourteen types of books, damasks, tapestries, and bedclothes, jousting arms, parade, battle, and single arms, musical instruments and hunting nets, whose valuations are not surprising: one shoulder buckle was 5,000 florins,[101] a crystal goblet with precious stones 700,[102] a unicorn horn with a gold band 1,500,[103] and a volume of Plutarch, 70.[104] The absence could be assigned to various causes, but the fact remains that in the same arc of time, few "paintings" would have been valued at more than the little Plutarch. This was determined not only by the cost of some raw materials or the cultural undervaluation of painting: if today the paintings of the old masters have astronomic prices compared to other types of collections, it does not

follow that the same hierarchy existed in the past, even in the more recent past. Gérard Labrot, using a sample of twelve thousand paintings extracted from 641 inventories discovered that in Naples, between 1640 and 1740, an average painting was worth 1 ducat, 4 *tarì* and 6 *grana*, a figure that fell to 1 ducat, 1 *tarì*, and 7 *grana* between 1711 and 1764, an important drop of 32 percent.[105] In mid-Seicento Rome, in Domenico Sartorio and Lorenzo Donato's shop "the paintings with figures cost a *scudo* or so, the heads five *giulii*, or just half, and still lifes eight *giulii*, probably like the landscapes."[106] In a similar manner, Renata Ago has determined that often the frames were more costly than the paintings: from seventy-five of the inventories she has studied, she has found four series of 30, 26, 36, and 43 paintings, the average values of which were respectively equal to 1.09, 1.37, 2.81, and 5.44 *scudi*.[107] These prices are quite low, and confirm the existence of "paintings at all prices, from less than a *scudo* . . . to ten, twenty, fifty that could find their way into the most varied households, of boatmen, pasta makers, bakers, doctors, perfumers, lawyers, and merchants."[108]

Nor was this a transitory phase, since even in the Settecento there was a predominance of pictorial production "semi-serial as opposed to the unitary values of a handful of tuppence, less than a velvet or taffeta curtain, or tack for a horse, or a sack of white flour or a few pounds of meat."[109]

Even in the Este, Gonzaga, Farnese, and Savoy documents that I have examined, the economic value of paintings and sculpture, except rare cases and not counting ancient statuary, was still singularly low in mid-Settecento. The Seicentesque records mentioned by Richard Goldthwaite[110] (the 10,000 ducats paid by the king of Spain at the Stuart sale for a work by Raphael, or the more dubious 7,000 ducats spent by Spinola in 1650 for a Veronese) remain modest when compared to other types; a carpet, a suit, a belt, a beret, a sword, a little panel, a *consolle*, a bed, a soup service, an oil cruet, an inkwell, a saddle, a falcon, a horse—just to name a few—could cost infinitely more. The most expensive portrait by Van Dyck (452 liras) cost less than a quarter of a dress for Paola Adorno Brignole.[111]

These are not bizarre or fanciful cases circumscribed by Quattro-Cinquecentesque glitter: Vincenzo I Gonzaga, who purchased the *Madonna della Perla* from the Canossa in exchange for the fief of Cagliano in the Monferrato, with the title of Marquis and related income, for a fabulous price of fifty thousand *scudi*, assuming that our Ottocentesque source is honest,[112] is not an example, since this is the same person who in a week's time in 1589 lost 15,630 liras playing cards. On 28 January were given "to his most illustrious S.r Hercole Gonzaga, as owing from His Highness, won playing, *ducatoons* 600, which makes liras 3,630," while on 7 February were paid out "to S.r Count Pirro Viante *ducatoons* 2,000 of 6 liras 6 each won by His Highness."[113]

Moreover, even taking into consideration the famous Gonzaga collections, one finds similar valuations. The equally incomplete[114] inventory published by Raffaella Morselli[115] between 1627 and 1628 set the estimate at more than 20,000 pieces, among which were 1,358 paintings. These were valued in nine days and for a total of 80,428 liras. The most important works by Titian and Giulio Romano were valued at 600 liras each, while Raphael reached 1,200, Correggio 600, Mantegna 900, Andrea del Sarto 900, Palma il Vecchio 150, Federico Zuccari 480.

Nevertheless, skimming the pages of the volume, we see that a pearl necklace was valued at 50,000 liras,[116] a golden *centiglio* 60,000,[117] "a large diamond *taura gropito, scantonato sopra un cantone, legato in panizzola d'oro*, and another large diamond with no base, also *scantonato* by a *cantone*, and mounted like the former" 120,000,[118] a *gianetta*-style tack for a horse, 20,000.[119]

To the 1,358 pieces in the Gonzaghesque gallery were attributed a total value of less than that of one single mounted diamond, a fact on which it is necessary to dwell. Even if one doubts the "expertise" of the experts, it is true that Duke Carlo I of Nevers between 1628 and 1630 sold about 90 paintings, 191 busts, statues, and heads, and other objects for 68,000 large ducats, or the equal of about 680,000 Mantuan liras, of which the statues were the most valuable part.

One might suppose there had been an initial underestimation, but in any case I believe that the opinion of Mr. Giulio Campagna, head of the Wardrobe of jewels and paintings of the court of His Majesty the Duke of Mantua, is more convincing. In 1631 he judged the damage of theft and destruction brought by the sack[120] of the Gonzaga residences the year before to be 18 million liras. This total lessens the scandal of the sale held between 1628 and 1630, whose 68,000 large ducats correspond to 0.037 percent of what was lost in the months in which the imperial soldiers held sway in the city of Virgil.

Other proofs can be brought for the same and successive periods. If in the arc of twenty-nine years, from 1605 to 1633, Scipione Borghese invested only 0.49 percent of his income in painting and sculpture, less than a third of his charitable[121] spendings. The 1694 inventory of the Brignole-Sale gallery showed an evaluation of 20,000 ducats, while in the division for the heirs in 1717, which included the domestic furnishings, it represented only 13 percent of the sum, including the furniture, wall hangings, and silver.[122] Nor was this an Italian affectation caused by a surfeit of supply: Cardinal Richelieu, owner of one of the most famous French painting collections, considered that his 250 paintings were worth 80,000 *livres*, compared to the 90,000 of one piece of silver and the 250,000 of a devotional article.[123]

These examples find innumerable confirmations in the primary sources. Leafing through the pages of a Quattro-Settecentesque daily account book, one discovers that a cabinet maker could earn sums that few painters ever saw, and a carver of hard stones, an armorer, a lute maker, a glass blower or clock maker received compensations greater than many sculptors. Still in the Settecento, as Alvar González Palacios notes, "David Roentgen—the great German cabinetmaker—accumulated a considerable fortune . . . the turners of ivory had a reputation of being nearly sorcerers, while the "mysterious" ones who knew the secrets of porcelain were searched out by the sovereigns of all Europe."[124]

Many artificers turned their talents to the most disparate sectors, and technical and material eclecticism was common for reasons that go beyond the mere utilitarian calculation that "anything goes," as it was the formative baggage of the best and brightest. From the analysis of the accounts of the Florentine shop of Bernardo di Stefano Rosselli, carried out by Alessandro Guidotti for the period 1475–1525, we see that there was a great production of paintings, altarpieces, devotional paintings, paintings on paper and parchment, tabernacles, and large fresco cycles, without overlooking the restorations and many interventions in one's own and others' works. Nevertheless the same shop, thanks to various collaborations, also produced candles (simply colored or gilt, with metallic parts added, images with floral elements, coats of arms, half-bust or full-figure images of saints), plaster figures (Madonnas and child; crucifixes; heads of Christ and Saint John; female heads; heads of Scipio, Hannibal, Augustus Caesar, and Nero; stories of battles; coats of arms—especially Medici); decorative painting for rulers, rafters, beams, and ceiling moldings bordered with leaves, olive leaves, swags of fruit, eggs, rosebuds, roses, daisies, poppies, saffron flowers, and motifs in all colors; beds, bedsteads, and footboards (with coats of arms, greenery, architectural ornamentation, and imitation marble); strongboxes (green, marbled, with grotesques and coats of arms); cages for parrots and other

birds; masks; fake fabrics and fabrics painted for *palios*; shop and hotel signs; mirrors; coin boxes for charities; plaques; large shields; canes; pea-shooters; breadboxes; balusters; and decorations for the entire house (balconies, walls, furniture, and other furnishings).[125]

The obsession with the virtues of specialization risks obliterating the joys of research and the pleasures of experimentation: Antonio del Pollaiolo and Verrocchio both practiced goldsmithing; Pollaiolo and Botticelli were interested in embroidery; Squarcione was a tailor; Giorgione made "gates for beds and closets"; Sebastiano del Piombo and Andrea Previtali decorated furniture; Cennini was both goldsmith and sculptor; while Leonardo, in the letter in which he requested entry into Ludovico il Moro's service, sung mostly of his talents as designer of bridges and vehicles, listing "in tenth and last place" that he also knew how to paint and sculpt. Giulio Romano oversaw the making of hundreds of domestic items (trays and light fixtures, bowls and andirons, cups and bellows)[126] and "all the mannerists . . . were madly in love with planning and making little bronzes, very refined articles in gold, crystal and decorated glass, and every kind of furnishing."[127] Cerano made do as stucco worker, and famous architects like Carlo Maderno, Carlo Fontana, and Borromini were interested in furniture and furnishings, while the cabinetmaker Jan Van Santen became Cardinal Borghese's favorite architect. Bernini paid attention equally to real and ephemeral architecture, paintings and mirrors, organs and harps, engravings and carriages, and amused himself with being head of a theater company with which he occasionally trod the stage. The list of crossovers in the following centuries, perfectly traced by González Palacios,[128] makes one think: Piranesi planned wondrous interiors; Solimena designed medals; Appiani collaborated with Maggiolini.

Thus it is not easy to understand the causes of the monomania for painting that—in virtue of the ingenuous equation, art = painting, art market = painting market, sustained by many economists and some historians—ignores undeniable historical data, the first of which is represented by the great number of places, surfaces, materials, and objects that could be painted.

At mid-Trecento, according to Cennino Cennini, a painter had to be able to paint on parchment, fabric (velvet, other silks, and wool), panels, walls, iron, paper, boxes and strongboxes, glass and windows, without overlooking "how one must draw on fabric or in cendal for the embroiderers," "how one must work horse covers, livery and jackets for tournaments and jousts," or "how one works in mosaics to adorn relics ; and of mosaics made of quills and eggshells."[129] After four centuries the list had lengthened immeasurably, since that noble art had been exercised on external and internal walls, windows and shutters, windowsills and balconies, ceilings and floors, fireplaces and stoves, doors and lunettes, curtains and screens, canopies and hangings, beds and *trabache*, cases and *cassoni*, birthing *deschi* and strongboxes, panels of all sizes, musical instruments and wall hangings (the famous *sughi d'erba,* fake tapestries painted on cotton or silk), wallpaper and playing cards, signs and flags, banners and standards, vases and chairs, cabinets and closets, coaches and carriages, arms and armor, tabernacles and funerary decorations, paper and stucco arms, lacquers and enamels, glass and stones, coppers and leathers, fabrics, papier-mâché, and even cages for songbirds.

Not always were the makers miserable decorators: "During the fifteenth century one can still find Botticelli painting banners and *cassoni* (trousseau chests); Tura painting horse trappings and furniture; Catena painting cabinets and bedsteads . . . in the sixteenth century Bronzino painted a harpsichord cover for the duke of Urbino,"[130] and in 1642 Poussin, writing to Cassiano Dal Pozzo from France, complained of "always being asked to do trifling things, that is, design a frontispiece for a book or ornaments for cabinets, fireplaces, book covers, and other stupid little things."[131]

Besides the plurality of activities, the frequency with which different artificers, painters, sculptors, and architects cooperated in realizing complex projects should be noted, and this is a reason why it is difficult to understand why the fragment of a modest polyptych panel painting should be considered a work of art when a *cassone*, a spinet, or a painted canopy with the same subjects and by equally talented hands should not be.[132] There could be the collaboration of six, seven, eight specialists or shops involved in the making of a wall cabinet, each responsible for separate elements, so that one does not understand why the cabinet in its entirety should be reputed a "high example" of craftsmanship when some components, from sculptures in bronze or ivory to miniatures on enamel and glass, can each be considered works of art.

It is therefore useful to ponder the good sense and correctness of some hierarchizations, since the economic data prove the existence of criteria of valuation that, above and beyond the value of raw materials, recognized the equal, if not superior dignity of products that are today overlooked or undervalued.

In this regard, apart from the undeniable success of a few "geniuses," one should not forget the effective social status and concrete conditions of life and work of the mass of painters and sculptors who only just managed to make ends meet, paid by the day or the job like other workers, and often earning even less. Even admitting that the hegemonic demands of the Florentine, Milanese, or Roman academies had some effect, the echoes of those demands must be kept separated from the concrete results.

Whoever expected that economic values could reflect and confirm historical-critical classifications can only be astonished or deluded by the empirical evidence: the pages of any Wardrobe register of the Cinque-Seicento reveal that a wall hanging, a suit of armor, a little bronze, a prie-dieu, an orange squeezer, a mirror, a clock, an armchair, or lamp could cost ten, one hundred, a thousand, or ten thousand times more than a painting or sculpture. In synthesis, from the economic point of view, rigid distinctions between Art (the fine arts) and craftsmanship were for the most part very weak and unfounded. In defending this statement, I may not pass over in silence the difficulties encountered in subtracting myself from the tare of my Italian historical and art-historical education, exclusively based on the triad "exemplary and mutually agreed."[133] It is an age-old burden, one that still conditions the viewpoints of educational programs: the profile of the craftsman drawn in the schools coincides all too often with that of the shoemakers, potters, knife sharpeners, and weavers of straw chair seats; in sum, of workers of no account who have survived, one does not know how, despite progress.

For these reasons, a study of the art markets has a deeper value: economic history can favor the bringing together of worlds both prisoner and victim of inveterate prejudices. Such operation is not meant to diminish or humiliate art, but to demonstrate that in many cases so-called craftsmanship was not lesser, and merits much more consideration and respect. Having decided to accord equal merit to the study of the *arts*, with no added adjectives, I have avoided the separation of genres and concentrated instead on their relationships, affinities, collaborations, exchanges, reciprocal influence, and points of contact. These let us identify the mechanisms of transmission and refinement of not just techno-productive knowledge, but also the vectors of propagation of models of consumption and styles of living, contamination of entire sectors of industry, processes of migration and professional formation, recruitment of human capital, the institutional forms of encouragement of innovation and of safeguarding copyright, etc., elements that are fundamental to a transversal and full historical treatment of the theme.

PLAN OF THE BOOK

Considering the merits and defects of the above picture, I hope that my reasons for structuring the book by themes will be clear. This is not, I repeat forcefully, a collection of essays, but the best way to circumscribe that which I continue to believe is an area of study that can be shared. I have posed the aim of reducing to common denominators questions that, however close they may be to each other, risk becoming victims of specialist flattery or of excessively rigid chronological subdivisions. Doing so would be a shame, since on economic themes alone the experts in the different sectors and periods run the risk of working in parallel and missing the opportunity to compare problems of common interest (from occupational impact to contract studies, from technological transfers to the politics of "pricing," to cite a few examples), even though the conditions exist for conducting diachronic analyses over the long term, national and international comparisons, and intersectorial studies.

Whoever concerns himself with Settecentesque *populuxe* or *marchands merciers* may find interesting points in the study of Quattro and Cinquecentesque patents. A scholar of Colbertian *ateliers* can find singular analogies in the manufactures of the Italian principalities of early Cinquecento, an expert of English or Dutch eighteenth-century auctions may be surprised by the Venetian Quattrocento version or those in Florence in the next century, a specialist in sixteenth-century architecture can find stimuli in late Cinquecentesque ephemera, and so on.

On the planes of both method and content, the points of contact and areas of intersection are so numerous as to call for the overlooking of corporate jealousies. Once beyond the pioneer phase in which the scarcity of literature and linguistic idiosyncrasies justified the prudent defense of fields that were not yet contiguous, today the proliferation of studies and sameness of interests push us in the other direction. It seems opportune to work on convergent axes.

I have set out seven chapters that cover a broad arc of time and a vast range of genres, touching various geographical areas and institutional arrangements, ranging over differing historical veins. They are based on heterogeneous primary sources, often unpublished (the research took place in about ten libraries and a half dozen archives, with a long and pleasant stay in the Public Record Office at Kew), and of varying document types (juridical, economic, customs, diaries, account books, treatises, correspondence, manuscripts, etc.).

In addition, I have tried when possible to treat the information using experimental methods. To do this I have created some databases that can be found on the Internet[134] and that I used in my study of the careers, occupational and economic impact, analysis of spillovers, contracts, and the flow of customs.

The principle that underlies the laying out of each chapter has been just one: to furnish a historically updated picture, offer an ample bibliography, and examine closely the four or five questions that seemed most apt to the development of future studies.

In building the plan of the volume and the sequence of chapters, I have tried to deal with the elements of an abstract "market," from time to time matching a single theme with diverse sectors. Thus, after this introduction, in the first chapter, "Historiographies," I have reconstructed the economic, historical-economic, and art-historical debates; in the second, "Psychology and Ethics of Consumption,"[135] I have traced the psychological, ethical, and behavioral outlines of "consumers" through the reading of ancient literature and medieval and modern treatises. In the third, "Demand Analysis,"[136] I have examined the structure and dynamics of the demand in some of the great courts between Quattro and Cinquecento; in the fourth, "Supply and Labor Markets,"[137] the job markets and the impact of occupation in

architecture between Cinque and Seicento; in the fifth, "Services," or the supply of ephemeral goods, professional and performative services between Cinque and Settecento; in the sixth, "Prices," the formation of prices in early modern history; while in the seventh, "The Laws,"[138] I have reviewed the legal debate about cultural heritage protection between Quattro and Ottocento, describing the mechanisms of provisioning and the flow of international commerce.

The parts are intimately related, and I hope may contribute to the re-conjoining of scholarly tribes seduced by the comfort of specialization. Study of the arts markets transcends the borders of their reservations, placing before us questions that are not secondary, but fundamental to the development of important and promising fields of research.

Historiographies

The Perspectives of Economics, Economic History, and Art History

ECONOMICS, ECONOMIC HISTORY, AND ART HISTORY

Only recently have the art markets become a field of study for various scholars, even though it was not easy to gain their interest, after decades of embarrassment and omissions that explain the disgraceful conditions in which these circles found themselves, that the nobility of art contrasted with vile commerce, echoing those warnings of the casting of the merchants from the temples of the beautiful and sublime. To explain this evolution, I have attempted to reconstruct the decisive moments of the three principal veins, beginning with economics, following that with the contribution of economic history, and then finally, art history.

In following the steps of the many scholars who have studied these arguments, one may not ignore the influence of the so-called "cultural economics"—a conjunction that would have seemed to be an unnatural oxymoron thirty years ago, a useless provocation in doubtful taste.

And yet, from the beginnings of the nineteenth-century democracies, the relation between economy and culture began to present itself in critical terms, as is witnessed by the apprehension on the part of those who were forced to think up technical solutions and rhetorical devices to fill the gaps left by the collapse of the institutions (royal academies or aristocratic and ecclesiastic patronage, to mention only a couple) that had for centuries, and splendidly, fulfilled their duties without worrying excessively about the economic reverberations of their projects.

It is however undeniable that the tumult of the nineteenth century redefined the agendas of the more perceptive thinkers, relegating the treatment of that unhappy nexus to an eccentric argument with respect to the epic transformations that were under way. With the sporadic exception of short texts and memoirs—mostly stemming from diverse traditions—such as the "merchandising" manuals, memoirs, or pamphlets of a physiocratic kind (one is reminded of the salacious polemic between Gerard Hoet Jr. and Johan van Gool,[1] the *Memoirs* of William Buchanan,[2] or the little treatise by Charles Roehn),[3] reactions ranged from indifference to intolerance rather than igniting particular enthusiasm in earlier economists.

In the world of utility and reason, of indigent masses and bestial need, of sensible demand and supply, there could be no place for art, or credit for artists, intellectuals, and poets. And the relation between the two opposing conceptions of the world was destined to suffer the

consequences of a mutual misunderstanding, as one can see from an examination of the undeniably emblematic Ruskin affair.

There has been an ongoing misunderstanding that John Ruskin was the father of the so-called "political economy of art," a mythical image that the British thinker would certainly have refused even if it meant patricide. In truth he did not work in favor of an irenic compromise, but moved from the art field to lambaste with Old Testament fury the immoral materialism of the classic economists, in line with other champions of Victorianism, from Coleridge to Jane Marcet, De Quincey to Harriet Martineau, Carlyle to Morris, Hole to Neale, and Ludlow to Maurice.[4]

From his point of view, art was not a trinket meant to drag a smile from the keepers of the "dismal science," but on the contrary, the divine force that would chastise those who idolized egotism and profit: not a redemptive light, but the lightning from heaven that would incinerate the nonbelievers. These were not pacific, but rather bellicose intentions, a question of life or death that placed mankind at a point of no return. Only by fully considering just what is at stake can one intuit why Ruskin spent his nervous energy and reputation in this battle whose victory did not bring the domestication of the economic Leviathan, but if anything the suppression of the monster, symbolized by Ruskin's choice of Saint George as patron of his crusade.

The arguments used to document the events—disastrous beginnings and posthumous triumph—of the economic and social thought of the "prophet of Brantwood,"[5] who exercised such a profound influence on the earlier social historians of art (such as Antal, Klingender, and Hauser), explain why his fate was so unhappy, given that the purpose of the graduate student and then Slade Professor at Oxford was not the constitution of a new branch of political economy but a criticism resolving it, capable of arresting the triumphal march of the Four Horsemen of the Apocalypse: Smith (who had begun a book on laws governing costume, arts, and sciences, but destroyed it before he died), Ricardo, Malthus, and Mill.

Ruskin assumed a much more uncomfortable position than that held up by a certain vulgate in search of an improbable justification, but important to the understanding of the later sometimes perverse development of the relations between the two disciplines, as one can see in the copious bibliography that after a long silence[6] has recently returned to a consideration of the question.[7]

From these studies, we see that Ruskin's interest in these problems manifested itself early, going back to 1847 but intensifying in 1857, the year in which in concomitance with the Great Art Treasures Exhibition (seen by more than a million people) in Manchester, he gave two public lectures, on July 10 and 13, that became the backbone of *The Political Economy of Art*, published immediately by Smith-Elder & Co.[8]

In this miscellany, Ruskin—who came from the friendly field of artistic-literary criticism, where he already enjoyed a certain status—approached new problems: the titles of the dissertations collected in this agile anthology (*Use, Accumulation, Distribution*, etc.) reinterpreted in a polemic manner the catchwords and articles of faith of the doctrinal corpus of that "so-called modern science of classical political economy"[9] that he returned to attack in *Unto This Last: Four Essays on the First Principles of Political Economy*, printed in 1862 at London by Smith-Elder & Co., and in New York by Merrill.

In each of the articles included in the book, the Anglo-Saxon public intellectual aimed at important targets: in *The Roots of Honour* he seriously criticized the epistemic principles of classical economy; in *The Vein of Wealth* he stigmatized the uncertain, immoral, and imprecise

nature of capitalism; in *Qui Judicatis Terram* he condemned the blasphemy of economic justice; in *Ad Valorem* he attacked Ricardo and Mill, contesting the distinction between productive and nonproductive labor and redefining the concepts of value, wealth, price, and product.

The reaction of the press was disastrous, even if foreseeable: if the *Times* stated that, about economics, the author of *Modern Painters* was "a mere innocent," the *Literary Gazette* spoke of "one of the most miserable spectacles, intellectually speaking, to which it had ever been witness," while the *Saturday Review* panned his writing as "eruptions of windy hysterics, absolute nonsense, utter imbecility, intolerable twaddle."

The acrimony of his judges was not mitigated by the passage of time, and even the series of appeals launched between 1862 and 1863, and printed in 1872 with the title *Munera Pulveris: Six Essays on the Elements of Political Economy*,[10] turned out to be an enduring flop[11] despite the seriousness of the questions brought forward. Think only of the passages in *The Crown of Wild Olive*[12] in which Ruskin complains of the unpardonable lack of attention to the question of consumption: "I have fearlessly declared your so called science of Political Economy to be no science; because, namely, it has omitted the study of exactly the most important branch of the business—the study of spending."[13]

The space dedicated to these events should not deceive, since Ruskin's initial lack of success was not owing to his faults, but rather to the sensitivity—or insensitivity—of the times, distracted by other needs (consider the debates on professional-artistic education, on the care of the patrimony, and on the control of the commerce of art objects) that induced the intelligentsia to procrastinate.

The values recognized in the world of art were at the opposite pole of those of political economy, which found incomprehensible—if not disgraceful—the uselessness, the nonproductivity, the irrationality, the spiritualism of the former. With the disappearance or weakening of dynastic pride, pomp of magnates, the obligations of rank, and the desire for personal engagement, culture became the object of fiscal debate and anonymous parliamentary interrogation. De facto it was reduced to a cypher, a place in the budget that was inevitably sacrificed to the needs of the hungry masses and to the "modesty" (*pruderie*) of *élites* unable to free themselves from past example. Thus a new rhetoric was needed, nicely veiled by Minerva's cloak; state culture was to have few resources as a pedagogical lever acting on the education of taste and for the moral elevation of the less wealthy classes, while in the name of the magnificent and progressive fates, the "antique" values were scorned as is evidenced by avant-garde ferments, the careless treatment of academicians, the mockery of the traditionalists.

This situation explains the shallowness and partiality of economic literature of the nineteenth and proto-twentieth centuries, which, when not animated by polemical aims,[14] busied itself only with commenting on the results of auctions, as one can see from the works of Blanc,[15] Defer,[16] Redford,[17] Roberts,[18] Mireur,[19] and Graves.[20]

In these texts, the references to the "trade and commerce of art" possessed the docile character of simple information; they did not denounce the relationships of force that existed and the areas of exercise of the respective authorities, but were sold in appendices and rubrics like those in the sector's periodicals, which were very successful,[21] aided by the diffusion of photography and the evolution of printing techniques.

Even though they furnished titillating news about prices and did not disdain scandal (the purchases of foreign millionaires, the despoiling of national treasures, the plague of thefts, the corruptibility of parish priests . . .) these publications did not face the question, but talked around it. They alluded to it without touching it, and procrastinated with an armed truce;

many facts remained unspeakable, nor could they suspect the involvement of connoisseurs and scholars surrounded by an aura of sacrality that the plague of commerce could never corrupt.

The reflections of the few economists who personally, and frequently on their own time,[22] became involved in these events show the impossibility of arriving at a real confrontation, given the incompatibility of values and the idiosyncrasy of languages. When they referred to examples loaned from the artistic context, they put their fingers on the uniqueness typical of the worst scholasticism. Exceptions that confirmed the rules were observed in the prosaic world of normal people, of primary needs, of useful things.[23] The assumption that works of art, prices of paintings of old masters, and collectors were clear examples of goods, values, and "anti-economic" characters par excellence supported and perpetuated the perception of the negative and anti-economic nature of the values and hierarchies reigning in the art field, a solution that justified ipso facto any lack of interest in this anachronistic "upside-down world."

THE BIRTH OF CULTURAL ECONOMICS

The echo of prejudice was long-lived, with sporadic interferences (think of the role of Keynes in the constitution of the Arts Council) that were not always happy,[24] and only in the mid-1960s did a real discussion about markets, production, and cultural consumption open up with the birth of cultural economy, today recognized and practiced by the international scientific community.

The moment in which that happy or unhappy event took place is in any case revealing, since, together with Marxist criticism, the arrows of some Anglo-Saxon economists, anxious to prove the inequality of the mechanisms of receipt and distribution of public funds destined to support cultural activities and institutions, began to hit the target.

The pedagogic rationalization was hard put to sustain an accusatory castle built on well-argued theses and valid empirical research: even the museums and theaters were called to account for their economic activities. It became necessary to redesign the terms of the relationships between "culture and economy," and out of this need came a process tied to the concourse of two vectors of change. The first was the progressive semantic broadening/slippage of the idea of cultural goods that, from the original and exclusive aesthetic criterion of the keeping of "things of artistic interest" and "natural beauty," gradually shifted to cover the semitotality of witnesses of past civilization, even the more recent. In parallel, besides the traditional functions of keeping and conservation, the institutions were forced to consider their responsibilities in terms of management, economic valorization, communication, and publication, in search of the occupational, touristic, and formative influence on the common weal.

The second novelty was the repositioning of public strategies after the discovery of so-called "Baumol's disease" (the degenerative pathology responsible for the increase in the costs of the performing arts discovered by Baumol and Bowen in 1966),[25] and coincidentally with the crisis of the traditional welfare models that had been able to count on the return of cultural goods and activities to the protected sphere of pure public goods. The presence of the "public" as financer of the live spectacle, as cultural organizer, or museum manager not only had to respond to criteria of managerial efficiency, but was also contested by the evolution of the cultural industries and by the lowering of intersectorial barriers.

The flowering of the studies from the early seventies and eighties occurs in this climate: in 1973 William Hendon founded ACEI (Association for Cultural Economics International), in 1976 Mark Blaug's *Manifesto* was published,[26] and the next year the *Journal of Cultural Economics* was born. The association's activity was intense[27] in its first fifteen years, though it was limited to disciplines ranging from the horizons of science to finance and political economics.

On the contrary, the attention of the early practitioners of the historiographic[28] debate should be applauded even though it diminished in the early nineties, when, with the advent of cultural management, the opening of the investigative fan coincided with a quantitative drift and unstoppable specialization. Thus were consolidated the sealed compartments within which research on principles of the functionality of art markets and the return on investments in collected goods gained interest.

GERALD REITLINGER, "THE ECONOMICS OF TASTE," AND THE QUESTION OF "ART INVESTMENTS"

This kind of research underwent a brisk acceleration when English art historian Gerald Reitlinger wrote a three-volume work called *The Economics of Taste*[29] between 1961 and 1970, in which he listed the prices of various categories of collectibles and commented on their fluctuations—almost always positive—in that era, even though he emphasized their erratic nature in earlier decades and centuries.

If the first signs of the sixties' boom had already caught the attention of historians of more refined tastes (think of the argument between Haskell and Stone in 1959,[30] of the "Cities, Court and Artists" conference organized by Past and Present the following year, or Erik Duverger's contribution to the International Congress of Art History in Bonn, 1964),[31] the availability of the copious data collected by Reitlinger induced many economists to construct, rather casually, historical series used in a way that in the past would have been unforeseeable and certainly unexpected. Thus, even though he had warned the reader that "Art as an investment is a conception scarcely older than the early 1950s,"[32] Gerald Reitling found himself willy-nilly the chosen source for the computation of returns, on a multicentury basis, of so-called "art investments," an exercise that has, between 1961 and 2005, given us diverse monographs and more than sixty articles published by prestigious economic journals.

But this proliferation hid and hides many weak points in the sources used in constructing the historical series, in the transactions contemplated, and lastly, in the methods of calculation, themes on which historians have some observations to make. To begin with, from the analysis of the content of thirty-one articles published between 1961 and 2004 (the summary notes are in table 1), one can see that notwithstanding the titles' mention of generic "returns on art investments," twenty-six of them are interested in paintings, four in prints and drawings, and one in sculpture. This is not an unimportant coincidence, since this monomania is reflected in the predilections of some historians who are convinced that art can be represented in terms exclusively not of "painting"—a domain that is too vague and protean—but only by "paintings," and mostly by those on canvas at auction. This limitation of the field of research, not justified by a historical outlook, has in time undergone further reductions, since most economists are oriented towards the details of prices taken from auctions—reiterated over the years—of the same paintings, with minimum periods of a decade of ownership.

Table 1. Analysis of the Content of Thirty-One Articles on Returns on Art Investments Published between 1961 and 2004

Author and publishing year	Collection category	Sample size	Data sources	Return calculation period	Calculation method	Transaction costs	Real return rate
	PAINTINGS						
	Post-Impressionists			1930–1960			11.87
	Impressionists			1930–1960			6.67
	Modern masters			1945–1960			18.73
	Expressionists	For every category:		1950–1960			29.42
	English portraitists			1925–1960			−0.41
Rush 1961	Barbizon school	maximum 15 artists, selected on subjective base	Auction	1925–1960	Rush index	No	−4.11
	Dutch artists in the seventeenth century			1925–1960			0.99
	Italian primitives			1926–1960			9.98
	Italians until 1450			1925–1960			7.39
	Venetians in the mid-sixteenth century			1927–1960			6.48
	Italian Baroque (1550–1700)			1945–1960			7.93
Sotheby's-Times and Keen 1971	Old masters	Not indicated	Auction	1950–1969	Sotheby's-Times index	No	8.76
	Impressionists						14.76
	Twentieth century						18.76
Stein 1977	Works of art made by artists who died before 1946		Auction	1946–1968	Geometric average	No	
	Sold in USA	8,950					7.80
	Sold in UK	35,823					7.80
Baumol 1986	Works of art sold in auction twice and owned for more than 20 years	640	Auction	1652–1961	Repeat sales method	No	0.55
Frey and Pommerehne 1989b	Works of art made by the 800 most famous artists in the world and owned for more than 20 years	783 1,198 415	Auction	1635–1949 1635–1987 1950–1987	Repeat sales method	Yes, return rates are net of the transaction costs (estimated 0.4%)	1.40 1.50 1.70
Goetzmann 1993	Paintings	2,809	Auction	1716–1986	Repeat sales method	No	2.00
Mok et al. 1993	Modern Chinese paintings	20	Auction	1980–1990	Repeat sales method	No	53.00 (nominal)

Study	Type of art	Number	Market	Period	Method	Transaction costs	Return
Buelens, Ginsburg 1993	Paintings	1,111	Auction	1750–1961	Double sale method	No	0.65
	English art	5,541					-0.26
	Non-English art	557					1.55
	Dutch art	149					2.59
	Italian art	169					1.57
	Impressionists	37					4.06
De La Barre, Docclo, Ginsburgh 1994	Great Impressionists	24,540	Auction	1962–1991	Hedonic method	Not included in the calculation, even if they are high (20–25%)	12.00 (nominal)
	Other Impressionists	6,410					8.00 (nominal)
Chanel et al. 1996	Impressionists	1,972	Auction	1855–1969	Hedonic method Geometric average Repeat sales method	No	4.90
	Post-Impressionists	245					5.90
	Post-Impressionists	245					5.00
Agnello, Pierce 1996	Paintings made by 66 American artists (nineteenth century)	15,216	Auction	1971–1992	Repeat sales method	No	3.25
Ginsburg and Penders 1997	Minimal art	357	Auction	1972–1992	Hedonic method	No	23.80
	Conceptual art	690					18.90
	Land art	697					20.00
Czujack 1997	Paintings made by Picasso	921	Auction	1963–1994	Hedonic method	No	2.99
Candela and Scorcu 1997	Modern paintings and contemporary paintings sold in Italy	22,371	Auction	1983–1994	Representative painting method	No	0.21
Locatelli, Zanola 1999	Paintings	1,446	Auction	1987–1995	Repeat sales method	Yes, the values are net of the transaction costs. Calculated as follows: 15% (first sale) and 10% (second sale)	They build price indexes to allow comparison with other types of investment

(continued on next page)

Table 1. Analysis of the Content of Thirty-One Articles on Returns on Art Investments Published between 1961 and 2004 *(continued)*

Author and publishing year	Collection category	Sample size	Data sources	Return calculation period	Calculation method	Transaction costs	Real return rate
PAINTINGS							
Flores, Gins-burgh, Jeanfils 1999	Great European masters	25,000			Hedonic method	No	London: 5.20 Paris: 5.80 NY: 4.60
	Other European artists American artists	6,000 6,000	Auction	1962–1991		No No	London: 3.30 Paris: 3.40 NY: 4.70
Landes 2000	Modern and contemporary art	86 works of art from the Ganz collection	Auction	1941–1997	Composite returns	Yes	12.06 (gross) 11.74 (net)
Moses and Pei 2002	Paintings	4,896, among which: Americans 899 Impressionists 1,709 Old masters 2,288	Auction	1875–1999 1900–1999 1950–1999	Repeat sales method	No No No	4.90 5.20 8.20
Renneboog and Van Houtte 2002	Paintings made by Belgian artists between 1850 and 1950	10,500	Auction	1970–1997 1970–1989	Hedonic method	Non calculated, but cited as yield reduction factor	5.60 (nominal) 8.40 (nominal)
Agnello 2002	Works of art made by 91 American artists born before WWII	25,217	Auction	1971–1996	Hedonic method	No	6.90 (short period) 4.20 (long period)
Rengers and Velthuis 2002	Contemporary art	11,869	Dutch galleries	1992–1998	Hedonic method multilevel	No	Analysis of the price determinants
Ashenfelter, Graddy and Stevens 2002	Impressionists and modern art Contemporary art	16,226 4,299	Auction	1982–1994	Repeat sales method; hedonic method	No	Calculated price indexes
Candela, Figini and Scorcu 2002	Old masters	101,199	Auction	1990–2001	Hedonic method	No	Analysis of the price determinants

Study	Market segment	Number of observations	Market	Period	Method	Transaction costs net	Annual returns calculation, 1986 to 2003, for every market segment
Spiegel 2003	Nineteenth century Twentieth century Old masters Post war	Not specified ("bought in" included)	Auction	1985–2003	Repeat sales method	No	24.70 (nominal) 21.60 (nominal) 30.30 (nominal)
Candela, Figini and Scorcu 2003	Old masters Nineteenth century Modern and contemporary art	300,000	Auction	1990–2001	For every artist there is a price index based on the ratio between the estimation and the hammer price.	No	
Higgs and Worthington 2004	Contemporary art Impressionists Modern European Nineteenth century Old masters Surrealists Twentieth century UK	Not specified	Auction	1976–2001	Composite returns	No	4.20 3.70 2.10 2.50 2.80 2.00 2.50
PRINTS AND DRAWINGS							
Pesando 1993	Prints (made by several authors) Prints made by Picasso	27,961 6,010	Auction	1977–1992	Repeat sales method	Not calculated, but cited as yield reduction factors	1.51 2.1
Holub et al. 1993	Drawings Wash drawings	6,900	Auction	1950–1970	Medium price method	No	11.30 15.80
Pesando and Shum 1999	Prints made by Picasso	8,257	Auction	1977–1996	Repeat sales method	No	1.48
Candela and Scorcu 2001	Modern and contemporary prints Modern and contemporary drawings	19,375 (from 180 to 1,012 per year, with a constant number of 900)	Secondary market (catalog of the Prandi gallery)	1977–1998 1977–1998	Representative painting method (medium return)	No	7.40 6.90
SCULPTURES							
Locatelli, Zanola 2002	Sculptures	27,101	Auction	1987–1995	Hedonic method	Yes, the values are net of the transaction costs. Calculated as 10%	They build price indexes to allow comparison with other types of investment

In this manner, a small amount of information has been collected on very few works, gathered together in minimal samples and secular series. Contradiction has not cooled the enthusiasm of the practitioners in this field of study: William Baumol has calculated the returns in art investments on a worldwide scale for the period 1652–1961 by following the changes of ownership of 640 works, Frey and Pommerehne have analyzed 1,198 between the years 1635–1987, Goetzmann has 2,809 for 1716–1986, while Moses and Mei have monitored 4,986 for the period 1875–1999.[33]

It is redundant to point out that these exercises of style have favored the more successful genres (old masters and Impressionists are an overwhelming majority) and the masterpieces of the more celebrated artists (Frey and Pommerehne decided to evaluate only the "works of the 800 most famous artists in the world kept for more than 20 years"), often belonging to equally famous collectors. This approach has determined in turn the exclusion of many artists who knew fame and glory when living, but later fell out of grace, and vice versa—as if the reflections of Francis Haskell[34] on the ups and downs of Vermeer, Delaroche, Meissonier, and Alma-Tademal, or Giovanni Previtali's on that of the "primitives,"[35] not to mention the difficult beginnings of many Parisian geniuses, had nothing to teach us.

In any case, the pretense of calculating, on a world-wide scale, the multicentury gains of "art investments" (that is, all, repeat all, the consequent expressive forms) by using samples of two, four, eleven, or forty yearly transactions of "paintings" (without specifying whether the prices included the value of the frames, often worth more than the canvases) produced by very few painters is a motive for caution—if not embarrassment—in accepting the conclusions. To judge from a historical perspective, broad, variegated, and changeable markets like art on the basis of the results of a single auction, even though important, out of the thousands of existing categories of collectionism seems to me misleading and methodologically wrong,[36] since various scholars have proven the inadequacy and incorrectness of these selection criteria. If Burton Fredericksen[37] and the crew of the Getty Provenance Index have demonstrated that in London alone in the first two decades of the nineteenth century more than eight thousand paintings were sold at auction, Ad Van der Woude and Michael Montias have maintained convincingly that in Holland in the seventeenth century, between five and ten million paintings were produced,[38] and large numbers have also come from the investigations of Martin Jan Bok[39] for Holland between 1580 and 1700, from Robert Lenman[40] for the German market, from Ian Pears,[41] David Ormrod,[42] and Hugh Brigstocke[43] for the English. There is a problem not only of volume but also of the quality of the statistical sample: anyone with the desire or courage to attempt to determine the gain on a worldwide scale and over centuries of "art investments" should pay at least a minimum of attention to the number of artists known to art historians. Instead we find that in nine out of ten studies on the world market, not one Italian painter of the nineteenth century is to be found, even though the dictionaries and biographical resources list thousands of names of artists whose works were purchased by an even greater number of collectors and museums, through channels of distribution that were not auctions. These latter, even though existing for centuries,[44] represent only one of the many means of sales, and one should also be reminded that the above-mentioned studies included only Christie's and Sotheby's, ignoring the important venues in France, Italy, and Germany.

The points about the weaknesses of these studies are made not from a desire to criticize the sources pedantically, but from a respect for unavoidable exegetic principles. Whoever wishes to draw a historically credible and believable portrait of a market—above all when claiming to consider national or even worldwide cases—should analyze it in its entirety, from

the periphery to the center, from country portraitists to court favorites, from the most banal genres to the greatest masterpieces.

Unfortunately the choice of using almost exclusively auction results—furthermore without distinguishing between minimum, sale, or reserve prices, and without including the transaction costs (commissions, taxes, insurance, transport, expertise, packing)—has excluded all the other types of exchange, pricing, and return. This is a doubtful choice, given that in the art system numerous players have coexisted for centuries, involved in a multitude of transactions generating widely varying prices and returns. It would not be a serious problem if the success of these studies, with their enormous defects, had not filled a primary role in the affirmation of the theme in historiography without the corresponding sentiments having provoked a reciprocal curiosity. Having in fact followed and practiced the economic discussion since the end of the nineties,[45] I do not find it surprising that the two major types of research ran along parallel lines without any fruitful encounters up until the recent change. Various historians have tried to bring out the incongruencies through dialogue, but they have not been listened to, nor are they any longer read: if up to fifteen years ago the economists regularly mentioned the work of Haskell, Taylor, Boime, Rheims, Montias, or Saarinen, in none of the articles published in the last five years on this theme in economic journals have I found a single bibliographical reference to the hundreds of writings that the historians of art, of collecting, of economy and sociology dedicated to them.

THE ECONOMIC-HISTORICAL DEBATE FROM WERNER SOMBART TO THE FIFTIES

Luckily, the indifference of the economists towards historical publishing has had as counterattraction the growing interest on the part of historians of economy, who in recent years have returned to look at questions that, without their being fully aware or remembering it, accompanied the very genesis of their discipline.

This has occurred because the polemics on luxury that animated the European and Italian political-economical debate (remember the contributions of Verri or Beccaria) from the end of the Seicento to early Novecento[46] were reflected in the predilections and orientations of the earliest keepers of the subject—which, however, did not live up to its promising beginnings.

In fact, one may not ignore the condition of marginality in which those who tried to sustain the importance of artistic production and consumption found themselves—axiomatically associated with the sumptuary, of which it constituted perhaps the best part—in the moment in which the social scientists of socialist, Catholic, or liberal bent were agreed in deprecating the famous economic and social system that had for centuries fed the demand and sustained the supply.

Just scan the biography of Thorstein Veblen,[47] the Yale Ph.D. who spent his last years in a mountain shack after a difficult career in academia, or follow the unsteady fortunes of the work of Werner Sombart, and it is easy to realize the unpopularity of the theorists who disagreed with the industrial-rational-productive mantra and founded their own analysis of consumption, and especially elite consumption. More than difficult, it was outright sacrilegious, and between the end of the nineteenth century and beginning of the twentieth, the genesis of capitalism was too serious a question to allow its aura to be disturbed by a

Veblen who emphasized the propulsive role of visible consumption and emulative envy,[48] or by Sombart's heretical arguments in favor of the hedonistic, irrational, and licentious origin of *Moderne Kapitalismus.*[49]

Nevertheless, Sombart is a very important figure, since added to the peripheral nature of his academic position (he was exiled to Breslau until 1906 and then called to Berlin, where he remained until 1931) ample and often polemical[50] attention was paid to his work, which had a great influence on Italian economic historians.

If his theories about the specificity of capitalistic development in the Bel Paese had been completely received, interest in our theme would have developed earlier. This is not an outlandish hypothesis. Even though the thoughts of the German professor now take up little space in texts of economic history and thought, having fallen into the useful domain of the sociology of consumption, one finds echoes in the pages from the early thirties of a great historian such as Gino Luzzato, where up until 1950, his theories on the genesis of capitalism were regularly contrasted, on an equal plane, to those of Max Weber. The eclipse of his fortunes could have been foreseen by taking a look at his biography, governed by a constant inspiration to excite the enmity of as many adversaries as possible. Thus Sombart laughed at historical pedantry (even though he matured in the Scholler school, like Doren), attacked the British neoclassicists, argued with Weber, fought with Bücher's students, and repudiated his own Marxist beginnings. In addition, he cited with great nonchalance poets and writers of memoirs; iconographic programs and musical components; novels and theatrical texts; manuscripts dug out of remote monasteries; statistics from Parisian newspapers; and Dante, Petrarch, and unknown treatise writers.

Even accepting the ambiguity of some of his theses (consider his thoughts about the Jews), methodological inconsistencies, and an excessively polemic *vis*, Sombart remains an acute and bright scholar. If anything, free of prejudicial influences and ideological frames, his ideas arrived too late to be perceived as a follow-up to Mandeville's *Fable of the Bees* or Hume's *On Refinement in the Arts,*[51] and too soon to be appreciated by the intellectual circles that dominated those Promethian times.

And yet, venial sins apart, he hit the bull's-eye in recognizing that "We have approached the problem of luxury with all the emotion of the good bourgeois who is content not to have too much, and discussed it only briefly and with the help of moralistic rationales,"[52] without forgetting that the question was never placed at the center of an interpretive plan, but was always, sometimes too much, multifactorial: it was certainly an important part of a vast argument, subversive in its time, about the factors that had determined the birth of modern capitalism.[53] These variables in *Luxus und Kapitalismus* became identified as the centrality of consumption (in contrast to his colleagues' passion for production and intermediation) in the influence of aristocratic and courtly values and styles (in contrast to the explicating dictatorship of the bourgeois counterparts), in the importance of urban and metropolitan contexts, in the prevalence of desire over usefulness (in one blow upsetting Catholic, Socialist, and liberal moralists), in the function of dissipation (criticizing the virtue of saving and the necessity of accumulation), in the organicity of fashion, in the importance of feminine choices (in a masculine world of decision); and in the permanence in the West of that culture of prestige that the anthropological studies of Mauss, Boas, and Malinowski had found among the wildest and least-civilized populations on earth.

And yet, the passages in which he affirms that "Luxury has been the element most responsible for capitalist development, since the end of the time of early capitalism," and that its

"capacity to create markets"[54] should be admitted, are anything but mad. He anticipated the conclusions of the historians and sociologists who have recently successfully looked at the birth of the consumer society, commodification processes, material culture, the evolution of retail activity, the sociability of fashion and shopping.

His insistence on repeating the centrality of the instances and the distinctive practices of the *élites* of the *antico regime* (*ancien régime*), however, was fractured by overwhelming forces: the liberal partisans of the bourgeois, accumulative, and productive origins of capitalism; the progressive leftists who blamed the pre-revolutionary ruling classes for all the misery overcome by magnificent and progressive fate; the Catholic authors of a solidarity that did not go well with the immorality of its explicative variables; assorted knights, more or less convinced, of the modernity that was eliminating atavistic classes, modes, and virtues (where atavism, in the positivist sciences, was the *trait d'union* that marked the border between the aborigines encountered by explorers and anthropologists, and the "urban cavemen" who committed the worst sorts of crimes against the consortia of civilization and modern representative institutions).

The key points of Sombartian interpretation—the emulative nature of distinction, economic primacy of dissipation, and the dominion of beauty over usefulness—became, in the words of his detractors, ruin, vanity, and waste, while those who had raised them up as the basic values of European civilization were condemned without appeal, in the conviction that the new, more frugal and egalitarian forms of coexistence would have canceled out the memory of those caprices. And then there was the belief, overcome with difficulty, that in Europe —and even more so here in Italy—these "anti-economic" customs had been guilty of a missed or delayed appointment with the joys of progress. The step from there to considering them responsible at least in part for the decadence of the Italian society and economy after the splendid late Middle Ages was a short one.

I do not intend to support Sombart's theses to the bitter end, but only show that some of his criticisms of contemporary dogmatisms were well-founded and largely acceptable. One could question, if anything, the style and timing with which they were expressed, because they touched raw nerves, and the reconstruction was too journalistic for it to be serenely historicized. He placed Europe, the courts, the aristocrats, capital, the *cocottes*, and the rites of the *ancien régime* at the center of his hermeneutic castle just in the very instant in which their lengthy fortune had begun to decline. He insisted on the elitist and consumeristic character of the origins of capitalism while the man of the masses and large industrial production was taking hold; he spoke of Marie Antoinette's haberdasher while Eiffel was planning the Bon Marché, Jourdain the Samaritaine, and Sullivan Chicago's Carson, Pirie and Scott.

Despite these weaknesses, however, his work caused energetic discussion among the economic historians interested in our problems, which we should take into account[55] considering the ties that, well before the birth of the Axis, united the exponents of the German historical school to the actors on the Italian scene, and the brief season ending with the 1940s, during which some of his theses were welcomed by important Italian colleagues.

If the genesis of his fortune lies in his youthful works in which he, after taking his degree in law at Pisa, sang the praises of Italian primacy, the later unhappy reception may be ascribed to the pro-Renaissance approach in his writing where he continued to reassess the importance of events in the Middle Ages.

Theses like this could not meet with unconditional acceptance in a time when our economic history had practically no university chairs and was in the clutches of both

nationalism—post-unification and then Fascist—and the local forces resident in the deputations for the history of the fatherland. Both of these forces, for different reasons, encouraged the celebrations of ancient glory, of the Risorgimento and the centuries of freedom and glory in which our communes, republics, bankers and merchants were at the forefront in every corner of the globe, earning the respect and envy of world powers. Thus, far from entering into the reasons and perspective of the research, Sombart's results challenged the scholars to demonstrate that "here" the existence of a capitalistic mentality, praxis, and logic harked back to earlier periods that long preceded the Renaissance, finding ancestral forefathers who were evidently apologists.

This explains why from the early fifties Italian economic historians[56] have for the most part looked at ancient and medieval questions, or leaped forward to the Sette-Ottocento, following the theme "commerce-finance-money-work-prices-industry" (textile or heavy, but in any case, *grand*). The hiatus of the Quattrocento to Seicento indicated a kind of embarrassment, as if the crisis whose existence was presupposed was the only cause of the state of political, economic, and moral prostration in which the peninsula was constrained to lie until illuminated reformism and final *Risorgimento*. As Amintore Fanfani noted in 1933 in the final pages of his *Le origini dello spirito capitalistico in Italia*, "It is an unquestionable fact that in the Quattrocento men had an overwhelming aspiration to live in happy and rustic peace," and "bit by bit as the idea of enjoying [wealth] . . . overtakes purchasing, the Italians, who had been the agents of the greatest economic expansion that history had ever seen, became the enriched desirous of the serenity of the villa adorned with noble arms . . . Does this aid in explaining the economic decadence of Italy?"[57]

The rhetorical ending reveals a conviction that belonged not only to the scholar from Pieve Santo Stefano but also to scholars of widely varying education and disposition: Renaissance, and even worse Baroque, consumption stirred ambivalent feelings in many. While no one denied the prestige of the greater successes (motive, if anything, of national popular pride), many disparaged the conditions in which they developed, in the widespread opinion that the Quattro-Seicentesque principalities were the miscreants responsible for the French invasion and foreign sackings, of the non-unification of Italy, of the petrification of wealth, the courtiers' squanderings (Rigoletto's "vile damned race"), and the betrayal of the bourgeois who fled from commerce to investments.

In light of these facts, one can understand how from the twenties to the fifties, with only rare exceptions, there was a substantially hostile attitude towards production and artistic-sumptuary consumption. This happened because the changes in the sociopolitical picture succeeded in placing, from time to time, limits that for different motives blocked their treatment, amidst growing neglect: to praise showy consumption in autarchic and postbellum times, or to celebrate the redistributive functions of the courtiers' weaknesses in the faces of the faithful Fascist wives or parsimonious rebuilders, would certainly have encountered general disapproval.

It should anyway be noted, for the sake of honesty, that up until the mid-forties the question was not dismissed with the same energy as in the following thirty years.[58] The interests of the discipline came before ideology: it fled from analysis of consumption and did not consider artistic and sumptuary production, of whatever entity, to be worthy of special attention.

This lack of interest was dictated by opposing, equally stigmatizing reasons; when these objects were made by workshops or individuals, they could only be "handmade," an adjective that revealed the stuntedness of a system incapable of promoting a mature and strong industrial

revolution. When instead they were made by princely or state factories (consider the Venetian or Genoese cases)[59] the embarrassment caused by their immensity (frequently larger than many large businesses of the nineteenth century, the Venetian Arsenal in mid-Cinquecento had 6,000–7,000 employees and the Royal Wool Manufactory in Linz in mid-Settecento had 26,000 employees) was overcome *ad arte* by affirming that the prerequisite of "production for the market" was lacking, and the aim of profit-making did not exist. These were liberty-killing projects, then, that frustrated the ambitions of private entrepreneurs who could not combat the unfair competition of subjects who, indifferent to budget constraints, abused their dominant positions.

In this manner, the interpretation dear to classic and neoclassic economists who disparaged public or quasi-state enterprises (the large Medicean, Estense, Aragonese, Gonzagesque, Savoy, or Papal *ateliers*) was reinforced in the conviction that their activity distorted the best allocation of productive elements.

Considering the credit given to Benedetto Croce's theories by his more observant followers, who on the aesthetic and art-historical plane had relegated the arts to a corner from which they have perhaps yet to escape even today, one sees why that combination had caused a strategic splitting. To the history of art—ethereal, aristocratic, and distant from worldly cares—was assigned the job of praising Italic genius while avoiding the plague of mammon, while to solid and bourgeois economic history was given the treatment of the more serious and real problems.

It was under these conditions that the two histories split off, ignoring each other until the fifties, and then pausing only to glower at each other; if in the earlier phase theirs was a scholarly etiquette that, following a misunderstood principle of mutual respect, accepted the impossibility of finding common ground, in the latter phase the parties disapproved of the excesses of economic materialism and the irresponsible absolutions—almost an apology for a crime—of patrons who were often coincident with the vituperated *ancien régime* elite. Thus, while art acquired a useless and inoffensive sacredness, economic history spent itself in the narration of the epics of the Atlantises of trade, industry, and finance.

In any case the path was not linear, nor was there a lack of rethinking and open-mindedness, which is why it is proper to retrace the more important moments, beginning with the contributions of the two eminent German historians Josef Kulischer and Alfred Doren, who knew the Sombartian theories well and exercised an enduring influence over their Italian colleagues. The former, in his book printed by Oldenbourg in 1928–29, dissociated himself immediately from his compatriot's theses. In his work on medieval economic history he briefly mentioned commerce in luxury goods (raw material, spices, and textiles), in the volume on modern history he noted, in the Italian case, only the Venetian production of mirrors, giving to the theme, for Europe, only three pages.[60] Nor did Alfred Doren shift from this interpretational track in his successful *Storia economica dell'Italia nel Medio Evo*, edited by Gino Luzzatto and printed in 1936,[61] in which he repeated some points from the *Italienische Wirtschaftsgeschichte* printed in 1934,[62] dedicating a couple of pages to the so-called "artistic industries" and affirming that "with the arms industry we have reached the limits of that which is called the artistic industry—a border that is as uncertain and difficult to define as is the one separating the artistic industry from pure art." Much more interesting is the disclaimer placed in the footnote: "That which follows has no pretence of being complete. In this field at the borderline between art history and economic history the final word rests with the art historian."[63]

Having abdicated, the few lines aimed at blacksmiths, goldsmiths, foundrymen, gilt leathers, *faïences*, painting on glass; to Sienese silversmiths, to Pisan ivory sculpture, and to Venetian mosaics; to marble inlay, tapestries, and lace, were brief notes that did not diminish the solidity of a reconstruction anchored to industrial production, to great banks, to long-distance commerce, to enterprising merchants and financiers who operated on the international chessboard. The modesty with which Doren had confessed his shortcomings, almost excusing himself for having made the attempt, was not, however, due to personal lacunae, as he had received an education not unlike many German art historians. He took his degree in philosophy in Berlin in 1892, had been a student of Lamprecht and Schmoller, a good friend of Aby Warburg, an able musician,[64] and author of a refined article on Fortuna[65] and a splendid edition of the Orsanmichele's[66] *Libro del Pilastro*, and presenter, at the X International Congress of Art History in Rome in 1922, of the contribution *Deutsche Künstler im mittelalterlichen Italien*,[67] in which he had synthesized the results of learned archival research.

Thus his retreat had other, more ideological than biographical, reasons. These can be seen also in the circumspection with which the principal Italian historians of the time treated the theme, incidentally approached in the work of Gioacchino Volpe,[68] Corrado Barbagallo,[69] Arturo Segre,[70] Filippo Carli,[71] Pietro Bonfante,[72] Vittorio Franchini, and Giovanni Lorenzoni,[73] but the object of decidedly greater attention in the work of Gino Luzzatto, Armando Sapori, Amintore Fanfani, and Gino Barbieri.[74]

Luzzatto's case is interesting because he made an important contribution to the affirmation of economic history in Italy, appearing for almost a half century as the most authoritative contributor. The Paduan teacher had a full cultural background (he finished studies in literature, history, law, and economics), was conversant with German history and an early interlocutor of English and French history, and was a careful translator and editor of the Italian editions of Doren, Sombart, and Kulischer, with whom he shared, as with many colleagues, a broad educational background. Perhaps it was this exceptional sensibility that sparked the interest in his *Storia economica dell'età moderna e contemporanea*,[75] printed first in 1932. In this work, which deals with the revolution in consumption in the sixteenth century, the professor at Ca' Foscari wrote:

> As to luxury products, for those that may be considered products of an artistic industry, it is still Italy that dominates the market. As for the weaving of silks, the love of luxury, for refinement, for everything that has the character of art, it exercises an efficacious stimulus on many industries that serve to beautify the body, the house, public and religious buildings: artistic woodwork, ironwork, copper, metals, and precious stones flower a bit everywhere, but in particular in the larger commercial centers, where they offer one of the more frequent and gainful means of payment of the imported raw materials. Art itself, not only in its industrial forms, but also in its more pure expressions, is in this period an important object of exportation, whether because foreign princes and merchants gave commissions to our artists and exported our paintings and sculpture, or, as is rather more frequent, because many Italian artists have traveled out into Europe from the Atlantic coast to Poland . . . It is a real Italian migration that extends to all Mediterranean countries and central and western Europe . . . mostly made of merchants and their factors, financiers, architects, sculptors, painters and their assistants, artisans specialized in technical procedures as yet unknown in other nations. It is thus an eminently qualified emigration, which in the first instance does not represent, with only a few exceptions, a loss for the Italian economy, but rather a gain; because for the most part it is temporary and contact with the fatherland is not weakened, and to it flow a great part of the profits and earnings produced there, from which instead is derived a greater demand for Italian products.[76]

The above passages, for audacity and acuteness, could have been Sombartian, and show the poise of unchanged values: not only was the Quattro-Seicentesque economy analyzed in terms free of any constraints, but elements of capital importance were detected *in nuce*, from the "efficacious stimulus" exercised "on many other industries," to references "to the person, the house, and buildings" (the triad at the foundation of today's material culture), from such "qualified" migrational spillover to the "more intense demand for Italian products" in foreign markets.

The question remains as to why he did not take up and develop these intuitions in later works, even if one answer could come from *Storia economica d'Italia: il Medioevo*, first printed in 1949.[77] There, in the final two pages of chapter 8 (*Agricoltura e industria nell'età comunale*), Luzzatto noted: "At the opposite pole from the wool industry, which in the larger centers took on the characteristics of mass production, meant to satisfy the demand of a very vast clientele, and thus falls under the control of capital, there were the artistic industries which have because of their very nature, an individual character, and tied as they are to taste, to the artistic sense, to technical procedures that are kept strictly secret and transmitted from father to son, never leave the confines of the artisan workshop, in the best sense of the term."[78]

Even though he dealt with artistic silk textiles (damask, brocade, tapestries), artistic wood-work, ironwork, copper, bronze, gold, silver, ceramics, mosaics, ivory, and glasswork in a quick two pages, only a few years after the opening of credit in 1932, Luzzatto, with words that almost echoed Doren, repeated the embarrassment felt in violating the sacred temple of art: "With artistic ceramics, bronze work, and goldsmithery itself, one enters into a field in which it is difficult to establish a clear line of demarcation between industry and art: from the artisan workshops that habitually supply a purely commercial production, comes from time to time work that is perfect and original, even though—for the most part—we do not know the name of the creator."[79] These last four lines are essential to distinguishing the motives that in the coming years would inhibit the examination of similar products, given that the admission of the greatness of their makers meant ipso facto the hypothetical salability: if the artisan workshops habitually supplied a *purely commercial* product, then this practice could not break up the *perfect* and *original* works. With this doubt, he abstained from improper judgments, and perhaps for this reason the argument was not touched in later works.[80]

Armando Sapori's position was different; in the preface to his *Studi di storia economica medievale*, he criticized Sombart more than once (he could not tolerate the anti-medieval stance), but mentioned that "Whoever, in Italy, looks up at the private and public palaces, the churches and temples of the Duecento and Trecento, and in their beauty recognizes the expert hand of the artistic master, will not be able to understand how the anonymous mass of small artisans could have found the initiative and put together the capital for such grand works."[81]

This promising beginning was, however, immediately contradicted in the following pages. If on page 539 the Sienese historian, able portraitist, sculptor, and ceramist endorsed Mariano Pierro's theses associating luxury consumption to the exodus of the gold- and silversmiths and the decline in birth rate (a classic combination, in which the bimetallic hemorrhage and wifely sterility metaphorically incarnated the pernicious unproductiveness of these expenses), on the following page he instead observed: "To say that Princes, the high clergy and high nobility (increasingly diminished in its economic, as well as political functions) were the only clients of international merchants, is improper . . . I cannot believe that that middle class that raised palaces worthy of hosting, more than the public palaces, Kings and Emperors . . . then went about in humble attire in those rooms frescoed by artists and full of tapestries, and I do not believe that they were entirely content with frugal meals."[82] The useless luxury

consumption condemned the next day could be useful in the anti-Sombartian argument, but only to demonstrate its broad spread among the strata of society and in times earlier than those of Renaissance glory.

This tactical approach, based on continuous shifts, was, however, generational: one celebrated the qualities of the products and their makers that pointed out our sophistication to the world, but one diligently avoided mention of the clients' vices. De facto, the artistic-sumptuary items had been positive for the Italian economy as long as they satisfied the desires of "foreign" buyers. The development of a strong domestic demand was seen as a misfortune, even though the rector of the Bocconi University had noted that "in contrast to the relative ease of knowing the seller, there is the difficulty in knowing the clients; but I hope that I will be believed if I say that this kind of research is not only not impossible, but holds out the attraction of extraordinary results".[83]

As had already happened to Luzzatto, these illuminations that could have marked a turning point for later studies, at least in the history of consumption, were not followed up, either in the third enlarged edition of the *Studi di storia economica (secoli* xiii-xiv-xv*)* of 1955,[84] or in the contribution of 1952 to the III International Convention of Renaissance Studies entitled *Il Rinascimento: significati e limiti*, of which Delio Cantimori had to say: "Sapori's lack of discipline lay in remembering that that which for the sciences, art, and philosophy is the age of *Rebirth*, is instead an age of decadence and involution for economists."[85]

This ambiguity recurs in Amintore Fanfani's works in a less nuanced manner (he too was a passionate connoisseur of art, drawing, and painting). In his book of 1943 on the history of labor between the Quattro and Seicento, he recognized that "Workers in the building industry must have been extremely numerous, if one is to judge from the number of buildings constructed in the Cinquecento and Seicento in every Italian city . . . and . . . from the Quattrocento there is no need to say that real and true artistic activity absorbs an ever increasing number of people and that the list of only the geniuses who in sculpture, painting, architecture honored Italy in the fifteenth, sixteenth and seventeenth centuries is itself proof of our statement. Equally the minor arts, especially in their industrial applications in the Quattro and in the Cinquecento, more than in the Seicento, gave occupation to no small number of artisans."[86] He goes on to praise the ivories, glass, artistic leathers, mosaics, and Venetian lace, marble, and Florentine goldsmiths, Milanese arms, cameos, and inlay, Neapolitan coral, Genoese filigree, ceramics, silk fabrics, printing, and the production of musical instruments, carriages, furniture, and mechanical clocks.[87]

In contrast to the praise for the producers, there were trenchant comments about their clients: a slanted viewpoint that was certainly not new, even if the irrevocable pronouncement that the Aretine historian sent down had deeper roots, since he considered the sixteenth and seventeenth centuries "an era of closure and repose, during which in Italy the last descendants of a great tradition still did marvelous things, cultivating the arts with the carefulness of the great, of the 'arrived,'"[88] and considered "the Italian Signorias counter-educational; it was to their crushing arbitrariness that we owe the first emigrations . . . to the sleepy celebrations that they promoted do we owe the people's love for enjoyment and festivities, . . . to the politics of garnering fame and glory with the greatest, or even with the grand, do we owe the spectacular manifestations, precursors of Spanish fashion in costume, Baroqueness in art, and dilapidation of the economy."[89]

But the most interesting point in the passage is the declared attack on historians of art and literature, symptomatic of a changed attitude whose hostility, sometimes dissimulated in

a false indifference, informed the relations between the various fields until a short time ago: "Let the historians continue, if they will, under the influence of literary and art historians, to exalt the age of princes; thus they will prepare sufficient material for the day in which that manifestation of decadence and that source of deeper corruption of the Italian nation which was the century that, occupying part of the Quattrocento and part of the Cinquecento, for too long in our history books has been held up and revered as the age of the early principates."[90] Thus, in the apocalyptic view of the future premier, little or nothing was salvageable, not even the artistic proto-industries.[91]

THE PSYCHOSIS OF DECLINE

These last quotations confirm the widespread nature of the perception of post-Duecento economic decline, the bitter fruit of a collective softening to which the aestheticizing lifestyles and joyful consumption of the Italian population beginning in the fourteenth century were in no way extraneous.

Incapable or unwilling to pay attention to the positive points and beneficial effects of this kind of tendency,[92] some scholars ended by confusing the causal connections of the relationship between the supposed industrial decadence (partially compensated by the development of a precocious service industry) and the flowering of conspicuous consumption. These latter, far from being ascribed as among the effects of the crisis, were instead identified as initiating factors capable of causing perverse reactions that in the final instance would be responsible for the collapse in the Seicento and following deficiencies.

The *querelle* of decline, taken up again by Carlo Maria Cipolla in his articles published in the *Economic History Review* in 1949 and 1952,[93] remained at the center of the debate in the 1950s and 1960s, as is carefully traced by Luigi De Rosa in his historiographic assessment in 1970,[94] and the debate involved the large group of scholars who had come of age during World War II. They continued medieval studies, took up some questions about the Renaissance and the Baroque, and turned with great enthusiasm to the problems of the Sette to Novecento without abandoning the already established line of argumentation. Thus, not only in Italy, one was occupied primarily with institutes, bank and insurance institutions and agencies, financial intermediation and commercial distribution, prices and monetary questions, fairs and exchanges, finances and public debt, historical demography, agrarian economy, labor markets and their relative regulatory forms, and of protoindustrial and industrial production such as worksites, extractive and metallurgic activities, and above all, textiles (first wool and then also cotton and silk)—endeavors that seemed to possess the dimensional and managerial qualities of large industry. Nevertheless, looking quickly at the infinite and good bibliography on textiles, one sees that the phases following manufacture (planning, packaging, distribution, and sales of finished items and accessories) were barely touched upon,[95] and the same destiny held for embroidery, notions, buttons, socks, buckles, feathers, lace trim, underwear, hair, furs, tapes, veils, lace, cosmetic products, and wigs, which came under the aegis of "costume historians" until the 1970s.

The theme of consumption, when it was brought up, was an appendix to price, salary, and standard-of-living investigations that was first interested in goods that satisfied primary and vital needs, and especially foodstuffs. From there, the attention to the needs of the urban

proletariat and the removal of anything luxurious or not essential to the ends of subsistence, a key word—the even more miserable relative of survival—that is often found in the titles of studies on famines and economic crises.

The questions analyzed here, with only rare exceptions, were put aside for other priorities and taken up only for the *vexata quaestio* of the causes of the decadence and of the "two crises," in which the nexus between economy and art was resolved in intentionally scandalous terms.

Up to this moment, it had in fact been held, with the help of orientations more or less ingenuously deterministic on the part of historians of art and culture, that the florid artistic and cultural production and consumption was a *mechanical* result—not certainly a cause, nor a concurring cause—of the presence of prosperous economies and open societies, having in view the splendid Italian, Flemish, and Hanseatic examples. In the praises that Sismondi sang of the Italian flowering in the Trecento, the creative periods were daughters of republicanism and democracy, inseparable companions of economic supremacies and commercial success.[96] From the Voltaire of the *Essai sur les moeurs* to the Herder of the *Ideen zur Philosophie der Geschichte der Menschheit*, to the last of the Enlightenment followers, the idea had filtered through that art and culture prospered in the wealthier and freer nations. If John Millar in his *Observations Concerning the Distinction of Ranks in Society* of 1771 had stated: "In the twelfth and thirteenth centuries, many of the Italian towns had arrived at a great perfection in manufactures . . . The advancement of the common arts of life was naturally succeeded by that of the fine arts and of the sciences, and Florence, which had led the way in the former, was likewise the first that made considerable advances in the latter."[97] Adam Ferguson in *Principles of Moral and Political Science*, published in Edinburgh in 1792, had repeated: "The progress of fine arts belonged generally to the history of the wealthiest nations."[98]

Reinforced by the Marxian thesis that spiritual production (the *Geistige Produktion* that included art and culture) was a superstructure based on solid economic foundations, these concepts were absorbed by historical schools of varying orientation, and markedly by many art historians: art remained the daughter of wealth, and it was impossible to consider it the mother or even stepmother of this same. It could be considered, with difficulty and not without upset, a product, but less than ever a factor of production.

A sense of the relation between economy and art was never discussed until Roberto Sabatino Lopez attempted it in a lecture in 1953 at the Metropolitan Museum in New York, and again at a meeting of the American Historical Association the following year.

On both occasions, faced with hostile audiences, the Genoese iconoclast affirmed that the Italian economy had reached its high point of success in the thirteenth century and that after the crisis of mid-Trecento in the Renaissance (which is to say "roughly the period between 1330 and 1530")[99] entered into depression; notwithstanding that the "luxury industries alone maintained and perhaps increased their production," this "reflects the decline of production for the masses and the growing distance between the very rich and the very poor."[100] A reevaluation, or better a super-reevaluation of the distinctive value of culture, considered to be the main means for entry into the inner circles of Renaissance society, which "contrary to widespread popular belief . . . was essentially aristocratic,"[101] begins to make the general picture less clear.

In Lopez's interpretation, the phenomenon had induced the statesmen—who earlier had struggled to aggrandize their states—to compete "with one another to gather works of art," while the businessmen who used to do business "now invested in books."[102] Thus he brought himself to hypothesize that between the movements of economic and artistic cycles, there could be, but was not always, an inverse relationship: the periods of depression, the so-called

hard times, would stimulate investment and spending in culture more than would periods of growth, in which the animal spirits of capitalism required so much energy that there was none left over for futile pastimes.

This appearance on the opposite field opened up a wasp's nest of argument, but did not make the Genoese scholar desist; rather, he broadened his thesis in an article written with Harry Miskimin[103] and was immediately contested point-by-point by Cipolla.[104] That temerarious statement, even if not given much credit today,[105] at any rate had the merit of awakening the curiosity of those who had always thought that behind the artistic and cultural explosion of the Italian Renaissance or the Dutch Golden Age was hidden the strong thrust of economic well-being, and forced the academy to deal with another point of view.

In any case Cipolla, who had harshly criticized Lopez's theses, did not use the occasion to further his argument, but only fed another myth of decline, as did others of his generation, remembering the welcome accorded to hard times, and perhaps fearful of historians' reactions.[106] For these reasons, in the 1960s the art markets' events did not excite much curiosity even within the animated debate over the revolution in consumption, which is a theme that might have been ready for a critical rereading, but that in practice was refused at such a high level as to obliterate the examination of products and consumption considered to be elite and economically marginal.

If anything, the next decade registered further distancing with the complicity of the Marxist orientation of much history, and thus, after the incursions of Basil Yamey[107] and Federico Melis[108] in 1972, no one took up the invitation two years later by Fernand Braudel, when he stated that "The culture in the peninsula had become, towards mid-Cinquecento—a great business, a grand industry . . . there are almost regional specializations, a species of subdivisions of labor . . . the most important characteristic is the participation of the growing mass of people in these active businesses. There are more construction sites, more painters, more writing than Italy had ever seen before. There is a greater intellectual effervescence and more and larger intellectual circles . . . Never as then has the primacy of culture been so officially accepted," repeating the necessity to pay attention to "every sort of cultural good and agent: artists, but also merchants, workers, simple travelers, without whom the goods would not have left Italy. Who are these agents? How did they function, and where? These questions are often asked and receive insufficient replies."[109]

Unfortunately the pleas of the famous French historian did not bring an enthusiastic response, as can be seen from the writings from the same year by Philip Jones, Carlo Maria Cipolla, and Ruggero Romano. The first, in the Einaudi synthesis of medieval and Renaissance economy, treated the question superficially,[110] and the second also resolved the question in just a few lines of the *Storia economica dell'Europa preindustriale* in which he fleetingly cites "the various services for the maintenance and decoration of the home, and in the case of the noble classes, services in relation to different types of amusement, such as the demand for musicians, poets, midgets, and buffoons, falconers, and stablemen, etc."[111]

Ruggero Romano's aversion was much stronger, as he, in the group of essays printed in 1971 under the prosaic title *Tra due crisi: l'Italia del Rinascimento*, proposed to "clarify how and why Italy between '300 and '700 fell from the highest heights to the deepest abyss. And this—the histories tell us—while a phenomenon like the "Renaissance" unfolded, boasting of splendors almost unique in the history of civilized Europe and the world, misery, ugliness, humiliations, compromises."[112] Considering the premises, it is not surprising that in the essay *Arte e società nell'Italia del Rinascimento* (already published in a Hungarian journal in 1965),[113] the historian from Fermo defined Renaissance artistic production as an "extraordinary contradiction"; "while the Italian economy and above all the patriciate entered into a phase of economic stagnation . . .

it was possible for this class to engage in important spending, the inevitable reverse of the coin that has on its face the marvelous spectacle of exceptional artistic refinement."[114]

The judgment, thus, could only be negative, since the "extraordinary process of immobilization of money represented by the immobilization of the great capital spent in the construction of buildings and in the creation of art collections,"[115] even though they had been "a source of earnings for a large number of workers, it remains that these expenditures are of a fundamentally nonproductive nature: one finds oneself facing a phenomenon of conspicuous consumption which *had to have* (the italics are his) serious consequences for the Italian economy."[116]

A quick comparison with Fanfani's 1943 text shows us an unexpectedly identical point of view, especially as to the grave consequences to the "contradictory nonproductive immobilization" that Romano continued to insist on in his essay *La storia economica. Dal secolo* xiv *al Seicento*, published in the Einaudi *Storia d'Italia* of 1974,[117] where he repeats his discomfort, which was in any case shared by exponents of other historical schools.[118]

The climate improved only with the conference organized by the Francesco Datini Institute in 1977 on *Investimenti e civiltà urbana nei secoli xiii–xviii*, whose proceedings were unfortunately not published until 1989,[119] and this explains why in other works of a general nature printed in the following years there are no significant references, either in the volume of the *Annali* of the Einaudi *Storia d'Italia* edited by Romano and Ugo Tucci in 1983,[120] or in the second volume of *Storia dell'economia italiana* in 1991,[121] where the pages by Gigliola De Divitiis[122] are in conspicuous contradiction.

It was not to be before the 1980s that one would see an early rekindling of the flame, despite the constant discovery of precious information. One cannot in fact deny that the sources usually examined by traditional research on international commerce and accounting history, princely and great bankers' finances, urban production and noble patrimonies, gave facts and information of great interest. But it is plausible that, more than prejudicial ideologies, it was the excessive familiarity of rubbing shoulders that distracted attention, almost as if the evidence were an ancillary element, off the trajectory of the great choral events that were studied, confusing the *basso continuo* with the indistinct roar of background noise. Very few scholars did not encounter, in scanning an account book, or a will, diary, inventory, a piece of commercial correspondence, of acquisition, sale, gift, or inheritances of art and luxury items, but these discoveries by virtue of their repetition were not at all exceptional. Art was such a constant guest in Italian houses that it became a virtually invisible part of the furnishings, one reason that limited the collection of these notes in dedicated publications.

THE RELAUNCHING OF THE 1980s

The occasion for a new departure came in 1985 when the Datini Institute dedicated its seventeenth study week to the *Aspetti economici del mecenatismo, secc. xiv–xviii*,[123] picking up the threads of the discussion begun in 1977. That event furnished an important indicator and marked the beginnings of a gradual process of rapprochement between the national (Italian) and international areas of traditional research in economic history. Even the moment in which this step was taken—essential to its academic accreditation—was not coincidental, since apart from the influence exerted by the successes of "New Art History" and the newborn economy of art, the world of the social sciences was going through a transitional phase during which ideological conditioning was diminishing because of a conspicuous generational turnover.

These phenomena favored the approach to arguments that had earlier suffered from tacit vetoes and strong suspicion (the reprehensibility of luxury, immorality of waste, aristocratic vanity, the nonproductivity of expenditures in the search for distinction), while the rigidity of other dogmatisms diminished (economy as the science of "industrial production").

In this sense, it is instructive to observe the distance that separates the thoughts of John Munro and Richard Goldthwaite. The former, still influenced by Lopez's theory, compared the economic development of Flanders and Brabant in the Quattrocento with the cultural situation of the Low Countries in the following century, verifying the coexistence of contradictory phenomena and the absence of a clear relationship of correlation between the two cycles.[124] The latter, instead, in his seminal *The Empire of Things: Consumer Demand in Renaissance Italy*[125] established the basis for a complete reexamination of the theme, in line with the conclusions that had been reached in the early 1980s by scholars from other historical disciplines, while the premises were set for overcoming inveterate jealousies, as one can see in the quality of the results obtained by the first interdisciplinary groups and especially the Dutch,[126] and by the initiation of broad projects such as the exemplary Provenance Index directed by Burton Fredericksen at the Getty Institute of Los Angeles, which involved a systematic census and recuperation of primary sources.

These signals were received by a part of the scholarly world as a release, especially by the younger members who were perhaps attracted by the climate of confrontation—not always peaceful—that was alive on those early occasions, as one may see in the program of the convention *Arte, committenza ed economia a Roma e nelle corti del Rinascimento (1420–1530)*, which was held at Rome in 1990[127] and was the first of a long series. The authoritativeness of the participants of the Roman seminar marked a turning point that was counterposed by a convergence of lines of research that had not communicated earlier, and among whom were those who had followed up on the pioneer work of Domenico Sella on building.[128]

I believe that it was not by chance that Richard Goldthwaite, who reawakened attention to art markets and sumptuary consumption, arrived at this point through his studies of Florentine Renaissance construction,[129] and responded to Antonio Di Vittorio's appeal, at the conclusion of his good reconstruction of the Italian historical-economic debate of the twenty-year period 1966–1986, that observed that the history of building and urban history were "sectors not much treated by our historians."[130]

RICHARD GOLDTHWAITE AND THE SUCCESSES OF THE DECADE 1995–2005

Both in the essay in *I Tatti Studies* in 1987,[131] and in the monograph printed six years later,[132] Richard Goldthwaite, in answering an apparently simple question—"Why were so many works of art produced in the Italian Renaissance?"[133]—faced the question for the first time in deeper terms, letting us intuit the interactions that existed between analytic planes traditionally out of phase. The Johns Hopkins professor not only underlined, even in the title of the book, the determinate role of demand, turning the traditional supply-side orientation of much historiography on its head, but called for an extension of the perimeters of investigation and adoption of more rigorous methodologies. These could overcome the impasse shown by Franco Franceschi, who observed a few years later, in a documented historical essay: "For the rest there have been very few monographs on single themes, cities, or areas that have consciously undertaken the aim of investigating the possible connections existing between

economic and cultural phenomena."[134] The prestige and authority that Goldthwaite enjoyed, and enjoys, caused an immediate reaction, while in the twenty-sixth study week of the Datini Institute *Il tempo libero. Economia e società. Secoli xiii–xviii*, held in Prato from 18 to 23 April 1994, contiguous questions were approached: think of the interventions on festivals, on ephemera, spectacles, and aristocratic and courtly pastimes, which raised the question of artistic and semi-artistic "services."

Just a few months later—in August of the same year, to be precise—the eleventh International Congress of Economic History was held in Milan, and for the first time a session was dedicated to the artistic markets.[135] Other events followed, and in 1998 at the next International Congress of Economic History, in Madrid, the organizers of the section *Art Markets in History* selected three precise axes of study: "1. The demand for arts, analysing the range of art objects purchased by households and social clusters of households to reconstruct society's demand for art; 2. the conditions of artistic creativity and communication between different artistic centres and artistic milieux; 3. art markets which may serve as link between the first two questions, due to dynamics of the market and its potential for innovation."[136]

The Spanish meeting marked a point of no return, as one may see by the imposing number of articles and books that have been published since,[137] and by the quantity of initiatives dedicated to more specific topics such as copies, fakes, price formation, artists' careers, production of color, thefts, smuggling, the relations of critics and intermediaries, museums' acquisition policies, etc.

Soon after, both the thirty-third study week at the Datini, titled *Economia ed Arte. Secc. xiii–xviii* and held at Prato in 2001, and the thirty-sixth week dedicated to *L'edilizia prima della Rivoluzione Industriale. Secc. xiii–xviii* in 2004 declared the discipline's interest in the question, also underscored in the next convention of the Italian Society of Economic History. The art markets were no longer an eccentric pastime of a few, but could represent a fertile terrain for the verification of much more ambitious and prolific historical theses.

THE CONTRIBUTION OF SOCIAL ART HISTORY UP TO THE SEVENTIES

Observing the ramified world of art-historical materials, one cannot deny that interest in the "art markets" (by now a requisite for any Anglo-Saxon monograph) came after a tormented *iter*, given that the dynamics of accreditation have not followed a regular path, but rather seem to be the epilogue to a lengthy siege carried on many fronts and ending in the capitulation of the mother discipline, which, shaken by crises and contractions, had given birth to specializations and specialists who had worked in parallel for a long time.

This palingenesis explains the greater or lesser casualness with which the *disiecta membra* have faced that *part maudite* represented by the relationship between art and economy, this last agreement in its more pure and strict etymological sense. It is thus worth our while to review the stations of this *via crucis*, separating the various paths that were followed to a common end. It would in fact be unfair to give credit only to social art history for having posed the question and forget the contributions of the historians of collecting, care, criticism, museology, conservation, technique, connoisseurship, architecture, scenography, material culture, and law, as well as the numerous scholars of ancient, modern, and contemporary art.

An attempt to connect the threads that have entangled this no-longer-obscure object of historiographical desire must recognize the merits of social art history—which has worn

various ideological armors, and not only Marxist—in challenging the backwardness of the purists, posing embarrassing questions, and opening new roads to the knowledge of an artistic world that, as Enrico Castelnuovo mentioned, was then occupied "with art history without Wölfflin, by interpretative monographs of an idealistic bent, by the increasing complications of *connoisseurship* and attribution as well as the early iconographical explorations."[138]

Thus, one may not ignore the contributions in the early twentieth century from German scholars such as Hans Flörke,[139] Paul Drey,[140] Lu Märten,[141] Hanna Lerner-Lehmkuhl,[142] Alfred Von Martin,[143] Martin Wackernagel,[144] Henry Thode,[145] and on up to the early Nicholas Pevsner.[146] These, influenced by post-Weberian sociology and by the historical school, extended their interests to patrons, institutions, associative and regulatory bodies, to the processes and techniques of production, to types of contracts, and to the more properly socio-professional dimensions of artistic activity moving along the Tuscan-Flemish route. Some of their conclusions were questionable, but in any case always stimulating. Recognition of birthright does not diminish, but rather places in a different perspective the contribution of the scholars who, beginning in the thirties and after World War II, took up the threads of that debate—such as Frederick Antal,[147] Francis Klingender,[148] and Arnold Hauser.[149] This trio shared with its above-mentioned predecessors the joys and sorrows of the Mitteleuropean culture of the early decades of the twentieth century,[150] but was brought together by the adhesion, even though each in his own manner, to Marxism, which in the same years was causing more than one continental intellectual to deal with—looking mostly at the present and recent past—the "art market" (publication of the work of the same name by Karel Teige was in 1936).[151]

That "second"—or first, depending on one's point of view—group of "social historians" of art reproposed on a more sophisticated and theoretical plane (with a consequent abstraction from documented facts) the question of the relationship between art, economy, and society, often reducing them, as the critics did not fail to observe, exclusively to the antagonistic artist-patron dialectic, but attempting in any case to throw light on interclass conflict, identity demands, relational textures, the hierarchization of the fruition processes, and the political-hegemonic meaning of production, rather than on artistic consumption.

These works, for various but understandable motives, did not gain immediate favor. On the contrary, one could agree with Enrico Castelnuovo that the welcome was rather cool,[152] while bearing in mind that Antal died in 1954 and Klingender the year after.

The coolness soon turned cold, since there was no lack of criticism from illustrious colleagues who, acting in defense of unrenounceable methodological principles,[153] mistook the historic vocation of these writings, accusing them of using second-hand sociology or mere political propaganda. According to detractors, the heterogeneity of the ends forced the interpretation of the facts and reduced them to ideological preconceptions, using a rough mechanism and monolithic determinism as levers.

These forces all too often availed themselves of the mirror theory, which hypothesized simplistically that "the relations between the social and economic forces in a given historical moment are reflected in the world view of this same moment and that this is in turn mirrored in artistic production."[154]

Ernst Gombrich particularly distinguished himself among the adversaries in suggesting the interpretation of these phenomena by another means, "that of the chronicle of the changes in the material conditions in which art was done and created in the past," traced by a diligent, close, and documented examination of the "institutional structures within which the artistic activity of an era was carried out."[155] Attention to change was kept alive by the constant monitoring of social emulation, of fashions, of professional emancipation and technological

innovation, but did not recognize the explanatory primacy of the socioeconomic variables against which Gombrich did not hesitate to polemicize,[156] as he was convinced that there was no dependent relationship between determinate artistic forms and specific social structures.[157]

In this way, the passage developed from the macrosociology (at that time beauty queen of the social sciences) of Hauser's theories and the great Antalian frescoes to a microsociology of chronicle, falsely modest but with the intention of not giving in to ideological tendencies constructed on impressionistic generalizations, facile parallelisms, and dubious analogies.

The method proposed by Gombrich is nicely exemplified in his 1960 article on Medici patronage,[158] and allied itself with the empiricist predilections of Anglo-Saxon historiography and enjoyed undeniable success, remaining an academic canon until the end of the 1960s, when the criticisms, otherwise armed, of the neo-Marxists began to hit their mark. These attacks—not by accident—caused the rediscovery and posthumous success of the "founding fathers" and brought up a wave of accusations against their earlier denigrators, now accused, with the energy and vehemence of the time, of neo-positivism.

Out of the dialectic between the different ways of conceiving and qualifying the "social" following, art history grew specialized studies aimed at more circumscribed themes: investigations of the social status and living conditions of the artists increased and developed together with those of the museums, academies, and the "institutions of mediation," that is, those subjects that, according to Castelnuovo, occupied themselves with "legitimization, promotion, education, selection, consecration, exchange, sale, conservation, protection, inventory, explanation, and reproduction"[159]—breaking up the monopoly of the dyadic master-servant/ patron-artist relationship.

That generation of scholars, among whom Andre Chastel[160] and Francis Haskell[161] stood out for their diversity of approach, took on new questions and affirmed itself with overlooked periods, working with untapped primary sources and opening themselves up to comparison with historians *tout court*. This brought the conditions for the consecration of new fields of research, among which shone that of the trio customer-patron-collector—fields that at the end of the 1950s had been trod by the new young sociologists of art, attracted by the possibility of combining empirical research with social theorizing. One's thoughts run to the groundbreaking texts of Alice Saarinen[162] on the great American collectors, of Raymonde Moulin[163] on the French contemporary art market, or the Whites[164] on the socioeconomic milieu of the Impressionists and post-Impressionists, who supplied important suggestions to those who were interested in the formation of prices, the productivity of artistic work, and the professionalization of the intermediaries. At the same time, the history of collecting was losing the encomiastic characteristics that were so typical of much nineteenth-century literature (and still survives in the work of Francis Taylor)[165]—one could die of indigestion of archival gleanings—and turning towards arguments closer to historical interests, where attention was displaced from the collected objects to purchase practices, to their cultural significance, to the vast network of protagonists, whether leads or understudies, of major and minor events.

SIEGES, SURRENDERS, AND CEASE-FIRES, 1980–1990

In the late seventies, in the wake of fortune's having smiled on "social history," which seduced also musicologists and historians of theater and literature, the history of art underwent a revolution; see New Art History *et similia* that further amplified the scope of thematic material.

Many of these paths converged willy-nilly with arguments of an economic nature, from the relations between connoisseurs, collectors, and intermediaries to the connections between tutelary provisions and commercial dynamics, from politics of museum acquisition to the production of copies and fakes, while courageous exhibitions were being mounted—think of those in Italy dedicated to ephemera, to the products of courts and of sumptuary arts—and previously ignored sources from auction catalogs to export licenses were being examined.

It is true that the "market" remained in the background, liminal and in a way lateral to the discipline's curiosity, but the march went on ceaselessly, both in the studies dedicated to the early modern period (from Peter Burke to Michael Baxandall)[166] and in those dealing with the eighteenth and nineteenth centuries. These gained the favor of quite a few scholars (for example the work of Maas,[167] Boime,[168] Robertson,[169] or Brigstocke[170]), while sociological inquiries continued and biographies more attentive to economic factors were published.[171]

The 1980s began this way, marked by the success of neo-institutionalism, cultural studies, and anthropology of consumption[172] that were converging on a common hunting terrain, and where the most intellectually sought-for prey was luxury products,[173] the phenomena of social emulation and distinction, the birth of consumerism and of the modern consumer societies.[174] These lines of investigation on the one hand required the resolution of unanswered questions and on the other demolished fences, traced new methodological paths, and encouraged incursions into the no longer sacred temples of art, provocatively reduced to a commodity that could now be tested by the most experimental treatment, in which a portrait could rival a porcelain stove, a *bronzetto* the cabinet in which it was kept, a sculpture its own pedestal.

For the disciples/proponents of material culture, materialism became an essential condition for the examination of overlooked aspects of traditional history, such as the use of objects, the meanings they might have for different peoples, their wanderings and status changes, their owners, the relations between these and the spaces in which they were kept, etc. These tensions were relaxed only at the end of the decade, when in a climate of enthusiastic confusion, the last disciplinary hesitations fell, the lines of art history were broken and moved along various paths leading to the multicolored bazaar of material culture, or to the new fortresses of specialization, more minute but more armed.

Thus the early investigations of national and regional cases began to appear, critical and open to dialogue with the social sciences, as one can see from research on German,[175] Dutch,[176] French,[177] and British[178] markets. These studies, using more recent events, used sources that were richer in biographical facts and figures, and managed to suggest common, albeit perfectible, analytic modules. At the same time, studies were being published that were dedicated to more particular aspects, such as the success of single artistic genres[179] and strategies of artistic positioning,[180] in which individual resolutions as well as group dynamics[181] were investigated.

Similar considerations hold for the publications consecrated, without using either apologetic tones or moral condemnation, to the art merchants, who have long been missing[182] from Italian history. There are few works comparable to those dealing with the principal foreign dealers;[183] to their professional *iter*; to the evolution of promotional, sales, and payment techniques;[184] and even to their numerical consistency, even if there were commendable efforts and results such as the article by Sophie Couvra on the commercial annals and specialized press,[185] Annemieke Hoogenboom's[186] list of merchants active in Holland during the first half of the nineteenth century, or the repertoire of Parisian intermediaries compiled by Marianne Grivel.[187]

The situation concerning studies on collecting and collectors was different, since Italy boasted an old, erudite, and illustrious tradition, not always problematic and inclined to theorization. Fortunately in those years scholars like Krzysztof Pomian[188] and Adalgisa Lugli,[189]

who had been trained in other methods, entered into the argument and posed more articulate problems, broke up the traditional disciplinary partitions, and called the attention of a larger public to extra-artistic collections (among these stand out the studies on the scientific, botanical, and naturalistic) and their significance and impact, supplying useful elements that gave an autonomous theoretical dignity to similar studies. This was an essential step in opening the debate on collecting to different interlocutors (for example, economists, sociologists, and psychologists) with differing approaches who had an undeniable influence on the manner in which the history of collecting related to the objects of its studies. In earlier studies, this had often coincided with the compilation of detailed biographies of isolated collectors, and single works that could bring out attribution questions in which, following the trail of each single work, one lost all sense of the relation between them, their relation with the institutions and venues that had held them, with the mediators who had prestidigitated them, with contemporary and later reception, in effect with their entire cultural history. With time, the revolutionary ardor has diminished somewhat (note the more recent numbers of the *Journal of the History of Collections*, not by chance founded in 1989), victim of its own success, even if there has been no lack of interesting contributions from historians *tout court*.[190] In any case, the stimulation was felt even in the artistic field, where, in concomitance with academic recognition of the "history of collecting" and the first university courses dedicated to it, the publications by Cristina De Benedictis,[191] Paola Barocchi,[192] and Giovanna Gaeta Bertelà[193] are outstanding and comparable to the best non-Italian works.[194]

If anything, in Italy there were very few works on bourgeois and entrepreneurial collecting and on the changes these brought, along the lines of what had been written about the French[195] and English,[196] nor was there correlation between socio-professional extraction and tastes, on the dichotomy between monothematics and eclectics, on the impact the associations of collectors and/or "art lovers" exercised on the structure of the markets, on the success of some genres, and on the mechanisms of price formation, along the lines of the research by Walter Grasskamp[197] or Julie Codell.[198]

These studies of necessity brought a different approach also to the questions of connoisseurship,[199] touching delicately on nerves that in Italy were raw, even if there was an interesting foreign bibliography[200] that had unveiled, sometimes exaggerating in its use of gossip, the little altars of some of our art-historical and critical *monstre sacré* whose involvement in commerce was anything but casual and disinterested. This was a taboo that was difficult to overcome because of possible embarrassment, like the study of acquisition policies in museums, especially foreign ones, that were beginning to be accused of some of the "great transformations" that had occurred in the somewhat cloudy field of intermediation.[201] In fact, the role of the great European and North American institutions in the systematic drain of masterpieces was clear, a practice that, with all the risks involved, had brought appreciation (even economic) of goods, artists, schools, and genres that had been long overlooked.

After the gestation period, the artistic markets began in the 1990s to enjoy growing interest not only among contemporary scholars but also among medievalists and modernists, until they became, in a paradoxical evolution with respect to the point of departure, a mainstream theme that could bring back—if not to order, at least to the camp—the troops that had perhaps been disoriented by the dizzying order to "break ranks."

The Psychology and Ethics of Consumption

The Debate on Liberality, Magnificence, and Splendor

HE WHO SPENDS MORE, SPENDS BETTER

For some years now my good humor has been menaced by the declarations of those who praise "Italy's first-place standing with its historical artistic patrimony." As much as I detest the patter of percentages tossed about freely (and anyway never less than 50 percent) to establish the exact proportions of our national pride, in this moment I may not subtract myself from the obligation to try to respond to the question posed by Richard Goldthwaite at the beginning of his famous book: "Why were so many works of art produced in the Renaissance in Italy?"[1]

This question, which has stimulated contrasting reactions for centuries, has brought many replies that are implicitly or explicitly correlated to various macro variables: the primacy of "politics" and the function of the Holy Roman Church, the humanist inheritance and princely ambitions, on up to and including economic factors such as the growth of income, accumulation of capital, the tendency to save, immobilization of investments, etc.

Rather than following this line of inquiry, which pays more attention to the large socio-institutional transformations than to single behavioral dynamics, I would prefer to explore a less beaten path that coincides with the ethical and ideological origins of a phenomenon that generated a "psychology of consumption." The "consumption" of the Italian Renaissance in its individual and collective variants had solid and deep ideological rather than cultural roots, as it was the result of an ethical debate that legitimated and de-moralized practices and behaviors formerly considered immoral.

This radical subversion, supported by the opinions of the most prestigious classical *auctoritates,* was based on the rediscovery and celebrations of liberality and magnificence, two virtues that even though they had attracted the attention of classicists[2] and historians of art and architecture,[3] do not seem to have stirred equal interest among historians of economy and economic thought.[4]

ANCIENT VIRTUES OR MODERN VICES?

Sketching a picture of an Italian gentleman at the end of the sixteenth century, Torquato Alessandri defined in precise terms the prerequisites necessary for someone to be legitimately and honorably accorded that title: "the maintenance of a large, well-furnished house always open to guests, with many horses in the stables, and servants in the house; always dressed in rich and diverse silk cloths, wearing around his neck a magnificent chain of gold and large diamond rings on the fingers, large golden buttons, an embroidered and perfumed collar, wonderful jewels in the hair, golden sequins in the bag, without forgetting to prepare a huge feast showing all of God's bounty every day."[5]

This description was neither polemical nor mocking, nor did it have a heavily moralistic tone. It merely represented with proper precision the lifestyle of a great part of the Italian elites, marked by the maintenance of honorably liberal conduct. Liberality is really the initial term of our discussion. The goods described by Alessandri, like those listed by Sabba da Castiglione in his famous *Ricordo circa gli ornamenti della Casa,*[6] are not manifestations of a reprehensible ostentation. They are the pledge of the ancient lineage to maintain their own honor unspoiled, and the endowment by means of which aspiring nobles could ratify the marriage with the much-yearned-for "blue blood."

In both cases, one does not have before one luxurious consumption or voluptuary spending, superfluous goods or capricious waste: behavior marked by the daily liberal employment of wealth could irrefutably show real nobility of spirit, more than could be shown through not always adamantine genealogies. This was because in the sixteenth century's sense liberality, "lying between the two extremes of avarice and prodigality," was properly "a moral virtue which moderates our feelings with regard to the desire and greed for money. By money we mean any kind of substance or thing which could be measured by the price of money: and this virtue is exercised by dispensing money usefully, where, when, and to whom it is needed."[7]

Liberality is therefore a private virtue that assumed the form of a secular charity whose innate redistributive propensity could be used to correct the errors of Fortune, ennobling "fortune" so that it could be conveniently shared with worthy persons, because "rich and powerful men, when they present their wealth to those who are worthy, through liberality, do not want to enrich them, but simply reward them for services and honors received."[8] Thus, "He will be liberal who will spend his wealth in support of his household, friends, relatives, and of literary and virtuous men; and finally in support of those who through no fault, but through the blind stroke of Fortune, have fallen into disgrace and poverty. The liberal man has to do all these actions not out of a vain wish for honor and ostentation, but out of mere virtue and charity."[9]

Aristocratic wealth had to escape, then, from the accumulating temptations of avarice in order to preserve its real equalizing vocation, which was perennially unbalanced in favor of giving.[10] The liberal use of wealth is not an end in itself, but is the means that guarantees at last equity in the allocative process: "The liberal man lies between these two extremes, vices of avarice and prodigality. He does not dissipate his wealth, or give presents to the unworthy. He shares with upright judgment his income with others, according to the time, place, and quality of people."[11]

This was an instrument that was used with conscience. Spending and giving were two things that were owed to the house, rather than being whims. Their purpose was to correct the sufferings caused by a destiny that was blind to the merits of individuals. In this way it legitimized the inequalities of the social hierarchy. No sin was worse than avarice, which was

not perceived as a crime against humanity, but a grave blow to the honor of class and the prestige of peers; a shortcoming of duty to the rank that legitimized preeminence by virtue of this superior ability to judge, recognize, and reward the merits of subordinates, "sharing his income with others." Not only were spending and giving not morally reprehensible, the contrary was true. Someone who did not meet this caste obligation revealed baseness of spirit. Such a person is one "who, while spending, feels great displeasure, as happens to the illiberal or the miserly."[12]

Knowing how to spend and to give thus became incontrovertible proofs of a person's value and his capacity to recognize the value of others, the significance of the occasion, the merit of a decision to elude the traps of "the other kind of liberality, which is fake, when somebody is generous when he must be the most miserly, when he spends where he must not spend and gives to someone unworthy of the gift."[13]

In absolute terms "excessive spending" did not exist, as is witnessed by the lack of attention to "prodigality, that is, unlimited spending with no order, no style, and no limits,"[14] but rather senseless expenses and gifts, lacking judgment, while the "truly liberal takes care of his things, and does not dispense of them indiscriminately and with no reason, in order to use them later where necessary in those times and places, and with those persons, which the honest and just circumstances of virtue require."[15]

"Spending with measure, order, and method," "giving money usefully where, when, and to whom it was needed," "giving according to the time, the place and the quality of people," which on the one hand revealed the purposeful, prudently anticipatory nature of liberal acts as alien as possible from that perception of casual and careless *dépense* which is still deeply rooted in many historians. On the other hand there were different but just as important ways of dislocating and demoralizing the notion of waste, luxurious and superfluous, by means of the affirmation of a concept of "business expense" that tied the quality of the person to the quality of the things surrounding him.

There was no good that could not find its natural correspondent in the social order, there was no need that could not be legitimately proved by someone. However, as the lower orders drew closer, appropriating to themselves the goods previously owned only by upper groups, so did the elites innovate, refine, and increase the value of their goods in an attempt to reestablish proper social distances. But this citation game, in which goods immediately signaled recognizability, could only be based on a constant raising of the ante. None of the actors in the comedy of life could refuse to play. If one did not want to lose reputation or risk the scorn of one's equals, if one did not want to prejudice one's ambitions, or if one simply wanted to maintain social position, it was necessary to own certain goods.

In order to reestablish the proper social distances, Giovan Battista Pigna could underline that "close to liberality" was "magnificence, which is in great things,"[16] while Alessandro Piccolomini confirmed that

> close to the virtue of liberality, there is that splendid virtue which is called magnificence, and even though magnificence is in some way similar to liberality, it is nevertheless different from it in many ways. These two virtues are similar, because each of them is related to the use of wealth, but in this aspect they differ: Liberality concerns every action that, with regard to the use of money, could be performed in everyday life, such as gifts and payments, alms and household expenses. Magnificence, however, takes place only in those expenditures that happen rarely, for important reasons and special occasions. Only someone who makes great things while spending could be properly called

"magnificent." This occurs mostly if he spends on public occasions, special commissions, or honors of the Republic, such as appointments of magistrates, receptions of emperors, kings, and princes, gifts for the most distinguished lords, great embassies, building of temples, porticos, and theaters, display of public festivals and comedies, and other occasions when the honor and dignity of the state need to be defended. In the same way, this virtue could show itself on rare private occasions, such as weddings, parties, banquets, receptions of distinguished guests, expenditures on town and country residences, domestic ornaments and furnishings, and other similar things where one can see sumptuousness and grandness. In magnificent actions, three aspects should be considered: who spends, how much is spent, and the object of the expenditure. But considering how much is spent, it is obvious that the expenses should be proportional to the quality of the spender. In fact, the way of spending of an emperor, a prince, and so on is different from that of other ranks and conditions of human beings. The same expense that will be magnificent for a private gentleman will not be so for a prince.[17]

To avoid misunderstandings, here we see reestablished the proper distances from the powerful apparition of a superlative virtue, exclusive of the few elected for whom is valid the firm response given by Sigismondo Sigismondi to the question whether "those who are always spending on banquets, houses, gifts, weddings, and other similar things, thus consuming thousands of pounds, even though they will never receive such signs from anybody, are guilty of a vicious action." He replied that "if these expenditures were proportionate to the strength and degree of those making them, they were not only not vicious but were proof of a great virtue known as magnificence, this virtue consisting in the undertaking of great expenditures, carried out as a great man would carry them out. Whoever did not meet these obligations would have shown meanness, or more accurately, cowardice of soul, which consists in not spending perfectly in proportion to the occasion and need. There is no virtue more suitable to a great man than liberality and magnificence, but magnificence is the greater of the two, because liberality can also be exercised by a poor man."[18]

It is in the last line that the theoretical justification for the exponential growth in pomp, luxury, and noble grandness can be found: "liberality can also be exercised by a poor man," and if liberality remained a private virtue that was forced to measure itself against a simple "luxurious" dimension, magnificence was becoming a public duty aimed at safeguarding the dignity of the whole state, rather than the honor of the individual.

We should not, then, be surprised by the exhortation: "The magnific man cannot refuse or avoid the occasions for doing great things, and when the occasion arrives, has to seek to perform them to the utmost for the sake of his own dignity and the dignity of those for whom they are done."[19] If the imitative processes of a bourgeois and plebian sort were stigmatized as carriers of social disorder, this censure and punishment was not applied to aristocratic magnificence, which was not only not condemned but was encouraged: "The magnific man should make every effort so that his works cannot be easily imitated, and should always seek to out-do what has already been done by others on similar occasions. His country houses must be magnificent and splendid, the gardens sumptuous, the town house grand and splendid and furnished in accordance with his degree and something more."[20]

In this way, the largesse by which the elite squandered its wealth was not subjected to any ethical criticism, but was encouraged, praised, and promoted, so that it became an absolute social imperative, as pointed out by Giulio Cesare Capaccio: "I do not want princes to combine fame with the poverty of Epaminonda, of Aristide, or of Lissandro, or that they seek the

glory of Focione, of Fabricio, of Curio and Publicola, because that time is past. It is necessary now that they be rich and that they use their wealth with Magnanimity."[21]

Nevertheless, the reference "because that time is past" confirms that these were not wholly new concepts, but ideas that were again coming forth from ancient times. Seneca had argued in *De beneficiis* that liberality was the sure and proven sign of nobility: "Aristotle himself has said that nothing gives somebody more glory than generosity, rather than nobility, because he is noble who relies on the glory of his ancestors, and he is liberal who honors the virtue of his ancestors. So that all liberal men are noble, but not all noble men are liberal, while some noble men are so distant from the virtue of their ancestors that, despite their nobility, they are becoming incredibly abject and vile."[22]

AB ORIGINE: LIBERALITY AND MAGNIFICENCE IN ARISTOTELIAN THOUGHT

In order to reply to the earlier question it is necessary look at the Greek beginnings, when the two virtues were called ἐλευθεριότης (*liberalitas*-liberality) and μεγαλοπρέπεια (*magnificentia*-magnificence). ἐλευθεριότης can be translated as the condition-sentiment-action of a free man / not servant, and derives from the noun form of the adjective ἐλευθέριος (proper to a man who is free, literally liberal), linked to the adjective ἐλεύθερος (*liber*-free) and to the noun ἐλευθερία (*libertas*-liberty), which signified liberty, independence, the condition of not being a servant or slave. μεγαλοπρέπεια on the other hand comes from the fusion of the prefix μεγαλο (μέγασ-*magnus*-great), in this case closely tied to the idea of μέγεθος (*magnitudo*-magnitude), and the verb πρέπω. This verb has a double significance, since it can be translated as "to stand out, to be noted, to be distinguished, to signal, to emerge," as well as "to be convenient, proper, decorous": τό πρέπον was translated into Latin as *decorum* (the same holds in English), in confirmation of the strong social tones of this "convenience."[23]

Both roots are mentioned in various pre-Aristotelian sources. and Sarah Maclaren in her study on magnificence has analyzed the significant attributes of the μεγαλοπρέπεια in the works of Gorgias, Herodotus, Isocrates, and Senofonte[24] and in numerous Platonic dialogues.[25] There are similar, sporadic mentions in the *Eudemian Ethics,* attributed to Aristotle (1221a, 5–10) where both appear in a long list of moral virtues. One has to wait until Book IV of the *Nicomachean Ethics* before Aristotle offers a systematic treatment of the two terms. ἐλευθεριότης is here defined as the golden mean in regard to material goods.[26] The liberal man is praised for his equilibrium in giving and receiving material goods, with more praise being awarded for giving,[27] while the dominion of "material goods" includes all the things whose value could be measured by money.[28]

Liberality lies between the two opposing vices of prodigality (ἀσωτία-*prodigalitas*) and avarice (ἀνελευθερία-*avaritia*), which are positions of excess and defect with regard to material goods. Nevertheless it is more liberal to give to those to whom one should give than to receive from those from whom one should receive, or not to receive from where nothing should be taken.[29] It is more virtuous to do good than to receive it, to do that which is morally beautiful rather than to abstain from that which is base.

The liberal man does not give at random, however, but in a correct way. His objective is the moral beauty of his action and respect for the conditions that make for correct giving,

distributing the correct amount with pleasure, at the proper time, to those who genuinely deserve such attention.

This action is not linked to the absolute size of monetary resources and, by extension, to the social position of the giver. Liberality is calculated according to individual wealth, as it does not rest on the absolute amount of things given, but in the spiritual disposition of the giver, and it is this disposition that makes the liberal man give in proportion to his wealth.[30] For this reason, although Aristotle mentions that it is a common opinion that those who have inherited rather than acquired wealth are the most liberal, as they have never experienced straitened circumstances,[31] it is not easy for a liberal person to become rich, as he is not inclined either to take or to hold, but to give; he values his material goods only so far as they make giving possible. The more worthy, therefore, tend to be the less wealthy.

At this point, having specified the characteristics of liberality, Aristotle focuses on two extreme vices. Prodigality and avarice are excesses and defects of the two expressions of liberality, giving and taking. Prodigality is first perceived as a self-destructive form of indulgence (the prodigal destroys himself with his own hands by depriving himself of the necessary means for survival). The main faults of the prodigal are his incapacity to give the right amount with pleasure, considering correctly how much, to whom, and when to give. However, a wise guide can transform the prodigal into a liberal man, since the prodigal possesses the traits of the liberal man. The prodigal gives and does not take, but he does not do as he should, nor in the correct way.[32] This explains why prodigality is considered better than avarice. Furthermore, and this is an idea destined to have long-lasting consequences in the history of Western elites, only private citizens can exhaust their wealth rapidly in giving, and thus be considered prodigals.[33] For this reason tyrants could not be called prodigals, because it would not be easy for them to use up their resources in giving or spending.[34]

Avarice is an incurable vice that is much more widespread than prodigality since most men prefer to accumulate wealth rather than distribute it. Avarice can have a double origin: The defect in giving, characteristic of misers, stingy and mean people, is the excess of taking. It is typical of those who greedily seek as much as possible for themselves, as happens in the case of usurers, bawds, gamblers, and pirates. Just for these reasons avarice is said to be the opposite of liberality[35] and is considered to be a worse evil than prodigality: a judgment that will weigh like a millstone on Cinquecentesque absolutions.[36]

Next follows the chapter on magnificence. μεγαλοπρέπεια is also a virtue connected with material goods. It is differentiated from liberality by the fact that it does not extend to all the actions related to material goods but only to distribution or consumption and expenditure, and in this respect magnificence exceeds liberality in grandness.[37] As its name indicates, magnificence consists of large and suitable expenditures, carried out with style and pleasure, whose ultimate aim is moral beauty. If its suitability is proportionate to the spender and to the circumstance and object of the expenditure, its grandness must be absolute. The magnific is always liberal, but the liberal is not always magnific.[38]

The extreme vices are also given for this case. Magnificence is the golden mean between the excess of vulgarity and absence of taste (βαναυσία καί ἀπειροκαλία) and the defect of paltriness and meanness (μικροπρέπεια). The vulgar person spends in a mistaken way, basing a display on pomp for occasions not worthy of it. It is not aimed at moral beauty, but at the display of wealth to arouse admiration. The paltry person, on the other hand, has the opposite defect. He seeks to save on everything, constantly complaining about expenses and ruining the final result.

The magnific man is therefore similar to a wise man, because he can see what is suitable and spend great amounts in proportion. His works will therefore be like his expenditure, large and appropriate. The work must be worthy of the expenditure, and the expenditure worthy of the work, or greater than it. Further, and this is a step of great importance, the magnific man will spend with pleasure and with style, because to keep a detailed account of expenditure is niggardly.[39] In later passages Aristotle lists the areas in which magnificence can show itself, beginning obviously with religion (offerings, gifts, sacrifices, buildings), in order to speak in favor of expenditure in the public interest: theatrical spectacles, banquets, equipping fleets, and so on. In these cases expenditure is made in relation to the spender, showing who the person is and what his resources are. For this reason a poor man can never be magnific, because he does not have the resources with which to make great expenditures in the appropriate way.[40] On the other hand suitable magnificence is only possible for men of high birth, illustrious men; and for those in possession of similar resources they acquired by their own efforts or inherited from ancestors, or who possess important social connections.[41]

Aristotle includes among the great private expenses all those that happen once, such as marriage ceremonies *et similia,* expenses that involve the city and people of high rank, the accommodation of foreign guests, gifts received and exchanged. The reason for including these is in the public nature of these private expenses. The magnific man does not spend for himself, but for the common good,[42] and for this representative function the magnific man should build a house suitable to his wealth, because a house is a kind of ornament, and he should spend on durable things since these are the most beautiful.[43]

This is a philosophy that theorizes authoritatively about the social legitimacy of aristocratic consumption, and elegantly removes the issue of luxury from the province of morality. If Aristotle, talking about liberality, uses such terms as "giving" and "distributing," when he speaks about magnificence he voluntarily uses "expenditure." We are therefore dealing with a theory of needs and consumption that has crossed the threshold of primary needs to reveal the weft of twenty-five centuries of consumption patterns that were burdened by the weight of irrefutable ideological heritage.

The references to the moral beauty of some forms of expenditure and the punctilious listing of the conditions that guarantee its correctness, the careful analysis of the social profile of the liberal and magnific man, the fundamental distinction between private luxury and expenses of "public representation,"[44] the designation of the common good as the ultimate aim of the magnific's actions,[45] the incidental meaning, rich in historical significance, by which niggardly account-keeping was seen as genuinely miserly, the calculated repetition of the grandness, beauty, and permanence that works should possess, entered silently into the genetic inheritance of European elites and profoundly influenced their mentality, informing that mentality with a discretion that cries out clamorously at the discovery of nearly identical cultural structures in exotic tribal contexts.

RECEPTION AND EVOLUTION IN THE ROMAN PERIOD

The Latin world, for a long time immersed in its bucolic environment, did not consider the problem of the most virtuous way of using wealth, the Ciceronian precepts remaining in force: "Roman people hate private luxury,[46] Roman people like public magnificence."[47]

However, reflections on this issue were the undesired but secondary effects of the process of Hellenization of Roman society that occurred in the second century B.C. after the conquest of Hellenistic kingdoms. "The Hellenistic Greek cities enjoyed a refined high culture, the brilliant pomp of kingship, the traditions of Classical Athens, especially the philosophical schools and rational thought, yet at the same time mystery cults promising individual salvation. In Italy, on the other hand, traditional religion was keyed to the lives of farmers and closely tied to the state; patriarchal family units were closely knit, the simple patterns of life had remained unchanged for generations, and cultural life was barren, with no literature or art."[48]

This was neither a peaceful nor generous comparison, as shown in the title of a brilliant work by Jacob Isager: "The Hellenization of Rome: Luxuria or liberalitas?"[49] While the most conservative wing of Roman society was trying to defend the ancestors' morals from the incursions of Greek *luxuriae,* making use of the same arguments employed by ancient Greeks for dealing with the advance of Eastern luxury,[50] the most active fringes of the Roman intelligentsia wanted to adopt a liberal and magnific lifestyle. With this, up to the first century B.C., *liberalitas* signified a balanced and virtuous relation with wealth in an almost wholly private context. Along with *beneficentia,* it was a valid instrument for expressing *benignitas,* good spirit, with the great difference that *beneficentia* referred to works and actions, and *liberalitas* to the wise use of money and the correct granting of *beneficia.*[51]

The situation changed in the late republican period, when *liberalitas* gradually lost the link with *libertas* as a term identifying a condition, sentiment, or action of the free man,[52] a semantic function delegated to *ingenuitas,* to take on meanings that became more political. Nevertheless, from the dictatorship of Silla onwards,[53] *liberalitas* was increasingly associated with the self-interested employment of private wealth and power.[54] It thus included actions not present in the Greek world, where they were considered prerogatives of the magnific: public distribution of food and money (*congiaria* and *donativa*), public games, gladiatorial spectacles, ruinous banquets, grandiose buildings[55] whose main purpose was the speedy construction of political credit that could be easily spent in the turbulent Roman political arena.

This phenomenon explains why authorities like Quintilian argued that the *prodigus* (the prodigal man) was *liberalis* and that *luxuria* was not a vice but an expression of *liberalitas.*[56] This inverted the association that saw *luxuria* as always accompanied by *avaritia* and *ambitio.*[57] The term *liberalitas* was associated with increasing frequency to the rather less noble political-clientary dimension,[58] as an euphemistic description of the obvious forms of corruption or to nobilitate the typical actions of charitable giving, the euergetism that the *populares* politicians easily practiced.[59]

With this we can understand the reasons behind the attempt to restore Cicero, who in the first and second books of *De officiis* dwelt at length on liberality, with the intent of circumscribing the subversive influence of degeneration. In emphasizing the role of *amici* (friends) and of *nostros* (clients), the recipients of attention from the liberal man, and the importance of the fact that the memory of the gift should remain in the minds of sons and grandsons so they not be ungrateful, Cicero admitted the client nature of Latin liberality that had been absent from the Greek context, and sanctioned the unreality of the inverse hierarchical sequence *patriae, propinquis, adfinibus, amicis* that had been proposed by Livy (Ep. 9.30). The abandonment of the anonymous position in which Greek liberality manifested itself appeared in the list of actions that were considered genuinely liberal: freeing pirates' prisoners, paying friends' debts, paying their children's dowries, helping them to find money or increasing their wealth. There still remained a doubt about what happened when a liberal man had many friends, or as

happened to the magistrates *aediles,* faced the institutional obligation of personally providing for such expenditure (public games, gladiatorial spectacles, public works). How was it possible to retain liberal conduct without falling into the temptation of *largitio,* of *profusio*?[60] The answer is twofold: subsidizing lasting projects of which not only an ephemeral record would remain, like walls, arsenals, ports, aqueducts,[61] and opposing the expenses for unnecessary public works such as theaters, porticoes and new temples.[62]

This position remained ambiguous because of the growing competition of *munificentia,* a term that appeared at the end of Julius Caesar's period to identify the grandness of certain architectural initiatives and public games offered by him[63] and that enriched, and confused, the relative linguistic picture.

Slightly stretching the interpretative line but still respecting the difference of degree, I have discovered some similarities with the previous tripartite division of *benignitas* (goodwill)— *beneficentia* (expressed through actions and works)—*liberalitas* (through the wise use of money and the granting of *beneficia*). These virtues, in the highest forms of social expression,[64] generate the analogous sequence *magnanimitas—magnificentia—munificentia. Magnanimitas,* grandness of spirit, comes directly from Aristotlelian μεγαλοψυχία.[65] It showed itself through the great works of *magnificus* or through the enormous donations in money of *munificus.*[66]

It was the advent of the principate that cleared the field of every potential misunderstanding: The term *liberalitas* fell into disgrace as a result of the embarrassing etymological parallel with a *libertas* that had already definitively been lost and as a result of the use to which the term had been put in the turbulent period that preceded the accession of Augustus. Only in the first century A.D. did it reappear in the Roman political vocabulary, even if by then it had become an almost exclusively imperial virtue and action.[67] This term was used to identify specific forms of evergetism of immediate political value, without signifying differences from the synonymous *congiarium.*[68]

But as liberality declined, *magnificentia publica* was on the increase, since Augustus gave it new style and significance. In fact, in his project to restore the ancient values that had been betrayed, he conducted a merciless war against private luxury[69] and specifically against building luxury,[70] but at the same time he proposed a great campaign of architectural improvement.[71] This plan, while it focused on collective needs with the construction of aqueducts, fountains, drains, markets and slaughterhouses, parks and public gardens, was above all directed at religious buildings, giving to the term that religious nuance which led to the fifteenth century rediscovery.

FROM THE MEDIEVAL DEBATE TO THE FIFTEENTH-CENTURY RENAISSANCE

The fall of the Roman Empire did not stop the debate about the liberal and magnificent usage of wealth, thanks to the numerous interventions of the church hierarchy.

Patristic literature devoted ample space to these arguments, setting in action an interesting Christianization process of the Greek and Latin lexicons. However, if reflections about magnificence remained stuck on the theological level, the pronouncements on liberality were very different.[72] This term was used as a synonym for *elemosyna-largitio/largitas.*[73]

The two words *largitio/liberalitas* included in their semantic field *misericordia* and *caritas,*

the definition being given as "both a general Christian attitude towards the neighbor (on a theological-moral level of significance) and a multitude of charitable practices, that is public and private forms of management of socially approved wealth (at an administrative level of significance)."[74] In this sense, if liberality governed the set of roots defining the equal charitable distribution of wealth and superfluous goods,[75] avarice headed the terrible vices threatening the cohesion and solidarity of the Christian community.

A decisive stimulus for restarting discussion of the issue came from the rediscovery of Aristotelian texts in the thirteenth century and specifically with the appearance of the first translation into Latin of the *Nicomachean Ethics* in 1247, which deeply influenced authors like Brunetto Latini (ca. 1220–1294), Thomas Aquinas (ca.1226–1274), and Aegidius Romanus (ca. 1246–1316).

Brunetto Latini limited his work to a succinct but precise paraphrase of the *Nicomachean Ethics*, reducing *magnanimitas* to a virtue concerned with the employment of economic means[76] and straining the Greek and Latin interpretations, justified by the effort to "operationalize" the religious significance of the concept.[77]

Aquinas integrated the reproposition of the Aristotelian arch-text with numerous quotations and exempla from Roman (often Ciceronian) and patristic sources. As far as liberality is concerned the most important observations involve the fine distinction from magnificence.[78] It also contains significant emphasis on the propaedeutics of the exercise of this virtue, that is, the acquisition and administration of wealth: "So liberality does not regard only the use of money, but also preparing and preserving money for a suitable use."[79]

These references were already present in the Greek text, but were given more space in Aquinas's treatment, which was intended to discipline possible excesses of a virtue that already had a socially undifferentiated profile. Every good Christian, whether rich or poor, could be liberal, but "the use of money regards the liberal man in one way, and the magnific man in another way; in fact it concerns the liberal man by a regular affection for the money."[80]

In order to absolve the sins of the magnific,[81] Aquinas followed a line of argumentation that while not ignoring the importance of works of collective interest (as when something is made that interests all the citizens),[82] proposed the realization of eminently religious works[83] in complete harmony with the architectural *renovatio* promoted by the Holy Roman Church.

The work of the most brilliant of the followers of Aquinas was much more influential. Aegidius Romanus's *De regimine principum,* which was finished between 1277 and 1279, and popularized in 1288, provoked open revolution. While he did not abandon the original Aristotelian passages as far as the relations between liberality and magnificence were concerned, Aegidius Romanus argued firstly that "for kings and princes it could not in any way be possible to be prodigal, and that for them it is particularly detestable to be greedy and really suitable to be liberal."[84] He insisted on the fact that "since kings and princes have a lot of properties and wealth, they should give bigger recompenses and they should spend with more pleasure and promptness,"[85] above all in works that did not coincide with the traditional religious sphere: "having honorable houses, making appropriate weddings, equipping admirable armies."[86]

In such a way Aegidius managed to praise the lay spirit of magnificence, thus constructing an excellent moral alibi for princes who wanted to exploit Christian morality, and laying out at the same time the details of that style of "princely" life that, absolved of stringent moral obligations, attracted the attention of the princes of the church, as is witnessed by the papal attempts to censure the scandalous opulence of the cardinals' tables.[87] In the meantime, however, the debate moved from the abstract focus of the scholastic disputations to the more

concrete decisions of municipal and feudal councils[88]: as "late medieval Aristotelian response to a new political phenomenon, the North Italian regional or territorial"[89] and the Dominican Galvano Fiamma, though recognizing an expressive domain, prevalently architectonic with strong religious overtones, for magnificence,[90] suggested that the prince should have "a magnificent habitation" as "an appropriate place of residence for a multitude of officials,"[91] to commemorate the glory and exalt the dignity of his state.

Magnificence in the Tre- and Quattrocento, even while preponderantly architectural, in this way abandoned the religious field and invaded the lay world, ready to satisfy the celebratory needs of the emerging classes and translate into visual terms the new relationships of power and the consequent symbolisms rising in the communes, republics, and numerous *signorie*.

The time was maturing in which the princely example would find enthusiastic supporters even among those who could not claim to have blue blood, as is shown by the vivacity of the Tuscan debate in early Quattrocento,[92] which, fed by the works of Leonardo Bruni,[93] argued precociously for the appropriation of this virtue in its exclusively elite sense.

If Leon Battista Alberti argued that "unnecessary expenditures are liked if they are made with some reason, while they do not hurt if they are not made. And this kind of unnecessary expenditures consists in painting the loggia, buying silverware, being magnificent with pomp, with clothing, with liberality. Expenditures made in order to delight in pleasures and polite entertainment are unnecessary, but not without some reason,"[94] Buonaccorso da Montemagno, in his *De Nobilitate* of 1429 makes one of his speakers assert that "a useful additional aspect to nobility of blood was constituted by wealth, by which the noble man was able to exercise liberality."[95]

The sides of the debate became more defined,[96] and saw in opposing lineups those like Francesco Filelfo who considered magnificence to be simply a plutocratic virtue to be practiced by anyone who is rich[97] and those like Giovanni Sabatino degli Arienti who in his *De Triumphis religionis*[98]considered it pertinent only to nobility.

Thus in Sabatino's apologetic work (heavily influenced by his close rapport with the Florentine milieu[99] entertained by the Ferrarese branch of the Strozzi house),[100] the canonical exaltation of the magnificence of Duke Ercole I d'Este[101] is not surprising, but that it included in the domain of the virtues an ample set of activities and consumptions has been neglected: lavish banquets and sumptuous hospitality, rich greetings and magnificent weddings, elaborate comedies and great jousts and tournaments, great hunts and splendid funerals.

THE REVOLUTION OF SPLENDOR

Towards the end of the fifteenth century there was, however, a further change of register thanks to the audaciousness of Giovanni Pontano, who entitled *De splendore*[102] the fourth of five treatises published in Naples in 1498.[103]

In this brief text the author from Umbria, although substantially faithful to the Aristotelian-Aquinian interpretations of liberality and magnificence,[104] elaborated the innovative concept of *splendor*, which "in ornamentis domesticis, in cultu corporis, in supelectile, in apparatu rerum diversarum praelucet."[105]

The futile world of the *accessory* thus became promoted as proven proof of domestic magnificence, which could shine from the furnishings (*supelex*) such as vases, plates, fabrics, and

furniture, without which one could not live *comfortably,* up to the decorative objects *(ornamenta),* such as statues, paintings, tapestries, ivory chairs, hangings interwoven with precious stones, and crystal vases, etc.

Splendor shed augmented light on the most common of objects, nobilitating a universe of forms, materials, colors, fragrances, sounds, and tastes and offering a decisive contribution to the principles on which the styles of the Italian Renaissance were based.

The idea of *commodità* was very different from our lazy and dull idea of *comfort,* far ahead of the problems of the architects engaged in giving it form,[106] as one can infer from the fame of the fireplaces, the chimneys and hearths designed at Urbino by Francesco di Giorgio, from the solutions excogitated by Raphael and Antonio da Sangallo the Younger to avoid the spread of smoke, smells, and noise from the kitchens to the dining halls, to the Scamozzi proposals for the placement of sewers, septic tanks, and cisterns.

No, *splendor* did not define a more hygienic, functional, or practical concept of domestic livability and sociability, but rather reformulated the minimal requirements of living in society, because the *things* had not only to be numerous, but also excellent in quality, because of the maker's ability or in the quality of materials adopted, or both (*tum egregia cum aliqua etiam vel artificis, vel materiae, vel utriusque prestantia*).

The most striking thing in this domestication process—which pushed the influence of eminently public virtues increasingly into the private sector—is the personal, even intimate ambience of its multiple expressions. In fact, besides care for the body, praise of physical (and moral) cleanliness, and care for clothing, the humanist from Cerreto extended the *inutile dominio* of *splendor* to its extreme limits; from banquets to gardens, from horses to dogs, from falcons to hunting equipment.

The cipher that marks the astonishing grandeur of the material culture of the period is written in golden characters not so much in the famous masterpieces that still today leave us breathless in the rooms of the great museums, but rather in the objects more often found in their deposits. Enameled leathers and gold buckles, silver graters and collars tempested with precious stones, diamond buttons and ebony chests, urinals of crystal and small ivory cases, lemon squeezers and spectacles, rattles and *tarocchi* cards, swordsticks and basins, rugs and *beautiful things* confirm that the search for splendor corresponded with the satisfaction of common needs, whose answer did not stop at the border of the tangible but was reflected in the elaboration of intangible small pleasures. Thus modes of conversation, reception, dancing, playing, dining, hosting, and seducing incarnated a model of civil society that was successful for centuries. As Amedeo Quondam observed in commenting on the fifth book of *De Conviventia:* "In sum, even in Pontano's times . . . the Italians can be considered owners of a 'better form,' this only because taken directly from the model of the *pristina forma,* in its imitation and emulation."[107]

With Pontano, then, an almost epoch-making break was made with respect to the "exceptional" nature of magnificence. Splendor entered into the houses of the elite by the front door and elevated the most common domestic items to the rank of works of art, no longer superfluous luxury goods but indispensable companions of life and society.

At the root of these transformations are not only the lay demands patronized by Pontano and other authors, but equally those promoted by the cardinals' courts,[108] now needing more than ever solid moral justification. One may infer this from the wavering pronouncements of Paolo Cortesio, who in the *Sentenze* reaffirmed the charitable essence of liberality and embraced only the more conservative theses concerning magnificence,[109] while in the

De Cardinalatu he stated defiantly that since cardinals[110] were princes (even if princes of the church) and could not be accused of being wasteful, they could spend in the same way and to the same degree as lay princes.

THE DEBATE IN THE CINQUECENTO

Attention to the signs of status and marks of prestige thus arose from the process of closing of societal ranks that in the second half of the Cinquecento was leading up to the shining crystallization of Italian society.[111] The prize was political: to modify the profile of those virtues in an elite sense, demonstrating that "liberality is a proper virtue of the aristocrat, while scholars state that tenacity and avarice are the sure signs of an ignoble and vile spirit."[112]

The bourgeois liberality that could be exercised by any good Christian in the fifteenth century who had the quality of dignity, now became an exclusively noble prerogative, while the aristocratic magnificence of the sixteenth century became a heroic princely attribute. In both cases the ideological foundations of noble and patrician behavioral models had to be reinforced in the vain and desperate attempt to inhibit the phenomenon of social emulation. So the real dangers did not arise from the mass consumption of luxury or artistic goods, which had already been definitively de-moralized,[113] but from efforts to increase them to levels beyond the capacity of social status, so as to endanger a social peace that not even the tightening of sumptuary laws was able to protect,[114] as "the artisan now wishes to be the equal of the citizen, the citizen the equal of the gentleman, the gentleman the equal of the noble, and the noble the equal of the prince, and these are intolerable things beyond reason and measure that displease God and lead to a thousand sins."[115]

The exhortations to avoid "games, useless banquets, in the desire to exceed the number of servants, to compete with the richest and vainest persons in clothing and parties, in feeding dogs and horses, and many other superfluous things beyond the decency of one's own social state"[116] had little or no effect. Similarly the scandalized references to the fact that "I omit to mention furnishings, since they have reached such excessive luxury, that those displayed in country houses today outdo in value those our forebears, even the most noble and richest citizens, used in the capital cities only a few years ago, and it is permitted in clothing that it also take advantage of the usage or rather abuse of the times . . . and then the walls, tables, chairs, and in the end everything is covered with velvets, damasks, rugs, and the finest of tapestries, and that clothing in proportion is full of embroideries and vain ornamentation and of great cost with the richest of linings; and that every day there is a search to find new inventions and display."[117] In a similar context even the passion for works of art and archaeological goods had become a mass phenomenon. How otherwise could one ignore the cosmic distance between the atmosphere of austere admiration evoked by Titian's portrait of the famous antiquarian Jacopo da Strada, intimate of the earth's mighty characters, and the disrespectful mockery of Giuseppe Orologgi, who laughed: "There are those at Rome whom everybody calls antiquarians. They state that they are able to recognize any kind of ancient object and that they know everything about them. They say the most thievish and scurrilous things in the world. This kind of man used often to play strange jokes on 'modern men,' and they repeatedly say what is more convenient for them, finding ears that are always willing to believe everything that they want to say."[118] Silvio Antoniano, on the other hand, derided "those who desire pictures from

famous painters, or those who want jewels and similar things, which are bought at high price, moreover by those who have this kind of appetite, despite the fact that when needed only very small sums are received for them."[119]

This phenomenon embarrassed the aristocratic families who could not go on raising the ante in the unending game of social prestige, as Annibale Romei pointed out in one of his discourses: "It happens that those who are equal to others in terms of nobility but inferior in terms of wealth, being unable to bear the pomp and the arrogance of the richest in their lifestyle, clothing, and other external matters, crushed by the richest and discontented with their own condition, would easily seek to make the prince fall and install a republic."[120] Nor was the bewildering policy of product differentiation enough to stop the mounting tide of collective emulation that already existed in the second half of the sixteenth century, by adopting the goods most suitable for satisfying the growing needs of social distinction of each social class. Shining examples are the pages dedicated by Cardinal Gabriele Paleotti to the subjects who had to be painted to satisfy the needs of various audiences,[121] Giovanni Paolo Lomazzo's wonderful Book VII,[122] or the equally surprising Book III of Giovanni Battista Armenini,[123] in which a good painter must carefully consider the needs of "persons for whom work is performed, as these works vary a great deal in their use and quality, in the same way that the customs, professions, and nobility of patrons vary." Anxiety about maintaining and reestablishing correct social distances concerned not only relations between the noble and patrician ranks and the bourgeoisie, but also relations between the different ranks of the aristocracy: "So it happens that human beings are by nature so vain and ambitious, that the plebeians compete in their manner of dress to be taken for nobles, the nobles for princes, and they put all their energies into improving only their external appearance and do not worry about living in their houses like beggars as long as they can seem rich in the city squares."[124]

It was then necessary to justify the increasing aristocratic consumption; the only limits to it were their excessive affectation[125] and ridiculous ostentation,[126] marking the difference between simply liberal lifestyles and lifestyles marked by the attainment of heroic magnificence, because "the way of spending of an emperor, a prince, and so on is different from that of other ranks and conditions of human beings. The same expense that will be magnificent for a private gentleman, will not be so for a prince."[127]

It is therefore clear that there was an interpretative distance separating the positions of the late fifteenth and early sixteenth centuries on the issue of magnificence from that of the late sixteenth and early seventeenth centuries. At first this virtue was contained in the genetic inheritance of every good prince,[128] but it remained a virtue that the rich, as well as princes, could practice, regardless of the quality of their blood. A century later, being noble was not enough; it was necessary to be a prince, a hero.[129] The nobleman was to the hero as liberality was to magnificence. It is not by chance that Francesco India, in his dialogue on heroic virtues, asked "if this heroic virtue could exist in a man of any grade and condition, and, if it could not exist in every kind of person, in which kind of men could it be found."[130] His answer was that "Peripatetics believe that this heroic virtue could be found only in men of high birth who had grown up with illustrious forces and resources and whose actions are very splendid. So Peripatetics say that the heroic virtue is splendor and excellence in the pursuit of the aim of life. Such greatness is a matter of illustrious resources and conditions, and so the Peripatetics do not want magnificence to be attributed to anybody. So it happens that those who are called and celebrated as heroes have illustrious origin and lineage, and according to the opinion of these Peripatetics this heroic virtue shines particularly in the man raised to the grade of prince,

who is a common and clear example to nations. This is a sublime and illustrious position, in which all things shine with majesty."[131]

It would, however, be erroneous, unjust, and historically incorrect to argue that aristocratic liberality, splendor, and magnificence were pursued in an atmosphere characterized by improvisation, caprice, indulgence, or failure to remember economic reality. On the contrary, the elite knew that such gestures were necessary as a matter of honoring the responsibilities required by their social rank.

Similar anxieties justified both the efforts to limit, categorizing the range of expression of liberality, and the rise of theoretical positions that censured the excesses and abuses of magnificence, suggesting to princes, laymen, and ecclesiastics alike a more sober conduct and attention to financial well-being. Nevertheless, if Machiavelli's scandalous "invitations" to parsimony[132] derived from the tensions of realpolitik and the need for stable and ample financial resources,[133] the domestic tone that dominates one of the dialogues of Nicoló Franco was very different: "in which the author introduces an avaricious servant, who reprimands his Lord for his liberality by teaching him the art of managing his court and by showing him all the ways of saving and making money."[134]

This text anticipates many arguments destined to enjoy credit in the late sixteenth and seventeenth centuries, when the pressures of the newly counter-reformed church proposed theses in which "the sparing hand of the prince could be considered not as a proof of avarice, but as a demonstration of prudence"[135] followed by promptings for moderation in matters of court *oeconomica*.

One must not think that these treatises remained dead letters. There was no object or gesture that was not measurable and measured, valuable and valued, as each thing, including the most trivial, measured and reflected the position occupied by its owner or consumer in the social order. The qualities of both things and men were inseparable twins, the undeniable evidence of reciprocal value. Food and clothing, weapons and jewels, horses and gifts, hospitality and amusements had all to be measured exactly for the smallest hierarchical nuance, ensuring equity in a mechanism that found its own existence justified by the asymmetrical distribution of goods and services of unequal quality.

Demand Analysis

*The Example of the Este Courts between the
Fifteenth and Seventeenth Centuries*

REPUBLICS AND PRINCIPATES

For some decades now the word pair "art-court" has held sway in the titles of innumerable essays and monographs almost as though it were a catchphrase meant to be immediately understood by the most distracted reader. And yet, despite isolated attempts,[1] the juridical-institutional profiles of court artists, the varying forms of satisfaction of demand for artistic-luxury goods and services, and the politics of court patronage have not been completely examined, but remain tied to the brilliant interpretation in Martin Warnke's[2] analysis of a nearly antique secondary literature.

Warnke himself explained this lacuna, noting the difficulties he encountered in the late 1960s in finding a publisher for his work. The figure of the court artist at that time was out of fashion because of prejudice against the tyrannical and liberticide nature of courts— those disgraceful alliances of fatuity and servilism, intrigue and conformity. A melodramatic environment in which the geniuses dear to twentieth-century critics (as heroic, solitary, and eccentric as the poets, even after the revelations of Kris and Kurtz and the Wittkowers) must have cursed the fate that forced them to work in the golden prison of princely patronage.

There is no doubt that the attitude lacked solid justification. Nevertheless, one can still observe the effect, because studies on the art markets continue to favor activity in the capitals and domains of the republics (pre-Medician Florence, Venice, and Genoa), in the vice-realms lacking important courts (post-Sforzescan Milan and Seicentesque Naples), or in the great legate cities (Bologna), while leaving the Roman anomaly in the background, that curia with too many courts, if one remembers only that the reorganization of the Holy College decided in 1586 by Sixtus V in the constitution *Postquam verus* established that there would not be more than seventy cardinals.

When one speaks of courts then, one does it in order to examine the development of a single collection (wherein the bulimia of accumulation has the advantage of any acquisition strategy) or celebratory politics of an individualistic nature (often elevated to the dynastic, as if there could be a hereditary taste). Thus there is not much space left for the analysis of the modalities of courtly demand (direct patronage, acquisitions in the secondary market, gifts, exchanges, confiscations, forced sales, etc.), for examination of the varying politics of patronage, or of the system of "court workshops," or for investigation of "court manufactures."

Court and market spoken in one breath has thus been perceived as a contradiction in terms: where there was one the other could not be; the vices of the principates were antithetic to republican virtues, virtues that on the economic plane would have been reflected in the merits of artistic scenes and professional independence.

Legitimate as it may be, I, however, think that the position can be held only with difficulty since the so-called republican virtues were only rarely put into practice and we know less of the forms of satisfaction of the courts and of their correlated patronage policies than we think we do. The courts, in fact, have been reduced to mute background, places so familiar that we take for granted the knowledge of their most elementary mechanisms.

Thus we know in great detail of the careers of portraitists of third and fourth rank and much about any single fresco, the obscure poem, the *editio princeps* or of the series of crockery produced at Camerino or at Saluzzo, but often we do not know what the courts were, where their boundaries were, how many lived there and in what manner, what were the rights, duties, and privileges of the courtiers, how they were recruited, paid, fired, etc., lacunae that to a greater degree touch on artistic activities and professions.

This is a serious shortcoming since it induces us to consider the courts as static institutions and identical in time and space to the point where the word itself—an authentic undifferentiated locus—has become a *passe-partout* used to close, rather than open, the door to many possible questions.

Whether the court was lay or ecclesiastic, male or female, young or old, autochthonous or allochthonous, Quattro- or Settecentesque, central or peripheral, reigning or *particolare*, imperial or podestarial, papal or episcopal, colossal or minuscule mattered little. To paraphrase Gertrude Stein, "A court is a court is a court," and art and culture were its natural companions, its physiological complements.

And yet the various forms assumed by demand in the Italian courts deserve to be studied in their infinite variety, complications, and facets; for this reason I have tried to overcome the limits of Warnke's analysis, which have been well summed up by Evelyn Welch: "For Warnke, as for many other scholars considering the notion of a Renaissance 'rise of the artist,' the figure under discussion was almost always a painter even though art and artist were rarely so narrowly defined in the period itself," when "the title *pittore da corte* is not common in Renaissance documentation."[3]

Not only is it necessary to bring the effective weight of painterly and sculptural activity back into a more consonant proportion (from calculations on the budgets of the Este courts in the Cinquecento it is clear that the above constituted less than 0.4 percent of the ducal expenditures and 3–4 percent of those of the *particolari* courts maintained by the princes and princesses of the blood), but also to correct the imprecision of many approaches to the theme.

To work for a court did not ever automatically implicate belonging to its rolls since there were varied and diverse levels of aggregation and integration supported by an equal number of forms of contractual, paracontractual, and salary arrangements. Only some of the artisans who were in service were courtiers in the proper sense of the term, and thus bearers of specific rights and subject to certain duties; nor must one believe that everyone wished to enter and be a permanent part. For some people it could be counterproductive, as they would have been paid less and could not have accepted jobs from other patrons. Entrance into a court could be convenient in some moments of a career, especially at the beginning or the end,[4] but it was not always and in every case desirable.

For these reasons, considering the scale, the characteristics, and the exemplary dimensions

for our comparison of the Ferrarese house's demand for artistic and luxury goods and services, and underscoring the abundance and variety of the primary sources—thanks to which I have been able to bring out little-known aspects and test research methodologies that are otherwise inapplicable—I concentrated on the Este case, which is blessed with an abundant and prestigious historiography.[5]

FROM THE COURT TO THE COURTS

The first criticism that I intend to make against the prevailing perceptions of courtly demand regards its presumed singularity and homogeneity,[6] almost as if the desires or tastes of a ruler could inform and render uniform the behavior and choices of entire households, a hypothesis that is in conflict with the independence shown by the exponents of the various branches. This *reductio ad ordinem* not only obliterates the debate on matronage, "which claims not only a difference in gender in respect to the agent, but also emphasizes the fact that certain models of female patronage could differ from their male counterparts"[7] but also forgets that "there were great women patrons, hundreds of them, whom we can name and identify,"[8] condemning to silence the differences contained in the word itself.

The courts were vital, continually changing organisms that confirmed the evolution of many variables, from the anagraphic to the politic, and it is misleading to depict them as immutable bodies, inanimate and indifferent. If I use the plural, it is because at Ferrara, as in other Italian capitals, there was not only the ducal court, but also a group of independent courts, the so called *particolari*, making up the Este house.

Besides the ducal courts that, among the *salariati di bolletta* (the courtiers who received one salary in money and another in kind) and *bocche* (literally *mouths,* those individuals paid only in rations) between the mid-fifteenth and late sixteenth century, had an average of 550–750 elements, there were also the duchesses' courts, more contained but no less interesting: Eleanora of Aragon and Lucrezia Borgia counted usually around 110–120 *bocche,* while Renée of Valois always kept about 150–160 and Margherita Gonzaga, 80–90. The numerical inferiority was counterpoised by a marked cosmopolitanism: If the courts of Eleonora of Aragon and of Lucrezia Borgia boasted a strong presence of ladies, officials, artists, and artisans of Spanish, Neapolitan, and Roman origin, that of Renée of Valois was a French court transplanted to this beautiful part of the Po Valley. The courts of Anna Sforza and Margherita Gonzaga were Lombard colonies, while that of Barbara Habsburg seemed to contemporaries a curious German isle.

Alongside the two principal courts there were those called "*particolari,*" maintained by the other blood princes and princesses of the Este house, including cardinals, and by illustrious exiles. Ferrara also contained other celebrated courts of considerable size, including those of the Bentivoglio, and of Lucrezia Borgia's relatives (Don Gerolamo), and we must not forget the friends of Eleonora of Aragon, Ercole I's wife, who did her utmost to sweeten the prolonged exile in Ferrara of those of her relatives who had fled Naples.[9] These were nuclei of a certain size, if the Este functionaries who for almost thirty years cited Isabella of Aragon's retinue as the court of the Queen of Naples and noted the existence of over sixty members.

This situation, consolidated in the early 1480s, allowed every prince and princess of the blood to develop his own patronage policy, cultivate individual tastes, and follow his own

collecting practices. This is not an anomaly of the lower Po Valley: even though the *particolari* courts have never been seriously examined, they were common in almost all the Italian principates, and remained so from the end of the fifteenth century, effecting designs and strategies that it would be unfair to call slavish imitations, satellites that faithfully followed in the orbits described by the solar princely will.

Even if they did not have the size of the ducal court nor the political and social centrality, the courts of the various branches had very similar organizational, economic, and relational schemes. Between 1495 and 1500 there were already ten[10] in Ferrara, fifty years later the number had grown to twelve.[11]

Now the proliferation of the *particolari* courts can be placed in the late 1470s, when the stormy political atmosphere imposed a direction over interfamily relations meant to foster an obedience that would place the interests of the Este house before those of its single members. But the accord with the cadet branch came at a high price: the concession of patrimonial and economic endowments that could guarantee the survival of the courts and a "princely" style of living.

In this sense, warned by the divisions that had taken place in the Gonzaga marquisate and alarmed by the conspiracies of the late seventies, Duke Ercole I saw himself forced in the last twenty years of the Quattrocento to second the formation of the *particolari* courts. There was an increase especially in the annuities of the princes and princesses of the blood. Until 1488, compared with income of over 300,000 liras the duke assigned 8,400 to his consort Eleonora of Aragon, and 3,000, 3,600, and 840 respectively to the brothers Sigismondo, Rinaldo Maria, and Alberto, but nothing to the sons. In 1493 the duchess received 25,050 liras and in 1494 Sigismondo, Rinaldo Maria, and Alberto had 31,500, 3,000, and 5,333 liras at their disposition annually, while the heir apparent Alfonso received 1,500 and his wife Anna Sforza, 600.

If, however, the Aragonese consort and the brothers of the duke could consider themselves satisfied with these experiments in parity, the sons and daughters-in-law of the Ferrarese sovereign had to wait to see recognition of their prerogatives: while in 1500 the courts of the princes Ferrante and Sigismondo were made up of about twenty *salariati,* just a few months after the father's death Ferrante maintained almost 100 and Sigismondo more than 60. Further underlining the flight from the not always magnetic paternal roof, in the course of the last five years of the fifteenth century almost all the princes and princesses of the Este house took up independent residences, following the poli-residential model typical of many households. In December 1496 Prince Alfonso, his wife Anna Sforza. and Princes Sigismondo and Giulio lived in the palace in San Francesco, with Cardinal Ippolito I lodged in the ducal palace near the Charterhouse.[12] Five years later the dauphine Lucrezia Borgia and her husband Alfonso were resident in Castelvecchio, while the duke's brothers Alberto, Rinaldo Maria, and Sigismondo were in the palaces of San Luca, the Paradiso, and the Diamanti. Cardinal Ippolito I was still near the Charterhouse, the princes Sigismondo and Ferdinando in the residences in San Francesco and Schifanoia, while from among the goods confiscated from Giulio "Nicola da Correggio got the palace in via de gli Angeli."[13]

Independent living and growth in retinues required the establishment of patrimonial funds, financial endowments, and structural organization to sustain the detachment from ducal tutelage. Freedom and autonomy presupposed the adoption of an exact formula and of a common lifestyle calling for the ownership of specific goods and for the display of predetermined symbols.

To meet this demand the dukes not only increased the annuities, which would not have met the need, but were also forced to sign over sources of income and personal income, in hopes of obtaining a more equal division of the patrimony and equalizing the financial status of the Este princes and princesses, who in proportion spent more for works of art, building, performances, and luxury goods than did the dukes themselves.

This climate of latent rivalry shows us the variety, wealth, and heterogeneity of the Este demand, which reflected a pronounced and often only inferred autonomous character: if between 1506 and 1508 Duke Alfonso I had only one goldsmith and one painter on his rolls, the duchess, Lucrezia Borgia had two goldsmiths and twelve painters in her employ. She paid from her own pocket, and she had most probably chosen them herself. And again, while in 1516 Duke Alfonso I maintained seventeen musicians and singers, in the same year his brother Cardinal Ippolito I kept twenty-one,[14] and the same is true for the sculptors, goldsmiths, miniaturists, and tapestry weavers paid by the princes and princesses of the other Este courts, whose names show the existence of often exclusive supply, and deprive the adjective "Estense" of any significance of unity.[15] Don Alfonso d'Este, Marquis of Montecchio, engaged artisans who had never been on the payroll of his brother or nephew, Renée of Valois employed mostly French[16] jewelers, and the same was true for Francesco d'Este or Cardinal Ippolito II. Residence in the same city did not necessarily mean drawing from the same labor pools or recruitment of individuals gravitating only in the orbit of the ducal court, and the differences that mark the tastes and approaches of the different dukes should be underlined, as their predilections—in the artistic realm—differ from generation to generation.

In any case, excessive simplification should be avoided as it is the fruit of a widespread preconception about the compactness of dynastic strategies and the accepted superiority of ducal circles. The fact that the female Ferrarese courts (but the argument, with the exception of Isabella d'Este or Caterina or Maria de' Medici, holds true for other Italian cases)[17] are little studied[18]—they are erroneously considered headless appendages of the male courts—and that the universe of the *particolari*[19] was long in the dark, does not authorize us to believe that all of these nine, ten, or twelve courts indulged in obsequious forms of *captatio benevolentiae* or imitated slavishly the intuitions of the lords of Ferrara. Rather, the strategies of the aristocratic families and high functionaries of the ducal court should be looked at, to understand if and to what degree their choices conformed to the tastes of the current sovereign: a fascinating exercise, as one can deduce from Guido Rebecchini's research on the Gonzaga.[20]

The princes and princesses of the blood were not just courtiers. They were proud members of the House of Este, with rights and prerogatives very like those of the duke. But intuition, the ability to recognize talent and refinement of taste, was not correlated to power and wealth, or to mere size: the small court of a minuscule state was not necessarily lesser from a cultural point of view. This is a basic element, as I have not found the presence of any rigid correlation between the dimensions of the states and the courts that dominate them, nor between those courts and their prestige.

DUCAL DEMAND AND ESTENSE DEMAND

Before the appearance of research, especially of a prosopographic nature, on the intervention policies and patronage strategies of the female branches, minor and secondary, it would be

proper to use the adjective "Estense" with a certain caution. The courts were more poly-phonic, disobedient, and eccentric than one might suppose, anything but cohesive and not always dedicated to the perception of a common feeling nor to the expression of an adaman-tine dynastic identity.

To extend the analysis of the Estense demand, the most interesting aspect from an eco-nomic and social point of view is the multiplying effect of the "dynastic" expenditures, keeping in mind that in absolute and consolidated terms the Estense finances showed a con-stant increase up to the end of the Cinquecento that was largely obscured by the ducal ups and downs, weighed down by divisions of inheritances and by the fulfilling of state obligations.

Thus, if at the end of the 1470s the dukes' funds, above and beyond the annuities for wives, children, in-laws, brothers, sisters, and other relatives, were almost tenfold the sum of those of all the princes and princesses of the blood, eighty years later, even if the dukes, after annuities, could count on an income greater than 500,000 liras a year, the sum of the incomes of all the princes and princesses of the blood amounted to a more than equal sum of about 500,000–600,000 liras,[21] after which there was a return to ducal superiority at the end of the sixteenth century, when Alfonso II saw an income greater than 1,200,000 liras, compared to the cumulative 700,000–800,000 of the various branches of the Estense tree.

Nevertheless, if one analyzes the expenses of the diverse Estense courts in detail, one dis-covers that while the duchesses, cardinals, princes, and princesses might reserve 35–40 percent of their income for artistic, architectural, and luxury spending, the dukes themselves only rarely exceeded a limit of 25 percent and on average spent 15–16 percent, as I have observed in examining the budgets of twenty-one years between 1500–1541 and 1576–1594, and reclassifying the expenditures into fourteen categories.[22]

From this research, which can been seen in tables 2 and 3, one observes that the sum of the expenses of the competent offices, to wit Munitions and Construction, brickworks, ironworks, munitions of Castello, Mesola,[23] wardrobe, labor and administration and stores, oscillated between a minimum of 6.06 percent in 1527 and a maximum of 33.19 percent in 1579 (the year in which Duke Alfonso II tied the knot with Margherita Gonzaga), giving an average of 15.73 percent, to which two percentage points deriving from the sum of the stipends and pay-ments in kind to the artisans registered in the *Bollette dei salariati* should be added.

This is an aggregate sum that overestimates the effective weight of the artistic, architectural, performance, and sumptuary components because it also includes the expenses sustained for military architecture and hydraulic engineering (exclusive of land reclamation) and for the maintenance of the foundries and brickworks, while the wardrobe and stores spent great sums for the purchase of fabrics, furs, and skins and for the making of shoes and clothing. In reality, excluding the years in which there were weddings, coronations, funerals, triumphs, or entries of important guests, that is, in normal times, painting and sculpture patronage was a rather modest 0.3–0.4 percent of the entire ducal expenditure.

It is the cumulative effect of the dynastic expenditures that should be underlined: If in 1560 Duke Alfonso II's wardrobe spent around 50,000 liras, between 17 June and 31 Decem-ber of that same year Luigi's put out more than 40,000[24] to suppliers never mentioned earlier in the ducal ledgers. This phenomenon favored the employ of different individuals, enlarged the perimeters of the labor market, and ensured the existence of a plurality of channels and pools of labor recruitment, factors that explain why in the Cinquecento a good part of the resources used to satisfy Estense artistic demand came from the *particolari* courts, which, not being subject to the state obligations (think only of the costs of administration and judicial,

Table 2. Structure of the Expenditures of the Ducal Budgets from 1500 to 1541 (in percentage values)

		1500	1503	1517	1518	1521	1523	1524	1527	1529	1541
State	Defence	7.94%	6.88%	15.70%	12.91%	52.30%	66.97%	28.06%	42.74%	40.65%	4.06%
State	Diplomacy	3.26%	3.27%	6.78%	4.33%	3.17%	5.58%	5.60%	5.01%	8.29%	3.32%
State	Administration	10.55%	4.80%	3.84%		0.83%	0.46%	0.44%	0.58%	0.47%	3.07%
State	State affairs										21.94%
State	Salts						0.01%	0.01%	0.05%	1.64%	3.81%
Home	Land property						0.07%	5.00%	0.09%	0.08%	0.79%
Home	Manufactures										12.79%
Home	Building activity	3.37%	4.74%	11.86%	23.00%	13.21%	6.84%	9.47%	5.34%	5.67%	7.25%
Court	Salaries and benefits	36.69%	41.04%	22.85%	24.84%	7.79%	8.23%	8.66%	11.20%	16.19%	19.60%
Court	Wardrobe	9.31%	8.99%	13.31%		10.36%	4.95%	5.07%	0.73%	1.64%	3.43%
Court	Granary, cellars and wood	7.94%	7.57%	8.20%	4.53%	3.43%	2.24%	30.98%	3.71%	4.21%	4.56%
Court	Foodstuffs	14.78%	15.91%	11.49%	11.29%	4.50%	3.74%	4.09%	6.45%	7.24%	6.91%
Court	Mobility	2.22%	3.82%	4.92%	0.87%	0.25%	0.24%	0.39%	0.37%	0.45%	1.94%
Other	Other and extraordinary expenses	3.92%	2.98%	1.06%	18.23%	4.16%	0.68%	2.22%	23.74%	13.47%	6.56%
Total in %		100.00%	100.00%	100.00%	100.00%	100.00%	100.00%	100.00%	100.00%	100.00%	100.00%
Total in Liras		236,273	257,153	198,407	146,720	285,174	375,577	368,962	383,530	495,173	388,098

Table 3. Structure of the Expenditures of the Ducal Budgets from 1576 to 1594 (in percentage values)

		1576	1577	1578	1579	1580	1587	1590	1591	1592	1594
State	Defence	4.59%	10.71%	6.95%	3.69%	2.57%	2.67%	3.39%	4.19%	5.04%	10.19%
State	Diplomacy	6.09%	5.08%	5.44%	6.82%	5.40%	4.65%	4.63%	8.60%	7.22%	9.28%
State	Administration	2.51%	6.28%	15.87%	9.98%	7.58%	8.90%	4.39%	14.00%	6.53%	6.49%
State	State affairs	35.43%	0.21%	6.04%	6.18%	15.43%	27.34%	22.03%	3.36%	8.19%	10.41%
State	Salts	2.46%	4.20%	2.49%	2.16%	2.02%			10.12%	1.44%	0.04%
Home	Land property	5.12%	7.85%	4.80%	3.26%	2.87%	1.50%	3.18%	5.21%	4.63%	6.12%
Home	Manufactures				0.58%	0.41%					
Home	Building activity	9.33%	14.78%	16.58%	20.83%	14.73%	10.59%	4.26%	6.64%	9.36%	10.12%
Court	Salaries and benefits	13.13%	16.99%	13.72%	10.63%	10.58%	7.83%	6.02%	8.03%	8.78%	9.44%
Court	Wardrobe	5.02%	6.79%	6.38%	12.37%	5.29%	3.62%	3.45%	3.14%	5.01%	6.50%
Court	Granary, cellars and wood	6.01%	6.75%	5.97%	5.20%	8.24%	7.71%	9.48%	7.43%	12.11%	9.93%
Court	Foodstuffs	9.51%	18.18%	14.80%	16.02%	12.51%	11.17%	8.89%	12.23%	17.14%	20.32%
Court	Mobility	0.27%	0.90%	0.63%	1.05%	0.45%	0.33%	0.53%	0.42%	0.38%	1.14%
Other	Various and extraordinary expenses	0.53%	1.28%	0.33%	1.25%	11.92%	13.70%	29.74%	16.64%	14.16%	0.04%
	Total in %	100.00%	100.00%	100.00%	100.00%	100.00%	100.00%	100.00%	100.00%	100.00%	100.00%
	Total in Liras	872,433	673,489	848,023	1,122,377	1,212,670	1,280,697	1,654,725	1,308,470	1,184,693	1,352,667

Note: The entry Defence is the result of the sum of the values included in "*soldo*, war expenditure, halberdiers, bombardiers etc."; Diplomacy includes "*ufficio del mese, cancelleria per andare, staffette e cavallari, ambasciatori e massaria di camera*" ("month duty, safe-conduct, couriers and horse-drovers, ambassadors and house administrators"); Administration includes "*censo che si deve alla camera apostolica, notai, scritture, creditori di Camera, usi, livelli, affitti, legati, compositioni, elemosine e doni*" ("census aimed to the Apostolic Chamber, notaries, deeds, treasurers, customs, perpetual leases, leases, legacies, payments, charity and donations"); State affairs includes "*denari dati al Serenissimo Duca, incetta di denari di Castello, cose note a S.A. e prestiti*" ("money aimed to the Serene Duke, forestalling of money from Castello, things well-known to His Highness and loans"); Salts included "*sali, conti di sali e saline di Comacchio*" ("salts, salt accounts, salt-works in Comacchio"); Land property includes "*possessioni, castaldarie, giardini, orti, risaie, bonifiche, beni acquistati e confiscati*" ("properties, farms, gardens, rice-fields, reclamations, aquired and confiscated goods"); Manufactures includes "*Arte della Lana, forno di Garfagnana, sapone*" ("the wool guild, oven in Garfagnana, soap"); Building activity includes "*Munizioni e Fabbriche, Munizione di Castello, Munizione del Ferro, Fornaci, Mesola, navi, navigli e barche*" ("Munitions and building, Munitions of Castello, Ironworks, furnaces, Mesola, ships, fleets and boats"); Salaries and benefits includes "*salariati, appannaggi di principi e salariati straordinari*" ("wage-earnings, appanages for princes and extraordinary wage-earnings"); Wardrobe includes "*Guardaroba e Fontico*" ("wardrobe and warehouse"; they were responsible for apparel, personal care specialist, furniture); Granary, cellars and wood includes "*granai, cantine e legnaie*" ("barn, cellar, wood-store"); Foodstuffs includes "*spenderia, scalchi, spisanti, spezieria, pollami, carni, pesce fresco e salato, grassa, acqua, fornaio, spese per animali, stranieri alloggiati*" ("expense, carvers, grocery, spices, poultry, meat, fresh and salty fish, fat, water, baker, expense for animals, and foreign people housed"); Mobility includes "*stalla, strami, salari di famigli, bestie, selleria e marescalcheria*" ("stable, fodders, wages for men-servants, animals, saddlery, farriers"); Various and extraordinary expenses includes the remaining entries.

Source: Elaboration of data contained in ASMO, CDE, AC, Significati, nos. 8, 12, 17, 18, 21, 22 (1500–23) and LCD, nos. 293, 307, 312, 358, 364, 443, 453, 459, 467, 473, 478; Grassa, Carteggi, b. 1, foglio sciolto Spese del ser.mo S.re Nostro dell'anno 1594. From 1521 to 1529 there was an ongoing war.

diplomatic, and military corps) that weighed on the ducal budget, could spend more freely. Consider in this regard the comparison between the painting and sculptural patronage of the dukes Ercole II and Alfonso II, the second of whom has passed into history as the man who sank Estense finances, and those of Cardinal Ippolito II (the names and incomes of each can be found in tables 4, 5, and 6).

Given that I selected the data randomly and that in 1565 Alfonso II wed Barbara Habsburg, causing a rise in expenses that would affect the budget even the following year, one discovers that in normal circumstances the outlay of the cardinals' courts was greater than the dukes': One must simply sum up the analogous expenses of the other princes and princesses of the blood to realize that it is necessary to pay greater attention to the "consolidated" dynastic expenses.

FORMS OF HIRING AND PROFESSIONAL ORGANIZATION

One of the more surprising elements that emerges from comparing the patronage of Duke Alfonso II and of Cardinal Ippolito II is that only 2 of the 139 artists found[25] were entered at least once in a *ruolo dei salariati*, and not even one in the ducal *ruoli*, while Girolamo Muziano appears in the cardinal's *bolletta* of 1565 and Livio Agresti in the one of 1568. This evidence shows that the mechanisms of inclusion/exclusion were anything but simple. Certainly mere physical proximity or any form of occasional collaboration was not enough to justify the title of court artist. As Francis Haskell observed in his work on seventeenth-century

Table 4. A Comparison between the Painting and Sculptural Patronage of the Duke Alfonso II and Cardinal Ippolito II, from 1565 to 1570

Year	Alfonso II Number of orders	Alfonso II Number of artists	Alfonso II Expenditure in L,S,D	Ippolito II Number of orders	Ippolito II Number of artists	Ippolito II Expenditure in L,S,D
1565	143	14	7,614; 00; 00	115	23	3,545; 04; 00
1566	52	7	4,389; 00; 00	29	14	2,383; 10; 00
1567	42	4	1,065; 16; 06	14	12	1,078; 02; 00
1568	12	5	1,431; 15; 06	78	49	14,483; 02; 00
1569	24	4	1,166; 03; 09	132	34	4,928; 14; 00
1570	31	11	1,010; 16; 00	39	11	3,303; 04; 00

Legend: L,S,D is the acronym for liras, soldi, denari; the number of orders identifies every single accounting entry; the number of artists identifies the owners of shops or team leaders, beneficiaries of the orders. The expenditures in liras, soldi and denari under the patronage of Ippolito II come out of the conversion performed by the Author, since the source provides values in Scudi and Baiocchi Pontifici.

Sources: ASMO, CDE, AC, *Guardaroba*, nos. 153, 157, 158, 160, 162, 166, 170; *Munizioni e Fabbriche*, n. 140; AP, nos. 106, 829bis, 853, 854, 873, 883, 896, 897, 898, 942, 961, 962, 963, 972, 991, 993, 993bis, 995.

Table 5. The Patronage of the Dukes Ercole II (1550–1558) and Alfonso II (1559–1570)

Start	End	Career duration (years)	Title Name Surname	Qualification	Invoice in liras and soldi	Annual average invoice in liras
1555	1556	2	M.ro Alfonso Bellone	painter	280.14	140
1565	1565	1	M.ro Bartolomeo Facino	painter	516.08	516
1554	1556	3	M.ro Battista Bolognese	painter	221.16	74
1550	1559	10	M.ro Camillo Pittore	painter	890	89
1565	1566	2	M.ro Cesare Filippi	painter	553.15	277
1565	1570	6	M.ro Filippo Vecchi	painter	2,624.14	437
1554	1554	1	M.ro Gabriele Pittore	painter	12	12
1551	1570	20	M.ro Gerolamo Bonazolo	painter	2,251.09	113
1554	1570	17	M.ro Gerolamo Cabrileto	painter	1,851.15	109
1554	1560	7	M.ro Giacomo Sandri d'Argenta	painter	659.07	94
1553	1553	1	M.ro Giovanni d'Olanda	painter	6	6
1554	1556	3	M.ro Giovanni Battista Bolognese	painter	248.06	83
1554	1554	1	M.ro Giovanni Battista Rossato	painter	6.1	6
1554	1555	2	M.ro Giovanni Pietro Pellizzone	lapidist	15.04	8
1556	1559	4	M.ro Giulio Bianchi	painter	128	32
1559	1565	7	M.ro Giuseppe Bastarolo	painter	534.16	76
1554	1570	17	Ms Leonardo da Brescia	painter	24,394.05	1,435
1551	1554	4	M.ro Luca Fiammingo	painter	516.11	129
1565	1565	1	M.ro Ludovico Pasetti	painter	160	160
1562	1565	4	Ms Ludovico Ranzi	sculptor	435.17	109
1556	1570	15	Ms Ludovico Settevecchi	painter	5,048.13	337
1554	1556	3	M.ro Nicolò Francese	lapidist	59.09	20
1559	1559	1	M.ro Nicolò Mastellaro	painter	85.1	85
1551	1551	1	M.ro Nicolò Pittore	painter	8.03	8
1570	1570	1	M.ro Nicolò Pittore	painter	6.1	6
1559	1565	7	M.ro Nicolò Rosselli	painter	66	9
1555	1555	1	Ms Pastorino Vetraio	glass blower	43.16	43
1553	1553	1	M.ro Piero d'Olanda	painter	6	6
1565	1570	6	M.ro Rainaldo Costabili	painter	288.12	48
1565	1568	4	M.ro Sebastiano Filippi	painter	1,431.14	358
1551	1554	4	M.ro Sebastiano Pittore	painter	14.04	4
1565	1570	6	M.ro Tiberio Vargas	painter	229.16	38

Legend: M.ro = Maestro; Ms = Messer.

Sources: ASMO, CDE, AC, *Munizioni e Fabbriche*, no. 140; *Guardaroba*, nos. 109, 111, 113, 117, 118, 121, 123, 124, 126, 127, 128, 134, 138, 141, 145, 148, 153, 157, 158, 160, 162, 166, 170.

Table 6. The Patronage of Ippolito II d'Este, 1561–1570

Start	End	Career duration (years)	Title Name Surname	Qualification	Invoice in liras and soldi	Annual average invoice in liras
1570	1570	1	Ms Accursio Accursi	antiquarian	185.12	185
1567	1568	2	M.ro Agostino Carboni	sculptor	36.16	18
1568	1568	1	Alessandro da Cesena	antiquarian	44	44
1569	1569	1	Alessandro da Orvieto	painter	100.16	100
1569	1569	1	Alessandro Scalza	painter	48	48
1565	1565	1	Aloisio Pittore	painter	28.16	28
1569	1570	2	M.ro Andrea Casella	sculptor	436	218
1568	1568	1	Andrea da Reggio	painter	44	44
1565	1565	1	M.ro Andrea Pittore	painter	84.16	84
1565	1569	5	M.ro Andrea Scultore	sculptor	549.04	110
1568	1568	1	Ms Antonio Bertolotto	antiquarian	80	80
1568	1568	1	Antonio da Pesaro	painter	44	44
1565	1565	1	Antonio Doratore	gilder	26.12	26
1568	1568	1	M.ro Antonio Fiorentino	painter	16	16
1567	1569	3	Ms Antonio Salvi	antiquarian	97.08	32
1570	1570	1	M.ro Bartolomeo de Velli	quarryman	16	16
1570	1570	1	M.ro Bartolomeo di Conti	stuccoist	32	32
1565	1565	1	Battista Doratore	gilder	19.04	19
1566	1566	1	Ms Battista Scultore	sculptor	278.08	278
1568	1568	1	Benedetto Fiorentino Stuccatore	stuccoist	48	48
1561	1561	1	M.ro Benedetto Scultore	sculptor	10.08	10
1568	1568	1	Bernardo Chiaravalle Pittore	painter	96	96
1568	1568	1	Bernardo da Melia	painter	40	40
1565	1565	1	Camillo Pittore	painter	42.12	42
1565	1568	4	Cecchino Pietrasanta	painter	85	21
1568	1568	1	Ms Cesare Castaglis	antiquarian	400	400
1566	1569	4	Ms Cesare Nebbia	painter	200	50
1568	1568	1	Cornelio Fiammingo	painter	144	144
1569	1569	1	Cosimo dal Borgo	painter	91.18	91
1569	1569	1	Cristiano Fiammingo Pittore	painter	164.16	164
1568	1568	1	S.r Cristoforo Rois	antiquarian	148.1	148
1568	1568	1	Dionisio Fiammingo	painter	164.16	164
1568	1568	1	Domenico da Millo	painter	40	40
1565	1565	1	Domenico Ferrarese Pittore	painter	30	30
1565	1566	2	M.ro Domenico Fiorentino	painter	67.12	34
1566	1567	2	Ms Federico Zuccari	painter	568.12	284

1569	1569	1	Ferdinando da Orvieto	painter	100	100
1569	1569	1	Ferrante Fiorentino	painter	91.04	91
1566	1566	1	M.ro Flaminio Architetto	architect	32	32
1568	1568	1	Ms Francesco Giolli	painter	118	118
1565	1565	1	Francesco Pittore	painter	9.12	9
1570	1570	1	Ms Francesco Roncione	antiquarian	148.08	148
1568	1569	2	Ms Gaspare Gasparini	painter	141.04	71
1565	1565	1	Gaspare Pittore	painter	46	46
1563	1563	1	M.ro Gerolamo Pittore	painter	14.06	14
1568	1568	1	Giacomo Catanni	painter	16	16
1570	1570	1	Ms Giacomo Cugliarino Siciliano	antiquarian	480	480
1569	1569	1	Giacomo Palma	painter	81.12	81
1561	1561	1	M.ro Giacomo Scultore	sculptor	44	44
1567	1569	3	M.ro Gilio della Vieletta Fiammingo	sculptor	964.16	321
1568	1568	1	M.ro Giovanni dal Borgo	painter	60	60
1570	1570	1	M.ro Giovanni de Vecchi	painter	160	160
1566	1566	1	M.ro Giovanni del Giglio	painter	209.04	209
1568	1569	2	M.ro Giovanni Fiorentino	stuccoist	185.12	93
1569	1569	1	M.ro Giovanni Gapei Veneziano	painter	120	120
1566	1567	2	Ms Giovanni Malanca	sculptor	780	390
1565	1565	1	Giovanni Pittore	painter	28	28
1568	1568	1	Giovanni Angelo da Pesaro	painter	144	144
1568	1568	1	Ms Giovanni Antonio Longhi	antiquarian	55.14	55
1568	1568	1	Giovanni Antonio Martinelli	painter	10	10
1570	1570	1	Ms Giovanni Antonio Stampa	antiquarian	56	56
1569	1569	1	Giovanni Battista da Modena	painter	59.12	59
1567	1567	1	Ms Giovanni Battista dalla Porta	sculptor	240	240
1569	1569	1	M.ro Giovanni Battista Fiorentino	painter	152	152
1568	1568	1	Giovanni Battista Pittore	painter	22.12	22
1569	1569	1	M.ro Giovanni Domenico Fiorentino	painter	24	24
1566	1566	1	Giovanni Maria da Modena	antiquarian	26	26
1568	1568	1	Giovanni Paolo Severi da Fermo	painter	44	44
1561	1566	6	Ms Girolamo Muziano	painter	2,718.03	453
1569	1569	1	Girolamo Perugino	merchant	16	16
1565	1565	1	Girolamo Pittore	painter	13.04	13
1569	1569	1	Giulio da Urbino	painter	46	46
1567	1567	1	M.ro Giulio Fiammingo	painter	26	26
1566	1566	1	M.ro Giulio Mantovano	painter	12	12
1568	1568	1	Guglielmo Zanforti	tapestry weaver	10,140.00	10,140

(continued on next page)

Table 6. The Patronage of Ippolito II d'Este, 1561–1570 *(continued)*

Start	End	Career duration (years)	Title Name Surname	Qualification	Invoice in liras and soldi	Annual average invoice in liras
1568	1568	1	Guidonio Gelfo	painter	93.16	93
1569	1569	1	Lazzaro Francese	painter	29.12	29
1569	1569	1	M.ro Leandro Veneziano	painter	88	88
1569	1570	2	M.ro Leonardo Sormano	sculptor	788.08	394
1565	1565	1	Leonida Stuccatore	stuccoist	10.16	10
1568	1568	1	Lidonio dal Borgo	painter	40	40
1568	1568	1	M.ro Livio Agresti	painter	179.19	179
1568	1569	2	Lorenzo Bochetto Fiammingo	painter	157.15	79
1569	1569	1	Luca Antonio da Caglio	painter	174	174
1565	1565	1	M.ro Luigi Carchiera	painter	162.04	162
1563	1563	1	Maestro degli Orologi	clockmaker	80.16	80
1565	1565	1	Marcello Stuccatore	stuccoist	22.16	22
1568	1569	2	Matteo Martus da Lechio	painter	201.04	101
1569	1570	2	Matteo Neroni da Genova	painter	938.08	469
1561	1570	10	M.ro Nicolò di Longhi	sculptor	1,332.00	133
1568	1568	1	M.ro Nicolò Rosselli	painter	293.04	293
1568	1568	1	Orazio Pittore	painter	6.04	6
1568	1568	1	Pace da Bologna	painter	30	30
1569	1569	1	Paolo da Caglio	painter	131.19	131
1568	1569	2	M.ro Paolo da Cervia	painter	235.07	118
1565	1565	1	Patrizio Pittore	painter	2.08	2
1565	1565	1	Ms Pier Leone Doratore	gilder	51.04	51
1566	1568	3	M.ro Pierino del Gagliardo	sculptor	250.16	83
1569	1570	2	M.ro Pietro della Motta	sculptor	240	120
1570	1570	1	Ms Pietro Ottomano	goldsmith	420.16	420
1568	1568	1	Pompeo Severi da Pesaro	painter	80	80
1570	1570	1	M.ro Raffaele Motta	painter	8	8
1565	1565	1	Ranieri Pittore	painter	30.12	30
1569	1569	1	M.ro Sperandio di Finis	sculptor	64	64
1567	1567	1	M.ro Stella Fiammingo	painter	24	24
1569	1569	1	Ms Tommaso dalla Porta	sculptor	240	240
1566	1568	3	M.ro Ulisse Macciolini	painter	178	59
1569	1569	1	Valerio Bocca Romano	painter	117.04	117
1566	1568	3	Ms Vincenzo Stampa	antiquarian	504	168

Legend: M.ro = Maestro; Ms = Messer; S.r = Signor.
Sources: ASMO, CDE, AP, nos. 106, 829bis, 853, 854, 873, 883, 895, 896, 897, 898, 942, 959, 961, 962, 963, 964, 972, 982, 984, 987, 991, 993, 993bis, 995, 1003.

artistic patronage, there were different degrees of intensity in relationships between patron and artist that did not always result in the establishment of a close—sometimes suffocating—relationship of the *servitù particolare* type that derived from the entrance into a *familia* or prince's court, whether it be lay or ecclesiastic. While the few who succeeded obtained "all the honours, authority, prerogatives, immunities, advantages, rights, rewards, emoluments, exemptions and other benefits accruing to the post," it is also true that "such a position was more frequent with architects than with painters."[26]

The fundamental problem lies in the limitations of exclusivity that the relationship required, limits that could be useful in some phases of a career but penalizing in others. There were contrasting forces at work that tended to limit the numbers of those welcomed *in perpetuum* into the rolls of the salaried at court, even if the same restraint is not seen in the freedom with which the patent of "court artist" was attributed to whoever worked there. This tendency derived in part from a reduced awareness of the juridical-institutional condition of the courts and in part from a lack of attention given to organizational mechanisms, to the forms of contractual and paracontractual organization, or to the schemes of retribution.

This is a lacuna that should be filled, since when one examines court demand one is faced with multitudes of individuals recruited and paid according to plans and for periods that were diverse. At Ferrara, for example, there were four different categories of employee.

These were the *salariati di bolletta*, effective and permanent members of the court; the *stipendiati del Soldo*, who worked for a given period; those who worked continuously and semi-exclusively in some court offices but did not have privileges like the first two groups, and finally, the persons who worked occasionally, often with no contract or written order and who were paid by "the job" (by which was meant a workday), or "the body," when a single item or small lots were commissioned (like furniture, decorations, furnishings, etc.) or when there was payment for delivery of an object and its installation (regardless of the time involved), or "the service," as in the case of musicians, singers, actors, dancers, etc., or those who undertook repairs, restoration, maintenance, and the like who were not paid by the day.

Coming to analysis of the *salariati di bolletta*, one finds the members of the music office (*officio della mussicha*),[27] led by a music master who directed eight to fifteen singers, six to ten instrumentalists, and seven to ten pipers. Next come the *artefici* (one painter,[28] one sculptor, one goldsmith, one or two miniaturists, an inlayer), the "antiquarians,"[29] who from the midfifties appeared in the "rolls" of the various entourages, the employees of the Office of Munitions and Construction and the maestri of the office of the Magistranze (I will examine both in the next chapter) under the direction of the *castellano*: a couple of carpenters, one or two blacksmiths, a potter, a maestro and apprentice of musical instruments, a turner, a stone worker, a wood-carver, the two or three armorers who managed the ducal armory, two to three gardeners, and the head of the herbal and botanic gardens. At the end were the cooks and some employees of the wardrobe: the master tailor, master embroiderer, fur master, and one or two tapestry makers, each of which was accompanied by numerous assistants.

The *salariati di bolletta* oscillated, depending on the period, between forty and seventy in number (the difference depends on the quantity of musicians and singers) and enjoyed particular benefits, drawing a salary both in money and in kind. The former was made up of a fixed sum (the *ordinario*) payable monthly in silver or bronze alloy coins,[30] and a special stipend (the *extraordinario*). The distinction between the two was fixed during the negotiations preceding assumption to court rank, when the artist and the ducal representative agreed on the duration of work and/or the type of work to be paid for by the monthly wage (it corresponded to the amount of money that an artisan earned in twenty days of work) and that to

be paid for separately because it exceeded the agreed limits (expressed probably in a number of pieces or hours or days worked).

The contractual nature of these relations should not be underestimated since the competition between the Italian and European courts and the resistance of some governments enticed the more ambitious into multiple transactions—sometimes complicated by the presence of agents and intermediaries—in order to gain the best possible conditions. For many the entrance into court could be a milestone in their *cursus honorum,* while for others it would be less attractive, as one can see in the doubts expressed by Vasari, Tintoretto, Beccafumi, Titian, and Rubens.[31]

The considerable difference in monetary retribution confirms that the schemes were personalized and the fruit of ad hoc negotiation. To analyze, for example, the salaries of the employees of the large music office in 1475: The forty-six members (singers, tenors, sopranos, and *contrabbasso,* chapel singers, musicians, pipers, and trombonists) received stipends on sixteen different levels, from a minimum of 33 liras and 6 soldi annually to a maximum of 266 liras and 8 soldi.[32] In 1502, during a war, fifty-one were paid by the Ufficio del Soldo, the levels had increased to twenty-four, and the salaries ranged between 12 and 288 liras annually,[33] only to drop again in 1559–1560 (when there were twelve chaplains, eight musicians, and six singers)[34] to seven levels of between 24 and 306 liras yearly—and increase again at the end of the century. In 1597–1598 the thirty-one chaplains, musicians, and singers were under nineteen different types of payment agreement, from a minimum of 18 to a maximum of 760 liras yearly.[35] But money was only one of the many components of retribution. More important still was the salary in kind, or *provisione,* calculated on the basis of the hierarchical position and family standing (numbers and ages of dependents) of the recipient, and was equivalent to double, triple, or even five times the value of the monetary salary. The *provisione* was also calculated *ad personam,* and it differed both quantitatively and qualitatively,[36] consisting of regular provision of foodstuffs and goods for domestic use,[37] fabrics, footwear, and clothing. The housing allowance should not be left out of the accounting, nor should the provisioning of horses and mules accommodated in the ducal stables, the services of court doctors, instruction offered to children and relatives, work done at home by wives and children (embroidering, sewing, tailoring, spinning, weaving, etc), the customary gifts associated with specific events (births and marriages, dowries, pensions for the old courtiers, widows and heirs, the cost of funerals), numerous fiscal exemptions, jurisdictional privileges (permission to bear arms and to hunt), the granting of feudal privileges (especially land use and rental) and the attributions of ecclesiastical benefices, as well as inheritances.

And then there was the not indifferent amount of tips, alms, gifts and counter gifts from the dukes, duchesses, princes, and princesses of the blood and from the guests stroked by the officials in charge of hospitality. This practice, which allowed the *salariati di bolletta* to take in sums greater than their monthly salaries, shows in the "alms, travel, or small pleasures" account books, where this type of activity was registered in chronological order, with the description of the thousands of "Roman golden scudi" distributed by Cardinal Ippolito II d'Este in 1563[38] or in 1566, following a scheme that considered the hierarchical levels of the beneficiaries, the amount of attention received, the rank of the host, and the prestige of the occasion.[39] The sums were in any case modest in comparison to the 200 gold ducats that Cardinal Luigi d'Este gave on 28 July 1573 to the Duke of Mantua's steward "to be given to the officers"[40] or to the 375 large gold ducats that Vincenzo I Gonzaga distributed on 21 December 1592 in Ferrara.[41]

In any case, from the point of view of earnings, the Ferrarese lords treated their employees

very well. Many musicians and singers earned more than the "general factors" (ministers pleni-potentiary) and many gentlemen; tailors and tapestry weavers were paid better than valets and chancellors; an armorer could take in twice as much as notaries and accountants; a wood-carver as much as a court treasurer. Intellectual and manual labor were on the same plane from an economic point of view, while professionals and mechanics appeared equal, in virtue of their recognized importance to the Este, who in establishing long-term relationships put their trust in having an honest if not complete adhesion to their own artistic programs, by protago-nists who could be not only docile executors but also convinced collaborators.

By contrast, the second group, the *stipendiati* (those placed on regular salary) *del Soldo,* was part of the office that paid the Este military and certain categories of individuals, such as cooks, singers, musicians, drummers, and horn players, and many painters, sculptors, tailors, engravers, and illuminators.

The reason for this condition of employment resided in the specific treatment reserved for those who depended on the Soldo, who enjoyed virtually identical treatment to that of the *salariati di bolletta,* but only for limited periods (calculated in terms of months). In the case of cooks, musicians, and singers this was usually a probationary period before regular employment in the ranks of the *salariati di bolletta,* or else an administrative reaction to war-time's peregrinations, because it also followed the dukes into war; for the others it was the "economic" answer to the need to differentiate patronage. It was impossible to accept all the painters, sculptors, illuminators, and engravers who worked at court for periods of variable duration as full courtiers, so the duke used this condition to facilitate their employment with-out prejudicing his finances, since permanent employment at court brought a heavy expense.

For this reason, between 1484 and 1528 the following were paid by the Soldo: 57 singers, 21 musicians, 22 cooks, 2 wood-carvers, 1 lutist, 1 grammar teacher, 6 armorers, 1 miniaturist, an engineer, 6 painters, 13 tailors, 1 furrier, 2 sculptors, 1 stone carver, and 19 trumpeters.[42]

After these came the members of the third group that included artists and artisans who worked permanently for the court offices without enjoying the benefits of the two previous categories (i.e. the salary in kind).

There were about one hundred of these working full time, but with no contract or guar-antee of longevity. They received a regular monetary salary based on the work performed, according to a pay scale based on the "jobs" supplied or the "bodies" realized. Many less spe-cialized artists and artisans such as blacksmiths, cabinetmakers, gilders, decorators, *scaranari* (armchair makers who produced some of the court furniture), sword makers, tailors, embroi-derers, master masons, stuccoists, armorers, pelterers and coppersmiths, engravers, potters, silversmiths, glassblowers, chisellers, etc., fell into this category.

Finally, there were those people paid on "spot" contracts several times with regularly nota-rized documents but more often without. This kind of agreement was used in the hiring of the members of theatrical companies and choirs, the musicians, the acrobats and dancers who entertained the Este courts, as well as certain painters, like Leonardo da Brescia, who between 1554 and 1578 received the astronomical sum of 24,394 liras in 329 payments by the Ducal Chamber, or his rival Ludovico Settevecchi, who between 1556 and 1570, for 145 orders, earned 5,049 liras, or various entrepreneurs involved in building works, as well as the broad front made up of merchants and salesmen of every sort, both local and not.

In this case too, the comparison between the expenses of the dukes and that of other mem-bers of the House of Este is interesting. One need only consider tables 5 and 6, which show the results of a prosopographic survey of 871 pay notes (only 25 of them refer to payments for

the execution of paintings) from the ducal offices in favor of painters, sculptors, and antiquarians between 1550 and 1570 and of 431 notes made by the functionaries of Cardinal Ippolito II from 1561 to 1570.

Even though the payments made by the officers of the cardinal often refer to work carried out at Tivoli or Rome, it should be noted that the two dukes (Ercole I from 1550 to 1558, Alfonso II from 1559 to 1570) paid over the course of twenty years only 32 painters, sculptors, and antiquarians, while the cardinal recruited 109 in a decade. Considering, then, the average size of yearly individual billings, which is a useful tool for measuring the exclusivity and pervasiveness of relations with patrons, one must note the clear prevalence of the cardinal's engagements over the ducal, with 192 liras against 157, despite the greater breadth of the sample given by the prince of the Holy Roman Church. It should also be underlined that only 2 of the 139 worked for both courts: Maestro Camillo was paid, assuming it really is the same man, first by Ercole II between 1550 and 1559 and then by Ippolito II in 1565, and the painter Nicolò Roselli, who in seven years (from 1559 to 1565) of working for the duke took in a little more than a fifth of that which he earned in a single year (1568) under Ippolito II.

PROFESSIONAL HIERARCHIES, CAREERS, AND GEOGRAPHICAL ORIGINS OF THE ARTISANS

Elements worthy of note have emerged from the analysis carried out in the section above. The first and perhaps most banal is the rare presence of painters and sculptors among the *salariati di bolletta* as compared to musicians, singers, and those whom many today would consider simply artisans. This is a signal of a countertendency in respect to much historical opinion, but it should not surprise us because stable and permanent entry in the rolls of the *salariati di bolletta,* the real courtiers, represented a considerable outlay for dukes, duchesses, and the other princes and princesses of the blood, and it tied them to lifelong choices.

There were, however, different needs, because there were artistic realms in which the search for novelty was favored (as in the pictorial, sculptural, theatrical, and performing domains) and other fields of expression that instead required continuity, harmony, and everyday practice (such as musical executions associated with the daily liturgical offices) or the amortization of large investments (from the glassblowers' ovens to the foundries), of the making of teams of specialists (potters, armorers, and gardeners), of lengthy execution times (from illuminators to tapestry weavers), and of an intimate knowledge of organizational mechanisms and supply systems (the wardrobe and munitions and construction offices).

These were "demand functions" that sprang from opposing needs, and explain the breadth of the range of forms of employment quite apart from any supposed supremacy of any given artistic genre. When the alternatives between internalizing or externalizing militated against the employment and recruitment into court ranks, all the other contractual options were explored and intermediate solutions found.

In some cases the Este just purchased without intervening in the ideational phase or exercising specific customizing, as for example when purchasing tapestries,[43] fabrics, books, sculptures,[44] furniture and decoration, leather goods, ivories, rugs, coins and medals, carvings,[45] gold and silver works, *naturalia*,[46] and archaeological artifacts.[47] Even though historians have only recently begun to show interest in these forms of shopping,[48] their importance should not be underestimated because there was a healthy secondary market that was ready

to satisfy the requests of the most difficult buyer and did not shy away from conducting the trade. Thus one can understand how it could be that from mid-Quattrocento the major-domos, house maestri, and wardrobe maestri of the Este House could carry out purchasing missions both in foreign countries (Lyon was the most frequented seat) and in Italy, and then mostly in Rome, Genoa, Bologna, Milan, Florence, Venice, and Senigallia.

The case of works commissioned for the princes and princesses of the Este house is different. When novelty and change were desired, the work was often trusted to external suppliers engaged for the occasion, and according to whim and need, while specialized competences, conspicuous investments, and lengthy projects were preferably entrusted to *salariati di bolletta* (permanent members of the court), as in the case of the musicians, singers, tapestry workers, tailors, dance masters, clockmakers, etc. These requirements explain why the *salariati di bolletta* usually remained tied to their pater- or materfamilias for very long periods, as can be deduced from reading the data presented in table 7. Although these data underestimate the

Table 7. The Length of Service in the Ducal Court for Artisans Registered in the Rolls of the Salariati di Bolletta between 1457 and 1628

Category	Number of artisans	Career duration (years)
Antiquarians	2	10.5
Tapestry weavers	9	12
Architects	7	10.57
Armorers	16	11.75
Dance masters	6	14.16
Singers	182	9.3
Potters	3	5.67
Cooks	101	13.37
Cabinet makers	10	13.54
Smiths	10	11.43
Engravers	7	11.65
Stone carvers	10	12.93
Lutists	3	22.62
Musicians	200	15.89
Goldsmiths	2	9.5
Clockmakers	13	11.53
Furriers	3	17.33
Painters	6	3
Embroiderers	2	15.5
Tailors	11	14.9
Sculptors	1	8
Turners	10	7.73
TOTAL	614	12.64

Source: http.guidoguerzoni.org, database "Artefici Estensi 1457–1628."

effective longevity at court, they do confirm the remarkable length of careers[49] and the lengthy service relations that had their raison d'être in the idiosyncratic profile of the talents needed and in the preferences given to the development of long-term relations.

Members of the House of Este wished to be served by those whose talents were equal to their loyalty because the secrets, dangers, and interests in play imposed loyalty as a primary criterion of selection, valuation, and promotion. Intimate relations with musicians, singers, and maestri of different sorts could be fatal if they were to be tempted by the flattery of schemers, and similar considerations held for stewards who arranged meals and banquets, for the perfumers, apothecaries, and barbers who prepared essences, medicines, and unguents, or for the tailors and embroiderers who produced the clothing for their nightly repose and daily fatigue. In years afflicted by implacable poisoners and traitorous blades, it would seem logical to try to limit the presence of persons extraneous to the customary circle of employ and to sustain the inclusion of elements already connected to someone in service, in order to enjoy further instruments of control. The newcomer's belonging to provenly loyal families not only guaranteed the knowledge of rules, procedures, places, and persons—often these were boys and girls who had grown up inside the court—but lessened the risk of unhappy choices, because there was the deterrent factor of possible transversal punishment. There were also objects of great value and copious amounts of money in circulation, so that the simplest of domestic operations was a test of the honesty of any employee. In the kitchen the scullery maids washed gold and silver services of untold value, the porters cared for jackets whose any single button was equal to a life's salary, while in the wardrobe thousands of ducats were spent.

The need to pay persons of proven loyalty, however, was not ascribable only to the duties carried out firsthand, but also in relation to the commissions that many *salariati di bolletta* carried out, even at lower levels of the hierarchy. The documents of the "officers of the house," which have still not been thoroughly studied, show in fact the existence of numerous commissions that substantiate the transactional nature of the powers held and indicate how widespread were the principles of responsibility that were characteristic of the "managerial" work of many artisans, who often spent the greater part of their time coordinating and directing the work of others. In Ferrara, even the porters of the tapestries or the wardrobe, the pariahs of courtly labor, most of the time did not do the work of moving and transporting tapestries, rugs, and furniture, but worked as team leaders, paying and directing colleagues engaged for the job, to whom they anticipated daily payment from their own pockets, and the same held true for the court washerwomen who supervised those who "washed clothes in the Po." Thus the great disproportion between the small number of artisans at court and the imposing group of "colleagues" involved in the various offices. If between 1506 and 1559 we find in the *bollette dei salariati* one goldsmith in a single year, in that same period there were thirty-one goldsmiths and jewelers from whom items were commissioned,[50] where, compared with the eleven tailors listed in the rolls of the ducal courts from 1457 to 1628, between 1529 and 1534 the officers of Duke Ercole I paid twenty-six[51] tailors at least once.

The attachment was, however, justified by additional factors. The first was represented by the heterogeneity of geographical origins, since the princes and princesses of the House of Este recruited the best specialists from within and outside of Europe. Thus, to encourage the introduction of work in glass,[52] they enticed maestri from Murano, and to guarantee first-quality bricks they hired specialists from Modena and Piacenza, while for impeccable majolica they brought in experts from Faenza, and for porcelain, specialists from Venice, while the best armorers came from Brescia and Milan. The same was true for the other foreigners: artillery

and foundrymen from Switzerland and Germany, cooks, musicians, and tailors from France, Flemish singers and tapestry weavers, Spanish goldsmiths and embroiderers, etc., whose talents helped to transform a city of 30,000 inhabitants into a continental capital whose demographic composition was positively influenced by these practices, as one can see in the data of table 8, which shows the geographic origins of the foreign artisans who served in the ducal courts between 1457 and 1628. Of the 614 artisans included, 196 (30 percent) came from territories not under ducal authority and, of these, 91 (15 percent) were not Italian. Even more pronounced was the cosmopolitanism of the *particolari* courts: if we find fourteen Frenchmen among Cardinal Ippolito II's *salariati di bolletta,* among Cardinal Luigi's cooks alone there were seven, accompanied by two dozen apprentices and helpers.[53]

Those who accepted the move to the lower Po Valley from remote places took the change seriously, because it meant the removal of entire families and leaving the homeland and many loved ones. It was difficult to return soon, as the contract was for some years, so as to allow for some benefices (such as citizenship or inscription in the rolls of the city's guilds) and being able to count on the large colonies of compatriots that already lived in Ferrara: the university students, the compatriots in service in the *particolari* or female courts, the members of the ducal guard (in the Cinquecento there were hundreds of Swiss guards and German halberdiers) and of the standing militia (limiting scrutiny to the 236 artillerymen and founders stipended by the Soldo between 1501 and 1545, I have found the names of 21 French and 37 German[54] maestri), many of whom arrived looking to make their fortunes.[55]

THE SIZE OF THE DEMAND AND ITS CONSEQUENCES

The politics of the Este house did not favor a small number of favorites nor block the development of the local productive fabric, since the *salariati di bolletta* by themselves could not satisfy the imposing demand. In 1467 an inventory of the tapestries already reported more than 433 pieces[56] in the care of the ducal tapestry office, the library in 1518 had more than 900 volumes of printed books and manuscripts,[57] the *credenze* (*sideboard*) that managed the services—not only for the table—of gold, silver, copper, majolica, semiprecious stone, glass and crystal held thousands of items, nor any less numerous were the jewels, arms, the apparatus and the valuables kept in the wardrobe and the little wardrobe (*Guardarobbetta*).

While in 1503 the officer of the linen had assessed the presence of 1,448 linen sheets, each numbered,[58] the list drawn up by Duke Alfonso's wardrobe maestro in 1561 reported the presence of thousands of items of clothing and home decorations, among which were 357 shirts, "342 tunics of all kinds and camisoles and jackets, 166 socks, pants, and bonnets, 247 jackets, sleeves, and busts," 201 hats, various crates and safes full of things of no great value (arms, old silver, "country horns that are no good," collars, threads, etc.), 55 cardinal's outfits, 402 pewter items, 562 books of all sorts, 11 dog covers, various items "for babies and wet-nurses (24 swaddling bands, 5 diaper rags, some lengths of cloth for babies, a swaddling cover worked in gold, various small blankets), 165 small cloths for the nose, 39 mule covers, and more than 300 furs."[59]

What is astonishing, however, above and beyond the exorbitant number of things and the incredible variety of styles, materials, provenance, and working, is their quality:[60] Of the 1,701 articles in silver inventories of the ducal wardrobe following the death of Alfonso II, the key to

Table 8. Geographic Origins of the Artisans Registered in the Rolls of the Salariati di Bolletta between 1457 and 1628

Italy	Number of artisans	Italy	Number of artisans
Alba	1	Parma	2
Ancona	1	Pistoia	1
Argenta	2	Poschiavo	2
Arquà	2	Reggio	1
Assisi	1	Rimini	1
Bassano	1	Rome	1
Bergamo	1	Romagna	1
Bologna	4	San Felice	1
Brescia	1	San Martino	1
Calabria	1	San Secondo	1
Carpi	7	Scandiano	3
Colorno	6	Trani	1
Como	2	Udine	1
Correggio	3	Valenza	1
Cremona	1	Venice	5
Faenza	5	Vercelli	1
Firenze	2	Vicenza	1
Foligno	1	Vignola	1
Forlì	1	*Total Italy*	105
Friuli	1		
Genoa	1	*Other nations*	*Number of craftsmen*
Legnago	1	Egypt	1
Lodi	3	Flanders	24
Lombardy	1	France	27
Lucca	2	Germany	20
Lugo	3	Greece	2
Mantua	2	United Kingdom	1
Milan	2	Savoy	1
Mirandola	1	Spain	9
Modena	7	Switzerland	4
Montecchio	2	Turkey	1
Montepulciano	2	Hungary	1
Naples	1		
Nola	1	*Total Other Nations*	91
Norcia	2	*Total Italy + Total Other Nations*	196
Padua	4		

Source: http.guidoguerzoni.org, database "Artefici Estensi 1457–1628."

the size of that material culture is not represented by the three fountains each weighing thirty-five kilos or the 75 cups, 795 plates, and 284 round plates often weighing two kilos each, but by the small spittoon, the spoon with a small pin to cleanse the tongue, a covered medicine glass, a small dipper for syrups, the bed warmers,[61] a small sugar grater, an *ovaruolo* (egg cup),[62] a small cake pan,[63] or the little ice-bowls for cooling wine.[64]

There was no institution more capable than the courts of promoting feverish processes of invention, differentiation, specialization, and perfection of the forms, materials, and functions: whatever came to their attention, proposals and projects, variants and innovations. It is enough to scan the pages of one of the numerous inventories of the Estense kitchens to find hundreds and sometimes thousands of tools listed, dozens of models of pots, strainers, every kind of container made of every sort of material, tubs, pails, little forks, scoops, spits, tripods, churns, presses, graters, mortars, etc. These sources reveal the widespread taste for detail and the pleasure taken in perfection, as well as a desire to improve the form, appearance, and functionality of any object, even the most banal, from the handle of a colander to the fireplace bellows, from a dog's collar to the mule's bit, from a button to a falcon's hood.

Desires of this kind were satisfied by the unending labor of thousands who fed this sumptuary economy of astonishing dimensions that was not only the duke's: Scanning the pages of an inventory of Cardinal Luigi d'Este's wardrobe from 1580, one notes—among the headings relative to tens of thousands of items—23,283 leather "squares" of gilt, silvered, enameled, and painted leather in 59 rooms *di corami* (of stamped leather), 175 tapestries, 184 little tables, 65 rugs, 140 statues, 11 clocks, 40 velvet boxes, 52 brass fireplace hoods, more than 500 chairs, 187 beds, 14 carriages, 4 gilt chariots, and 1,209 objects of silver.[65] Furthermore, when dealing with apparently banal objects, one must remember that there were bedsteads "in the old style covered in ebony and inlaid with white with four fluted columns and with a border; covered in ebony and gilt with the sides showing all around and with four pyramids the column; of walnut with the Story of Vulcan on the canopy with columns and gilt apples,"[66] while among the dozens of mule and horse trappings shone the one "for a pontifical scarlet mule cloth with riveting, the headpiece with a gold tassel and crimson silk, with the breastplate similar to the reins with tassels and gilt stirrups draped in scarlet cloth,"[67] or that for a horse "corsair-like of leather covered in black velvet with a fringe in gold and black silk and headpiece, reins, breast, and gilt shoulder pieces."[68]

Faced with the entity of these numbers, with the plethora of precious materials and the incredible quantity of work involved, one can understand why, notwithstanding that the execution of some work was reserved to the *salariati di bolletta*,[69] demand from the Este courts caused beneficial effects on the entire productive and labor system of the city with its diffusion of such refined and innovative products, processes, knowledge, techniques, and technologies that the members of the House of Este maintained with their conspicuous investments. It is confirmed by the Brescian kilns, the glass and brick kilns that redesigned the profile of the city, and the introduction of new or suspended activities (as in the case of the soap factory). Between the end of the Quattrocento and the beginning of the Cinquecento both Duke Ercole I and Cardinal Ippolito I set up manufactories for silk fabrics—similar to the one established in Mantua in 1523—for clothing that was often sold to the members of the various courts, undertakings that let one understand their relative ease in overcoming any resistance from the guilds.

The theme is of special interest, even if it has been somewhat ignored in the literature[70]—which has rarely looked at the relationships between principates and guilds, at least in the

capitals—and is still influenced by Martin Warnke's[71] opinions, convinced that the guilds had always opposed a tenacious if vain opposition to the requests of foreign artisans working for European and Italian princes.

Even though customary defenses cannot be excluded, in the Este case I have not found, at least up until now, explicit guild protests against the Este employment practice, neither for the clear inequality of power nor for the effectiveness of the solutions used to weaken the protests.

I do not believe that the courts weakened the Ferrarese guild system. On the contrary I think that they reinforced it, thanks to their maintenance of a steady demand with their great volume of spending (the Este, in the form of salaries and purchases of goods and services, returned 70 percent of their income, including that from subject territories, income from foreign fiefs, and ecclesiastical benefices enjoyed in Europe into circulation in Ferrara, with the great volatility of fashions (which caused rapid obsolescence and expensive changes, to the understandable pleasure of producers and intermediaries), with the large number of buyers tied to the court circuits and the flow of wealthy guests.

The new statutes promoted at Ferrara in 1535 confirm the vitality of the Ferrarese guilds, which registered a quantitative as well as qualitative growth thanks to the transmission of technologies, experience and knowledge guaranteed by the employment of Europe's best-known specialists. Further, the suppliers themselves may have softened the resistance. Many of the more important court suppliers were listed as "heads," "leaders," or "masters" in the guilds, a sign that agreement could be gained through open policies of persuasion since the acquiescence was assured by favors done for the leaders of the guilds, already mollified by the heavy demand.

It should not be forgotten that the *princeps faber* much praised in the apologetic literature of the fifteenth and sixteenth centuries was only a literary figure. Seeing the operational scale and organizational structures of Este manufactories (from tapestries to the ducal silks, to the glass furnaces and the soap manufacture, from iron munitions to the studios of the potters busy making majolica and porcelain), one can trace a close relationship between the presence of some of these artistic activities and the adoption of productive and management models that anticipate the presumed intuitions of Colbert by two centuries, according to a scheme common to the analogous Medici, Gonzaga, Aragonese, Sforza, and Savoy manufactories.

These phenomena demonstrate the importance of the occupational impact of the demand exerted by the different courts, whose disappearance caused by the unforeseen Devolution of 1598 brought the urban economy to its knees in less than ten years. To be sure of the relevance, I carried out a prosopographic test of the 2,520 single payment orders effected by the office of the ducal wardrobe and the central treasury in the six years of greatest financial crisis of the Cinquecento (1529–1534), the period in which outlay was more contained.[72] During these years the 41,390 liras paid out by the wardrobe were employed to pay twelve monasteries at least once (for cutting, embroidering, mending, and sewing), one pawnshop, and 499 persons belonging to seventy-seven diverse professional groups.[73]

These figures are imposing and reveal the nature of the patronage "policy" that in periods of recession favored equity of distribution. In moments of crisis the average individual's bills dropped quite a lot, but the work was broken down to ensure a greater possibility of subsistence, guaranteeing the rotation of workers and furnishers of raw goods, semifinished and finished products. Once the emergency was past, the system went back to full speed, and the principal suppliers made deals in virtue of good relations with some functionaries and thanks to the existence of independent patronage and matronage circuits.

The relations between suppliers and officers of the court bring us back to the systems of delegation and levels of subdelegation of decisions, generally attributed to the will of the

single patrons or matrons, who in the midst of a thousand duties would have found time to manage every little detail. And yet the duties of a maestro of the wardrobe, of a director of silver, of an antiquarian or a prefect in the *Fabbriche* were not only to control accurately, as if they were simple bureaucrats or incompetent representatives: Many of them, at least in certain procedures, decided by themselves what would be purchased and above all, to whom work would be entrusted.

Of the 4,995 liras spent by the officers of Cardinal Ippolito I's wardrobe in 1514, 976 were used in Venice by Reverend Roberto Macigno to purchase fabrics, pewter, and glass, while 712 liras were put out for similar reasons by the reverend Francesco Zerbinati at the Recanati[74] fair. Similarly the magnificent Sir Tommaso Mosti, wardrobe master to Cardinal Ippolito II, in May 1556 bought in the course of two days at Venice "from goldsmith della Croce in Rialto two rugs and an elaborated and gilt silver basin for 75 gold scudi, from Calemanno the Jew, three 'caiarini' rugs, and one round and two wide for 100 gold scudi, from Salamone the Jew two rugs for 85,5 gold scudi, from Mandolino the Jew in the Venetian ghetto a suit of red satin for 20 gold scudi," and then spent another 538 liras.[75] In the same way, Count Giulio Tassoni Estense, majordomo at the court of Don Alfonso d'Este and Giulia della Rovere, on 28 January 1550 spent, again in Venice, 1,941 liras in buying from Mandolino degli Angeli Hebrew various sable furs and five painted *spalliere* (head of the bed) and from Guglielmo Zanforto another twelve *spalliere*.[76]

These sums reveal the trust they enjoyed as well as the discretion with which they managed certain operations, in comparison to which the decorations for a *cassone* (chest), the realization of a series of serving platters, or the gilding of a basin, were indeed small affairs.

All the more reason then, to understand what the limits of their competences could be, following the paths indicated by Alessandro Cecchi in his research on Pierfrancesco Riccio, majordomo to Cosimo I de' Medici.[77] The power, and not only of interdiction, wielded by these functionaries and their collaborators was denounced by Vasari, who complained that he had been kept at a distance from the duke because "certain persons had formed a faction under the protection of the above-named Messer Pier Francesco Riccio, and whoever was not of that faction had no share in the favors of the court, even though he might be able and deserving. This was the reason that many who, with the aid of so great a prince might have become excellent, found themselves neglected, none being employed save those chosen by Tasso, who, being a gay person, got Riccio so well under his thumb with his jokes, that in certain affairs he neither proposed nor did anything save what was suggested by Tasso, who was architect to the palace and did all the work."[78]

But we are talking about thousands of officials who served for centuries in hundreds and hundreds of courts and of whom we know next to nothing even though they held considerable power, as one can see from the surveys that I have carried out on the supply networks of some of the Este courts and from analyzing the roles of the persons deputed to assume these decisions. Starting from the hypothesis that good business could be done by maintaining relations with a number of courts, I followed the supply of precious fabrics (satins, silks, damasks, velvets) from 206 merchants—in large part Ferrarese—who supplied the ducal court of Ercole II between 1533 and 1557, comparing these values with those of the suppliers of the wardrobe officials of Prince Don Alfonsino (in 1545–1546), of Don Alfonso, Marquis of Montecchio (from 1556 to 1558), and of Cardinal Ippolito II (in 1556, 1557, and 1558). Eighty-eight persons,[79] divisible into twenty-seven professional categories, worked for the cardinal, while for Don Alfonso, just in the field of stuffs there were thirty intermediaries.[80]

Scanning the data in table 9 relative to the eighty chief suppliers of precious fabrics to the court of Duke Ercole II between 1533 and 1557, with the sums of the deliveries to the

Table 9. Eighty Chief Suppliers of Precious Fabrics to the Court of Duke Ercole II between 1533 and 1557, with the Sums of the Deliveries to the Courts of the Princes Don Alfonsino (1545–1546), Don Alfonso (1556–1558), and Cardinal Ippolito II (1556–1558)

A	B	C	D	E	F	G	H	I
Francesco Contugi	46,868	24	19	2,467	2	387		14
Antonio da Vento	14,464	24	14	1,033				
Alberto and Gianbattista Masi	12,736	25	15	849			1,323	
Bongiovanni Marigella	8,749	16	10	875				
Andrea Rodi	8,315	6	5	1,663				
Giulio, Sebastiano and Zaninello Zaninelli	7,748	24	16	484	2		39	5
Francesco, Gerolamo and Vincenzo Vincenti	5,278	24	20	264				
Battista Venturini	5,249	14	11	477	2		390	5
Isacco and Leone di Lazzaro Ebrei	4,911	18	12	409	1	1,686		
Ippolito Tesini	4,760	24	10	476				
Giacomo Tombesi and heirs	4,721	24	18	262	1		644	
Odoardo Balbo	4,249	26	18	236				
Giangerolamo Cappelli (heirs)	3,697	10	8	462				
Camillo Galiera alias da Parma	3,333	17	8	417				
Giovanni Bonetti il Rosso	3,240	24	17	191	2	314		47
Domenico Maria dalle Balle	3,139	5	5	628				
Antonio and Rasini brothers	2,697	24	17	159	3	181	25	113
Bernardino da Monte	2,552	8	5	510				
Andrea Correggiati	2,429	18	10	243				
Albertino and Francesco Picchiati	2,423	25	12	202	2		5	18
Giulio dal Moro (eredi)	2,147	25	18	119	1		65	
Tiberio Rizzi	1,678	24	18	93	3	80	613	12
Lorenzo Guicciardini	1,573	7	3	524				

Bassano Burri	1,354	3	3	451			
Michele Valiero	1,274	11	6	212			
Nicola Scuri	758	4	4	190			
Matteo Prandi	1,220	14	4	305			
Maggio Bordella Levita Ebreo	730	10	6	122			
Alfonso Raimondi da Reggio	718	2	2	359			
Pietro Antonio dalla Seta	711	13	4	178			
Ludovico Zipponari	710	23	11	65			
Francesco Gambertino	708	3	2	354			
Ippolito Linarolo	696	2	2	348			
Gabriele Ariosti	685	1	1	685			
Giovanni Scotti	580	2	2	290			
Alfonso Silvestri	564	10	3	188			
Paolo Biondi	527	1	1	527			
Francesco Mona	518	23	8	65			
Gerolamo Cavalieri	508	1	1	508			
Isacco Rabbino Ebreo	505	7	5	101	1	1,085	2,123
Domenico Gallo da Venezia	474	2	2	474			
Francesco dall'Olio	474	3	2	237			
Angelino Ebreo	433	8	4	108			
Abramo de Luna Ebreo	403	14	9	45			
Tommaso Nigrisoli	403	11	4	101	1	209	
Francesco Bianchi	389	1	1	389	1		
Giacomo Novelli	344	12	7	49	1		10
Giovanni Magni	339	1	1	339			

(continued on next page)

Table 9. Eighty Chief Suppliers of Precious Fabrics to the Court of Duke Ercole II between 1533 and 1557, with the Sums of the Deliveries to the Courts of the Princes Don Alfonsino (1545–1546), Don Alfonso (1556–1558), and Cardinal Ippolito II (1556–1558) (continued)

A	B	C	D	E	F	G	H	I
Pietro Francese	327	3	2	164	1			59
Pietro Maria Mantovano	323	5	2	162				
Giovanni Maria Maganza	308	17	5	62	2	214		306
Nicola Dolcetti	308	2	2	154				
Ugo Boiardi	306	1	1	306				
Alfonso Prosperi	301	16	4	75				
Francesco Calzetta	298	14	5	60				
Pietro Maria Gardo dalla Seta	242	7	2	121				
Alessandro Rodi	240	1	1	240				
Ippolito Argoati	218	6	3	73	1		949	
Mengino Patella	212	5	4	53				
Alberto Corregiari	208	2	2	104				
Mosè Sacerdoti Ebreo	205	4	4	51				
Bacchio Tolomei Fiorentino	204	12	6	34	2	423	30	
Giacobbe Capritti Ebreo	188	6	5	38	1			87
Venturino dal Finale	186	1	1	186				
Vincenzo da Cremona	179	1	1	179				
Giovanni Magnon	178	11	4	45				
Patrizio Muzzi	173	5	3	58				
Giovanni di Peri	169	1	1	169				
Francesca di Simone da Trento	166	1	1	166				
Gerolamo dalle Carte	165	1	1	165				
Giacomo Boiardi	165	21	6	28	2			259

A	B	C	D	E	F	G	H	I
Antonio Marigella	164	2	2	82	1			3
Lionello dal Sale	159	21	6	27				
Albertino Da Vento	159	2	2	80				
Giovanni Mastellaro	156	10	2	78				
Isacco Levita Ebreo	156	3	2	78				
Giovanni Maria Mazzolini	151	3	2	76				
Giacobbe Todesco Hebreo	150	17	5	30	1			87
Terzo Terzi	141	11	2	71	1			19
Gerolamo Casanova	135	3	3	45				

Legend:
A = name and surname of the supplier;
B = total sales in liras in the period 1533–1557, only to the ducal court;
C = supplier's career duration in years;
D = supply duration, in years;
E = average year sales, in liras;
F = number of further Este courts to which the supplier supplied goods;
G, H, I = Overall value of supplies to the courts of don Alfonsino (1545–1546), don Alfonso (1556–1558), Ippolito II (1556–1558) in liras.

Sources: ASMO, CDE, AC, Guardaroba, no. 152; Fontico, nos. 3, 5, 6, 7, 10, 13, 18, 19, 21, 23, 24, 26, 28, 30, 32, 34, 35, 37, 40; AP, nos. 170, 387, 569 e 571.

courts of the princes Don Alfonsino (1545–1546), Don Alfonso (1556–1558), and Cardinal Ippolito II (1556–1558), we see that some persons took in, over a couple of business years with a single *particolari* court, a sum equal to what could be earned in twenty-four years of career service in the ducal Fontico. This is a sign that the different courts not only ensured the possibility of accumulating orders, but also the opportunity of initiating a career by maintaining special relations with a single entourage, in the hopes of later increasing business through the Este network.

I speak of hopes because the individuals who simultaneously supplied various courts did not have equal treatment everywhere: It is the case, for example, of the rag seller Isach Raben the Hebrew, who, even though he did not have special relations with the ducal officials (he sold 77 liras worth to them in 1566 and then disappeared from the ledgers), in the same year appears as one of the principal suppliers to the wardrobe offices of Cardinal Ippolito II and of Don Alfonso, Marquis of Montecchio, with sales respectively of 1,394 and 413 liras. Isach Raben apparently had excellent introductions to these courts, if between 1545 and 1546 he sold to Don Alfonsino d'Este, the younger brother of Don Alfonso, merchandise for a value of 1,459 liras[81] and in 1550 supplied goods of the value of 1,243 liras[82] to Don Alfonso himself.

In the same manner one of the principal ducal suppliers, Messer Antonio da Vento, although having succeeded in selling much to Ippolito II, sold almost nothing to the court of Don Alfonso, contrary to the case of the mercer Gerolamo Signorello (unfortunately we have no record of his sales to the ducal wardrobe),[83] who sold items to the tune of thousands of liras to Don Alfonso and Giulia della Rovere without ever managing to enter into the good graces of the officials of Ippolito II. This is information relative to only three of the ten courts in Ferrara in that particular year, which had the habit of tying themselves to specific suppliers, ensuring a minimum of competition and guaranteeing the possibility of work to almost everyone. This is the only way to explain the presence in 1596 in the district of Ferrara (including the city and more than ninety villages in the county), of as many as 171 tailors, not including those directly employed by the lords of the House of Este.[84]

A FERRARESE ANOMALY?

I do not believe that the image described above portrays a Ferrarese anomaly but instead a situation common to many Italian courts, as one can see by examining the data in table 10, in which I have illustrated the presence of some categories of singers, musicians, and artisans in the rolls of the courts of the dukes of Parma, Mantua, Florence, Urbino, and Turin in the second half of the Cinquecento.

There are sensible differences between the different contexts that are not ascribable to the existence of radically different models, but to contingent factors for which it is difficult to postulate a normative rule. The personality of the various sovereigns was influential, as no one denies, as favor and interest in the arts could change quite a lot from one generation to the next (think only of the successions of Ottavio and Ranuccio Farnese or Guglielmo and Vincenzo Gonzaga), and political conditions were equally influenced, as one may deduce from the ranks of Emanuele Filiberto of Savoy, forced on several occasions to spend more than 40 percent of his income on warfare. Nevertheless the absolute dimensions of the rolls did not cause radical alterations in government structures or artistic and performance activity, which had outstanding elements of similarity in different geographical contexts.

Table 10. The Presence of Artisans in the Rolls of the Courts of the Dukes of Parma, Mantua, Florence, Urbino, and Turin in the Second Half of the Cinquecento

	Parma	Mantua	Florence	Urbino	Turin
Tapestry weavers and paper-hangers			2 (1550) 2 (1559)	1 (1584)	2 (1562) 2 (1568) 1 (1573) 2 (1576)
Architects, engineers, and prefects in the Fabbriche	2 (1551) 1 (1565) 1 (1576) 2 (1586)	1(1577) 1 (1587) 1 (1591)	6 (1588)	1 (1584)	
Armorers, harquebusiers, and armorers	1 (1551) 1 (1565) 2 (1576) 2 (1586)	1 (1577) 1 (1587) 1 (1591)	4 (1550) 3 (1559)	2 (1584)	2 (1562) 2 (1568)
Dancers			1 (1559)		
Cantors, singers, musicians and, trombonists	12 (1565) 17 (1576) 16 (1586) 5 (1593)	12 (1577) 12 (1587) 13 (1591)	14 (1550) 14 (1559) 2 (1588)		6 (1562) 6 (1568)
Potters and majolica masters	1 (1593)				
Ebanists				1 (1584)	
Blacksmiths	1 (1565) 1 (1586)				
Foundrymen		1 (1587) 1 (1559)	1 (1591) 2 (1577)		
Plumbers	1 (1568) 1 (1593)				
Gardeners	4 (1567) 4 (1576) 5 (1586) 5 (1593)	5 (1577) 6 (1587) 7 (1591)	1 (1559)	1 (1584)	
Engravers and carvers	3 (1576)		1 (1559) 1 (1588)		
Inlayers		1 (1591)			
Lapidists	7 (1565)	1 (1591)			
Illuminators		1 (1591)		1 (1584)	
Goldsmiths, silversmiths, and jewelers	1 (1576) 3 (1586) 1 (1593)	1 (1577)	3 (1550) 1 (1559) 1 (1577) 1 (1588)	1 (1584)	1 (1568) 1 (1573)
Clockmakers		1 (1577)	1 (1559)	1 (1584)	
Furriers				1 (1584)	
Painters	6 (1565) 2 (1576) 2 (1586) 2 (1593)	1 (1577) 1 (1587)	1 (1550) 1 (2559) 2 (1577) 2 (1588)	1 (1584)	

(continued on next page)

Table 10. The Presence of Artisans in the Rolls of the Courts of the Dukes of Parma, Mantua, Florence, Urbino, and Turin in the Second Half of the Cinquecento *(continued)*

	Parma	*Mantua*	*Florence*	*Urbino*	*Turin*
Embroiderers		2 (1577) 1 (1591)	2 (1550)		
Tailors and sock makers	1 (1567) 1 (1576) 1 (1586)	1 (1587)	2 (1550) 3 (1559)	1 (1584)	1 (1562) 1 (1568) 1 (1573) 1 (1576)
Sculptors	1 (1565) 3 (1576) 1 (1586) 1 (1593)		1 (1550) 1 (1559) 4 (1577) 2 (1588)	1 (1584)	
Herbalists			1 (1559)		
Weavers of cloths and brocades		1 (1591)	4 (1550) 1 (1559)		
Latheturner		1 (1591)			
Other	13 master artisans (1586)	further 20 without qualification "according to H.M will" (1591)		2 masons of court (1584)	

Sources: For the Farnese court of Parma: ASPR, Computisteria Farnesiana di Parma e Piacenza, Tesoreria e computisteria Farnesiana e Borbonica, see Romani 1978; for the Gonzaga court of Mantua: ASMN, Archivio Gonzaga, no. 395, D. XII, no. 5 and no. 1346; for the roles in 1577: De Maddalena 1961, 226–239 (manuscript transcription in Biblioteca Ambrosiana, Manoscritti, T. 13 sup.); for the court of Urbino: ASFI, Ducato d'Urbino, classe I, divisione B, filza X, no. 19 e Appendice, no. 32; for the Savoy court: Stango 1987; for the Medici court: ASFI, Acquisti e Doni, Archivio Mediceo e Manoscritti.

The court of Cosimo I de'Medici in 1559 had one half the number of *salariati di bolletta* of the Este, but instead had a number of musicians, singers, and artisans not unlike that of the Duke of Ferrara, as we find three trombonists, five musicians, an organist, a harpist, a dancer, a singer, three trumpeters, a studio *semplicista* (herbalist), a painter, a sculptor, a jeweler, two tapestry weavers, a cameo carver, a founder and apprentice in the foundry, a gardener, a clocksmith, two tailors, a weaver, a sock maker, three harquebusiers, and a historian (Messer Ludovico Domenichi da Piacenza, listed separately with the dwarf Bartholomeo).[85]

The same argument holds for the entourages of Ottavio Farnese or Francesco Maria II Della Rovere, which although the court had only 254 mouths (circa one-third of the Mantuan or Ferrarese) in 1584, still had a tapestry weaver, an architect, two armorers, a cabinetmaker, a gardener, an illuminator, a goldsmith, a furrier, a painter, a tailor, a sculptor, and two masons.

Compared to this substantial similarity the case of the counts of Novellara takes on interest, as they, even though governing a minuscule state and having a court with about eighty mouths, not only discovered a painter of the likes of Lelio Orsi and maintained close relations

with a top musician like Jacques de Wert, but also surrounded themselves with a number of musicians, singers, dancers, and artisans not so different from those of the courts of the neighboring states, even if the terms of employment were lighter.

In fact, the policies of recruiting were different: between 1563 and 1567 Ottavio Farnese hired nearly *en bloc* eleven Flemish and Dutch musicians, singers, painters, and blacksmiths—often with long-term contracts (in 1563 "Danielo Biancho Flemish Ferraro . . . contracted to stay for four years" and in 1566 "Arnolfo Flemish painter of glass . . . contracted to stay six years with his Excellency without leaving"[86])—who went to enlarge the already substantial community of northern Europeans present in the Parmesan ranks, which had grown with the return of Duchess Margherita of Austria.[87]

There were also inconsistencies in salary policies, even if it is difficult to make meaningful comparisons: The monetary component was sometimes the smaller part and the payment in kind difficult to assemble and compute, as there were practices and habits that were anything but simple, and the sources are reticent or missing. At Urbino, for example, differently from the treatment of other artisans, the painter Cesare Magiero, the sculptor Giovanni Toscano, Messer Giovanni Giacomo "who worked ebony," and the illuminator Simone Fiammingo in 1584 received their provision in money "from the purse of His Altezza Serenissima," with no preset[88] values, whereas in Mantua in 1591 the pressman Pavolo Novort received circa 629 liras the year, with no payment in kind, while his colleague the founder Cesare Chinali, besides 360 liras annually, was entitled to receive bread, *panelle* (oil-cake), *vitto* (food), beef, fish, salt, oil, candles, and flour all year[89] for two mouths.

The very term *provvigione* or *provvisione*, repeated everywhere, is ambiguous and induces one to proceed with caution with diachronic and geographic comparisons, both because of the fragmentary nature of the pay scale profiles, and the variations that could be found at the local levels in respect to different duties.[90]

When, however, a comparison can be based on more stable foundations, similarities emerge. In 1591 the court of Duke Vincenzo I Gonzaga registered the presence, in its rolls of the salaried, of four women singers, seven singers and musicians, seven weavers, twelve *artefici*, seven gardeners, and another twenty-eight masters "to his Altezza's pleasure," among whom were an armorer, a lathe worker, an inlayer, an illuminator, an embroiderer, and two instrumentalists.[91] The structure is similar to that in Florence in 1587 and at Ferrara in 1598.[92]

The only exceptional factor in the Estense case is the state of conservation of the primary sources, and I am convinced that an examination of the Aragonese and Sforzesque sources destroyed in World War II, of the Gonzaga's torn to bits in the early Ottocento, or those from Urbino dispersed after the Devolution of 1631, would have revealed analogous scenarios. I would hazard the hypothesis that the model functioned also in other contexts that have yet to be really examined, from the myriads of cardinal's courts to the dozens of dukedoms, counties, and marquisates along the Po (from San Secondo to Correggio, from Sabbioneta to Novellara, from Guastalla to Casale Monferrato), between Liguria and Tuscany (Massa, Piombino) or in the regions lying between Romagna and the Marches, and including the great fiefs of central Italy from Castro to Bracciano.

This hypothesis, however, brings back into discussion the negative judgment that chance has assigned to luxury and to the wastefulness of the Italian principates, which would have prejudiced the possibility of arriving at the accumulation of capital required by industrialization, according to one scheme that sees a contrast between the frivolous artisan uselessness of the elite economy of the courts and the serious industrial utility of the worst of mass markets.

And yet, in these paradigms many things do not add up. If it were so that the courts bled industrious bourgeois and wore out the productive structures by excessive fiscal draining, one could not explain either the crises that occurred in the abandoned cities (think of the destinies of Ferrara, Milan, Urbino, Camerino, Carpi, Rimini, Pesaro, Saluzzo, Forlì, Cesena, or Mantua) or the development of the centers in which new ones were established (from Parma to Modena, from Turin to Florence).

These thoughts do not concern just the relations between courts and capitals, but also the spheres of other kinds of relationships: a lively, exigent, and constant demand like this was able to accelerate the speed of monetary circulation and keep productive and logistic systems busy that were apparently too large for the states where they operated. But these mechanisms did not benefit only local and national economies, as they also sustained external centers. This is demonstrated by the great amount of purchases effected by the Estense emissaries in Florence, Lucca, Genoa, Bologna, Ancona, Senigallia, Naples, Lyon, Rome, and Venice and the relations with artisans, financiers, inventors, and merchants from the most disparate towns.

Without these centers of consumption inclined to such "foolish" spending, the distribution channels would not have existed, and the markets for a large part of the artisans' products and better manufactured items and the relative work markets would have suffered a sclerosis. One may not praise the virtues of producers and intermediaries without recognizing the role of their principal clients and appreciating the stimulus that the refined tastes and foresight of the court economic policies had on the country system. Artistic-sumptuary consumption, besides calling out individual talent, mobilized precious materials, precious fabrics, and metals that otherwise could be coined. Behind a commissioned chessboard, a closet, a clock, a miniature, or an elaborated table were years and years of labor, often of teams, a thorough knowledge of the materials and their statics and mechanics, a pronounced professional mobility, assiduous comparisons with the greatest international experts, the spread of secrets, and the carrying out of technological and scientific research. Nor must we forget the impact on commerce, whether in volume or type of exchange (consider the millions of sponges and shells imported to construct grottos, statues, and fountains, or the amber, ivories, stones, crystals, corals, feathers, mother-of-pearl, woods, lacquers, pigments that came from every corner of the earth) or for the promotion exercised on the furthest markets by the exportation of very desirable manufactures *all'italiana*.

The greatness and the strength of this economy of opulence do not lie only in the large Titianesque canvasses or the Michelangelesque paintings, but in the details of objects that very rarely pass in front of our distracted gaze. The sense of that economic model and the measure of its ability to act as the flywheel of development and prosperity reside instead in buttons and braided frogs, embroidery and trousseaus, busts and ruffs, low boots and mules, dog collars and falcons' hoods, keys and locks, bridles and suitcases, fire dogs and candle snuffers, orange squeezers and garden pots, hairpins and lipsticks, tennis racquets and fishing lines, bindings and watermarks, stamps and waxes, fortunate witnesses to a style whose value remains.

Supply and Labor Markets

Organizational Structure, Management Techniques, and Economic Impacts of Ducal Este Building Yards in the Cinquecento

THE POLITICS OF BUILDING

The importance of the economic and occupational impact of a broadened artistic demand became, I believe, clearly evident in the previous chapter. In the light of those considerations I intend to examine the question by looking at what happened in the architectural field, an artistic area that early modern economic historians of the last thirty years have investigated with increasing interest,[1] as one can deduce from the ample historiography so well examined by Alberto Grohmann in his contribution to the conference held at the Datini Institute of Prato in 2004[2] dedicated to the "Building Sector before the Industrial Revolution." Unlike the greater part of these studies, in this chapter I intend to concentrate above all on the construction labor market and the economic and occupational impact of building investments by investigating systems of selection and management of suppliers, the structure and evolutionary dynamic of the client networks, the impact on employment, and the politics of the pricing of goods and services produced and acquired by different Este courts in the course of the sixteenth century.[3]

To approach the question I have created and processed large prosopographical data bases,[4] analyzing almost 60,000 payments to individuals working in 730 sites, mostly in the district of Ferrara:[5] 47,119 were taken from the *Memoriali* and payment registers (*registri dei mandati*) kept by the officials of the ducal Office of Munitions and Construction (Munizioni e Fabbriche) during the years 1551, 1552, 1554, 1555, 1562, 1565, 1566, and 1576.[6] More than 1,200 of these are payments made in 1557 to the men working on the construction of Prince Alfonso d'Este, Marquis of Montecchio's, Casino,[7] and lastly, 10,988 are pertinent to the workers engaged in the construction of the Mesola complex between 1584 and 1590.[8] At the same time, to integrate the quantitative data, I scanned the usual sources for this kind of study: notary acts, contracts, agreements, papers, regulations, registers, various accounting documents, etc.

The decision to meld the more traditional methods with those of mass prosopography came out of the desire to examine questions that are otherwise not approachable, such as

the numbers of workers, an estimate of their annual income, the distribution of the projects in time, a calculation of their macroeconomic impact, the longevity of suppliers' relations, workers' careers, the politics of hiring and conditions of the labor market, the cycles of Cinquecentesque spending and their function in countering economic trends, etc. These are questions that have already been dealt with, but I want to look at them again over a shorter time-span and with more emphasis on the politics of building over the short or middle term rather than single building-yards, in order to test hypotheses and substantiate statements that would otherwise remain vague.

Discovery that in a city of 30,000 inhabitants the duke's constructions involved, in a solar year, 1,377 individuals (1562), or that only 5[9] of the 3,906 engaged by the Office of Munitions and Construction between 1551 and 1576 were paid at least once in each of these eight years, compared to the 2,859 (73 percent) paid in a single year, has been made possible by the use of a method that limits the risk of expressing imprecise opinions.

I don't intend to imitate the exact sciences or show useless statistical paraphernalia, but to contribute where I can to the collecting of measurements and numbers that will allow critical analysis of the data and aid in its interpretation. There are in fact cases in which the nature of the sources permits the prosopographic approach to ask fascinating questions that would otherwise be excluded.

The choice of years was dictated by specific requirements, starting with the half-decade 1551–1555, which was chosen for its relative normality: the aged and ill duke reigned (Ercole II died in 1558) over a pacified state that was, however, afflicted by a subsistence crisis between 1554 and 1555. The existence of homogeneous sources over a short span of time has permitted examination of a period with no exceptional events, unmarked by special projects and with a stable nucleus of ducal officials. The decision to work on such a short chronological period was born of the desire to study aspects that had been overlooked by traditional historical methods that generally concentrate on the life spans of single construction projects.[10]

The analysis of "building politics" means following it each and every minute, hour, and season to discover the *basso continuo* of the activity in a short enough period that at least part of the distorting factors inherent in looking at a medium to long period can be neutralized.

This perspective that appears to be microhistorical can furnish fecund indications and extend the perimeters of the phenomenon in hand—which in this case is not a few masterpieces but hundreds of projects of varying size, duration, scope, and complexity. There were ordinary maintenance and extraordinary projects, modest renovations and large constructions: drains and thermal baths, henhouses and *studioli,* the Saint Bernard dogs' reconstructed doghouse of 1552 and the handball court that was restored ten years later at the Paradise palace. And then, too, there were foundations and roofs, interiors and exteriors, civil and military architecture, talents like Marcantonio Pasi, Galasso Alghisi, Giovanni Battista Aleotti, Pirro Ligorio, and Terzo Terzi and picturesque laborers like the barrowman Antonio "Cleanbelly" and the worker Giovanni "from the Pearfields," the well-digger Domenico Bellagamba ("of the nice legs"), the porter Domenico Quattrocchi ("Four Eyes"), the mason Francesco Brazo Crudel ("Cruel Arm"), and wagoner Matteo Chillo "Senz'anima" ("Soulless").

These juxtapositions were entirely natural, falling in an atmosphere that could see, in the course of a single week, the cabinetmaker Bernardo di Verzilio working on a triumphal chariot and "fixing eight doghouses" (17–24 March 1576), the painter Ludovico Settevecchi busy with "work in the garden above the kitchen at Castle," and in "painting the merlons in the garden" as well as the fresco "in the rooms of Mr. Alessandro Mantovano at Castle"

(20–27 January 1562), the master mason Pietro Tristani occupied "in building wardrobes for Her Serene Highness, the rooms of Mrs. Lunarda in Court, a door in the Horse room, emptying a small furnace, inserting *occhi e guerzi* in Madama Leonora's room, making the windows of a dining room, painting the sacresty of the chapel, unloading bricks and stone, fixing a fireplace in Master Francesco Gobbo's rooms and a room and *camerino* in the wrestler's house" (16–23 February 1566).

I did not intend to contest proven hierarchies but if anything to try to encompass wholly the broad, variegated, and even commonplace in the executive arc of construction, which in the case of the dukes of Este—even though these considerations are valid for other cases, national and international—employed thousands of persons in very varying jobs and circumstances, and which I wished to place on a single analytic basis.

Master stonecutter Giovanni Maria Pellizzone, between 1551 and 1562, repaired marbles, measured stones, supplied stones of all kinds, and made dozens of balustrades, hundreds of stone and marble eagles, numerous cistern covers, the cornices of the Erculean gate in Modena and the new gate at Carpi, openings for oven doors, windowsills, little porphyry grinding stones, pedestals, pilasters, and bases in marble. His colleague Giovanni da Vento, in the course of 1562, was remunerated for having made "bases, frames and dovetails for various parts of the Castle, little stoves for the retorts, steps for windows for lord Ercole's lower rooms in Modena, stones *di tre teste e quadri,* a door entrance with his bricks" and for having cut "cornerstones, benches, windows, the edge of a sink for the secret kitchen at the Castle, an oven opening, small benches and seats, the pavement of the bucket room of San Taddeo in Court Vecchia, the tower of Belriguardo, the *selegatta* above the wall around the bathroom, the decoration of a tassel on the fireplace of brick, small well-springs for the bathroom, cornice brick to hide the merlons in the garden, shaped bricks, cartoons, round bricks, little squares, squares to place in the mill wheels, a chimney decoration of stone, a sink and a bucket holder in the pages' rooms," and so on.

In the same way, the majority of the workmen carried out an infinity of jobs with no discrimination or reduction: work was work, whether one was working on a masterpiece or making a proper septic tank. There were not only the major works, and the full, if relatively modest, calendar of routine operations provided good opportunities and many professional relationships. The practice of building at court continued daily and this constant translated into large volumes of activity, often overshadowed by the carefulness of the single job.

In this half-decade of relative normality (1551–1555) the only exceptional event whose collateral effects I wanted to gauge was the subsistence crisis that hit the duchy between the second half of 1554 and the end of 1555. The elevated fragmentation of the commissions in 1555 (70 percent of the 882 individuals paid at least once received in the course of the year less than 10 liras, the equivalent of about twenty working days), led me to conduct parallel controls, analyzing the payments in 1557 in the building of another Este court. I wished to understand if ducal building expenses could take on anticyclical connotations and what would be the role—not at all marginal—of the investments steered towards this sector from other courts of the Este family.

The choice fell on that of Don Alfonso, Marquis of Montecchio, half-brother of Duke Ercole II, the only Este particular court for which enough primary sources survive for my period and theme.

Somewhat surprisingly, the analysis of the material revealed the existence of an "Este labor market," within which diverse workers—penalized by the "political" parceling out of ducal

commissions—were compensated by earning sums from other princes and princesses of the blood decidedly superior to those that could be had from the duke's own building yards.

The same comparison has also permitted verification of the degree to which the ducal clientele coincided with that of the other branches of the House of Este: there was relatively little overlapping of the different networks, or perhaps one should say that the preferred suppliers of ducal functionaries did not receive the same treatment in all the courts in Ferrara. And finally, to ascertain the presence or absence of territorial payment standards, I have analyzed the orders from 1555–1556 for the ducal yard for the fortification of Carpi[11] in the study by Manuela Ghizzoni.[12]

The case for 1562 is different, it being the year that saw the twenty-nine-year-old Duke Alfonso II busy with an ambitious architectural project, and followed by the same officials who had earlier served his father who died in 1558. These are among the few survivors of the purge of 1559–1560 during which Alfonso II fired more than 180 courtiers, most of them inherited from his father.[13]

This year lent itself to the affirmation of two interesting hypotheses: the existence of a positive correlation between the size of the building investments and the dynastic cycles and the impact of succession on the composition of client networks, since the choice of many suppliers was delegated to officials whose nomination depended on the succession changes. If it is true that in the Este history during 1400–1500 rarely did one see such quick and heavy firings as those carried out by Alfonso II, usually the insertion of new officials carried with it changes in the supply system. However, Alfonso II did not let go the principal paternal officials: Galasso Alghisi, formerly architect to Duke Ercole II in 1558, remained in service to the son until 1568; Alessandro Rovinio, chief of artillery munitions, began in 1558 and remained until 1578; Giovanni Alfonso dal Corno, chief of the wood munitions, arrived in 1555 and disappeared in 1578; Filippo Dolcetti, official of munitions, began in 1559 and finished in 1585, while his colleague Tommaso Pancieri began in 1558 and finished in 1563.

Different yet is the case of the years 1565 and 1566. In 1565 Alfonso II married his second wife, Barbara Habsburg, and the wedding was embellished by a lavish program of events, mostly ephemera, whose economic weight I would like to consider. Of the 66,721 liras spent in 1565, more than 10,775 can be attributed to court festivals. This information, even if incidental, points out the weight of celebrations (weddings, funerals, nominations of bishops and conferrings of cardinalates, arrivals of important guests, visits from illustrious relatives or the celebrations against the Lutherans of which the last was held in the last ten days of December 1562) and underlines the suitability of extending the borders of historic-economic research into hitherto overlooked areas.

And finally, 1576 was chosen to ascertain the longevity of suppliers' relationships over a quarter century after I learned that the turnover rate in ten years was rather high: Only 154 of the 882 listed suppliers in 1555 were mentioned at least once among the 954 listed in the register of 1565, and of these only 47 appear among the recipients of vouchers in 1576.

This phenomenon confirms the high turnover rate of personnel, thanks to the contribution of factors extrinsic to the normal volatility of employment in the sector. My sense is that there was a desire to divide the commissions among a greater number of individuals in order to cover cases of political needs, inherent in the control of a nerve center of the Ferrarese labor market.

ORGANIZATIONAL STRUCTURES AND THE
FUNCTIONS OF THE COMPETENT OFFICES

After the method and the sources were identified, the question of organization remained. Even though there is no lack of fine studies about the organization of late medieval and modern[14] yards, I wanted to understand the logic and modes of functioning of the court offices—Munizioni e Fabbriche (Munitions and Buildings) and *Magistranze*—which in the sixteenth century governed the planning, management, administration, and control of building and workshop activities. This is an obligatory step given that the offices in question—in their size, area of activity, and resources managed as well as the consistency of the organization—may be compared to better-known entities such as the archbishop's *Mensa* in Milan, the Scrittoio delle Fabbriche in Florence, or the Reverend Fabbrica of Saint Peter's in Rome, where, as Fausto Piola Caselli reminds us, "Finishing the Dome in only 433 working days, about 1,000 workers laboured without interruption from July 1588 until May 1590."[15]

Nevertheless, the basic question is another. These data, even though the inevitably didactic nature may seem tedious, highlight the industrial nature of these activities, which involved a degree of complexity that required structures capable of presiding over the entire production line: from the supplying of raw materials to the delivery of the finished product, the production of bricks and unfinished pieces to the recruiting of the workforce and managing the shops and administration, from managing the cash flow to planning major projects.

Thus, before examining the day-to-day situation I wanted to understand the *architecture* of the system: the organization of the competent offices, their specific duties, the internal hierarchies, the levels of delegation, mechanisms of communication and decision making, and the administrative procedures and accounting methods, in order to verify to what degree it is comparable to similarly complex structures.[16]

By examining the papers of the officials and through a prosopographic analysis of the careers of nearly two hundred officials—carried out by scrutinizing the registers of the *bolletta dei salariati* and the *bolletta del soldo*—I obtained an initial perimeter of the field under investigation, which has permitted easier interpretation of the correspondence (having already determined the position, duties and powers of the correspondents) and gathering of information useful for the elaboration of the data. At this point, comparing the different sources, I have tried to reconstruct the structure of the office as well as its various appendages, beginning with the analysis of the spheres of competence.

These were rather broad, given that the Office of Munitions and Construction had managed construction (civil, religious, and military) in the city, in the Ferrara district, and in the territories since the late Quattrocento. It also coordinated land reclamation and water engineering, arranged for jousts, tourneys, *palii* (horse races), balls, plays, ball games, etc. and the celebrations of births, baptisms, weddings (wood for construction, artillery, saltpeter, at the Castle), and followed the naval activities (storage and maintenance of brigantines, galleys, boats, and bucentaurs), the construction of coaches and carriages and the Munizione del Ferro (where the artillery was founded and gunpowder was produced), and finally it governed the ovens in which bricks, lime, chalk, and glass were produced.

This was obviously an enormous office, headed by a pair of officers: the superior (or superintendent) of munitions and the ducal engineer (in the second half of the Cinquecento this title changed to architect),[17] who referred directly to the ducal general factors (ministers of

finance *ante litteram*). Directly under them were about thirty officers who coordinated (their duties were primarily administrative and managerial) the work of hundreds.

In fact, above and beyond construction workers, the Munitions and Construction office had to deal with supplies (often coming from the Este farms, woods and mines, the clay and sand, the lengths and bundles of wood to fire the ducal ovens making bricks, chalk, and lime), delivery (not all transport was covered by the boats in the ducal fleet), and lading operations, and coordination of the making of saltpeter, ironworks, and ovens.

The first two were entrusted to a *maestro di getto* (foundryman), who directed the production and storage of gunpowder in the powder house and the founding of the pieces of famous Este artillery, with the help of two or three carpenters, an equal number of blacksmiths, some foundry workers, and four or five day-workers.

Two *officers of the ovens* presided over the ovens for glass, chalk, and brick. While the glass-making oven was subcontracted for periods of five or nine years, and the contractors paid a monetary fee as well as supplying materials required by the ducal officers at a fixed price and at fixed intervals,[18] the ovens in Ferrara, Modena, and on some of the properties that produced brick and lime used for ducal construction were managed differently. Two officers of the ovens in fact coordinated the work of eight or nine kiln workers, often from Piacenza, Modena, or Mantua.[19] These men were businessmen–squad leaders who did not receive a fixed salary: they received congruent down payments,[20] but were in fact paid by "the body" and "the job." While specific agreements regulated the production of molded brick and unbaked roof tiles at 12 soldi the thousand throughout the Cinquecento, other contracts covered the costs of loading, baking, and emptying the ovens: The baking of the bricks cost 8 soldi the thousand, and the baking of lime a flat fee of 13 liras.[21] The porters and earth removers who were not part of the oven crews were, by contrast, paid by the day: the former received 6 soldi a day, the latter 5 a day.

Economically the office was very important, considering the resources involved (rarely less than 10,000 liras a year), the quantity and variety of production,[22] and the impact on the labor market. This explains the precision of the administrative devices used in its management, whose products were sometimes sold to third parties erecting buildings who were not members of the Este family.

For this reason the products and purchases of primary materials (clay, sand, and the large quantities of wood that came by ship to Ferrara from every part of the duchy) were kept in separate account books, as well as the quantities produced by every type of oven (reclassified by single oven), while consumption was charged to each project.

Finally there was the shipyard activity that the officials of Munitions and Construction managed through the marine office, which governed the numerous vessels in the ducal fleet. In the earliest inventory I found, written in 1511, there is in fact mention of thirty-six ships,[23] almost always governed by *paroni* (masters) at the head of salaried crews. Inside the marine office, sometimes called Ships and Boats, the management and administration was entrusted to the boat chief, who coordinated the work of the two boat officers, of the captains of the port of Ferrara, of the nocturnal Po port, of the port castle, and the chiefs of military, civil, and commercial boating.

The duties of the office of the Magistranze were of a slightly different tenor. It had been broken off from Munitions and Construction and made independent during the second decade of the Cinquecento, when it was put in the charge of the castle captain or *castellano,* an office that was sometimes in the hands of one of the two general factors. This official directed

two concierges and two to three keykeepers[24] who provided the concierge and key custody services for the court's buildings, as well as the gardeners, the keeper of the herb and botanic gardens, and lastly, the nucleus of *artifici* or *magistranze* constituted in the same period[25] and consisting of various specialized artisans:[26] a pair of carpenters, one or two blacksmith/ carpenters, a potter, a master and hand for the musical instruments, a turner, a stonecutter, a wood-carver, two or three armorers, and gunsmiths in charge of the ducal armory.

These were not simple artisans, as one may surmise, via a random check, from the analysis of the case of the armory. The persons responsible for the office followed the production of arms and armor, made expensive purchases, carried out administrative duties (marking the arms held by third parties and writing and updating the lists for taxation purposes), and kept thousands of pieces in various warehouses.[27] When Castle Vecchio went up in flames on 1 February 1554, "Five thousand arquebuses were burned in the duke's armory, as well as a great amount of plate and mail armor."[28]

The artisans of the Magistranze were not mere workers but rather experts, supervisors and coordinators of the activities carried out by the individuals who worked under their guidance in dozens and dozens of work sites. In the last two months of 1565, for example, there were fifty sites open at a single moment, frequently working the night through, as one can see from the many payments for nocturnal labor that was paid by the hour.

One must, then, consider those who worked as *magistranze* from a different point of view. Though personally engaged in interventions executed inside the ducal palace, they were more *managerial*—you will, I hope, excuse the term—than one might expect. The court blacksmith, in fact, far from being the muscle-bound reincarnation of Vulcan, spent more time checking the work of pieceworkers and external workers than he did with hammer and bellows: analysis of the 10,127 pay vouchers in 1562 shows that in twelve months fifty blacksmiths were paid at least once,[29] and to these must be added the helpers, workers, and strikers.

THE STATUS OF THE WORKERS: THEIR NUMBERS AND FORMS OF EMPLOYMENT

After having defined the nature of the organization and reconstructed the structure of authority, traced the lines of command, and singled out the key individuals, I concentrated on the workers' status and the numeric consistency and contractual formulas for the suppliers, for whom there were six categories.

The first three were those in the *salariati di bolletta,* the *stipendiati del soldo,* and some of the permanent workers in the offices coordinated by Munitions and Construction and the Magistranze, as I explained in the previous chapter. The conditions for the members of the fourth group were different: the suppliers of goods, services, and professional services engaged occasionally or with contracts inherent in specific transactions. Thousands of people, belonging to 103 different categories: forty were directly employed in construction activities,[30] nine in transport and lading,[31] and sixty-four provided materials, semifinished materials, finished materials, tools, and specialized services.[32] The borders of this universe were vast, and it did not include the existence of other specializations. Whereas Nicoletta Marconi noted that the stonecutters of the Reverend Fabbrica of Saint Peter's could be subdivided into rough cutters, squarers, polishers, grinders, chiselers, and sculptors,[33] analysis of the twelve categories of

merchants cited in the Ferrarese sources reveals the presence of hardware sales,[34] tin and lead, solder and objects made of brass and copper (heaters, shovels and pots, buckets); working tools;[35] tools made of wood;[36] combustibles like charcoal, pitch, and firewood; construction materials;[37] leather goods and animal and vegetable fats;[38] articles such as colors, glues, lacquers, brushes, pigments, enamels, solvents, sponges, and talcs; stone and lithic elements;[39] glassware; fabrics and notions;[40] cordage (canapa, strings, bags, brooms, tow and reed-matting); and paper, pencils, carton, and special papers.

The variety of types does not refer to modest local workers. Among the merchants are foreigners with businesses involving dizzying sums. In a single transaction on 19 January 1566, Giacomo Valverda from Verona disposed of merchandise worth more than 2,324 liras: 2,000 boards at 83 liras the hundred, fifty ladders at 8 liras each, seventeen rafters at 4 liras 10 soldi each, fifty-one *conventini* at 3 liras each, thirty-one *catene* (chains) at 18 soldi, and eighteen *antenne* (cranes) at 8 soldi. This sum is not far from the 1,607 liras taken in between 20 May 1551 and 20 October 1552 by his compatriot Sebastiano Lotti for the sale of boards, stairs, rafters, and construction wood, or from the 1,013 liras collected between 31 January and 16 February 1566 by Antonio Alberini, another Veronese wood merchant.

These numbers deserve attention because they underline the economic importance of the construction business, which was able to feed very large supply networks of a surprising variety:[41] far from being only labor intensive, they claimed the involvement of numerous artisans and many merchants. To estimate their weight I have bunched the incomes of the three principal supply groups: those involved in transport and lading, sellers of raw materials, tools, and other merchandise, and lastly the workers on the building sites. For the eight years studied, the first accounted for 9.5 percent, the second 28.5 percent, and the third 62 percent.

This final figure is overestimated, however, because many blacksmiths, carpenters, cabinetmakers, window makers, masons, and stonecutters supplied semifinished and finished goods as well as installation. Nevertheless, many of these pieces were produced by the same individuals in the days in which they were not on site, which is why one can estimate that 65 percent of the expenses of the ducal court supported labor-intensive activities (meaning transport and building work, generally), while 35 percent covered mere intermediation.

These estimates are consistent with those of other studies:[42] If Andrzé Wyrobisz revealed that in Quattrocento Venice the costs of building material and its transport amounted to almost double that of paying masons, carpenters, and stonecutters,[43] in the Vicenza case (1550–1556) studied by Howard Burns,[44] material and transport counted for 45 percent of costs, as opposed to the 55 percent of the work on site. In the yard of the ducal palace of Venice (1574–1577) studied by Isabella Cecchini, the salaries of workers, architects, professionals, and artists represented 44.3 percent of the total cost,[45] while Gabriella Sivori Porri has established that in the Seicento, in "Genoese building the overall cost of labor accounted for 35–40 percent . . . and the cost of materials the remaining 60–65 percent."[46]

These are not easy computations to make, nor are they entirely trustworthy.[47] Many individuals were paid for furnishing raw materials, semifinished, and finished pieces and for installing them, and it is not always easy to distinguish the compensation for the labor from the value of the installed, modified, or repaired goods. Looking, for example, at the nine payment orders between 10 and 31 January 1562 in favor of the stonecutter Ottavio Carobini, we see that on 10 January he received 8 liras 9 soldi 4 denari for "having given three pieces of unfinished stone to make a frame with two teals for the end of the snail stairway between the rooms of his Serene Highness," 4 liras for having "given two pieces of raw stone to cover the

walls of the room of the Old Court—pieces five feet square at 16 soldi the foot" and then 2 liras 8 soldi for the work to "finish the above mentioned stones."

On 16 January he received 4 liras for having "given a piece of unfinished stone in order to make a *preda da doza* for the center of the Castle courtyard," 8 liras 8 soldi for having "supplied material for the snail exit from the rooms of the Castle," and 5 liras 4 soldi for having "given a long stone needed to make the opening for an oven"; and finally on 31 January, he received 1 lira 4 soldi for having "given marble pieces for the work on the end of the snail staircase of the little rooms," 8 liras for "sandstone for diverse jobs to be done by Master Luciano di Ranzi sculptor for his Serene Highness," and 1 lira 16 soldi for having "paid for three workers to fix a part of the well in the Old Court."

This case has been chosen at random from thousands (in the same year Carobini was paid another seventy-eight times for similar reasons), which confirms the difficulty in separating the cost of raw materials, semifinished, and finished products from the payment for their installation, partial modification, or repair.

All the self-produced wares are exempt from this accounting: from the bricks from the duke's ovens (the consumption, but not the monetary value, can be reconstructed by reading the books of the office of the ovens) to the wood from the farms and woodlands belonging to the Este in the lower Po Valley, along the Adriatic shore and in the Appennines.[48]

Considering instead the suppliers of professional services, I have established the presence of at least three different types of organization and payment: the workers on the site, the pieceworkers paid by a set amount of money, and the subcontractors.[49]

The workers on site were recruited in spot engagements for medium- and short-term jobs; notary papers were rare and the contracts were drawn up only for more important projects. I do not believe that this is owing to the unavailability of ducal funds or to the lack of ability of those entrusted with the works; more simply it is due to the relationship between the costs of the jobs and the quantity of notary documents and costs of managing thousands of written documents, factors explaining the rarity of use of more formal contracts for this type of engagement. There were, indeed, three kinds of remuneration: by the *opera,* equal to a day's work and remunerated according to schemes that reveal notable variances even within a given professional group; by the *corpo,* when the pay covered the delivery of a product and its installation (independent of the time employed); and for the installation of material supplied by the purchaser, ending in the payment of each finished job, as happened with those who were involved in transportation or loading and unloading.

Recruitment was carried out by ducal officers, and it does not seem that there were engagements by auction or *incanto o stima,* as there were in Florence but not in Venice.[50] From that point of view, and underlining a certain nearness to Venetian usage, verification by retrieval of the names of the workers and the sites in which they worked shows that the maestri did not take on important new jobs before the one in hand was completed, even if I must still examine the existence of specific articles forbidding the accumulation of projects in the guild rules.

These limitations did not, however, inhibit the formation of wealth. In almost all the professional groups, I have come across individuals who worked more intensely and continuously than their competitors. One can deduce this from the volume of business of the blacksmiths Antonio and Francesco Goretti (the former between May 1551 and December 1552 took in 2,321 liras in 191 payments, the latter in the two-year period 1554–1555 received 2,300 liras from 556 orders); of the sawyer Giovanni Scaranaro, who between 1551 and 1566 was paid 2,244 liras for 426 orders; of the carpenter and cabinetmaker Giacomo

Datamara, who earned 3,241 from 469 orders between 1552 and 1555; of the stonecutter Giovanni da Vento, who took in 4,776 liras from 594 billings between 1551 and 1576; of the blacksmith Giovanni Maria Paoli, with his 1,854 liras from 228 orders in the single year 1576; of the porter Giovanni Pietro da Trento, holding the absolute record of 1,914 orders between 1551 and 1566 for a total of 2,387 liras; and of the Bolognese window maker Pirino Margotto, who earned 5,989 liras between 1551 and 1566 from 542 bills, or his compatriot Tusino, a carpenter who made 1,640 liras[51] between 1551 and 1562, from 914 jobs.

These sums are remarkable, if one considers only that between 1550 and 1570 the income of the duchy amounted to about 700,000 liras yearly.

Besides these fortunate workers however, there were thousands of people paid for shorter periods of time, or incapable of getting jobs with the same sort of continuity: From my prosopographic analysis it is clear that those paid at least once a year in 1551 numbered 564, 506 in 1552, 858 in 1554, 882 in 1955, 1,377 in 1562, 954 in 1565, 603 in 1566, 630 in 1576, right up to the 1,004 engaged at Mesola in 1584, the site that saw 852 individual workers in 1585 and 801 in 1586.

Noteworthy as they are, these numbers are underestimated. Given that those entered in the order books and *memoriali* were only the maestri and accompanying maestri, if there were any; in sum, those who would in fact receive payment. Since the maestri usually worked with a boy and a helper, the estimates should be doubled if they are to provide a more precise indication of effective employment.

There are similar problems involved in estimating the numbers who fell into the fifth category of suppliers: the pieceworkers paid by *somma*.[52] In some shops, in fact, different categories of worker were paid by the piece, when the job could be calculated in linear or surface measures, or the pieces or parts produced could be counted, a system that could be easily applied to the production of stairs, floors, windows, paving, internal walls, doors, decoration, moldings, paintings and bas-relief, and masonry.

The parameters for payment of piecework were agreed upon by the officers in charge and transcribed into special registers: from the foundation excavation paid by the squared measure to the erection of the walls paid on the basis of the thousands of bricks laid, from the construction of the dikes and digging of drains paid by the *pertica* (unit of measurement for length and surface) to the sawing of wood, which was paid by the foot. The system was rather detailed, as the "book of the current prices for taxed jobs," written in 1575, lists 630 different prices[53] just for carpentry jobs. Among the twenty-five fees relative to the construction of different types of windows, one discovers that "for double windows 4 by 6 feet, 12 soldi were due; framed windows 4 by 6 feet, 16 soldi; simple windows with their *reme* 4 by 6, 10 soldi; windows with two double parts, 4 by 6 feet, 10 soldi; framed windows in two simple parts at 15 soldi the part, 30 soldi; windows in two simple parts, 25 soldi; simple windows, 3 feet, 8 soldi; windows with two double parts with *stazoni*, 40 soldi; double windows with their *stazoni*, 7.5 feet by 4.5, 20 soldi; windows in four parts at 20 soldi the part, 80 soldi; windows with three-part frames each, 120 soldi," etc.[54]

The presence of such detailed definition must not come as a surprise. In the duchy's workshops the specialization of the artisans and the interdependence of the construction processes could be quite elevated, and in the projects a certain amount of piecework was useful in that it lightened the administrative load, off-loaded the responsibility of the quality of production onto subcontractors, and reduced turnover among the workers. This last was a delicate aspect since frequently materials and tools were left on-site unguarded, and were stolen.

Lastly there was the sixth category, that of the contractors who took unto themselves large projects. In 1488 the mason Nicola Fiorato enjoyed a credit of 1,840 liras "for having constructed at his own expense fifty-four pilasters and two heads . . . and two pieces of wall . . . and that is 379,000 bricks."[55] Almost a century later, in 1583, the three masons Giovanni Cagnone, Antonio Calegari, and Bernardino Burazzo contracted firmly to construct the ducal palace at Mesola "in the manner and form of the plan that Messer Marcantonio Pasi has shown them . . . to be about 33 feet, more or less, above the foundation "with four towers rising "about 14 feet above the palace's cornice."[56]

The three requested, and were granted, the maintenance of not more than twelve trowel maestri, payment of residual credit as soon as the palace was roofed, and payment for workers even if the work was finished after the deadline because of the paucity of raw materials or slowness of third parties. These passages illustrate just how important it is to study further in this field, as we are talking about colossal sums,[57] figures comparable to the most important construction entrepreneurs of the era:[58] We are far from the humdrum, everyday, sometimes miserable portrait provided by a certain vein of historiography.

MODES AND TIMES OF REMUNERATION AND PAY

Analysis of the modes and times of payment and examination of the whole business of suppliers has given some interesting notions, starting with the regularity with which payments were effected, according to observed midweek deadlines, easily distinguishable in the order and *memoriali* books, which report daily movements. In order to test the veracity of these affirmations I have reconstructed the monthly distribution of payments of the Office of Munitions and Construction in the years 1576–1580 and 1588–1594 (periods frequently judged harshly by historians critical of Duke Alfonso II's avidity) in order to monitor activity over long, continuous, and contiguous arcs of time; see table 11.

With the exception of the usual December closings, connected to the fiscal calendar and to the deadlines for pluriannual rental properties and contracts for customs and taxes, in the course of the other months the payment rhythm followed the ongoing work, with no brusque interruptions or sudden starts. It was the number of sites working and the volume of activity of each that determined the amount of monthly outlay, not the desire to control, procrastinate, or concentrate them in any special moment. In itself this is not surprising, since this praxis met the habitual needs typical of a sector in which foreign workers required timely advance and final payments. Nevertheless, the regularity of the payments also answered to imperatives of economic policy, since any irregularity could have prejudiced the use of expenses to counter crises. The possibility of increasing the speed with which money circulated and sustained the urban and local economy in fact depended on the capacity to stagger payments on at least a weekly basis in order to guarantee a constant uninterrupted flow. Given that the salaries of the builders were almost immediately recirculated into the economy in the form of purchases of primary goods and services, it was of capital importance to ensure regular emission, thus governing the function of the mechanisms transmitting wealth over the entire economic system.

But along with the regularity of pay periods came, by contrast, accentuated variances in salaries, variances that involved compensation to individuals belonging to single professional groups as well as compensation to single individuals. In fact, this in itself should not

Table 11. Monthly Distribution of Payments (in liras) of the Office of Munitions and Building in the Years 1576–1580 and 1588–1594

Month	1576	1577	1578	1579	1580	1588	1590	1591	1592	1594
January	4,708	5,866	1,596	7,702	7,288	2,863	5,572	4,349	7,360	8,198
February	1,533	849	5,616	18,307	9,385	10,631	2,289	4,305	4,546	4,134
March	4,732	2,584	6,041	15,501	6,050	9,512	8,886	7,661	10,732	14,808
April	6,703	1,030	4,796	9,638	7,599	10,565	7,124	4,588	5,480	7,364
May	15,940	10,769	7,353	5,989	4,468	12,417	2,258	3,127	6,749	8,500
June	2,467	1,201	7,549	1,484	9,274	7,754	4,652	14,156	6,974	13,125
July	4,047	3,746	8,390	13,855	12,214	14,302	9,089	9,551	8,726	12,444
August	3,252	9,201	11,001	4,180	7,721	11,815	2,867	6,021	9,348	7,854
September	3,684	2,193	10,578	13,634	10,209	9,066	2,218	1,333	9,083	4,049
October	4,174	11,416	7,224	4,919	15,152	10,321	3,664	7,863	4,300	352
November	6,757	6,162	8,109	9,327	8,087	14,346	7,699	4,462	7,841	12,714
December	6,757	19,019	20,415	15,232	9,985	17,075	6,252	16,333	14,378	11,227

Source: Elaboration of data contained on ASMO, CDE, LCD, nos. 443, 453, 459, 467, 473, 478, 483.

be surprising since, as Domenico Sella noted in his excellent work of 1968, the literature on construction salaries began as an almost detached sector of pricing history, and suffers from the same congenital defects. These studies have for the most part been carried out "with the same criteria that, in the past, have marked pricing history: elaboration of a historical series of data, measuring the variations in value over a given period: . . . of given quantities, presumably homogeneous, of goods and services, with of these and other values."[59] Out of this has come the construction of historical series over long and very long periods, frequently intended for comparison and anchored to a limited sample of primary goods (grains, butter, beer, or wine), which prices were usually converted into metallic equivalents (grams of gold or silver). The heterogenesis of the ends has sometimes induced scholars to omit or avoid deviations and anomalies, paying attention to the services, honorariums, and contexts that offered—or seemed to offer—greater guarantees of homogeneity and stability.

Unfortunately, this attitude has frustrated analysis of the formation of salaries and their internal variants, of the modes of fixing and negotiation of daily salaries, of daily and seasonal variations, of the contractual power of individuals and professional groups, of the techniques used in conducting negotiations, of the costs of transactions correlated to the processes of definition of honoraria, etc.

However, we are not dealing with erudite notes or capricious analytics but with the indexes that allow us to measure the maturity of the labor markets and their degree of sophistication, two questions at the center of my study. I have therefore concentrated on the variations registered on the individual and collective levels, after having ascertained that in the course of the twenty-five years in hand, there were no increases in remuneration parameters due to inflation. Examination of table 12, which gives the pay for a single day's work—otherwise known as *opera*—carried out by the various categories of maestri between 1551 and 1576 shows that they were paid in very different ways. In any given month or week a carpenter could earn 8 or 14 soldi per *opera,* a mason 7 or 12. The same held true for many professional groups, without, however, influencing the salaries of helpers, workers, manual laborers, and *compagni,* whose salary oscillations within their professional groups were practically nil, despite the results of other studies.[60]

The variants were remarkable since in some cases the differential between the lowest and highest daily pay was as much as or greater than 700 percent (porters), 500 percent (carpenters, cabinetmakers, masons, and wagoners), 400 percent (caulkers and sawyers), or 300 percent (stonecutters and inlayers). This is not a new discovery, since similar variations have been observed before,[61] even if the present picture lets us broaden the spectrum of analysis and generalize the weight of the phenomenon. In the case of the Este, the pay of some categories of workers—paradoxically, the more specialized—saw a lesser breadth of oscillation and a smaller number of pay levels (roofers, window makers, well diggers, and lathe workers), while such groups of unspecialized workers as wagoners and porters who enjoyed respectively 8 or 11 different payments per diem, even if this was still far from the 16 of carpenters/cabinetmakers or the 17 of sawyers.

But how can it be that a porter, a mason, or a sawyer could in one day earn seven, five, or four times what other porters, masons, or sawyers earned within the same week?

The answer is neither simple nor obvious, since one cannot impute this variety to lacunae in the sources or to carelessness on the part of the officers of the treasury. The 60,000 orders that I have seen were written up with great precision, and the writers almost always note the number of *opere* involved and the sum due for each of them. Thus one must look for other

Table 12. The Pay for a Single Day's Work, Carried Out by the Various Categories of Maestri between 1551 and 1576 (in Soldi and Denari of Liras Marchesane)

Category	*The pay for a single day's work* (opera) *in soldi and denari*
Caulkers	5 – 6 – 7 – 8 – 9 – 10 – 10.08 – 11 – 12 – 14 – 16 – 18 – 20
Wheelbarrow men	3 – 6 – 7 – 8 – 9 – 10 – 12 – 15
Roofers	6 – 7 – 8 – 9 – 10 – 11 – 12 – 14
Porters	2 – 4 – 6 – 7 – 8 – 9 – 10 – 11 – 12 – 14 – 15
Window makers	8 – 10 – 11 – 12
Inlayers	6 – 7 – 8 – 9 – 10 – 11 – 12 – 13 – 14 – 18
Blacksmiths	4 – 5 – 6 – 7 – 8 – 9 – 10 – 12 – 14
Carpenters	3 – 4 – 5 – 6 – 7 – 8 – 9 – 10 – 10.09 – 11 – 12 – 12.08 – 13 – 14 – 15 – 16
Masons	3 – 5 – 6 – 7 – 8 – 8.06 – 9 – 10 – 11 – 12 – 14 – 15
Well diggers	6 – 7 – 8 – 9 – 10 – 11 – 12
Sawyers	3.06 – 4.06 – 5 – 5.06 – 5.09 – 6 – 6.06 – 7 – 8 – 9 – 10 – 11 – 12 – 13 – 14 – 15
Stonecutters	5 – 6 – 7 – 7.04 – 8 – 9 – 10 – 11 – 12 – 13 – 14 – 15 – 18
Latheworkers	7 – 8 – 9 – 10 – 11 – 12

Source: Elaboration of the database "Munizione e Fabbriche 1551–1576," on http.guidoguerzoni. org. It is useful to remark that in twenty-five years the average wages of the masons did not grow: the highest values can be referred to wages paid in 1551; the lowest can be referred to wages paid in 1576.

possible explanations for the causes of a phenomenon that does not coincide with the presupposed homogeneity of salary levels assumed by some historians.

The differences could be ascribed to the influence of structural factors (seasonal variants, types of workshop, travel time to the site, age and experience of the maestri, makeup of the squads, fractioning of daily payment owing to interruptions, partial payment in kind, etc.) and economic trends (inflation, organizational changes, favoritism, personal relations, etc.).

In looking at the presence of possible seasonal variants, I have not found any significant correlation between the salary averages and the times of year. Any correlation would, logically, cause a sensible increase in pay in the spring and summer, given the longer workday, less probability of interruptions owing to bad weather, and the increase in workers' bargaining power because of the demand for field workers. And yet, examining the masons, one can see some cases analogous to that of Battista Ficino, who in June 1551, 1552, and 1554 received 8 and 9 soldi per *opera,* as opposed to the 8 and then 11 for those given in January 1552 and 1562. Likewise, looking over the 116 orders for Antonio Bianchetta between 1554 and 1576, we see that in the winter months he received 8, 9, 11, and 12 soldi per *opera,* and in the summer 8, 9, and 11. These are two randomly chosen cases that, however, demonstrate the substantial lack of seasonal influence; at most, the rains or other conditions that caused work to be suspended caused the payment to be emitted in fractions of *opera:*[62] but even in this case, the treasury officers specified the amount of the fraction (a job and a half, a job and a quarter, . . . and a third, etc.), without changing the absolute values of the entire *opera.*

One might suppose that the breadth of the salary spread was owing to the application of different politics from one yard to another or between zones in the duchy. However, examining the 729 building yards listed by the Este functionaries in the eight years of our period that differed in longevity, complexity, distance, typology of enterprise, and degree of interdependence in the working phases, I have not noted the presence of any anomaly. On a given site one finds maestri who although belonging to the same professional group received quite different remuneration and maestri who, according to the case, received each day sums that were equally variable. There were, however, no yards in which the workers systematically received, for the same work, sums greater or lesser than those of coworkers in other jobs, for any given specialization.

In this respect even the comparison by Manuela Ghizzoni of 5,638 pay vouchers written by the Este officers between 1555 and 1556 for the fortifications of Carpi has confirmed the presence of conditions, praxis, and measures nearly identical with those in Ferrara: at Carpi, too, the carpenters earned 6, 7, 8, 10, 12, or 14 soldi per *opera,* compared to the 6, 8, 10, 12, or 14 of the masons.[63] If anything, there were also, in the case of Carpi, the same differences between the average value of the *opera* given by maestri belonging to different professional groups as in the Ferrarese and Mesola yards.

These differences probably reflect the greater specialization of workers, their experience (construction workers started at eleven to twelve years of age), and the varying difficulties of the work; from the analysis of the averages in the eight years examined it emerges that the caulkers earned on average 10.3 soldi per *opera,* the roofers 9.5, carpenters 9.1, inlayers 8.7, turners 8.6, porters 8.5, wagoners 8.3, etc.

Similar considerations pertain also to the ages of the maestri (deducible from the lengths of their careers) and for the longevity of their working relationships, since I did not find any "prize for faithfulness" expressed in terms of differences in remuneration.

Favor meant larger numbers of engagements and a greater continuity in work relationships, but was not expressed in systematic salary differences accorded to the older and more assiduous suppliers. Examination of the variants present on the individual level corroborates this interpretation. The carpenter and cabinetmaker Tusino Bolognese, with 914 orders to his name between 1551 and 1562 for the 839 cases in which the sources report the amount paid per *opera,* earned 1 soldo once, 2 soldi once, 3 soldi 3 times, 5 soldi 79 times, 6 soldi 7 times, 7 soldi 8 times, 8 soldi 215 times, 8 soldi 10 denari twice, 9 soldi 168 times, 10 soldi 347 times, 10 soldi 8 denari once only, 10 soldi 9 denari once, 11 soldi twice, and 12 soldi on three occasions.

The prices of *opera* were probably less standardized than one might think, and the pricing depended on multiple factors that included the various degrees of difficulty and execution times of the projects.

These difficulties brought the need to engage persons of varying experience and capabilities, the use of more or less sophisticated instruments and machines, the employment of a greater number of work hours per *opera* when in a rush or if the relative phase imposed the speedy conclusion of the job, the enlistment of more helpers (separately paid, however) and the presence of other maestri, the assumption of greater responsibilities, the exercise of supervision and coordination, etc.

I am therefore convinced that it is important to throw light on these mechanisms, looking at the variants and deviations from the smooth and straight road of the average salary. The search for the norm and the mode of payment can lead one to overlook, or even obliterate,

the wealth, variety, and refinement of professions that may seem simple and repetitive at first glance. The range of work in which masons, stonecutters, carpenters, blacksmiths, and cabinetmakers could be involved was, and not only in the case of the Este, nearly limitless and each time required the definition of a fair price covering the value of applied knowledge, talent, and experience.

One can observe the effects of this phenomenon also on the dimensions and dynamics of the businesses of the suppliers, who show the same variety as does the payment of single workers. Standardizing the denominations of the building yards and the titles, names, surnames, and professions of those named on the payment orders, I have been able to arrange them alphabetically, verify the number of orders for each, the complete value of each, how many workers were paid at least once, and how many building yards were open (see in this regard table 13).

If one excepts the years 1565–1566, which were conditioned by the expenses for the wedding ceremony of Duke Alfonso II and Barbara Habsburg, one sees the variations in the absolute values of the expenses and in the number of individuals paid at least once, with a substantial constancy in the average value of the single payments, equal to 4.55 liras in 1551, 3.69 in 1552, 5.87 in 1554, 4.58 in 1555, and 4.35 in 1562, which was the year in which twice as many work-orders were written as in 1551; analogously the average number of workers per single building yard shows no radical changes, 7.2 in 1551, 6.8 in 1552, 8.8 in 1554, 9.9 in 1555, and 7.9 in 1566, and confirming the hypothesis that in the years of crisis (1554–1555) the commissions were more heavily fractioned.

THE BUSINESS: DIMENSIONS, DISTRIBUTION, AND EXPLANATORY FACTORS

But the numbers in themselves do not reveal the most interesting information: the distribution of business annually with its remarkable diversity. One can deduce this from reading the data in table 14, which illustrates the consistency of the suppliers, the dynamics of their careers, and the amount of annual business: three elements that let us understand the logic behind the assigning of commissions, the principles that inspired recruitment policies, and the influence of ducal payments on the suppliers' volume of business.

Table 13. The Activities of the Office of Munitions and Construction in the Years 1551, 1552, 1554, 1555, 1562, 1565, and 1566

	1551	*1552*	*1554*	*1555*	*1562*	*1565*	*1566*
Number of payment orders	5,557	4,386	7,802	8,299	10,134	5,013	2,514
Total expense in liras	25,264	16,197	45,772	37,970	44,066	66,721	42,565
Number of building yards/ cost centers	78	74	97	89	133	89	76
Number of workers paid at least once	564	506	858	882	1,377	954	603

Source: database "Munizione e Fabbriche 1551–1576" on www.guidoguerzoni.org.

Table 14. The Amount of Business Earned by Individuals Paid at Least Once in the Years 1551–76 (years 1551, 1552, 1554, 1555, 1562, 1565, 1566, and 1576)

Distribution of the amount of business earned by individuals paid at least once in the years 1551–76	Individuals	Percentage	Distribution of the amount of business earned by individuals paid at least once in the years 1551–76	Individuals	Percentage
0 ≤ 1 lira	843	21.902	700 ≤ 800 liras	9	0.234
1 ≤ 2 liras	479	12.445	800 ≤ 900 liras	9	0.234
2 ≤ 3 liras	347	9.015	900 ≤ 1,000 liras	7	0.182
3 ≤ 4 liras	193	5.014	1,000 ≤ 1,100 liras	7	0.182
4 ≤ 5 liras	159	4.131	1,100 ≤ 1,200 liras	4	0.104
5 ≤ 6 liras	114	2.962	1,200 ≤ 1,300 liras	5	0.13
6 ≤ 7 liras	96	2.494	1,300 ≤ 1,400 liras	1	0.026
7 ≤ 8 liras	115	2.988	1,400 ≤ 1,500 liras	4	0.104
8 ≤ 10 liras	139	3.611	1,500 ≤ 1,600 liras	4	0.104
10 ≤ 15 liras	265	6.885	1,600 ≤ 1,700 liras	7	0.182
15 ≤ 20 liras	151	3.923	1,700 ≤ 1,800 liras	2	0.052
20 ≤ 50 liras	379	9.847	2,000 ≤ 3,000 liras	12	0.312
50 ≤ 100 liras	194	5.04	3,000 ≤ 4,000 liras	8	0.208
100 ≤ 200 liras	133	3.455	4,000 ≤ 5,000 liras	6	0.156
200 ≤ 300 liras	59	1.533	5,000 ≤ 6,000 liras	3	0.078
300 ≤ 400 liras	38	0.987	6,000 ≤ 7,000 liras	3	0.078
400 ≤ 500 liras	27	0.701	9,000 ≤ 10,000 liras	3	0.078
500 ≤ 600 liras	16	0.416			
600 ≤ 700 liras	8	0.208	Total	3,849	100

Note: The previous data refer to 3,849 individuals out of 3,906 individuals who received payments at least once.
Source: The data of the latter are results of elaboration of the database "Munizioni e Fabbriche 1551–1576," in www.guidoguerzoni.org.

The most interesting element is to be found in the extreme fragmentation of the commissions. With the exception of a relatively small number of favorites, the ducal officers attempted to provide work, even if only a little, for everyone.

The factors that induce me to affirm this thesis are to be found not only in the numbers of individuals (2,135, or 55.46 percent of the 3,849 for whom it has been possible to calculate the volume)[64] who during this period earned less than 6 liras (equal to about fifteen workdays) but in the same distribution of suppliers by billing class, a distribution that clearly shows how many received really meager sums over the eight-year period, if it is true that 75.37 percent of the suppliers took in less than 20 liras, a sum equivalent to not quite fifty workdays.

This distribution logic answered to the combined presence of various factors, in part coincident with the effects of the engagement practices typical of the sector (short term and difficult to accumulate because of guilds' rules), in part deriving from the refined courtly demand (imposing the need for specialists), and from the results of a design of a political nature.

For the dukes, in fact, the first obligation—moral rather than economic—lay in the distribution of the commissions following criteria that I would not hesitate to brand political. From a simply economic point of view, and reasoning logically, it would have been more opportune to insist on using fewer suppliers capable of furnishing goods and services of equal quality and lower prices. This sort of decision would have reduced them to a minimal indispensable number, limited turnover, and favored long-term agreements tied to the lowest market prices.[65] Nevertheless, from a political point of view, it was important to give work to *almost everyone* so as to keep the client network alive with a healthy flow of favors and privileges. This concern explains both the large number of suppliers involved, despite the lack of economic advantage, and the large amount of turnover among the *favorites*; most of them, in fact, usually earned well for a couple of years and then disappeared or had only occasional commissions. If we look at the career longevity of the 3,849 persons above mentioned, we see that 2,625 worked in only one of the eight years, 616 in two, 286 in three, 169 in four, 88 in five, 36 in six, 24 in seven, and only 5 in all of the eight years.

However, we must not lose sight of the fact that the intent of these measures was to take in capital and relational rents, subdivided among the parties interested in the processes. While the large suppliers and cooperating officers divided the earnings, a cash *prize* could keep alive the hopes, obedience, and devotion of those temporarily excluded from this *unfair trade,* while the dukes conserved and increased their relational capital, preferring debts of gratitude to cash outlay, the "personal credit" to the financial debt. In this regard the Ferrarese lords—and like them, probably many other Italian princes and patrons—seemed to tolerate the presence of these tacit *residual rights* for the officers in charge of the administration of the house and the state. Aware of the political advantage of these small economic losses, these rights allowed the existence of sustainable levels of inefficiency, an inefficiency that was relative but never casual, ignored, or unrecognized. This was the price of maintaining, remunerating, and purchasing consent in a society dedicated to the cult of effectiveness. For this reason the processes were monitored continuously, thousands of data were recorded, dozens of notaries and accountants were kept busy conducting regular checks and controls, while rather strict norms and procedures were codified and circulated. The officers were so conscious of their rights and duties, of just how far they could—shall we say—personalize the management of their offices, that they succeeded in doing their own business without incurring the princes' displeasure.

All this took place within the formal framework; in fact, there were no arbitrary or radically different remuneration policies among the *cantieri*. On the contrary, the favors took the form of a greater number of commissions given by the officers to certain individuals,

quantities that allowed overpaying for some work or adding *opera* that did not appear in the more detailed accountings.

Accounting accuracy, in this sense, could have been useful to cover the frauds and swindling, not infrequent in the sector, which constituted one of the well-known unwritten rules. If Giuseppe Papagno and Marzio Romani calculated that in the construction of the Citadel of Parma (1589–1597), one-half of the 400,000 scudi expended by the Farnese was dispersed in thievery and fraud,[66] and according to Daniela Lamberini, the famous Antonio Giannetti, keeper of the forts and factotum to Cosimo I de' Medici for construction, was "as wily as a farmer and courtly as a minister, unctuous and servile with superiors, ambivalent with the architect, tough, astute and Spanishly inflexible with subalterns, continually looking to his own best interests, moving to hide his not infrequent excesses and embezzlings, ably greasing the wheels of his protectors. A typical product of his times . . . a portrait of the Cinquecentesque procurer, whether civil or military."[67]

Being aware of these risks, the dukes, in order to avoid the inconvenience of these arrangements, often rotated the officers in charge, and with these rotations came the substitution of the favored suppliers. In this regard, beyond the hypotheses of the physiological volatility of construction engagements, the high rate of turnover of suppliers can in part be explained as a by-product of policies meant to redistribute income, and in part as a consequence of the measures governing the turnover of purchasing and hiring officials. In this case, too, the principle of rotation of officers (and their related personal clients), ensured moments of glory for all the players over the long term.

In this respect the sum of compensation for building in the other Este courts was rather important, as it contributed to the support of a system that was almost too large for the city: In 1596 there were eighty-three master blacksmiths in the district of Ferrara[68]—a rather large quantity for a territory with about 40,000 inhabitants.

In order to underline the importance of the "aggregate Este demand," I have compared the names and volume of business of the ducal suppliers with those of the maestri engaged by Don Alfonso d'Este, Marquis of Montecchio, between 23 April and 6 September 1557 for the building of the Casino (see table 15). This comparison has revealed that many workers, on the annual and pluriennial basis, worked much more frequently for the minor courts than for the duke's: The blacksmith Antonio Lanzotto earned three times in four and a half months of work for the court of Don Alfonso, Marquis of Montecchio, what he had earned over three years of work for Duke Ercole II, and the mason Ludovico Tristano earned five times as much.

With the exception of the two near monopolies of Pirino Margotto and Giovanni da Vento, the majority of the workers who worked for Don Alfonso d'Este on a project lasting four and a half months earned more in these few weeks than they had in six years of career under the duke. Further, as I have noted in other studies on supply systems, the fact that some workers were engaged simultaneously with diverse courts does not mean that they always enjoyed the same kind of favorable treatment. The picture that emerges has denoted the presence of a highly independent clientele: more than half of the more than eighty masons, manual laborers, stonecutters, sawyers, blacksmiths, painters, and roofers who worked on the construction of the Casino of Don Alfonso were never called on again by the ducal functionaries in the preceding five years or the following nineteen. Keeping in mind that in these years in Ferrara there were a dozen courts, one may understand why the engagements by the particular courts to the workers overlooked by the duke's officers guaranteed a minimum of competition within the city and a possibility of work for a greater number of workers.

Table 15. Comparison between the Volume of Business (in liras, soldi, and denari) of the Ducal Suppliers (in six years of career) with that of the Maestri Engaged by Don Alfonso d'Este Marquis of Montecchio between 23 April and 6 September 1557 for the building of the Casino

Supplier	Qualification	Prince Don Alfonso	Duke Ercole II				Duke Alfonso II	
		1557	1551	1552	1554	1555	1562	1565
Alessandro Azzi	mason	39, 18, 00						
Alfonso Azzi	mason	63, 00, 08						
Gerolamo Bianchi	mason	26, 08, 00			2, 16, 00		29, 02, 00	31, 07, 00
Giulio Bianchi	carpenter	44, 07, 00						
Gerolamo Cervaliera	carpenter	31, 04, 00						
Gianantonio Cibolione	stonecutter	14, 08, 00						
Antonio Copricasa	roofer	9, 08, 00		2, 16, 00				
Bernardino Corgiola	carpenter	20, 06, 00			3, 08, 00	21, 10, 00		
Giacomo Corino	stonecutter	12, 00, 00	9, 00, 00					
Giovanni da Vento	stonecutter	32, 08, 06	87, 08, 00	19, 06, 03	2,062, 19, 04	232, 17, 04	1,011, 17, 03	524, 01, 09
Cesare Datamara	carpenter	4, 18, 00			3, 00, 00			
Bartolomeo Facino	painter	16, 04, 00						30,00,00
Antonio Lanzotto	carpenter	149, 16, 06	1, 00, 00		47, 10, 00		58, 19, 00	232, 14, 03
Marco Macapan	stonecutter	12, 00, 00						
Pirino Margotto	window-maker	61, 02, 00	364, 12, 11	106, 05, 08	1,067, 13, 01	851, 18, 03	1,015, 14, 07	2,014, 19, 04
Antonio Maria Marigella	mason	56, 04, 00					5, 05, 00	22, 04, 00
Ambrogio Morsaro	locksmith	57, 06, 00						
Gabriele Rosetto	carpenter	3, 08, 00				1, 16, 00	3, 00, 00	
Lionello Sbarbaio	painter	16, 04, 00						
Pietro Segatore	sawyer	13, 04, 00			25, 16, 07	6, 15, 10	8, 12, 00	6, 00, 00
Giovanni Maria Spampanino	mason	49, 07, 00	4, 01, 00		0, 08, 00	21, 14, 00	67, 04, 00	2, 08, 00
Antonio Tristano	mason	21, 00, 00					3, 06, 00	
Ludovico Tristano	mason	49, 17, 06	6, 08, 00	0, 09, 00		2, 05, 00	0, 08, 00	

Source: Concerning the volume of business of the suppliers who worked for Don Alfonso d'Este, Marquis of Montecchio, I elaborated more than 1.200 individual payment orders registered in ASMO, CDE, AP, no. 543, Compendio di tutta la spesa fata [mancante] fabrica del Ill.mo S.re don Alfonso da Este al [mancante], 1557–1558.

PRE-KEYNESIAN BRICKS: CYCLICAL FACTORS AND COUNTERCRISIS CHARACTERISTICS IN THE CINQUECENTO

In the *Discorsi di Scipione Ammirato sopra Cornelio Tacito,* published at Florence in 1594, there is an interesting passage in which the writer from Lecce affirms that "among the works of the princes, those considered greatest are cutting through hills to shorten roads, draining swamps to purify the air, large constructions, both holy and secular, because besides the reason for which they are built, they take away *otio,* the father of untruth and thievery, two great sicknesses of states."[69]

This explicit association of great interventions in the infrastructure, construction, and environment and the reduction of *otio*—meaning in this context forced un- or underemployment—is rather important. It in fact introduces an element that is not always taken into account in the analysis of architectonic choices, especially those that concern, besides the chosen site, the times of activation and mainly the dates of the works' beginning and phases of acceleration.[70]

The observations of Scipione Ammirato were not radical novelties. In 1588, in the translation of the *Six Books of a Republic* by Jean Bodin, the French treatise writer wrote a paragraph in which not only the benefits of public works and construction activities were clearly exalted, but even their redistributive functions were clearly described. In this regard he declared that "public revenues, obtained by legal taxation and capital, should be spent in part in the restoration of cities, reinforcement of fortresses, new constructions, frontiers, passages, bridges, fleets, edifying public buildings, founding colleges and schools. . . . activities that are the most useful for any republic, because the arts and craftsmen are sustained, the poverty of plebeians is comforted. The envy and the refusal of taxes are removed when the prince redistributes to the general public and in particular to his private subjects the money he has obtained from them."[71]

The last passage raises a question that in the same years was faced by other illustrious commentators. Giovanni Botero, who in 1588 published *Three Books on the Greatness of Cities,* in his *Ten Books on the Reason of State*, printed in Venice the following year, expressed similar opinions in the paragraph dedicated to magnific and honorable princely enterprises; they are, he stated, "also very engaging and important, and almost heroic, the works and honored enterprises of princes, and these are of two kinds, because some are civilian and others military. Among the civilian there are constructions that for their grandness or utility are marvellous . . . aqueducts, bridges over rivers or streams, improvements of marshy lands, and the streets . . . and channels, the hospitals, churches, monasteries, the cities," suggesting on the following page that it was preferable to avoid excessive taxation on subjects. In this regard, to keep them "happy and quiet, constructions . . . will be appropriate, since they will provide more utility, and common pleasure: these facts will relieve the fiscal burden, make pleasant the gravities and sweet the fatigues, because interest satisfies everybody."[72]

The chronology is not suspicious, but quite sincere. I do not believe that after the hard crisis that struck Italy in the late 1580s these opinions could be perceived as common encomiastic *topoi,* comparable with the passages concerning the most important Egyptian, Greek, and Roman constructions that could be found in the treatises about magnificence.

Those were times of change, and I am convinced that[73] the leaders of the sixteenth and seventeenth centuries were aware of the economic and occupational effects and of the possible countercrisis function of their investments in infrastructure and construction,[74] effects that are nicely described in Richard Goldthwaite's statement: "A palace represented employment for between 200 and 400 men for an entire year."[75]

In order to verify the good sense of this theory, I have reconstructed the historic series of income and outlay of the Este duchy's treasury, extrapolated the entries relative to construction in the broad sense, and compared each year's total of expenses with the sum of expenses sustained by the Office of Munitions and Construction (table 16).

Even knowing that payments increased and decreased and that from one year to the next this could happen without implying irregularities or deferments of payments, the increase registered both absolutely and in relation to building expenses in the Cinquecento is in plain view, a phenomenon determined by the action of variables of two distinct areas, both subject to types of cyclical change.

There was an ordinary building policy related to the various phases of the dynastic cycles; in this regard, beginning with the last quarter of the fifteenth century and in the sixteenth century and in the absence of serious difficulties (wars, political emergencies, extraordinary expenses, natural disasters like the earthquakes of 1570–1572, or flooding by the Po, etc.) in the first years of the new duke's government the expenses were relatively higher than those incurred in his more mature years (the exception—Alfonso II—will be explained shortly). Architecture is an important testing ground to measure the ambitions of new leaders, who undertook with greater speed and enthusiasm projects meant to transform the profile of the urban and suburban landscape, altering the design and arrangement of spaces and preexisting constructions. Once this first phase, whose length varied from house to house, was over, expenses tended to settle down to normal levels, and public, religious, and private residential construction works would be favored, along with maintenance (rooms, decorative cycles, passageways, service areas, restoration, garden works, floors, roofs, doors and frames, piping, wells, drains, sewers, etc.) and new small and medium-sized buildings, as well as ephemera.

Another phase of activity assumed extraordinary characteristics, again in its anticyclical and countercrisis effectiveness, as it concentrated on large projects of civil public architecture and private residences, massive interventions on urban and territorial defensive systems, important reclamations, and works of hydraulic engineering (restoring dikes, shoring up riverbanks, excavating under water, deviating and canalizing, etc.).

It is therefore possible that the beginnings of these more ambitious projects could be deferred or anticipated in response to economic or social concerns, since the points of major expense often coincided with moments of acute crisis. Perhaps this did not happen by chance, as one can see from the comparison of the Este expenses in the 1550s with those of the 1580s and 1590s, when the economy and all Italian society were hard hit by recurring subsistence crises, by health problems, by the opening of new markets, by the successes of northern European competitors, and by the loss of competitiveness and attractiveness on the part of some national productive sectors.

It could be mere coincidence, but beginning in 1585 in the Este duchy construction expenses grew markedly, doubling, tripling, and quintupling their own average part of the ducal finances, notwithstanding an even more sensible increase in the overall volume of income and outlay. These resources, however, were not invested in a small group of large projects, so I agree with Francesco Ceccarelli in his comment on Este affairs in the second half of the Cinquecento: "In Ferrara, as has been well illustrated, architectural production was not comparable to that expressed in the same period by other Italian centers of equal rank. Some of the more important initiatives remained in the planning or actuable embryonic stage; others never saw any qualitative results. The great ducal building projects, with some exceptions, would be outside the capital."[76]

However, I do not believe that the great patrons were only intent on imitating the excellent men of classical antiquity celebrating the patron's glory or disposed to ruin institutions, states,

Table 16. Historic Series of Income and Outlay of the Este Duchy's Treasury, Extrapolating the Entries Relative to Construction in the Broad Sense, and Comparing Each Year's Total of Expenses with the Sum of Expenses Sustained by the Office of Munitions and Building in the XVI Century (absolute and percentage values)

Year	Total outlay	Building expenditure	Percentage	Notes
1500	278,966	7,974	2.9	
1503	298,520	12,178	4.1	
1517	222,061	23,525	10.6	
1518	168,741	33,739	20	War + loss of Modena e Reggio
1521	309,805	37,663	12.2	War + loss of Modena e Reggio
1523	368,014	25,672	7	War+ loss of Modena e Reggio
1524	298,097	34,742	11.7	War + loss of Modena e Reggio
1527	413,730	20,465	4.9	War + loss of Modena e Reggio
1529	523,803	28,099	5.4	
1541	416,867	28,127	6.7	
1543	700,762	24,361	3.5	Payment for the fief of Carpi
1551		25,264		
1552		16,197		
1554		45,772		
1555		37,970		
1562		44,066		
1565		66,721		Wedding with Barbara Habsburg
1566		42,565		
1576	599,590	101,470	16.9	
1577	689,244	116,363	16.9	
1578	872,505	145,081	16.6	
1579	1,014,568	119,600	11.8	
1580	977,091	182,874	18.7	
1587	939,683	135,602	14.4	
1588	1,282,466	176,537	13.8	
1590	1,032,167	75,124	7.3	
1591	1,188,113	94,797	8	
1592	1,184,339	117,699	9.9	
1593		104,246		
1594	1,263,866	117,882	9.3	
1595		52,674		
1596	1,430,632	74,721	5.2	444,000 liras paid for the investiture

Note: The amount of outlay do not coincide exactly with those registered in tables 2 and 3 because the informative sources are different.

Source: The data of the latter are results of elaboration of the registries contained in ASMO, CDE, AP, no. 141; AC: Significati, no. 8; Munizioni e Fabbriche, nos. 113, 118, 124, 127, 145, 153, 157; e LCD, nos. 208, 259, 260, 276, 284, 290, 306, 312, 357, 363, 443, 453, 459, 467, 473, 478, 483 and 489.

and finances in order to celebrate their own magnificence. They were certainly aware of the lexicons of magnificence and magnanimity, as well as the fascination of *monumenta historiae*, but this would not make them less sensible to the problems of their own times or inattentive to the demands of their society, which every prince and head of family must satisfy to fulfill the moral obligations of his position.

Frequently, however, their decisions have been read as individual and/or celebrative, and the reasons for a project's being begun or blocked have found plausible explanations in the promptings of the classical model, in overweening personal ambition, in the desire to coagulate in the red of brick the noble blood of one's own line; rarely have external factors such as collective needs, requests of the local community, economic, health, or subsistence crises been considered. Yet Giuseppe Papagno and Marzio Romani have neatly underlined the nexus that was not at all casual, that united the food shortage and economic crisis that assailed the Farnese duchy at the beginning of the 1590s at the opening of a building yard that provided work for 3,000 people, emphasizing the fact that the governor of Parma on 12 February 1591 had begged Ranuccio Farnese to begin the construction in order to "support the poor people of the county."[77]

I do not believe that patronage was unilateral, deaf, and autocratic, not hearing other voices or arguments other than ambition, pride, pretentiousness, pomposity, and vanity. In this sense the considerations expressed about princely patronage could also pertain to municipal and ecclesiastic commissions, whose patrons, perhaps, did not overlook the benefits gained from their architectural and civic projects.

The building boom that occurred in many parts of Italy in the sixteenth and eighteenth centuries was one cause of the economic crisis, according to the model proposed for the late Middle Ages by Roberto Sabatino Lopez,[78] and yet a pre-Keynesian reply insisted on an ambient of intervention that included not only the great private and ecclesiastic buildings but also numerous public works.

Carlo Maria Cipolla, who was not notoriously fond of hyperbole, gave a precise response in 1981 when he observed that "examples of public works started in order to counteract bouts of unemployment are so abundant that there is only the difficulty of choice."[79]

This writer leans toward the second theory, even without examining the better-known cases. If in fact one reflects, to note an important but sometimes overlooked reality, on the interesting scheme drawn by Gabriella Sivori Porro for the Genoese situation, one sees trends that are perhaps not entirely casual. Not only is most construction activity in the years 1539–1540 (as Cipolla underlined) and 1580–1590s, the years of the end of the Italian wars and the beginning of the serious end of a century of crisis, but in the second half of the Cinquecento thirty-nine extra-urban villas were built as against thirteen in the first half, and in the last twenty years of the century forty-two churches, convents, and monasteries were constructed against the twenty-six of the earlier four score years, and then there were the great number of public works initiated beginning in 1581, streets, squares, civic seats, town walls and ramparts, aqueducts, ports and their docks, wharfs, etc.[80]

In this sense I am inclined to believe that the renewal of architectural patronage that took place in the post-Tridentine era, during which, according to Giovan Battista Armenini, "it seemed that all Christianity is competing to make very beautiful temples, chapels, and monasteries,"[81] took into account these aspects too and displayed extremely concrete forms of piety. Architecture brought work, earnings, dignity, and respect for God and gratitude for his ministers on earth, thanks to whose works in masonry and brick many of the faithful could, with some hard work, put food on their tables.

From this point of view the observations of Claudia Conforti on the major changes in the modes of production in the late Cinquecento ("It is known that Gregorio XIII (1572–1585) and even more, Sisto V (1585–1590) encouraged quantity and speed of work in architectural and civil works, and favored the subdivision of roles"[82]) confirm the validity of a hypothesis that merits more attention and further verification. When Ms. Conforti emphasizes that "in *cantiere* this option translates into the generalized adoption of piecework, of job contracts fractioned and assigned by auction,"[83] she singles out mechanisms that privilege the broadening of the base of recruitment of the workers and a growth in competition between individuals, crews, and businesses. But this scenario presumably required an increase in the number of qualified workers that, even though diminishing the quality of the product, favored the inclusion of less specialized workers and controlled salaries, typical measures of "public works" undertaken to counteract recession periods or keep a tolerable lid on unemployment.

MULTIPLYING EFFECTS AND POLITICAL ASPECTS OF CONSTRUCTION PROGRAMS

For the above reasons I am inclined to believe that the decisions taken in the architectural field were not always arrived at lightheartedly or quickly. They were too important and pregnant with consequences to be taken casually, especially when the decision makers were in the habit of applying rational criteria, foreseeing the implications of their every move, like good chess players.

According to this perspective the heavy increase in building expense that occurred during Alfonso II's reign (he became duke in 1559) was not the result of a plan dictated by the eccentricity of the inscrutable Ferrara lord. Interventions of this size could react to the dynamics of economic trends, and especially negative ones, in the short and long term. In fact, beyond multiplying the exchanges and accelerating the speed of monetary circulation, they also involved workers having no special qualifications, so that for a good part of the urban and extra-urban population the added income acted as a social buffer softening the harder blows of recessive spirals.

The anonymous author of the *Curious Records of the Florentine Plague of 1630* remembered immediately that Grand Duke Ferdinando II, in order to assist the population struck by the epidemic, ordered that "the facade of S. Maria del Fiore be begun and the building of Palazzo de' Pitti be concluded, to help many artisans and the masses. And since the peasants are the limbs of the state, even those were involved, making them excavate moats and drains for the use and embellishment of the city."[84]

To be able to measure the efficacy of this instrument of economic and social policy I have reconsidered the division of the outlay of the Office of Munitions and Construction and other offices connected to it (kilns, munitions of the Castello, and the great projects), which in the latter Cinquecento saw the delivery of goods (materials, raw materials, and various merchandise) and labor (including transportation) accounting for, respectively, 35 percent and 65 percent of the payments made. At this point I looked at the average remuneration of the different professional groups, their relative weights within the statistic sample being used, and the relation between the workdays of the maestri and those of boys, apprentices, and workers. The average is a little greater than 8 soldi 4 denari daily: such is the estimated daily pay of a theoretical—even if generic—worker in the ducal yards.

With this as a basis, out of every 1,000 liras of expense, 350 went to pay merchants, middlemen, and intermediaries, while the remaining 650 were used to remunerate 1,560 workdays.[85] Having hypothesized, according to the most classic of estimates, that in the construction sector a worker worked an average of 180–200 days yearly,[86] I have deduced that 1,560 days corresponded to full employment of eight maestri, to whom we should, of course, add the usual number of helpers and manual laborers.

Given that these are cautious estimates based on a rather broad sample, one can divine the countercrisis role of building expenses, since the 16,197 liras expended in 1552 corresponded to the full employment of 130 persons, the 116,363 of 1577 were equal to 930 full-time employees, and the 182,874 of 1580 to 1,460.

But the full employment of 1,460 workers, to which we must add hands and helpers, ensured the sustenance of at least 6,000–7,000 people, or a fifth of the town's population. This is a figure that obviously slightly overestimates the true incidence in the Ferrarese situation, since 78 of the 729 open building yards were located in other parts of the duchy[87] and a portion of the workers also came from afar to search for work. Nevertheless there were phenomena that counterbalanced the territorial dispersion of the benefits and reinforced the impact in the area of the initial investments.

In order to measure correctly the whole of the effects of the initial expense, we must in fact calculate also the value of that which economic literature on impact analysis generally refers to as indirect effects and induced effects. Among the former would be the summing of monetary values of the purchases of goods and services by suppliers of raw materials, materials, tools, and other merchandise. The merchants, artisans, and intermediaries who supplied the ducal offices and *cantieri* in fact spent in Ferrara and surrounding areas a part of their income to pay for transport and warehousing, lading, lodging, food, buying and selling of edible goods, various purchases, payment of customs and taxes, etc.

To this sum would then have to be added the effects deriving from the speedy reintroduction of a good part of the workers' salaries themselves into the economy; whether they were foreigners or residents in the Ferrarese district, the construction workers were consumers who worked on the short and very short term, spending daily for primary goods and services that caused a quick redistribution of income among local businessmen. But in order to satisfy the increase in demand, these latter were in turn forced to acquire a greater quantity of goods and services from third parties, thus causing a further multiplication effect on the consolidated outlay, an effect that in this case was usually only over the short term.

Finally one must also consider, in purely abstract terms, the so-called induced effects, or those tied to the increased income of the city's population, which in the majority of cases followed similar models of consumption, with a fixed demand in respect to the purchase of primary goods and services (rents, firewood, and foodstuffs) and flexible in respect to elective goods.

Paying attention to this particular aspect enables us to understand more easily the reasons for the punctuality of payment and for the rather reduced weight of the corvees and of unpaid jobs, two almost counterproductive measures from the point of view of economic policy.

The measure discussed in the preceding paragraph solidified into the implementation of a ducal *construction policy* that was different from those conceived and followed by other princes and princesses of the House of Este, by the aristocrats and patrician exponents more closely tied to the court circuits, the city of Ferrara, and the ecclesiastical bodies.

Even if the apparently casual use of the term "policy" could provoke some resistance, I

would like to note the usefulness and appropriateness of a root that synthetically expresses the ends and the questions that underlay these interventions much more that other more neutral terms such as "program" or "activity."

Architectural and engineering works, civil or military, permanent or ephemeral, did not answer only to the need to demonstrate spatially the aspirations and will of traditionally understood "policy," in its dynastic or personalistic manifestation. On the contrary, recent "political" rereading of many architectural projects,[88] rereading in which I recognize without hesitation the epistemic fecundity and cultural legitimacy, has paradoxically distanced historians from investigating the happenings before and during the transposition into spatially visible and tangible forms of hegemony, relationships of force, and propagandistic designs.

One could perhaps suggest a different rereading of maintenance and creation of consent. "Building policy" in fact found efficacious and concrete operative levers in the economic sphere of induced effects and in the control of occupation. Figures showing the number of employed, just like the modes of recruitment of the workforce and the ways of managing patronage, invite us to look at the question from another point of view, since consent and adherence to certain artistic, architectural, and cultural projects could also come out of direct participation in their realization. Thanks to these works, hundreds of thousands of people bound their destinies doubly to the destinies of the patrons, even though little has been said about these important choral masses.

And yet I think that in the surprising dimensions of the beneficiaries are hidden many answers to the questions proposed above. Transforming a possible element of financial weakness into a strong political lever, the great patrons became, in the eyes of thousands and thousands, not abstract rulers but *domini* in the real sense of the word. The devotion and respect of the less privileged classes was not founded on an abstract principle of being subjects, but was made concrete day after day in an effective subjecting, a real dependency: There were dukes, grand dukes, bishops, cardinals, and popes who put dinner on one's table and guaranteed a roof over one's head.

Thus there could be a real and not only ideological adherence to the messages evoked by the architectural programs. Architecture was not just an instrument for representing the values and symbols of politics, or an ancillary to celebratory strategies. It was in addition an instrument of politics *tout court,* in its capillary marking of the territory, urban and domestic spaces, control of the labor market, and governing of its interests, along with ordinary economic balances and imbalances.

Services

The Economy of the Feast and the Feast of the Economy—Some Thoughts on Ephemera

CONVERGENCES

In the last thirty years the scholars of art and architecture and theatrical and musical historians have often met on a common ground that concerns the machinery and apparatus constructed on the occasions of the so-called *ephemera*: banquets, carnivals, spectacles of all sorts, fireworks displays, weddings, funerals, triumphs, arrivals, possessions, processions, tournaments, jousts, palios, obstacle courses, *quintane* (quintains), water battles, balls, football and tennis matches, equestrian parades and military reviews, "sieges," and so on.

This step was important, marked by the continental schools (Italy[1] and France[2] in the first instance), but quickly taken up, in the wake of Roy Strong's[3] opportune text, by other Anglo-Saxon[4] scholars who have made a valid contribution in broadening horizons chronologically (after the Renaissance and Baroque, the ancient, medieval, and eighteenth- and nineteenth-century festivals), geographically (looking at events distant from the traditional Roman, Florentine, and Venetian[5] hunts), institutionally (examining lay and ecclesiastic, public and private[6] celebrations) with a good attention to themes like technical staging apparatus,[7] fireworks,[8] and edible sculpture.[9]

A scan of the book titles, articles, and exhibition catalogs from twenty or thirty years ago assures us that the coupled terms that occurred most frequently were always the same: art and politics, art and power, art and persuasion, art and propaganda, to note only the most popular ones.

Reading them, I have often had the impression that there was a desire to find a hidden political meaning in any given public event, and in every artistic creation the revelation of a will to hegemony, in every gesture the pursuit of an ulterior motive, in every word a cryptic allegory, and in every project a manipulatory design. I was equally struck, not forgetting that the first to take interest in these manifestations were the historians of the performing arts,[10] by the time needed for the theme to be noticed by art and architecture historians who had perhaps been suspicious of the transience of these events, almost as if the brevity of their existence postulated a lesser value, an occasional and distracted effort on the part of the planners and creators.

The *festa* after all, was meant to be a moment of abandon, a quick parenthesis in earthly labors, a suspension of and contrast to the principles of seriousness and dedication that

informed the conduct of those who were devotees of Art with a capital *A*, that which was destined to remain always before the eyes of humanity, the true ancient Aristotelian motto that things made to last are the most beautiful.

And yet those suppositions seemed to me to lack a foundation just as the prejudices lacked motivation: for a long period at least until mid-Ottocento, the varicolored, light, and frivolous universe of the ephemera was the center of an expenditure of energy, wealth, and attention that rivaled any applied to the works that opposed the destructive activity of Time. On the contrary, in various moments between the Cinque- and Settecento, the transient attracted even greater interest, which shows just how unjustified the historical disciplines were in dimissing the phenomenon critically.

PANEM ET CIRCENSES

In approaching ephemera, at least three questions made me curious. First of all, given the titanic dimensions and complexity of these undertakings, I wondered if those architects, literary men, poets, painters, and musicians who have excited so much of our admiration were hidden in the background. These were sophisticated choral productions, complete works of art skillfully created by specialists (for example the Roman *festaroli*) capable of coordinating hundreds and sometimes thousands of workers and suppliers, and often in possession of qualifications that should give pause to those who think the division of labor was developed only in the factories of the nineteenth century.

Considering the quantity of workers involved, the diversity of professions, and their degree of refinement, I wondered if so much magnificence could be based on unquestioned acquired rights or rapacious fiscal policy. After all, to take two examples: In Mantua more than three hundred people worked, even in night shifts, to build a *barriera* (barricade) for the 1591[11] carnival; while in Modena in 1635,[12] a tourney was set up using the same amount of personnel full time over some months, with the cooperation of thirty-five groups of workers. Thus one can understand why on the occasions of weddings, triumphs, or funerals the towns' guilds sent requests and memoranda to avoid calling in outside workers and expounding their own cause, given the amount of money expended for these affairs. As I examined the extant archival material I was increasingly impressed by the large number of individuals involved: Is it really possible that the bases of late Cinquecento and Seicento economy could have been based on such flimsy foundations, of which no trace other than the literary and iconographic has survived? Was it possible that an Italian city in mid-Seicento reserved 10 percent of its annual budget to finance a weeklong festival or that a reception or a banquet could cost thousands of ducats?

The answers are for the most part affirmative and there was also a constant increase between the Quattro- and Seicento: For the entry of Carlo V into Siena in May 1536, about 750 scudi were spent (the whitewashing of the Hapsburg lodgings cost 36 scudi, and Beccafumi's restoration of the gold horse set up in the square another 70).[13] In January 1564 the Medici correspondent Fabrizio Ferrari revealed that the Milanese governor in order to welcome Their Most Serene Ernst and Rudolph I von Hapsburg, passing through on their way to Spain, had forked over, in the space of only a few days, "36 thousand scudi, or about eight thousand for the masquerade and apparatus for the festa and merry-go-round, two thousand for furnishings, five hundred to Sr. Castellano di Milano for the salute in the castle."[14] These are

enormous sums: For the carnival concerts of 1560 the Duke of Ferrara, Alfonso II, budgeted 17,839 liras[15] (in a year in which the Este duchy income was not greater than 700,000), and this sum was to be outdone again by the 25,109 liras spent by his brother-in-law Vincenzo I Gonzaga for the *barriera,* the comedies, the *guintanade*, and the masquerades prepared for the 1591[16] carnival, and both were outshown by the 35,599 ducats estimated in the following century for the Venetian doge's galley parade.[17]

These squanderings set the example in a contest of raising the ante that invited the curiosity of many Italian courts and cities, always interested in knowing costs and comparing greatness: thus on 6 February 1607 Pietro Accolti wrote to Florence from Paris, recounting that the royal court was preparing "a very happy carnival because every evening there are either comedies or ballet in the palace . . . and the other evening Mons of Vendome organized a marvelous and remarkably expensive spectacle which cost him more that 10 thousand scudi . . . and they're going to be organized a most wonderful *barriera* to entertain the ladies as well as a naval battle that Mons. of Gullion wants to hold."[18]

In the face of this evidence, chosen at random from hundreds of examples like it, I cannot understand why so little attention was given to an initiative that mobilized unparalleled crowds, talents, and economic resources. In the face of the size, the heterogeneity, and the specialization of the workers and suppliers involved, and of their whirlwind of business, I do not think it is right to continue to insist almost exclusively on political functions or artistic and cultural developments.

I do not believe that the style of the propagandistic direction was enough to guarantee a lasting consensus over the course of centuries, nor am I convinced by the reductive literature of those who see a simple *renovatio* of the *panem et circenses* scheme exemplified by Giovanni Botero: "The populace is by its very nature unstable, desirous of novelty, and so if it is not held back by various means by its prince, it will look for it itself even through change in the state, and in government: thus all wise princes must introduce some popular amusements, in which, the more the virtues of spirit and body are excited, the more will it be appropriate," citing Greek and Roman exempla, Theodoric, king of the Goths, and "Matteo and Galeazzo Visconti in Milan; and Lorenzo, and Pietro de' Medici [who] in Florence, with various tourneys, jousts, & other similar inventions acquired the love and the goodwill of the people."[19] Above and beyond the attraction of the quotation, the political perspective is too limited if it does not include the economic effect and social implications of these undertakings. The level of enthusiastic participation by all social levels in these events and the consensus that they brought suggest that popular support could derive also from another form of participation correlated to the accompanying benefits.

These manifestations also underline the role, at least equal in financial and occupational terms, played by the provision of "services" and by the production of "ephemeral products" compared to the normally treated durable goods. Between 1588 and 1589, on the occasion of the entry into Florence of Christine of Lorraine, 110 liras were spent on placing "the capital letters of various sizes for the writings of the epitaphs under the stories of the apparatus of the triumphal arches,"[20] whereas for the Gonzaghesque *barriera* of 1591, 100 scudi were required—a sum that would have purchased a painting from a very good painter—to print 3,300 small images on paper of cupids, Venuses, Vulcan, the Cyclops, Death, the Muses, Apollo, Perseus, and Pallas (33 scudi) and to have a florist make "forty garlands for horsemen's prizes, and one for Apollo, nine for the Muses, four for the four seasons and flowers for the coiffures of the four young ladies called again to dance"[21] costing altogether 67 scudi.

Without falling into the trap of ingenuous materialism, one could say a few more words about the management mechanisms and accounting procedures, the intersectorial transfers of technical and technological knowledge, on the mobility of the workers or the development of organizational capabilities that have often been associated only with industry.

THE CAREFUL MANAGEMENT OF EXPENSES

It may seem paradoxical but it was the very transitory nature of these projects that required outstanding qualities of planning, management, administrative, and realization; it was one thing to work at the slow pace of the large building projects or with the renegotiable deadlines of the shops, and another to move and control workers, accountants, machinery, tools, animals, suppliers in small spaces and brief periods, or to solve in hours or minutes the most difficult problems. It was in fact necessary to find the most ingenious of technical solutions and at the same time deal with the many derivative problems of these enormous projects. In 1565 at Florence an octagonal theater fourteen meters high was built,[22] for the staging of *Il mondo festeggiante* given for Cosimo III de' Medici's marriage to Margherite of Orléans in 1661 Piero Tacca widened the amphitheater in the Boboli gardens so it could seat the 20,000,[23] who watched a production using 400 characters and preceded by an automa fifteen meters high. This represented an "Atlas with the world on his shoulders: it had a unique sound device and a mechanism that allowed it to move from the back to the center of the theater, and announce in a strong voice the descent of Hercules on earth to celebrate the couple."[24] And then there were cyclopic movements. For the party for the birth of the French Dauphin in 1662 in Rome "The entire Trinità dei Monti hill was transformed, including a chasm full of flames that were meant to suffocate the flying statue of Discord,"[25] and there are frequent descriptions of artificial mountains more than thirty meters high, deviations of watercourses (like the small Parma river for naumachies in the Pilotta theater), and of the flooding of squares and arenas (for example piazza Navona).

These projects were not simple: one had to provide for permissions and passes for the foreign artists and workers, reserve lodgings and contract fees with the eating places and hotels where they resided, pay the customs and taxes on the supplies, guarantee the daily accounting, make repeated checks (since in the tumult of things it was easy to lose control), ensure payments and keep an eye on cash flow, monitor the needs of primary materials, tools, and semifinished pieces and defend them from thievery, find substitutes and helpers, define the routes to be used by heavier machinery, manage the shifts and night work (the work was often carried out round the clock), guarantee safety for the public and workers on the site, etc. These were not easy jobs, given that the mechanisms and instruments for communication, decision, and control were subject to easily imaginable pressures, given the tight schedule, centrality of the work sites, the protests of residents and shopkeepers, the undesired presence of parasites and goldbricks in search of work or illicit profits, and so on.

To deal with these problems, the managers tried out quite sophisticated administrative and procedural solutions, as one may gather from the standardization of supplies, the use of very detailed accounting systems, frequent inspections, planning of purchases, and valuations of estimates down to the price of transferal of the transactions between the different offices or the magistracy.

Obviously I will not go into all these aspects even if I intend to underline that these realizations were not at all based on fantastic Pindaric digressions. The culture of ephemera was based on a solid, worldly, and busy culture of doing, because under normal conditions not even a nail would be wasted. That which might seem to be a joke of dubious taste has found confirmation in my readings of the accounting documentation for some Cinque- and Seicentesque ephemera, the centuries of the most open squanderings. If one examines, for example, one of the reports of the expenses sustained in Florence in 1565 for the wedding of Francesco de' Medici and Giovanna of Austria, relative to the materials and tools given to painters, sculptors, and woodworkers, the accuracy of the accounts that daily monitored the assignment of dozens and dozens of items to each worker is very clear.[26] Similarly, for the tournament in Modena in 1679 to celebrate Cesare d'Este Junior, the various expenses were kept separate by keeping various notebooks even for the different uses of ironware, whose data can be seen in table 17. The 111 items have been taken from a screening of the transcriptions of the accountants following the project in which, it is well to remember, the acquisition of ironware represented 10 percent of the entire cost, as one may infer from reading table 18, which reclassifies the costs by categories indicated by the Modenese administrators.

The 123,760 nails and three hammers, the 152,600 *broche* (pins), and the two *taglie fer-rate* (ironshod planks) are there as reminders to us just how unfounded are our suspicions of a lack of seriousness in the management of these projects, while the 5,896 liras earned by the *pennacchieri* (plume makers) or the 4,411 that went to the embroiderers underline the breadth and articulation of supplying networks. It was such that, in order to manage it, specific task forces and extraordinary accounting instruments were often called into play.

One need simply leaf through any account book for a banquet to understand just how minute and analytic the notes can be for these exorbitant expenses: scanning some Venetian registers, if for the "refreshment for the occasion of the Most Serene Princes of Savoy begun on 21 April 1608" 3,675 ducats[27] were spent, and for the "Most Excellent Sir Pomponio Bellieure Ambassador Extraordinary of the Most Christian King in 1635" were spent 13,305.[28] The attention paid to woodwork, colors, and nails was identical to that to victuals, accurately classified. In the ledger of 1635 there are ten quite detailed items listed.[29] In the twenty pages set aside for expenses for "spices, conserves, sugar, wax, almond, and *scaleter*" were noted the daily purchases (with all the unit costs) of articles such as "*muschiado* sugar, confected fennel, citron water, marzapane paste, boxes of cinnamon or dressed lettuce," and among the fruits were listed ten varieties of pear: "*cacoli, moscatoni, ruzeni, chiossi, zuccoli, cedrini, berganti, quagia* pears for cakes and cooking."

PRODUCTION OF ENTERTAINMENT

Beyond precision in accounting, there was a high level of standardization of procedures used to determine the prices of items supplied, the wages of the workers, and the honorariums of the artists. Because the work was carried out elbow to elbow, day in, day out, there was no tolerance for slow contracting or obvious disparities in pay scales or in the agreements with the intermediaries working in the same sorts of merchandise. This explains the attention paid to standardization of prices, meals, lodgings, shipping, transportation, and the specifics of raw materials, jobs, and tools.

Table 17. Uses of Ironware for the Tournament in 1679

Material	Quantity	Material	Quantity	Material	Quantity
Planks	7,656	Basin	1	Mutton leather with hair	12
Sewing needles	36	Thin rope with three strands	688 L	Jointed planks	157
Needles for mallet	1,000	Filing rope	108 L	Big jointed planks	4
Needles for sack	20	Ordinary rope	635 L	Cutting stones	16,567
Door rings	1,765	Strained rope	2,217 L	Lead	4 L
Big rings	32	Small ferules	14,052	Pulley bearings	12
Planks	435	Ferules	2,067 L	Hooks	17 L
Bark planks	108	Iron stair supports	2	Riparelle	27
Small beech planks	280	Iron for small torches	164	Fur cuttings	616 L
Reinforced planks	384	Metal–strip iron for buckets	7 L	Axles for wheels	3
Big walnut planks	11	Iron for jointed stairs	24 L	Saltaleone, mess-tin	6
Rods	62	Rolled iron	37.5 L	Small hatchets	10
Hammer handles	101 L	Double buckles	50	Selavini	28,400
Beech handles	24	Big buckles	1	Locks	5
Shovels	18	Wire	966 L	Compasses	382 B
Tin bands	893	Venice strand	97 L	String	65 L
Bezzole	659	Shirt rag	32 L	Belts	53
Bronze bushings	24	Gavolli e razze	11	Screw spurs	10
Spiral bushings	48	Grapelle da lancia	52	Iron brackets	2
Main beams	25	Guerzi da punta	2	Stirrups	683

Material	Quantity	Material	Quantity	Material	Quantity
Hempen cords	75 L	Laces	306 L	Tin	115 L
Pins	152,600	Lances	35	Tow	389 L
Small tins for lamps	300	Brasses	20	Cloths for stuccos	684 L
Bells	6	Various woods	56	Mats	470
Wooden pails	4,758	Iron alloys	1,643 L	Iron traps	2
Architraves	36	Big lamps	422	Traps	133
Wooden pins	178	Hand held lamps	1,225	Hempen cloth	2,509 B
Pulley rims	301	Hammers	3	Oil-cloth	35 B
Wheel rims	5	Iron rings	19	*Tempioni*	328
Wooden rims	6 F	Elm-wood	8	Pliers	1
Walnut rims	148	*Orbesi grossi*	6	Traces	2
Chiaponi	70	Fuses	2	Small beams	403
Nails	123,760	Bones for lanterns	12	Small beams	2,464
Cighignole da dozza	4	Whale bone	70	Big beams	441
Belt	23 B	High quality brass	1.4 L	Cow leather	20 L
Bronze pulleys	41	Steel pans	4	Tin vases for oil	3
Lighting springs	9	Small copper shovels with iron handle	9.7 L	Javelins	37

Legend: L = libbre (0.345137kg); B = braccia (0.673600m); F = fasci (bunches).
Source: Elaboration of data contained in ASMO, Archivio per materie, Spettacoli pubblici, busta 9A, Torneo Cesare Junior 1679, *Squarzetto de ferramenta, 1679.*

Table 18. Reclassified Costs by Categories Sustained for the Tournament in 1679

Cost items	Liras	Soldi
Wool and silk drapes/cloths, spun and beaten gold and silver, tinsel, silk, gold and silver leather	26,129	15
Hardware and bronze pulleys	11,499	12
Various woods	11,170	5
Strings, cloths, floats, tows	5,404	
Iron vases, maces, darts, spears, daggers, musket barrels, "*zacchi*", berets, shoes, low boots, cudgels and "*grupole*"	1,854	3
Oilcloths, leather cuttings, rugs, button moulds	853	4
Colors, talc, gold, paper, carton	4,164	16
Wax and tallow candels	3,045	12
Reed-matting, clay vases, coal, belts	778	12
Stones	372	14
Painters, sculptors, carvers, engravers, copiers	8,708	15
Embroiderers	4,411	
Gilders	2,820	15
Plume makers	5,896	9
Tailors	1,535	14
Workers, carpenters, sawyers, masons, pavers, blacksmiths, pelterers, dyers, wagoners	20,238	18
Stable boy in Parma	3,052	16
TOTAL	110,683	

Source: Elaboration of data contained on ASMO, Archivio per materie, Spettacoli pubblici, busta 9A, Torneo Cesare Junior 1679, *Quaderni diversi, 1679.*

It may seem incredible that those monuments to fantasy could rise from works wherein order and precision reigned and deadlines were respected, even if frantically and with very little leeway, because these projects were managed in a military rhythm and style, in a constant battle against the clock. The letters that the engineers, architects, and overseers wrote daily to their patrons spoke incessantly of the work's progress and the ability—or feared incapacity—to honor the agreements, often bound by fixed deadlines, as with religious and patron-saint holidays, the funerals, birthdays, or arrivals of special guests. For this reason, considering the very short times, the most feared events were interruptions of work, lack of raw materials, a lack of man- and brainpower. At the moment of celebrating the rites of abundance where exaggeration, festivity, the cornucopia, the Cockaigne, and enjoyment became charged with clear symbolic meanings, poverty, want, and scarcity would have been experienced as a mourning, auguring ill. These things did happen, as one can see from the desperation with which project directors greeted thunderstorms and tempests, hail and snow, windstorms and sudden fires, explosions and breakdowns that could ruin the results of months of hard work in only a few moments.

MASS AND POWER: A METHODOLOGICAL PROPOSAL

If one were to credit the opinions of the more hostile treatise writers, one could only deprecate the full holiday calendar of the Cinquecento and especially the Sei- and Settecento, indicated in the polemics on poverty as the principal cause of the desperation and inactivity pervading Italian society at that time. And yet, seen from another point of view, that mad dance was a motor that with industrial rhythm redistributed income and enlivened the economic picture. As Daniel Roche has noted, "The Christian may not and must not serve two patrons; the accumulation of goods is not an end. But wealth exists, and inequality of luck is legitimate and unarguable. In the same way, the conciliation of the world and the need to be saved presuppose the existence of redistribution to guarantee earthly and spiritual retribution both present and future. Luxury, which includes artistic and sumptuary expenses, is a legitimate use of wealth, but it is inferior in quality to charity. It is a means, not an end. Holistic economy, from which modern economy will break, admits waste, which takes its place in a system in which two principles regulate economic and social equilibrium, contemporarily and contradictorily: exchange and gift."[30]

The holiday, the waste, the immoral aristocratic and clerical *dépense* stoked the fires of bourgeois accumulation and mitigated the wounds of the indigent, celebrating the solemn rite of redistribution of wealth among the various urban classes. This happened not only by means of alms-giving (the throwing of coins or foodstuffs to the plebeians reevokes the imperial *congiaria,*[31] the orgy of pigs, goats, and cattle torn to bits by the hungry crowds, the fountains that spout wine into the toothless mouths of the populace) but by means of a very thickly woven network of economic and clientele relationships whose analysis has been entirely obliterated, squashed between the cult of the directors and protagonists and compassion for the unhappy condition of the great part of the public.

Again the concentration on geniuses, alone and indomitable, has pushed critics to ignore the fate of the masses that worked under their inspired watch. For these reasons, wishing to give a face and name to those who were involved and provide a first, even though rough,

estimate of their numbers, I decided to try a prosopographic approach, used in many studies of economic and institutional history, but never, as far as I know, in studies of ephemera, despite the possibilities that it offers.

The decision came from the conviction that studies on artistic and architectural patronage, and especially those concerning projects that involved hundreds or thousands, cannot subtract themselves from the undelayable joining, compromising as it may be, of quality and quantity, of individual biography and collective *epopeé* since "prosopography allows . . . the combination of political history of men and the 'events' with the 'anonymous' social history of long-term evolutions, in order to study the individuals that are the basis of both,"[32] even if prosopography as "social history of institutions" has been "a road rarely followed by Italian historians."[33]

Prosopography is almost an obligatory approach since, as François Autrand had already pointed out in 1981 in an article in *De l'histoire de l'État à la prosopographie*,[34] the history of institutions coincides with that of its members and "only a better understanding of the participants can lead us to a better appreciation of the functioning success or failure of medieval or early modern institutions."[35]

These solutions can cause, for some, intolerably painful losses of details; but the more ambitious the aim and the larger the mass of documentation, the more essential it is to assume a historically far-sighted view, as this history so far has been infected with myopia. We know every last detail of the existences of men of letters, musicians, dancers, and scenographers even of third and fourth rank, and we know a lot about their preparatory drawings, *libretti*, prints, single poems or the music the singer used on a particular occasion, but often we are ignorant of how many collaborators there were, where they came from, what they knew, how they had been hired and with what duties and privileges, etc.

It is thus necessary to try to know all, and I mean all, of those who worked, from the first of the architects to the least of the barrow men, to revive the impetus of a project that must include the entire universe of workers, of interpreters and suppliers of goods and services (a notion that allows the inclusion of the army of musicians, singers, actors, and comedians who participated: In the "festival of the pig" at Bologna in 1672 there were at least 150 characters on stage and dozens and dozens of workers in the three *back-stages*)[36] and not just single persons or specific subgroups. This should occur even when great names are in play: Leonardo did the apparatus for the entrance of Isabelle of Aragon into Milan in 1489, Pontormo, Andrea del Sarto, and Rosso Fiorentino in 1515 prepared the decorations for Leone X's visit to Florence, Vasari directed the entries of the spouses of the first Tuscan dukes, the welcome for Henry III in Venice in 1574 was organized by Palladio and Tintoretto, while the arrival of Pope Clement VII in Bologna was followed by Guido Reni.[37]

Behind the prodigies of art history, of the theater, of music and literature there were unknown thousands, a further reason for covering the entire range of their positions, qualifications, professions, and roles, and drawing up a "collective biography" to embrace all the various types who participated in the production.

It is a necessary act because their numbers were indeed extraordinary and almost always the sources underestimate the reality. For example, the books for the Mantuan carnival in 1591 hold more than a hundred single orders, but each order could hide large groups of people. If Messer Cesare the embroiderer was paid "to cover the expense of seventeen people who worked on the embroidery for twelve days,"[38] other payments were made out to "Cesare Finati et al., Stefano de lisi carpenter et al., Bernardino Martinelli *bracento* and others."[39] Etc.

The orders do reveal an interesting scenario: between 17 and 25 February 1591 the carver Cesare Finati coordinated a squad of twenty-one members,[40] the master tailor Cesare, to sew fabric and upholstry, was aided by seven women (Lucia, Lavinia, Angela, Laura, Francesca, Margarita, and Catenena),[41] the lathe worker Giovanni da Noda was helped by twelve colleagues, the *brazente* Francesco Florio by twenty, etc.

Likewise in Florence, while for the apparatus of 1565, fourteen painters and seventeen sculptors were named,[42] for the entry of 1589 more than ninety painters were engaged,[43] a number that lets us imagine the whole number of participants, given the work of various groups of specialists.

To describe this phenomenon there is no better instrument than a prosopographic register: It lacks exact chronological references or minute biographical details, but is able to give information about the general aspect and baselines. One must only make one's choices and assume responsibility, since prosopographic approaches include sensible differences, based on the gap that separates the interpretation of prosopography as mere "investigation of the common background characteristic of a group of actors in history by means of a collective study of their lives,"[44] from that proposed by Neithard Bulst, which coincides with a clear separation of prosopography as "collection et relevé de toutes les personnes d'un cercle de vie délimité dans le temps et dan l'espace" and a *historische Personenforschung*, which presents itself as "la mise en valeur des données prosopographiques sous des aspects divers de l'interprétation historique"; with the former "subordonnée à la Personenforschung et la précède ce qui en conséquence la rend indépendante de la Personenforschung et la classifie en science auxiliaire," so much that "si dans la suite nous employons le terme prosopographique nous entendons par là—contrairement à sa signification en allemand—la combination entre Prosopographie et Personenforschung."[45]

The results of this approach have been interesting, even if there have been difficulties in planning the architecture of the system, in the codification of data, standardization of data, in resolving cases of homonymy and the formulation of hypotheses about missing facts. For the setting up of a single device in Modena in 1635, the expenses in the eight months from 19 January to 27 September were 43,177 liras 4 soldi, a sum equal to 4 percent of the state budget, and involving at least 220 people. The sum of workers is underestimated because it does not include those paid by crew chiefs or the workers paid *forfait* (on 3 February, 437 liras were paid "to the workers on the cover for the square," between 10 and 16 March 397 liras were paid out to generic workers, while on 18 June, 2,576 went to "the architect, with painters from Ferrara, Bologna, Scandiano, bombardiers and carpenters") or the groups who appeared to carry out quick and precise jobs like "the nine Christian tailors who helped to sew the cloths" and were paid on 9 June, the "nine Jews who worked on the emeralds," paid on 9 April, or the "fourteen painters and gilders from Ferrara" paid on 14 April.[46] Also noteworthy was the amount of the sums earned: The *magnani* (locksmiths) Giovanni Battista Morelli and Francesco Vellani received respectively 393 and 361 liras, the rope merchant Luciano Molinelli, almost 363, the founder Anchise Censori 552, the innkeeper at the Posta Antonio Berti 294, and so forth.[47] Without denying that the world of the festival required the presence of serious *loisir* professionals, more attention should be given to the multitudes of porters, wagoners, quarriers, excavators, water carriers, masons, blacksmiths, turners, carpenters, sawyers, painters, decorators, stucco workers, tailors, embroiderers, garland makers, shopkeepers, accountants, fireworks experts, cooks, and apothecaries who permitted the protagonists to carry out their assigned roles. Thousands of fates of which little or nothing has been written: a fact that by itself should tweak the interest of future generations of historians.

THE SPREAD OF TECHNICAL KNOWLEDGE AND
OF TECHNOLOGICAL INNOVATIONS

There has been an equally surprising silence concerning the drive caused by the dissemination of technical knowledge and technologies, which far from being ephemera like the objects of their attention, consolidated engineering, architectonic, and scientific knowledge inside processes whose collective dimensions did not regard just their fruition, but also and especially the phases of planning and realization. Nevertheless, despite the points that the question could suggest to historians of economics and technology, anyone who would like to consult a bibliography or find basic information about the magicians of stucchi or waxworks, geniuses of papier-mâché and virtuosos of lighting, the plumbers specialized in playful waterworks, the fireworks men capable of shooting off smoky images of vases, eagles, clocks, and swords,[48] or the makers of ice, sugar, butter, and marzipan sculptures, would have a hard time finding any information, given that there are few writings, and these are frequently of an anecdotal type that does not do justice to the subject.

And yet these workers are emblematic since their experiences show many affinities with those of contemporary technicians. They had notions of mechanics, optics, chemistry, and physics (from statics to the science of materials) refined through tough apprenticeships to architects, machinists, and engineers[49] and by the reading of learned treatises.

It is enough to leaf through the volumes printed between Cinque- and Settecento on the secrets of scenery making or to look at the preparatory sketches for a fireworks show or a naumachia to realize just how technically wealthy and technologically advanced this professional ambient was. The machines for the apotheosis constructed by Vigarani in 1662 for the spectacles at the Tuileries were able to hold more than one hundred heavily attired characters suspended in air.[50] To lift many tons seventy feet into the air, fill enormous squares with water, simulate thunder, storms, and explosions or illuminate like daylight the facades of monumental buildings were not child's play, not to speak of the knowledge needed to manage the scenic machinery made up of gears, pulleys, and lifting mechanisms placed in small areas or anyway limited spatially.

Unfortunately these contributions are still underestimated: the study of the relations between art, technique, and technology has concentrated mostly on construction techniques and on material used in painting, sculpture, and architecture without further investigating the relations that some artistic production maintained with chemistry, mechanics, and physics. And yet, in some cases, the contacts between these worlds—apparently distant—were closer than one might think, given that the average competence needed to design a water mill, a pumping system, or a mechanism able to draw particularly heavy weights was used in the making of the *macchine da fuoco* (fireworks) and the stage machinery to move very heavy ships and wagons or to make divine chariots, angels, fates, cupids, and schools of cherubim fly. In some cases, even, the technological performances were an integral part of the ephemeral event, as when on the Grand Canal in front of Ca' Foscari on the occasion of Henry III's visit, a floating furnace was set up and fully illuminated at night so that the French sovereign could admire the maestri from Murano engaged in the blowing of glass animals and *imprese* of every kind, size, and color.[51]

Hybrid and refined capabilities were necessary to carry out these projects, and the Italian passion for these events cultivated and spread them, creating a job market that was at least macroregional[52] in this country at mid-Cinquecento, wherein entrepreneurs, agents, and

technicians moved around constantly according to the demand of the most varied patrons, who often called them all over Europe and beyond. With the more famous architects and engineers who, like Vigarani, Mauro, and the Bibiena emigrated from Italy, there was a small army of collaborators[53] flattered by the invitations of the most important continental courts and attracted by the credit that those forms of art had acquired among foreign observers. They were fascinated by the work of these obscure specialists[54] and pleased to take home the prints that the Italian patrons—aware of the communication effected by these gifts—distributed liberally to their more important guests.[55]

It was not just exaggerated local pride that enlivened the pleasure with which the Medicean resident Cosimo Baroncelli described in his letter of 22 April 1605 to Curzio Picchena the great surprise of the people of Antwerp at the grandiose festival organized by Giovanni de' Medici on his relative Alessandro's rise to the pontificate: "And so yesterday evening with the aid of this city there were lights for everything and it made such a superb and lovely scene, that these people were no less surprised than satisfied by the six large barrels of wine that were given to the populace. There was a large castle of fireworks with many rockets and whirligigs all around, that displayed great taste and a most delightful show, while there was also the sound of drums and trumpets and their echo continually up until the very end, and all windows of the houses were full of very attractive lanterns and there was also music of various wind instruments and at the foot of the machinery. . . . And in sum the festival was so successful that the Flemish allowed that they had never seen anything like it in their country."[56]

"FAST GOODS": SOME DEBTS OF GRATITUDE

Besides the knowledge and very refined know-how, there was another level of awareness that I can only outline here, even if it is witness to the usefulness of this kind of study. Masses of individuals were busy every day with thousands of tools of the most bizarre shapes and uses, almost always designed and invented for use on that particular job, and supported the birth of an extraordinarily rich material culture of which unfortunately no trace has remained. Equally, the need to limit the weights, encumbrances, and costs of structures that were to be erected, dismantled, and carefully taken away as they were frequently recycled,[57] encouraged the invention of techniques and production that would have an impact on more durable products. Consider, for example the success of the productions that imitated the use of more precious and costly materials such as imitation marbles and woods, gilding, silver-plating and metalizing, the fake precious stones, prints on fabric, painted tapestries, the trompe-l'oeil, plaster, stucco and papier-mâché sculptures and arms of leather, paper, tin and cardboard. These solutions migrated into many popular artistic productions, into the building projects and interior decorating, exploiting the capacities developed in these ambients to create low-cost imitations that could fool the cleverest eyes. The same follows for the massive use of less noble and more easily worked materials like wax, tin, copper and brass, lacquers, glass paste and coral, enamels, paper, cardboard, and papier-mâché that made a determinative contribution to the differentiation and enrichment of the productive range of various categories of domestic goods that are near relatives to many contemporary objects.

Giorgio da Castelfranco, called Giorgione, *The Liberal and Mechanical Arts*, Italy, Castelfranco Veneto, Casa Pellizzari, 1500–1505

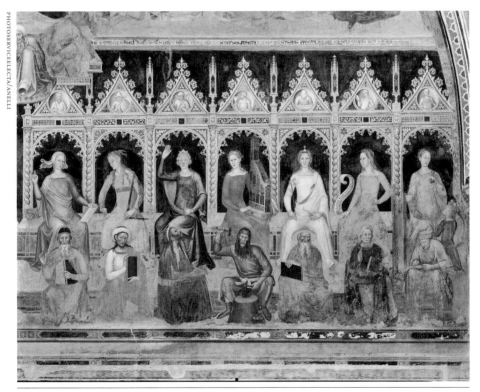

Andrea Bonaiuti, called Andrea da Firenze, *The Seven Liberal Arts*, Italy, Florence, Basilica di Santa Maria Novella, Chapel of the Spaniards, 1365–1367

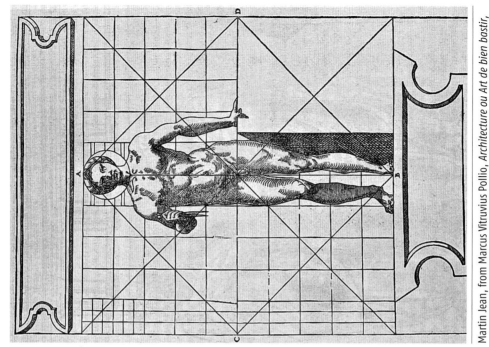

Martin Jean, from Marcus Vitruvius Pollio, *Architecture ou Art de bien bastir, de Marc Vitruve Pollion, mis de latin en francoys par Ian Martin, Paris 1547* (detail), Italy, Rome, Bibliotheca Hertziana, 1547

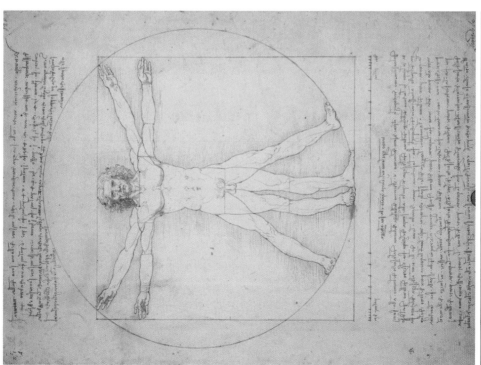

Leonardo da Vinci, *Vitruvian Man (the proportions of the human body according to Vitruvius)*, Italy, Venice, Gallerie dell'Accademia, 1490

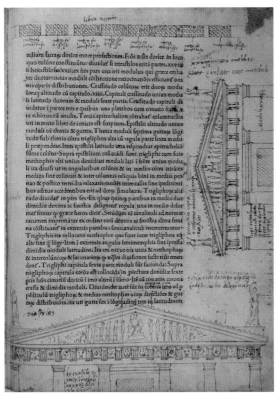

Marcus Vitruvius Pollio, drawing by Giovan Battista da Sangallo, *De architectura*, Italy, Rome, Palazzo Corsini, Biblioteca dell'Accademia dei Lincei, first half XVI century

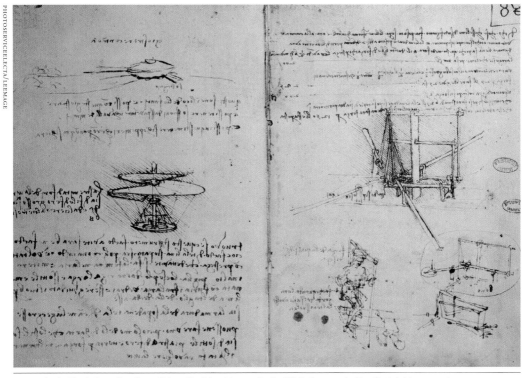

Leonardo da Vinci, *Drawing for a Flying Machine*, France, Paris, Bibliotheque de l'Institut de France, 1487

Antonio Benci, called Antonio del Pollaiolo, *Silver Cross* (detail), Italy, Florence, Museo dell'Opera del Duomo, 1457–1459

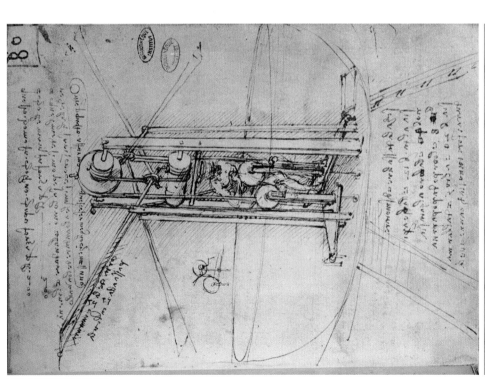

Leonardo da Vinci, *Drawing for a Flying Machine*, France, Paris, Bibliotheque de l'Institut de France, 1487

Antonio Benci, called Antonio del Pollaiolo, *Silver Bas-Relief*, Italy, Florence, Museo dell'Opera del Duomo, 1477–1480

Giorgio Vasari, *Le Vite de' più eccellenti architetti, pittori, et scultori italiani, da Cimabue insino a' tempi nostri*, Florence, 1550 (first edition)

Artist unknown, *Portrait of Tiberio Tinelli* (1587–1638), c. 1675

Luca Giordano, *Self Portrait*, Italy, Naples, Pinacoteca del Pio Monte della Misericordia, 1691–1692

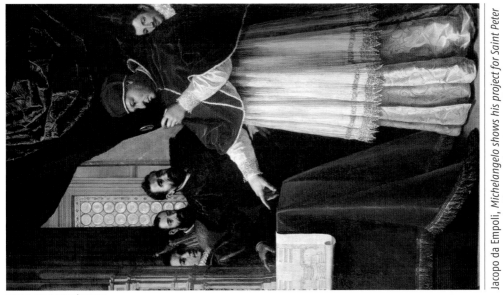

Jacopo da Empoli, *Michelangelo shows his project for Saint Peter to Pope Leo X*, Italy, Florence, Casa Buonarroti

Leonardo da Vinci, *Portrait of Isabella d'Este*, France, Paris, Musée du Louvre, Cabinet des dessins, 1500

Agnolo di Cosimo di Mariano, called il Bronzino, *Cosimo I*, Italy, Turin, Galleria Sabauda, 1555

Giorgio Vasari, *Cosimo I Returns from Exile*, Italy, Florence, Palazzo Vecchio, 1563–1565

Artist unknown, *Portrait of Lucretia Borgia*, engraving XIX century

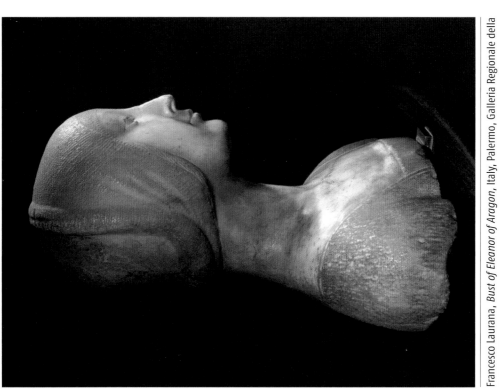

Francesco Laurana, *Bust of Eleanor of Aragon*, Italy, Palermo, Galleria Regionale della Sicilia, 1468

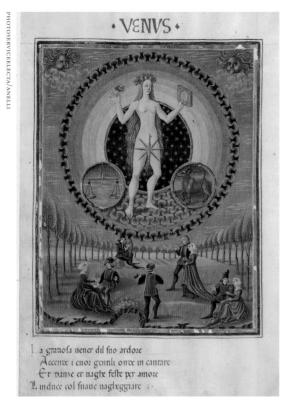

La granofa uener dil fuo ardore
Accende i cuoz gentili once in cantare
Er vanze er vaghe fefte per amore
E induce col fuaue vagheggiare ·.

Cristoforo De Predis, *De Sphaera Mundi: Venus*, Italy, Modena, Biblioteca Estense, 1470–1480

Giovanni Karcher, *Emblem of Tapestry of San Maurelio* (detail), Italy, Ferrara, Museo della Cattedrale, 1553

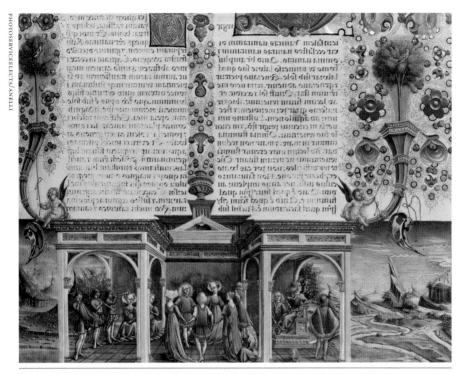

Taddeo Crivelli, *Borso's Bible*, Italy, Modena, Biblioteca Estense, 1455–1461

Giovanni Karcher, *Tapestry of San Maurelio* (detail),
Italy, Ferrara, Museo della Cattedrale, 1553

Giovanni Fontanesi, *View of Villa d'Este at Tivoli*, Italy, Modena, Galleria Estense, 1840

Giovanni Paolo Pannini, *Silvio Valenti Gonzaga's gallery*, France, Marseille, Musée des Beaux, Arts, 1740

Antonio Canova, *Portrait of Pope Pius VII*, Italy, Rome, Promoteca Capitolina, 1804–1807

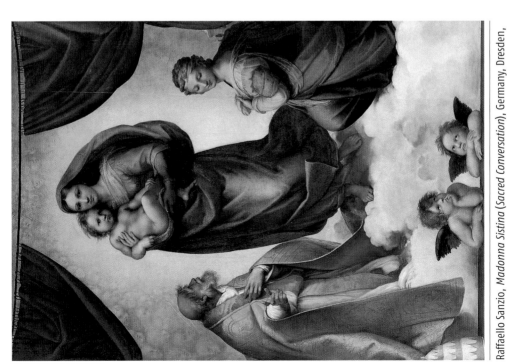

Raffaello Sanzio, *Madonna Sistina (Sacred Conversation)*, Germany, Dresden, Gemäldegalerie, 1513–1514

Doge's Palace, Venice (external view), 1340–1419

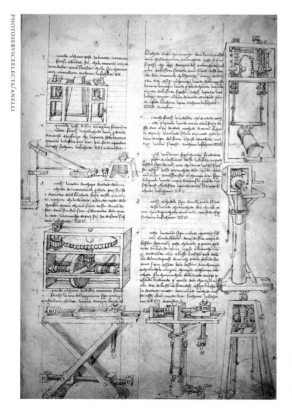

Francesco di Giorgio Martini, *Trattato di architettura, ingegneria e arte militare*, Italy, Florence, Biblioteca Medicea Laurenziana, 1480–82

TRATTATO
DELL'ARTE
DE LA PITTVRA,
DI GIO. PAOLO LOMAZZO
MILANESE PITTORE.

Diuiso in sette libri.

Ne' quali si contiene tutta la Theorica, &
la prattica d'essa pittura.

CON PRIVILEGIO.

IN MILANO.
Appresso Paolo Gottardo Pontio, l'Anno 1584.
Con licentia de' Superiori.

Giovanni Paolo Lomazzo, *Trattato dell'arte de la pittura*,
Italy, Milan, Biblioteca Trivulziana, 1584

CAPITAL AND LABOUR.

R. J. Hamerton, *Capital and Labour*, "Punch Magazine," vol. 5, July–Dec, London 1843, p. 49, cartoon
no. 5, 1843

Prices
Known Facts and Unresolved Problems

THE PRICE QUESTION: ORIGIN AND DEVELOPMENTS

Dealing with the formation of prices of artworks and luxury goods is not simple given that price history boasts a past of a size and quality great enough to frighten anyone, since for almost half a century it constituted a nearly autonomous sector, and then become one of the principal areas of economic research. On the other hand, as Earl J. Hamilton wrote in 1944, "The prices of commodities and wages of labor recorded in contemporaneous account books are the oldest continuous objective economic data in existence," and economic historians "have not neglected this great intellectual resource."[1] Nevertheless, despite the quantity of studies there remain some congenital defects that have marked the rise, and in alternating phases, the declines and revivals. Reviewing the genesis of the phenomenon, one realizes that the impulse to collate and elaborate prices was not dictated by the desire to understand the logic, politics, and forms of pricing, but rather by the intention to construct long- and very long-term series anchored to baskets of basic goods (grains, beer, or wine)—whose prices were usually converted into their metallic equivalents (grams of gold or silver) in order to make comparisons. These attitudes explain the lack of interest in the more complex models of consumption, the formation of prices of unique and rare goods, and their variations in the short term on the part of generations of scholars. Ruggero Romano's observation of 1966 is in fact still valid: "We know very little about the short- and even less about the very short-term movements,"[2] and not very much about the modalities of fixing and negotiation, of the behavior of different social groups, of the making of deals, costs of sales transactions, etc.

ART OF THE MARKET, MARKET PRICES?

Recent studies on the activities of artists' workshops and art dealers have brought to light the importance of serial production of standardized products of low or middling-low quality, often sold by more or less specialized middlemen who interrupted the relationship between buyers and producers, sometimes causing consistent price rises.[3] The studies of Gérard Labrot on serial paintings, of Paolo Coen on calcographic laboratories, of Susanne Kubersky-Piredda on devotional images, of Rita Maria Comanducci on tabernacles and painted plaster figures,

of Arne Flaten on medals, Bernard Aikema on tapestries, Marta Ajmar on majolica, Andrew Blume and Michelle O'Malley on altarpieces, Bruno Santi on glazed sculpture, Marco Spallanzani on majolica and carpets, Alessandro Guidotti on plaster casts, furnishings, and decorative paintings, and Arnold Esch's observations on religious articles all bear witness to the above.[4]

If Anglo-Saxon historians saw, not entirely improperly, the stigmata of an early commodification of artistic products in these phenomena—which we billed as a mixture of craft and decorative work lacking the necessary originality and inventiveness to be real works of art—other scholars went further and maintained that "the value of art works, as of everything else that is sold on the market, is determined simultaneously by supply and demand conditions."[5]

Nevertheless, the peremptory affirmation of one of the leading experts, Michael Montias, does not convince me on various levels, and I am not alone in my doubts. Given the sizable oscillations in altarpiece prices between the Quattro- and Cinquecento, Michelle O'Malley noticed that the difference could usually be explained in terms of dimensions or by the number of figures represented, and understood by extending the range of elements investigated, so that strategies of pricing "included a collection of economic factors that were related as much to fees conventionally paid within areas and time periods as to requirements of an individual commission, and that encompassed objectively-priced elements as well as variety of intangible aspects such as reputation, relationships, and concepts of honour and prestige."[6]

Similarly Andrew Blume wondered whether high quality was always in correlation to higher prices and asked, "Is there a price for quality?"[7] Even though these are recently studied questions, when one examines the production made "for the market" and connotated by a marked propensity towards standardization and seriality, the relation between the costs of raw materials, prices, and values may be more easily approached in that the relation between the costs of raw materials and services and the value of craftsmanship followed a more regular development, anchored to parameters of calculation already known to treatise writers of the Cinquecento. For example, Vincenzo Borghini in his *Selva di notizie* printed between the 1560s and 1580s observed: "As to the value, it seems to me necessary to make a certain distinction, because there is the cost of the materials, the cost of preparing the material, . . . and the cost of the art," specifying that this latter must be divided into three parts, "as a work has need of three things: genius, time, and work, and all three have primacy."[8]

In this wording the cost of material referred to the raw materials and unfinished elements (canvasses, colors, wood and stone materials, precious and non precious stones, kaolin, fabrics, more or less noble metals, etc.), while preparation included corresponding services (packing and transport, which for sculpture or large pieces could be significant), and the cost of the art covered three factors: *genius,* the most difficult to measure; *time,* divisible into hours/fractions/days (including overtime costs) paid according to criteria sometimes set by the guilds; and *work,* which judged the difficulty of the project, according to the materials used, size, and techniques necessary (such as founding, engraving, firing, etc.)[9] and sometimes was expressed in relative terms when a whole figure corresponded to two half-figures or four heads.[10]

It is clear that in the serial productions made from molds and forms or that followed easily imitated models the weight of the subjective factors could shade off to zero and the price became the sum of costs of raw materials, time, and the middleman's margin, following customary patterns. Nevertheless, while recognizing the importance of these studies, I think that what little we know of the prices of these items is insufficient to allow us to assume that they are market prices, generalizing from diffusion in other sectors and from a more demanding and cultured public and ambient. If Arne Flaten has verified that the medal maker Niccolò

Fiorentino's "repeated reverses, and his uniface Paintings, suggest a pricing and labor-based hierarchy. It seems a safe assumption that by the 1480s a patron could choose the size of the medal, the number to be cast, the materials (gold, silver, bronze, lead, or gilded), provide the inscription, and presumably he or she could dictate the subject or composition of the reverse,"[11] Luigi Spezzaferro has noted that "in mid-Seicento Mola's easel paintings, far from being all his, were the product of an organized workshop . . . that obviously seems close to the organization of a modern manufactory."[12]

Above and beyond doubts about authorship, one has only sketchy knowledge of the costs of transactions, of distribution structures, of the forms and characteristics of the chains of intermediation and of their ways of creating value, not to mention the arrangements between middlemen[13] and in the sales to the end buyer, even if it is known that there were complaints by the makers who felt cheated by the merchants' large price increases.[14] Often the "shop" prices or prices for entire collections were wholesale prices, but retail prices remain yet to be discovered, since their sums have often been collected from sources that bring problems of interpretation and do not clarify the modalities of generation and appropriation of the margins that matured in the passage along the distribution chain. These are not eccentric observations, since the retail price included the cost of services from which the wholesale price was exempt, from packing to transport, clearing customs and paying taxes and customs fees, from the modalities of payment to the most sophisticated forms of customization.

There was a broad choice of options that depended on the combinations chosen by the subjects involved, so that for any given object the transaction between an artist and a merchant could be that of a transaction between an agent and a collector, while the result of negotiation between a restorer and an expert could differ from that between a beneficiary and an auctioneer: the price was the stake in an antihistorical bet, the winnings in a great game having arenas and interested spectators (editors, publishers, printers, engravers, restorers, and critics), more or less able players (artists, connoisseurs, collectors, museums, virtuosos, dilettantes, the curious), rules and theories, laws and regulations,[15] that lengthened and complicated the chains of value, extenuating the dimensions of the combinatory matrixes and increasing the number of possible prices.

LOOKING FOR LOST OBJECTIVITY: VICES AND EFFECTS OF COMPARATIVISM

Despite the limits just mentioned, in recent years there has been a proliferation of collections and serial elaborations of the prices of paintings, sculpture, altars, tapestries, frescos, bronzes, and gold work, to cite only some of the categories.[16] It seems that centuries have passed since those efforts were greeted by diffidence, but nevertheless I confess I harbor doubts about the ends that push a growing number of scholars to undertake these exercises, since sometimes the collector's desires prevail over the caution proper to the methodology of those who concern themselves with such enigmatic values.[17]

One cannot deny a clear distortion of ends, since, far from surveying the information in order to first face the formation of prices and understand the roles and dynamics of the variables that influence them, the data are often used explicitly or implicitly in comparison, to understand not whether but rather how much the price reflected the cultural value of a work,

the critical fortune of a genre, the success and reputation of an artist,[18] geographic differentiation in tastes, the cost-appropriateness of the purchases, the hierarchies of some sectors of collection, the standard of living of the proprietors, and so on.[19]

This tendency is not without dangers already stigmatized by the treatise writers of the Cinquecento since, as Vincenzo Borghini noted, "Without knowing anything else, many deduce from the price the value of things and go to buy the most expensive wine, supposing it to be the best. I say that, given that artifice has become salable, to derive value from price is dangerous, first because tastes vary, and one likes this and another that, and some spend more willingly here and others there. . . . The other, true, reason is that appraisal should precede price and because the thing is good, even if someone estimated and paid a lot, and not that it is good because it costs a lot. It is clear that first one judges and then pays, and whoever argues against this argues backwards. Thus I wish to conclude that the price is not the rule nor the real measure of the excellence or goodness of art."[20]

I do not wish to deny the usefulness of comparisons but rather underline the need to proceed with caution in gathering and serializing data, trying to interpret them through a variety of verifications and using a logical system that attempts to move from the numbers to the intrinsic aspects of the transactions. Instead, faced with the variations in the sources—and I am not yet referring to those in the geographic ambient or in a diachronic sense—the attention of scholars has been concentrated on objective parameters like dimensions, surfaces, types of support, techniques adopted, height, weight, quantity (think of goldsmith work), and the quality of raw materials (pigments, for example), subjects, head counting, the places for which the works were destined, the conservation condition, the presence of arbitral colleges, estimated values, identity of experts, etc., in the hope of discovering and considering the factors that objectively determined the prices and would explain their erratic nature.

Thus, following the example set by diverse economists anxious to find variables for their regressions, Pierre Gérin-Jean elaborated multifactor models,[21] Martin Jan Bok created indexes relative to the times of realization,[22] Andrew Blume[23] and Michelle O'Malley have continued to look at the size and number of the figures,[24] Isabella Cecchini has pointed out the importance of genres and subjects,[25] Susanne Kubersky-Piredda has verified the relationship between the costs of raw materials and the work,[26] in an attempt to define parameters that would allow a correlation of prices to the cultural value of the works, conduct space-time comparisons, and calculate approximately the weight of relational and subjective elements.

These are worthy efforts that, however, do not cancel many reservations because even the most refined regressions do not prove the preponderance of single factors in the formation of prices, which are often conditioned by variables like talent, ability, reputation, fame, acquaintances, social relations, professional status, international prestige, etc.

I do not believe that using economic values to historicize and giving hierarchy to cultural values will get us very far; having followed the same debate tabled on the same questions by economists, I sense the risk of repeating the same errors, coming to conclusions without examining the more fascinating aspects of the problem. The collecting of prices should not be essential only to serial and comparative elaboration, but a prelude to the proposal of questions that illuminate the limits of traditional interpretative patterns and bring a revision of the respective fundamental assumptions.

This is the real challenge, the real stakes in this game: to start from the price of the work with no clear idea of what the pricing strategies were is very risky, obliterating the transformations that have occurred over time and ignoring the embeddedness of the economic in the

social, a principle by now accepted. Before trying to deal with priceless masterpieces, one should perhaps ask oneself what was or could have been the price in a time and society in which the price was almost never visible, public, and fixed, but in the best of cases the outcome of dickering, a process of negotiation.

If this question is not dealt with first, the uses of the data and series will be corrupted by an original sin, bringing further confusion to the meaning of the terms used and to the results of the study. The difficulties, in fact, are not in the gathering of the greater part of the numbers, without paying attention to the circumstances in which they appear and to the reasons for their having been documented: The worthy collections of contracts[27] put together in the last thirty years have given us precious information but do not tell us much about prenegotiation conditions or the motivations of the counterparts, the frequency of their dealings, or the existence of other relations or expectations. The period in which it was all "grist for the mill" is past, and there is no point in returning to comparing measures that are intrinsically different; instead of racking one's brains in deflative exercises, indulging in multiple regressions,[28] or spending years reconstructing the course and exchanges of various exotic coins (the painter Tiberio Tinelli, between 1618 and 1633, was paid in Venice in eight types of gold coin, six types of silver, and various divisional types, not to mention the letters of credit of exchange and payment in kind),[29] it would be worth asking oneself what the numbers were and what they meant, what information they hide and what factors determined them.

For these reasons, instead of the price it is more useful to reconstruct carefully the history of transactions, trying to discover the conditions and the circumstances in which they occurred, that is to say the place and the time, the forms and the terms of payment, the persons involved, the modes of transport and times of delivery, the possibility of paying in cash or kind, the guarantees and fidejussions, taxes and duties, possible fiscal indemnities, presence/absence of corporate limitations, longevity of delivery associations, and so on. These factors, not always specified in the contracts or mentioned in the documents, were fundamental in their impact since that which at first glance might seem a market price was in reality the fruit of lengthy negotiation that could include the concession of fiscal exemptions, minimum guarantees, franchises, monopolies, and guarantees of limitations of competition, favorable rental rates, rent-free spaces, contributions to new commercial enterprises, jurisdictional privileges, introductions to other wealthy or influential clients, etc.

PITFALLS IN THE DOCUMENTS: INVENTORIES, CIRCUITS, ESTIMATES, AND QUALITY

Following the path just indicated, my first thoughts concern the spotty nature of finding prices and the heterogeneity of their sources: twenty or thirty examples over thirty years do not make a useful foundation for a series when there are serious differences among the documents in which they are found. The estimate derived from an inventory written by the tutor of a minor heir will be different from that transcribed in a rental contract (paintings were often rented), the information in a cardinal's wardrobe account book should not be compared to the notes of an agent in incognito, the amount of the tenth contract written in the native town with a lay patron is not like that written for the first time with a confraternity in another town, goods lying unsold in a warehouse may not be considered on the same plane as a lot sold

in a bankruptcy auction, and so on. Even when the source bears the same name and seems to belong to the same documentary category, one must not make assumptions about the contents, because the types covered various and differing ends.[30] Only legal inventories could be written "of guarantee, of use, and habitation, in irregular successions, in the acceptance of inheritance with the benefit of the inventory . . . in the expected inheritance, when an executor has been named and, finally, in the legal and customary community and within the dowry regulations,"[31] and to these were added those indicated by bankruptcies, sequestrations and liens, requests for fidejussions and guarantees, the calculations of unsold stock, management of the offices, the calculation of gains and losses in the most varied of economic activities, etc. The finalities also had no small influence over the reported values, since the sums in postmortem inventories could be lowered in order to lessen inheritance taxes or favor/harm a given beneficiary, when those on the list of pledges with the pawnbroker could, according to the interest of the writers, be increased or decreased by the loan makers. Furthermore the inventories hardly ever mentioned the age of the good or the year of its acquisition and are rather shy of making attributions[32]—two elements that do not allow the dating and paternity/maternity of the items listed.

There was also the custom of unscrupulous intervention on many objects (consider repaintings or the "completions" of works,[33] the dismantling and founding of jewels and furnishings, of the modifications made to furnishings and decorations, to the casual pastiches of antiques or the cuttings and pastings inflicted on carpets and tapestries), nor should we ignore the importance of channels of distribution of second-, third-, and fourthhand used goods[34] that put back into circulation goods whose provenance, dating, production, and acquisition remain nearly untraceable because of the longevity of life cycles and the ease with which they entered and exited patrimonial ambients. It is enough to scan the registers of any pawnbroker to verify just how commonly and frequently works of art and luxury items were pawned,[35] used as coverage by persons of all social extractions.

Reference to pledges suggests that we should not confuse sale prices with estimates because often the latter did not include the causes of depreciation connected with difficulties in selling (quickly finding a buyer willing to make a large outlay), to problems of attribution, to a poor state of conservation (not always reported), or to the need for speed in liquidation (when imposed by bankruptcy, court, or inheritance).

It was well known that "paintings by important painters, other jewels, and similar things that one buys, the most appetizing of things, expensive . . . when in need one only recovers the smallest part,"[36] for causes clearly expressed in the purchase contract for the collection of antiquities of the brothers Della Valle-Capranica: "Res tanti valet, quanti vendi potest, ultraque statuarum, et similium antiquarum rerum precium, valde incertum sit, et satis varium esse solet, quia potius ex opinione, vel affectione singulorum, quam ratione, vel scientia universorum regulatur, maxime cum talium rerum commercium apud paucos consistat, et raro fieri soleat."[37]

Thus we understand, on the rare occasions on which it is possible to compare the estimated value with the effective sale price, the causes of the differences between the two sums: In the 1669 sale of Tommaso da Batio's collection the prices are 22 percent lower than the estimated value, and in the sale of the Ceva-Grimaldi collection in 1764 the drop is 8 percent, while in a third case there was an increase of 40 percent.[38] Similarly the estimate of the collection of Giovanni Andrea Lumaga done in 1677 by Tomas Francesco Ergo and Pieter de Coster for the widow Lucrezia Bonamin set a value of 4,170 ducats, which did not convince

the beneficiaries, who then had a second estimate done by Nicolò Allegri and Lelio Bonetti, who after a month determined that the collection was worth 18,373.[39]

The disparity was not always dependent on the incompetence or dishonesty of the experts: There were diverse methods and hundreds of professionals (in Bologna in the Seicento, there were at least fifty-one experts of painting, drawing, sculpture, and prints, thirty specialized in furnishings, one in frames, one in medals, one in clocks, eight in books, thirty in jewels and goldsmithery and silversmithery, and 205 generics),[40] without forgetting that in some cases it was objectively difficult to formulate sensible conjectures.[41]

Once the obstacles put up by the sources and the need to examine them are faced and overcome, there are still other unresolved problems. Think, for example, of the identity and the quality of the works: Luca Giordano boasted of painting with three brushes, one of gold, one of silver, and one bronze, so as to satisfy various levels of demand,[42] while Guido Reni noted that a full figure could cost 2–3 scudi if executed by one of the lesser painters, about fifteen if the painter was ordinary, and much, much more if the patron wanted someone as extraordinary as he.[43]

Even in adhering to the most rigorous methodology of microhistory and following a buyer who worked with a single institution in one city in one year, behind the apparent and comforting precision of the categories are hidden almost unavoidable difficulties. Take for example the furnishings of the Florentine residence of Marquis Giovan Vincenzo Salviati in 1686, as studied by Valeria Pinchera, and to wit: "58 beds, 4 large tables, 37 tables and small tables, 72 side tables, 5 side boards, 7 *cassettoni* (chests of drawers), 10 cupboards, two desks and three credenzas," to which were added, in the inventory of 1711, 37 more sideboards and 11 *cassettoni*, while the tables were reduced to only 44 pieces.[44]

What information can we glean in terms of congruity and comparability of their economic value? Can we suppose that the sideboards or the small tables indicated objects with the same characteristics, so that we can compare the prices of those sold in Florence at a given moment or risk the comparison with those in Genoa or Lucca?

Given the current state of our knowledge I do not believe it proper to try. Often the same names were applied to different articles in different places; and whoever wrote the documents could describe them in alternate ways that changed over time, and then there were also the cases—my thoughts turn to the court registers, ecclesiastical institutions, and large aristocratic houses—in which there are hundreds, sometimes even thousands of objects listed in the same way: even when the lists were accompanied by notes on the material (a *scrana di nogara* [walnut chair]), a jasper vase, a door with *quadri di corame* [squares of stamped leather]) or the style (antique, Roman, French, Turkish, etc.), there is never enough information to make reasonable comparisons, even when the objects are apparently identical.[45]

FACTORS OF PRODUCTION, UNFINISHED PIECES, TRANSACTION COSTS, AND FIXED COSTS

With these doubts resolved, other elements complicate the situation because many scholars have found that prices have a composite nature, being made up of the sum of the costs of the various production factors (raw material, unfinished material, services rendered, and the work of third parties), of diverse transaction costs, and of the application of certain pro quota

fees whose calculation is propaedeutic to the understanding of the processes determining the "objective" component of the final sums, in which these elements bore unequal portions.

Starting with the raw materials, if it is true that the contracts (available—and not always—for the more complex works) specified the required characteristics, less frequently do they indicate the price,[46] the amount to be used,[47] and the quality. The lack of written agreements makes this information even more elusive because there were retail and wholesale prices—not always known—(at Rome, in mid-Seicento, ultramarine blue had more than twenty prices, from 3 to 50 scudi the ounce, and similar differences can be found in other cities for other pigments), and there were many points of sale.[48]

Nevertheless even in the seemingly simple case of paintings (consider the effect of raw materials on sculpture production, founding, or in jewelry or cabinetwork) the above considerations concern not only the colors or leaves of gold or silver but also the raw canvasses, the wooden supports, the priming, frames,[49] drawing paper, brushes, skins and bristles, sponges and talcum, oils, paints and solvents, charcoal pencils, chalks and white lead, fixatives, easels, lacquers and enamels, pay for the models (who, according to Bernini in mid-Seicento, could earn as much as 15 scudi a month),[50] not to mention the frames that often cost more than the paintings[51] (and which, according to commercial custom, were to be supplied along with a support) and of other accessories (such as satin drapes, often painted, which provided protection from light and dust).

Our reservations based on our modest knowledge of the costs of these factors extend also to assistants, helpers, and apprentices' pay, and most of all to the unfinished elements and the phases of the productive processes outsourced into a network of collaborators and subcontractors,[52] whose monetary equivalents, influenced by the frequency of the jobs, urgency, the presence or absence of specific contractual vetoes or corporative norms, the number of craftsmen involved, etc., are rarely noted.

The same may be said for the costs of transactions such as packing and shipping,[53] the payment of duties and entry and transit fees and the installation honorarium (which covered small adjustments and modifications, fixing part or substituting damaged pieces), the return of items rejected by the buyer, and periodic interventions for ordinary maintenance.

These items could have significant influence in the final price: the *Nativity* altarpiece that Andrea della Robbia executed in 1487 for the Sicilian Antonio Barrese cost between 70 and 75 florins, but had to be divided into parts that were then placed in seventeen crates built by the carpenter Francesco di Giovanni and taken to Pisa and Palermo, for a total cost of 108 florins 8 soldi.[54]

We must not forget the commissions that had to be paid to the agents and middlemen (in Venice at the end of the Seicento, the middleman's part of transactions of artworks amounted to 5 percent of the sale value),[55] costs of experts, and operations of restoration and cleaning, which were not always minor. It is clear that the comparison of prices noted by the same author and concerning almost identical works made or commissioned in different locales needs to include the knowledge of these mechanisms or at least foresee their influence; when the works were relatively inexpensive, transportation could account for 25–30 percent of the price.

Further, as in other fields, a part of the sale margin had to be set aside as insurance against the inevitable risks[56] and to cover general operating expenses (office rent, the laboratories and warehouses, which in large cities could be very expensive, heating, travel expenses), and of course, taxes.[57]

The payments themselves pose problems of interpretation, in respect to the terms (there were deposits and down payments, in cash or credit), the guarantees and penalties (collaterals, fidejussions, recession clauses, late-payment fees, etc.), the deadlines (the payments usually accompanied the work's progress, but some jobs were finished months or even years late), the means of payment (gold, silver, or various divisional monies, letters of credit, payment in kind, bartered services—masses were common—and exchanges), the losses and gains on exchanges, inflation, and the modes of time payment offered to purchasers from the lower-middle and middle classes.

These reconstructions are not easy, but it would be useful to know the amount of some variables, to avoid the risk, specular to that denounced in these latter pages, of explaining the structure of prices and their variations by mostly subjective factors of not being able to reconstruct the "chain of value" of the production processes, the relative passages and consequent price increases, the components of elaboration, intermediation between workers, and so on.

ORIGINALS, COPIES, AND REPLICAS

Another dilemma is the different values attributed to authorship and originality, which today clearly prevails over other pricing factors (one should nowadays speak rather of branding), but which in the past was controlled by the massive presence of copies, pastiches, replications, works of the school, and so on.[58] The phenomenon was already widespread by the Quattrocento and exploded in the seventeenth century: of the 3,542 paintings counted by Renata Ago in seventy-five Roman inventories, 1,764 were copies;[59] in Venice "the number of copies in the inventories . . . is the same as the number of originals,"[60] and in the Neapolitan collections there are thousands of copies,[61] while the master mason and art merchant Giuseppe Sardi had on display "of Raffaello Sanzio . . . ten copies, ranging from the fifteen scudi cost of Moses with the tablets of the Law on majolica to the scudo of the three goddesses and three Graces, to the five paintings and six copies of the School of Annibale Carracci included among the eight scudi of the Venus with two putti to the fifty *baiocchi* of the Poliphemus and Galatea, five copies of Domenichino and fourteen of Guido Reni, from the fourteen scudi of Aurora Rospigliosi to the forty *baiocchi* of Lucrezia, of Caravaggio eleven works of followers and four copies."[62]

The reasons for this diffusion are various and depended on the tastes, preparation, and expectations of the different categories of owners; for the more refined collectors the copy could be a divertissement that tested the eyes of the most unerring connoisseur, when "it is so well done that it fools, and the buyer . . . having the copy and the original, cannot distinguish."[63] In this sense as Linda Borean has noted, "The status of the copy was fed by openly competitive connotations," since one was dealing not only with completing a series or substituting "originals not available on the market because in private galleries or places of worship," but with proving "a knowledge on the part of the owner that put him in a position to connect, compare, and appreciate that kind of artistic product, able to compete with the model."[64]

For other buyers, however, there were still other motives; for example in Naples Gérard Labrot has established that the choice of copies for the local aristocracy was more a question of strategy than of taste: "Et cette préoccupation permanente de glorification explique la quête fréquente, en plus de noms éclatants, de grands formats et de certains sujets spectaculaires,"

where the clear preference of bourgeois collectors for the copies of local artists is explained by the "accessibilité immédiate et considérations économiques."[65] Nevertheless, that which today would seem to be an enormous case of copyright infringement was then considered to be normal practice and did not scandalize. For the artists, the copies, pastiches, and replicas were a necessary part of the formative process, in which the comparison could transform itself into a quick vehicle of self-promotion, since the craftsman capable of "painting according to the manner of a famous and popular master and fool the most intelligent" did it "in quest of honor, so as to become known and appreciated."[66]

Originality was not always welcome, and often the purchasers were fixated on certain works (Titian painted no less than eleven versions of the *Ecce homo*), unconcerned that others owned similar or identical works; they were not always attracted by the subtle fascination of the unique and original piece but gave to reproductions a value whose importance vanishes in the age of technical reproducibility and were pleased to possess "that piece," regardless of who had executed it. These demands were not snobbishly rejected by the producers, since copies and replicas, often done by helpers, relatives, and assistants in the circle or workshop, were economically convenient and speeded up production by following models and procedures that required minimal or no participation on the part of the maestro: Pier Francesco Mola and many others like him "painted a composition . . . and then had his students and/or collaborators make various replicas that he would then retouch and sell under his own name as autograph and authentic works."[67]

These practices were common not only in painting and sculptural ambients but also in contiguous fields where there were often crossovers of pattern, motifs, and subjects between different artists and genres, as one can deduce from the similarities between paintings and majolica,[68] engravings and fabrics, prints and pottery, elements that have revealed just how broad the multimedial circulation of some iconographic themes was, thanks to a wealth of models[69] that included standardized and repetitive elaborations and solutions in molds, prototypes, and forms ready for use and reuse in an exciting and infinite rebus of quotations.[70]

Contradictory phenomena cohabited in this game of references since the price of a copy by a famous artist could be greater than the original it reproduced. Even though this happened rarely for obvious reasons, the existence of a demand for reproductions, in an atmosphere of uncertain connoisseurship, made estimates difficult and complicated appraisals, defining values that in some cases maintained a proportional relationship with the originals (a principle that our contemporary notion of fake cannot in the least include), almost as if the price of the copy incorporated and reflected, apart from the ability of the copier, the value of the originals.[71]

FIXED PRICES

Mention of copies brings up another interesting point, since many serial products were connected to fixed prices that once defined could remain the same for decades. Leafing through the *Libro delle partite del Banco de Roman de Lardi,* which records the payments of a Ferrarese banker from 1 January 1529 to 24 December 1534,[72] we might take it to be an ordinary account book. Nevertheless, running through the eighty-nine pages and 1,873 items, one sees unusual payments for furnishings, mirrors, spectacles, toy swords, viola strings, dog collars,

copper urinals, wagon bells, crane feathers, pencil sharpeners, carpets, the washing of a dromedary, the remuneration "for having used cupping glasses on seven boys who were full of the mange," dozens of devices to trap "birds of prey," and so on. It is in reality a register kept by one of the bankers charged by the ducal court with making payments to smaller suppliers, in order to simplify the account keeping overwhelmed by the revolution in Cinquecentesque consumerism that brought the birth of tens of thousands of objects and services whose price range was very extensive. To contain this explosion, beginning in late Cinquecento interesting normative schemes came into use, as I have been able to see in the Farnese *Libri de' precii*,[73] which is similar to the *Tariffe dei prezzi dei generi e lavori delle diverse manifatture con la Reale Guardaroba*[74] discovered in the Medici archives. The books found in Parma cover the periods 1611–1710 and 1683–1716 and record the prices paid by the courts of the dukes of Parma and Piacenza over more than a century. There are hundreds of pages of the fees charged by more than ninety kinds of artisans, artists, and professionals and relative to more than 180 types of merchandise and services, and thousands of prices. This is a fascinating window on a world as rich as it is little examined, that allows us to know the sums corresponded to "pipes for fountains, baskets of carnations for vases, tin candle snuffers, new iron canary cages, new wooden nightingale cages, cages for blackbirds with rods, plank floors and feed boxes, scratchers for the hunting dogs, Ciceronian dictionaries, missals for the dead, the tanning of his R.H.'s leopard and ocelot hides, music paper, paper for windows, balls of colored leather, hooks for paintings, little chocks for under the doors, shoes for midgets, drills, lampglass, etc."

Even more interesting are the clauses indicating the quantity, size, materials, provenances, controls, conditions, and methods of delivery, the ways and times of payment, the discounts and special offers. Thus on 1 February 1628, in virtue of "the agreement made with Guglielmo Racheri, maker of clay flower pots to whom we must pay a third less than the usual price such as follows, that is, pots of a height of 11 *once* and width of 13 *once* 3 liras, medium pots 8 *once* high and 10 *once* wide 1 lira 10 soldi, small pots 6 *once* high and 8 *once* wide 1 soldi 2 denari 6, and if there is need for larger or for smaller they will be paid discounting a third of the price and for the policy in rank 1628 at number 80 included in the policy for his house rental at that number."[75] This passage, chosen at random from hundreds, shows how complex the systems were, since it is not clear whether the consistent 33 percent discount applied to the ordinary prices was compensated by a reduced house rental, since Guglielmo Ranchieri resided in a building belonging to the duke. The extent of this practice shows that many administrators preferred to stipulate long-term agreements and fixed prices.

The extent of this practice provided continuity and homogeneity of supply, reduced the risks of interruptions, and allowed the functionaries to solve controversial situations and contain the discretion in the choices. There was a logic to it even if the price-fixing did not seem to fulfill a desire to reduce spending but rather to reduce the complexity of accounting, managing, relational and fiscal questions, bringing order to organisms that were subject to powerful centrifugal forces. The institutions in the *ancien régime* maintained relationships with thousands of subjects, and managed relationships that developed over decades, with frequent multilateral compensations. In this sense the fixed price supply contracts and long-term suppliers simplified administration (managing transactions with hundreds or thousands of persons in double-entry bookkeeping was difficult) and supply procedures. One must then also consider the costs of management of the relationships, normally ignored, because they included obligations the costs of which could be greater than the savings of operating in the market.

MULTIPLE ROLES, CLIENT NETWORKS, AND
THE HABITS THAT MAKE A MONK

The cases just cited confirm the frequent assumption of multiple roles, an element that recurs in the biographies of many talented persons capable of moving in different ambients (producers, experts, agents, restorers, intermediaries, planners, impresarios, directors of works, teachers, etc.) and dealing with a ramified selection of buyers and patrons: private persons, courts, universities, hospitals, guilds, orphanages, monasteries, abbeys, churches, confraternities, town magistratures, etc. Nevertheless the frequency with which the craftsman finds himself at once creditor and debtor, seller and buyer poses some questions: a potter or cabinetmaker, for example, could offer to the bursar of a convent lower than average prices and obtain reductions for the purchase of grains or the wine from the *decime* or the concession of a city kitchen garden as a balance, in the context of a strategy based on mutual relationships. In other words, not only is it difficult to keep the components relative to goods and those relative to included services separate, but it is still more difficult to determine the extramonetary dimension of commercial relations whose effective value was influenced by the presence or absence of clauses and agreements not at all accessory and frequently stipulated verbally, according to not easily intelligible rules of custom. In examining the work of a sculptor or miniaturist it is not unimportant to know how much of his salary was paid in kind: they could be housed for days or months, receive food rations, clothing, send mail, be transported, use rooms, machines, and tools, have helpers, enjoy tax relief, have health insurance, find employment for family members, etc. In this sense, the price of the painting, or crucifix, or inlay does not reveal the effective economic value of the transaction, making any conclusions that exclude these elements quite risky.

At the same time, alongside the individuals wearing more than one hat were those who had four or five relatives, numerous friends, and even more numerous associates—a frequent, and not significant occurrence, if it were not for the fact that, strange to say, many of the more important workers were related or somehow tied to those who were responsible for choosing them. It would be malicious to suppose that this practice were general, as a foreshadowing example of the anarchical and corrupt climate that reigned in Italian society. The question is more complex than that and cannot be sloughed off in moralistic or simplistic terms. Many buyers paid pegged prices, and this had its effect on the often restricted choices of their employees, whose margins of discretion, except in very rare cases,[76] remain in deep silence.

Thus there was a surtax, more or less light depending on the engagement, that the purchase cost and maintenance of the agreement included at all levels of the hierarchic scale. In a labor market like the arts, dominated by family, friendship, neighborhood, and apprenticeship ties, the clientele had specific maintenance costs, which were expressed by the differential between prices expressed by those fortunate enough to have close relations with the best and most established clients and those cut off from the world of big business and forced to operate at less than cost, paying the surcharge exacted by those who had more stable entrées.

On the other hand the question underlines the need to consider also the identities and the professions of the customers: How did the artisans behave with the administrators, the heads of houses, majordomos, bookkeepers, factors, and *spenditori,* the functionaries who carried out the purchases and orders of ecclesiastic and assistential institutions, bishoprics and cardinalates, communities and magistratures, courts and diplomatics, not to speak of the principal patrician houses? Economic theory suggests that the greater the contractual power of the

purchaser the smaller the price should be. Nevertheless, history suggests differently, not only because of the corruptibility of these decision makers, since, as Domenico Romoli revealed, the *spenditori* "are of the nature of thieves, and the avarice of managing money flays them."[77] In reality these functionaries were subject to opposing pressures that from the point of view of the purchasers could translate into divergent desires. Economic principles, inasmuch as they were perceived or used in an incorrect way, called for a reduction of costs, the search for economies of scale and scope, the reduction of supply relations to impersonal and rational transactions, but the orders and acquisitions on such a large scale were a formidable lever. Economic inefficiency could become political efficiency, thoughtless waste cynical calculation: between the inflexible, anonymous, and cold prices of the market and those inefficient and excessive ones accepted by maestri of the wardrobe and majordomos there was a political margin that was of greater value than any savings.

GEOGRAPHICAL ARBITRAGE, SOCIAL DISPARITY, AND RITUAL "SHOPPING"

The places and circumstances in which the transactions occurred were also extremely important. There were profound differences between deals made in famous markets like Venice, Florence, Milan, or Rome and those in smaller centers where the clientele was primarily local and there was a substantial difference in behavior and strategy between those who purchased and donated in the course of official voyages or travel undertaken with great reserve.

Purchases made in the large cities or fairs were of considerable size and usually were concluded in a few hours: the behavior of buyers and sellers could not have been identical at Venice and Siena or at Milan and Mantua. In the principal centers there were dozens of competitors, and the majority of the clientele were big buyers: agents of princes and courts, international merchants, passing aristocrats, diplomats, or high-level prelates who usually purchased large quantities of merchandise at a given moment.

In this kind of circumstance, even presuming that the sellers cultivated the wealthier clients, the possibility of quickly finding others of the same caliber remained high, should the relationship become unsatisfactory since transactions took place very frequently and there were good possibilities of dealing with perfect strangers. By contrast, in cities like Turin, Mantua, Lecce, or Urbino the best clientele was more or less stable, with less and slower turnover. In these conditions the conduct of the seller could discount the reduced possibility of acquiring new clients of a certain level; the relations with the few ranking clients were determinant, because they were often in debt for conspicuous sums, a fact that helped tie them to a given supplier. The value of relational capital was higher, and the politics of pricing could reflect the desire to protect, in the first instance, some key relationships above and beyond maximum profit-taking in the short and middle term. In a context like Venice, Rome, or Milan on the other hand, the formation of prices could have been conditioned by the lower frequency of transactions with the usual protagonists, by the more accentuated impersonality of the exchange, by the greater risks of opportunistic behavior typical of dealing with strangers who declare themselves ready to spend large sums, by the ease of substitution of the counterparts (a seller could quickly and easily find other clients, and vice versa), and by the weight of competition (at Piacenza there were three sellers of gilt leathers, in Venice there were almost sixty), etc.

Nevertheless, if the factors just mentioned could have determined an increase in average

prices, incorporating a premium against the larger risks of negotiations, one may imagine that the enormous quantity of outlay and of quantities purchased in a single deal encouraged the buyers to request reductions in prices and sellers to grant them in order to keep their customers.

It is also opportune to understand the circumstances in which the purchases matured. Otherwise one cannot understand the function of officials like the *spenditori cavalcanti* who rode ahead of the groups of important persons to buy their needs incognito, or of the agents who on behalf of their wealthier clients acquired paintings, furnishings, and antiques in various markets.[78]

The secrecy was crucial since revelation of the name of the real buyer could cause an immediate price increase: Diomede Leoni, Medici agent in Rome, complained with Cardinal Ferdinando de' Medici of having to hire a subagent, since "the price of grain increases when I show my face in Campo di Fiore."[79]

As soon as word got around of the arrival of an important person, or of his interest in certain items, there would be an immediate rise in prices proportionate to the wealth and rank of the potential buyer, who protected himself behind very discreet agents and emissaries who attempted to purchase in a timely manner and avoid paying a tax on wealth and fame: the more noble and famous the buyer, and especially if he were a foreigner, the higher the corresponding price to be asked.

LOWLY PRICES AND NOBLE HONORS

The higher the rungs that one looks at in the social hierarchy the more important it is to face a paradox. The greater part of studies on prices is concentrated on unique works, produced by individuals whose authorship is certain, or ceded by subjects who could prove it with documentary evidence, circumstances that have induced researchers to focus on the more famous artists and illustrious owners. This choice must, however, discount the reluctance with which many craftsmen and collectors considered price to be an honest and honorable measure of the value of their works and persons. This situation recurred often in the more refined contexts which favored the *liberal* aspirations that I spoke of in the introduction and second chapter; as Paolo Peruta noted, "Respect for the mechanical arts is one thing & another that for the liberal ones: so that in the latter is the honorable name, & premium; in the former there is a more proper price, & merchandise . . . because the mercenary craftsman in working does not consider the use to others, but only his own, whereas the virtuoso does just the contrary; and thus it is his intention to benefit others; it is in fact this that makes his work the more perfect, and more worthy of honor."[80]

Far from being an intellectual affectation, these considerations rejected prices and held them to be synonymous with vile trading and mechanical compensation, whereas the true artist and real connoisseur aimed for use to others, not his own, a condition that postulated a fact of not working or selling for necessity but in order to gain honors and prizes. It was up to the tact of the client or buyer to find less dishonorable forms of recompense consonant with the presenter of the fruit of his own talent and genius. Vincenzo Borghini himself, after having said that prices derive from the sum of the expenses for raw material, of working that material, and of art, pointed out: "Because earlier we spoke of the price, I do not know if I have made

myself understood when I say that the price is in part for excellence. I will say more, and I will say that which one gives to a person who works, whether it be by hand or by intellect, is called price, by which I mean financial worth and, as our elders would say, goods for money, and we say weigh and pay. The other for now I would call prize, understood as I will now explain, that is, as a thought for and recognition of a thing well and beneficially worked. . . . But since it can be that a thing has in itself the one and the other (whereby many like to be provided for by a prince, who does not mind about gain), I say, speaking about these arts, that since necessity induces craftsmen to make a price, they are excused, as long as they know . . . that in order for these arts to be mercenary they must become mechanical and much less noble than is their nature."[81]

Within this process was also at work, as always, the influence of classical mythology full of anecdotes about the self-sacrifice of many artificers, the astronomic sums earned by some of them, and the impossibility of weighing *ingenium* against the time employed or costs of raw materials. Thus in 1585 Romano Alberti recorded that the ancients, "Romans like the Greeks, had great respect for these arts; because they would buy a panel painting at stupendous prices, as one reads of the panels that Caesar bought from Aristides, the very famous painter, for the sum of eighty talents each . . . (which according to Budeo and other contemporaries, amount to 48,000 scudi, as the talent equaled 600 of our gold scudi); that, even though Caesar was a very rich and powerful citizen, it was no less a large sum. And of King Attalus it is similarly recorded that he paid one hundred talents for a panel from the same Aristides, or 60,000 scudi; and again we read of Candaules, king of Lydia, who paid his own weight in gold for a panel by Bularchus; and no less we find that Marco Agrippa . . . paid for two panels, one of Ajax, the other Venus, to the Cizeni people, 130,000 scudi."[82] In a similar way, in 1590, Giovanni Botero observed: "Compare the colors with the paintings and the price of those with the value of the latter, & understand, how much greater is the value of the work than the material. The great painter Zeuxis gave his paintings away; because he said generously that there was no price that could buy them."[83]

These excerpts repeat some passages by Leon Battista Alberti,[84] in turn repeated by Baldassare Castiglione,[85] and treatise writers in the following years broadly quoted the *auctoritates* (Pliny at their head) that had dealt with the problem, and Varchi again in his *Lezzione* of 1546: "The [antique] panels earned great praise and were so esteemed, even by the painters themselves, that they wanted rather to give them, some of them, than receive a sum, as they judged them to be greater than any value,"[86] while two years later Paolo Pino, discussing Eumaro, Cimone Cleoneo, Polignoto, Tasio, and Apollodoro revealed: "They became full of the riches of the true alchemy of painting, began to give away their works, estimating any high price inferior to them; with this presentation they were incredibly presented."[87]

Demand strategy ran along two tracks; on the one hand it recognized *ab antiquo* the impossibility of measuring artistic value and its sovereign disinterest, a virtue that should have been reflected also in the owners of the works, following a trajectory that led to the gift-countergift of the many anecdotes about the artists who, tired of common or careless interlocutors, preferred to give away their works or destroy them.

There was at stake not only the equilibrium between costs, prices, and values, but also the social status of the works and the moral stature of their creators and owners in a privileged situation, since as Francesco D'Olanda noted in his *Dialoghi romani,* "The recompense and payments that are paid in Italy seem to me to be an important reason for the fact that one cannot paint anywhere else, if not there, because often for a head or a face are paid a

thousand cruzados; and for many works the pay is . . . in a different measure from that of other domains."[88]

On the other hand the rejection of criteria of more objective measurability (nearly unchanged from a contractual point of view, up to mid-Settecento) reconfirmed the intellectual nature of the artistic professions, underlined the nobility of those who practiced them for love, and exalted those who donated their works in order to share the joy. In a context of this sort it was logical to reject the predetermination of any economic value or the involvement in humiliating negotiations unworthy of gentlemen since, as Pino warned in 1548 "the painter . . . abhors trading, that most vile and mechanical thing which is inconsistent with our art."[89]

No price could have ever recompensed the immeasurable value of genius and the pleasures of connoisseurship, principles that were valid also for transactions between collectors: "Painting, not a necessary but a pleasurable thing, and having latitude and difference because of the excellence of the maestro and for the antiquity, for the rarity of that time and maestro and for its conservation . . . in itself cannot have a set price."[90]

Works of art should not and must not be priced—an important passage since whoever denied the possibility did not limit himself to an ideological position, but voiced the reasons that determined this sort of resolution, listing the factors that should be taken into consideration: "In addition to the quality of the patron who owns it and the living artist who does it, rich or poor, with or without pleasure, whether you know him or not, if the artist who did it has acquired fame or not . . . is the quality and social position of he who wants it and would buy it, because at one price a prince and person of respect and comfort would buy it, and at another someone of mediocre status and fortune, in a way when he buys at an agreed price, and another at the cost of a gift and to exchange courtesies received. . . . And we add the buyer, because we see . . . that for the same painting, bought from those who make a market at tens of scudi, the prince will pay hundreds, as one sees continually."[91]

When there was a price, then, it varied according to the rank of the persons involved and the circumstances in which the deal was made, and for a given piece the artists and the collectors could set quite different prices: "Albani was furious when he discovered that the just completed *Europa* intended for Count Angelo Oddi of Perugia, at the agreed on price of 100 ducatoons, was instead to be sent to Cospi, who, unbeknown to the painter, had gotten it from Oddi for Leopold at cost. When the painter received from Cospi the payment of 100 piastres of Florentine silver, Albani, 'engorged with anger,' objected that he would have asked at least twice as much of a Medici."[92]

The solution of gift and countergift[93] was thus encouraged, sometimes bringing unforeseen results having little or nothing to do with careful calculations and precise measurements: "One must at last consider the way in which the owner or artist releases the piece, giving it, either as a gift and observance, trusting everything to the prudence and goodwill of the buyer, or at an agreed price. In the first way, being proper to men of great genius and generosity, whether artist or man of taste, and dealing with buyers who do not wish to be outdone in graciousness, like princes or grand lords who know and want to know who the seller is, and who does without not to be safe nor for want of them, in this case there is no other price than the virtuous and heroic act of depriving oneself by giving one's taste and effort to discretion, and in this the apex and aim of honor in not wanting to be outdone in acts of justice or mutual exchange. In that way one has seen extravagant price and payment for the heroic liberality of some grateful person or prince. So for all these respects it does not seem that one can give a fixed price to painting."[94]

The relation expressed by the scheme of gift-countergift was apparently inspired by more equitable principles and allowed the pleasure of exchange of equally precious objects or privileges (often jewels, clothes, accessories, titles, benefices, etc.) even if the mechanisms were not simple since there were mutually conflicting forces and aspirations in motion. In similar cases it often happened that the pricing of the work would be delegated to the receiver by the seller, who in this way put himself under his judgment: when Claude Lorrain, in 1681, asked Lorenzo Onofrio Colonna to pay him for works commissioned, he did not quote any price, but only mentioned how much he had earned for two canvasses "of like size," and trusted himself "entirely to your generosity."[95]

This tactic gave the weight of the decision to the buyer/donor, played on *amour propre*, dynastic pride, fear of not being up to the rank and competitors. It was not without risks, and had been practiced by some great maestri and some collectors in the Cinque- and Seicento who did not set a figure but, having finished or given the piece, explicitly or implicitly requested that the patron/buyer "value" it. This remission tickled the grandeur of the counterparts, who then had the embarrassment of the choice, knowing that it was probably better to be generous than not: a situation from which all artists could profit. When in 1651 Francesco d'Este wished to remunerate Bernini for the portrait bust he had commissioned from him, he thought he could get away with paying 400 scudi, a notable sum, considering that he could have given 150 to Algardi. Nevertheless the Duke of Modena, before making a false step, consulted with that great connoisseur of refined Capitoline custom, Cardinal Rinaldo d'Este, who dissuaded him from offering a sum so ignoble and convinced him to pay out 3,000 scudi, the same that Pope Innocent X had just given Bernini for the *Fontana dei fiumi* in Piazza Navona,[96] and thus he equaled the magnificence of the pope.

ECONOMIES AND DISECONOMIES OF THE GIFT

One must not, however, believe that the scheme of the gift or favor always worked to the advantage of the weaker party; diverse patrons and collectors were aware of the positive effects of their attentions on those who had the honor to serve them, and pretended to pay nothing for reasons that mirror those of their counterparts: the nephews of Paul III were convinced that Titian should be paid nothing for his portrait of the pope and be happy with the privilege of portraying him, because it was not for the artist to reflect on the client, but the contrary. Following this kind of argument, the Farnese did not pay for the two papal paintings of 1543 and the third by Ranuccio, because "in doing the portrait of the pope and his nephews, Titian augmented his own prestige and also the price of his work with other buyers. There was then no need to pay him, because the compensation was implicit in the honor conferred by the most highly elevated rank of his client."[97]

In this regard, if it is true that the prices could be commensurate with the prestige of the buyer, there was no lack of cases in which the more powerful tried to avoid their obligations by calling on all their persuasive forces; think only of the intricate legal and financial vicissitudes between the Balbi and the Pallavicini, the origins of the peregrinations of collections of statuary studied by Osvaldo Raggio,[98] or the Mantuan or Florentine cases examined by Guido Rebecchini and Suzy Butters, on the occasions in which dukes, cardinals, and grand dukes obtained by gift from some subjects important collections of paintings, exotica, medals,

naturalia, and antiques, or else acquired them *en bloc* at truly favorable prices. In these cases the gift was the perfect alibi to mask and nobilitate the use of blackmail that exploited clear power differences.

In this way in Mantua Nicola Maffei wrote in his will that his collection of antiques not be dispersed unless the duke desired it, and Federico II Gonzaga did not miss his opportunity; likewise the doctor and state counselor left his collection to Vincenzo I, beseeching him to "do me the favor of preferring my heirs and successors," while the former counselor Nicolò Avellani gave to Ferdinando I the best of his painting collection after having spent two years in prison for fraud, and gained permission to move to Venice after only a few weeks.[99]

These are not isolated cases, as we can see from the occurrences relative to the acquisition of the Della Valle-Capranica brothers' antique collection by Cardinal Ferdinando de' Medici, which was initially valued at 9,000 scudi (a very good price), and was finally sold for only 4,000. The theoretical reasons used to justify the motives of this sort of valuation have been explained in the preceding pages, but it should be pointed out that the Della Valle-Capranica needed to provide a dowry for their sister Faustina quickly and that the collection to be sold was under *fide commisso,* a bond that the Medici cardinal could easily loosen.

The outcome of these strategies was not guaranteed, even if the decision to donate a work[100] or to practice heavy discounts[101] was common to many entry strategies, since entry into the good graces of important patrons and collectors could mean gaining remunerative jobs, often procured by those who gravitated in the chosen relational network. The basic problem, however, lies in the alterity of the stakes of the game that the price hides and does not reveal. During the decade-long relationship between Titian and Federico II Gonzaga there was also the attempt on the part of the painter to acquire some lands belonging to Benedictine monks of San Giorgio Maggiore in Venice (a deal during which the Mantuan duke put pressure on the chapter of the Abbey of San Benedetto in Polirone), as well as an ecclesiastic benefice connected with the church of Santa Maria in Cedole, near the birthplace of Virgil,[102] to his son Pomponio, an occurrence like that treated by Zapperi,[103] while the collections donated by Nicola Maffei and Nicola Avellani to the Mantuan dukes brought entrance and permanence in the court for their heirs.

It is not sensible, then, to reason in terms of patronage and not think that those bonds extended beyond artistic transactions. The cases are numerous and must induce us to examine closely the conditions, the circumstances, the relational capital, the contractual power, the family ties, the privileges, the endowments—in short, the biography—of those who were successively involved in the phases of negotiating and setting prices. In a given city, on a given day, for a given item, one could compare or contrast subjects with different stories, ends, and expectations, whose combinations could determine unrepeatable contracts that explain why a given piece could be sold for very different prices.

The Laws

The Birth of Cultural Heritage and the Impact of Preservation Laws on the Art Trade

THE TEACHINGS OF LEGAL HISTORY

The legal factors are essential to understanding the dynamics of the art markets, even if their modes and their spheres of influence have not been carefully studied, with the exception of rare and circumscribed cases. In fact there are ample and varied cases of legislative provisions and legal resolutions that have had a notable impact on these commercial equilibria, sensitive to minimal variations and supersensitive to major ones. That occurred because of the "saprophagous and saprophilous" nature of the traffic, which has always been nurtured by decomposition, and fibrillated whenever difficulties, traumas, and accidents struck individuals, classes, institutions, and territories.

Beside the *basso continuo* of ordinary transactions, in fact, the exchanges became effervescent and the demobilizations epoch-making when the "bodies" were boned and decomposed: whether that be social (the suppressions of the religious orders, the crisis of the aristocracy touched by the collapse of income from their land), political (the sacks, booty, and thievery of invading armies, from Rome to Mantua, and Napoleon to Hitler),[1] the contested dynastic changes, the confiscations from families banished or involved in real or presumed plots, the flights and exiles that followed coups, revolutions, and violent changes in the ruling classes[2] or expropriations from religious minorities (as happened to the great Jewish art dealers and collectors during World War II), cultural (the growth of bourgeois business, the birth of large national museums, or the arrival of North American buyers), economic (the bankrupts and financial crises), demographic (deaths of collectors), etc.

A more critical reader could object that in my reconstruction the conditions more favorable to the liberation, even if forced, of the works from their state of "captivity" in a collection and/or institution coincided, de facto, with an absence of norms or even—when these were present—with a suspension of the state of law and with patent violations of the norms ordinarily in force. This was true when the infractions occurred without extraordinary provisions having been adopted or promoted that authorized the abuse or legalized the misdeed, two rather common phenomena.

In reality in my statement there is no trace of the evil eye but an invitation to reflect on the nature and meaning of these forms of possession. Individuals and institutions very rarely

separated themselves spontaneously from the collections that they had built or had charge of, showing that they were not always susceptible to the song of the economic siren.

When artworks entered into collections they were subtracted from the world and the commonness of its circulation, often losing their original function and value. They were deprived so they could speak, and with great eloquence, of their new owners: the loss or suspension of their original function and value testified to the plentiful resources of the owner and his enviable ability keep them unproductive. The excuse of "investment" covers up the constant desire to show the world their own possibilities to de-accumulate, to disperse the productive resource *par excellence*—money—in the collection of useless and unproductive goods, which are reduced to signs of that which, from the economic point of view, the heirs who are disposed to sell have always enjoyed.

The law from this point of view is the system of rules that has regulated and regulates the playing of this exciting game. Even in less stormy times in fact, the legal debates and instruments conditioned the activity of intermediation and mobilization of single works and entire collections.

First of all, considering the weight of post mortem dispersion, the dispositions that modified inheritances[3] were determinant, whether they concerned the relative fiscal treatment (payment of inheritance taxes has often been a decisive stimulus) or they touched on the faculties of the heirs. In this regard, consider the limitations of a trust,[4] or the rights of the *majorat:* when the power of alienation of land and buildings was limited and could force the heirs to recoup by ceding the furnishings and when instead the limits included these latter, smuggling and the increase of value of the works left on the market were indirectly favored.

No less important were the rules regulating donations to individuals, museums, and philanthropic institutions and those that established conditions in cases of marriage, separation, divorce, adoption, and guardianship of minors. Last were the provisions that regarded intermediary activities, with the increase, lowering, or annulment of taxes on the sale, importation, exportation, and profits, and above all the complicated panorama of measures with which pre-unification and unified states controlled the cultural heritage by limiting or prohibiting its circulation or applying the right of preemption.

It would be fascinating to deal with all the facets of this question, but an entire book would not suffice, and so I have decided to concentrate on the last aspect, which has increasingly consolidated itself as the history of the means of protection[5] progressively freed from the scholarly veins that in the past considered it subordinate to criticism, conservation, or museum history. This is an important field, and I am convinced that it is possible to use it to define some tendencies in artistic commerce that have always been subject to the influence of provisions apt to favor the birth of new types of collecting, discovery of local markets or the re-placing of some critical fortunes. Even though not dealing with desired and instigated phenomena, one may not ignore them by presupposing their substantial neutrality or purely reactive nature given that in different forms, times, and modes, they caused rather important reactions from an economic point of view.

The notion of "cultural heritage" encompasses a heterogeneous set of goods that in the course of time and in the sphere of a historicization process, comes to be recognized as the conveyor of specific cultural traditions. It is considered reliable evidence of an accepted and unifying identity, as the traces of a past that deserves to be preserved from the destructive actions of time and mankind in the interest of the community. Cultural heritage and preservation laws are the obverse sides of the same coin. They recognize and legitimize each other, and cannot therefore be analyzed separately.

It is redundant to state that the study will not be easy to carry out because while terms such as history, historicization, identity, tradition, memory, collectivity and preservation are not always clear nor universally accepted, the outcome of their lengthy superimposition and juxtaposition makes them even more complicated; these concepts have undergone considerable modification in the past five centuries, and still carry different connotations, making life difficult for those who would try to sort them out.

TIME, HISTORY, AND HISTORICIZATION PROCESSES

The two words defining cultural heritage, "culture" and "heritage"—meant here in the sense of patrilinear inheritance—are both the products of time, and are therefore subject to historical and philosophical judgments.

While the intellectual community nowadays attaches equal importance to every history and to every artifact expressive of a material and intellectual manifestation, a few years ago this was not so. It is sufficient to consider the long *damnatio memoriae* of the Middle Ages, to criticize the seventeenth century as dissolute and unwarlike, and to neglect the cultures of so-called "underdeveloped countries" or "primitive people" to realize my point. These positions were not only translated into precise historiographic and philosophic predilections or repression, but also into concrete acts of preservation or destruction of documents, artifacts or evidence dating back to the aforesaid periods. Preferences, aversions, and intellectual trends, although subjective, decided their destiny.[6]

In this regard, the idea of cultural heritage is not only an entity that is materially residual and saved by chance, between inertia and mischance, from the damage of time and human fury, but also the result of processes that are culturally known and modeled by preferences that exalt or play down "documentary" importance more than the artistic or cultural relevance of certain goods. In Italy during the sixteenth century, the point in time that determined the recognition of the "antiquity" of an object, and called measures of protection into play, was "the age of Constantine." It was therefore possible to melt down medieval coins and to demolish Romanesque buildings without difficulty. Similarly, in the first half of the nineteenth century, the preference for political and diplomatic history led some archivists to destroy important funds dedicated to out-of-fashion historiographic subjects or to periods considered unworthy of attention by the most authoritative scholars.[7]

These cases are not just the sad prerogatives of remote times:[8] This was an extremely uncertain debate, fragmented by contradictory trends and by the absence of precise disciplinary limits. Not only did the various historiographic and philosophical schools express contrasting and changeable judgments, but their own "technical" appendices, history of art and aesthetics, struggled to impose themselves as branches of disciplines worthy of the attention.

THE NOTION OF IMPORTANCE AND THE HYBRID AND AMBIGUOUS CHARACTER OF NOTIONS OF IDENTITY, COLLECTIVE INTEREST, AND PUBLIC WELFARE

The presence of multifarious and changeable critical positions was reflected in the formulation of notions of "importance." In Italy, for example, where the problem of abundance, almost an excess of cultural goods, has been felt for almost six centuries, this question was particularly dramatic. What should be preserved and safeguarded? What criteria should be adopted to define a good as worthy of protection, deserving to be saved from the dangers of time and mankind in order to perpetuate its memory?

Today the "dignity of preservation" has become almost all-inclusive because the border of the past is always nearer and history is increasingly contemporary. Until the nineteenth century, however, the relativism of judgments, the instability of theoretical trends, and the presence of several schools of thought determined highly prejudicial or preservatory actions. Suffice it to think of the destruction of enclosure walls, fortified citadels, and historical urban centers perpetrated in the name of architectural and civil progress or think about the obstacles that the legislators encountered in protecting natural areas and landscapes (they succeeded only in 1922,[9] after some horrendous acts, the first of a long series, had already been committed), to realize the centrality of the problem, which was not dealt with equally quickly in all the geographical contexts.

Reviewing the chronology of protectionist provisions, we see that the earlier ones were introduced by the Pontifical State in 1425, in the Tuscan Grand Duchy in 1571, in the Kingdoms of Naples and Sicily in 1755, in the Duchy of Parma in 1760 (after Philip of Bourbon had authorized the sale of Raphael's Sistine *Madonna* [1754] to August III of Saxony), in the Lombard territories in 1745 and the Venetian 1773, in the Duchy of Massa in 1818, in Lucca in 1819, in the Sardinian Kingdom in 1832, and the Duchy of Modena in 1859. Thus the imbalances between politics of intervention and the uncertainty with which a more stable notion of "relevance" resistant to historiographical fashion, intellectual caprices, juridical cavils, and commercial pressures become obvious.

The more interesting fact lies in the different answers to the single question: While certain states (such as the Papal one) adopted a policy of systematic preservation, using an almost all-inclusive criterion of judgment (as early as 1624 the regulations included figures, statues, antiquities, ornaments, ancient and modern works in metal, marble, and other stones), other territories (such as the Grand Duchy of Tuscany and the Lombard-Venetian territories between Sette- and Ottocento) resorted to extremely ambiguous criteria that paved the way for endless debates.

What were to be considered "excellent goods"? What criteria could define the "highest interest," considering that it was not only artistic (in a phase in which the term "art" was not clear) but also "historiographic"? In the understandable and not completely unwelcome confusion that emanated from these various interpretations, the final purpose of every safeguard policy remained unchanged: It was to guarantee to posterity the fruits of a heritage that established identity—if not national, at least civic or dynastic—and thereby preserve "the interests and the memory of the collectivity" and the "public welfare."

These were extremely vague concepts. What idea of regional or national identity could there be in a territory such as Italy, characterized by secular autonomies, blatant parochialism, exasperated localism, and very different, but vital, traditions. Was it possible to talk about

collective interests and memories, or of public welfare in pre-unitary states where monarchies shared their power with the aristocracy and the clergy, where "collectivity" was represented by only a small portion of the whole population?

The answer could be negative. The "public welfare," the "collective interest" of sixteenth- to nineteenth-century measures coincided with the interests of the prince, the patrician oligarchy, the church and its class of allies: they were closer to the *publicum decus* of Latin jurisprudence than to subsequent twentieth-century interpretations. Cultural heritage was in fact the heritage of the aristocracy and the clergy, who "made" the history whose memory and image they wanted to impose and preserve. This explains the iconoclastic fury[10] that nearly always characterized popular insurrections of political or religious nature and the proliferation of preservation measures in periods when the ruling classes felt threatened.

I think it is no accident that preservation laws mushroomed and became stricter when the institutions that held power perceived their own vulnerability, signs of their decline, and the emergence of new social and political forces, as one can see by reading table 19, which gives the chronology of regulations in some pre-unification states.

The coincidence and the chronology are not surprising: the preservation laws were the first legislative measures taken by governments constituted after traumatic events (for example the Counter-Reformation). These observations force one to consider the transformations that accompanied, and still characterize, the phases of transition from one sociopolitical and institutional structure to another, while keeping a weather eye on diachronics and caesura.

THE PRECOCIOUS ITALIAN CASE, THE JURIDICAL PRECEDENTS, AND THE FIRST PRESERVATION LAWS

What is particularly surprising about the Italian case is the early emergence of the preservation issue and the "modernity" of the measures taken. Taking into account the laws promulgated, what immediately stands out is the importance attached to the heritage of monuments, the regularization of archaeological excavations and findings, and urban preservation, which show that the gravity of the threat was perceived as early as the first decades of the Quattrocento. The factors that determined the adoption of these measures were numerous and heterogeneous. First of all there were merely practical reasons. Up to the first years of the sixteenth century, after Bramante's interventions ("maestro ruinante"), ancient artifacts were normally used in building, since the popes authorized their architects to use all the stones and marble[11] that could be taken from the ruins of ancient Rome, save only the items that bore inscriptions. Thus it is not surprising that in 1519 Baldassare Castiglione and Raphael sent a heartfelt appeal to the pope to curtail[12] this practice, as they had observed the architect "of the temple of St. Peter" and "all this new Rome that now can be seen, vast, beautiful, ornate with palaces, churches and other buildings, has been created with the mortar made from ancient marbles."[13] The phenomenon was assuming worrisome proportions, adding to the effects of the devastation perpetrated between the thirteenth and the beginning of the fifteenth century. During the "captivity of Avignon," Roberto, King of Sicily, brought an incredible amount of stones, marbles, and statues to Naples; with the material taken from the Colosseum several Roman churches were built, and beautiful remains of temples and buildings were pillaged to erect new edifices.[14]

Table 19. The Chronology of Regulations in Some Pre-Unification States

Sardinian Kingdom	Duchy of Parma	Duchy of Modena	Lombard-Venetian Territories	Tuscan Grand Duchy	Duchy of Massa	Duchy of Lucca	Pontifical State	Kingdoms of Naples and Sicily
1832	1760	1859	1745	1571	1818	1819	1425	1755
1818		1773	1597			1515	1755	
1822		1773	1597			1534	1766	
1856		1778	1600			1562	1769	
		1791	1602			1574	1802	
		1796	1602			1624	1813	
		1802	1602			1646	1822	
		1804	1602			1686	1822	
		1804	1602			1701	1824	
		1808	1602			1704	1827	
		1809	1603			1717	1830	
		1812	1603			1726	1839	
		1813	1610			1733	1839	
		1815	1610			1750	1843	
		1816	1744			1801	1851	
		1816	1750			1802	1860	
		1816	1754			1803		
		1817	1761			1819		
		1818	1766			1820		
		1818	1780			1821		
		1819	1781					
		1827	1781					
		1833	1782					
		1834	1791					
		1846	1816					
		1846	1818					
		1846	1819					
		1849	1819					
		1849	1854					
		1851	1857					
		1857	1859					
		1860	1860					

Cultural influences were also important. At the same time that the renaissance in classical studies reaffirmed the value of ancient ruins and objects and gave them the status of cult objects and collectable items,[15] the long-buried traces of Latin jurisprudence were resurfacing. Reconnecting the threads that joined the capital of the caesars with the city of the popes, the urtexts of Roman law were rediscovered,[16] and Latin picture-galleries and public libraries were exalted in the *legatum ad patriam* (a sort of donation to the state).[17] Furthermore, magistracies that had disappeared for centuries reappeared. The official in charge of disciplining urban matters, reintroduced by Martin V in 1425 with the bull *Etsi de cunctarum,* the so-called *Maestri delle strade* (Masters of the Streets)[18] had the same functions as the *Comes nitentium rerum.* Equally the bull *Cum almam nostram Urbem,* written by Pius II Piccolomini 28 April 1462, forbade "under pain of excommunication, jail and confiscations, the demolition, reduction, ruining, or destruction of monuments and ancient ruins," while the bull *Cum provida Sanctorum Patrum decreta* by Sixtus IV della Rovere in 1474 forbade taking works of art out of religious buildings.[19]

However, the heaviest burden of the heritage—which has always influenced the Italian legislative debate, which is particularly sensitive to the Latin jurisprudential tradition—was the introduction of "privately oriented" regulations. The Roman juridical exception, for example, consisting in the notion of "highest public interest," contributed to the safeguard of the monumental heritage, which could considerably restrict the rights of individuals. Only on 10 October 1574 did Gregory XIII Boncompagni with the bull *Quae publica utilia* succeed in affirming the primacy of public interest over private, contrasting the initiatives supporting *privatis cupiditatibus et commodis.*

This renewed sensitivity would have to face two new phenomena beginning around mid-Cinquecento. The first of these was the increase in the collecting spree throughout Europe, which combined the most traditional branches (numismatics, medals, epigraphics, sculpture, plaster casts, vases, glassware, cameos, bronzes, accessories and jewels, etc.) with a marked interest in contemporary productions (paintings, engravings, jewels, tapestries, glass and ceramics, engravings, etc.). The second phenomenon was the emergence of artists recognized as having reached the same level as the ancient masters: Their followers surpassed their masters, giving birth to a new tradition.

Needless to say the vast majority of European collectors saw that Italy was a treasure trove: the obstacles that Francis I, King of France,[20] had to overcome in order to buy the works of Italian painters show the ruthless competition and intensity of desire. For the first time, on 24 October 1602, by explicit order of the Grand Duke of Tuscany, export of the works created by seventeen "deceased painters"[21] from his territory was prohibited and on 6 November of the same year Pietro Perugino was added to the list. This measure not only listed the names of the artists whose works were considered "inalienable," but also provided an institutional framework for the preservation mechanisms. A special board was appointed (made up of twelve members of the Drawing Academy) to be in charge of the evaluation and possible granting of export permits, establishing the limits and parameters of their activity (permits for the works of living painters were automatically granted, their export being encouraged by the abolition of custom fees), sanctions for offenders, and bonuses for the controllers.

If, however, one excepts the pontifical efforts, which continued with the measures taken by Paul III (1534), Pius IV (1562), Gregory XIII (1574), and the Medici popes, the awareness of preservation was not equally distributed in the Italian states, and there were different opinions about the preservation of certain categories of goods. Beside the early measures taken in the

Papal State and in the Grand Duchy of Tuscany, there are cases of late or heterogeneous adoptions: the Savoy states passed the first safeguard laws in 1832, while the Este duchy introduced them only in 1859.

The effects of this phenomenon may easily be imagined, since up until the first protective law of 1902, and as regards exportations through the provision-chain, up until the reorganization of 1909, the coexistence of systems of differing rigor and with different measures of judgment created "free areas" a few miles away from the borders of states where prohibitions were in force and more or less strict controls were made and goods could be sold and exported that in other places were more closely protected.[22]

Thus the strategies of market agents changed, ready to take advantage of the juridical inconsistencies to make their deals,[23] and that determined the growth or stagnation of sectors connected to the art market (restoring, painting, and printing of copies, reproductions, and forgeries).[24]

Thus, by virtue of the indulgence of its laws, the Republic of Venice remained the main Italian center for art commerce in the seventeenth and eighteenth centuries,[25] and only regulations made by the Austrian government in 1818 and 1827[26] succeeded in braking the leaps of the Venetian merchants and collectors.[27]

But there were several reasons for the blatant difference in conditions in areas so close to each other. On the one hand, some secular governments lacked the authority, the coercive power, and the network of officials; on the other hand, these governments were often the first to abuse their position in order to demolish or pillage as they pleased. In several principalities and seignories, the weakness of the central powers and a precarious political balance restrained rulers from punishing too severely infringements committed by members of the aristocratic class. The aristocrats therefore continued to have at their disposal the architectural, archaeological, and movable heritage of private individuals or public institutions.

It should not be forgotten that the protective laws did not stop at blocking already compromised situations but also determined the creation of new genres of collectors and new sectors of commerce, which rose to work with the juridical inconsistencies: in this way commerce and taste, trade and connoisseurship influenced each other, and legal provisions did not stop with chasing the headlong rush of connoisseurship, de jure sanctioning the de facto developments. On the one hand the regulations recognized the value of products, genres, and periods and on the other stimulated art merchants and collectors to discover new ones; once a sector was "closed" and protected, they started to search for and poach new items that were not mentioned in the lists of banned goods.

If there were laws inhibiting or prohibiting the trade in Renaissance masterpieces, it might be convenient to sell and collect primitive or "contemporary" works. If the sculpture sector was "closed" by new juridical measures, prints and drawings could offer both economic and aesthetic satisfactions. Similarly, if it was becoming more and more difficult to obtain Magna Graecia ware, this was not true for fifteenth- or sixteenth-century pottery, and so on.

Thus preservation laws not only "certified" the value of certain categories of potentially collectible objects, but considerably affected the process of intermediation and of price formation by creating artificial conditions of scarcity that brought an increase in costs (tied to eluding the protection system) and incited thievery and forgery, by compelling market agents to focus on new, and previously neglected, market niches.

WERE THESE FEARS GROUNDED? THE SITUATION IN THE
SEVENTEENTH AND EIGHTEENTH CENTURIES

How justified were the voices that railed against the rapacity of foreign collectors (a term that, at that time, included those Italians living in different regional states), lamented the pillaging by "ruthless" merchants and "shameless" owners, and stigmatized the frequency of thefts and desecration?

These fears were largely justified from the beginning of the seventeenth century; in this sense, the large sales by the aristocracy were the first signs of a vaster process of dismantling: in 1628 Charles I of Nevers, eighth Duke of Mantua, sold ninety paintings, 191 busts, statues, heads and other objects to Daniel Nys,[28] followed by Francesco III Este, Duke of Modena, who sold the best works of his famous picture-gallery to August III of Saxony.[29] Nevertheless, the beneficiaries of these sales, which also involved relatively minor collections, were not always foreigners, considering the vivacity of Italian collectors in this period.

The real enemies were the passing of time, the negligence of the Italian people, and the first signs of the declining authority and economic strength of the aristocracy, the clergy, and those institutions such as hospitals, universities, orphanages, charitable institutions, colleges, boarding schools, etc. that were often in possession of priceless artistic goods.

In comparison with these fine cracks, the examples given by the constitution of the Capitoline Museum inaugurated by Papa Clement XII in 1734 with the donation of the Albani collection, and purchased by the pope to prevent its exportation, or by the family pact of 1737 that forbade the exportation of the Medici collections of the grand duchy, determined the nature of the museums (without transforming them into deposit structures, like the Capitoline). The Ercolano excavations began in 1738 by Charles Bourbon show that it was possible to avoid the dispersion of important collections, introducing the right of preemption on the sale of public and private properties and restoring some space to the legal argument.

In 1704 the pontifical lawmakers included manuscripts and public or private archival funds in the list of protected categories. In 1707, 1717, and 1733 the regulations imposed by Cardinal Spinola extended the export prohibition to foreigners, introducing for the first time the important distinction between "rare items for art and erudition" and items that did not possess the requisite of "rarity."[30] In 1750, the Valenti edict banned "the commerce of forged items at the expense of the good faith of foreigners and to the discredit of public trade."[31]

The other states did not remain idle. The Austrian territories of Lombardy had already introduced strict measures in 1745. On 18 April 1754, the famous Leopoldina Law was promulgated in the Grand Duchy of Tuscany, followed in 1755 by the Prammatica LVII of Charles III, King of Naples and Sicily.[32] In 1760 came the turn of the Duchy of Parma, followed in 1773 by a measure taken in Venice by the Consiglio dei Dieci, which introduced the listing of the most important paintings of the town in a specific inventory.

The problem, however, lay in the limited criteria of restriction, which did not cover equally the public and private arenas, but in the first instance tried to protect the interests of the reigning houses. By way of example, *il Motu proprio*, with which Pietro Leopoldo liberalized archeological excavations in Tuscany on 5 August 1780 and "the extraction from the state of antique monuments, coins, and other precious antique items,"[33] found a surmountable obstacle in the contrasting opinion of the director of the Royal Gallery, "charged with knowing what could be worth acquiring for the Gallery, and from our Taxes will be paid a price strictly corresponding to the rarity and beauty of the monuments."[34] Not a fine-toothed comb, if,

as Fabia Borroni Salvadori observed, the director of the Royal Gallery and his collaborators authorized the exportation of more than three thousand paintings, innumerable copies, and some hundreds of sculptures[35] between 1760 and the early nineteenth century.

These initiatives, far from striking the interests of private citizens, had the aim of protecting the dignity of ecclesiastical bodies and organizations, slowing exportation, and regulating the very relaxed[36] commercial practices in a phase in which there were centrifugal forces, welcomed by traffickers, surrounding the suppressions of the ecclesiastical institutions—from the reforms of Empress Maria Theresa of Austria in 1760 to the expulsion of the Jesuits in 1764, from the Leopoldine suppression of the 1780s[37] to the reforms of Joseph II of Austria in 1792—putting onto the market many copies from antiquity, paintings, sculptures, books, manuscripts and codes, musical instruments, sacred ornaments and vestments, often of excellent quality, and enlivening the commercial picture of the late Sette- and early Ottocento.[38]

As the individual chronological coincidences confirm, this was a chain reaction that the Italian states could not avoid: collectors and art dealers were amazingly quick to take advantage of imbalances in national rules. This preoccupation explains the strict measures taken by the police to staunch the "hemorrhage" of works of art. However, a settling of accounts was drawing near.

The revolution and Napoleon disturbed the European elites for more than fifty years. These events struck the unprepared and incredulous institutions that had firmly held the reins of political, religious, social, and economic order of the old continent for more than five centuries. Monarchies, aristocracies, religious institutions, magistracies, corporations, moral institutions, and so on were crushed by the first popular insurrection on a European scale. The effect of their collapse on the cultural heritage was immediate and perceived in all its dramatic aspects, as a vast number of studies confirms.[39]

After a century of "playing at war" the French began to play seriously. The abolition of trusts and *majorat,* the confiscations, thefts, special taxation, and ransoms displaced goods that had remained in the same hands for centuries. The severe economic crisis and the inflationary phenomena did the rest: antique households were forced to cede their treasures, venerable institutions were denuded of their belongings, *homini novissimi* strode the turbulent stage of European collecting.

The fear and amazement of events between 1790 and 1815 were enormous and help to explain the intense legislative activity that almost immediately followed the reestablishment of order. Out of this came the first organic provisions to protect the cultural heritage. In the Papal States the famous *Chirografo* of Pius VII was sent to the press in 1802, followed in 1819 and 1820 by the edicts of Cardinal Pacca. The Duchy of Lucca adopted similar measures in 1819, as did the Kingdoms of Naples and Sicily (which also controlled from 1847 the former Duchy of Parma and Piacenza) in 1822, the Lombard-Venetian territories between 1815 and 1819, and the Savoy state in 1832.

The problem now was not to oppose single adversaries but rather to prop up the shaky structure of the pre-Revolutionary powers. The material appendices that had for centuries protected and exalted their image now seemed impelled by irresistible forces towards fractioning, flight, and decline.

What impression would believers have, on entering a church deprived of its huge paintings, statues, altars, sacred ornaments, and ex-votos? What would be the feelings of those who, visiting the dwellings of aristocratic families, noticed the progressive disappearance of paintings, tapestries, libraries, furniture, cabinets of antiquities, china, and silverware?

These anxieties explain the strictness of the regulations introduced in the sixty years preceding the unification of Italy (1860). First of all, besides the strengthening of the juridical devices that regulated archaeological findings and excavation activities, the limits of preservation and safeguard were extended to categories that had previously been neglected. Such was the case of ancient books, manuscripts, incunabula, codexes, and public and private archival-documentary material, which were protected by the measures introduced in the Papal States in 1819 and in the Lombard-Venetian territories in 1804, 1815, and 1817.[40]

The inspection activities and the controls on the existing heritage were reinforced. Following the Venetian example of 1773 and the Milanese one of 1804, new projects of cataloging the most valuable heritage items were carried out, strengthening the police power of the officials in charge and sometimes instituting compulsory notification, which was introduced in the Duchy of Lucca in 1819 and the Papal States in 1820. By this method, officials could describe the antique objects "of singular and famous value" owned by individuals in order to compile an inventory in duplicate, to avoid the sale or damage of items included in the list, and to limit the actions of the owners.

These measures led to the institution of a central bureaucratic body, to the creation of peripheral ones that superintended specific geographic areas, and to the reinforcement of those institutions responsible for supervision, evaluation, and control. Academies, libraries, special commissions, and peripheral delegations had their powers considerably extended even if they were not given the means and infrastructure to cope with their titanic new duties. Similarly, the police forces responsible for the repression of smuggling and illegal trade were enlarged,[41] and the sanctions against lawbreakers made heavier. The 1802 edict of Cardinal Doria Pamphili threatened substantial pecuniary penalties, as well as contemplating periods of imprisonment of up to five years, extending the penalty to those who cooperated in the export of protected goods from the pontifical states: porters, carpenters, carters, muleteers, and boatmen.

Museum acquisitions were favored thanks to the strengthening of the preemption right granted to public institutions, the creation of special funds for the purchase (article 17 of the Doria Pamphilij edict had destined 10,000 piastre, a considerable sum) of goods that belonged to moral and religious institutions; the sale of these goods to private individuals was prohibited or restricted. Moreover, the authorities managed to perfect those juridical mechanisms that prevented heirs from selling or dispersing private collections. There was more control over sales[42] ordered by the courts and on those institutions such as pawnshops that were forced by statutory obligations to sell the movables in their possession in order to collect debts.

There was then a somewhat vain attempt at scrupulous regulation of commercial activities, establishing the rights and duties of those operating in the field and regularizing the delicate matters of export and the circulation of goods within national borders.

Nearly all the states introduced very strict regulations that underlined the validity of an unwritten law well known to historians of law: The rigor of the rules and the frequency with which they were emanated constituted a proof of their carelessness, a tangible indication of the difficulties to be had in countering a phenomenon of irresistible force and proportions. They published lists of goods in which trade and export were prohibited, lists like the *Chirografo* of Pope Pius VII in 1802, which was imitated by several other Italian governments, included statues and bas-reliefs in marble and enamel, Latin and Greek frescos, mosaics, vases, glasses, engraved gems and stones, cameos, medals, bronzes, Latin inscriptions, candlesticks, cinerary

urns, olla, sarcophagi, pottery, columns, capitals, architraves, frames, marbles, lapis lazuli, alabaster, porphyry, granite, basalt, serpentine, any similar material except white marble, and paintings on panels and on canvas.

Further, the lawmakers compelled art dealers, collectors, institutions and "privileged," "very privileged persons," clergy, and charitable institutions[43] to apply for an export license for every transaction, including those relative to the sale to citizens resident in the same state. This license was granted or refused by collegiate commissions created to evaluate each request for export, and it implied compliance with strict procedural rules. For instance, works that could be exported had to be packaged and sealed in the presence of officials who would also stamp and countersign the customs passes. Finally, several states appealed to customs policies, imposing particularly substantial tax rates on certain categories of goods, an element that, besides favoring illegal practices, introduced a patent conflict of interest.

The Pacca edict in itself, though forbidding the sale of antiquities, allowed the concession of exportation licenses for the works on which a tax equal to 20 percent of the declared value had been paid, which certainly did not encourage inspection procedures.

These decisions were not taken lightheartedly: Italian governments were extremely worried about the severe and chronic indebtedness of state finances and were aware that the fiscal revenues coming from the art trade represented a crucial heading in their exhausted budgets. Moreover, there was a legitimate fear that excessively discriminating measures[44] could reduce or stop the flow of foreign travelers who not only contributed substantially to the economic prosperity of the tourist/service sector (and their contribution was more important than what could be naively considered) but often came from nations with whom diplomatic relationships were as delicate as they were crucial to the maintenance of often uncertain balances.

But there were other elements that acted to disturb the situation. The first was represented by the discretionary power of the parameters adopted by the examining commissions. In order to accept the demand of art dealers and to satisfy the requests of wealthy collectors, parameters such as "supreme interest," "highest value," or "rarity" were introduced, establishing parameters that were as empirical and they were debatable, and whose terms of comparison were often in the quality of the works present in the princely and state collections that had the right of preemption; it is not fortuitous that Enrico Stumpo has found in diverse cases judgments analogous to those in which Florence in the 1820s authorized export licenses based on the "fact that having seen the painting here described, I do not find it fitting for the Royal Gallery."[45]

In the absence of solid historical and aesthetic criteria, the arbitrariness of decisions was obvious; for example, the authorities did not include prints, engravings, and drawings in the sphere of highest values, nor the works of the so-called primitive painters, that is to say the artists operating before Raphael. Thanks to this kind of carelessness, the Berlin Museum could acquire and export Edward Solly's famous collection of master paintings of the Quattrocento with laughable ease in 1821—just one of the many cases.

THE EFFECTS OF THE REGULATIONS: SOME EMPIRICAL FINDINGS ON NINETEENTH-CENTURY TRAFFIC

What were the effects of the various regulations? To estimate the efficacy and measure the impact of the legal and illegal intermediations I have tried to quantify the flow of exportation and importation, using a known source: customs data. Used for the first time by Ian Pears, for his book on the diffusion of painting collections in eighteenth-century England,[46] these data have in time found other readers.[47] Unfortunately the analogous Italian pre-unification sources, with the partial exception of the series collected in the Kingdoms of Naples and Sicily,[48] have not yet been carefully studied, and the twentieth-century syntheses give us indications that are not very useful,[49] because of the lateness in compilation, the lack of apt specifications (the pontifical customs registers contemplated only a generic heading "beautiful works of art" expressed in monetary value), and the little attention paid to available sources in the Central Archive in Rome. While waiting for the results of Enrico Stumpo's research, I turned to foreign sources, and especially the English, which represent a sample indicative enough both in the accuracy and systematic quality of the information, and in the large number of collections that were built there in the nineteenth century.[50]

Reading the registers concerning the importation into Great Britain from the Italian states between 1800 and 1899 in the Public Record Office at Kew, we find that customs listed more than forty categories of collectible goods and artistic manufactures: ancient vases, arms, armor, artworks in metal, snuffboxes, books printed before and after 1801, manufactures of brass, bronzes (figurines and ornaments), cabinet wares, cameos, carpets and rugs, casts, china and porcelain, clocks, copper objects, crystal, drawings, earthware, furniture, frames for paintings, silvered glass and mirrors, jewels, scientific instruments, Magna Graecia wares, manuscripts, maps and charts, medals, minerals and fossils, musical instruments, pictures and oil paintings, plate silver, prints and drawings, engravings, precious stones, stones, marble, statues (busts of bronzes, busts of marble), tapestries, and watches.

These categories were further subdivided into subsets that give a surprising cross-section of the variety and grades of differentiation of products and the evolution of tastes, visible in the continuous adjustments in the categories of merchandise, which is the reason why I emphasize the limits of this otherwise precious source. There is hardly ever any distinction between antique and modern works (up to 1819 the books were listed as bound or unbound, while the heading "manuscripts" appears only in 1826, and is described in units of weight);[51] there are constant variations in criteria of denomination;[52] the information was subject to the owners' and shippers' tricks meant to avoid the tax (piling canvases together, for example, or falsifying the dating);[53] and it does not include shipments from neighboring ports (Malta, Corsica, southeastern France) or lots that arrived from other places (many travelers continued their grand tours in other areas of the Mediterranean region).

Nevertheless, the elaboration of the customs data gives interesting indications. Apropos of this, even though I transcribed the data relative to all the categories mentioned above, which if considered as a homogeneous group give a realistic and impressive idea of the amount of traffic (the sum of exportations of *objects d'art* was in sixth or seventh place among the headings), I intend to draw the reader's attention to table 20, in which I have recorded the quantities of prints, engravings and drawings, antique books, and paintings imported into Great Britain (not into the United Kingdom, which at that time also included Ireland) from four states

Table 20. Quantities of Prints, Engravings and Drawings, Antique Books and Paintings Imported into Great Britain from Four Italian Pre-Unitarian States between 1820 and 1870

Year	paintings				prints, engravings, drawings				antique books			
	Lombard Venetian territories	Tuscan Grand Duchy	Pontifical States	Kingdoms of Naples and Sicily	Lombard Venetian Territories	Tuscan Grand Duchy	Pontifical States	Kingdoms of Naples and Sicily	Lombard Venetian territories	Tuscan Grand Duchy	Pontifical States	Kingdoms of Naples and Sicily
1820	57	429	9	36	41	7,612	709	1,544	829	7,805	760	1,822
1821	9	331		75	7	9,802		1,125	2,248	12,265	7	1,641
1822	154	316		38	247	6,609		661	486	8,514		21
1823	25	294	3	91	357	4,826		560	284	7,944		1,158
1824	45	407		52	82	23,927		950	786	11,647		666
1825	70	550		30	14,814	30,079		2,172	4,694	25,619		32,846
1826	76	680		131	607	28,326		1,355	525	5,703		850
1827	375	768		197	182	22,388		1,153	475	10,830		750
1828	100	1,681	3	127	384	15,017	696	3,448	284	9,948	27	1,126
1829	142	1,933		105	51	30,319	133	2,603	989	9,233	28	712
1830	77	1,678		266	5,916	44,298		3,424	1,694	8,977		269
1831	319	1,204		151	656	20,883		2,381	315	14,633		245
1832	254	1,114	74	214	1,435	19,004	446	3,724	123	8,204	1,085	1,950
1833	134	1,355	6	315	701	22,331	445	5,722	4,059	8,235		450
1834	177	1,511		156	847	20,552	63	3,362	2,130	9,444		627
1835	158	1,346		299	877	19,736		4,848	6,386	6,588		282
1836	803	1,820		331	1,876	34,061		3,280	2,125	9,563		61
1837	550	2,216	23	319	714	17,802		2,932	4,175	8,155		243
1838	69	2,206		339	915	22,071		2,269	7,746	10,328		755

Year												
1839	170	2,791	10	439	948	17,169	125	9,521	702	28,229		1,718
1840	173	3,407	109	798	1,043	35,116	232	2,831	1,726	10,214		2,483
1841	813	2,827	104	313	576	9,583	50	1,690	2,081	7,553		4,491
1842	188	2,699	19	239	966	18,891		4,456	583	8,041		281
1843	221	2,077	26	333	529	36,815	361	2,758	1,419	4,598	274	520
1844	114	2,442	23	264	1,153	36,049	3	3,174	1,606	8,623		945
1845	205	3,079	2	442	1,241	50,120		5,182	3,116	6,375		240
1846	108	3,104	26	351	583	30,813	467	4,989	1,822	17,000		963
1847	216	2,310	160	798	2,293	33,694	6,138	5,012	6,642	15,539	2,156	1,307
1848	115	1,765	71	219	255	17,009	9,373	1,362	743	3,684	1,071	15
1849	169	1,146	36	85	966	10,392	7,699	582	829	1,781	476	21
1850	114	1,045	2	175	2,106	17,764	689	2,441	287	2,556	28	833
1851	81	2,731	3	200	631	25,551	1,071	2,542	91	6,962	33	187
1852	239	1,243	37	241	994	14,343	2,182	2,833	2,111	14,592		1,227
1853	86	1,139	1	196					11	5,663	9	7
1855	111	2,667	1			7,263		570		9,821		17
1856	272	2,307		147	30	11,760	1	23	300	4,196		
1857	139	2,752	2	188	1,050	10,260		39	32	3,544		
1858	1,502	1,887	65	150		12,240		480	647	6,409		49
1859	77	2,426	1	89	1,770	11,340		14	42	3,295		
1860	101	1,451		70	1,230	9,540		3	356	1,667		
1861	13	1,447	30	82		4,620		30		105		84
1862	60	1,212	8	119	5,386			265	52	10,266	84	1,090

(continued on next page)

Table 20. Quantities of Prints, Engravings and Drawings, Antique Books and Paintings Imported into Great Britain from Four Italian Pre-Unitarian States between 1820 and 1870 (continued)

Year	paintings				prints, engravings, drawings				antique books			
	Lombard Venetian territories	Tuscan Grand Duchy	Pontifical States	Kingdoms of Naples and Sicily	Lombard Venetian Territories	Tuscan Grand Duchy	Pontifical States	Kingdoms of Naples and Sicily	Lombard Venetian territories	Tuscan Grand Duchy	Pontifical States	Kingdoms of Naples and Sicily
1863	74	1,126		189	38	1,275		814	202	5,775		508
1864	114	1,227	16	510		2,267		4,566	1,534	8,918		1,309
1865	85	990	18	208		2,906		320	0	7,227	356	2,274
1866	134	810		118	4,888	3,211		309	496	13,423		2,899
1867	309	1,419		116	7,310	6,330		719	1,215	6,311		2,050
1868	68	1,710	40	192	5,919	2,509		371	390	5,924	421	593
1869	116	708		116		1,537			708	9,232		12,626
1870		444										

Note: The books printed before 1801 were considered *"antique books"* by custom officers.
Source: Public Record Office at Kew, London, Series Customs, nos. 4 and 5, Microfiches from 1820 to 1870. The register 1854 was not found.

of the ancien régime—the Grand Duchy of Tuscany, the Pontifical States, the Kingdoms of Naples and Sicily, and the Lombard-Venetian territories—between 1820 and 1870.

The correlation between strictness of preservation policies and dispersion rate is noticeable: during this period the Grand Duchy of Tuscany adopted a relatively "open" policy, protecting only the highest expressions of traditional collecting (old master paintings, manuscripts, medals, sculpture, ancient coins); the Lombard-Venetian territories and the Kingdoms of Naples and Sicily an intermediate one, favoring importation from abroad, encouraging exportation of contemporary production and not impeding internal transactions while still trying to discourage the flight of more antique works and not lose sight of financial needs and agreements of a diplomatic nature, while the Pontifical States had the strictest and most severe protection system.

The consequences are before the eyes of everyone. If it is true that a minor portion of the pristine wealth has remained in Tuscany and in the Venetian region, compared with the holdings in the areas that pursued shrewder strategies, even if the economic consequences of the "promotion" exercised on the critical fortunes of the works from the more porous and sacked territories have yet to be verified, these fortunes would have reverberated in the amount of contemporary production. This point is controversial, since the direct promotion exercised on foreign markets by the facility of exportation of certain objects was contrasted by the indirect, and delayed, influence ensured by the more careful protection. The safeguarding of the originals, combined with the public nature of visibility guaranteed by museum access, in fact favored a vast production of copies, reproductions, and "objects in style," stimulated interventions of conservation, and made famous our long-lived industry of fakes. These sectors could count on the desires of thousands of intermediaries, institutions, and collectors to have works whose circulation was restricted, by producing a great number of forgeries, not just of paintings and antiquities, but also furniture, furnishings, arms and armor, prints and engravings, bronzes and goldsmith works.

The facts are in themselves important, equal to the indications of the growing value of single categories of collectables that can be inferred from the average prices declared by the customs officers. From 1815 to 1860 the value of every Italian painting imported into Great Britain oscillated between 2 and 3 pounds sterling (in 1860 the 1622 paintings imported were valued at 3,244 pounds, or an average of 2 pounds each), in 1862 this figure rose to 9.3 pounds (1,399 paintings at 13,047 pounds), in 1864, 10.28 was reached (1,867 for 19,210 pounds), in 1865 it skipped to 23.12 (1,301 for 30,084 pounds), and in 1866 it was at 27.65 (1,062 for 29,373 pounds). The undeniable growth reached notable heights in other sectors (for example prints and drawings, sculpture, Greek, Roman, and Etruscan vases, gems and antique arms, books published before 1780, and manuscripts) and cannot be related to inflation, given that in this period prices rose at a much slower rate and paintings certainly did not make up part of the "basket" on which long-term variants are calculated.

The method could obviously be perfected, but, barebones as it is, the collation of the data present in other lists would give us more pregnant measures: elaboration of the information from the French, Swiss, Austrian, and American customs (just to cite a few examples)[54] would let us estimate the quantity and value of our export flow in the century that may have seen the financing of the industrial takeoff by selling the family jewels.

THE FAMILY JEWELS AFTER UNIFICATION

Two important phenomena should not be neglected: the great sensation caused by the heated economic and juridical debate between free-traders and protectionist-mercantilists, and the political debate on the "liberal" state. The effects of these events, which greatly influenced the jurisprudential and parliamentary activity of the fifty years postunification (1860–1910),[55] were immediately perceived. While the consequences of the free-trader orientation, as we have seen from the numbers, were for good or ill immediately perceived, the protest against the rigor of "illiberal" regulations such as those meant to safeguard the heritage was also influential: these regulations heavily restricted the sphere of personal freedom, binding the autonomy of individuals in ways that many deemed unacceptable.[56]

These ideas were partly the result of demagogic calculations (it is not surprising that they came from aristocrats, who were prevented from selling their personal collections or those belonging to institutions under their patronage) and partly proof of a sincere adhesion to the new liberal faith. In this regard, the strictness of the rules, considered as the expression of reactionary governments, of police states, of hardly tolerated foreign rules (such as in the case of Lombard-Venetian territories) were in conflict with the liberal and patriotic principles of the Italian Risorgimento.

For these and other reasons, far from following the more virtuous examples, united Italy did not pursue a tenacious plan of harmonization of different legislative systems. This would not have been easy to accomplish. Centuries of localism and parochialism had created a jungle of rules, and the newborn state did not always wish to cut in; on the one hand there was a lack of power (the central Direction for excavations and museums was established only in 1875, and with only a few officers), and on the other hand the state would not dare to compromise delicate relationships with peripheral potentates who were still influential and jealous of the prerogatives acquired in earlier times, nor did it intend to feed resentment against the invasive Savoy centralism, which, lacking important conservative traditions, dictated "lines of address and control in contexts with a greater density of conservation rules," imposing "a bureaucracy and administrative practice that were new and still lacked legitimization."[57]

Nevertheless the preservation of cultural heritage, stimulated by memories of the events of the Risorgimento, immediately became once again the center of political and parliamentary argument.

The suppressions between 1855 and 1867 played a determinate role leading to the suppression of a huge number of ecclesiastical and moral institutions (whose properties were alienated and movables devolved upon preexistent cultural institutions, or when there were none, on the local administrations that were to provide for their return to their original places or a distasteful transfer to libraries, academies, and museums of capital cities), as did the controversies over the abolition of the majorat and trusts foreseen in the extension of the Civil Code to the former pontifical states in 1865.[58]

The inundation began in 1855—when in the old provinces (Liguria, Sardinia, Piedmont) of the Kingdom of Sardinia numerous ecclesiastical institutions were suppressed and their goods, movable and real estate, devolved upon the tax office—and followed by the suppressions carried out in Umbria, Marches, and the Neapolitan provinces (Abruzzi, Molise, Campania, Basilicata, Puglia, Calabria) in 1860–1861, which closed 2,075 male and female religious houses.

Given this experience, the lawmakers thought they would extend these benefits to the

whole nation; in 1864 Vacca (minister of justice) and Sella (minister of finances) admitted that the aim of the laws of abolition was to fill the state's reduced coffers (preparations for the third war of independence were under way), and they worked so well for this good cause that on 7 July 1866 the *Regio Decreto* number 3,036 was emitted, to "suppress religious and lay orders, corporations, and congregations, conservatories and retreats of ecclesiastical character." With some exceptions, the goods devolved on the state, and the Fund for the Cult was created, an independent administration that substituted the Ecclesiastical Fund, and provided for all the obligations of the goods passed to the state, and all the cult[59] expenses. The measures of 1866–1867 (which affected Lombardy, the Veneto, Emilia, Tuscany, and Sicily above all) brought another 1,925 houses to expropriation, so that on 31 December 1877, 4,000 institutes had been expropriated.[60]

Convents, monasteries, abbeys, cloisters, churches, sanctuaries, common-houses, chapels, schools, basilicas, oratories, confraternity seats, conservatories, and hospitals that for centuries had housed male and female religious of all types were emptied: Their occupants and contents (men, women, animals, and goods of all sorts) were turned out for sale or new placement. It is pointless to indicate that the almost two thousand structures affected by these dispositions contained paintings, sculpture groups, libraries, archives, furnishings, furniture, musical instruments and fabrics, priceless and desired by museums, collectors, intermediaries, indigenous and foreign profiteers.

In this way the need emerged to ensure the well-being of this heritage—threatened by lack of care, commercial appetites, conflicts of competences,[61] battles among local potentates, local rivalries, and the absence of devices apt to heal legislative details—against the annoyance with which the heads of departments involved (Defense, Justice, and Finance) greeted the attempts by the Ministry of Public Instruction to have some say in the matter. It had not been formally foreseen that in the expropriations, or even in the inventory operations, that there would be any involvement of the Ministry.

The resolution of the question of care was trusted to that most classic of compromises: with the law of 28 June 1871 the dispositions of the pre-unification states were left active, without providing specific procedural information or defining the responsibilities of the competent organs. In certain cases, such as in that of the *fidei-commissum* galleries, saved by the law of 28 June 1871,[62] and in the regularization of moral institutions, the lawmakers favored a substantial continuity with the protectionist and rigorously statist character of a certain pre-unification jurisprudence, while in other cases they encouraged "private" interests. The stakes were too high for the Italian state to carry on a safeguard policy *à outrance*. The budgets of the state and of peripheral administrations registered serious deficits, and the sale of properties confiscated from the clergy or donated by private individuals was tacitly considered as a legitimate instrument *in articulo mortis* for smoothing over the most serious losses and keeping away the ghost of bankruptcy, which in 1866 was making our good Prime Minister Ricasoli lose some sleep.

The consequences of this "distraction" were not long in coming; the sale of terrain and buildings that began in October 1867 went well, thanks also to the functionaries' hard work. At first managed by expensive public auctions, these were soon substituted by private dealing. And in a trice the more precious pieces were sold, to the equal satisfaction of the Treasury and the enthusiastic purchasers.[63] The movable property, which was discovered to have an unhappy vulnerability, was no better off, being saved from shipwreck only when the local authorities stepped in to preserve their existence and public property: one of the few positive

aspects of the affair was the birth of local and institutional museums that emerged in answer to the threat of centralized expropriation even if it did open lengthy debates about the criteria of relocation and modes of display.[64]

Unfortunately, the towns and central organs did not always have the will and funds necessary to cope with emergencies, nor did the *commissioni provinciali conservatrici* founded in 1866 and given bland consultation powers have any defensive weapons. This explains the land of milk and honey of the forty years from 1865 to 1905, in which theft, smuggling, sales by the ecclesiastical *Cassa* and the authorities that were custodians of the goods prospered, along with the demands—generally accepted—by the confraternities and patrons of churches and chapels who in good and bad faith took advantage of the uncertainty over property rights to claim possession and right to sell some goods.

Similarly, the ecclesiastic complaint about the miserable conditions of the "low" clergy was certainly justified. For many country or parish priests, the sale of books, paintings, sacred ornaments, and ex-votos had become an irresistible temptation, and the warnings of canon and civil law were ineffective against hunger and indigence and the intention to "inhibit or compromise the transfer of property"[65] to local politicians, who were often vehemently anticlerical. Then, too, the protests of the declining aristocratic class should not be forgotten. They turned to the sale of hereditary assets to minimize or conceal their impoverishment and to face the emergence of the new bourgeois elites. All these factors help to explain the legislative gap that marks the fifty years preceding the laws passed in 1902–1904: The reform bills of the ministers Correnti (1872), Bonghi (1876), Coppino (1876), De Sanctis (1878), Coppino (1886 and 1888), Villari (1892), Martini (1892), and Gallo (1898 and 1900) did not obtain parliamentary approval. The appeals of the most sensitive promoters went unheard, as were those of the jurists[66] who printed, as a warning, the regulations of the ancient states.[67]

While other European nations were adopting modern legislative instruments[68] and encouraging the publication of texts focusing on comparative legislation,[69] Italy could not yet manage to free herself from a juridical heritage that was almost "antiquarian." These were great years for Italian and foreign collectors. The former, mostly members of the bourgeoisie wishing to emulate ancient aristocratic vices, plunged enthusiastically into a treasure hunt that offered rewarding surprises all over the country. The latter, either prestigious institutions or private individuals, followed suit with the result that in a few years the prices of several collectable categories rose dramatically, making the temptation to sell almost irresistible.

For these reasons exportations kept up the pre-unification trend in quantity, since a part of the supply was absorbed by the growth of internal demand, through the acquisitions of private collectors, donations to museum institutions, purchases by municipalities, and the shift from the ancient ecclesiastic and aristocratic collections to bourgeois ones. From the qualitative point of view, things became worse: The free-trade fervor that made Senator Luigi Ferraris scream that, as far as commerce was concerned, a painting by Raphael was worth a couple of oxen,[70] the presence in Parliament of a group of deputies resolutely prepared to safeguard the rights of individual citizens from the interference and restriction that they considered abominable in a "liberal" state, and the credit enjoyed by those who welcomed free circulation in the world of Italian works of art, "wonderful witnesses of the Italian way of life," were adding to the effects of a series of favorable judgments on petitions made by some private citizens against the ban on exports, and to the ludicrous results of several trials.

The state lost a lawsuit against Count Conestabile della Staffa (who, ironically, was the brother of Giancarlo, illustrious scholar and paladin of protection), guilty of having

sold to foreign buyers some pieces from his renowned picture-gallery (among them, for 310,000 liras in gold, he sold the famous *Madonna del Libro,* the last work of Raphael still in Perugia). The entire collection, including a hundred or so paintings, had been offered to the Umbrian town for 400,000 liras, but for the *Madonna* by Raphael alone the director of the museum in Saint Petersburg offered 330,000 liras; there was no way of competing with offers of this kind, no matter the entreaties from the provincial commissions, prefects, mayors, press, and citizenry.[71]

Then there was the case of Prince Maffeo Barberini Colonna di Sciarra, who between 1892 and 1894 sold some famous paintings to foreign buyers, such as the *Violinista* by Raphael: on 16 April 1893 the Thirteenth Section of the Civil Court of Rome sentenced him to three months of imprisonment, a 5,000-liras fine, and payment of the evaluated price of the objects sold, which amounted to 1,266,000 liras. Nevertheless the Appeals Court in Ancona in its sentence of 12 October 1894 absolved him, with a fine of 1,800 liras that was condoned by the amnesty decree of 22 April 1895: and so twenty-seven paintings and four sculptures remained abroad, exported to London by the Marquis de Ribiers. Similarly, the civil court of Rome in 1901 convicted Prince Mario Chigi Albani and the art dealer Despretz for the sale abroad of Botticelli's *Madonna dell'Eucarestia*; their fine was equal to the sum collected from the sale, that is to say 315,000 liras. The sentence of the Cassation Court acquitted the prince on grounds of the "nonexistence of a crime" and sentenced Despretz to three months of imprisonment and a fine of 2,000 liras, which later was remitted.[72]

The scenario was discouraging for the few and badly paid officials who had to face such adversaries,[73] and their appeals to the Ministry of Public Education to increase their personnel went unanswered while the outflow of materials went on undisturbed, although there were some positive results. It is enough to read a few pages from the "campaigns in Italy" of museum agents and of famous foreign collectors to realize how critical that period was. Moreover, several courts of cassation continued to allow petitions of citizens who had been prevented from renovating, restoring, or demolishing their properties and from selling their collections, thus recognizing the full *ius utendi et abutendi*, the "right of use and abuse," of private property. This climate explains the consistency of flow registered by postunification customs, which also reported importations and allows us to estimate, even though roughly, the sums in the commercial balances. If we look at the "Statistics of Special Commerce of Importation and Exportation" published beginning in 1871, we discover that in the fifteenth category, significantly titled "Mercery, knick-knacks, and various," and after the headings "elephants' teeth, wolves' teeth, bones and hoofs, raw animal horn, other materials to be cut and worked," there was the term "museum objects," whose exportation and importation were expressed in weight and in value.

That classification, which did not include books, furniture, work in gold and silver, arms, precious stones and fossils, glasswork and pottery, was substituted in 1878 by the term "objects for collection," which was the last heading of the sixteenth and last category of mercery, that of "various objects," for which the customs officers, notably competent, indicated only a "declared value" in liras.

From the data in table 21 for the period 1871–1887 it is clear that these were important sums, and anyway underestimated. Enrico Stumpo has in fact demonstrated that in 1891 the Florentine royal exportation office by itself authorized the merchandizing of 26,813 mostly modern pieces for a value of 2,315,187 liras,[74] even if the more interesting fact is the reduced proportion of antiques. In 1886 from Rome "were exported antiques and ancient and modern

art objects for a total value of 2,937,299 liras, of which those considered to be antique and liable to taxation had a value of 99,466 liras, or little more than 3 percent."[75]

There is no doubt that a good part of the older objects had been modernized to avoid customs taxes. However, this information, which still needs to be put in order, demonstrates just how important the coattail effect of antiques was on modern productions, legal and not. According to Stumpo's estimates, in the second half of the nineteenth century the exportation of artistic works and objects was worth at least 12 million liras annually, which puts it in first place in the category of "manufactures." These are imposing sums that, if on the one hand they reveal the contiguity with the productive system of the ancien régime, on the other prepare the terrain for the birth of some Novecentesque districts that exploited their rich technical-formative inheritance.

The worldwide success of the neo-Renaissance style and objects "of the period" was not limited: the difficulty in procuring originals of certain quality and date stimulated "overseas, for example, the demand for entire furnishings in 'style'—from fireplaces to fountains, fabrics, and plaster models. Box after box, and sometimes wagonloads, of works in marble and alabaster, oil paintings, inlaid chairs, ironwork, mosaics, terra-cottas, bronzes, antique and modern prints, watercolors, gilt frames, busts whose declared value was never very high,

Table 21. Italian Importations and Exportations of "Museum Objects" (from 1878 "objects for collection," from 1893 "objects for collection and art") in the Period 1871–1887

Year	Importations in kilograms	Importations in Liras	Exportations in kilograms	Exportations in Liras	Balance in liras
1871	145,000	105,000	55,000	320,000	215,000
1872	39,748	400,000	426,853	2,600,000	2,200,000
1873	228,330	2,566,000	484,089	3,540,879	974,879
1874	464,174	4,010,374	501,359	6,013,176	2,002,802
1875	327,669	3,467,000	544,108	7,617,512	4,150,512
1876	91,075	921,500	520,023	7,021,623	6,100,123
1877	59,218	580,180	440,478	4,758,318	4,178,138
1878		623,400		4,699,872	4,076,472
1879		526,204		1,914,476	1,388,272
1880		1,032,009		2,522,842	1,490,833
1881		673,961		3,899,876	3,225,915
1882		688,213		3,433,107	2,744,894
1883		390,676		3,110,257	2,719,581
1884		392,618		3,354,917	2,962,299
1885		466,344		2,904,289	2,437,945
1886		559,189		2,977,455	2,418,266
1887		472,550		2,953,236	2,480,686

Source: Statistics of special commerce of importation and exportation from 1871 to 1887.

usually between 500 and 1,200 liras, but sometimes as much as 5,000, 6,000, or even 10,000 liras,"[76] left Leghorn for New York, Boston, Cincinnati, and Philadelphia, and also Brazil, Mexico City, Texas, or Minnesota between 1898 and 1907. But Leghorn's case is one among many, a demonstration of the fact that the production was never interrupted, and that the economic and occupational return was not discountable.

Thus one can understand—not justify—the caution with which the subject is approached, given that the great masterpieces functioned as bait to whet the buyers' appetites and feed a conspicuous production intended for foreign travelers, domestic demand, and foreign markets. Apart from the effects, some deleterious, of the lack of maturation of artists and movements distracted by earnings from reproductions of works, motifs, and subjects in the antique style, this sector consolidated interests and provided work for tens of thousands of artisans whose economic contribution has been overshadowed by the predominating interest in the newborn industrial system. It is not by accident that the legislative climate changed slightly only during the first years of the twentieth century, as a result of nationalism and the outcries provoked by local and national newspapers,[77] which protested against the departure of famous masterpieces, a refrain that would be repeated.

On 12 June 1902, after a parliamentary "forcing," law number 185 was at last promulgated. This law was a juridical device characterized by considerable strictness, but not devoid of worrisome deficiencies[78] and oddities,[79] which were perceived and overcome by subsequent law number 364 of 20 June 1909, which introduced remarkable improvements.[80] This attitude substantially affirmed the supreme public interest in the safeguard of architectural, monumental, archaeological, artistic, and historical heritage, a principle that has never been discussed so much as in recent years.

Notes

INTRODUCTION

1. The two quotations are from Stumpo 2005, 247; and Stumpo 2003, 702.
2. Belfanti and Fontana 2005, 620–621.
3. Ibid., 621.
4. For background information, the reader may see my writings in the Bibliography.
5. See, for example, Hirschman 1980; Hirschman and Holbrook 1982; Holbrook and Hirschman 1982; Holbrook, Chestnut, Oliva, and Greenleaf 1984; Havlena and Holbrook 1986; Havlena and Holak 1995; Holbrook and Schindler 1995.
6. Montias's essay of 1981 is an exception.
7. Burke 1972, 75, 76, 105.
8. Ibid., 106–7.
9. Koerner and Rausing 2003, 427.
10. See Ago 1998.
11. Cf. Bibliography; on the debate that followed the discovery of Polanyi, see the interventions of Rotstein 1970; Douglass 1977; and Silver 1983.
12. Finley 1973 and Sahlins 1974. Useful notions may be found also in Andreau, Briant, Descat 1997 and Temin 2002.
13. See Schwartz 1985; Dyer 1989; De Vries 1993; Feinstein 1998; Van Zanden 1999; Boulton 2000; Allen 2001.
14. Bourdieu 1971; Goux 1973.
15. Bataille 1967, It. trans. 1992, 1–22 and 57–88.
16. Lyotard 1974.
17. Baudrillard 1968 and [1972] 1974.
18. I refer to the essay of 1994.
19. Consider Douglas and Isherwood 1979, It. trans. 1984, and particularly the chapters "Il silenzio della teoria utilitaristica" and "L'autocritica degli economisti," 17–28; and Appadurai's 1986 essay.
20. Muensterberger 1994, 11.
21. Baudrillard 1968, 14.
22. See Venturini 1992; Coen 2001; Labrot 2002 and 2004; Cecchini 2003a; Comanducci 2003; Kubersky-Piredda 2003 and 2005; Montecuccoli degli Erri 2003; Holmes 2004.
23. See Wackernagel 1938; Baxandall [1972] 1978; Guidotti 1986; Spezzaferro 1989 and 2004; Goldthwaite 1993; Esch 1995; Thomas 1995; Santi 1998; Cecchini 2000; Ago 2002 and 2006; Comanducci 2002 and 2003; Kubersky-Piredda 2002 and 2003; Labrot 2002 and 2004; Spallanzani 2002; Aikema 2003; Ajmar 2003; Blume 2003; Cappelletti 2003; Flaten 2003; Dal Pozzolo 2003; Montecuccoli degli Erri 2003; O'Malley 2003 and 2005; Lorizzo 2003; Spear 2003 and 2004; Cavazzini 2004a and 2004b; Coen 2004.

24. Ago 2002, 401.
25. Lorizzo 2003, 329.
26. Coen 2004, 434.
27. See North 1992; Montias 1993 and 1996a; Honig 1998; Vermeylen 2003.
28. Comanducci 1999, 162.
29. Ibid., 162.
30. Cecchini 2000, in particular 151–184.
31. Conti 2003–2004. I am grateful to Ms. Conti for her generosity in supplying the statistical data regarding her research.
32. Just think, besides the works cited in note 23, of Puncuh 1984; Bonfait 1990 and 2002; Marshall 2000; Giusberti and Cariati 2002; Murphy 2003; and of Goldthwaite's 2004 essay.
33. Haskell 1959b, 940.
34. See Shapiro 1964 and Chambers 1970.
35. See Wackernagel 1938; Haskell 1963; Hirschfeld 1968; Chambers 1970; Trevor-Roper 1976; Settis 1981; Wilkins and Wilkins 1996; Roeck 1999.
36. See De Marchi and Van Miegroet 1994 and 1999; Hilaire-Pérez 2002.
37. See Nelson and Zeckhauser 2003; Noldus 2003; and the essays by Howarth, Noldus, and Dooley in Keblusek, Noldus, Cools 2006.
38. See also Montias 1996b; De Marchi, Van Miegroet, and Raiff 1998; and Nelson and Zeckhauser 2008.
39. Sombart 1913, It. trans. 1988, 97.
40. Pouillon 1978, 585.
41. The articles have been republished in Kristeller 1980, 163.
42. Ibid., 164.
43. Butters 2005, 209.
44. Kristeller 1980, 165.
45. Shiner 2001, 5.
46. Besides the prevalent significance of ability and the consequently modest social standing of artisans, various scholars of the history of science and epistemology have shown that art "signifies procedures, and as such it was the equivalent of terms like 'method' or 'compendium.' In effect, debates concerning method are the *locus classicus* for discussions of 'arte' during the Renaissance period" (Farago 1991, 27).
47. The concept of art stabilized in the eighteenth and nineteenth centuries excluded the more practical arts in favor of the privileged and "non-utilitarian" of the imagination, able to produce pleasure in the beholder, and only at the end of the eighteenth century did the terms "artist" and "genius" become synonymous. Apropos of this, Suzy Butters has noted: "The concept of 'irregular genius' began to make itself known at the end of the eighteenth century, with the category of 'fine art,' thanks to the growing attention towards 'taste,' aesthetic pleasure and the interpreting skills of those who were able to appreciate 'art works'" (Butters 2005, 217).
48. Baxandall 1971, 15.
49. Ibid., 16.
50. Ibid., 16.
51. Cited in Comanducci 1999, 152.
52. I refer to the works of Kris and Kurtz 1934; Wittkower R. and Wittkower M. 1963; Klibansky, Panofsky, and Saxl 1964.
53. Cf. Agosti B., Agosti G. 1997.

54. Alessandro Conti records: "The commission that was to decide the placing of the new giant by Michelangelo, the David, in 1504 shows clearly that the medium in which one worked did not influence one's status as an artist. Of the thirty-three *maestri* present or anyway called, there were only nine real painters, Attavante is an illuminator, Giovanni delle Corniole an engraver of gems, six are goldsmiths or jewellers, then there is an embroiderer, the clockmaker Lorenzo della Volpaia; of the six sculptors Andrea Della Robbia and Benedetto Buglioni work exclusively in terracotta, while there were four architects, but Giuliano and Antonio da Sangallo and Baccio D'Agnolo all began as carpenters, the same as the most clever Cecca and two others besides." (Conti A. 1979, 187).

55. Simi Varanelli 1995. On the reevaluation positions, see the ample bibliography in notes 13, 19.

56. See Alessio 1965; Larner 1969; Klinkenberg 1976; Whitney 1990.

57. Simi Varanelli 1995, 33. On page 34 the Roman scholar affirms: "In Aquinas' work the various levels or values of the arts are arranged in an extremely clear triadic scheme: *artes adventiciae* or *subministrativae*, *artes factivae* and *artes architectonicae*, in order of increasing importance. Within this scheme the title *artifex* referred only to the *architector* who conceived and projected: this was true for painters, sculptors, and architects, who did not work without *forma vel idea sui operis* and were therefore considered *principales artifices*, knowledgeable in *ars architectonica*. Dependent upon them were the real and true artisans: to wit, the *manuales artifices* who could not reach beyond the merely executive work fixed by the *ars factiva*, which was in turn superior to the *ars adventicia* that included the less qualified workers (assistants, manual laborers, etc.)."

58. Whitney 1990, 140.

59. See Barasch 1985, chap. I, "Antiquity," 1–44.

60. Tatarkiewicz 1973, 458.

61. Kristeller 1980, 166–174.

62. Ibid., 169.

63. The text was not written by Leonardo, but reassembled, posthumously and apocryphally, by his students on the basis of the master's loose notes, while the title was coined for editorial reasons in the Ottocento, as occurred also to the so-called *Vite degli artisti* (*Lives of the Artists*) by Vasari, another successful invention, since the Cinquecentesque editions bore a different title, emphasizing the dangers of these semantic slips.

64. Cf. Bibliography.

65. Williams 1997, 22.

66. See for this Farago 1992 and La Barbera 1997.

67. Cited in Burke 1972, 68.

68. Ibid., 90.

69. Cited in Bologna 1972, 77.

70. Bologna 1979, 252.

71. Ibid., 248.

72. Ibid., 202.

73. González Palacios 2000, 9.

74. Kubler 1962, 14–15.

75. Burke 1972, 63.

76. See the many cases in Conti A. 1979 and Ames-Lewis 2000.

77. For example, Kemp 1989; Soussloff 1997, in particular 44–72; Jacks (ed.) 1998; Woods-Marsden 1998; Barker, Webb, Woods 1999; Ames-Lewis 2000; Emison 2004.

78. See Bonfait 1993 and Williams 1995, 523–525.

79. Gilio [1564] 1961, 11.
80. See Greci 1988; Borelli 1991; Degrassi 1996; Guenzi, Massa, Piola Caselli 1998; and Guenzi, Massa, Moioli 1999.
81. Urzì 1933.
82. Shell 1995, 54.
83. Cariati 1998, 27; the names are in the Appendix at 7–25.
84. Tedoldi 2003, 68 and 91.
85. Comanducci 1998; their names have been listed in Appendix III.
86. Ibid., 272–369.
87. Fanfani 1943, 96.
88. Subacchi 1996, 240.
89. Favaro 1975. The total comes from the sum of the data in 137–155.
90. Montecuccoli degli Erri 2003, 145.
91. Beltrami 1954, 211. This number corresponds to the owners of shops, *capi mistri*, their sons, the workers, the students, the young, and the wives of the *capi mistri*.
92. Travaglini 1999; the data are on 286–289.
93. Lorizzo 2003; I have drawn the number from the data on pages 331–334.
94. Cavazzini 2004a, 365–366.
95. Coen 2004, 425–426.
96. *Allgemeines Künstler-Lexicon* 1992–2004.
97. Marshall 2000, 16.
98. See Favaro 1975, 119–121; Burke 1979, 91; Montecuccoli degli Erri 2003, 143.
99. Haskell 1959b, 954.
100. Spallanzani 1996.
101. Ibid., 139.
102. Ibid., 144.
103. Ibid., 146.
104. Ibid., 153.
105. Labrot 2002, 272.
106. Cavazzini 2004a, 367.
107. Ago 2002, 382, and note 19 on 400.
108. Cavazzini 2004a, 353.
109. Coen 2004, 424.
110. Goldthwaite 2004, 16.
111. Tagliaferro 2002, 545. For similar themes, see Jardine 1996; Thornton 1997; Burns, Collareta, and Gasparotto 2000; Syson and Thornton 2001.
112. Rebecchini 2003, 119.
113. ASMN, Archivio Gonzaga, n. 410/B, D. XII-8, fasc. 43, c. 36r.
114. As Morselli notes, lacking from the evaluation are the items from the library, the famous Scientific Museum, the so-called catacombs and annexed parts of the treasure of Santa Barbara, the musical instruments, cameos, gems and medals, arms and parade arms, the objects in the rooms in *Castello*, *Corte Nuova*, and in part also in *Corte Vecchia* (Morselli 2000, 80).
115. Morselli 2000.
116. Ibid., 240.
117. Ibid., 241.
118. Ibid., 243.

119. Ibid., 252.
120. Ibid., 112.
121. Reinhardt 1984, 98.
122. Tagliaferro 1995, 27.
123. Brown 1995, 228.
124. González Palacios 2000, 9.
125. Guidotti 1986, 549–550.
126. For other cases see Holman 1997.
127. From Bologna 1972, 35.
128. Besides González Palacios 2000, see the indications in Id. 1993.
129. Cennini [1350] 2003, esp. chapters CLXIV, 184; CLXVIII, 187; CLXXII, 192–195.
130. Burke 1972, 53
131. Cit. in Conti A. 1979, 238.
132. See Sheard, Paoletti 1978, 38–74.
133. Bologna 1972, 48.
134. The data are on the site: www.guidoguerzoni.org, in the database section, under the corresponding titles.
135. An early version of the text can be found in Guerzoni 1999c.
136. An early reduced version is in Guerzoni 1998c.
137. A first draft was presented in Guerzoni 2002.
138. The outline was traced in Guerzoni 1997.

CHAPTER 1. HISTORIOGRAPHIES: THE PERSPECTIVES OF ECONOMICS, ECONOMIC HISTORY, AND ART HISTORY

1. For more information, see De Vries 1985.
2. Buchanan 1824.
3. Roehn 1841.
4. Apropos of this, see Thompson 1988 and Knowles 2001.
5. Some of the many: Stoddart 1998; Birch 1999, and the first chapter of O'Gorman 2001.
6. After the efforts of John Tyree Fain in the early fifties (see the essays of 1951 and 1952, which preceded the 1956 monograph), attention on this facet of Ruskin's intellectual production was kept alive only thanks to the work of Jaudel 1972; Sherburne 1972; Anthony 1983; and Spear 1984.
7. See Stoddart 1990; Austin 1991; Maas H. 1999; Forbes 2000; Moore G. 2000. For the Italian case, see Franzini 1994.
8. Ruskin 1857.
9. Ruskin 1862, It. trans. 1946, 97.
10. Ruskin 1872. The American edition was printed the same year in New York, by Wiley.
11. Cf. Henderson 1979, 1.
12. Ruskin 1866.
13. Ibid., 77.
14. I refer to the campaigns promoted by Socialist circles against the public financing of theaters, or the debates on the conservation of the patrimony analyzed in the last chapter.

15. Blanc 1857–58.
16. Defer 1863–68.
17. Redford 1888–89.
18. Roberts 1897.
19. Mireur 1900–11.
20. Graves 1918–21.
21. See Lamberti 1977.
22. Even the genesis of *Cultural Economics* saw some personal interests: Sir Alan Peacock had studied composition and orchestra direction, Basil Yamey was a careful collector, Ruth Towse was an opera singer, Michael Hutter had studied art history, and William Baumol is a melomaniac.
23. See White 1999.
24. It would be interesting to see further research on the "economic politics of art" carried out by totalitarian regimes, which has sparked some interest only recently.
25. Baumol and Bowen 1966.
26. Blaug 1976. In his *Introduction: What is the Economics of the Arts About?* the English historian of economic thought observed: "Economists experience little difficulty in appraising activities which appear, at first glance, to have nothing to do with economic ends; their apparatus will not always be equally illuminating but in a surprising number of instances it yields immediate, dramatic insights. So it is, I believe, in the case of the arts" (ivi, 13).
27. Limiting myself to monographs published before the nineties, I must note the works of Hendon 1979; Throsby and Withers 1979; Feld, O'Hare, and Schuster 1983; Hendon, Shanahan, Hilhorst, Van Staalen 1983; Shanahan, Hendon 1983; Shanahan, Hendon, Hilhorst, Van Staalen 1983; Hendon, Shaw, and Grant 1984; Lee-Owen, Hendon 1985; Hendon, Shanahan, and MacDonald 1986; O'Hagan and Duffy 1987; Shaw, Hendon, Waits 1987; Frey and Pommerehne 1989a; Hillman-Chartrand, Hendon, McCaughey 1989.
28. This one may deduce from the presence in collected articles and in journals of a number of essays of a historical bent, and from the awareness of historiographic production to the questions taken up by economists.
29. Reitlinger 1961, 1963, and 1970.
30. Haskell 1959a; Stone 1959.
31. Duverger 1967.
32. Reitlinger 1970, 14.
33. Cf. Baumol 1986; Frey and Pommerehne 1989b; Goetzmann 1993; Moses and Mei 2002.
34. Haskell 1976 and 1978.
35. Previtali 1964.
36. The absence of other types of exchange would be more acceptable if only the primacy of auctions over other distribution channels and other types of transactions could be proven. Unfortunately, even the estimation of the weight of the different agencies carries discordant opinions. According to the writers of the *EU Commission Art Market Report*, in 1999 the world art market was dominated by merchants, whose quota reached 78%, compared to the 22% of the auction houses, a division that is similar to the results found in 2001 by MIT Consultants that saw the merchants at 70% and the auction houses at 30%. These percentages were turned upside down by Kusin & Company, in the report prepared for TEFAF on the Euro-American market, that placed the *dealers* at 48% and the houses at 52%—values again denied in 2003 by Dominique Sagot-Duvaroux, who estimated worldwide the auction houses at 25% and the *others* at 75%. The uncertainty is even greater on the Italian front: according to Nomisma, the earnings of the auction houses and

galleries in 2000 was 510 million Euro, compared to the 1.5 billion Euro calculated by Intermatrix for Art'è in 2002.

37. Fredericksen 1989–93.

38. According to Ad Van der Woude 1991, 301, production between 1580 and 1800 was equal to 9.3 million paintings, a value smaller than that estimated by Montias 1990, 1993, and 1996a.

39. Bok 2002.

40. Lenman 1993.

41. Pears 1988.

42. Ormrod 1998.

43. Brigstocke 1982.

44. Cf. Parkinson 1978; Cowan 1998; Ketelsen 1998; Schnapper 1998; Montias 1999; not forgetting Marillier 1926; Towner 1970; Norton, Dillon 1984; and Herbert 1990.

45. The practice is reflected in my publications cited in the Bibliography.

46. See Borghero 1973; Sekora 1977; Ciriacono 1978; Pallach 1987; Berry 1994; Berg, Eger 2003.

47. See the *Cronologia* of Veblen's life by Francesco Di Domenico, in Veblen 1899, It. trans. 1981, 27–47.

48. Ibid., chap. IV, 56–80.

49. For a recent examination of the impact of the work, see the *Presentazione* by Roberta Sassatelli, in Sombart 1913, It. trans. 2003, 7–56.

50. Cf. Backhaus 1996.

51. It is no accident that Sombart (1913) began the fifth chapter, "La nascita del capitalismo dal lusso," citing Abbey Coyer's 1757 *Développement et défense du système de la noblesse commerçante*: "Luxury is like fire, that warms and may burn. If it consumes opulent houses, it sustains manufacture. If it withers the patrimony of the dissolute, it feeds the worker. If it diminishes the wealth of the few, it increases the substance of the masses. If one condemns the fabrics from Lyon, the tapestries, lace, mirrors, elegant furniture, delicious foods, all of a sudden I see millions of arms lose strength and as many voices cry out for bread" (ivi, 154).

52. Sombart 1913, It. trans. 1988, 156.

53. Sombart 1902, It. trans. 1925. His observations on the manufacture of rugs and lace (p. 364), the building industry (p. 365: "the building industry to date has been studied by art historians, but not by economic historians, even though the sources are full of this kind of information, and enough so to encourage research"), on the manufacture of artistic furniture (p. 366), porcelain, majolica, glassware, and arms (pp. 367–368) are notable.

54. Sombart 1913, It. trans. 1988, 157.

55. The following historical reconstruction does not, obviously, pretend to be exhaustive considering the imposing mass of studies on the question, which is also the reason for my limiting myself to the more famous historians and more general works.

56. For the Italian economic history of the period, see the able reconstruction by Luigi De Rosa, *La storia economica nell'età di Federico Chabod, e la seguente Discussione*, in Vigezzi 1983, 369–412.

57. Fanfani 1933, 169–170.

58. I do not believe it accidental that Augusto Calabi, in the first number of the *Rivista di Storia Economica*, edited by Giulio Einaudi and printed in 1936, was able to publish an interesting article entitled *The economy of artistic graphic production*, in which he traced the development of production and distribution of prints and engravings in modern history.

59. Luxury products, in the wake of Sombartian relaunchings and research on mercantilism, were dealt with up until the forties and then no longer.

60. Kulischer 1928–29, It. trans. 1964. In volume I, *Il Medioevo*, the references to "luxury commerce" are on 391–393, while in the second, *L'epoca moderna*, the Venetian products are cited on 261, while the relative productions are dealt with on 259–261.

61. Doren 1936.

62. Doren 1934.

63. Doren 1936, 290.

64. As Armando Sapori remembered in his obituary: "Those who knew him personally and were tied to him by friendship as well as respect cannot but recall, beside the more well-known figure of the scientist, the no less individual figure of the artist, who seemed to have an external reflection in the lines of his face, in the elegance of the gesture of his aristocratic hand, and, above all, in the expression that revealed his joy in seeing beautiful things" (Sapori 1940, vol. II, 1071).

65. Doren 1922–23.

66. Doren 1906.

67. Doren 1922.

68. See Volpe 1923, 309–319.

69. Take for example, in Barbagallo 1927, the passage on 108 on "the vanity and pomp, obviously pernicious, of the late medieval elite (the houses of the rich crowned with towers, bastions, and arrow-slits like those of feudal times . . . their clothing as magnificent as monarchs')."

70. Segre 1923; the only passages worthy of note, found in the last chapter ("Il commercio italiano nell'età moderna"), are reserved for the paper makers and producers of valuable majolica in the Marches (p. 511) and to Francesco I de' Medici, of whom he says, "The interest in certain industries, to which he applied himself personally, such as the successful founding of rock crystal, and making rather fine porcelain . . . that would have given the name of the second Medici grand duke some import if the enormities of his private life and frequent cruelties did not still produce a lively sense of aversion in scholars" (p. 495).

71. Cf. Carli 1936, especially the thirty lines on luxury production on 80–81.

72. Bonfante 1938. Not even in the final chapters XXXII–XLI on 202–256 do we find mention of artistic-luxury production.

73. Lorenzoni 1939.

74. Cf. Barbieri 1940a, 13–16, and 1940b, especially 274–287.

75. Luzzatto 1932, 61: "The rising standard of living in broader strata of the population can be seen not only in the thousands of palaces and villas constructed in the Quattrocento and Cinquecento, not only the works of art of every sort produced by order of princes or simply private citizens, but also in the writings that speak of women's luxuries, of the showiness of the houses, the horses, carriages, Pantagruelian banquets, the rustics dressing to imitate city people and lose themselves amongst them; and the numerous sumptuary laws which attempted to slow excessive expenses for clothing, food, weddings, and so on."

76. Ibid., 87–89.

77. Luzzatto 1949.

78. Ibid., 203–204.

79. Ibid., 205.

80. I refer to the monographs of 1957, 1958, and 1963.

81. Sapori 1940, vol. I, ix.

82. Ibid., 539–540.

83. Ibid., 561.

84. Sapori 1955. There are no important references in chapter XXIV of the first volume ("La funzione

economica della nobiltà," 577–595) nor in chapter xxxiv of the third volume ("Medioevo e Rinascimento: proposta di una nuova periodizzazione," 441–453).

85. Cantimori 1957, 938.
86. Fanfani 1943, 64.
87. Ibid., 64–73.
88. Ibid., 8.
89. Ibid., 10–11.
90. Ibid., 10–11.
91. "On a reduced scale the Italian upper class anticipated the Colbertian policy of luxury industries . . . and thus did not prepare the various states of the peninsula to become exporters in the near future . . . with the example and the pretenses of the action of the lords and princes is economically counter-educational: it encourages luxury . . . They encourage the arts, but in the long run with broad possibilities, instead of pushing artists to found a Perseus, they push them to sculpt Hercules and Cacus, substituting for the interest in astonishing with refinery that of surprising with dimension" (ibid., 13–14).
92. The division into periods and the conceptualizing of Renaissance economy, after the interpretative proposal by Sapori and the quick response by Michel Mollat (1958), have been treated with diminishing interest. The opposite tendency: beyond the essay by Ugo Tucci 1991, I would like to note the recent essay by Molà and Franceschi 2005 and the volume by Bianchini, Cattini 2006.
93. Cipolla 1949 and 1952.
94. I refer to the De Rosa essay of 1970.
95. The lacuna has been recently corrected by the essays collected in Belfanti, Giusberti 2003.
96. Sismondi 1809–18.
97. Cited in Burke 1972, 5.
98. Ibid., 7.
99. Lopez 1962, 32.
100. Ibid., 37.
101. Ibid., 47.
102. Ibid., 48.
103. Lopez, in the article written with Miskimin (1962), remembered when he dared to place "economic depression in the midst of artistic plenty, a lively discussion" arose "which is a polite understatement of the fact that I narrowly escaped lynching" (p. 408).
104. Cipolla 1964.
105. Arnold Esch has relegated the importance of Lopez's thesis to that of a "quip."
106. Prof. De Maddalena, having earned his degree with a thesis on the Florentine art market of the Quattrocento, in a conversation of about ten years ago told me of an episode that took place at the end of the fifties. Invited to speak before a group of art historians, he was upbraided by Roberto Longhi, who, annoyed by his speech, exhorted him to give it up, that art was not for those who deal with double-entry bookkeeping.
107. Yamey 1972.
108. Melis 1972b. There are instead no references in his work of 1962 or in 1972a.
109. Braudel 1974, 2173 and 2145. Maurice Aymard, his student, was of a different opinion, and he had studied Italian history so much that in his essay of 1978, even admitting that "Woollen cloth, silk and fabrics, arms, paper and glass, all the so-called 'industrial' products that made Italy's prestige in the fifteenth and sixteenth centuries and give us the first serious data on non-agricultural

production . . . are luxury or semi-luxury products reserved for exportation or for a wealthy city clientele," maintains that "their temporary success does not reach as far as local craftsmanship or into the countryside . . . and does not in any way prepare for the creation of a national market" since these products are doubly and structurally sensitive "to the variations in demand and to competition" (pp. 1160–1161).

110. In Jones (1974) I have found no noteworthy passages. While in 1978 the English historian, in his minute examination of the character of the Italian economy of the fifteenth and sixteenth centuries, emphasized that "in manufacture and commerce, at least in the international sector, one notes a marked tendency towards the production and exchange of luxury and semi-luxury objects" (p. 362), pointing out the gravity of the passage "from the productive employment of all kinds [of capital], towards sumptuary expense: aristocratic opulence, building, art and culture" were guilty of having made "Italy, in her moving towards capitalism, either stop midway, or regress into 'feudal capitalism'" (p. 363).

111. Cipolla [1974] 1994, 42.

112. Romano R. 1971b, 7.

113. Romano R. 1971a, 100–115.

114. Ibid., 100.

115. Ibid., 100.

116. Ibid., 101.

117. Romano R. 1974. Consider the passage in which he condemned the Trecentesque production of luxury fabrics, that "of this orientation of the industrial activity towards sectors of luxury production the [negative] consequences will be enormous and will be felt for centuries" (p. 1853), or of the line in which, speaking of the crisis of the seventeenth and eighteenth centuries, he asked himself: "To take refuge in luxury products? Certainly, it is theoretically still a viable alternative. But in practice it is for the most part impossible" (p. 1913), deprecating the successes of the glassware, gilt leather, and lace industries (p. 1889) that must have diverted capital and energy away from more worthy sectors.

118. Just as an example, in the fifth volume of *Storia economica Cambridge*, printed in England in 1977 and in Italy the following year, Kellebenz, who had also studied princely finances, resolved in little more than a page (of the article's one hundred total), in the penultimate paragraph of his contribution, the treatment of the production (of consumption, obviously, there is nothing said) of luxury items (Kellebenz 1978, in particular 625–626).

119. The initiative was not greatly followed by Italian historians, but there were outstanding sessions like *L'arte e la città*, with the participation of Peter Burke and Hans Konigsberger, or *Investimenti e ceti*, with the very good essays by Miguel-Angel Ladero Quesada and Gérard Labrot, now printed in Guarducci 1989.

120. Romano, Tucci 1983.

121. Romano, Ruggero 1991, vol. II, *L'età moderna: verso la crisi*. In this volume there is no significant reference in the essay by Maria Antonietta Visceglia (*I consumi in Italia in età moderna*, 211–241) nor in that by Leandro Perini (*La funzione dello Stato*, 285–308), which on 302–303 mentions in passing the eighteenth-century silk industry of San Leucio.

122. In the essay *L'Italia fuori dall'Italia* (pp. 309–336), De Divitiis, dealing with the migration of Italian technicians, recalls that "The manufacture of fabrics interwoven with gold at Lyon may be dated to the arrival in the city of a group of Venetian workers . . . that artisans from Murano, at the end of the sixteenth century, founded glassworks in Austria, Germany, Bohemia, Holland, and Belgium" (p. 330), and also notes that (p. 322) in Antwerp the Italians dealt in precious

stones, jewels, and works of art, and it was to Lyon that the Italians transferred their Genevan branches, "making of Lyon a grand market of Italian luxury products" (p. 323).

123. Even though I had access to the printed versions of most of these essays, they were collected and published on CD-ROM by the Institute in 1990.

124. Munro 1983.

125. Goldthwaite 1987b; see also Brown 1989 and Labrot 1993, 29–65.

126. See Montias 1982 and 1989; Alpers [1988] 1990; Ekkart 1991; Kempers 1991; Robertson 1992; Bok 1994; De Marchi, Van Miegroet 1994.

127. The proceedings were collected in Esch, Frommel 1995.

128. Sella 1968.

129. Goldthwaite 1973, [1980] 1984, and 1990.

130. Di Vittorio 1989, 283.

131. Goldthwaite 1987a.

132. Goldthwaite 1993.

133. Ibid., It. trans. 1995, 7.

134. Franceschi 2002, 163. Further considerations may be found also in the essay of 2003, and especially in the paragraph "Gli storici economici e la legislazione suntuaria: un incontro mancato."

135. The proceedings of the convention were published in North 1996.

136. North, Ormrod 1998, 2.

137. To note only the monographs, I need to mention also Grivel 1986; Bertrand Dorléac 1992; Solkin 1993; Janssen 1995; Drechsler 1996; Falkenburg, de Jong, Meijers, Ramakers, and Westermann 2000; Warwick 2000.

138. Castelnuovo, *Premessa all'edizione italiana*, in Wackernagel 1938, It. trans. 1994, 11.

139. Flörke 1901 and 1905.

140. Drey 1910.

141. Märten 1914.

142. Lerner-Lehmkuhl 1936.

143. Martin 1932.

144. Wackernagel 1938.

145. While Wackernagel finished his monograph on Florence, Henry Thode died in 1920 before he could conclude an analogous volume on Venice.

146. I refer, more than to the well-known work of 1940, to the long essay of 1928, 1–214.

147. Antal 1947. The volume had been finished in the thirties, but because of his personal difficulties, was published only in 1947.

148. Klingender 1947. Klingender had already published *Marxism and Modern Art; an Approach to Social Realism* in 1943.

149. Hauser 1953.

150. Frederick Antal was born in Budapest in 1887 of a wealthy Jewish family and studied in Berlin with Wölfflin, in Vienna with Dvořák, and finally in Paris, joining in 1916 the circle Budapester Sonntagskreis, of which Georg Lukács, Karl Mannheim, Arnold Hauser, Charles de Tolnay, and Johannes Wilde were also members. Klingender was English and born in 1907 at Goslar, in Germany, where he remained for more than twenty years, taking a doctorate in sociology in 1934 at the London School of Economics and Political Science night school, since he had to work in an advertising agency to maintain his family: his father, former painter of animals, suffered on reentry to England the crisis of his chosen genre. Arnold Hauser was born in 1892 at Timisoara and finished his advanced studies at Budapest, specializing in German and romance

philology, entering into the Budapester Sonntagskreis in 1916, and taking his doctorate in aesthetics in 1918; after the Hungarian upheavals of 1919, he moved to Italy, dedicating himself to art-historical studies, and subsequently moved to Berlin, where he lived until 1925, the year in which, fearing the advance of National Socialism, he moved to Vienna, where he worked until 1938 for a cinema production firm.

151. Teige 1936.
152. Castelnuovo 1976, in particular 11–14 and 17–22.
153. Ibid., 26, note 8.
154. Ibid., 11.
155. Ibid., 21.
156. Cf. Gombrich 1975, especially the section *Limits of Social Determinism*, 21–27.
157. Compare the observations by Carlo Ginzburg 1966, and especially 1049–1050.
158. Gombrich 1960.
159. Castelnuovo 1977, especially 19–21.
160. Chastel 1963 and 1966.
161. Haskell 1963, 1976, 1981b, 1989; Haskell and Penny [1981] 1984.
162. Saarinen 1958.
163. Moulin 1976a.
164. White H. and White C. 1965.
165. Taylor 1948.
166. Baxandall [1972] 1978.
167. Maas J. 1975.
168. Boime 1976.
169. Robertson 1978.
170. Brigstocke 1982.
171. For example, Alpers [1988] 1990; Montias 1989.
172. Besides the essay mentioned in the first chapter, I think of the works of Gregory 1982; Hyde 1983; Thomas 1991; Weiner 1992; Myers 2001.
173. In addition I note Fox, Turner 1998; Berg and Clifford 1999; Shovlin 2000; Wyett 2000. For a useful updating of the bibliographic panorama, see Stuard 2005.
174. McKendrick, Brewer, and Plumb 1982; Weatherill 1988; Shammas 1990; Brewer, Porter 1993; Jardine 1996; Sargentson 1996; Martines 1998; Brewer 2002.
175. Risch-Stolz 1990 and Lenman 1992, 1993, 1996.
176. Besides the works mentioned in the first chapter, see Hoogenboom 1993–94.
177. Green 1987, 1989; Moureau and Sagot-Duvaroux 1992; and Mainardi 1993.
178. Risch-Stolz 1988; Solkin 1993; Bignamini 1993; Plax 1995–96; Guerzoni 1996.
179. See Mattioli Rossi 1980; Pointon 1984; Lippincott 1995.
180. Miller 1992.
181. On artists' associations, I recommend Hoogenboom 1993; Grasskamp 1993; Codell 1995.
182. The studies by Olivato 1974a; Martinelli 1978; Maggio Serra 1991; Carloni 1992; Gasparri and Ghiandoni 1993; Levi 1993b, are exceptions.
183. Fidell-Beaufort, Kleinfield, Welcher, and Mayor 1979; Edwards 1996; McLellan 1996. A pleasing exception within the Italian context is in Ferrazza 1985 and 1993.
184. Apropos of this, see Miller 1989; Bayer 1992; Jensen 1994; and Dekkers 1996.
185. Couvra 1994.
186. Hoogenboom 1993–94.

187. Grivel 1986.
188. Pomian 1987.
189. Lugli 1990.
190. I am thinking of Raggio's (2000) very well done book.
191. De Benedictis 1991.
192. Barocchi 1979 and 1987.
193. Barocchi and Gaeta Bertelà 1993.
194. For example Fink 1978; Sutton 1985; Hermann 1991.
195. See Boime 1976 and Weisberg 1990.
196. Where the works of Macleod 1987 and Kidson 1992 stand out. Apropos of which I do not believe that it is accidental that 30 of the 42 English businessmen awarded the rank of peer and deceased before 1915 were famous collectors (71%), with a percentage of 86% (13 out of 15) for those ennobled between 1880 and 1889, or that among the 220 British millionaires who died between 1809 and 1914 as many as 109 (49%) were equally important collectors, and the percentage rises to 62% if we consider only those of aristocratic origin (Guerzoni 1996).
197. Grasskamp 1993.
198. Codell 1995.
199. Consider, for the Italian case, the proceedings of the conventions coordinated by Marisa Dalai Emiliani—Cf. Dalai Emiliani, Bartoletti, Di Fabio 1989; and Dalai Emiliani, Agosti, Manca, Panzeri 1993—and of the works of Levi D. 1988 and 1989; Tucker 1998.
200. Bailey 1984; Dowd 1985; Johnson-Mcallister 1986; Simpson 1986; Jowell 1996.
201. Anderson 1991; Mundt 1993; Nadalini 1993.

CHAPTER 2. THE PSYCHOLOGY AND ETHICS OF CONSUMPTION: THE DEBATE ON LIBERALITY, MAGNIFICENCE, AND SPLENDOR

1. Goldthwaite 1993, It. trans. 1995, 7.
2. I here note the works of general interest: Berve 1926; Borsanyi 1938; Barbieri 1957–58; Kloft 1970; Manning 1985; Pietilä-Castrén 1987; Wesch-Klein 1990; Hesberg 1992; Forbis 1993; Maclaren 2003.
3. Considering only studies on the Italian question, I cite Fraser-Jenkins 1970; Gundersheimer 1972; Pacciani 1980; Green 1990; Spilner 1993; Clough 1995; Cole-Ambrose 1995; Rubin 1995; Giordano 2002; Warnke 1995.
4. The exceptions are in the studies by Bianchini 1976, 1981, 1985, 1999; Todeschini 1992; Goldthwaite 1993, It. trans. 1995, in particular 218–223; and Vivenza 1995.
5. Alessandri 1609, 89.
6. See in Castiglione 1558, the *Ricordo circa gli ornamenti della Casa.*
7. Antoniano [1584] 1821, 2:39–41.
8. Della Casa [1571] 1970, 183.
9. Piccolomini 1552, book 5, 105v–106r.
10. Since "liberality shows itself better in giving than in receiving" (Piccolomini 1552, book 5, 103v–104r), and "this virtue lies more in giving than in receiving, because this action is much more difficult, praised, and meritorious" (Antoniano [1584] 1821, 2:39–41).
11. Piccolomini 1552, book 5, 105v.

12. Assandri 1616, book 4, 298.
13. Fabrini 1547, book 4, 81v.
14. Ibid., book 4, 81v.
15. Antoniano [1584] 1821, 2:39–41.
16. Pigna 1561, book 2, 35–36.
17. Piccolomini 1552, book 5, 106r–107r.
18. Sigismondi 1604, 23.
19. Piccolomini 1552, book 5, 107v–108r.
20. Piccolomini 1552, book 5, 107v–108r.
21. Capaccio 1620, 162.
22. Capaccio 1620, 273.
23. See Labowsky 1934 and Pohlenz 1935.
24. See Maclaren 2003, nn. 2–8, 40.
25. In the *Politeia* (402 and 486) they represent two, albeit separate, noble characteristics of the mind of a freeborn man, while in the *Theaetetus* (144) l' ἐλευθεριότησ is specifically associated with the liberal use of wealth.
26. Aristotle, *Etica Nicomachea*, IV, 1, 1119, 22–23.
27. Ibid., IV, 1, 1119b, 25–26.
28. Ibid., IV, 1, 1119b, 26–27.
29. Ibid., IV, 1, 1120a, 10–13.
30. Ibid., IV, 2, 1120b, 7–8.
31. Ibid., IV, 2, 1120b, 11–12.
32. Ibid., IV, 3, 1121a, 22–23.
33. Ibid., IV, 3, 1121a, 18–21.
34. Ibid., IV, 2, 1120b, 24–27.
35. Ibid., IV, 3, 1122a, 13–14.
36. For example Paolo Paruta stated that "giving is not among the most noble and most perfect of its operations, and, according to this better part of itself, is called virtue by the others, and similar to justice. And thus also one derives that of the two vices, that are in opposition, prodigality is to be esteemed less distant from virtue than avariciousness" (1579, 183).
37. Aristotle, *Etica Nicomachea*, IV, 4, 1122a, 23.
38. Ibid., IV, 4, 1122a, 29–30.
39. Ibid., IV, 4, 1122b, 8.
40. Ibid., IV, 5, 1122b, 26–28.
41. Ibid., IV, 5, 1122b, 30–35.
42. Ibid., IV, 5, 1123a, 4–8.
43. Ibid., IV, 5, 1123a, 7–9.
44. See Ampolo 1984 and Büsing 1995.
45. Büsing 1995.
46. The term "public magnificence" referred above all to public works both religious and civil and to celebrations of military successes. I do not think that it was by chance that the use of this term spread throughout the period of the Punic Wars (see Pietilä-Castrén 1987), when the Roman Senate approved the *Oppia* and *Orchia* laws in 215 B.C., which were intended to limit *luxuria privata* (private luxury). For further details see Sauerwein 1970; Miles 1987; and Hunt 1996, in particular 19–20.
47. Cicero, *Pro Murena*, 36.76.

48. Zanker 1987, Eng. trans. 1990, 1–2.
49. Isager 1993, 257–275.
50. See Mills 1984 and Braund 1994.
51. This distinction clearly results in Cicero's *De officiis*, as in II, 52, 15: "Deinceps de beneficentia ac de liberalitate dicendum est, cuius est ratio duplex: nam aut opera benigne fit indigentibus aut pecunia." For further details see Vivenza 1995, 507.
52. See Stylow 1972 and Manning 1985, 82 n. 7.
53. Manning 1985, 77.
54. In theory, the action of the genuinely liberal man should be characterized by the absence of any form of personal interest, as a pure act of altruism, as emphasized in other passages by Seneca's *De beneficiis* 5.9.2, "Itaque nec liberalis est qui sibi donat," and Cicero 1965, *Laelius*, 30–31: "benefici liberalesque sumus, non ut exigamus gratiam, neque enim beneficium faeneramur sed natura propensi ad liberalitatem sumus."
55. Running through the list of the meanings attributed to the term *liberalitas* in the epigraphic and numismatic sources compiled by Guido Barbieri (1957–58), we found among the emperor's liberalities: *donativa, institutiones alimentariae,* land grants, remissions of debts, restitutions of goods from state treasury to individuals, nominations to political positions, games, privileges to provinces and cities; among those granted to individuals: public money distributions, assistance to the food administration office, plays, games and spectacles, banquets and food distribution, public works such as amphitheaters, arches, basilicas, libraries, forums, slaughterhouses, walls, porticoes, statues, temples, theaters, spas, and baths.
56. Manning 1985, 78.
57. In Fischer 1983 and Slob 1986. For the relationships between *liberalitas* and *largitio*, see Forbis 1993, 489 nn. 32–33.
58. See Berve 1926, columns 82–84; Borsanyi 1938, 41; Hellegouarc'h 1963, 219; Veyne 1976, It trans. 1984, 377; Manning 1985, 77–78.
59. It thus became increasingly difficult to distinguish the limits that separated *liberalitas* from the terms identifying large-scale corruption, *ambitus* and *largitio*, and the word came more often to have a meaning linked exclusively to politics and patronage, as Cicero recognized in *De oratore* II.105: "Nam et de pecuniis repetundis, quae maximae sunt, neganda fere sunt omnia, et de ambitu raro illud datur, ut possis liberalitatem et benignitatem ab ambitu ac largitione seiungere."
60. Echoes of this adversion might be found in the harsh criticisms of Cicero against the lost treatise *On Wealth* of Teophrastus, where there is lavish praise for the magnificence of popular spectacles, valuing the capacity of wealth to meet these expenses.
61. In this manner Cicero throws a large part of the actions that Aristotle ascribed as expressions of private magnificence back into the channel with prodigality, II, 15.55: "Omnino duo sunt genera largorum, quorum alteri prodigy, alteri liberales: prodigi, qui epulis et viscerationibus et gladiatorum muneribus ludorum venationumque apparatu pecunias profundunt in eas res, quarum memoriam aut brevem aut nullam omnino sint relicturi."
62. Cicero, *De officiis*, II, 17.60: "Atque etiam illae impensae meliores, muri, navalia, portus, aquarum ductus omniaque, quae ad usum rei publicae pertinent . . . Theatra, porticus, nova templa verecundius reprehendo." Furthermore Cicero mentions (II, 17.60: "Sed de hoc genere toto in iis libris, quos de republica scripsi, diligenter est disputatum") that he dealt with building expenses at length in one of the six books (for Emanuele Narducci it might have been the fifth) of *De Re publica*, which has come to us in fragmentary form.
63. Kloft 1970, 47 n. 4; further information in Forbis 1993, 486 n. 17.

64. Between *liberalitas* and *munificentia* there seems to exist only differences in degree: In fact, if *liberalitas* does not have particular social connotations, *munificentia* is an aristocratic, princely, or regal virtue, as can be seen in Mrozek 1984; Johnson 1985; and Forbis 1993, 486.

65. It is no accident that the seventh and eighth chapters of book 4 of the *Nicomachean Ethics* follow directly on from the passages dedicated to liberality and magnificence; this order is kept also in the first book of Cicero's *De officiis*: The pages on *magnanimitas* follow those reserved to beneficence and liberality. On this virtue and later Christian reformulations, see Knoche 1935 and Gauthier 1951.

66. Since *magnificentia* remained exclusively a state characteristic, honor was awarded to *munificentia*, which meant to make very large gifts (*munus-facere*), or to spend enormous sums of money, as stated by Forbis 1993, 486 nn. 16 and 17, who often found the term associated with monies left by wealthy persons to their native cities.

67. For further details, see Kloft 1970 and 1987; and Dopico-Cainzos 1993.

68. The *congiaria* were public distributions of food and/or money, given to the entire Roman plebs. They were similar to the *donativa* that were given to victorious soldiers or campaign veterans. Originally, the *congiaria* were distributions of food; as the etymological origin of the term *congius* shows, it was a standard cubic unit of measurement of 3.25 liters, used for wine and cereals. Later, more or less since Caesar's *congiaria in denarios*, they became distributions of silver and bronze coins. Some Latin scholars, for example Adrien Blanchet, believe *congiarium* was synonymous with *liberalitas* (1904, 1192) and Guido Barbieri, who, following the interpretations of Strack and Van Berchem in the 1930s, stops at a very precise chronological reconstruction of the Roman imperial *liberalitates*, from Caesar to Galerio Massimiano, strongly convinced that (1957–58, 839) "liberalitas or congiarium: there is no difference between the two words, as can be seen from the coins used from the beginning of the II century A.D." Helmut Berve (1926, cols. 84–86), on the other hand, argues that the *liberalitates* were donations and expenses based on the private princely wealth, the *patrimonium*, while the *congiaria* were a burden on the state treasury, the *fiscus*. At any rate, for further details see Millar 1991 and Corbier 1997.

69. See Kloft 1996.

70. See Romano 1994.

71. On the characters of Augustus's *magnificentia publica*, see Zanker 1987, It. trans. 1989, in particular pages 146–150 of chap. 4; and Hesberg 1992.

72. See Todeschini 1992, 200–215; and 1994, 123 and 193–194.

73. As we can see in the passage from Aquinas's *Summa*: "et alio nomine liberalitas largitas nominatur" ([1269] 1949, IIa, IIIae, quaestio 117, ar. 2, co.).

74. Todeschini 1994, 123.

75. For instance for Ambrosius (quoted in Todeschini 1992, 219), liberality, placed between the two extremes of *inhumanum* and *prodigum*, consists in "giving abundantly to pilgrims, not superfluous but suitable things, not superabundant but convenient to human nature" (*largire peregrinis, non superflua sed competentia, non redundantia sed congrua humanitati*), while still in the thirteenth century Guillame Pérault considered as synonymous *liberalitas, misericordia*, and *largitas* (liberality, mercy, and largesse), reinforcing the Christianity of his interpretation with numerous exempla quoted from the Old and New Testament and Gospels (in Pérault [1236–48] 1595, chap. 73, "De liberalitate, misericordia et largitate," 306).

76. "Liberality, magnificence, and magnanimity are similar, since all of them regard the receiving and giving of money," in Latini [1270] 1869, 52. See on the same theme Gauthier 1951, 55–118 and 119–176; Greaves 1964; and Van Houdt 1999, 322–323.

77. Latini [1260] 1869, 37: "He is magnanimous who is suited to the greatest works, and who rejoices and enjoys in doing great things," and "the real magnanimity is only in the greatest things, that is to say in the actions in which man serves God the glorious."

78. Aquinas [1269] 1949, IIa, IIIae, quaestio 117, ar. 3, ra. 1: "Magnificence regards also the use of wealth, but according to some special reason, that is, when wealth is used in the achievement of some great work. So magnificence is in some way additional with respect to liberality."

79. Aquinas [1269] 1949, IIa, IIIae, quaestio 117, ar. 3, ra. 2.

80. Aquinas [1269] 1949, IIa, IIIae, quaestio 134, ar. 3, ra. 2.

81. Aquinas [1269] 1949, IIa, IIIae, quaestio 134, ar 3, co: "Magnificence regards the intention of making some great work; and in order to ensure that some great work was conveniently carried out, proportionate expenditures are required; in fact the great works cannot been made without great expenditures. So magnificence concerns making great expenditures in something that was made conveniently great."

82. Aquinas [1269] 1949, IIa, IIIae, quaestio 134, ar. 3, ra. 3: "sicut cum facit aliquid ad quod tota civitas studet."

83. Aquinas [1269] 1949, IIa, IIIae, quaestio 134, ar. 2, ra. 2: "In fact no aim of human works is greater than honoring God, and for this reason magnificence principally makes great works in order to honor God."

84. Aegidius 1491, chap. 18.

85. Aegidius 1491, chap. 20.

86. Aegidius 1491, chap. 20.

87. See Guillemain 1966, 254–256 and Zacour 1975.

88. Luis Green (1990, 98 n. 3) found the term "magnificence" cited in some Milanese letters from 1356–1357, while Paula Spilner (1993, 455) has found it in the document from 1371 in which the Florentine *Signoria* and counsels approved the plan for the addition to Palazzo Vecchio.

89. Green 1990, 98.

90. In the chapter "De magnificentia edificiorum" of his *Opusculum de rebus gestis ab Azone, Luchino et Johanne Vicecomitibus*, 101: "honorabiles sumptus, quos debet facere princeps magnificus, sunt circa Deum" (quoted in Green 1990, 98).

91. Quoted in Green 1990, 101.

92. During this period the necessity to furnish an ideologically legitimate support for the ambitions of the oligarchic faction arose, as one can deduce from the reading of Pacciani 1980.

93. Bruni in the second decade of fifteenth century translated *Nicomachean Ethics* and between 1420 and 1421 translated and commented on the pseudo-Aristotelian *Economics*, as observed by Frigo 1985, 28–29.

94. Alberti [1432–34] 1969, *Liber tertius familiae: economicus*, 258.

95. Quoted in Donati 1988, 10.

96. See King 1975, 547–553.

97. Filelfo [1443] 1537, 78ff.

98. See Shepherd 1998.

99. The text by Sabadino degli Arienti has some similarities to both the work that Timoteo Maffei wrote between 1454 and 1456, *In magnificentiae Cosmi Medicei Florentini detractores* (analyzed in detail by Fraser-Jenkins 1970), and the chapter "De liberalitate et magnificentia" in the second book of *De Principe*, which Bartolomeo Sacchi, called Platina, dedicated in the 1470s to the young Federico Gonzaga.

100. On the relationships between Florence and Ferrara, see Kent 1977, 313–314.

101. Argenteus 1496, 34r: "consists in things sumptuous, great and sublime, and its name resounds largesse and grandness in expending gold and silver in eminent, high, and divine works that are suitable for the magnificent man."

102. The text is divided into eight paragraphs (I. Prologus, II. Duo esse sordidorum genera, III. Qualem esse deceat viri splendidi supelectilem, IV. De ornamentis, V. De apparatu, VI. De cultu atque ornatu corporis, VII. De habendis gemmis ac margaritis, VIII. De hortis ac villis), and has been recently studied by Welch (2002a) and Quondam (2004).

103. I used the edition of Pontano (1518). In truth, in 1498, these little texts were printed with the titles *De liberalitate, De beneficentia, De magnificentia, De splendore, De conviventia,* analyzed by Tateo 1965 and 1999.

104. Pontano 1518, *De liberalitate liber,* 97r–117v and *De magnificentia liber,* 124r–137r.

105. Pontano 1518, *De splendore liber,* 136r–140v.

106. For these themes see Pagliara 2001, 41–43.

107. Quondam 2004, 35.

108. See, for instance, Byatt 1983.

109. Cortesio 1504, *Liber tertium, distinctio octava de virtutibus moralibus*: "liberalitatem definimus ut ea sit ad bene de multis promerendum opitulatrix virtus. . . . magnificentiam autem volumus ex eadem fortitudine nasci quae sit magnorum operum confectrix cum decentia sumptuum collocandorum."

110. Cortesio 1510, in particular the *Liber oeconomicus,* lv–lviii.

111. See Donati 1988, in particular chapter, "*La svolta di metà Cinquecento: verso una omogenea ideologia nobiliare,*" 128–150.

112. Muzio 1575, 9.

113. See in Berry 1994, chap. 5, "The De-moralisation of Luxury," 101–108.

114. See Hughes-Owen 1986; Hunt 1996; Muzzarelli 1996; Kovesi Killerby 2002.

115. Antoniano [1584] 1821, 2:29.

116. Antoniano [1584] 1821, 2:27.

117. Antoniano [1584] 1821, 2:27.

118. Orologgi 1562, 124–125.

119. Antoniano [1584] 1821, 2:27.

120. Romei 1591, 259.

121. Paleotti [1582] 1960, 500: "painters, men of letters, ecclesiastics and the third kind of persons, who should necessarily be satisfied: the idiots—who are the majority of the population—for whom sacred pictures were introduced."

122. Lomazzo 1585. In book 7, chapter 21 are listed the pictures to be used in sepulchers, cemeteries, underground churches and other melancholy places; in chapter 22 those used in important religious buildings, in chapter 23 those used in large rooms (meeting rooms and audience chambers), in chapter 24 those used in palaces and princely residences, in chapter 25 those used in fountains, gardens, and rooms for pleasure, in chapter 26 those used in schools and colleges, and in chapter 27 those used in taverns and similar places.

123. Armenini 1586, book 3, devoted to the "distinction and convenience of paintings according to the places and the qualities of persons."

124. Romei 1591, 259.

125. Antoniano [1584] 1821, 1:382: "The good father should not accept that his young son have his face painted, his ears pierced, and his hair curled. The young son has not to appear in public as an affected female, full of scent and lasciviousness, dressed with pomp."

126. See in Gracian [1583] 1693, the *maximes* dedicated to ostentation, nos. 85, 106, 123, 127, 203; in particular no. 277, pp. 319–320, *L'Homme d'ostentation*, where "Toutes le fois que l'ostentation s'est faite à contretems, elle a mal réussi, rien ne soufre moins l'afectation, que l'ostentation échaüe, parce qu'elle aproche sort de la vanité, et que celle-ci est tres-sujete au mê pris. Elle a besain d'un grand temperament paur ne pas donner dans le vulgaire."

127. Piccolomini 1552, book 5, 107r.

128. Castiglione [1528] 1981, 389: since "the good and wise prince will be very fair, sober, temperate, strong and learned, full of liberality, magnificence, religion and clemency."

129. On theorizing the hero, see Botteri 1986.

130. India 1591, 61–62.

131. Ibid., 61–62.

132. Machiavelli [1532] 1960, chap. 16, "De liberalitate et parsimonia," 66: "If somebody wants to preserve among men the fame of being liberal, it is necessary not to omit any quality of sumptuousness; in this way a prince will always squander in similar works all his wealth. Thus, he will be obliged, if he wants to preserve the fame of being liberal, to burden people heavily and to impose the highest taxes, and to do all those things that can be done in order to raise money. This will make him odious to his subjects, and nobody will esteem him."

133. Machiavelli [1532] 1960, 67: "A prince with sufficient money can defend himself from whoever wages war on him as well as he can perform exploits without burdening people. Thus, he will be liberal with those from whom he will not take away anything, who are innumerable, while he will be miserly with those to whom he will not give anything, who are a few."

134. Franco [1539] 1542, dialogue 5, 78v, where the servant reprimands his lord, asking: "Were are the accounts? I promise you that whoever did the spending kept the money. I can assure you that whoever managed earned a lot. Why is it not possible to see any accounts regarding the kitchen, the pantry, the stable, the wardrobe? Dear Lord, I am sure that for every capon you eat, the sauce costs the same as the capon. You do not wear any jacket made of satin, which had not been accounted for as golden cloth. . . . In which court did it ever happen, except in this one, that the servants eat the same bread that is distributed on the lord's own table? You have to do in your household as is done in all the other courts: You must give your servants unleavened, badly cooked black bread, as happens in every other court."

135. Peregrini 1634, chap. 6, p. 174.

CHAPTER 3. DEMAND ANALYSIS: THE EXAMPLE OF THE ESTE COURTS BETWEEN THE FIFTEENTH AND SEVENTEENTH CENTURIES

1. Cf. Kempers 1987; Esch and Frommel 1995; Talvacchia 1996; Ciammitti, Ostrow, and Settis 1998; Stockhausen 2002; Welch 2002b; Campbell 2004.

2. Warnke 1970 and [1985] 1991.

3. Welch 2004, 19.

4. See further Campbell 2002, 327–331.

5. See Gundersheimer 1972 and [1973] 1988; Newcomb 1980; the volumes by Papagno and Quondam 1982; Tuohy 1982; Pade, Petersen, and Quarta 1987; Salmons and Moretti 1984; Lockwood [1984] 1987; Mottola Molfino, Natale, and Di Lorenzo 1991; Bertozzi 1994; Campbell 1997.

6. Typical examples are the titles of the exhibition catalogs of 3 October 2003 to 11 January 2004 in Brussels and from 14 March to June 13 in Ferrara, respectively, *Un rinascimento singolare. La corte degli Este a Ferrara* (Bentini and Afosrini 2003) and *Este a Ferrara. Il Castello per la città* (Bentini 2004).

7. Cf. the *Premessa,* in Matthews-Grieco and Zarri 2000, 287.

8. Anderson 1996, 130.

9. Both Don Carlo, the son of Federico the bastard, and Queen Isabella (the wife of Ferdinand the Catholic), died in Ferrara in the ducal palace of San Francesco, the former on 10 December 1520, and the latter on 8 May 1533.

10. That is, the courts of Sigismondo (brother of Duke Ercole I) with 90 members, of Rinaldo (brother of the duke) with 25, of Alberto (brother of the duke) with 25, of Duke Ercole I with 550 and of Duchess Eleonora of Aragon with 110, of the heir apparent Alfonso I with 90 and of his wife Lucrezia Borgia with 70, of the duke's second son Cardinal Ippolito I with 120, of the third son Ferrante with 35, and the fourth Sigismondo with 50.

11. There were in fact the courts of Cardinal Ippolito II (the duke's brother) with 250 members, of Don Francesco (the duke's brother) and of his consort Maria di Cardona with 90, of Don Alfonso Marquis of Montecchio (brother to the duke) and of his wife Giulia Della Rovere with 130, of Duke Ercole II with 520 and of the Duchess Renata of Valois with 150, of the heir apparent Alfonso II with 300 and his wife Lucrezia de' Medici with 80, of Prince Luigi (second son of the duke, later cardinal) with 120, of Laura Eustochia Dianti (second wife of Duke Alfonso I, father of Duke Ercole) with 60, of Lucrezia and Eleonora (daughters of the duke) with 30 members, and of Don Alfonsino with circa 60.

12. Diario ferrarese [1409–1502] 1930, 193.

13. Frizzi 1847–48, 4:225.

14. Prizer 1998, 305–306.

15. The artists' names were published in Guerzoni 2002, 192.

16. They were Jacques Vignon, Gabriel Lepère, and Philippe de la Porte, whose lives were traced in Franceschini 2001, especially on pages 67–68.

17. An exception can be found in the essays by Smith 1997; Edelstein 2000; Welch 2000; and McIver 2001 on Veronica Gambara da Correggio and Silvia Sanvitale.

18. I point out the countercurrent of Gundersheimer 1980 and Biondi 1998, in which the Modenese scholar studied the matronage of the duchesses Virginia de' Medici, Isabella di Savoia, Maria Farnese, Lucrezia Barberini, and Laura Martinozzi; Franceschini 2000; Laureati 2002.

19. With the exception of the cardinals' courts, as one can deduce from the works of Cremonini 1998; Guarino and Mancini 1998; Hollingsworth 2005.

20. Rebecchini 2002. Further on the same theme: Curti and Righi Guerzoni 1998.

21. For the raw data, see Guerzoni 1999a, 83. Missing from the table are the data from every year for each of the named princes and, above all, the information relative to incomes of other members of the Este house, such as Don Francesco, brother of Duke Ercole II, who according to the chronicles of the time had an annual income of more than 300,000 liras, or that of Laura Eustochia Dianti, last wife of Duke Alfonso I.

22. Respectively defense; diplomacy; administration; state affairs; salt; land; manufactures; building activity; salaries and benefits; wardrobe; granaries, cellars, and wood; foodstuffs; mobility; various; and extraordinary.

23. Mesola is the name of the region in the delta where Alfonso II in 1578 began the construction of a new city, and the sums expended were so great that it had its own specific budget.

24. The sum has been drawn from the elaboration of data in the ledger in ASMO, CDE, AP, no. 1337, *Registro dei mandati della guardaroba,* 1560.

25. See tables 5 and 6.

26. Haskell 1963, 6; It. trans. 1985, 30.

27. For further information see Lockwood 1984, It. trans. 1987, especially paragraphs 2–6 of the fourth chapter, pages 168–228.

28. The reduced presence of "court painters" is not surprising: Between 1462 and 1628 there were only six in the courts of the Estense dukes who could boast—for very short periods—this title: Cosme Tura from 1462 to 1471, maestro Polo in 1471, maestro Baldissera da Rizo in 1471, Ercole de Roberti from 1488 to 1499, Pellegrino da Udine from 1507 to 1513, and Dosso Dossi in 1531. The data can be seen at http.guidoguerzoni.org, in the database "Cortigiani estensi 1457–1628."

29. These duties were carried out informally throughout late Quattrocento by the *offiziali or camerlenghi* of the tower of Rigobello, in Castle Vecchio, who had charge of the library, the jewels, precious stones, clothing and ceremonial objects, the private collections and archive of the House of Este. The title of antiquarian appeared instead for the first time in 1551 at the court of Ippolito II (in ASMO, CDE, AP, no. 903, *Bolletta di provisionati di casa del Cardinale Ippolito II,* 1551), when it was Pirro Ligorio who occupied the post. At the ducal courts Enea Vico was the first *salariato di bolletta* to appear under the title, from 1564 to 1567, while Pirro Ligorio held the post from 1568 to 1583.

30. With the exception of one or two months' pay that were regularly withheld every year: the *paga morta delle mura* and the *paga morta de corte.*

31. Warnke 1985, It. trans. 1991, 102–104.

32. ASMO, CDE, BS, no. 7, *Registro di Bolletta,* 1475.

33. ASMO, CDE, Soldo, no. 22bis, *Memoriale del Soldo,* 1502.

34. ASMO, CDE, BS, no. 63, *Registro di Bolletta,* 1559 and no. 65, *Bolletta del Bancho,* 1560.

35. ASMN, Archivio Gonzaga, no. 395, D. XII, no. 5, *Compendio di tutti li salariati di S.A. che sono a Bolletta,* 1598, 26r–26v.

36. There were eight types of bread (*pane intiero da signore di primo e secondo fiore, pan taia, roseffo, frescho, da famiglia, da cani, biscotto*) and four of wine (*da signore, da tinello, da famiglia fresco e buido*), meat and fish that were of a higher or lower quality (only the duke and his *familia* regularly ate ocean fish and shellfish, as well as sturgeon and freshwater crayfish), houses and horses of different value, clothing, footwear and hats of different fabrics and prestige, and so on.

37. The *salariati di bolletta* had the right to receive one or more daily food rations according to the number of their dependent relatives or servants—called *bocche* (mouths). The rations consisted of meat (normally beef) or freshwater fish (a pound [450 grams]) per day. There were five meat days (from Sunday to Thursday), and two fish days, (Friday and Saturday). During Lent only fish was eaten. There was also a wine allowance of two *bozze or boccali,* equivalent to 2.8 liters per day, a bread allowance of 800 grams per day, and regular (weekly and monthly) distribution of oil, salt, salt meat, lard and cheese, candles, and firewood. Furthermore, there were Christmas and Easter alms—consisting in eggs and capons, sweetbreads and fruits, cheeses and spices.

38. In ASMO, CDE, AP, no. 959, *Libro H,* 1563.

39. The case of the tips given to the officials who cared for the Ferrarese cardinal between 19 and 22 July 1566, during a trip from Tivoli to Ferrara are examples. On the nineteenth, as dinner and overnight guest of the bishop of Nocera Umbra, Ippolito distributed 12 golden scudi; on the twentieth he gave 15 to the "servants of the archbishop of Urbino" who had cared for him in the

Cagli palace; on the following day he gave out 44 in the house of the cardinal of Urbino at Fossombrone; and again the next day, guest of the Duchess of Urbino at Pesaro, the cardinal gave out another 29. In ASMO, CDE, AP, no. 971, *Libro de' minuti piaceri*, MCLXVI, 18r, 19r, 19v, 20v.

40. In ASMO, CDE, AP, no. 1310, *Compendio delli denari spesi per man del signor conte Ottavio Estense Tassone in servicio del Monsignore Illustrissimo e Reverendissimo Cardinale d'Este in Franza*, 1573, c. 2.

41. ASMN, Archivio Gonzaga, n. 402, D. XII, no. 7, *A dì 31 decembre 1592 Conto della spesa fatta per mane di me Hippolito di Guidoni de liras 20.460 havuti dal S.or Ottaviano Capriano a render raggione*, c. 7r-287. Two hundred "were left with the family of the most serene Duke of Ferrara, fifty to his stables, fifty to his Camera, ushers and those who work in the Chamber of Madam the Duchess, twenty-five to the Swiss and twenty-five to the Germans of the guard of the Serenissimo of Ferrara, twenty-five to the soldiers of the Castello." The sum total was 2,418 liras 15 soldi of Mantuan liras.

42. The names and careers can be found in Guerzoni 2002, 199–200.

43. The sums expended in purchasing the precious tapestries were so large (think of the 10,140 liras paid out on 20 July 1568 by Cardinal Ippolito to Guglielmo Zanforti for "seven pieces of tapestry *a boscaria*") that the Este required their resident ambassadors to provide accurate descriptions of the series available on the market or even bought by their more important rivals, as one can infer from reading the letter from Alvarotti, Ferrarese ambassador to the French court, reported to Ercole II from Blois on 27 November 1550: "It seems that S.S.R. has just bought a tapestry and jewels from Mons. D'Estampes for 10,000 scudi that are worth more than 20,000 per tapestry; twelve large tapestries that are the twelve months of the year all in gold and silk were made and taken to sell in France at the time of the former king and the merchant wanted 20,000 scudi for them." (ASMO, CDE, Ambasciatori, Francia, no. 28, lettera del 27 novembre 1550 di Giacomo Alvarotti al duca Ercole II).

44. The events surrounding the "statue of Ercole," commissioned in 1550 by Ercole II from the Venetian workshop of Sansovino and shipped by boat to Ferrara on 18 August 1553, and that caused the resident Gerolamo Faletti to undertake long and extenuating negotiations, so that on 8 August 1554, writing to the duke, Faletti remarked that in Venice "there was a young man from Ferrara, a very famous sculptor, who had invited him and the imperial ambassador to see some of his works "that certainly smack of antiquity." If the duke wished he could order a statue of Ercole, which "he must deliver in eight months at the latest, and would make with some nice damage so that it looks like the other" [that is, the one commissioned of Sansovino]" (ASMO, CDE, Ambasciatori, Venezia, no. 43, lettera dell'8 agosto 1554 di Gerolamo Faletti al duca Ercole II).

45. Consider the tabernacle proposed by the Estense resident in Venice, Gerolamo Faletti: "Ms. Nicolò Crasso doctor in Venetia started sixteen years ago to have built a tabernacle out of mountain crystal and circa six feet high, which has turned out very beautifully, silver relief, pieces of crystal of a size never before seen, an object worthy of any great prince of your rank" (ASMO, CDE, Ambasciatori, Venezia, no. 47, lettera del 31 luglio 1563 di Gerolamo Faletti al duca Alfonso II).

46. The episode of the "sasso di Bergomo" is exemplary: "The count G. Battista writes that he will bring it to Venice, the ambassador already has four that are more ancient, one of 1,150 years, the second 1,132, the third 1,080, and the fourth is modern. While traveling he had see "many others that were very old," and among them a statue of Luxonia, daughter of C. Atio, paternal forefather of Foresto, recently found among the Este ruins" (ASMO, CDE, Ambasciatori, Venezia, no. 47, lettera del 12 aprile 1561 di Gerolamo Faletti al duca Alfonso II).

47. Ancient statuary was in great demand even though hard to obtain. Alessandro Grandi, the Ferrarese agent in Rome, explained on 23 June 1559 that, even though he had found "some crystal vases, and an antiquarian has some statues . . . but they cannot be exported except with a special license, which the authorities will not grant, and contraband is severely punished," and on 8 July the same year he met "difficulty in obtaining statues from excavations. . . . I have shown the Diana to an expert in antiquities, and he says that the only ancient part is the bust down to midleg, and the left arm. The statues of Hercules have been cut and taken from an ancient pestle where there were sculpted at that time in half relief and measure a palm and a half . . . but one does not find the strength of Hercules all together if not rarely. . . . The thing of antiques is the need for time to find them and have them looked at by someone intelligent, because they cannot be found so quickly. But to be advised and in the business gives more play to the buyer, and then one must await the occasion, and the time of other quality." Downhearted on July 12th, he complained that "I cannot find any road, not only of statues, but even of pieces of marble, whether slabs or mixed, and it is already two years that in Civitavecchia there have been certain pieces of columns of mixed that can be cut into disks and a small table that the most excellent of Curisa had me take in his name and that of the most serene Queen, nor has it been possible to extract it, even though S. Ecc. had given permission" (ASMO, CDE, Ambasciatori, Roma, no. 26, lettere del 23 giugno e dell'8 e 12 luglio 1559 di Alessandro Grandi al duca Alfonso II).

48. See Welch 2005.

49. For the problems in calculating careers, I refer the interested reader to Guerzoni 1999b, and especially pages 45–71.

50. The names have been published in Guerzoni 2002, 201–202.

51. The names are in http.guidoguerzoni.org, database "Fornitori della Guardaroba ducale 1529–1534."

52. See further *Instrumento di consegna degli edifici ed utensili spetanti alla Società stabilita per l'arte de vetri in Ferrara nell'anno antecedente fra Giovanni da Caligo e Francesco Malosselli da Murano del 1452* in ASMO, CDE, Archivio per materie, Arti e mestieri, Vetrai, no. 37.

53. The names appear in the http.guidoguerzoni.org database "Cortigiani estensi 1457–1628."

54. The names are in the www.guidoguerzoni.org database "Bombardieri e fonditori del Soldo."

55. For example, among the twenty-six tailors paid by the ducal wardrobe between 1529 and 1535, there are the maestri Giacomo da Sermide, Tommaso dal Friuli, Bartolomeo da Mantova, Stefano Francese, Ludovico Padovano, Martino Alemano, and Giovanni Gerolamo da Mantova.

56. These were "Cortine da razo da sala 41 (41 satin curtains for halls), apparamenti da leto da più persone 23 (23 wedding sheets), cortine da cendale da appicare a diti ut p.to de diti apparamenti 9 (9 curtains made of cendale (a kind of satin) hanging around beds), cortine da sarza da appicare a tali soprascripti apparamenti 21 (21 baize curtains hanging around beds), coperturi de razo da leto 77 (77 satin bedspreads), spaliere di razo 23 (23 satin heads of the bed), bancali di razo 127 (127 satin table cloths), antiporti 34 (34 door-curtains), tapedi 74 (74 carpets), ornamenti e robe de più et diverse condecione (solo descritti) (ornaments and various stuff)." In ASMO, CDE, AC, Arazzi e Tappezzerie, no. 1, Inventario de tapezarie, 1457–67.

57. See for this a document from 1494 (ASMO, CDE, AC, Biblioteca, no. 1, Carteggi, fasc. 4): The inventory made for Mr. Gironimo Ziliolo of the books found in the oratory of the Ex.tia of the *signore* and Andrea da le Voze and Bartolomio Negrisolli and the *fra* of the wardrobe. The list was in alphabetical order and included texts in vernacular, Latin, and French, entered by author and title, numbered (by order of loan) and placed in marked closets: considering the additions made up to 1516, there were at least 518 volumes, to which we must add the more than 400 manuscripts from the studio.

58. ASMO, CDE, AC, Guardaroba, no. 102, *Inventario de pagni de lino consignati al maestro Francesco Recamadore officiale sopra la drapamenta della corte ducale,* 1503.

59. ASMO, CDE, AC, Guardaroba, no. 185, *Inventario delle robbe della ducale guardaroba principiato alli 16 de febbraio 1561, et quali robbe furono consegnate insieme con le chiavi di essa guardaroba al molto m.co s.re Ercole Bonaccioli fatto et publicato da sua eccellentia ducal guardarobiero il di ultimo di giugno 1561.*

60. ASMO, CDE, AP, no. 130, *Inventario di gioie dell'heredità del serenissimo Alfonso 2 e de mobili della guardaroba mancati secondo il Guardarobiere di detto serenissimo, 1598–1608.*

61. Ibid., 31r.

62. Ibid., 33r.

63. Ibid., 37r.

64. Ibid., 38v.

65. These figures have been calculated from my elaborations of the ledger in ASMO, CDE, AP, no. 1353, *Inventario generale della guardaroba di robbe fatte 1580;* of the silver I point out 43 different articles for the mass, 56 basins and mugs, 2 bottles, 3 inkwells, 5 small bells, 87 candlesticks and holders, a coffee pot, 11 cups, 12 spoons, 140 spoons, knives, and small forks, 21 flasks, 12 forks, 2 graters, 1 globe, a pontifical staff, 2 small boats, 2 urinals, 17 bread containers, 514 plates, 2 reliquaries, 21 salt dishes, 2 bed warmers, 5 food warmers, 1 box, 16 soap dishes, 7 little pails, 71 cups, 141 round (plates) and 11 vases of all sizes.

66. Ibid., *carta* cxxvi.

67. Ibid., *carta* xcv.

68. Ibid., *carta* cxxxiii.

69. Think of the production, maintenance, and repair of the musical instruments, trusted from 1518 to the laboratory of Giovanni Marco da Lugo, master of musical instruments, then taken over by his son Domenico, or the construction of clocks delegated to the members of the Swiss family Emarquand, to the carpenters, turners, window makers, lapidists of the construction office, to the tapestry makers, embroiderers, furriers, tailors, shoemakers, and perfume makers.

70. I refer the reader to Hughes 1986.

71. Warnke [1985] 1991, 111–115.

72. In earlier years the wardrobe usually spent 30–35,000 liras yearly. Nevertheless in 1529 the duchy was exhausted at the end of nineteen years of conflict with the imperial and pontifical forces, which up until 1528 had occupied two-thirds of the Este territories; and then, above and beyond the cost of war, between 1529 and 1534, Alfonso paid out more than 800,000 liras to the imperial coffers for the Pact of Cologne, thanks to which he regained Modena and Reggio Emilia.

73. There were 3 tapestry makers, 5 armorers, 2 barbers, 6 boatmen, 2 *battilana* (wool combers), 3 cap makers, 13 sock makers, 8 hatmakers, 6 wagoners, 2 potters, one *cerchiaro* (hoop maker), 2 basketmakers, 1 *chiodarolo* (nail maker), 1 *chiovaro* (locksmith), 2 shearers, 6 *cintari* (belt makers), 1 knife maker, 3 blanket makers, 2 *conciacandelieri* (candlemakers), 7 *cordellari* (rope makers), 1 courier, 1 sifter, 24 sewers, 4 gilders, 17 blacksmiths, 36 porters, 4 carpenters, a spinner, 36 *fornaciari* (kiln men), 1 *garzadore* (carder), 3 *guainari* (sheath makers), 11 glovemakers, 7 inlayers, 6 washerwomen, 8 booksellers, 1 lutenist, 1 *mantellaro* (mantle maker), 2 *mascherari* (mask makers), 3 tub makers, 2 leather merchants, 1 wool merchant, 12 fur sellers, 8 silk merchants, 36 fabric merchants, 42 mercers, 1 pawnbroker, 6 *morsari* (bit makers), 2 renters of bags, 2 eyeglass makers, 12 goldsmiths, 1 clockmaker, 10 furriers, 1 *peltraro* (pewter maker), 4 *pennacchieri* (plume makers), 3 painters, 3 loaners, 3 perfumers, 8 menders, 7 embroiderers, 26 tailors, 2 *scaranari* (armchair makers), one *scatolaro* (box-maker), 4 *sellari* (saddlers), 2 brokers, 4 spot

removers, 5 *sogari* (saddlers), 6 sword makers, 1 spicer, 2 *storari* (mat makers), 3 rag pickers, 3 *stuari* (stove makers), 5 *tagliacalze* (shoemakers), one weaver, 11 dyers, one twister, 3 turners and 1 sail maker. The above has been extracted from the elaboration of data from ASMO, CDE, AC, Guardaroba, no. 152 and LCD, nos. 316, 320, 323, 327, 328, 330, Giornali di Uscita 1529, 1530, 1531, 1532, 1533, 1534. The names may be found in http.guidoguerzoni.org, database "Fornitori della Guardaroba ducale 1529–1534."

74. ASMO, CDE, AP, no. 139, Conto generale, 1514.

75. ASMO, CDE, AC, Guardaroba, no. 175, *Libro di mandati di spesa della guardaroba*, 1556–1558.

76. ASMO, CDE, AP, no. 569, *Zornale della Guardaroba dello Ill.mo Signor Don Alphonso*, 1555–1559, 8r.

77. Cecchi 1998; see also Capitelli 2004, especially 385–390.

78. Cecchi 1998, 119.

79. In this case there were 2 silversmiths, 3 *calegari* (cobblers), one circle maker, one *cordellaro* (rope maker), 3 blacksmiths, 1 porter, 2 carpenters, 1 window maker, one *forcinaro* (fork maker), 2 inlayers, 36 merchants, 6 mercers, one helmsman, one goldsmith, 3 furriers, one *peltraro* (pewter maker), 1 *pennacchiero* (plume maker), 1 painter, 1 embroiderer, 6 tailors, 1 *scaranaro* (high-backed chair maker), 2 saddlemakers, 2 silk workers, 3 sword makers, 3 *tagliacalze* (shoemakers), 2 *tiraoro* (gold rollers), and one *vellutaro* (velvet maker), as taken from the elaboration of data in ASMO, CDE, AC, Guardaroba, no. 175, *Libro di mandati di spesa della guardaroba,* 1556–1558.

80. The data are from ASMO, CDE, AP, no. 569, *Zornale della Guardaroba dello Ill.mo Signor Don Alphonso*, 1555–1559 and no. 571, *Registro della Guardaroba del Ill.mo Signor Don Alfonso da Este*, 1555–1557.

81. ASMO, CDE, AP, no. 385, *Libro de la Guardaroba de lo Illustrissimo Signor Don Alfonsino estense*, 1545–1546 and no. 387, *El libro de li conti de li merchadanti per guardarobba*, 1545–1546.

82. The sum comes from calculations made in the ledgers in ASMO, CDE, AC, Guardaroba, no. 170, *Libro de la Guardaroba*, 1550.

83. These items were not bought by the Fontico but rather by the ducal wardrobe.

84. The census of the businessmen was carried out in 1596 and is cited in Bocchi 1987–89, 1:264.

85. ASFI, Archivio Mediceo no. 631, *Appresso si da nota a V.ra Ecc. Ill.ma con la debita reverentia de salariati. Gentilhommini et altri della sua corte fatta per l'anno 1559 cominciando addì primo de marzo 1558 et quanto habbi el mese ciascuno di loro et quanto resti a havere per la provvisione corsali per tutto l'anno 1558 cioè per tutto febbraio tenutone conto per me Lattantio Gorini suo umile servitore.*

86. ASPR, Mastri farnesiani, no. 2, *Ruolo de provvisionati 1553 a 1570*, unnumbered ledger. The citations can be found on the pages of the corresponding letter (A for Arnolfo, D for Danielo): thus: "On 23 February 1566, Arnolfo Flemish painter on glass was taken on in Flanders by His Excellency to be sent to Italy, from the first day of January 1566, with the salary of three gold ducats a month and a pair of shoes, with the addition of food allotments beyond the three ducats if he has to stay more than six years with His Excellency without leaving," and "On 28 September 1563, Danielo Biancho Flemish ironworker came into the service of His excellency in Flanders . . . and agreed to 2½ gold ducats monthly and food and shoes, and he bound himself to stay four years in this way and because at Parma the *sese* won't be made another 48 *giuli* monthly were agreed for these shoes."

87. See in ASPR, Computisteria Farnesiana di Parma e Piacenza, no. 141, *Ruolo dei Provvigionati che erano al servizio di Margherita d'Austria Governatrice degli Abruzzi*, 1569–1577.

88. ASF, Ducato d'Urbino, Appendice, no. 32, *Indice dei salariati della corte del 1584*, at 13r: "Cesare

Magiero of Urbino, painter, *pino* bread and one gr. a day of *companatico*, one mouth, provisions from the purse of S. A. Serenissima, lodgings with his brother, tallow candles for six months 2 pounds and for the other six months one pound, wood for the wintertime"; for the other artisans mentioned, see 35v and 81v.

89. ASMN, Archivio Gonzaga, no. 395, D. XII, no. 5, *Rollo de' Salariati del Principe, che si è trovato nella filza dell'anno 1591, intitolata Affari Camerali*, 1591, 15.

90. If one takes into consideration the six painters in the rolls of the Farnese *provvisionati* in 1565, we find that Girolamo Mirola earned 248.40 scudi annually, Giovanni Antonio Bianchi 48, Giuseppe Fantuzzo 48, Cornelio Lettes 106.92, Uberto Mercior *pitor de vetri* 135.72, and Zanino Fiamingo 66.24 (Romani 1978, 1:33).

91. ASMN, Archivio Gonzaga, no. 395, D. XII, no. 5, *Rollo de' Salariati del Principe* which was found in the *filza* for 1591 called *Affari Camerali*, 1591.

92. ASMN, Archivio Gonzaga, no. 395, D. XII, no. 5, *Compendio di tutti li salariati di S.A. che sono a Bolletta*, 1598. In this list there are thirty-one chaplains and singers, five founders, doctors, and apothecaries, one antiquarian, and twenty-one artisans.

CHAPTER 4. SUPPLY AND LABOR MARKETS: ORGANIZATIONAL STRUCTURE, MANAGEMENT TECHNIQUES, AND ECONOMIC IMPACTS OF DUCAL ESTE BUILDING YARDS IN THE CINQUECENTO

1. I am thinking of the classic works by Sella 1968 and 1979; Goldthwaite 1973, [1980] 1984, and 1990; Romano 1974; Piola Caselli 1981; Doria 1986, 5–55; Lanaro, Marini, and Varanini 2000.

2. Grohmann 2005.

3. As concerns the architecture of the Este, I refer the reader to Zevi 1960 and 1971; Zorzi 1978; Marcianò 1991; Tuohy 1996; Ceccarelli 1998 and 2004; Folin 2003.

4. I have transcribed, standardized, and elaborated *mandati di pagamento ad personam* found in the *libri memoriali* and the *libri dei mandati,* two plentiful but homogeneous sources. For each payment I have noted the year, month, and day, *cantiere* concerned, the title, name, surname, any patronimics, toponimics, or nicknames of the bearers, the professions, number of assistants, workers, and hands, the reason for the payment, the daily salary or honorarium agreed on for the job, the number of full and partial days worked, the complete sum received. It was a job of mass prosopography more similar to the experiments of Francesco Gomez and Sandro Lombardini (1991) and of Oscar Itzcovich (1989 and 1990), whom I have cited in the bibliography, than to the databases developed by Margaret Haines for the *Opera* of the Duomo of Florence and by Lucio Riccetti in Orvieto, whose methodological principles have been explained in Riccetti 1989.

5. The *cantieri* expenses from other parts of the duchy were normally reported in separate account books, and may be consulted in the *fondo* Amministrazione dei Paesi in the Modena State Archives.

6. These data have come from the registers conserved in ASMO, CDE, AC, Munizioni e Fabbriche, nos. 113, 118, 124, 127, 145, 153, 157, and 206. The standardized transcriptions are available at the site http.guidoguerzoni.org, database "Munizioni e Fabbriche 1551–1576." The information was loaded with the help of Giorgia Mancini, Chiara Morassutto, and Paolo Salzani between 1997 and 2003 and some other students from the course History of Art Markets held at Bocconi University in the academic year 2001–2002. They have my most sincere gratitude.

7. In ASMO, CDE, AP, no. 543, *Compendio di tutta la spesa fata . . . (lacuna) fabrica del Ill.mo S.re don Alfonso da Este al . . . (lacuna) 1557–1558.*

8. In ASMO, CDE, AFP, *Mesola, buste* no. 248, *Diversi ricapiti, conti, promemoria, mandati di pagamento* and *Compendio di tutte le robbe di fornaci comprate da più persone per la fabbrica della Mesola dall'anno 1578 per tutto il 1586 cavati dai registri dei mandati fatto da Ercole da Fano, 1578–1586;* no. 250, *Libro d'entrata e spesa, 1584–6;* no. 252, *Registro del conto di tutti i mandati della spesa della fabbrica della Mesola per conto di Girolamo Ferrini, 1587–1590.* These may be consulted at the site www.guidoguerzoni.org, the database "Munizioni e Fabbriche/Mesola."

9. These were the wagoner Agostino Gambarello, the wood merchant Gaspare Finotto, the kiln man Vincenzo Zurlatto, the stonecutter Giovanni da Vento, and the sawyer Ludovico Dalla Mirandola.

10. Considering only works concerning Italian *cantieri,* I recommend to the reader Bentivoglio 1982; Calabi and Morachiello 1987; Fagliari Zeni Buchicchio 1988; Riccetti 1988 and 1994; Francia 1989; Braunstein 1990; Carità 1990; Guillaume 1991; Scotti 1991; Goy 1993; Turrini 1997; Brugnoli 2000; Haines 2002.

11. The 5.638 *mandati* are reported in ASMO, CDE, AFP, Carpi, Libri diversi, Fortificazioni, *Mandati de la Fabrica per la Fortificatione di Carpi 1555–6.*

12. Ghizzoni 1997, especially pages 109–148.

13. The court of Alfonso II did not spring from the traditional paternal "ribs" like other courts. In fact the court was almost new, since 95 percent of its members did not have either earlier Este careers or significant experience in service.

14. I refer to Quinterio 1980; Cortonesi 1983; Connell 1988; Piana 1989; Gianighian 1990; Haines and Riccetti 1996; D'Amelio and Marconi 2000; Lamberini 2000; Marconi 2000, 2001–2, and 2004; Ait and Lanconelli 2002.

15. Piola Caselli 1981, 55.

16. On the organization of the large *cantieri* between 1400 and 1600, see Calabi and Morachiello 1988; Calabi 1990; Frommel 1991; Tabarrini 2000; Ait 2002; Crouzet-Pavan 2003.

17. The figure of the ducal engineer remained among the salaried roles up through the first decade of the Cinquecento, when the post was filled by Biagio Rossetti and then again from the mid-1550s. Nevertheless, in those forty years between 1510 and 1550, various court architects were registered in the *bolletta* who perhaps covered the same functions as their former colleagues, the *incegnieri.*

18. For example: "per la ducal corte tutti li vedrami che gli sara bisogno . . . per li sottoscritti pretii e mercato: fiaschi mezani a 0.2.6 l'uno, fiaschi di uno boccale 0.2.0, fiaschi da mezo bocale 0.1.4, fiaschi grandi 0.3.0, fiaschi de due fiaschi grandi 0.5.0, inghistar 0.1.0, bocaline da pevere 0.1.0, bichieri comuni bianchi 0.0.3., ecc." (Everybody in the ducal court will see that . . . for prices and markets: half flasks 0.2.6, one tankard flask 0.2.0, half tankard flasks 0.1.4, large flasks 0.3.0, double-size flasks 0.5.0, small bottle 0.1.0, bottles for pepper 0.1.0, ordinary glasses 0.0.3, etc.) In ASMO, AC, Notai e cancellieri camerali ferraresi, no. LXIX/B, *Registrum locationum vallium. salinarum. vectigalium ac villicationum eurumdemque capitolorum cum literis factoralibus,* cc. 151–154.

19. See the *Autentico delle fornaci* of 1526 in ASMO, CDE, Fornaci, no. 3, *Libro Autentico di fornaci,* c. 1: "Vui Magnifico fatore generale sel ve piaze fadi pagare a li sottoscritti fornaxari liras dozentoventi le quali se ge presta per fare prede e chupi a uno descho per chadauno per soldi 12 il miaro a chrudo." The kiln men were Bettin da Piacenza, Antonio Rizo, Bartolomeo Merlo da Ferrara, Lazzaro Mantoan, Francesco Maria Lamberti, Agnolo da Piacenza, Piero Mantoan, and Alberto Magnan.

20. Almost all the kiln workers received an advance for *prestancia*, and the same was true of the advances given to the suppliers of wood and clay.

21. While the eight soldi the thousand of the kiln workers were paid to each member of the work squad (usually made up of eight to nine men with different jobs), the 13 liras of the lime kilns were paid at a flat rate.

22. For example in 1560 in the kilns of San Giorgio, San Benedetto, of the Barcho and of the Diamantina, the total production was 38,400 *cuppi* (cups), 5,500 *gavi* (cups), 929 *imbrixxi grandi e mezani* (medium and big tiles), 4,900 *limbelli* (bands), 9,450 *pocalli* (vessels to collect water), 882,534 *prede* (stones), 13,150 *prede da piazza* (stones to cover squares), 11,530 *prede da tre teste strete e larghe* (stones with three narrow and wide sides), 60,575 *prede francesi* (French stones), 26,725 *quaderleti* (stones), 10,395 *quadreri da liras 10* (small paving stones), 2,159 *quadreri da liras 8* (small paving stones), 3,830 *quadreri da liras 9* (small paving stones), 59,700 *tavelle* (hollow flat tiles), 1,154 *moggia* (brick pipes), and 11 *stara* of lime (1 *moggio* of 621,85 liters = 20 *stara*). These sums derive from the elaboration of the register conserved in ASMO, CDE, Fornaci, no. 6, *Libro de le fornase, 1559–60.*

23. In ASMO, CDE, AP, no. 39, cc. 2–12. There were eight galleons, two *fuste* (rowboats), two brigantines, a small *grippo* (small boat), three *barbotte* (small boats), six boats, three *schiffi* (small boats), a 21-oar boat, two 24-oar boats, an old *chiozese* boat (old boat from Chioggia [Venice]), one called the *mora* (a kind of boat called Moor), one *fisolera* (boat), a *peotina* boat, and three *bucintori* (bucentaurs).

24. Earlier the *portonari* (concierges) were registered with the officers under the authority of the *maestro di casa* (house master), while the key keepers answered to the *maestro di camera* (room master).

25. Earlier the *magistranze* were under Munitions and Construction.

26. Many artisans directed also individuals who do not appear in the *Bollette dei salariati di corte*: for example Antonio da Faenza, ducal potter in 1522, was helped by "three other artisans, one of whom, Francesco da Bologna, is also designated as a maker of vases." In Campori [1876] 1980, 20.

27. I have come across the lists relative to the armories *del zardino* (1508), of the *belfiore* (1511), of Reggio and of Modena (1520).

28. Rodi 1560, *Annali di Ferrara in cinque tomi,* 3:367.

29. See www.guidoguerzoni.org, database "Munizioni e Fabbriche," the names of the fifty smiths remunerated at least once in the year 1562.

30. In alphabetical order: *agrimensori* (land appraisers), *architetti* (architects), *battifango* (soil compactor), *battiloro* (gold beaters), *biancheggiatori* (whitewashers), *calafati* (caulkers), *campanari* (bell makers), *cavatori* (quarrymen), *copritetti* (roof coverers), *corniciai* (framers), *doratori* (gilders), *fenestrati* (window makers), *fornaciari* (kiln men), *gessatori* (plasterers), *giardinieri* (gardeners), *ingegneri* (engineers), *intarsiatori* (inlayers), *magnani* (locksmiths), *marangoni* (carpenters), *morsari* (bit makers), *muratori* (masons), *orefici* (goldsmiths), *pittori* (painters), *pittori da bassi* (unskilled painters), *pozzaroli* (well diggers), *predaroli* (brick sellers), *scalpellini* (stonecutters), *scultori* (sculptors), *scultori in cera* (wax sculptors), *segatori* (sawyers), *spazzacamini* (chimney sweeps), *stanadori* (road sweepers), *stuccatori* (stucco workers), *tagliapietra cotta* (stonecutter), *tagliapietre viva* (stonecutter), *taglia lime* (knife grinder), *tornitori* (turners), *tosabussi* (stop gap), *vuotapozzi* (people who empty wells), *zettadori* (foundrymen).

31. These were *asinai* (ass drivers), *barcaioli* (boatmen), *bovari* (cattle drivers), *burchiaroli* (boatmen), *carrettieri* (carters), *carriolai* (wheelbarrow drivers), *facchini* (porters), *mulattieri* (mule drivers),

paroni (boatmen). The distinctions between *barcaioli*, *burchiaroli*, and *paroni* were based on the sizes of the boats: The *barcaioli* used *gondola* (gondolas) and *barchette* (small boats), the *burchiaroli*, *burchi* (old boats) and *peotine* (small boats), the *paroni* barges, large boats and bucintori (bucentaurs).

32. These were *boccalari* (jug makers), *bombardieri* (bombardiers), *boscaioli* (woodsmen), *bottai* (coopers), *brozzari* (workers in bronze), *bugadari* (washerwomen), *carbonari* (coalmen), *cartolari* (papermakers), *cerchiari* (hoop makers), *cestari* (basket makers), *cimatori* (clippers), *collari* (yoke makers), *festari* (people in charge of feast organization), *fogaroli* (firemen), *fonditori* (foundrymen), *granadelari* (balas builders), *guainari* (case makers), *guantai* (glove makers), *lanternari* (lantern makers), *lanzari* (lance makers), *legnaioli* (wood sellers), *librai* (booksellers), *martelari* (hammerers), *mascarari* (mask makers), *mastellari* (tub makers), *dodici categorie di mercanti* (twelve categories of merchants), *munari* (millers), *oliari* (oil makers), *peltrari* (pewterers), *pesapan* (bread weighers), *pignattai* (potters), *profumieri* (perfumers), *remari* (rowers), *sabbionari* (sand conveyers), *sarti* (tailors), *saponari* (soap makers), *scaranari* (armchair makers), *scarpai* (shoemakers), *secchiari* (pail makers), *sellari* (saddlers), *setacciari* (sieve makers), *sogari* (saddlers), *spadai* (sword makers), *speziali* (grocers), *stampatori* (printers), *strazzaroli* (rag sellers), *stuari* (stove makers), *tamarazzari* (mattress makers), *tappezzieri* (paperhangers), *vasellari* (potters), *velari* (sailmakers), *vellutari* (velvet makers).

33. Marconi 2004, 44.

34. For hardware, I mean *agucchie* (knitting needles), *anelli* and *anelloni* (rings and big rings), *boccole* (bushings), *botole* (buttons), *broche* (pins), *chiodi* (nails), *catene* (chains), *catenacci* (bolts), *chiavadure* (hook bolts), *fibbie* (belts), *filo di ferro* (wire), *girelle* (pulleys), *lambrecchie* (lambrequins), *occhi* (spring rings), *serrature* (locks), *speroni a vite* (screw-spurs), *squadri di ferro* (iron squares), *staffe e staffoni* (stirrups).

35. In other words, *bacchetti da martello* (hammer handles), *badili* (shovels), *barelle* (stretchers), *botti* (barrels), *canteri* (wooden pails), *cariole* (wheelbarrows), *cazzuole* (floats), *ceselli* (chisels), *coltelli* (knives), *cesoie* (shears), *forbici* (scissors), *gavari* (mess tins), *lime* (files), *martelli* (hammers), *mastelli* (tubs), *mazze* (beetles), *picconi* (pickaxes), *rampini* (hooks), *raschietti* (scrape-finished items), *scalpelli* (chisel), *scodelle* (bowls), *secchie ferrate* (iron pails), *seghe* (saws), *seghetti* (small saws), *setacci* (sieves), *tenaglie* (tongs), *trapani* (drills), *zorni* (rags).

36. Which is to say: *antenne* (cranes) and *antenelle* (small cranes), boards of all kinds (whether for scaffolding or for fencing off a work area), *aste* (poles), *canne* and *cannette* (barrels), *cavalletti* (sawhorses), *cerchi* (rims), *finestre* (windows), *pali* (poles), *pertiche* (perches), *scale* and *scaloni* (stairs and staircases), *usci* (doors), *travi* (girders).

37. And especially *biacca* (white lead), *calce* (lime), *creta* (clay), *gesso* (chalk), *ghiaia* (gravel), *laterizi di ogni sorta* (every kind of brick), *pece greca* (greek pitch), *pietre* (stones), *sabbia* (sand), *scagliola* (scagliola), *terre gialle* and *nere* (yellow and black clay), *vasi di terra* (clay vases).

38. Most of all were sold wax and tallow candles, waxes, belts, leather, fats, laces, oils of olive linseed and walnut, bones, *sali da ruota*, black and white soaps.

39. Above all marbles, limestones, stones to be worked and lithic elements such as arches, columns, door and window frames, balustrades, shelves, steps, roofs, chimney and drain pieces, well-heads, beams.

40. By which I mean cloths of wool and silk, spun or beaten, *canutiglia* (tinsel), gilt or silvered leathers, thread, silk, rags, cloth and wax cloth.

41. See Caniato and Dal Borgo 1988; Della Torre 1990 and 2000; Giovannini 1995; Vaquero Piñeiro 1996a; Zanoboni 1996; Giustini 1997; Boucheron 2000; Cortonesi 2002; Riccetti 2003.

42. Fausto Piola Caselli has observed (1981, 114) that in the case of Avignon the costs of labor accounted for 45 percent, Richard Goldthwaite (1973, 118) showed that in the building of Palazzo Strozzi the salaries accounted for 50 percent, while Domenico Sella (1968, 59) noted that in various parts of Lombardy, in the Seicento, they accounted for 40 percent.

43. Wyrobisz 1965; the indication is in table 3, "Spese per costruzione in Venezia nel Quattrocento," 315.

44. Burns 1991, in particular pages 218–219.

45. Cecchini 2004; the sum results from the elaboration of data contained on pages 58–59.

46. Sivori Porro 1989, 378. For an interesting comparison, see Wilson and Mackley 1999, especially pages 444–449.

47. On the difficult calculation of real salaries of building workers and of their varied composition, one must consult Vigo 1974.

48. As an example, from 1493 the *Camera ducale* (Ducal Chamber) took in 1,500 liras and 300,000 bundles of wood (200,000 hard and 100,000 soft) for the rental of the mill and the woods of the *della Saleseda* near San Felice sul Panaro, while from 1503 the renter of the woods of Mesola paid a fee in kind "in so much wood worth 554 liras 3 soldi and 4 denari." In a similar way, according to my calculations, in 1471 the ducal lands produced 27,799 stakes, 170 *perteghe* (poles), 2.662 *dogorenti* (stakes as foundations and rafters), 1,278 bundles of wicker and 827,25 wagonloads of firewood (in ASMO, CDE, AC, Castalderie e possessioni, no. 29, *Ragione de castaldi 1471*), while in 1522 they sent to the wood storage shed in Ferrara 57,041 stakes and *perteghe* (poles), 12,785 *dogorenti*, 7,823 *carazi* (sedan chairs), 1,459 bundles of wicker, 10,250 *palesoli* (small beams), 3,142 little bundles, 5,235 *pali sechi* (dry poles), and 289 wagonloads of firewood (in ASMO, CDE, AC, Castalderie e possessioni, no. 46, *Ragioniero dei castaldi*, 1522).

49. I note as useful comparisons: Aleandri 1911; Klapisch Zuber [1969] 1973; Braunstein 1986; Danesi Squarzina 1989; Giordano 1991; Lamberini 1991; Vaquero Piñeiro 1999.

50. The Venetian absence in the Quattrocento was noted by Connell 1993, 66.

51. The data of the latter are results of elaboration of the database "Munizioni e Fabbriche 1551–1576," at www.guidoguerzoni.org.

52. Widely practiced also in other parts of Italy: for example in Tuscany the use of piecework using linear measure has been well documented, as one can deduce from the analysis by Goldthwaite 1980, It. trans. 1984, 190–197; and Pinto 1983.

53. In ASMO, CDE, AC, Munizioni e Fabbriche, no. 203, *Prezzi correnti de lavori tassati, 1575–1583*.

54. Ibid., c. 8.

55. In ASMO, CDE, Munizioni e Fabbriche, no. 22, *Libro Autentico di Munizioni e Fabriche*, 1488, c. 40.

56. In ASMO, CDE, Fabbriche e Villeggiature, no. 6, *Scritture diverse per conto della fabbrica della Mesola*, carte sciolte.

57. In the 1580s the yearly expenditures of the duchy were about 270,000 liras.

58. Take the case of Giuliano Leni so well examined by Ait and Vaquero Piñeiro (2000, 147–172).

59. Sella 1968, 7.

60. Amintore Fanfani affirmed (1943, 2 edition 1959, 326) that from 1499 to 1603 in Venice the salary of a manual laborer increased 200 percent if the summer maximums were compared, and 150 percent in the winter maximums; these values are close to the 136 percent found in Florence by Richard Goldthwaite (1980, It. trans. 1984, 606–608) in the period 1500–1599 and the 138 percent registered between 1499 and 1603 at Rome by Manuel Vaquero Piñeiro (1996b, 136).

61. Giuliano Pinto (1984, 74) had noted that already by the end of the Trecento "the *Opera* of the

Florence Cathedral paid its maestri as many as fifteen different salaries, and sometimes even more . . . and the same variety of remuneration is found in the Venetian and Veronese account books, and the evidence leads us to think that it was a generalized phenomenon." Equally Manuel Vaquero Piñeiro (1996b, 145–146) observed that in 1580 the daily salaries of stonecutters and masons working on the building of Saint Peter's oscillated respectively from a minimum of 5 and a maximum of 40 *bolognini* (including twelve intermediate levels) and from 10 and 35 *bolognini* (with sixteen levels). Thirty years later the spread was even wider: in 1609–1610 the stonecutters received between 7 and 60 *bolognini* daily, with sixteen levels, while in 1608–1609 the masons perceived sums from 10 to 45 *bolognini*, with fifteen levels. Even though we do not have data for 1580, presumably higher than the following years, it should be noted that in 1608–1609 the *Fabbrica* paid on average more than 200 masons and more than 120 stonecutters.

62. On these aspects, see the comments of Ait 1996, in particular 123–124.

63. Ghizzoni 1997, 140–141.

64. The institutions (for example "*Al dazio della pescaria*") and individuals ("to Paolo soldi 3 for a job") with no valid identification have not been included in the calculations. This choice explains the discrepancy between the 3,906 identified and the 3,849 involved in payments.

65. The choice to identify and privilege small groups of "court suppliers," whose praxis in the Sei- and Settencento I have documented in respect to the Medici and Farnese courts, shows that interest in fixing and regulating prices matured beginning with the end of the sixteenth century, with the hope also of reducing the accounting, management, and fiscal complexities.

66. Papagno and Romani 1989, 201 and 253–263.

67. In Lamberini 2002, 141. There are further indications in a book by the same author (Lamberini 1990).

68. In Bocchi 1987–89, 1:264.

69. Ammirato 1594, 148–149: "tra le opere de principi, gloriose sono state sempre tenute le tagliate de monti per acconciar le strade, i disseccamenti delle paludi per purificar l'aria, le fabbriche grandi, ò profane ò sacre, poiché oltre la cagione, perché elle si fanno, si toglie l'otio padre de mendici, e de ladri, due mali grandissimi de gli stati."

70. See the criticism of Mario Fanti of the thesis sustained by Giampiero Cuppini, who, in commenting on the discontinuous progress of the building of San Petronio and San Luca, noted that at Bologna, in modern times, "the thoughtful government of the city was able to use, cautiously, and certainly not carelessly, these immense works as factors in re-equilibrating the economic and political life of the city" (in Fanti 1989, 732).

71. Bodin 1588, 582.

72. Botero 1590, 97–98.

73. The passages previously quoted recur in many later texts: Fulvio Pacciani, writing in 1607 about public works, observed that "Caesar had these noble thoughts, when he tried to improve the Pontine marshes, and to open and fortify the street that from the sea reached the Tevere river through the back of the Apennines" (Pacciani 1607, 77); Girolamo Frachetta repeated: "Among the most illustrious princely initiatives, there are the constructions of new cities, the enlargements of the existing ones, and the restorations of those destroyed or spoiled, because through these entire popolations gain" (Frachetta 1613, 120).

74. On these themes, see also Johnson 1966–67 and 1969; Sosson 1984; Boucheron 2002.

75. Goldthwaite 1990, 53.

76. Ceccarelli 2001, 222.

77. Papagno and Romani 1982, 180–184.

78. Lopez 1952.
79. Cipolla 1981, 74.
80. Sivori Porro 1994, 265–6.
81. Armenini 1586, 31–32.
82. Conforti 2001, 15.
83. Conforti 2001, 15.
84. Catellacci 1897, 385.
85. 650 liras are equal to 13,000 soldi (each lira was made up of 20 soldi, and each of these of 12 denari). If the average workday was paid 8 soldi 4 denari, or 8.33 soldi, the 13,000 soldi were equal to 1,560.5 days.
86. Domenico Sella (1968, 19–20), has proposed that in normal conditions the builders worked about 200 days a year, the same figure found by Richard Goldthwaite (1980, It. trans. 1984, 423).
87. Which is to say, at Argenta (1), Brescello (4), Carpi (5), Comacchio (7), Finale Emilia (6), Longastrino (8), Lugo di Romagna (3), Magnavacca (9), Melara (1), Mesola (1), Modena (5), Ostellato (2), Pomposa (1), Pontelagoscuro (1), Quadra (2), Reggio Emilia (4), Rubiera (1), San Felice sul Panaro (3), Sant'Alberto (1), Trecenta (1), Ufficiodi Zaniolo in Romagna (1), Umana (2), Vacolino (5), Volana (3). Some *cantieri* remained in operation for some years, but in order to respect the criteria used by the ducal functionaries, I have considered those separately, recalculating them from year to year. The fact that their number was rather contained is anyway caused by the fact that a good part of the open *cantieri* in other parts of the duchy, especially those of middling size, were administered by the local functionaries and/or magistrates, and reported separately in special ledgers, which is why the relative vouchers do not appear in the ledgers of Munitions and Construction that I examined.
88. Of the vast literature, I note the works of Howard 1987; Braunfels 1988; Franchetti Pardo 1989; Christensen 1992; Vale 1992; Andenna 1994; Lubbock 1995; Miller 1995 and 2000; Trachtenberg 1997; Boucheron 1998; McPhee 2003; Scott 2003.

CHAPTER 5. SERVICES: THE ECONOMY OF THE FEAST AND THE FEAST OF THE ECONOMY—SOME THOUGHTS ON EPHEMERA

1. Studies on ephemera give some very interesting cues for economic historians, as one can see in the reading of works by Petrioli Tofani and Gaeta Bertelà 1969; Martini 1970; Grohs 1974; Fagiolo dell'Arco and Carandini 1977–78; Fagiolo dell'Arco and Madonna 1980; Petrioli Tofani 1980; Marchi 1983; Carandini 1994; Fagiolo et al. 1997; Fagiolo dell'Arco 1997.
2. See Bodart 1966; Decroisette 1975; Boiteux 1977 and 1988.
3. Strong 1973.
4. See Nagler 1964; Borsook 1969; Weil 1974; Mitchell 1986; Blumenthal 1990; Wisch and Scott 1990; Cropper 2000.
5. This is the case for example of the work of Ottani Cavina 1979; Garbero and Cantore 1980; Maule 1980; Mancini 1985; Matteucci 1985; Rigoli 1988; Dall'Acqua 1990; Bullegas 1996; Longo and Michelassi 2001. For cases outside of Italy one must cite Hugger, Burkert, and Lichtenhann 1987; Mulryne 2002; Jarrard 2003; Mulryne, Watanabe-O'Kelly, and Shewring 2003.
6. I am thinking of Casini's fine book of 1996.
7. For example Moli Frigola 1989 and Carini Motta 1994.

8. See Cavazzi 1982 and Moli Frigola 1985.

9. See Watson 1978.

10. The earliest studies on these lines were carried out by historians of music, spectacles, and theater, and one can see by the approach of the works of Bjurström 1966; Carpeggiani 1975; Mamone 1980; Benassati 1981; and Calore 1983.

11. ASMN, Archivio Gonzaga, no. 402, D. XII, no. 7, *Spese varie pel carnevale, barriera, commedia e quintana,* 1591.

12. ASMO, Archivio per materie, *Spettacoli pubblici,* no. 10, *Spese per la machina,* 1635.

13. ASSI, Balìa, no. 113, *Deliberazioni degli ufficiali sopra l'ornato.* I thank Guido Rebecchini for having copied and shown me this ledger.

14. ASFI, Archivio Mediceo del Principato, no. 1177, fasc. 5, c. 93. Courtesy The Medici Archive Project.

15. The calculations are elaborated from the data in ASMO, CDE, AC, *Guardaroba,* no. 178, *Compendio dei concerti fatti nel carnevale,* 1560.

16. ASMN, Archivio Gonzaga, no. 402, D. XII, no. 7, Account of the registered monies paid to me Ottaviano Capriano for orders and they are for the barrier apparatus, comedies, *guintanadi* and mascarades done for *Carnovale* this year, 1591, c. 85.

17. ASVE, Ufficiali alle rason vecchie, no. 222, *Decreti e scritture per l'allestimento di Sua Serenità. Ristretto del calcolo della spesa che circum circa può occorrere per preparare l'ornamento della Galea Ducale, fornimenti della stessa, addobbi, biancherie, livree, et altre robbe necessarie per la corte e famiglia di Sua Serenità,* 1692.

18. ASFI, Archivio Mediceo del Principato, no. 5157, c. 591. Courtesy The Medici Archive Project.

19. Botero 1590, 95.

20. ASFI, Depositeria generale, parte antica, no. 416, *Debitori e creditori delli archi trionfali dell'anno 1588,* c. 73.

21. ASMN, Archivio Gonzaga, no. 402, D. XII, no. 7, *Spese e affari economici,* c. 120.

22. Casini 1996, 226.

23. Cropper 2000, introduction, 12.

24. Ciseri 2000, 38–39.

25. Fagiolo dell'Arco 1997, 14.

26. ASFI, Depositeria generale, parte antica, no. 415, *Libro di inventari delle robbe date 1565,* 90r–93v. By way of example Alessandro Allori was given "92 pounds of *cimatura* (cloth shearings), 20 of *pelo* (nap), 1,476,6 of *limbellucci* (strips of leather), 2,141 of chalk from Volterra, 714 of wall plaster, 4 of bristles, 416.5 of white lead, 12 of linseed oil, 15 of *aguti* (nails), 21,2 of wire, 439,25 of iron shaped into arms, legs, and heads, more than 340 colors of various kinds, 296 small sheets of scrap paper *da straccio,* 1 large sheet of glue, 86 large sheets of scrap paper *reali da straccio,* 1 large sheet *reale* of Fabriano, 47 large brushes, 40 medium brushes, 29 small brushes, 3,100 leaves of gold and 400 of silver, 24 iron *maschietti* (hinges), 51 of hemp rope, and some boards."

27. ASVE, Ufficiali alle rason vecchie, no. 222, Expenses on behalf of *Clarissimo* Signor Agustin Contarini Supplier and Cashier of the Rason Vecchie for the refreshments on the occasion of their most Serene Highnesses of Savoy begun on 21 April 1608. The pages of the ledger are not numbered, but bear the following cost items: "wax, sugars and confections; meat and fowl; wines and *malvasie;* salads and salamis, all kinds of fish; various expenditures, regattas," and the total is in the *suma sumarum.*

28. ASVE, Ufficiali alle rason vecchie, no. 222, Copy of the account presented in the Eccellentissimo Coleggio of the purchases made for the Officio delle Rason Vecchie for the Lodgings for his most

Excellent Sigr. Pomponio Bellieure Ambassador Extraordinary of the Most Christian King, 1635. The situation is identical to the earlier one.

29. Ibid. These were "spices, preserves, sugars, wax, *mandoler* [almonds] and *scaleter* [biscuits]; bread, wine, *moscato/muscat, liatico* [a particular kind of wine], oil, vinegar, *casarol* (cheese) and salamis; meats, fowl, *osellami* (fowl) and milk products; sweet, salt, and *armado* fish; fruits, greens, flowers and *naranzer* (oranges); officers and servants; various expenses, wood and coal; bricks and *veri;* items rented, lost, or broken; *concieri di casa* (furnishings for the house) and expenses for the ill."

30. Roche 1986, 8.

31. See Meijer 1990 and Metcalf 1993.

32. Werner 1997, 5.

33. Leverotti 1992, 10.

34. Cf. Autrand 1981.

35. Bulst 1989, 15.

36. Maule 1980, 257.

37. Garbero and Cantore 1980, 6.

38. ASMN, Archivio Gonzaga, no. 402, D. XII, no. 7, Account of the undersigned money paid to me Ottaviano Capriano for orders for the apparatus of the barrier, comedies, quintains and masquerades for Carnival this year of 1591, 81r.

39. Ibid., 79r–80v.

40. Ibid., 96r–v, *adi 17 febraro 1591 per tutto di 25, per opere tra di e notte date a l'infrascritti che hanno lavorato alla barriera.* From the order one sees the involvement of diverse maestri: Raffaello Tosi, Francesco and Carlo Vicini, Giovan Mattia da Bologna, Giovan Battista Bollin, Antonio Tomasi, Ottavio Galardi, Battistino Gratia, Matteo Piazza with an apprentice, Giulio *spagnolo,* Domenico Vivaldi, Antonio Zavarese, Marcantonio Grasselli, Pietro Maureli, and Francesco Cassenigo.

41. ASMN, Archivio Gonzaga, no. 402, D. XII, no. 7, "Account of the undersigned money paid to me Ottaviano Capriano for orders for the apparatus of the barrier, comedies, quintains, and masquerades for Carnival this year of 1591," 96v.

42. I have found them in the ledger in ASFI, Depositeria generale, parte antica, no. 415, *Libro di inventari delle robbe date 1565.* The painters were Roberto Lippi, Battista di Matto, Bernardo painter, Carlo Allori, Cesare Vinci, Federico Fiammingo, Francesco di Pagnio Pagni, Giovanni della Strada, Iacopo del Ruta, Pier Francia di Iacomo, Santi di Tito, Tommaso da Strofriano, Vittorio Casini, and Alessandro Allori. The sculptors: Alessandro called Scherano, Domenico Poggini, Ignazio da Scissi, Lorenzo di Antonio, Moschino, Pompilio di Baldasarre Lanci da Urbino, Stefano di Michele dal Monte, Stoldo Lorenzi, Valerio Cioli, Vincenzo Dante, Vincenzo de Rossi, Zanobi Lastricati, Antonio di Gino, Battista di Domenico Lorenzi, Francesco dalla Cammilla, and Giambologna and Giovanni di Benedetto dell'Opera.

43. ASFI, Depositeria generale, parte antica, no. 416, *Debitori e creditori delli archi trionfali dell'anno 1588,* c. 73.

44. Stone 1971, 46.

45. Bulst 1986, 37.

46. This information comes from the elaboration of data in ASMO, Archivio per materie, *Spettacoli pubblici,* no. 10, *Spese per la machina,* 1635.

47. See the names in the www.guidoguerzoni.org database "Spese per la macchina 1635."

48. For example Pigozzi 1985 and Ciancarelli 1987, in particular 48–51.

49. See Adami's observations, 2003, 29–38.

50. Adami 2003, 28.

51. Fletcher 1994, 136.

52. For example, for the festival called "Difesa della Bellezza" and held in the Farnesi theater in Parma in 1618, five groups composed of six Bolognese painters, three from Ferrara, ten Piacenza, five Cremona and five Parma were paid (Ciancarelli 1987, 219).

53. For example the Ruggeri, fireworks technicians from Bologna, went to Paris for the wedding of Maria de' Medici, and stayed there until the end of the nineteenth century (Benassati 1985, 111), while Tommaso Francini, Medicean *fontaniere* and expert in automas, entered the service of Henry IV of France and was the first of a long line of royal gardeners (Fagiolo 1980, 54).

54. For example, Cardinal Bibbiena informed Luisa of Savoy that the English ambassadors had come to Italy "to bring to that king men who know how to arrange festivals in the Italian manner" (Angiolillo 1996, 7).

55. See Moore 1995, especially 587–589.

56. ASF, Archivio Mediceo del Principato, no. 5157, c. 343. Courtesy The Medici Archive Project.

57. See Garbero and Cantore 1980, 6.

CHAPTER 6. PRICES: KNOWN FACTS AND UNRESOLVED PROBLEMS

1. Hamilton 1944, 47.

2. Romano 1966, xix.

3. See Wackernagel [1938] 1994; Baxandall [1972] 1978; Spezzaferro 1989, 2001, and 2004; Bonfait 1990, 1992, and 2002; Goldthwaite [1993] 1995; Thomas 1995; Cariati 1998; Cecchini 2000; Sicca 2000 and 2002; Coen 2001; Ago 2002 and 2006; Giusberti and Cariati 2002; Cappelletti 2003; Comanducci 2003; Dal Pozzolo 2003; Lorizzo 2003; Montecuccoli degli Erri 2003; Murphy 2003; Spear 2003 and 2004; Cavazzini 2004a and 2004b.

4. See, in the order cited, Labrot 2002 and 2004; Coen 2002; Kubersky-Piredda 2002 and 2003; Comanducci 2002; Flaten 2003; Aikema 2003; Ajmar 2003; Blume 2003; O'Malley 2003 and 2005; Santi 1998; Spallanzani 2002; Guidotti 1986; Esch 1995, 24.

5. Montias 1987, 45. The quotation goes on to specify: "If the supply of art works depends more or less exclusively on labor costs—particularly if they or their close substitutes can be reproduced at will by the artist, his pupils or his imitators—then their market price will be set, irrespective of demand conditions, by these supply costs. When this is not the case, when an art work becomes in some sense unique because it has no close substitutes and cannot be reproduced by the artist's pupils or his imitators or even by the artist himself, then its price will rise above its initial supply costs, in which case its owner, who may or may not be the artist himself, may earn economic rents."

6. O'Malley 2003, 163. On the oscillations see also Spear 1994, 594; Ghelfi 1997, 33; Cecchini 2000, 249; Lanfranchi Strina 2000. In specular terms Olivier Bonfait (1990, 74 and 85) has demonstrated that Guercino's so-called "fixed prices" were chiefly an instrument of self-promotion and negotiation, the more effective because unexpected "exceptions to the rule."

7. Blume 2003, 151.

8. Borghini [1570–80] 1971, 630–631.

9. When Federigo Melis (1972b) examined the pricing structure of Cellini's *Perseus*, he ascertained that the artist requested 67.3 percent of 5,200 scudi for his labors; similarly when, after many delays in consignment, Pope Clement VII asked Cellini to return the gold chalice that had been

commissioned of him, even though unfinished, and with it the 500 gold scudi for the founding, the Tuscan sculptor replied that he would be glad to return the sum, but not the piece, since the chalice was the fruit of his labor, the value of which was to be calculated separately (Butters 2003, 26). On the same themes see also Wackernagel 1938, It. trans. 1994, 397–400 and Baxandall [1972], It. trans. 1978, 17–21.

10. Bonfait 1990, 73; and Ghelfi 1997, 27.
11. Flaten 2003, 131.
12. Spezzaferro 2004, 331. In a similar way Dal Pozzolo (2003, 53) observed that "the standardization of images is symptomatic of an 'industrial' process that is not limited to executive praxis."
13. The articles by McLellan (1996) and De Marchi, Van Miegroet, and Raiff (1998) are an exception.
14. Malvasia notes that when Guido Reni, after an argument with the papal treasurer, decided to abandon the profession and dedicate himself "to the merchandising and traffic in antique painting and drawings, which with advantageous resales he saw passing through the hands of dilettantes and ending in the studies in the galleries not only of Rome, but also France, Holland, England, with exorbitant earnings by the dealers, who enriched themselves, like Mastri, Manzini, Grati" (Malvasia [1678] 1974, 2:16), he was reproved by his first teacher Denis Calvaert, who in a fatherly way said: "It is not at all convenient that you take up this kind of business, which is fitting only for hand-wringers and barterers" (2:17). As to the fortunes of the intermediaries see also Cecchini 2000, 226–229 and Montecuccoli degli Erri 2003, 145–148.
15. See Pomian [1987] 1989 and 1993.
16. Cf. Benedict 1985; Guerzoni 1995; Portier 1996; Ghelfi 1997; De Marchi and Van Miegroet 1999.
17. Stürmer's 1983 notes regarding this are exemplary.
18. I agree with Andrea Spiriti (2004, 404) about the suitability of "not writing a history of development of fame using economic valuations, but rather the history of casual enough variations in data that are organic in reference to the ambients and not to the artist-individual."
19. See Montias 1987; Bonfait 1992; Robertson 1992; De Marchi and Van Miegroet 1994; Gérin-Jean 2000; Falomir Faus 2002; Blume 2003; Spiriti 2004.
20. Borghini [1570–80] 1971, 634–635.
21. Gérin-Jean 2000 and 2003.
22. Bok 1998, 106–107.
23. Blume 2003, 153–154.
24. O'Malley 2003, 175–176.
25. Cecchini 2003b, 130–135.
26. Kubersky-Piredda 2002, 350–353.
27. See also Glasser 1977; Borsook 1983 and 2005; Schiferl 1991; Thomas 1995; Buscher 2002 and 2004; Bardeschi Ciulich 2005; O'Malley 2005.
28. The Campaspe model of Gérin-Jean 2000 and 2003 does not convince me, as it mixes sources and objects in a confused way and even boasts predictive ends in virtue of the number of regressed variables (measure, type of support, number of figures, social status of the purchaser, etc.), even though he places paintings and objects like the Coppa Farnese on the same plane, a case in which, perhaps, the value of the material did have some weight.
29. Lanfranchi Strina 2000, xxx and xxxviii–xliii.
30. See Labrot 1992; Morselli 1997 and 1998; Schnapper 1998; Cecchini 2000; Borean and Mason 2002; Ago 2002 and 2006; Rebecchini 2002; Danesi Squarzina 2003.
31. Morselli 1997, xxix.

32. Isabella Cecchini (2000, 35) observed that in the 262 Venetian inventories she examined, paintings were evaluated in 23 percent of the cases and attributed in 39 percent; Raffaella Morselli (1997, 1), by contrast, has found that in only 10 percent of 968 Bolognese inventories from the seventeenth century that she studied was there any indication of the creator of the paintings and sculpture. Patrizia Cavazzini (2004a, 355) noted that "the early Seicento Roman inventories . . .] tend not to indicate either value or authorship"; and Federico Montecuccoli degli Erri (2003, 144) has found that, even in the Settecento, "the painters rarely felt the need to sign the canvas and the great majority of the inventories of collections do not bear the names of the painters, but only indicate the subject and describe the frames with great care."

33. Montecuccoli degli Erri 2003, 144.

34. See Cecchini 2000, 199–201; Allerston 2003; Dal Pozzolo 2003, 50–51; Welch 2003, 285–290.

35. Gozzano 2004, 152–155.

36. Antoniano [1584] 1821, 2:27.

37. Butters 2003, 34–35.

38. Labrot 2002, 271–272.

39. Borean 2002, 197.

40. Morselli 1997, 35–41.

41. When Cellini asked 10,000 scudi for the *Perseus*, and Duke Cosimo refused to pay it, the decision to have the work evaluated provoked indignation from the artist. who complained: "How can the price of my work be evaluated when there is no one in Florence who is capable of it?" (Butters 2003, 36). On the same themes see also Krohn 2003, especially 206–209.

42. Marshall 2000, 25.

43. Spear 2003, 316.

44. Pinchera 2002, 641.

45. In Venice that same *raso cremisi* (crimson satin) could have 9,500, 10,000, 10,500, 11,000, 11,500, 12,000, 12,600, 13,000, or 14,000 warp threads, and heavy price variations (Molà 2000, 148).

46. See Thomas 1995, 168–172.

47. The ultramarine blue "for one painting could cost up to scudi 100, but then fees were scudi 800 and more" (Spear 2004, 153).

48. At Rome, for example, in 1625 there were sixteen "sellers of colors" (Spear 2003, 310).

49. Pepper 1971, 316; and Ghelfi 1997, 34.

50. Spear 2003, 314.

51. Richard Spear noted: "For Both's [Jan Both] imperial-size landscapes, for example, Roscioli paid almost scudi 2.5 for a pair of frames and scudi 7 more to gild them, adding 25% to their cost. Comparatively that was not so expensive: for framing a copy of a D'Arpino, for which he had paid only scudi 12, Roscioli spent scudi 14, more than the purchase price" (Spear 2004, 151).

52. See also Guidotti 1986, 549–550; Thomas 1995, 12–13 and 210–212; Comanducci 1998, 83ff. and xxix–xxx; Montecuccoli degli Erri 2003, 151.

53. Ghelfi 1997, 31.

54. Santi 1998, 92.

55. Cecchini 2003a, 397.

56. Consider stone or wood ruined by errors of workmanship or discovered to be unfit for the ends for which it was purchased, porcelain and majolica damaged in firing, wastage and losses of working silver and gold, unsuccessful foundings, the breakage of fragile materials like coral, crystal, ivory, glass, amber, precious stones, wax, etc.

57. Hatfield 2002, 171–173.

58. I refer to De Marchi and Van Miegroet 1996; Spear 1997, 269–271; Cecchini 2000, 213–215; Mainardi 2000; Labrot 2002 and 2004; Puppi 2003; Cavazzini 2004b, 142.

59. Ago 2006, 140 and 146.

60. Cecchini 2000, 214.

61. Labrot 2004, 16–17.

62. Coen 2004, 431–433.

63. Mancini [1614–21] 1956, 134–135.

64. Borean 2000, 135–136.

65. Labrot 2004, 17 and 19. The four most-copied painters were (on page 21) Giordano with 141 copies, Tiziano with 33, Ribera and Stanzione, with 28 each.

66. Mancini [1614–21], 1956, 134–135.

67. Spezzaferro 2004, 331.

68. See Ajmar 2003, 55–56.

69. See O'Malley 2004 and Holmes 2004.

70. On the *libri veritatis,* the early attempts defending artistic copyright, see Bok 1998 and Cavazzini 2004b.

71. Gérard Labrot (2004, 17–20) noted that the copies of the most popular painters in the Neapolitan market (Ribera, Stanzione, Giordano, Caracciolo, Vaccaro, Solimena, Raphael, Domenichino, Reni, Guercino), bore average prices equal to 10.26 percent of the minimum of the originals and to 6.11 percent of the maximum.

72. In ASMO, CDE, AC, *Guardaroba,* no. 152.

73. In ASPR, Mastri farnesiani, no. 576 *Libro de' precii diversi,* 1611–1710, and no. 577 *Prezzi della Serenissima Casa,* 1683–1716.

74. In ASFI, Guardaroba Medicea, no. 1047. This register, which begins in 1697, lists in alphabetical order twenty-seven different categories of suppliers to the Medici wardrobe, to wit: *argentieri* (silversmiths), *battiloro* (gold beater), *calderari* (coppersmiths), *cappellai* (hatters), *carrozzieri* (coach makers), *collarettaie* (yoke makers), *cucitori* (sewers), *cuoiai* (leather dressers), *facchini* (porters), *fondaci* (foundrymen), *guantai* (glove makers), *lanaioli* (textile workers), *lanciai* (lance makers), *lavandaie* (washerwomen), *legnaioli* (wood sellers), *librai* (booksellers), *magnani* (locksmiths), *materassai* (mattress makers), *merciai* (haberdashers), *morsari* (bit makers), *pellicciai* (furriers), *sarti* (tailors), *setaioli* (silk weavers), *spadari* (sword makers), *spazzacamini* (chimney sweeps), *valigiai* (trunk makers), *vetrai* (glassblowers). For each of these categories the goods and services were in turn listed in alphabetical order and priced in liras, soldi, denari: for example, for the *lavandaie* (washerwomen), under A there were *Amittj imbiancatj* (white amices), *saldati e piegati* (starched and folded) *l'uno liras 0, soldi 3, denari 6,* and at letter C: *Camicj imbiancati* (white albs), *saldati e piegati* (starched and folded) *l'uno 1, 6, 8; Cotte* (surplices) *assette come sopra* (arranged as above) *1, 6, 8; Corporali* (corporals) *come sopra* (as above) *0, 6, 8; Cordigli* (girdles) *l'uno 0, 3, 4,* and so forth.

75. Ibid., 47r.

76. See also Cecchi 1998 and Capitelli 2004.

77. Romoli 1560, 3v–4r.

78. See Elam 1993; Cropper 2000; Furlotti 2002; Rebecchini 2002; Schwartz 2002.

79. Butters 2003, 26.

80. Paruta 1579, 234.

81. Borghini [1570–80] 1971, 634.

82. Alberti [1585] 1960–62, 222. The cases of Zeuxis, Parassio d'Efeso, Timomaco, and Teomnesto are cited in D'Olanda [1548] 2003, 154–159, and that of Zeuxis in Paleotti [1582] 1960, 169.

83. Botero 1590, 183.

84. Alberti [1435] 1950, 79.
85. Castiglione [1528] 1981, 107–108: "There have been found some painters who donated their works, as it seemed there was not gold enough or silver to pay for them."
86. Varchi [1546] 1960, 37.
87. Pino [1548] 1960, 123–124.
88. D'Olanda [1548] 2003, 112.
89. Pino [1548] 1960, 138.
90. Mancini [1614–21] 1956, 138.
91. Mancini [1614–21] 1956, 138–139.
92. Perini 1994, 387.
93. On the theme of gifts, see Fantoni 1985; Warwick 2000, 55–75; Furlotti 2002; Rebecchini 2002 and 2003; Butters 2003; Modesti 2003, 375–376; Donato 2004, 152–155.
94. Mancini [1614–21] 1956, 139.
95. Spear 2004, 147.
96. Southorn 1988, 34.
97. Zapperi 1990, 35.
98. Raggio 2002.
99. Rebecchini 2003, 115–116.
100. So Titian, to ingratiate himself with the young Federico Gonzaga, with whom he had not yet had any important relationship, gave him two portraits of mutual friends, the live and kicking Pietro Aretino and the departed and mourned Girolamo Adorno (Bodart 1998, 43–47). For a similar Titianesque affair, see Rebecchini 2003, 117–118, and the relations of Guercino with the courts of Mantua and Modena, in Bonfait 1990, 86.
101. Bonfait observed: "Often Guercino reduced the prices of the first work sold to a client in order to gain favorable attention" (1990, 85).
102. Rebecchini 2003, 117.
103. Zapperi 1990.

CHAPTER 7. THE LAWS: THE BIRTH OF CULTURAL HERITAGE AND THE IMPACT OF PRESERVATION LAWS ON THE ART TRADE

1. See Saunier 1902 and Wescher [1976] 1988. A look at English customs records from 1798 to 1808, shows that 41 paintings were sent to Spain, 118 sent in 1809, and 604 the following year with the arrival of the French troops. The same pattern is shown in Belgium and in Holland, whereas 621 works arrived in Italy in 1796, compared to the 214 of the twelve months earlier (see Guerzoni 1996).
2. See Furcy-Raynaud 1912 and Cleve 1995.
3. For a useful methodological overview, see Mandler 2001.
4. See Trifone 1914; Piccialuti 1999; Calonaci 2005; and Lemme 2005.
5. See Olivato 1974b; Mattaliano 1975; Emiliani 1978; Pinelli 1978–79; Rossi Pinelli 1978–79; D'Alessandro 1985; Bencivenni, Dalla Negra, and Grifoni 1987 and 1992; Levi 1988; Speroni 1988; Catoni 1993; Aa.Vv. 1995; Condemi 1997; Gioli 1997 and 2003; Bedin, Bello, and Rossi 1998; Tommasi 1998; D'Alconzo 1999; Ufficio centale per i beni archivistici 2000; Pommier 2000; Pagnano 2001; Balzani 2003; Barrella 2003; Di Teodoro 2003; Curzi 2004; Troilo 2005.
6. Haskell and Penny [1981] 1984, especially chapter 13.

7. Between 1824 and 1848 at Mantua were "torn into small pieces" and sold *al follo,* for almost nothing, almost thirty tons (to be precise, 293 quintals) of antique papers, among which were the accounts and administration records of various Gonzaga courts (Torelli 1920, 1:lxxxiii–lxxxvi).

8. In the early thirties of the last century, the ancient and extraordinarily rich archive of the Parma Corporation was donated to the Red Cross, which sold it by weight to raise funds; twenty years later, Prof. Armando Sapori, one of the most famous Italian historians, intercepted by chance a truck loaded with archival material that some officials wanted to send to be pulped. The professor saved the collection Saminiati-Pazzi that is today considered one of the most important series in Italy and probably in the whole world of commercial letters dating back to the fifteenth and sixteenth centuries.

9. In truth, law 688/1912 had already specified that among the "buildings and furnishings of historical, archaeological, paleontological, or artistic interest" protected by law 364/1909 were included villas, parks, and gardens of historic interest; nevertheless the first law on "natural beauty" (and the definition is important, as it remained such in the 1939 law) arrived only somewhat later with 778/1922: "for the safeguarding of natural beauty and buildings of special historical interest."

10. Castelnuovo 1985, 125–158.

11. Di Teodoro 2003, ii.

12. On the intricate affair of the letter to Leo X see Di Teodoro 2003.

13. Mariotti 1892, xxxvi.

14. Parpagliolo 1913, 2:18.

15. Haskell and Penny 1981, It. trans. 1984, 3–21; Franzoni 1984.

16. Consider the *Lex Municipalis, Lex Genitivae Juliae* and *Lex Malacitana* promulgated by Caesar, the measures introduced by Vespasian, Leone, Maiorano, Nero, the laws of the Costantinian constitution (Cod. 8, 10, 6) of the Theodosian code (1, 16 tit. 10, 1, 15) and of the *Pragmatic Sanction* of the Justinian code. See Falcone 1913, 17–19; and Sangiovanni 1938, chap. 1.

17. Grisolia 1952, 22.

18. Parpagliolo 1913, 2:19.

19. Di Teodoro 2003, 5.

20. Burke 1979, 100.

21. These were the works of Michelangelo Buonarroti, Raphael, Andrea del Sarto, Mecherino, Rosso Fiorentino, Leonardo da Vinci, il Francia bigio, Perin del Vaga, Jacopo da Pontormo, Titian, Francesco Salviati, Agnolo Bronzino, Daniello da Volterra, Fra Bartolomeo di S. Marco, Fra Bastiano dal Piombo, Filippo di Fra Filippo, il Parmigianino.

22. By virtue of the indulgence of its laws, the Republic of Venice remained the main Italian center for art commerce in the seventeenth and eighteenth centuries, according to Haskell 1981a, 5–38.

23. It is interesting to look at the case of the Lombard-Venetian territories after 1815: While the district of Lombardy was given good regulations in 1816, the Venetians obtained an extension of theirs only in 1818 and 1827, after complaints about the invasion of Lombard intermediaries wanting to exploit the legal mismatching. This can be verified by reading the manuscript volumes of the *Commercial balances* in the Hofkammer Archiv in Vienna, *Commerz Hofcommission Praesidial Akten, 350 ex 1819,* presumably in the twelfth category, "Various neutral merchandise."

24. See Ferretti 1981; Spier 2000; Puppi 2003; Mazzoni 2004.

25. Haskell 1981a, 11.

26. For the laws of 1818 see Cantucci 1953, 19; for those of 1827, Emiliani 1978, 210–211.

27. An interesting periodical has been dedicated to the Venetian collections, *Venezialtrove*, that has published various articles on the theme.

28. See Adinolfi 1994; and Morselli 2000, 146–158.
29. See Haskell 1981a, 10–17; Winkler 1989; Perini 1993.
30. Cantucci 1953, 11.
31. Speroni 1988, 195–196.
32. D'Alconzo 1999, 25–31.
33. Speroni 1988, 205–206.
34. Stumpo 2005, 252.
35. Borroni Salvadori 1984.
36. See Ministero della Pubblica Istruzione 1881.
37. See Fantozzi-Micali and Roselli 1980; Innocenti 1992.
38. See Roversi 1969; Bresson 1975; Mottola Molfino 1982; Gasparri 1983; Favaretto 1990, 1992, and 2000; Carloni 1993; Gasparri and Ghiandoni 1993; Sattel Bernardini 1993; Preti Hamard 1999–2000 and 2000; Coen 2001 and 2002; Fardella 2002.
39. See Rossi 1876–77; Vaccaj 1923–24; Blumer 1934 and 1936; Béguin 1959; Wescher 1976, It. trans. 1988, 55–91; Fleming 1979; Baracchi-Giovanardi 1984, 1991, 1995, and 1999; Garuti 1993; Carloni 1995; Salvalai 1998; Racioppi 2001.
40. Emiliani 1978, 85–86, 127–130, 179–180, and 188–190.
41. Thievery has not yet been treated systematically, even if there are methodological references like Barocchi and Gaeta-Bertelà 1991.
42. One of the most famous compulsory sales was held in Rome in 1857, when the Campana collections were dispersed: the Greek vases, a few statues, and the frescoes were acquired by the Russian Czar, sculptures and Renaissance majolica by the South Kensington Museum in London, and nearly all the paintings by Napoleon III (Haskell 1981a, 9).
43. Emiliani 1978, 123.
44. The safeguard laws of that time abounded with restrictions imposed on foreigners: For instance foreign teams working in archaeological excavations were forced to hand over all the objects found to the local authorities. Further, nonresident foreigners were compelled (in Rome and in the Kingdoms of Naples and Sicily) in certain cases to report to the competent authorities the cultural goods they owned.
45. Stumpo 2005, 252.
46. Pears 1988, 207–213. The data on pages 211–213 refer to imported prints.
47. Barber 1999, in particular 214, 224, and 229; and Rees 1999.
48. Scanning the classifications in the third category of merchandise, "Products of manufacturing industries," for importations from 1832–1855, we see that in the fifth group, "Clothing, furnishings, and similar," item no. 140, is listed as "paintings" and expressed in measure (not specified whether linear or square), while the seventh group "Objects in wood or cork," no. 151, is noted as "books in 8th and in 4th" and expressed in tomes. Unfortunately, as these items were not subject to customs tax, the relevant statistics about foreign shipments are lacking. For further details, see Graziani 1960.
49. See the statistics gathered in "Archivio Economico dell'Unificazione Italiana" by Parenti 1959; Bonelli 1961; Glazier 1966.
50. According to Pears 1988, 210, between 1722 and 1774 the importation of Italian paintings represented on average more than 40 percent of the total registered by English and Scottish customs, with a low point of 18.1 percent in 1747–1751 and a maximum of 54.2 percent in 1727–1731.
51. In 1826, 261 pounds were imported from the Tuscan Grand Duchy, from the Kingdom of Sardinia 8, and from the Kingdom of Naples 57, for a total of almost 150 kg.

52. Until 1819 "stones" included, among its subcategories, "tables polished" and "marbles sculptured," while up to 1826 the heading "pictures" was divided into three groups according to size: smaller than two square feet, between two and four, and over four. Likewise only in 1825 are prints distinguished from drawings, as well as "plain and colored," only to be newly regrouped in 1855 and include from 1861 "engravings and photographs," while from 1827 "vases ancients not of stone" were counted, and from 1844, separately from "Magna Grecia wares."

53. Consider the strange denomination I discovered in 1838 describing the importation subcategory from the Grand Duchy of Tuscany of "plate old for private use not battered."

54. This approach allows sterilization of actions of disturbance factors, such as smuggling or the role of the free ports, which in Leghorn, Genoa, Civitavecchia, Trieste, Ancona, and Venice were administered separately and had separate commercial regulations and different tariff rates, and compiled their statistics in an autonomous way. The study of these sources could give us useful information on the presence of possible archives and/or papers of insurers, commercial agents, shippers, and transporters: In the archives of the consulates and foreign commercial legations one finds reference to individuals who were not by any means marginal.

55. See Bencivenni, Dalla Negra, and Grifoni 1987 and 1992; Musacchio 1994; and Troilo 2005.

56. It should not be forgotten that the *Statuto Albertino* of 1848 recognized the first line of article 29: "all properties, with no exception, are inviolable."

57. Troilo 2005, 28.

58. The measure had been proposed and discussed, after the Napoleonic attempts, during the Repubblica Romana of 1848–1849 and returned in strength when it was supported by arguments like those of Carlo Armellini: "The hour of liberty that has rung for the people must also ring for things" (Parpagliolo 1913, 2:211).

59. Gioli 1997, 36.

60. Ibid., 68.

61. Soon after the Unification there was a proposal to establish regional collecting points, which, in the face of opposition from many municipalities, was dropped in favor of provincial institutes, which obviously caused similar protests on a smaller scale, given that no town was willing to abdicate the power to conserve its own local glory.

62. In reality law no. 286 of 28 June 1871 dissolved the trusts, but thanks to article 4, it ensured the inalienability and indivisibility of the collections in question "until there shall be special laws providing otherwise," thus underlining the validity of the pre-unification norms (Falcone 1913, 111–112).

63. It did not much matter if the Piedmont Badia of San Benigno of Fruttuaria was proposed to be the seat of a "neo-Gothic" *café-chantant* or if the tenant of the Convent of Santo Spirito in Ferrara had constructed a solid wall cutting the refectory in half, obscuring in every sense Garofalo's *Last Supper*. Public authorities and private citizens competed in finding the most playful solutions: if the Church of San Pietro in Pavia could be a hay barn, the *Chiostro verde* of Santa Maria Novella in Florence was chosen as the seat of the lottery, which by law had to be in the offices of the Finance Ministry, which was also installed in the convent; likewise the Pisan Church of San Francesco, which "contained the paintings of Simone Memmi, Taddeo Gaddi, and other of the best artists of that time," was designated to host "a very large saddlery, which sent up exhalations that ruined those important paintings," while numerous buildings were destined to serve as wardrobes, powder-houses, stables, warehouses, schools, hospitals, and boarding-schools, as one can see in reading Gioli 1997 and Troilo 2005.

64. See Emiliani 1973.

65. Troilo 2005, 55.
66. For example, Crispolti 1898 and Giampietro 1900.
67. See Ministero della Pubblica Istruzione 1881.
68. For instance, the Ancient Monument Protection Act promoted in England in 1882 by Sir John Lubbock; the French regulations of 30 March 1887, which followed the previous acts of 1834 and 1837; the Greek laws of 1834, Swedish of 29 November 1876 and of 30 May 1873, Finnish of 2 August 1883, Belgian of 1861, Austro-Hungarian of 1873 and 1881, Turkish of 9–21 February 1884.
69. Cf. Ballerini 1898.
70. Falcone 1913, 114.
71. Troilo 2005, 139.
72. See Grisolia 1952, 36–37; and Agosti 1993.
73. See Bencivenni, Dalla Negra, and Grifoni 1987 and 1992; Levi 1993a; Giannini 1996; Manieri Elia 1998.
74. Stumpo 2005, 260.
75. Ibid., 258.
76. Ibid., 267.
77. See Gennari Sartori 2001 and 2003.
78. For instance, there was no mention of the safeguard of natural areas threatened by building speculation and by new industrial complexes (this issue was addressed only by law 688 of 23 June 1912). Similarly, the safeguard of private and public archival material was neglected, this issue being regulated only in 1939, even if in the 1902 law, article 32, confirmed in the disposition of 1939, had inserted as archival material the "codexes and antique manuscripts."
79. In the realm of architectural safeguards, the owners of historical buildings were bound to preserve the original features only as far as external walls (façades and entrances) were concerned, but were allowed complete freedom to change or renovate the interiors at their pleasure.
80. First of all, it abolished the distinction between *monumenti* (monuments) and *oggetti mobili e immobili* (movable and immovable objects), replacing it with the more general term of *cose mobili e immobili* (movable and immovable things); then it replaced the criterion of *pregio di antichità e d'arte* (value of antiquity and art) adopted in the previous law with that of "historical, archaeological, palaeontological and artistic interest." It further imposed the same regulations for all the cultural institutions and provided a descriptive list of every object. It maintained the preemption right on sales made by private individuals and extended the expropriation right to movable goods as well. Finally, it eliminated the distinction between the interiors and exteriors of buildings, and rigorously disciplined exports and the issue of archaeological excavations and findings. For further details see Balzani 2003.

Bibliography

ARCHIVE AND MANUSCRIPT SOURCES

Novellara City Archive

Archivio dei conti Gonzaga, Carte d'amministrazione, seconda serie, Casa, corte e camera, nos. 6, 7, 9, 10, 12, 63–65, 82, 110, 114, 140, 162, 169, 179, 245, 248–252, 256, 284, 285, 289, 519, 533.

Florence State Archive (ASFI)

Acquisti e doni, filza no. 1, inserto no. 11.
Archivio mediceo del principato, nos. 631, 1177, 5157. Courtesy The Medici Archive Project.
Depositeria generale parte antica, nos. 415, 416.
Ducato d'Urbino, classe I, divisione B, filza X, no. 19 e Appendice, no. 32.
Guardaroba medicea, no. 1047.
Libri di commercio e famiglia, nos. 1342, 4771.
Manoscritti, no. 321.

Mantua State Archive (ASMN)

Archivio Gonzaga, nos. 393, 395, 402, 410/B, 1346, 3172.

Modena State Archive (ASMO)

Ambasciatori, Francia, no. 28; Roma, nos. 26, 71; Venezia, nos. 43, 47.
Amministrazione dei principi (AP), nos. 39, 40, 70, 73, 78, 86, 106, 130, 139, 141, 159, 170, 372, 385, 387, 428–434, 460, 543, 569–572, 575, 651, 829–830, 836, 837, 840, 842, 853, 854, 873, 883, 895–898, 901, 903, 942, 959, 961–964, 971, 972, 982, 984, 987, 991, 993, 993bis, 995, 1003, 1150–1154, 1158, 1201, 1236–1244, 1310, 1328, 1329, 1335–1339, 1353, 1480.
Amministrazione della casa (AC), Arazzi e Tappezzerie, nos. 1, 21; Armeria, busta unica; Arte della Lana, nos. 1–2; Biblioteca, no. 1; Castalderie e possessioni, nos. 29, 46; Fabbriche e Villeggiature, no. 6; Falconi, no. 1; Fontico, nos. 3, 5–7, 10, 13, 18, 19, 21, 23, 24, 26, 28, 30, 32, 34, 35, 37, 40; Fornaci, nos. 3, 4, 6; Gioie, ori e argenti, carteggi, no. 1; Grassa, carteggi, no. 1; Guardaroba, nos. 102, 109, 111, 113, 117, 118, 121, 123–128, 134, 138, 141, 145, 148, 152, 153, 157, 158, 160, 162, 166, 170, 175, 185; Munizioni e Fabbriche, nos. 22, 113, 118, 124, 127, 140, 145, 151–155, 157, 203, 206; Significati, nos. 1–8, 12, 17, 18, 21, 22.

Amministrazione finanziaria dei paesi (AFP), Mesola, nos. 248, 250, 252; Carpi, Libri diversi, Fortificazioni, Mandati de la Fabrica per la Fortificatione di Carpi 1555–1556.

Archivio per materie, Arti e mestieri, Vetrai, no. 37; Spettacoli Pubblici, no. 91.

Bolletta dei salariati (BS), nos. 1–140.

Camera Ducale Estense (CDE)

Libri camerali diversi (LCD), nos. 208, 259, 260, 276, 284, 290, 293, 306, 307, 312, 316, 320, 323, 327, 328, 330, 357, 358, 363, 364, 443, 453, 459, 467, 473, 478, 483, 489.

Notai e cancellieri camerali ferraresi, no. LXIX/B.

Soldo, nos. 1–75.

Parma State Archive

Computisteria farnesiana di Parma e Piacenza, nos. 139–143.

Mastri farnesiani, nos. 576–577.

Tesoreria e computisteria farnesiana e borbonica, Ruoli dei provvisionati, nos. 1–9.

Siena State Archive (ASSI)

Balia, no. 113.

Turin State Archive

Sezione I, Archivio di corte, Real Casa, Corti Estere, Ferrara e Bologna, mazzo 1 da inventariare, Modena, mazzi 1 e 2 da inventariare.

Sezioni riunite, Articolo 806, Paragrafo 2, Inventario 365, buste nos. 44–76.

Venice State Archive (ASVE)

Ufficiali alle rason vecchie, nos. 220–226.

Public Record Office at Kew, London

Customs, series no. 4, nos. 15–94.

Customs, series no. 5, registers from 1790 to 1890.

Manuscripts

Argenteus, Johannes Sabadinus. 1496. *De triumphis religionis.* Biblioteca Apostolica Vaticana, Fondo Rossiano, no. 176.

Messisbugo, Christofaro. 1540. *Compendio per l'anno 1540.* Biblioteca Estense di Modena, Raccolta

Campori, ms. 1582, gamma, E, I, 7, nell'edizione edita da L. Chiappini, *La corte estense alla metà del Cinquecento. I compendi di Cristoforo di Messisbugo*, Ferrara: Sate, 1984.

Rodi, Filippo. Ca. 1560. *Annali di Ferrara in cinque tomi*. Biblioteca Estense, Ms. It. a. H.3.9.

PUBLISHED SOURCES

Texts Originally Published before 1700

Adami, Antonio. 1657. *Il novitiato del Maestro di Casa*. Rome: Tommaso Coligni.

Aegidius, Romanus. 1491. *De Regimine principum (1277–1279)*. Rome: Stefano Planck.

Alberti, Leon Battista. [1432–34] 1969. *I libri della famiglia*. Edited by Ruggero Romano and Alberto Tenenti. Turin: Einaudi.

———. [1435] 1950. *De pictura*. Edited by Luigi Mallè. Florence: G. C. Sansoni.

Alberti, Romano. [1585] 1962. *Trattato della nobiltà della pittura*. Rome: Francesco Zannetti. Reprinted in *Trattati d'arte del Cinquecento fra Manierismo e Controriforma*, edited by Paola Barocchi, 3:195–236. Bari: Laterza.

Alessandri, Torquato. 1609. *Il Cavalier compito. Dialogo del Sig. Torquato d'Alessandri nel quale si discorre d'ogni scienza, di ragion di Stato, di Medicina, di Metheora, di dubbi Cavallereschi, e del modo novo d'imparar á schermir con spada bianca, e difendersi senz'armi*. Viterbo: Gerolamo Discepolo.

Ammirato, Scipione. 1594. *Discorsi del signor Scipione Ammirato sopra Cornelio Tacito nuovamente posti in luce, con due tavole, una dei discorsi, e luoghi di Cornelio sopra i quali son fondati, l'altra delle cose più notabili*. Florence: Filippo Giunti.

Antoniano, Silvio. [1584] 1821. *Dell'educazione cristiana e politica de' figliuoli libri tre*. 3 vols. Milan: Giuseppe Pogliani.

Aquinas, Thomas. [1266–73] 1949. *Summa Theologica*. Florence: Salani.

Aristotle. 1983. *Etica Eudemia*. Rome: Laterza.

———. 1993. *Etica Nicomachea*. Rome: Laterza.

Armenini, Giovanni Battista. 1586. *De' veri precetti della pittura, libri III*. Ravenna: Francesco Tebaldini.

Assandri, Giovanni Battista. 1616. *Della Economica, overo Disciplina domestica di Gio. Battista Assandri. Libri quattro*. Cremona: Marcantonio Belpiero.

Bodin, Jean. 1588. *I sei libri della Repubblica del sig. Giovanni Bodino, tradotti di lingua francese nell'Italian da Lorenzo Conti gentil'homo genovese*. Genoa: Girolamo Bartoli.

Borghini, Vincenzo. [1570–80] 1971. *Selva di Notizie*. In *Scritti d'arte del Cinquecento*, edited by Paola Barocchi, 3:611–673. Milan: Ricciardi.

Botero, Giovanni. 1590. *Della ragion di Stato libri dieci: Con tre libri delle cause della Grandezza e Magnificenza delle città*. Ferrara: Vittorio Baldini.

Boulanger, Jules Cesare. 1627. *De ludis privatis ac domesticis veterum liber unicus*. Lyon: Sumptibus Ludovici Prost Haeredis Roville.

Canonhiero, Andrea. 1609. *Il perfetto Cortegiano, et dell'uffizio del Prencipe verso 'l Cortegiano*. Rome: Bartolomeo Zanetti.

Capaccio, Giulio Cesare. 1620. *Il Principe del signore Giulio Cesare Capaccio, Gentil'huomo del Serenissimo Duca d'Urbino: Tratto da gli Emblemi dell'Alciato, Con Duecento e piú avvertimenti politici e morali utilissimi a qualunque Signore per l'ottima erudizione di Costumi, Economia e Governo di Stati*. Venice: Barezzo Barezzi.

Caporali, Cesare. 1590. *Dialogo sopra la Corte.* Ferrara: Benedetto Mamarello.

Castiglione, Baldassarre. [1528] 1981. *Il libro del cortegiano.* Edited by Amedeo Quondam. Milan: Garzanti.

Castiglione, Sabba. 1558. *Ricordi overo ammaestramenti di monsignor Sabba Castiglione cavalier gierosolimitano, ne quali con prudenti, e christiani discorsi si ragiona di tutte le materie honorate, che si ricercano à un vero gentiluomo.* Venice: Comin da Trino.

Castori, Bernardino. 1622. *Institutione Civile et Christiana per uno, che desideri vivere tanto in Corte, quanto altrove honoratamente, e cristianamente.* Rome: Alessandro Zannetti.

Cennini, Cennino. [1350] 2003. *Il libro dell'arte.* Edited by F. Frezzato. Vicenza: Neri Pozza.

Cicero. 1965. *Laelius.* Bologna: Zanichelli.

———. 1992. *De officiis.* Milan: Rizzoli.

———. 1994a. *De oratore.* Milan: Rizzoli.

———. 1994b. *Pro murena.* Milan: Fabbri.

Cortesio, Paolo. 1504. *Quattuor libri sentiarum Per Paulum Cortesium Protonotarium Apostolicum.* Rome: Eucharius Silber alias Franck calchographus.

———. 1510. *De Cardinalatu.* Castro Cortesio: Symeon Nicolai Nardi.

D'Olanda, Francesco. [1548] 2003. "De Pictura antiga." In *I trattati d'arte,* edited by G. Modroni. Livorno: Sillabe, 2003.

Della Casa, Giovanni. [1571] 1970. "Trattato degli uffici comuni tra gli amici superiori e inferiori." In *Prose di Giovanni Della Casa e altri trattatisti cinquecenteschi del comportamento,* edited by Arnaldo Di Benedetto, 1:135–189. Turin: UTET.

Diario ferrarese [1409–1502] 1930. "Diario ferrarese 1409–1502." In *Rerum Italicarum Scriptores, Raccolta degli storici italiani dal Cinquecento al Millecinquecento,* arranged by L. A. Muratori, new edition revised and corrected by G. Carducci, V. Fiorini, and P. Fedele, pt. 7, vol. 1. Bologna: Zanichelli.

Ducci, Lorenzo. 1601. *Arte aulica di Lorenzo Ducci.* Ferrara: Vittorio Baldini.

Evitascandolo, Cesare. 1598. *Dialogo del maestro di Casa.* Rome: Giovanni Martinelli.

Fabrini, Giovanni. 1547. *Il sacro regno e 'l Gran Patritio de 'l vero reggimento, e de la vera felicità de 'l Principe, e beatitudine umana.* Venice: Comin da Trino.

Filelfo, Francesco. [1443] 1537. *Convivia Mediolanensia.* Cologne: Gymnicus.

Frachetta, Gerolamo. 1613. *Il seminario de governi di stato e di guerra di Girolamo Frachetta da Rovigo.* Venice: Evangelista Deuchino.

Franco, Nicolò. [1539] 1542. *Dialogi piacevoli di M. Nicolo Franco, novamente con somma diligenza stampati.* Venice: Gabriel Giolito Ferrari.

Frigerio, Bartolomeo. 1579. *L'economo prudente di Bartolomeo Frigerio di Ferrara, Benefitiato di San Pietro in Roma: Nel quale con l'autorità della Sacra Scrittura, d'Aristotile, e d'altri gravi scrittori si mostra l'arte infallibile d'acquistare, e conservare la robba, e la riputatione di una Famiglia, e di una Corte.* Rome: Lodovico Grignani.

Fusoritto, Narni da. 1593. *Il maestro di Casa di Cesare Pandini.* Venice: Giovanni Varisco.

Gilio, Giovanni Andrea. [1564] 1961. *Dialogo nel quale si ragiona degli errori e degli abusi de' Pittori circa l'istorie.* Camerino: Antonio Gioioso. Reprinted in *Trattati d'arte del Cinquecento fra Manierismo e Controriforma,* edited by Paola Barocchi, 2:1–116. Bari: Laterza.

Gracian, Baltasar. [1583] 1693. *L'Homme de Cour de Baltasar Gracian.* Lyon: François Barbier.

India, Francesco. 1591. *L'Heroe overo della virtù heroica: Dialogo di Francesco India medico et filosofo veronese.* Verona: Gerolamo Discepolo.

Latini, Brunetto. [1270] 1869. *Il tesoro di Brunetto Latini volgarizzato da Bono Giamboni.* Vol. 2. Venice: Coi tipi del gondoliere.

Liberati, Francesco. 1658. *Il perfetto maestro di casa*. Rome: Angelo Bernabò dal Verme.

Lomazzo, Giovanni Paolo. 1585. *Trattato della pittura, scultura e architettura*. Milan: Paolo Gottardo Ponzio e Pietro Tini.

Machiavelli, Niccolò. [1532] 1960. *Il Principe*. Edited by Sergio Bertelli. Milan: Feltrinelli.

Malvasia, Carlo Cesare. [1678] 1974. *Felsina Pittrice: Vite de' Pittori Bolognesi*. Bologna: Barbieri. Anastatic printing. Bologna: Arnaldo Forni.

Mancini, Giulio. [1614–21] 1956. *Considerazioni sulla pittura*. Rome: Accademia Nazionale dei Lincei.

Muzio, Gerolamo. 1575. *Il gentilhuomo del Mutio Iustopolitano*. Venice: Luigi Valvassori and Giovanni Domenico Micheli.

Orologgi, Giuseppe. 1562. *L'inganno: Dialogo di m. Giuseppe Horologgi*. Venice: Gabriele Giolito Ferrari.

Pacciani, Fulvio. 1607. *Dell'arte di governare bene i popoli et di fare che il principe in un medesimo tempo sia temuto, & amato*. Siena: Silvestro Marchetti.

Paleotti, Gabriel. [1582] 1961. *Discorso intorno alle immagini sacre e profane*. Bologna: Alessandro Benacci. Reprinted in *Trattati d'arte del Cinquecento fra Manierismo e Controriforma*, edited by Paola Barocchi, 2:117–509. Bari: Laterza.

Paruta, Paolo. 1579. *Della perfettione della vita politica di M. Paolo Paruta nobile vinetiano. Libri tre*. Venice: Domenico Nicolini.

Pérault, Guillaume. [1236–48] 1595. *Virtutum vitiorumque exempla ex utriusque legis promptuario decerpta*. Lyon: Gulielmum Rovillium.

Peregrini, Matteo. 1634. *Della pratica comune a principi e servitori loro libri cinque*. Viterbo: Diotallevi.

Piccolomini, Alessandro. 1552. *De la institutione di tutta la vita de l'homo nato nobile e in città libera*. Venice: Giovanni Maria Bonelli.

Pigna, Giovanni Battista. 1561. *Gli Heroici di Gio. Battista Pigna*. Venice: Gabriele Giolito Ferrari.

Pino, Paolo. [1548] 1960. *Dialogo di Pittura*. Venice: Paolo Gherardo. Reprinted in *Trattati d'arte del Cinquecento fra Manierismo e Controriforma*, edited by P. Barocchi, 1:93–139. Bari: Laterza.

Pontano, Giovanni. 1518. *Ioannis Ioviani Pontani opera omnia soluta oratione composita*. Venice: Aldo.

Priscianese, Francesco. 1543. *Del governo della Corte d'un signore in Roma*. Rome: Francesco Priscianese.

Romei, Annibale. 1591. *Discorsi del conte Annibale Romei Gentil'huomo Ferrarese, di nuovo ristampati, ampliati, e con diligenza corretti*. Pavia: Andrea Viani.

Romoli, Domenico. 1560. *La singolare dottrina di M. Domenico Romoli sopranominato Panunto: Dell'ufficio dello Scalco, de i condimenti di tutte le vivande, et stagioni che si convengono a tutti gli animali, uccelli, et pesci, banchetti d'ogni tempo, et mangiare da apparecchiarsi di dì, in dì, per tutto l'anno a Prencipi*. Venice: Michele Tramezzino.

Sigismondi, Sigismondo. 1604. *Prattica cortigiana, morale et economica nella quale si discorre minutamente de' Ministri, che servono in Corte d'un Cardinale e si dimostrano le qualità, che loro convengono*. Ferrara: Vittorio Baldini.

Timotei, Michele. 1614. *Il cortegiano, nel quale si tratta di tutti li offitii della corte, offitiali, et ministri de prencipi*. Rome: Giacomo Mascardi.

Varchi, Benedetto. [1546] 1960. *Lezzione nella quale si disputa della maggioranza delle arti e qual sia più nobile, la scultura o la pittura, fatta da lui pubblicamente nella Accademia Fiorentina la terza domenica di Quaresima, l'anno 1546*. Florence: Lorenzo Torrentino. Reprinted in *Trattati d'arte del Cinquecento fra Manierismo e Controriforma*, edited by Paola Barocchi, 1:1–82. Bari: Laterza.

Texts Originally Published between 1701 and 1900

Ballerini, Franco. 1898. *Le Belle Arti nelle legislazioni passate e presenti italiane e straniere.* Genoa: Fassicomo e Scotti.

Blanc, Charles. 1857–58. *Le Trésor de la curiosité, tiré des catalogues de ventes . . . avec diverses notes & notices historiques & biografiques . . . et precédé d'une lettre à l'auteur sur la curiosité et les curieux.* 2 vols. Paris: J. Renouard.

Buchanan, William. 1824. *Memoirs of Paintings, with a Chronological History of the Importation of Pictures of Great Masters into England since the French Revolution.* London: R. Ackermann.

Campori, Giuseppe. [1876] 1980. *Maiolica e porcellana di Ferrara.* Modena: Tip. Carlo Vincenzi. Anastatic printing. Bologna: Forni.

Catellacci, Dante. 1897. "Curiosi ricordi del Contagio di Firenze del 1630." *Archivio Storico Italiano,* 5th ser., 20: 379–391.

Crispolti, Filippo. 1898. *La proprietà artistica e l'Editto Pacca innanzi ai magistrati.* Pistoia: G. Flori.

Defer, Pierre. 1863–68. *Catalogue Général des Ventes Publiques de Tableaux et Estampes 1737 jusqu'à Nos Jours, Contenant . . . les Prix . . . des Notes Biographiques Formant un Dictionnaire des Peintres et des Gravures les plus Célèbres de Toutes les écoles.* Paris: Aubry.

Frizzi, Antonio. 1847–48. *Memorie per la storia di Ferrara.* 4 vols. Ferrara: Abram Servadio.

Giampietro, Luigi. 1900. *Il reato di vendita od estrazione fraudolenta per l'estero degli oggetti di raro e singolare pregio artistico, non sottoposti al vincolo del fidecommesso, nella provincia Romana.* Rome: G. Bertero.

Mariotti, Filippo. 1892. *La legislazione delle Belle Arti.* Rome: Unione Cooperativa Editrice.

Ministero della Pubblica Istruzione. 1881. *Leggi, decreti, ordinanze e provvedimenti generali emanati dai cessati governi d'Italia per la conservazione dei monumenti e la esportazione delle opere d'arte.* Rome: Salvucci.

Redford, George. 1888–89. *Art Sales: A History of Sales of Pictures and Other Works of Art.* London: George Redford.

Roberts, William L. 1897. *Memorials of Christies's: A Record of Art Sales from 1766 to 1896.* London: George Bell and Sons.

Roehn, Charles. 1841. *Physiologie du Commerce des Arts.* Paris: Lagny Frères.

Rossi, Adamo. 1876–77. "Documenti sulle Requisizioni dei Quadri Fatte a Perugia dalla Francia ai Tempi della Repubblica e dell'Impero." *Giornale di erudizione artistica* 5 (1876): 224–56, 288–303; 6 (1877): 3–25, 65–110.

Ruskin, John. 1857. *The Political Economy of Art: Being the Substance (with additions) of Two Lectures Delivered at Manchester July 10th and 13th 1857.* London: Smith-Elder.

———. [1862] 1946. *Unto This Last: Four Essays on the First Principles of Political Economy.* London: Smith-Elder. Edited and translated by F. Villa as *I diritti del lavoro.* Bari: Laterza.

———. 1866. *The Crown of Wild Olive: Three Lectures on Work, Traffic and War.* London: Smith-Elder.

———. 1872. *Munera Pulveris.* London: Smith-Elder.

Sismondi, Jean Charles Léonard. [1809–18] 1831–32. *Histoire des republiques italiennes du moyen âge.* Paris: H. Nicolle. Translated as *Storia delle repubbliche italiane dei secoli di mezzo.* Capolago: Tipografia elvetica.

Veblen, Thorstein. [1899] 1981. *The Theory of the Leisure Class: An Economic Study in the Evolution of Institutions.* New York: Macmillan. Translated as *La teoria della classe agiata.* Turin: Einaudi.

Texts Published after 1901

Aa. Vv. 1995. *Musei, tutela e legislazione dei beni culturali a Napoli tra '700 e '800.* Naples: Luciano Editore.

Adami, Giuseppe. 2003. *Scenografia e scenotecnica barocca tra Ferrara e Parma, 1625–1631.* Rome: L'"Erma" di Bretschneider.

Adinolfi, Marco. 1994. "Il ruolo di Nicholas Lanier nell'acquisto della galleria dei Gonzaga per la Corona Britannica." *Civiltà mantovana* 29, no. 11: 27–33.

Agnello, Richard J. 2002. "Investment Returns and Risk for Art: Evidence from Auctions of American Paintings." *Eastern Economic Review* 28, no. 4: 443–464.

Agnello, Richard J., and Renée K. Pierce. 1996. "Investment Returns and Risk for Art: Evidence from Auctions of American Paintings (1971–1996)." Working paper, University of Delaware.

Ago, Renata. 1998. *Economia Barocca: Mercato e istituzioni nella Rome del Seicento.* Rome: Donzelli.

———. 2002. "Collezioni di quadri e collezioni di libri a Roma tra e secolo in xvi and xvii." *Quaderni Storici* 110, no. 2: 379–403.

———. 2006. *Il gusto delle cose: Una storia degli oggetti nella Rome del Seicento.* Rome: Donzelli.

Agosti, Giovanni. 1993. "Adolfo Venturi e le Gallerie fidecommissarie Romene (1891–1893)." *Roma moderna e contemporanea* 1: 95–120.

Agosti, Barbara, and Giovanni Agosti, eds. 1997. *Le tavole del Lomazzo.* Brescia: L'obliquo.

Aikema, Bernard. 2003. "Tesori ponentini per la Serenissima: Il commercio d'arte fiamminga a Venezia e nel Veneto fra Quattro e Cinquecento." In *Tra committenza e collezionismo: Studi sul mercato dell'arte nell'Italia settentrionale durante l'età moderna,* edited by Enrico Maria Dal Pozzolo and Leonida Tedoldi, 35–48. Vicenza: Terraferma.

Ait, Ivana. 1996. "Salariato e gerarchie del lavoro nell'edilizia pubblica Romana del Secolo xv." *Rivista storica del Lazio* 5: 101–130.

———. 2002. "Aspetti dell'attività edilizia a Roma: La fabbrica di S. Pietro nella seconda metà del '400." In *Maestranze e cantieri edili a Rome e nel Lazio: Lavoro, tecniche, materiali nei secoli* xii xv, edited by Ivana Ait and Angela Lanconelli, 39–53. Rome: Manziana.

Ait, Ivana, and Angela Lanconelli, eds. 2002. *Maestranze e cantieri edili a Rome e nel Lazio: Lavoro, tecniche, materiali nei secoli* xii and xv. Rome: Manziana.

Ait, Ivana, and Manuel Vaquero Piñeiro. 2000. *Dai Casali alla fabbrica di San Pietro. I Leni: Uomini d'affari del Rinascimento.* Rome: Ministero per i Beni e le Attività Culturali.

Ajmar, Marta. 2003. "Talking Pots: Strategies for Producing Novelty and the Consumption of Painted Pottery in Renaissance Italy." In *The Art Market in Italy, 15th–17th Centuries,* edited by Marcello Fantoni, Louisa Chevalier Matthew, and Sara F. Matthews-Grieco, 55–64. Modena: Panini.

Aleandri, Vittorio Emanuele. 1911. "Artisti e artieri lombardi a Vitorchiano nei secoli xv–xvi." *Archivio Storico Lombardo,* ser. 4a, vol. 36: 102–132.

Alessio, Franco. 1965. "La filosofia e le 'artes mechanicae' nel secolo xii." *Studi Medievali* 6, no. 1: 71–161.

Allen, Robert C. 2001. "The Great Divergence in European Wages and Prices from the Middle Ages to the First World War." *Explorations in Economic History* 38: 411–447.

Allerston, Patricia. 2003. "The Second-Hand Trade in the Arts in Early Modern Italy." In *The Art Market in Italy, 15th–17th Centuries,* edited by Marcello Fantoni, Louisa Chevalier Matthew, and Sara F. Matthews-Grieco, 301–312. Modena: Panini.

Allgemeines Künstler-Lexikon. 1992–2004. *Allgemeines Künstler-Lexicon. Die Bilden- den Künstler aller Zeiten und Völker.* 40 vols. Munich: K. G. Saur.

Alpers, Svetlana. [1988] 1990. *Rembrandt's Enterprise: The Studio and the Market.* Chicago: University of Chicago Press. Translated as *L'officina di Rembrandt: L'atelier e il mercato.* Turin: Einaudi.

Ames-Lewis, Francis. 2000. *The Intellectual Life of the Early Renaissance Artist.* New Haven: Yale University Press.

Ampolo, Carmine. 1984. "Il lusso nelle società arcaiche: Note preliminari sulla posizione del problema." *Opus* 3: 469–476.

Andenna, Giancarlo. 1994. "La simbologia del potere nelle città comunali lombarde: I palazzi pubblici." In *Le forme della propaganda politica nel Due e nel Trecento,* edited by Paolo Cammarosano, 369–393. Rome: École Française de Rome.

Anderson, Jaynie. 1991. "National Museums: The Art Market and Old Master Paintings." In "Kunst und Kunsttheorie 1400–1900," edited by P. Ganz, M. Gosebruch, N. Meier, and M. Warnke. *Wolfenbütteler Forschungen* 48: 375–404.

———. 1996. "Rewriting The History of Art Patronage." In "Women Patrons of Renaissance Art, 1300–1600," edited by Jaynie Anderson. *Renaissance Studies* 20, no. 2: 129–138.

Andreau, Jean, Pierre Briant, and Raymond Descat, eds. 1997. *Économie Antique: Prix et formation des prix dans les économies antiques.* Saint Bertrand-de-Comminges: Museé Archeologique Départemental.

Angiolillo, Marialuisa. 1996. *Feste di corte e di popolo nell'Italia del primo Rinascimento.* Rome: SEAM.

Antal, Frederick. [1947] 1960. *Florentine Painting and Its Social Background: The Bourgeois Republic before Cosimo de' Medici's Advent to Power:* xiv *and Early* xv *Centuries.* London: Kegan Paul. Translated as *La pittura fiorentina e il suo ambiente sociale nel Trecento e nel primo Quattrocento.* Turin: Einaudi.

Anthony, Peter. 1983. *John Ruskin's Labour: A Study of Ruskin's Social Theory.* Cambridge: Cambridge University Press.

Appadurai, Arjun. 1986. "Introduction: Commodities and the Politics of value." In *The Social Life of Things: Commodities in Cultural Perspective,* edited by Arjun Appadurai, 3–63. Cambridge: Cambridge University Press.

Ashenfelter, Orley, Kathryn Graddy, and Margaret Stevens. 2001. A Study of Sale Rates and Prices in Impressionist and Contemporary Art Auctions." Paper presented at the CEPR meeting.

Austin, Linda Marilyn. 1991. *The Practical Ruskin: Economics and Audience in the Late Work.* Baltimore: Johns Hopkins University Press.

Autrand, F. Françoise. 1981. "De l'histoire de l'État à la prosopographie." In *Aspects de la recherche historique en France et en Allemagne: Tendances et méthodes,* edited by G. A. Ritter and R. Vierhaus, 43–53. Göttingen: Vandenhoeck and Ruprecht.

Aymard, Maurice M. 1978. "La transizione dal feudalesimo al capitalismo." In *Storia d'Italia,* vol. 1, *Dal Feudalesimo al Capitalismo,* edited by R. Romano and C. Vivanti, 1131–1192. Turin: Einaudi.

Backhaus, Jurgen G. 1996. *Werner Sombart (1863–1941): Social Scientist.* Marburg: Metropolis.

Bailey, Colin B. 1984. "Lebrun et le commerce d'art pendant le Blocus continental." *Revue de l'art* 63: 35–46.

Balzani, Roberto. 2003. *Per le antichità e le belle arti: La legge n. 364 del 20 giugno 1909 el'Italia giolittiana.* Bologna: Il Mulino.

Baracchi-Giovanardi, Orianna. 1984. "Il modenese Antonio Boccolari e l'arte di 'strappare' gli affreschi del muro." *Atti e Memorie della Deputazione di Storia Patria per le Antiche Province Modenesi* 6: 319–340.

———. 1991. "Il patrimonio artistico ecclesiastico: Inventari delle soppressioni napoleoniche." *Atti e Memorie della Deputazione di Storia Patria per le Antiche Province Modenesi* 13: 205–245.

———. 1995. "Le soppressioni napoleoniche del 1811 e il patrimonio artistico ecclesiastico dei dipartimenti del Metauro, del Musone e del Tronto." *Atti e Memorie della Deputazione di Storia Patria per le Marche* 98: 281–351.

———. 1999. "Soppressioni ducali e patrimonio artistico ecclesiastico." *Atti e Memorie della Deputazione di Storia Patria per le Antiche Province Modenesi* 21: 413–444.

Barasch, Moshe. 1985. *Theories of Art: From Plato to Winckelmann.* New York: New York University Press.

Barbagallo, Corrado. 1927. *L'oro e il fuoco: Capitale e lavoro attraverso i secoli.* Milan: Corbaccio.

Barber, William. 1999. "International Commerce in the Fine Arts and American Political Economy, 1789–1913." In *Economic Engagements with Art,* edited by Neil De Marchi and Craufurd D. W. Goodwin, 209–234. Durham, NC: Duke University Press.

Barbieri, Gino. 1940a. *Note e documenti di storia economica italiana per l'età medievale e moderna.* Milan: Giuffrè.

———. 1940b. *Ideali economici degli italiani all'inizio dell'età moderna.* Milan: Giuffrè.

———. 1957–58. "Liberalitas." In *Dizionario Epigrafico di Antichità Romane,* edited by E. Di Ruggero, 4:838–885. Rome: Istituto italiano per la storia antica.

Bardeschi Ciulich, Lucilla. 2005. *I contratti di Michelangelo.* Florence: SPES.

Barker, Emma, Nick Webb, and Kim Woods, eds. 1999. *The Changing Status of the Artist.* New Haven: Yale University Press in association with Open University.

Barocchi, Paola, ed. 1960–62. *Trattati d'arte del Cinquecento: Fra Manierismo e Controriforma.* 3 vols. Bari: Laterza.

———, ed. 1971–77. *Scritti d'arte del Cinquecento.* 3 vols. Milan: Ricciardi.

———. 1979. "Storiografia e collezionismo dal Vasari al Lanzi." In *Storia dell'arte italiana,* pt. 1, *Materiali e Problemi,* edited by G. Previtali, vol. 2, *L'artista e il pubblico,* 3–82. Turin: Einaudi.

———. 1984. *Studi vasariani.* Turin: Einaudi.

———. 1987. *Il Cardinal Leopoldo: Archivio del collezioni medicee.* Milan: Ricciardi.

Barocchi, Paola, and Giovanna Gaeta-Bertelà. 1991. "Danni e furti di Giuseppe Bianchi in Galleria." *Annali della Scuola Normale Superiore di Pisa: Classe di Lettere e Filosofia,* 20, nos. 2–3: 553–568.

———. 1993. *Collezionismo mediceo: Cosimo, Francesco e il II Cardinale Ferdinando. Documenti 1540–1587.* Modena: Panini.

Barrella, Nadia. 2003. *Principi e princìpi della tutela: Episodi di storia della conservazione dei monumenti a Napoli tra Sette e Ottocento.* Naples: Luciano Editore.

Bataille, Georges. [1967] 1992. *La part maudite précédée de la Notion de dépense.* Paris: Éditions de Minuit. Translated as *La parte maledetta.* Turin: Bollati Boringhieri.

Baudrillard, Jean. 1968. *Le Système des objets.* Paris: Gallimard.

———. [1972] 1974. *Pour une critique de l'économie politique du signe.* Paris: Gallimard. Translated as *Per una critica dell'economia politica del segno.* Milan: Mazzotta.

———. 1994. "The System of Collecting." In *The Cultures of Collecting,* edited by J. Elsner and R. Cardinal, 7–24. London: Reaktion Books.

Baumol, William J. 1986. "Unnatural Value: Or Art Investment as a Floating Crap Game." *American Economic Review* 76: 10–14.

Baumol, William J., and William G. Bowen. 1966. *Performing Arts: The Economic Dilemma.* Cambridge: MIT Press.

Baxandall, Michael. 1971. *Giotto and the Orators: Humanist Observers of Painting in Italy and the Discovery of Pictorial Composition, 1350–1450.* Oxford: Clarendon Press.

———. [1972] 1978. *Painting and Experience in Fifteenth Century Italy.* Oxford: Oxford University Press. Translated as *Pittura ed esperienze sociali nell'Italia del Quattrocento.* Turin: Einaudi.

Bayer, Thomas Mann. 1992. "Marketing of Genius, Ingenious Marketing: The Role of Engravings in Mid-Nineteenth Century English Art Dealing." *Athanor* 11: 50–61.

Bedin, Simonetta, Laura Bello, and Alessia Rossi. 1998. *Tutela e restauro nello Stato pontificio.* Padova: Cedam.

Béguin, Sylvie. 1959. "Tableaux Provenants de Naples et de Rome en 1802, Restés en France." *Bulletin de la Société de l'Histoire de l'Art Français,* 117–198.

Belfanti, Carlo Marco, and Giovanni Luigi Fontana. 2005. "Rinascimento e made in Italy." In *Il Rinascimento italiano e l'Europa,* vol. 1, *Storia e Storiografia,* edited by Marcello Fantoni, 617–636. Treviso: Fondazione Cassamarca-Angelo Colla.

Belfanti, Carlo Marco, and Fabio Giusberti, eds. 2003. "La Moda." In *Storia d'Italia,* Annali 19. Turin: Einaudi.

Beltrami, Daniele. 1954. *Storia della popolazione di Venezia dalla fine del secolo* xvi *alla caduta della Repubblica.* Padua: Cedam.

Benassati, Giuseppina. 1981. "La pratica del torneo a Modena in età barocca: Appunti per una fenomenologia dello spettacolo nel Ducato Estense." *Il Carrobbio,* 56–65.

———. 1985. "Apparati pirotecnici a Reggio Emilia." In *In forma di Festa: Apparatori, decoratori, scenografi, impresari in Reggio Emilia dal 1600 al 1857,* 111–117, edited by M. Pigozzi. Reggio Emilia: Comune di Reggio Emilia.

Bencivenni, Mario, Riccardo Dalla Negra, and Paola Grifoni. 1987. *Monumenti e istituzioni.* Vol. 1, *La nascita dei servizi di tutela dei monumenti in Italia, 1860–1913.* Florence: Alinea.

———. 1992. *Monumenti e istituzioni.* Vol. 2, *Il decollo e la riforma dei servizi di tutela dei monumenti in Italia, 1880–1915.* Florence: Alinea.

Benedict, Philip. 1985. "Towards the Comparative Study of the Popular Market for Art: The Ownership of Paintings in Seventeenth-Century Metz." *Past and Present* 109: 100–117.

Bentini, Jadranka, ed. 2004. *Este a Ferrara: Il Castello per la città.* Exhibition catalog. Milan: Silvana Editoriale.

Bentini, Jadranka, and Grazia Afosrini, eds. 2003. *Un rinascimento singolare: La corte degli Este a Ferrara.* Exhibition catalog. Milan: Silvana Editoriale.

Bentini, Jadranka, and Luigi Spezzaferro, eds. 1987. *L'impresa di Alfonso: Saggi e documenti II sulla produzione artistica a Ferrara nel secondo Cinquecento.* Bologna: Nuova Alfa.

Bentivoglio, Enzo. 1982. "Nel cantiere del Palazzo del card. Raffaele Riario (La Cancelleria). Organizzazione, materiali, maestranze, personaggi." *Quaderni dell'Istituto di Storia dell'architettura* 169–172: 27–34.

Berg, Maxine, and Helen Clifford. 1999. *Consumers and Luxury: Consumer Culture in Europe, 1650–1850.* Manchester: Manchester University Press.

Berg, Maxine, and Elizabeth Eger, eds. 2003. *Luxury in the Eighteenth Century: Debates, Desires and Delectable Goods.* New York: Palgrave.

Berry, Christopher J. 1994. *The Idea of Luxury: A Conceptual and Historical Investigation.* Cambridge: Cambridge University Press.

Bertoni, Giulio. 1903. *La Biblioteca Estense e la coltura ferrarese ai tempi del Duca Ercole I.* Turin: Loescher.

Bertozzi, Marco, ed. 1994. *Alla corte degli Estensi: Filosofia, arte e cultura a Ferrara nei secoli* xv *e* xvi. Ferrara: Università degli Studi.

Bertrand Dorléac, Laurence, ed. 1992. *Le commerce de l'art de la Renaissance à nos jours.* Besançon: Éditions de La Manufacture.

Berve, Helmut. 1926. "Liberalitas, die freie, edel, großzügige Denkungsart und das entsprechende

Verhalten gegenüber den Mitmenschen." In *Paulys Realencyclopädie der classischen Altertumwissenschaft, neue Bearbeitung,* vol. 13.1, columns 82–93. Stuttgart: Fünfundzwanzigster Halbband.

Bianchini, Marco. 1976. "Elementi di economia nel pensiero politico di Cicerone." *Nuova Rivista Storica* 60: 1–21.

———. 1981. "Spreco." In *Enciclopedia Einaudi,* 12:396–417. Turin: Einaudi.

———. 1985. "L'economica' Romana come espressione della crisi della repubblica." *Cheiron* 4: 31–44.

———, ed. 1999. "I giochi del prestigio: Modelli e pratiche della distinzione sociale." *Cheiron* 31–32.

Bianchini, Marco, and Marco Cattini, eds. 2006. "Cinquecento Moderno." *Cheiron* 41.

Bignamini, Ilaria. 1993. "Osservazioni sulle istituzioni, il pubblico e il mercato delle arti in Inghilterra." *Zeitschrift für Kunstgeschichte* 53, no. 2: 177–197.

Biondi, Grazia. 1998. "Donne di casa d'Este tra realtà e maniera devota." In *Sovrane Passioni: Studi sul collezionismo estense,* edited by J. Bentini, 186–204. Milan: Federico Motta editore.

Birch, Dinah D., ed. 1999. *Ruskin and the Dawn of Modern.* Oxford: Oxford University Press.

Bjurström, Per. 1966. *Feast and Theatre in Queen Christina's Rome.* Stockholm: Nationalmuseum Stockholm.

Blanchet, André. 1904. "Liberalitas." In *Dictionnaire des antiquités Grecques et Romeines,* 13:1192. Paris: Hachette.

Blaug, Mark, ed. 1976. *The Economics of the Arts.* London: Martin Robertson.

Bluhm, Andreas, ed. 1999. *Theo van Gogh: Marchand de tableaux, collectionneur, frère de Vincent: 1857–1891.* Paris: Éditions de la Réunion des Musées Nationaux.

Blume, Andrew. 2003. "Botticelli and the Cost and Value of Altarpieces in Late Fifteenth-Century Florence." In *The Art Market in Italy, 15th–17th Centuries,* edited by Marcello Fantoni, Louisa C. Matthew, and Sara F. Matthews Grieco, 151–161. Modena: Panini.

Blumenthal, Arthur R. 1990. "Medici Patronage and the Festivals of 1589." In *Essays Honoring Irving Lavin on His Sixtieth Birthday,* 97–106. New York: Italica Press.

Blumer, Marie-Louise. 1934. "La Mission de Denon en Italie (1811)." *Revue des Études Napoléoniennes,* 38: 237–257.

———. 1936. "Catalogue des Peintures Transportées d'Italie en France de 1796 à 1814." *Bulletin de la Société de L'Histoire de l'Art Français,* 244–348.

Bocchi, Francesca, ed. 1987–89. *Storia illustrata di Ferrara.* Milan: AIEP.

Bodart, Didier. H. 1966. "Cérémonies et monuments Romeins à la mémoire d'Alexandre Farnèse duc de Parme et de Plaisance." *Bulletin de l'Institut Historique Belge de Rome* 37: 121–136.

———. 1998. *Tiziano e Federico II Gonzaga: Storia di un rapporto di committenza.* Rome: Bulzoni.

Boime, Albert. [1976] 1990. *Entrepreneurial Patronage in Nineteenth-Century France.* Baltimore: Johns Hopkins University Press. Partially reprinted as *Artisti e Imprenditori.* Turin: Bollati Boringhieri.

———. 1990. *Artisti e Imprenditori.* Turin: Bollati Boringhieri.

Boiteux, Martine. 1977. "Carnaval annexé. Essai de lecture d'une fête Romeine." *Annales* 32, no. 2: 356–380.

———. 1988. "Fêtes et cérémonies Romeines au temps de Carrache." In *Carrache et les décors profanes,* 183–214. Rome: École Française de Rome.

Bok, Jan Marten. 1994. *Vraag en aanbod op de Nederlandse kunstmarkt, 1580–1700.* Utrecht: Proefschrift Universiteit Utrecht.

———. 1998. "Pricing the Unpriced: How Dutch 17th-Century Painters Determined the Selling Price of Their Work." In *Markets for Art, 1400–1800,* edited by M. North and D. Ormrod, 101–110. Madrid: Secretariado de Publicaciones de la Universidad de Sevilla.

———. 2002. "Fluctuations in the Production of Portraits Made by Painters in the Northern

Netherlands, 1550–1800." In *Economia ed Arte, Secc.* xiii–xviii: *Atti della* xxxiii *Settimana di Studi dell'Istituto Internazionale di Storia Economica "F. Datini" Prato 30 April–4 May 2000*, edited by Simonetta Cavaciocchi, 649–661. Florence: Le Monnier.

Bologna, Ferdinando. 1972. *Dalle arti minori all'industrial design: Storia di un'ideologia.* Bari: Laterza.

———. 1979. "I metodi di studio dell'arte italiana e il problema metodologico oggi." In *Storia dell'arte italiana*, pt. 1, *Materiali e Problemi*, edited by G. Previtali, vol. 1, *Questioni e metodi*, 164–282. Turin: Einaudi.

Bonelli, Franco. 1961. *Il commercio estero dello Stato pontificio nel secolo* xix, 1st. ser., 11, 1. Rome: Archivio Economico dell'Unificazione Italiana.

Bonfait, Olivier. 1990. "Il pubblico del Guercino: Ricerche sul mercato dell'arte nel secolo xvii a Bologna." *Storia dell'Arte* 68: 71–94.

———. 1992. "La valeur de l'œuvre peinte: L'économie du mécénat de Pompeo Aldrovandi." In *Le commerce de l'art de la Renaissance à nos jours*, edited by L. Bertrand Dorléac. Besançon: Éditions de La Manufacture.

———. 1993. "La carrière des artistes." *Annales* 48, no. 6: 1497–1518.

———. 2002. "Le prix de la peinture à Bologne aux e ete siécles." In *Economia ed Arte, Secc.* xiii–xviii: *Atti della* xxxiii *Settimana di Studi dell'Istituto Internazionale di Storia Economica "F. Datini" Prato 30 April–4 May 2000*, edited by Simonetta Cavaciocchi, 837–849. Florence: Le Monnier.

Bonfante, Pietro. 1938. *Storia del commercio: Lezioni tenute nella Università Commerciale Luigi Bocconi.* Rome: Rodrigo.

Borean, Linda. 2000. *La quadreria di Agostino e Giovan Donato Correggio nel collezionismo veneziano del Seicento.* Udine: Forum.

———. 2002. "La quadreria di Giovanni Andrea Lumaga." In *Figure di collezionisti a Venezia tra Cinque e Seicento*, edited by Linda Borean and Stefania Mason, 191–231. Udine: Forum.

Borean, Linda, and Stefania Mason, eds. 2002. *Figure di collezionisti a Venezia tra Cinque e Seicento.* Udine: Forum.

Borelli, Giorgio, ed. 1991. "Fonti archivistiche e bibliografiche nei secoli dell'Età Moderna." *Studi storici Luigi Simeoni* 41.

Borghero, Carlo. 1973. *La polemica sul lusso nel Settecento Francese.* Turin: Einaudi.

Borroni Salvadori, Fabia. 1983. "Ignazio Enrico Hugford, Collezionista con la vocazione del mercante." *Annali della Scuola Normale Superiore di Pisa. Classe di Lettere eFilosofia*, 13, no. 4: 1025–1056.

———. 1984. "L'esportazione di opere d'arte nella Firenze della seconda metà del Settecento." *Amici dei Musei* 31: 8–11.

Borsanyi, Karl. 1938. "L'Histoire de l'idée de liberalitas." *Egyetemes Philologiai Koez-loeny* 23: 39–42.

Borsook, Eve. 1969. "Art and Politics at the Medici Court IV: Funeral Decors for Henry IV of France." *Mitteilungen des Kunsthistorisches Institutes in Florenz* 14: 201–234.

———. 1983. "Art and Business in Renaissance Florence and Venice." *Humanismus und Ökonomie, Mitteilung VIII der Kommission für Humanismusforschung*, 135–155.

———. 2005. *Collected Writings, 1954–2004.* Florence: privately printed.

Botteri, Santa Maria. 1986. "Per un discorso sull'eroe moderno: Quattro schede e una premessa." *Cheiron* 6: 9–24.

Boucheron, Patrick. 1998. *Le pouvoir de bâtir: Urbanisme et politique édilitaire à Milan* (xive–xve siècles). Rome: École Française de Rome.

———. 2000. "Une mode de construction princier: Signification politique et économique d'un matériau (Milan, xive–xve siècles)." In *La brique antique et médiévale: Production et consommation d'un*

matériau, edited by P. Boucheron, H. Broise, and Y. Thebert, 453–465. Rome: École Française de Rome.

———. 2002. "Bien public et intérêts privés: La dépense édilitaire dans les villes de l'Italie centro-septentrionale (xiiie–xve siècles)." In *La fiscalité des villes au Moyen Âge (Occident méditerranéen). La rédistribution de l'impôt,* vol. 3, edited by D. Menjot and M. Sánchez Martinez. Toulouse: Éditions Privat.

Boulton, Jeremy. 2000. "Food Prices and the Standard of Living in London in the Century of Revolution, 1580–1700." *Economic History Review* 3: 455–492.

Bourdieu, Pierre. 1971. "Le Marché des Biens Symboliques." *L'Année sociologique* 22: 49–126.

Braudel, Fernand. 1974. "L'Italia fuori dall'Italia: Due secoli e tre Italie." In *Storia d'Italia,* vol. 2, pt. 2, *Dalla caduta dell'Impero Romano al secolo* xviii, 2089–2248. Turin: Einaudi.

Braund, David. 1994. "The Luxuries of Athenian Democracy." *Greece & Rome* 41: 41–48.

Braunfels, Wolfgang. 1988. *Urban Design in Western Europe: Regime and Architecture, 900–1900.* Chicago: University of Chicago Press.

Braunstein, Philippe H. 1986. "Les salaires sur les chantiers monumentaux du Milanais à la fin du xvie siècle." In *Artistes, artisans et production artistique au Moyen Âge,* edited by X. Barral and Y. Altet, 1:123–131. Paris: Picard.

———. 1990. "Il cantiere del Duomo di Milano alla fine del xiv secolo: Lo spazio, gli uomini e l'opera." In *Ars et Ratio. Dalla torre di Babele al ponte di Rialto,* edited by J.-C. Maire Vigueur and A. Paravicini Bagliani, 147–164. Palermo: Sellerio.

Bresson, Agnès. 1975. "Peiresc et le commerce des antiquités à Rome." *Gazette des Beaux-Arts* 85: 61–72.

Brewer, John. 2002. "Positioning the Market: Art, Goods and Commodities in Early Modern Europe." In *Economia ed Arte, Secc.* xiii–xviii: *Atti della* xxxiii *Settimana di Studi dell'Istituto Internazionale di Storia Economica "F. Datini" Prato 30 April–4 May 2000,* edited by Simonetta Cavaciocchi, 139–148. Florence: Le Monnier.

Brewer, John, and Roy Porter, eds. 1993. *Consumption and the World of Goods.* London: Routledge.

Brigstocke, Hugh. 1982. *William Buchanan and the Nineteenth-Century Art Trade.* London: Paul Mellon Centre for Studies in British Art.

Brown, Judith C. 1989. "Prosperity or Hard Times in Renaissance Italy? Recent Trends in Renaissance Studies: Economic History." *Renaissance Quarterly* 42: 761–780.

Brown, Jonathan. 1995. *Kings and Connoisseurs. Collecting Art in Seventeenth-Century Europe.* New Haven: Yale University Press.

Brugnoli, Pierpaolo. 2000. "Primi appunti su materiali, manodopera e botteghe nell'edilizia privata della Verona del Quattrocento e del Cinquecento." In *Edilizia privata nella Verona rinascimentale,* edited by P. Lanaro, P. Marini, and G. M. Varanini, with collaboration of E. Demo, 218–232. Milan: Electa.

Buelens, Nathalie, and Victor Ginsburgh. 1993. "Revisiting Baumol's Art as a Floating Crap Game." *European Economic Review* 37: 1351–1371.

Bullegas, Sergio. 1996. *L'effimero barocco: Festa e spettacolo nella Sardegna del secolo* xvii. Cagliari: CUEC.

Bulst, Neithard. 1986. "La recherche prosopographique récente en Allemagne (1250–1650): Essai d'un bilan." In *Prosopographie et genèse de l'état moderne,* edited by F. Autrand, 35–52. Paris: L'École.

———. 1989. "Prosopography and the Computer: Problems and Possibilities." In *History and Computing II,* edited by P. Denley, S. Fogelvik, and C. Harvey, 12–18. Manchester: Manchester University Press.

Burke, Peter. [1972] 1984. *Culture and Society in Renaissance Italy 1420–1540*. London: Batsford. Translated as *Cultura e Società nell'Italia del Rinascimento*. Turin: Einaudi.

———. 1979. "L'artista: Momenti e aspetti." In *Storia dell'arte italiana*, pt. 1, *Materiali e Problemi*, edited by G. Previtali, vol. 2, *L'artista e il pubblico*, 84–113. Turin: Einaudi.

Burns, Howard. 1991. "Building and Construction in Palladio's Vicenza." In *Les Chantiers de la Renaissance*, edited by J. Guillaume, 191–226. Paris: Éditions Picard.

Burns, Howard, Marco Collareta, and Davide Gasparotto, eds. 2000. *Valerio Belli vicentino, 1468c.–1546*. Vicenza: Neri Pozza.

Buscher, Mareile. 2002. *Künstlerverträge in der Florentiner Renaissance*. Frankfurt am Main: Klostermann.

———. 2004. "I contratti degli artisti nella Firenze del Quattrocento nei loro aspetti giuridici." In *Filippino Lippi e Pietro Perugino: La deposizione della Santissima Annunziata e il suo restauro*, edited by F. Falletti and J. Katz Nelson, 148–157. Livorno: Sillabe.

Büsing, Hermann. 1995. "Großbauten und Prunkbauten im Klassischen Athen." In *Affirmationund Kritik: Zur politischen Funktion von Kunst und Literatur im Altertum*, edited by G. Binder and B. Effe, 69–90. Trier: Wissenschaftlicher.

Butters, Suzanne B. 2003. "Making Art Pay: The Meaning and Value of Art in Late Sixteenth-Century Rome and Florence." In *The Art Market in Italy, 15th–17th Centuries*, edited by Marcello Fantoni, Louisa C. Matthew, and Sara F. Matthews Grieco, 25–40. Modena: Panini.

———. 2005. "Dalla storia dell'arte alle arti, e ritorno." In *Il Rinascimento italiano e l'Europa*, vol. 1, *Storia e Storiografia*, edited by Marcello Fantoni, 201–223. Treviso: Fondazione Cassamarca-Angelo Colla.

Byatt, Lucinda. 1983. "'Una suprema magnificenza': Niccolò Ridolfi, a Florentine Cardinal in xvith Century Rome." Ph.D. diss., European Institute, Florence.

Caínzo, Maria D. 1993. "Liberalitas et aeternitas principis en Plinio el Joven." *Ktèma* 18: 227–243.

Calabi, Augusto. 1936. "L'economia della produzione artistica grafica." *Rivista di Storia Economica* 1: 67–73.

Calabi, Donatella. 1990. "Un grande cantiere pubblico nella Venezia del Cinquecento: Il ponte di Rialto e gli stabili speculativi di San Bartolomeo." In *Ars et Ratio*, edited by J. C. Maire Vigueur and A. Paravicini Bagliani, 110–123. Palermo: Sellerio.

Calabi, Donatella, and Paolo Morachiello. 1987. *Rialto: Le fabbriche e il ponte, 1514–1591*. Turin: Einaudi.

———. 1988. "Le pont du Rialto: Un chantier public a Venise à la fin du xvie siécle." *Annales* 43, no. 2: 453–476.

Calonaci, Stefano. 2005. *Dietro lo scudo incantato: I fedecommessi di famiglia e il trionfo della borghesia fiorentina (1400 ca.–1750)*. Florence: Le Monnier.

Calore, Marina. 1983. *Spettacoli a Modena tra '500 e '600: Dalla città alla capitale*. Modena: Aedes Muratoriana.

Campbell, Erin J. 2002. "The Art of Aging Gracefully: The Elderly Artist as Courtier in Early Modern Art Theory and Criticism." *Sixteenth Century Journal* 32, no. 2: 321–331.

Campbell, Stephen J. 1997. *Cosmé Tura of Ferrara: Style, Politics and the Renaissance City, 1450–1495*. New Haven: Yale University Press.

———, ed. 2004. *Artists at Court: Image-Making and Identity 1300–1550*. Chicago: University of Chicago Press.

Candela, Guido, Paolo Figini, and Antonello Scorcu. 2002. "Hedonic Prices in the Art Market: A Reassessment." Paper presented at the conference of the Association of Cultural Economics International, Rotterdam.

———. 2003. "Price Indices for Artists." Rotterdam: Conference paper.

Candela, Guido, and Antonello Scorcu. 1997. "A Price Index for Art Market Auctions: An Application to the Italian Market of Modern and Contemporary Oil Painting." *Journal of Cultural Economics* 21: 175–196.

Candela, Guido, and Antonello Scorcu. 2001. "In Search of Stylized Facts on Art Markets for Prints and Drawings in Italy." *Journal of Cultural Economics* 25: 219–231.

Caniato, Giovanni, and Michela Dal Borgo, eds. 1988. *Dai monti alla Laguna: Produzione artigianale e artistica del bellunese per la cantieristica veneziana.* Venice: La Stamperia di Venezia.

Cantimori, Delio. 1957. "Il problema rinascimentale posto da Armando Sapori." In *Studi in onore di Armando Sapori*, 2: 935–947. Milan: Istituto editoriale Cisalpino.

Cantucci, Michele. 1953. *La tutela giuridica delle cose d'interesse artistico o storico.* Padua: Milani.

Capitelli, Giovanna. 2004. "'Connoisseurship' al lavoro: La carriera di Nicolò Simonelli (1611–1671)." *Quaderni storici* 116, no. 2: 375–401.

Cappelletti, Francesca, ed. 2003. *Decorazione e collezionismo a Roma nel Seicento: Vicende di artisti, committenti e mercanti.* Rome: Gangemi.

Carandini, Silvia. 1994. *Il valore del falso: Errori, inganni, equivoci sulle scene europee in epoca barocca.* Rome: Bulzoni.

Cariati, Silvia. 1998. "Non dovranno trovar posto in chiesa immagini di bestie da soma, di cani, di pesci o di altri animali bruti. Pittura e mercato a Milan nell'età dei Borromeo." Ph.D. thesis in Economic and Social History, Bocconi University.

Carini Motta, Fabrizio. 1994. *Pratica delle macchine dei Teatri di Romano Carapecchia (1689–91).* Rome: E & A Editori Associati.

Carità, Giuseppe. 1990. "Il cantiere del duomo nuovo a Torino." In *Domenico della Rovere e il duomo nuovo di Torino: Rinascimento a Roma e in Piemonte*, edited by G. Romano, 201–228. Turin: Cassa di Risparmio di Torino/Editris.

Carli, Filippo. 1936. *Storia del commercio italiano.* Vol. 2, *Il mercato nell'età del comune.* Padua: Cedam.

Carloni, Rosella. 1992. "Note sui Cartoni: Una famiglia di scalpellini antiquari nella Roma del Sette-Ottocento." *Alma Roma* 33, nos. 3–4: 108–123.

———. 1993. "I fratelli Franzoni e le vendite antiquarie del primo Ottocento al Museo Vaticano." *Bollettino Monumenti Musei e Gallerie Pontificie* 13: 161–226.

———. 1995. "Per una ricostruzione della collezione dei dipinti di Luciano: Acquisti, vendite e qualche nota sul mercato antiquario Romano del primo Ottocento." In *Luciano Bonaparte, le sue collezioni d'arte, le sue residenze a Roma, nel Lazio, in Italia, 1804–1840*, edited by M. Nantoli, 5–47. Rome: Istituto Poligrafico di Stato.

Carpeggiani, Paolo. 1975. "Teatri e apparati scenici alla corte dei Gonzaga tra Cinque e Seicento." *Bollettino del Centro Internazionale di Studi di Architettura "Andrea Palladio"* 17: 101–118.

Casini, Matteo. 1996. *I gesti del principe: La festa politica a Firenze e Venezia in età rinascimentale.* Venice: Marsilio.

Castelnuovo, Enrico. 1976. "Per una storia sociale dell'arte I." *Paragone* 313: 3–30.

———. 1977. "Per una storia sociale dell'arte II." *Paragone* 323: 3–34.

———. 1985. *Arte, industria e rivoluzioni.* Turin: Einaudi.

Catoni, Maria Luisa. 1993. "Fra 'scuola' e 'custodia': La nascita degli organismi di tutela artistica." *Ricerche di storia dell'arte*, monographic fascicle, *L'archeologia italiana dall'Unità al Novecento*, 50: 41–52.

Cavaciocchi, Simonetta, ed. 2002. *Economia ed Arte, Secc. xiii–xviii: Atti della xxxiii Settimana di Studi dell'Istituto Internazionale di Storia Economica "F. Datini" Prato 30 April–4 May 2000*, edited by Simonetta Cavaciocchi. Florence: Le Monnier.

Cavazzi, Lucia, ed. 1982. *"Fochi d'allegrezza" a Roma dal Cinquecento all'Ottocento.* Exhibition catalog. Rome: Edizioni Quasar.

Cavazzini, Patrizia. 2004a. "La diffusione della pittura nella Rome di primo Seicento: Collezionisti ordinari e mercanti." *Quaderni storici* 116, no. 2: 353–374.

———. 2004b. "Claude's Apprenticeship in Rome: The Market for Copies and the Invention of the Liber Veritatis." *Konsthistorisk Tidskrift* 73, no. 3: 133–146.

Ceccarelli, Francesco. 1998. *La città di Alcina: Architettura e Politica alle foci del Po nel tardo Cinquecento.* Bologna: Il Mulino.

———. 2001. "Le architetture nei ducati estensi e nei principati padani." In *Storia dell'architettura italiana: Il secondo Cinquecento,* edited by C. Conforti and R. Tuttle, 220–239. Milan: Electa.

———. 2004. "Palazzi, castalderie e delizie: Forme degli insediamenti estensi nel Ferrarese tra Quattrocento e Cinquecento." In *Este a Ferrara: Il Castello per la città.* Exhibition catalog, edited by J. Bentini, 73–83. Milan: Silvana Editoriale.

Cecchi, Alessandro. 1998. "Il maggiordomo ducale Pierfrancesco Riccio e gli artisti della corte medicea." *Mitteilungen des Kunsthistorischen Institutes in Florenz* 42, no. 1: 115–143.

Cecchini, Isabella. 2000. *Quadri e commercio a Venezia durante il Seicento: Uno studio sul mercato dell'arte.* Venice: Marsilio.

———. 2003a. "Le figure del commercio: Cenni sul mercato pittorico veneziano nel secolo XVII." In *The Art Market in Italy, 15th–17th Centuries,* edited by Marcello Fantoni, Louisa Chevalier Matthew, and Sara F. Matthews-Grieco, 389–400. Modena: Panini.

———. 2003b. "Fatte varie, et diverse esperienze per essitar esse Pitture. Prezzi e valore di stima. Breve analisi di un campione seicentesco a Venezia." In *Tra committenza e collezionismo: Studi sul mercato dell'arte nell'Italia settentrionale durante l'età moderna,* edited by Enrico Maria Dal Pozzolo, and Leonida Tedoldi. 123–136. Vicenza: Terraferma.

———. 2004. "Il cantiere di Palazzo Ducale dopo l'incendio del 1574." *Storia di Venezia 2:* 39–59.

Chambers, David S. 1970. *Patrons and Artists in the Italian Renaissance.* London: Macmillan.

Chanel, Olivier, Louis-André Gérard-Varet, and Victor Ginsburgh. 1996. "The Relevance of Hedonic Price Indices." *Journal of Cultural Economics* 20: 1–24.

Chastel, André. *Les arts de l'Italie.* 1963. Paris: Presses Universitaires de France.

———. 1966. *Le grand atelier d'Italie, 1460–1500.* Paris: Gallimard. Translated as *La grande officina: Arte italiana 1460–1500.* Milan: Feltrinelli.

Christensen, Carl C. 1992. *Princes and Propaganda.* Kirksville, MO: Truman State University Press.

Ciammitti Luisa, Steven F. Ostrow, and Salvatore Settis, eds. 1998. *Dosso's Fate: Painting and Court Culture in Renaissance Italy.* Los Angeles: Getty Research Institute for the History of Art and the Humanities.

Ciancarelli, Roberto. 1987. *Il progetto di una festa barocca: Alle origini del Teatro Farnese di Parma (1618–1629).* Rome: Bulzoni.

Cipolla, Carlo Maria. 1949. "The Trends in Italian Economic History in the Later Middle Ages." *Economic History Review* 2, no. 2: 181–184.

———. 1952. "The Decline of Italy: The Case of a Fully Matured Economy." *Economic History Review* 5, no. 2: 178–187.

———, ed. 1959. *Storia dell'economia italiana.* Turin: Einaudi.

———. 1964. "Economic Depression of the Renaissance?" *Economic History Review,* new ser., 16, no. 3: 519–524.

———. 1981. "Economic Fluctuations, the Poor, and Public Policy (Italy, 16th and 17th Centuries)." In *Aspects of Poverty in Early Modern Europe,* edited by T. Riis, 65–77. Stuggart: Klett-Cotta.

———. 1994. *Storia economica dell'Europa preindustriale.* 2nd ed. Bologna: Il Mulino.

Ciriacono, Salvatore. 1978. "Per una storia dell'industria di lusso in Francia: La concorrenza italiana nei secoli XVI e XVII." *Ricerche di storia religiosa e sociale* 14: 181–202.

Ciseri, Ilaria. 2000. "Diplomazia dell'effimero: Autocelebrazione e omaggio allo straniero nell'iconografia della corte in festa." In *The Diplomacy of Art: Artistic Creation and Politics in Seicento Italy*, edited by E. Cropper, 21–43. Milan: Nuova Alfa Editoriale.

"Cities, Court, and Artists." 1961. *Past and Present* 19: 19–25.

Cleve, Ingeborg. 1995. "Kunst in Paris um 1800: Der Wandel der Kunstöffentlichkeit und die Popularisierung der Kunst seit der Französischen Revolution." *Frühe Neuzeit* 22, no. 2: 101–113.

Clough, Cecil H. 1995. "Pandolfo Petrucci e il concetto di magnificenza." In *Arte, committenza ed economia a Roma e nelle corti del Rinascimento*, edited by A. Esch and C. L. Frommel, 383–397. Turin: Einaudi.

Codell, Julie F. 1995. "Artists' Professional Societies: Production, Consumption, and Aesthetics." In *Towards a Modern Art World: Art in Britain c.1715–c.1880*, edited by R. Allen, 169–187. New Haven: Yale University Press.

Coen, Paolo. 2001. "Arte, cultura e mercato in una bottega Romana del XVIII secolo: L'impresa calcografica di Giuseppe e Mariano Vasi fra continuità e rinnovamento." *Bollettino d'arte—Ministero per i Beni Culturali e Ambientali* 86, 115: 23–74.

———. 2002. "L'attività di mercante d'arte e il profilo culturale di James Byres of Tonley (1737–1817)." *Roma Moderna e Contemporanea* 10, nos. 1–2: 153–178.

———. 2004. "Vendere e affittare quadri: Giuseppe Sardi, capomastro muratore e mercante d'arte (Roma, XVIII sec.)." *Quaderni Storici* 116, no. 2: 421–448.

Cole-Ambrose, Alison. 1995. *Virtue and Magnificence: Art of the Italian Renaissance Courts*. New York: Harry N. Abrams Hall.

Comanducci, Rita Maria. 1998. "La bottega dell'arte a Firenze tra la seconda metà del Quattrocento e la prima metà del Cinquecento." Ph.D. thesis in Economic History, University of Verona.

———. 1999. "'Buono artista della sua arte': Il concetto di 'Artista' e la pratica di lavoro nella bottega quattrocentesca." In *Arti Fiorentine: La grande storia dell'Artigianato*, vol. 2, *Il Quattrocento*, edited by F. Franceschi and G. Fossi, 149–165. Florence: Giunti.

———. 2002. "L'organizzazione produttiva della bottega d'arte fiorentina di Quattro e Cinquecento tra strategie innovative ed arcaismi di natura giuridica." In *Economia ed Arte, Secc. xiii–xviii: Atti della xxxiii Settimana di Studi dell'Istituto Internazionale di Storia Economica "F. Datini" Prato 30 April–4 May 2000*, edited by Simonetta Cavaciocchi, 751–759. Florence: Le Monnier.

———. 2003. "Produzione seriale e mercato dell'arte a Firenze tra Quattro e Cinquecento." In *The Art Market in Italy, 15th–17th Centuries*, edited by Marcello Fantoni, Louisa Chevalier Matthew, and Sara F. Matthews-Grieco. 105–114. Modena: Panini.

Condemi, Simonella. 1997. *La salvaguardia dei beni culturali: Lineamenti di storia della tutela*. Florence: Istituto per l'arte e il restauro Palazzo Spinelli.

Conforti, Claudia. 2001. "Architetti, committenti, cantieri." In *Storia dell'architettura italiana: Il secondo Cinquecento*, edited by C. Conforti and R. J. Tuttle, 9–22. Milan: Electa.

Connell, Susan. 1988. *The Employment of Sculptors and Stonemasons in Venice in the Fifteenth Century*. New York: Garland.

———. 1993. "Gli artigiani dell'edilizia." *Ricerche Venete* 2: 31–92.

Conti, Alessandro. 1979. "L'evoluzione dell'artista." In *Storia dell'arte italiana*, pt. 1, *Materiali e Problemi*, edited by G. Previtali, vol. 2, *L'artista e il pubblico*, 115–264. Turin: Einaudi.

Conti, Giada. 2003–2004. "Che fussero degne di restare nella città: Tutela ed esportazione dei beni culturali in Toscana (XIX–XX secolo)." Thesis, Bocconi University.

Corbier, Mireille. 1997. "Congiarium." In *Der Neue Pauly Enzyklopädie der Antike*, edited by Hubert Cancik und Helmuth Schneider, *Altertum*, III, CL, 125–126. Stuttgart: Verlag J. B. Metzler.

Cortonesi, Alfio. 1983. "Maestranze e cantieri edili nell'Europa tardomedievale." *Studi Storici* 24: 263–274.

————. 2002. "Fornaci e calcare a Rome e nel Lazio." In *Maestranze e cantieri edili a Roma e nel Lazio: Lavoro, tecniche, materiali nei secoli* xii–xv, edited by I. Ait and A. Lanconelli, 109–136. Rome: Manziana.

Couvra, Sophie. 1994. "Galeries et lieux d'exposition: Approche du commerce de l'art à Lyon dans la première moitié due siècle." *Travaux de l'Institut d'Histoire de l'Art de Lyon* 17: 127–135.

Cowan, Brian. 1998. "Arenas of Connoisseurship: Auctioning Art in Later Stuart England." In *Art Markets in Europe, 1400–1800,* edited by M. North and D. Ormrod, 153–165. Aldershot: Ashgate.

Cremonini, Claudia. 1998. "Le raccolte d'arte del cardinale Alessandro d'Este: Vicende collezionistiche tra Modena e Roma" In *Sovrane Passioni: Studi sul collezionismo estense,* edited by J. Bentini, 91–137. Milan: Federico Motta editore.

Cropper, Elizabeth, ed. 2000. *The Diplomacy of Art: Artistic Creation and Politics in Seicento Italy:* Milan: Nuova Alfa Editoriale.

Crouzet-Pavan, Elizabeth, ed. 2003. *Pouvoir et édilité: Les grands chantiers dans l'Italie communale et seigneuriale.* Rome: École Française de Rome.

Curti, Patrizia, and Lidia Righi Guerzoni. 1998. "Gentiluomini e collezionisti nella Modena Ducale" In *Sovrane Passioni: Studi sul collezionismo estense,* edited by J. Bentini, 261–291. Milan: Federico Motta editore.

Curzi, Valter. 2004. *Bene culturale e pubblica utilità: Politiche di tutela a Rome tra Ancien Régime e Restaurazione.* Bologna: Minerva Edizione.

Czujack, Corinna. 1997. "Picasso Paintings at Auction, 1963–1994." *Journal of Cultural Economics* 21: 229–247.

D'Alconzo, Paola. 1999. *L'anello del Re: Tutela del patrimonio storico-artistico nel regno di Napoli (1734–1824).* Florence: Edifir.

D'Alessandro, Alessandro. 1985. "La soppressione delle corporazioni religiose e la requisizione dei beni ecclesiastici in Umbria (1860–1870)." *Annali della Facoltà di Lettere e Filosofia di Perugia* 2: 81–95.

D'Amelio, Maria Grazia, and Nicoletta Marconi. 2000. "Machine, apparati e cantiere nella fabbrica borrominiana di Sant'Agnese in Agone a Roma." In *Francesco Borromini,* edited by C. L. Frommel and E. Sladek, 406–418. Milan: Electa.

Dal Pozzolo, Enrico Maria. 2003. "Cercar quadri e disegni nella Venezia del Cinquecento." In *Tra committenza e collezionismo: Studi sul mercato dell'arte nell'Italia settentrionale durante l'età moderna,* edited by Enrico Maria Dal Pozzolo and Leonida Tedoldi, 49–65. Vicenza: Terraferma.

Dal Pozzolo, Enrico Maria, and Leonida Tedoldi, eds. 2003. *Tra committenza e collezionismo: Studi sul mercato dell'arte nell'Italia settentrionale durante l'età moderna.* Vicenza: Terraferma.

Dalai Emiliani, Marisa, Giacomo Agosti, Maria Elisabetta Manca, and Matteo Panzeri, eds. 1993. *Giovanni Morelli e la cultura dei conoscitori.* Bergamo: P. Lubrina.

Dalai Emiliani, Marisa, Massimo Bartoletti, and Clario Di Fabio, eds. 1989. *Federigo Alizeri (Genova 1817–1882): Un "conoscitore" in Liguria tra ricerca erudita, promozione artistica e istituzioni civiche.* Genoa: Istituto di Storia dell'arte dell'Università di Genova.

Dall'Acqua, Marzio. 1990. "I tornei farnesiani e gonzagheschi tra tenzone e festa." In *La civiltà del torneo (secc. xii–xvii): Giostre e tornei tra medioevo ed età moderna,* 247–272. Narni: Centro Studi Storici di Narni.

Dangel, Jacqueline, and François Hinard, eds. 1998. *Liberalitas: Scripta varia.* Brussels: Latomus.

Danesi Squarzina, Silvia, ed. 1989. *Maestri fiorentini nei cantieri Romani del Quattrocento.* Rome: Officina.

———. ed. 2003. *La collezione Giustiniani. Inventari.* Turin: Einaudi.

De Benedictis, Cristina. 1991. *Per la storia del collezionismo italiano: Fonti e documenti.* Florence: Ponte alle Grazie.

De La Barre, Madeleine, Sophie Docclo, and Victor Ginsburgh. 1994. "Returns of Impressionist, Modern and Contemporary European Painters, 1962–1991." *Annales d'Économie et de Statistique* 35: 143–181.

De Maddalena, Aldo. 1961. *Le finanze del Ducato di Mantova all'epoca di Guglielmo Gonzaga.* Milan: Istituto Editoriale Cisalpino.

De Marchi, Neil, and Craufurd D. W. Goodwin, eds. 1999. *Economic Engagements with Art.* Durham, NC: Duke University Press.

De Marchi, Neil, and Hans J. Van Miegroet. 1994. "Art, Value, and Market Practices in the Netherlands in the Sevententh Century." *Art Bulletin* 76: 451–464.

———. 1996. "Pricing Invention: Originals, Copies and their Relation to Value in 17th Century Netherlandish Art Markets." In *Economics of the Arts,* edited by V. A. Ginsburgh and P. M. Menger, 27–70. Amsterdam: Seyle.

———. 1998. "Novelty and Fashion Circuits in the Mid-Seventeenth-Century Antwerp-Paris Art Trade." *Journal of Medieval and Early Modern Studies* 28, no. 1: 201–246.

———. 1999. "Ingenuity, Preference and the Pricing of Pictures: The Smith-Reynolds Connection." In *Economic Engagements with Art,* edited by Neil De Marchi and Craufurd D. W. Goodwin, 380–409. Durham, NC: Duke University Press.

De Marchi, Neil, Hans J. Van Miegroet, and Matthew E. Raiff. 1998. "Dealer-Dealer Pricing in the Mid-Seventeenth-Century Antwerp to Paris Art Trade." In *Art Markets in Europe, 1400–1800,* edited by M. North and D. Ormrod, 113–130. Aldershot: Ashgate.

De Rosa, Luigi. 1970. "Vent'anni di storiografia economica italiana." In *Ricerche storiche ed economiche in memoria di Corrado Barbagallo,* edited by L. De Rosa, 1:187–250. Naples: Edizioni Scientifiche Italiane.

———. 1983. "La storia economica nell'età di Federico Chabod." In *Federico Chabod e la "Nuova storiografia italiana 1919–1950,"* edited by B. Vigezzi, 369–391. Milan: Jaca Book.

De Vries, J. 1985. "De kunsthandel is zoo edel als eenigen, vermits er 'geen bedrog in is': De pamflettenstrijd tussen Gerard Hoet en Johan van Gool" [The art market is as noble as any other, since it is "without fraud": The pamphlet war between Gerard Hoet and Johan van Gool]. In *Achttiende-eeuwse kunst in de Nederlanden,* edited by C. Scheffer, M. Kersten, E. Bruinsma, M. Engelberts, and S. Kauffmann-Eenhuis, in *Leids Kunsthistorisch Jaarboek* 4: 1–16.

———. 1993. "Between Purchasing Power and the World of Goods: Understanding the Household in Early Modern Europe." In *Consumption and the World of Goods,* edited by J. Brewer and R. Porter, 85–132. London: Routledge.

Decroisette, Françoise. 1975. "Les fêtes du mariage de Cosme avec Marguerite Louise III d'Orléans à Florence, 1661." In *Les fêtes de la Renaissance,* edited by J. Jacquot and E. Konigson, 3: 421–436. Paris: CNRS.

Degrassi, Donata. 1996. *L'economia artigiana nell'Italia Medievale.* Florence: La Nuova Italia Scientifica.

Dekkers, Dieuwertje. 1996. "'Where Are the Dutchmen?' Promoting the Hague School in America, 1875–1900." *Simiolus* 24, 1: 54–73.

Della Torre, S. 1990. "Alcune osservazioni sull'uso di elementi lignei in edifici lombardi dei secoli XVI–XVII." In *Il modo di costruire,* edited by M. Casciato, S. Mornati, and C. P. Scavizzi, 135–145. Rome: Edilstampa.

———. 2000. "Tecnologia edilizia e organizzazione del cantiere nella Milano del secondo Cinquecento." *Annali di Architettura* 10–11: 299–309.

Di Teodoro, Francesco Paolo. 2003. *Raffaello, Baldassar Castiglione e la lettera a Leone x, con l'aggiunta di due saggi raffaelleschi.* Bologna: Minerva.

Di Vittorio, Antonio. 1989. "La storia economica del mondo moderno." In *La storiografia italiana degli ultimi vent'anni,* edited by L. De Rosa, vol. 2, *Età Moderna,* 235–308. Bari: Laterza.

Donati, Claudio. 1988. *L'idea di nobiltá in Italia, secoli* xiv–xviii. Bari: Laterza.

Donato, Maria Pia. 2004. "Il vizio virtuoso: Collezionismo e mercato a Roma nella prima metà del Settecento." *Quaderni Storici* 115, no. 1: 139–160.

Dopico-Cainzos, Maria D. 1993. "Liberalitas y aeternitas principis en Plinio el Joven." *Ktema* 18: 227–243.

Doren, Alfred. 1906. "Das Aktenbuch für Ghibertis Matthäusstatue an Or San Michele zu Florenz." In *Italienische Forschungen herausgegeben vom Kunsthistorischen Instituts in Florenz,* 1–48. Berlin: Bruno Cassirer.

———. 1922. "Deutsche Künstler im mittelalterlichen Italien." In *L'Italia e l'arte straniera: Atti del decimo congresso internazionale di storia dell'arte a Roma,* 158–169. Rome: Maglione e Strini.

———. 1922–23. "Fortuna im Mittelalter und in der Renaissance." *Vorträge der Bibliothek Warburg* 2, no. 1: 71–144.

———. 1934. *Italienische Wirtschaftsgeschichte.* Jena: Fischer.

———. 1936. *Wirtschaftsgeschichte Italiens im Mittelalter.* Translated as *Storia economica dell'Italia nel Medio Evo.* Padua: Cedam.

Doria, Giorgio. 1986. "Investimenti della nobiltà genovese nell'edilizia di prestigio (1530–1630)." *Studi Storici* 1: 5–55.

Douglas, Mary, and Baron Isherwood. [1979] 1984. *The World of Goods: Towards an Anthropology of Consumption.* London: Allen Lane. Translated as *Il mondo delle cose: Oggetti, valori, consumo.* Bologna: Il Mulino.

Dowd, Carol Togneri, ed. 1985. *The Travel Diaries of Otto Mündler, 1855–1858.* Leeds: Walpole Society.

Drechsler, Maximiliane. 1996. *Zwischen Kunst und Kommerz: Zur Geschichte des Austellugswesens zwischen 1775 und 1905.* Munich: Deutscher Kunstverlag.

Drey, Paul. 1910. *Die wirtschaftlichen Grundlagen der Malkunst: Versuch einer Kunstökonomie.* Stuttgart: J. G. Gottasche'sche Buchhandlung Nachfolger.

Duverger, Erik. 1967. "Réflexions sur le commerce d'art au xviiie siècle." In *Akten des 21 Internationalen Kongresses fur Kunstgeschichte, Bonn 1964,* 3:65–88. Berlin: Verlag Gebr. Mann.

Dyer, Christopher. 1989. *Standards of Living in the Later Middle Ages.* Cambridge: Cambridge University Press.

Edelstein, Bruce. 2000. "Nobildonne napoletane e committenza: Eleonora d'Aragona ed Eleonora di Toledo a confronto." *Quaderni Storici* 104, no. 2: 295–329.

Edwards, Jolynn. 1996. *Alexandre-Joseph Paillet: Expert et marchand de tableaux à la fin due* xviiie *siècle.* Paris: Arthena.

Ekkart, Rudi. 1991. "Das reduzierte œuvre: Das Rembrandt Research Project und der Kunstmarkt." *Kunst & Antiquitäten* 9: 17–21.

Elam, Caroline. 1993. "Art in the Service of Liberty: Battista della Palla, Art Agent for Francis I." *I Tatti Studies* 5: 33–109.

Elsner, John, and Roger Cardinal, eds. 1994. *The Cultures of Collecting.* London: Reaktion Book.

Emiliani, Andrea. 1973. "Musei e museologia." In *Storia d'Italia,* vol. 5, *I documenti,* part 2, 1615–1655. Turin: Einaudi.

————. 1978. *Leggi, bandi e provvedimenti per la tutela dei beni artistici e culturali negli antichi stati italiani 1571–1860.* Bologna: Alfa.

————. 1980. "Raccolte e musei italiani dall'umanesimo all'Unità nazionale." In Aa.Vv., *I Musei.* Milan: TCI.

Emison, Patricia A. 2004. *Creating the "Divine Artist": From Dante to Michelangelo.* Leiden: Brill.

Eralda, Noè. 1987. "La fortuna privata del principe e il bilancio dello stato Romano: Alcune riflessioni." *Athenaeum* 65: 27–65.

Esch, Arnold. 1995. "Sul rapporto fra arte ed economia nel Rinascimento italiano." In *Arte, committenze ed economia a Roma e nelle corti del Rinascimento,* edited by A. Esch and C. L. Frommel, 3–49. Turin: Einaudi.

————. 2002. "Prolusione: Economia ed arte: La dinamica del rapporto nella prospettiva dello storico." In *Economia ed Arte, Secc.* xiii–xviii: *Atti della* xxxiii *Settimana di Studi dell'Istituto Internazionale di Storia Economica "F. Datini" Prato 30 April–4 May 2000,* edited by Simonetta Cavaciocchi, 21–49. Florence: Le Monnier.

Esch, Arnold, and Cristoph Luitpold Frommel, eds. 1995. *Arte, committenza ed economia a Roma e nelle corti del Rinascimento.* Turin: Einaudi.

Fagiolo, Marcello. 1980. "Effimero e giardino: Il teatro della città e il teatro della natura." In Marcello Fagiolo et al., *Il potere e lo spazio: La scena del principe,* 31–54. Milan: Electa.

Fagiolo, Marcello, et al., eds. 1997. *La Festa a Roma dal Rinascimento al 1870.* Exhibition catalog. 2 vols. Turin: Allemandi.

Fagiolo dell'Arco, Maurizio. 1997. *La festa barocca.* Rome: Edizioni De Luca.

Fagiolo dell'Arco, Maurizio, and Silvia Carandini. 1977–78. *L'Effimero Barocco: Strutture della festa nella Roma del Seicento.* 2 vols. Rome: Bulzoni.

Fagiolo dell'Arco, Maurizio, and Maria Luisa Madonna. 1980. *L'effimero di Stato: Strutture e archetipi di una città d'illusione.* Rome: Officina.

Fagliari Zeni Buchicchio, Fabiano T. 1988. "La rocca del Bramante a Civitavecchia: Il cantiere e le maestranze da Giulio II a Paolo III." *Römisches Jahrbuch für Kunstgeschichte* 23–24: 275–383.

Fain, John Tyree. 1951. "Ruskin and Mill." *Modern Language Quarterly* 12: 150–154.

————. 1952. "Ruskin and Hobson." *PMLA* 67: 297–307.

————. 1956. *Ruskin and the Economists.* Nashville: Vanderbilt University Press.

Falcone, Nicola A. 1913. *Il codice delle belle Arti e Antichità.* Florence: Baldoni.

Falkenburg, Reindert, Jan de Jong, Dulcia Meijers, Bart Ramakers, and Mariët Westermann, eds. 2000. *Kunst voor de Markt, 1500–1700.* Zwolle: Waanders Uitgevers.

Falomir Faus, Miguel. 1933. "The Value of Painting in Renaissance Spain." In *Economia ed Arte, Secc.* xiii–xviii: *Atti della* xxxiii *Settimana di Studi dell'Istituto Internazionale di Storia Economica "F. Datini" Prato 30 April–4 May 2000,* edited by Simonetta Cavaciocchi, 231–260. Florence: Le Monnier.

Fanfani, Amintore. 1933. *Le origini dello spirito capitalistico in Italia.* Milan: Vita e Pensiero.

————. 1943. *Storia del lavoro in Italia. Dalla fine del secolo* xv *agli inizi del* xviii. (Second edition 1959.) Milan: Giuffrè.

Fanti, Mario. 1989. "La fabbrica della Basilica di San Petronio in Bologna tra il xiv e xv secolo." In *Investimenti e civiltà urbana, Secoli* xiii–xviii: *Atti della Settimana di Studi dell'Istituto Internazionale di Storia Economica "F. Datini" Prato 22 April–28 April 1987,* edited by A. Guarducci, 699–742. Florence: Le Monnier.

Fantoni, Marcello. 1985. "Feticci di prestigio, il dono alla corte medicea." In *Rituale, Cerimoniale, Etichetta,* edited by S. Bertelli and G. Crifò, 141–161. Milan: Bompiani.

———. 1994. *La corte del Granduca: Forma e simboli del potere mediceo tra Cinque e Seicento.* Rome: Bulzoni.

Fantoni, Marcello, Louisa Chevalier Matthew, and Sara F. Matthews-Grieco, eds. 2003. *The Art Market in Italy, 15th–17th Centuries.* Modena: Panini.

Fantozzi-Micali, Osanna, and Piero Roselli. 1980. *Le soppressioni dei conventi a Firenze: Riuso e trasformazioni dal sec.* xviii *in poi.* Florence: Libreria Editrice Fiorentina.

Farago, Claire J. 1991. "The Classification of Visual Arts in the Renaissance." In *The Shapes of Knowledge from Renaissance to the Enlightenment,* edited by D. R. Kelley and R. H. Popkin, 23–48. Dordrecht: Kluwer.

———. 1992. *Leonardo da Vinci's Paragone: A Critical Interpretation with a New Edition of the Text in the Codex Urbinas.* Leiden: Brill.

Fardella, Paola. 2002. *Antonio Canova a Napoli tra collezionismo e mercato.* Naples: Paparo.

Favaretto, Irene. 1990. "Sculture greche da collezioni veneziane disperse e il mercato d'arte antica a Venezia al tramonto della Serenissima." In *Venezia e l'archeologia: Un importante capitolo nella storia del gusto dell'antico nella cultura artistica veneziana,* 113–118. Rome: G. Bretschneider.

———. 1992. "De Venise en France: Le commerce d'antiquités entre le xvii et le xixe siècle." In *Anticomanie: La collection d'antiquités aux 18e et 19e siècles,* edited by A. F. Laurens and K. Pomian, 73–82. Paris: Éditions de l'École des Hautes Études en Sciences Sociales.

———. 2000. "Antonio Canova e le collezioni archeologiche veneziane nella seconda metà del Settecento." In *Antonio Canova e il suo ambiente artistico fra Venezia, Roma e Parigi,* edited by G. Pavanello, 71–93. Venice: Istituto Veneto di Scienze, Lettere ed Arti.

Favaro, Elena. 1975. *L'arte dei pittori in Venezia e i suoi statuti.* Florence: Olschki.

Feinstein, Charles H. 1998. "Pessimism Perpetuated: Real Wages and the Standard of Living in Britain during and after the Industrial Revolution." *Journal of Economic History* 58: 625–658.

Feld, Alan L., Michael O'Hare, and J. Mark Davidson Schuster. 1983. *Patrons Despite Themselves: Taxpayers and Arts Policy.* New York: New York University Press.

Ferrazza, Roberta. 1985. "Palazzo Davanzati: Elia Volpi e Leopoldo Bengujat." *Antichità viva* 24, nos. 5–6: 62–68.

———. 1993. *Palazzo Davanzati e le collezioni di Elia Volpi.* Florence: Centro Di.

Ferretti, Massimo. 1981. "Falsi e tradizione artistica." In *Storia dell'arte,* vol. 10, *Conservazione, falso, restauro,* edited by F. Zeri, 118–198. Turin: Einaudi.

Fidell-Beaufort, Madeleine. 2000. "The American Art Trade and French Painting at the End of the19th Century." *Van Gogh Museum Journal:* 100–107.

Fidell-Beaufort, Madeleine, Herbert L. Kleinfield, Jeanne K. Welcher, and Hyatt A. Mayor, eds. 1979. *The Diaries, 1871-1882, of Samuel P. Avery, Art Dealer.* New York: Arno Press.

Fink, Lois Marie. 1978. "French Art in the United States, 1850–1870: Three Dealers and Collectors." *Gazette des Beaux-Arts* 92: 87–100.

Finley, Moses I. 1973. *The Ancient Economy.* Berkeley: University of California Press.

Fischer, Siegfried. 1983. "Avaritia, Luxuria und Ambitio in der Satire II 3 des Horaz." *Philologus: Zeitschrift für das klassische Altertum* 127: 72–79.

Flaten, Arne Robert. 2003. "Portrait Medals and Assembly-Line Art in Late Quattrocento Florence." In *The Art Market in Italy, 15th–17th Centuries,* edited by Marcello Fantoni, Louisa Chevalier Matthew, and Sara F. Matthews-Grieco, 127–140. Modena: Panini.

Fleming, John. 1979. "Art Dealing in the Risorgimento, (I and II)." *Burlington Magazine* 121, no. 917: 492–508 and 121, no. 918: 568–578.

Fletcher, Jennifer M. 1994. "Fine Art and Festivity in Renaissance Venice: The Artist's Part." In *Sight &*

Insight: Essays on Art and Culture in Honour of E. H. Gombrich at 85, edited by J. Onians, 128–151. London: Phaidon.

Flores, Renato G., Victor Ginsburgh, and Philippe Jeanfils. 1999. "Long and Short Term Portfolio Choices of Paintings." *Journal of Cultural Economics* 23: 193–201.

Flörke, Hanns. 1901. *Der niederländische Kunst-handel im 17. und 18. Jahrhundert.* Basel: Basler Anzeiger.

———. 1905. *Studien zur niederländischen Kunst—und Kulturgeschichte: Die Formen des Kunsthandels, das Atelier und die Sammler in den Niederlanden vom 15.–18. Jahrhundert.* Munich: G. Müller.

Folin, Marco. 2003. "L'architettura e la città nel Quattrocento." In *Un rinascimento singolare: La corte degli Este a Ferrara,* exhibition catalog, edited by J. Bentini and G. Afosrini, 75–85. Milan: Silvana Editoriale.

Forbes, Linda. 2000. "The Legacy of John Ruskin and an Introduction to *Unto This Last*." *Organization and Environment* 13, no. 1: 86–88.

Forbis, Elizabeth P. 1993. "Liberalitas and Largitio: Terms for Private Munificence in Italian Honorary Inscriptions." *Athenaeum* 81: 483–498.

Fox, Robert, and Anthony Turner, eds. 1998. *Luxury Trades and Consumerism in Ancien Régime Paris.* Aldershot: Ashgate.

Franceschi, Franco. 2002. "La storiografia economica sul Rinascimento e le sue metamorfosi: Qualche riflessione." In *The Italian Renaissance in the Twentieth Century,* edited by A. J. Grieco, M. Rocke, and F. Gioffredi Superbi, 153–172. Florence: Olschki.

———. 2003. "La normativa suntuaria nella storia economica." In *Disciplinare il lusso: La legislazione suntuaria in Italia e in Europa tra Medioevo ed età moderna,* edited by M. G. Muzzarelli and A. Campanili, 163–178. Rome: Carocci.

Franceschini, Chiara. 2000. "La corte di Renata di Francia (1528–1560)." In *Storia di Ferrara,* vol. 6, *Il Rinascimento: Situazioni e Personaggi,* edited by A. Prosperi, 185–214. Ferrara: Corbo.

———. 2001. "Tra Ferrara e la Francia: Notizie su orefici e pittori al servizio di Renée de France." *Franco-Italica* 19–20: 65–104.

Franchetti Pardo, Vittorio. 1989. "Segnali architettonici e riconoscibilità politica di un territorio." In *D'une ville à l'autre: Structures matérielles et organisation de l'espace dans les villes européennes (xiiie–xvie siècles),* edited by J.-C. Maire Vigueur, 727–739. Rome: École Française de Rome.

Francia, Ennio. 1989. *1506–1606: Storia della costruzione del Nuovo San Pietro: Da Michelangelo a Bernini.* Rome: De Luca.

Franzini, Maurizio. 1994. "The Political Economy of Art di John Ruskin: Una rilettura alla luce della moderna teoria economica." In *The Dominion of Daedalus,* edited by J. Clegg and P. Tucker, 61–73. St. Albans: Brentham Press.

Franzoni, Claudio. 1984. "'Rimembranze d'infinite cose': Le collezioni rinascimentali di antichità." In *La memoria dell'antico nell'arte italiana,* vol. I, *L'uso dei classici,* edited by S. Settis, 299–360. Turin: Einaudi.

Fraser-Jenkins, Anthony D. 1970. "Cosimo de' Medici's Patronage of Architecture and the Theory of Magnificence." *Journal of the Warburg and Courtauld Institutes* 33: 162–170.

Fredericksen, Burton B. 1989–93. *The Index of Paintings Sold in the British Isles during the Nineteenth Century,* vol. 1 (1801–1805), vol. 2 (1806–1810), vol. 3 (1811–1815). Santa Barbara: ABC CLIO.

Frey, Bruno S., and Werner W. Pommerehne. 1989a. *Muses and Markets: Explorations in the Economics of the Arts.* Oxford: Basic Blackwell.

———. 1989b. "Art Investment: An Empirical Inquiry." *Southern Economic Journal* 56 (October): 396–409.

Frigo, Daniela. 1985. *Il padre di famiglia: Governo della casa e governo civile nella tradizione dell'Economica tra Cinque e Seicento.* Rome: Bulzoni.

Frommel, Christoph Luitpold. 1991. "Il cantiere di S. Pietro prima di Michelangelo." In *Les Chantiers de la Renaissance,* edited by J. Guillaume, 175–190. Paris: Éditions Picard.

Furcy-Raynaud, Marc. 1912. "Les Tableaux et Objects d'Art Saisis chez les Emigrés et Condamnés." *Archives de l'Art Français* 6: 245–343.

Furlotti, Barbara. 2002. "Ambasciatori, nobili, religiosi, mercanti d'arte e artisti: Alcune considerazioni sugli intermediari d'arte gonzagheschi." In *Gonzaga: La Celeste Galleria, L'esercizio del collezionismo,* edited by R. Morselli, 319–328. Milan: Electa.

Garbero, Elvira, and Suzanna Cantore. 1980. "Le entrate trionfali." In *Il Teatro a Reggio Emilia: Dal Rinascimento alla Rivoluzione francese,* edited by S. Romagnoli and E. Garbero, 3–28. Florence: Sansoni.

Garuti, Alfonso. 1993. "La dispersione del patrimonio artistico a Carpi durante le soppressioni napoleoniche." *Ravennatensia* 14: 37–53.

Gasparri, Carlo. 1983. "I marmi antichi degli Uffizi: Collezionismo mediceo e mercato antiquario Romano tra il XVI e il XVIII secolo." In *Uffizi: Quattro secoli di una galleria,* edited by P. Barocchi and G. Ragionieri, 217–231. Florence: Olschki.

Gasparri, Carlo, and Olivia Ghiandoni. 1993. "Lo studio Cavaceppi e le collezioni Torlonia." *Rivista dell'Istituto Nazionale d'Archeologia e Storia dell'Arte* 16.

Gauthier, Rene Antonin. 1951. *Magnanimité. L'idéal de la grandeur dans la philosophie païenne et dans la théologie chrétienne.* Paris: Vrin.

Gennari Sartori, Flaminia. 2001. "'Questo è il paese dei miliardi!': La vendita dei Van Dyck Cattaneo, 1907–1909." *Ricerche di Storia dell'Arte* 73: 37–47.

———. 2003. *The Melancholy of Masterpieces: Old Masters paintings in America 1900–1914.* Milan: 5 Continents.

Gérin-Jean, Paul. 2000. *Prix des œuvres d'art et hiérarchie des valeurs artistiques au temps des Medici.* Villeneuve d'Ascq: Presses Universitaires du Septentrion.

———. 2003. "Prices of Works of Art and Hierarchy of Artistic Value in the Italian Market (1400–1700)." In *The Art Market in Italy, 15th–17th Centuries,* edited by Marcello Fantoni, Louisa Chevalier Matthew, and Sara F. Matthews-Grieco, 181–193. Modena: Panini.

Ghelfi, Barbara. 1997. *Il libro dei conti del Guercino, 1629–1666.* Bologna: Nuova Alfa.

Ghizzoni, Manuela. 1997. *La pietra forte. Carpi: Città e cantieri alle fortificazioni (xii–xviii secolo).* Bologna: Grafis Edizioni.

Gianighian, Giorgio. 1990. "Appunti per una storia del cantiere a Venezia (secoli XVI–XVIII)." In *"Le arti edili a Venezia,"* edited by G. Caniato and M. Dal Borgo, 237–256. Rome: Edilstampa.

Giannini, Cristina. 1996. "Sotto lo scialbo: Firenze e la tutela del patrimonio alle soglie dell'Unità." *Bollettino della Accademia degli Euteleti della città di San Miniato* 63: 215–269.

Ginsburgh, Victor, and Anne-Françoise F. Penders. 1997. "Land, Art and Markets: An Analysis of Works Sold at Auction 1972–1992." *Journal of Cultural Economics* 21: 219–228.

Ginzburg, Carlo. 1966. "Da A. Warburg a E. H. Gombrich." *Studi Medievali* 7, no. 2: 1015–1065.

Gioli, Antonella. 1997. "Monumenti e oggetti d'arte nel Regno d'Italia: Il patrimonio artistico degli enti religiosi soppressi tra riuso, tutela e dispersione. Inventario dei 'Beni delle corporazioni religiose' 1860–1890." *Quaderni della Rassegna degli Archivi di Stato* 80.

———. 2003. *Storia, dibattiti e attualità della tutela del patrimonio artistico: Fonti materiali.* Milan: Cuem.

Giordano, Luisa. 1991. "I maestri muratori lombardi: Lavoro e remunerazione." In *Les Chantiers de la Renaissance,* edited by J. Guillaume, 165–173. Paris: Éditions Picard.

———. 2002. "Edificare per magnificienza: Testimonianze letterarie sulla teoria e la pratica della committenza di corte." In *Il principe architetto,* edited by A. Calzona, F. P. Fiore, A. Tenenti, and C. Vasoli, 215–227. Florence: Olschki.

Giovannini, Prisca. 1995. "I cavatori di 'pietre per far calcina' e le conoscenze sulla pietra da calce a Firenze (secoli xvi–xviii)." In *Le pietre delle città d'Italia,* edited by D. Lamberini, 213–225. Florence: Le Monnier.

Giusberti, Fabio, and Silvia Cariati. 2002. "'«Non dovranno trovar posto in chiesa immagini di bestie da soma, di cani, di pesci e di altri animali bruti'. Pittura e mercato a Milano nell'età dei Borromeo." In *Economia ed Arte, Secc.* xiii–xviii: *Atti della* xxxiii *Settimana di Studi dell'Istituto Internazionale di Storia Economica "F. Datini" Prato 30 April–4 May 2000,* edited by Simonetta Cavaciocchi, 393–402. Florence: Le Monnier.

Giustini, Laura. 1997. *Fornaci e laterizi a Roma dal* xv *al* xix *secolo.* Rome: Edizioni Kappa.

Glasser, Hannelore. 1977. "Artists' Contracts of the Early Renaissance" Ph.D. diss., Columbia University.

Glazier, Ira A. 1966. "Il commercio estero del Regno Lombardo Veneto dal 1815 al 1865." *Archivio Economico dell'Unificazione Italiana,* I, 15, 1.

Goetzmann, William N. 1993. "Accounting for Taste: Art and the Financial Markets over Three Centuries." *American Economic Review* 5: 1370–1376.

Goetzmann, William N., and Matthew Spiegel. 2003. "Art Market Repeat-Sales Indices Based upon Gabrius S.p.A. Data." Unpublished essay.

Goldthwaite, Richard A. 1973. "The Building of the Strozzi Palace: The Construction in Renaissance Florence." *Studies in Medieval and Renaissance History* 10: 99–194.

———. [1980] 1984. *The Building of Renaissance Florence: An Economic and Social History.* Baltimore: Johns Hopkins University Press. Translated as *La costruzione della Firenze rinascimentale. Una storia economica e sociale.* Bologna: Il Mulino.

———. 1987a. "The Economy of Renaissance Italy: The Precondition for Luxury Consumption." *I Tatti Studies* 2: 15–39.

———. 1987b. "The Empire of Things: Consumer Demand in Renaissance Italy." In *Patronage, Art, and Society in Renaissance Italy,* edited by F. W. Kent and P. Simons, 153–175. Oxford: Clarendon Press.

———. 1990. "Il contesto economico del palazzo fiorentino nel Rinascimento: Investimento, cantiere, consumi." *Annali di Architettura: Rivista del centro internazionale di studi di architettura Andrea Palladio* 2: 53–58.

———. [1993] 1995. *Wealth and the Demand for Arts in Italy 1300–1600.* Baltimore: Johns Hopkins University Press. Translated as *Ricchezza e domanda nel mercato dell'arte in Italia dal Trecento al Seicento: La cultura materiale e le origini del consumismo.* Milan: Unicopli.

———. 2004. "L'economia del collezionismo." In *L'Età di Rubens: Dimore, committenti e collezionisti genovesi,* edited by P. Boccardo, 13–21. Milan: Skira.

Gombrich, Ernst H. 1960. "The Early Medici as Patrons of Art: A Survey of Primary Sources." In *Italian Renaissance Studies: A Tribute to the Late Cecilia M. Ady,* edited by E. F. Jacob, 279–311. London: Faber & Faber.

———. 1975. *Art History and the Social Sciences.* Oxford: Clarendon Press.

Gomez, Francesco, and Sandro Lombardini. 1991. "Reti di relazioni: Metodi di analisi su una base di dati storici." *Quaderni Storici* 78, no. 3: 793–810.

González Palacios, Alvar. 1993. *Il gusto dei principi: Arte di corte del* xvii *e del* xviii *secolo.* Milan: Longanesi.

———. 2000. *Il tempio del gusto: Le arti decorative in Italia fra classicismi e barocco.* Vicenza: Neri Pozza.

Goux, Jean-Joseph. 1973. *Économie et symbolique: Freud, Marx.* Paris: Seuil.

Gozzano, Natalia. 2004. *La quadreria di Lorenzo Onofrio Colonna: Prestigio nobiliare e collezionismo nella Roma Barocca.* Rome: Bulzoni.

Goy, Richard J. 1993. "La fabbrica della Ca' D'oro." *Ricerche Venete* 2: 93–157.

Grampp, William D. 1989. *Pricing the Priceless: Art, Artists, and Economics.* New York: Basic Books.

Grasskamp, Walter. 1993. "Die Einbürgerung der Kunst: Korporative Kunstförderung im 19. Jahrhunder." *Kritische Berichte* 21, 3: 37–40.

Graves, Algernon. 1918–21. *Art Sales.* 3 vols. London: Charles Whittingham and Griggs.

Graziani, Augusto. 1960. "Il commercio estero del Regno delle Due Sicilie dal 1832 al 1858." *Archivio Economico dell'Unificazione Italiana,* I, 10, 1.

Greaves, Margaret. 1964. *The Blazon of Honour: A Study in Renaissance Magnanimity.* New York: Methuen.

Greci, Roberto. 1988. *Corporazioni e mondo del lavoro nell'Italia padana medievale.* Bologna: Clueb.

Green, Louis. 1990. "Galvano Fiamma, Azzone Visconti and the Revival of the Classical Theory of Magnificence." *Journal of the Warburg and Courtauld Institutes* 53: 98–113.

Green, Nicholas. 1987. "Dealing in Temperaments: Economic Transformation of the Artistic Field in France during the Second Half of the Nineteenth Century." *Art History* 10, no. 1: 59–78.

———. 1989. "Circuits of Production, Circuits of Consumption: The Case of Mid-Nineteenth-Century French Art Dealing." In "Nineteenth-Century French Art Institutions," edited by P. Mainardi, in *Art Journal* 48, no. 1: 29–34.

Gregory, Chris A. 1982. *Gifts and Commodities.* Cambridge: Cambridge University Press.

Grisolia, Mario. 1952. *La tutela delle cose d'arte.* Rome: Società Editrice del "Foro Italiano."

Grivel, Marianne. 1986. *Le commerce de l'estampe à Paris au* xviie *siècle.* Geneva: Droz.

Grohmann, Alberto. 2005. "L'edilizia e la città: Storiografia e fonti." In *L'edilizia prima della Rivoluzione Industriale, Secc.* xiii–xviii: *Atti della* xxxvi *Settimana di Studi dell'Istituto Internazionale di Storia Economica "F. Datini." Prato 26 April–30 April 2004,* edited by Simonetta Cavaciocchi. Florence: Le Monnier.

Grohs, Barbara, ed. 1974. "Feste e apparati." In *Gli ultimi Medici: Il tardo barocco a Firenze 1670–1743,* exhibition catalog, 478–491. Florence: Centro Di.

Guarducci, Annalisa, ed. 1989. "Investimenti e civiltà urbana Secoli xiii–xviii." *Atti della settimana di Studi dell'Istituto Internazionale di Storia Economica "F. Datini" Prato, 22 April–28 April 1977.* Florence: Le Monnier.

Guarino, Sergio, and Giorgia Mancini. 1998. "Il collezionismo minore di casa d'Este: Il caso del cardinale Rinaldo (1618–1672)." In *Sovrane Passioni: Studi sul collezionismo estense,* edited by J. Bentini, 165–186. Milan: Federico Motta editore.

Guenzi, Alberto, Paola Massa, and Angelo Moioli, eds. 1999. *Corporazioni e gruppi professionali nell'Italia Moderna.* Milan: Franco Angeli.

Guenzi, Alberto, Paola Massa, and Fausto Piola Caselli, eds. 1998. *Guilds, Markets and Work Regulations in Italy, 16th–19th Centuries.* Aldershot: Ashgate.

Guerzoni, Guido. 1995. "Reflections on Historical Series of Art Prices: Reitlinger's Data Re-visited." *Journal of Cultural Economics* 19: 251–260.

———. 1996. "The British Market of Paintings, 1789–1914." In *Economic History and the Arts,* edited by M. North, 97–132. Cologne: Böhlau.

———. 1997. "Cultural Heritage and Preservation Policies: A Few Notes on the History of the Italian Case." In *Economic Perspectives of Cultural Heritage,* edited by M. Hutter and I. Rizzo, 107–132. London: Macmillan–St. Martin's Press.

———. 1998a. "The Courts of Este in the First Half of xvith Century: Socioeconomic Aspects." In *The Court as an Economic Institution,* edited by M. Aymard and M. A. Romani, 89–113. Paris: Éditions de la Maison des Sciences des hommes.

———. 1998b. "Le organizzazioni artistiche e culturali." In *Manuale di Organizzazione,* edited by G. Costa and R. C. D. Nacamulli, 241–270. Turin: UTET.

———. 1998c. "The Demand for Art of Italian Renaissance Courts: The Case of Este (1471–1560)." In *Art Markets in Europe, 1400–1800,* edited by M. North and D. Ormrod, 61–80. Aldershot: Ashgate.

———. 1999a. "Angustia ducis, divitiae principum: Patrimoni e imprese estensi tra Quattro e Cinquecento." In *Tra rendita e investimenti. Formazione e gestione dei grandi patrimoni in età moderna e contemporanea,* edited by I. Lo Pane, 57–87. Bari: Cacucci.

———. 1999b. *Le corti estensi e la Devoluzione di Ferrara del 1598.* Modena: Archivio Storico Comunale.

———. 1999c. "Liberalitas, Magnificentia, Splendor" The Classic Origins of Italian Renaissance Life Style." In *Economic Engagements with Art,* edited by Neil De Marchi and Craufurd D. W. Goodwin, 332–379. Durham, NC: Duke University Press.

———. 2002. "Ricadute occupazionali ed impatti economici della committenza artistica delle corti estensi tra Quattro e Cinquecento." In *Economia ed Arte, Secc.* xiii–xviii*: Atti della* xxxiii *Settimana di Studi dell'Istituto Internazionale di Storia Economica "F. Datini" Prato 30 April–4 May 2000,* edited by Simonetta Cavaciocchi, 187–230. Florence: Le Monnier.

———. 2003a. "I diritti di proprietà reale e intellettuale dei musei." *Economia della Cultura* 1: 85–98.

———. 2003b. "Il dilemma dei beni culturali: Fair use versus strategie di valorizzazione economica." In *Not Economy: Economia digitale e paradossi della proprietà intellettuale,* edited by C. Formenti, 179–201. Milan: ETAS.

Guerzoni, Guido, and Marina Romani. 1998. "Breve storia dell'intervento pubblico in campo teatrale nell'Italia dell'800: Ovvero della natura ereditaria e congenita del morbo di Baumol." In *Istituzioni e mercati dell'arte,* edited by Walter Santagata, 197–228. Turin: UTET.

Guerzoni, Guido, and Walter Santagata. 2000. "Ad vocem 'Economia della Cultura.'" In *Enciclopedia Italiana di Scienze, Lettere ed Arti, Appendice 2000,* 1:184–186. Rome: Istituto della Enciclopedia Italiana Treccani.

———. 2001. "La Galleria Sabauda di Torino e la gestione di un distretto culturale." In *Economia del patrimonio monumentale,* edited by G. Mossetto and M. Vecco, 85–90. Milan: Franco Angeli.

Guerzoni, Guido, and Silvia Stabile. 2003. *I diritti dei musei: La valorizzazione dei beni culturali nella prospettiva del rights management.* Milan: ETAS.

Guerzoni, Guido, and Gabriele Troilo. 1998. "Silk Purses from Sows' Ears: Anachronistic Consumption, 'Mass Rarefaction' and the Emerging Character of the Consumer-Collector." In *The Active Consumer: Novelty and Surprise in Consumer Choice,* edited by M. Bianchi, 174–197. London: Routledge.

———. 2001. "Pour et contre le marketing." In *L'Avenir des Museés,* 135–154. Paris: Éditions de la Réunion des Musées Nationaux.

Guidotti, Alessandro. 1986. "Pubblico e privato, committenza e clientela: Botteghe e produzione artistica a Firenze tra xv e xvi secolo." *Ricerche storiche* 3: 535–550.

Guillaume, Jean, ed. 1991. *Les Chantiers de la Renaissance.* Paris: Éditions Picard.

Guillemain, Bernard. 1966. *La Cour pontificale d'Avignon, 1309–1376: Étude d'une société.* Paris: Éditions E. de Boccard.

Gundersheimer, Werner, ed. 1972. *Art and Life at the Court of Ercole I d'Este: The "De Triumphis religionis" of Giovanni Sabadino degli Arienti.* Geneva: Droz.

———. [1973] 1988. *Ferrara: The Style of a Renaissance Dispotism.* Princeton: Princeton University Press. Translated as *Ferrara estense: Lo stile del potere.* Modena: Panini.

———. 1980. "Women, Learning and Power: Eleonora of Aragon and the Court of Ferrara." In *Beyond their Sex: Learned Women of the European Past,* edited by P. H. Labalme, 43–67. New York: New York University Press.

Haines, Margaret. 2002. "La grande impresa civica di Santa Maria del Fiore." *Nuova Rivista Storica* 86: 19–48.

Haines, Margaret, and Lucio Riccetti, eds. 1996. *Opera: Carattere e ruolo delle fabbriche fino all'inizio dell'età moderna.* Florence: Olschki.

Hamilton, Earl J. 1944. "Use and Misuse of Price History." *Journal of Economic History* 4, issue supplement: *The Task of Economic History*, 47–60.

Haskell, Francis. 1959a. "The Market for Italian Art in the 17th Century." *Past and Present* 1, no. 15: 48–59.

———. 1959b. "Mecenatismo e patronato." In *Enciclopedia Universale dell'arte,* 8:939–956. Florence: Sansoni.

———. [1963] 1985. *Patrons and Painters: A Study in the Relations between Italian Art and Society in the Age of the Baroque.* London: Chatto & Windus. Translated as *Mecenati e pittori: Studio sui rapporti tra arte e società italiana nell'età barocca.* 2nd ed. Florence: Sansoni.

———. [1976] 1982. *Rediscoveries in Art.* London: Phaidon. Translated as *Riscoperte nell'arte.* Milan: Edizioni di Comunità.

———. 1978. *Arte e linguaggio della Politica.* Florence: SPE.

———. 1981a. "La dispersione e la conservazione del patrimonio artistico." In *Storia dell'arte italiana,* vol. 10, *Conservazione, falso, restauro,* edited by F. Zeri, 5–38. Turin: Einaudi.

———, 1981b. *Saloni, gallerie, musei e loro influenza sullo sviluppo dell'arte nei secoli* xix *e* xx. Bologna: Clueb.

———. 1989. *Le Metamorfosi del Gusto: Studi su arte e pubblico nel* xviii *e* xix *secolo.* Turin: Bollati Boringhieri.

Haskell, Francis, and Nicholas Penny. [1981] 1984. *Taste and the Antique: The Lure of Classical Sculpture 1500–1900.* New Haven: Yale University Press. Translated as *L'antico nella storia del gusto.* Turin: Einaudi.

Hatfield, Rab. 2002. *The Wealth of Michelangelo.* Rome: Edizioni di Storia e Letteratura.

Hauser, Arnold. [1953] 1955–56. *Sozialgeschichte der Kunst und Literatur.* Munich: Beck. Translated as *Storia sociale dell'arte.* Turin: Einaudi.

Havlena, William Joseph, and Susan Leah Holak. 1995. "'The Good Old Days': Observations on Nostalgia and its Role in Consumer Behaviour." *Advances in Consumer Research* 18: 323–329.

———. 1986. "The Varieties of Consumption Experience: Comparing Two Typologies of Emotion in Consumer Behavior." *Journal of Consumer Research* 13: 394–404.

Hellegouarc'h, Joseph. 1963. *Le vocabulaire Latin des relations et des parties politiques sous la République.* Paris: Les Belles Lettres.

Henderson, Willie. 1979. *John Ruskin's Political Economy.* London: Routledge.

Hendon, William S., ed. 1979. *The Economics of Art in Europe.* Akron: Association for Cultural Economics.

Hendon, William S., James L. Shanahan, Izak Th. H. Hilhorst, and Jaap van Staalen, eds. 1983. *Economic Research in the Performing Arts.* Akron, Ohio: Association for Cultural Economics.

Hendon, William S., James L. Shanahan, and Alice J. MacDonald, eds. 1986. *Economic Policy for the Arts.* Cambridge: Abt Books.

Hendon, William S., Douglas V. Shaw, and Nanacy K. Grant, eds. 1984. *Economics of Cultural Industries*. Akron, Ohio: Association for Cultural Economics.

Herbert, John. 1990. *Inside Christie's*. London: St. Martin's Press.

Hermann, Frank. 1991. "Peel and Solly: Two Nineteenth-Century Art Collectors and Their Sources of Supply." *Journal of the History of Collections* 3, no. 1: 89–96.

Hesberg, Henner von. 1992. "Publica magnificentia: Eine antiklassizistische Intention derfrühen augusteischen Baukunst." *Jahrbuch des Deutschen Archäologischen Instituts* 107: 125–147.

Higgs, Helen, and Andrew C. Worthington. 2004. "Transmission of Returns and Volatility in Art Markets: A Multivariate Analysis." *Applied Economics Letters* 11: 217–222.

Hilaire-Pérez, Liliane. 2002. "Diderot's Views on Artists' and Inventors' rights: Invention, Imitation and Reputation." *British Journal for the History of Science* 35, part 2, 125: 129–150.

Hillman-Chartrand, Harry, William Scott Hendon, and Claire McCaughey, eds. 1989. *Cultural Economics 88: A Canadian Perspective*. Akron, Ohio: Association for Cultural Economics.

Hirschfeld, Peter. 1968. *Mäzene: Die Rolle des Auftraggeber in der Kunst*. Munich: Deutscher Kunstverlag.

Hirschman, Elizabeth C. 1980. "Innovativeness, Novelty Seeking, and Consumer Creativity." *Journal of Consumer Research* 7: 283–295.

Hirschman, Elizabeth C., and Morris B. Holbrook. 1982. "Hedonic Consumption: Emergent Concept, Methods and Propositions." *Journal of Marketing* 46: 92–101.

Holbrook, Morris B., Robert W. Chestnut, Terence A. Oliva, and Eric A. Greenleaf. 1984. "Play as a Consumption Experience: The Roles of Emotions, Performance, and Personality in the Enjoyment of Games." *Journal of Consumer Research* 11: 728–739.

Holbrook, Morris B., and Elizabeth C. Hirschman. 1982. "The Experiential Aspect of Consumption: Consumer Fantasies, Feelings and Fun." *Journal of Consumer Research* 9: 132–140.

Holbrook, Morris B., and Robert M. Schindler. 1995. "Echoes of the Dear Departed Past: Some Work in Progress on Nostalgia." *Advances in Consumer Research* 18: 330–333.

Hollingsworth, Mary. 2005. *The Cardinal's Hat: Money, Ambition, and Everyday Life in the Court of a Borgia Prince*. New York: Woodstock.

Holman, Beth L. 1997. *Italian Renaissance Designs for the Decorative Arts*. New York: Cooper-Hewitt National Design Museum.

Holmes, Megan. 2004. "Copying Practices and Marketing Strategies in a Fifteenth-Century Florentine Painter's Workshop." In *Artistic Exchange and Cultural Translation in the Italian Renaissance City*, edited by S. J. Campbell and S. Milner, 38–74. Cambridge: University Press.

Holub, Hans Werner, Michael Hutter, and Gottfried Tappeiner. 1993. "Light and Shadow in Art Price Computation." *Journal of Cultural Economics* 17: 49–69.

Honig, Elizabeth A. 1998. *Painting and the Market in Early Modern Antwerp*. New Haven: Yale University Press.

Hoogenboom, Annemieke. 1993. *De stand des kunstenaars: De positie van kunstschilders in Nederland in de eerste helft van de negentiende eeuw*. Leiden: Primavera Pers.

———. 1993–94. "Art for the Market: Contemporary Painting in the Netherlands in the First Half of the Nineteenth Century." *Simiolus* 22, no. 3: 129–147.

Howard, Maurice. 1987. *The Early Tudor Country House: Architecture and Politics, 1490–1550*. London: G. Philip.

Hugger, Paul, Walter Burkert, and Ernst Lichtenhann, eds. 1987. *Stadt und Fest: Zu Geschichte und Gegenwart europaeischer Festkultur*. Stuttgart: Unterägi.

Hughes, Andrew. 1986. "'An Academy for Doing': The Accademia del disegno, the Guilds and the Principate in Sixteenth-Century Florence." *Oxford Art Journal* 9, no. 2: 3–10.

Hughes-Owen, Diane. 1986. "Sumptuary Laws and Social Relations in Renaissance Italy." In *Disputes and Settlements: Law and Human Relations in the West,* edited by J. Bossy, 69–99. Cambridge: Cambridge University Press.

Hunt, Alan. 1996. *Governance of the Consuming Passions: A History of Sumptuary Law.* New York: St. Martin's Press.

Hyde, Lewis. 1983. *The Gift: Imagination and the Erotic Life of Property.* New York: Random House.

Innocenti, Annalisa. 1992. "Dispersione degli oggetti d'arte durante la soppressione leopoldina." *Rivista d'arte* 44: 351–385.

Isager, Jacob. 1993. "The Hellenization of Rome: Luxuria or liberalitas?" In *Aspects of Hellenism in Italy: Towards a Cultural Unity?* edited by P. Guldager-Bilde, I. Nielsen, and M. Nielsen. Copenhagen: Museum Tusculanum.

Itzcovich, Oscar. 1989. "Masters and Apprentices in Genoese Society, 1450–1535." In *History and Computing,* edited by P. Denley, S. Fogelvik, and C. Harvey, 209–219. Manchester: Manchester University Press.

———. 1990. "Artigen." An Oracle database for mass prosopography. Nominal record linkage and kinship network reconstruction." In *L'Ordinateur et le métier d'historien,* 86–96. Bordeaux: Maison des Pays Ibériques.

Jacks, Philip, ed. 1998. *Vasari's Florence: Artists and Literati at the Medicean Court.* Cambridge: Cambridge University Press.

Janssen, Paul Huys. 1995. *Werken aan Kunst: Economische en bedrijfskundige aspecten vande kunstproduktie, 1400–1800.* Hilversum: Verloren.

Jardine, Lisa. 1996. *Worldly Goods: A New History of the Renaissance.* London: Nan A. Talese.

Jarrard, Alice. 2003. *Architecture as Performance in Seventeenth-Century Europe: Court Ritual in Modena, Rome, and Paris.* Cambridge: Cambridge University Press.

Jaudel, Philippe. 1972. *La pensée sociale de John Ruskin.* Paris: Librairie Marcel Didier.

Jensen, Robert. 1994. *Marketing Modernism in Fin-de-siècle Europe.* Princeton: Princeton University Press.

Johnson, David. 1985. "Munificence and Municipia: Bequests to Towns in Classical Roman Law." *Journal of Roman Studies* 75: 105–125.

Johnson, H. Thomas. 1966–67. "Cathedral Building and the Medieval Economy." *Explorations in Entrepreneurial Economy* 4: 191–210.

———. 1969. "The Economic Effect of Cathedral and Church in Medieval England: A Rejoinder." *Explorations in Entrepreneurial Economy* 6: 170–174.

Johnson-Mcallister, William. 1986. "Paintings, Provenance and Price: Speculations on 18th-Century Connoisseurship Apparatus in France." *Gazette des Beaux-Arts* 107: 191–199.

Jones, Philip. 1974. "La storia economica. Dalla caduta dell'Impero Romano al secolo xiv." In *Storia d'Italia,* vol. 2, pt. 2, *Dalla caduta dell'Impero romano al secolo* xviii, edited by R. Romano and C. Vivanti, 1467–1810. Turin: Einaudi.

———. 1978. "Economia e società nell'Italia Medievale." In *Storia d'Italia,* vol. 1, *Dal feudalesimo al capitalismo,* edited by R. Romano and C. Vivanti, 185–372. Turin: Einaudi.

Jowell, Frances Suzman. 1996. "Thoré-Bürger: A Critical Role in the Art Market." *Burlington Magazine* 1115: 115–129.

Keblusek, Marika, Badeloch Noldus, and Hans Cools. 2006. *Your Humble Servant: Agents in Early Modern Europe, 1500–1800.* Hilversum: Verloren.

Keen, Geraldine. 1971. *The Sales of Works of Art: A Study Based on the Times-Sotheby's Index.* London: Nelson.

Kellebenz, Hermann. 1978. "L'organizzazione della produzione industriale." In *Storia economica Cambridge,* vol. 5, *Economia e società nell'età moderna,* edited by E. E. Rich and C. Wilson, 533–632. Turin: Einaudi.

Kemp, Martin. 1989. "The Super Artist' as Genius: The Sixteenth Century View." In *Genius: The History of an Idea,* edited by P. Murray, 32–53. Oxford: Oxford University Press.

Kempers, Bram. 1987. *Painting, Power and Patronage: The Rise of the Professional Artist in Renaissance Italy.* New York: Penguin.

———. 1991. "Opdrachtgevers, verzamelaars en kopers: Visies op kunst in Hollandtijdens de Republiek." *Holland* 23, nos. 4–5: 196–209.

Kent, Francis William. 1977. "'Più superba di quella de Lorenzo': Courtly and Family Interest in the Building of Filippo Strozzi's Palace." *Renaissance Quarterly* 30: 311–323.

———. 2004. *Lorenzo de' Medici and the Art of Magnificence.* Baltimore: Johns Hopkins University Press.

Ketelsen, Thomas. 1998. "Art Auctions in Germany during the 18th-Century." In *Markets for Art, 1400–1800,* edited by M. North and D. Ormrod, 131–138. Madrid: Secretariado de Publicaciones de la Universidad de Sevilla.

Kidson, Alex. 1992. "Lever and the Collecting of Eighteenth-Century British Paintings." *Journal of the History of Collections* 4, no. 2: 201–209.

King, Margaret L. 1975. "Personal, Domestic and Republican Values in the Moral Philosophy of Giovanni Caldiera." *Renaissance Quarterly* 28: 535–574.

Klapisch Zuber, Christiane. [1969] 1973. *Les maîtres du marbre. Carrare: 1300–1600.* Paris: Sevpen. Translated as *Carrara e i maestri del marmo. 1300–1600,* edited by B. Cherubini. Massa: Deputazione di Storia Patria per le Antiche Province Modenesi.

Klibansky, Raymond, Erwin Panofsky, and Fritz Saxl. [1964] 1983. *Saturn and Melancholy: Studies in the History of Natural Philosophy, Religion and Art.* London: Nelson. Translated as *Saturno e la melanconia: Studi di storia della filosofia naturale, religione e arte.* Turin: Einaudi.

Klingender, Francis. 1943. *Marxism and Modern Art: An Approach to Social Realism.* London: Lawrence & Wishart.

———. [1947] 1972. *Art and the Industrial Revolution.* London: Carrington. Translated as *Arte e rivoluzione industriale.* Turin: Einaudi.

Klinkenberg, Hans Martin. 1976. "Der Verfall des Quadriviums im frühen Mittelalter." In *Artes Liberales: Von der antiken Bildung zur wissenschaft des Mittelalters,* edited by J. Koch, 1–32. Leiden, Brill.

Kloft, Hans. 1970. "Liberalitas Principis: Herkunft und Bedeutung. Studien zur Prinzipat-sideologie." Diss. Phil., Cologne.

———. 1987. "Freigebigkeit und Finanzen, der soziale und finanzielle Aspekt der augusteischen Liberalitas" In *Saeculum Augustum: Herrschaft und Gesellschaft,* edited by G. Binder, 361–388. Darmstadt: Wissenschaftliche Buchgesellschaft.

———. 1996. "Überlegungen zum Luxus in der frühen Römischen Kaiserzeit." In *Energeia: Studies on Ancient History and Epigraphy Presented to H. W. Pleket,* edited by J. H. M. Strubbe, R. A. Tybout, and H. S. Versnel, 113–134. Amsterdam: Gieben.

Knoche, Ulrich. 1935. "Magnitudo animi: Untersuchungen zur Entstehung und Entwicklung eines römischen Wertgedankes." *Philologus,* supplement 27, 3.

Knowles, Rob. 2001. "Carlyle, Ruskin, and Morris: Work across the 'River of Fire.'" *History of Economics Review* 34: 126–145.

Koerner, Joseph, and Lisbet Rausing. 2003. "Value." In *Critical Terms for Art History,* edited by R. Nelson and R. Shiff, 419–434. Chicago: University of Chicago Press.

Kovesi Killerby, Catherine. 2002. *Sumptuary Law in Italy 1200–1500.* Oxford: Clarendon Press.

Kris Ernst, and Otto Kurtz. [1934] 1980. *Die Legende vom Künstler: Ein historischer Versuch.* Vienna: Krystall Verlag. Translated from English revised version, *Legend, Myth, and Magic in the Image of the Artist: A Historical Experiment* (New Haven: Yale University Press, 1979), as *La leggenda dell'artista.* Turin: Bollati Boringhieri.

Kristeller, Oskar Paul. 1980. "The Modern System of the Arts." In *Renaissance Thought and the Arts: Collected Essays,* 163–227. Princeton: Princeton University Press.

Krohn, Deborah. 2003. "Taking Stocks: Evaluation of Works of Art in Renaissance Italy." In *The Art Market in Italy, 15th–17th Centuries,* edited by Marcello Fantoni, Louisa Chevalier Matthew, and Sara F. Matthews-Grieco, 203–211. Modena: Panini.

Kubersky-Piredda, Susanne. 2002. "Spesa della materia und spesa dell'arte: Die Preise von Altartalfen in der Florentiner Renaissance." In *Economia ed Arte, Secc.* xiii–xviii*: Atti della* xxxiii *Settimana di Studi dell'Istituto Internazionale di Storia Economica "F. Datini" Prato 30 April–4 May 2000,* edited by Simonetta Cavaciocchi, 339–353. Florence: Le Monnier.

———. 2003. "Immagini devozionali nel Rinascimento Fiorentino: Produzione, Commercio, Prezzi." In *The Art Market in Italy, 15th–17th Centuries,* edited by Marcello Fantoni, Louisa Chevalier Matthew, and Sara F. Matthews-Grieco, 115–125. Modena: Panini.

———. 2005. *Die Florentiner Maler der Renaissance und der Kunstmarkt ihrer Zeit.* Norderstedt: BoD.

Kubler, George. 1962. *The Shape of Time: Remarks on the History of Things.* New Haven: Yale University Press.

Kulischer, Josef M. [1928–29] 1964. *Allgemeine Wirtschaftsgeschichte des Mittelalters und der Neuzeit.* Munich: Oldenbourg. Translated by G. Böhm as *Storia economica del medio evo e dell'epoca moderna,* edited by G. Luzzatto. Florence: Sansoni.

La Barbera, Simonetta. 1997. *Il paragone delle arti nella teoria artistica del Cinquecento.* Bagheria: Cafaro.

Labowsky, Lotte. 1934. "Der Begriff des Prèpon in der Ethik des Panaitios." Diss. Phil., Leipzig.

Labrot, Gerard. 1992. *Collections of Painting in Naples, 1600–1780.* New York: K. G. Saur.

———. 1993. *Études napolitaines: Villages, palais, collections* xvie–xviie *siècles.* Seyssel: Champ Vallon.

———. 2002. "Un marché dynamique. La peinture de série à Naples. 1606–1775." In *Economia ed Arte, Secc.* xiii–xviii*: Atti della* xxxiii *Settimana di Studi dell'Istituto Internazionale di Storia Economica "F. Datini" Prato 30 April–4 May 2000,* edited by Simonetta Cavaciocchi, 261–283. Florence: Le Monnier.

———. 2004. "Éloge de la copie. Le marché napolitain (1614–1764)." *Annales* 59, no. 1: 7–35.

Lamberini, Daniela. 1990. *Il principe difeso: Vita e opere di Bernardo Puccini.* Florence: La Giuntina.

———. 1991. "Il cantiere delle fortificazioni nella Toscana del Cinquecento." In *Les Chantiers de la Renaissance,* edited by J. Guillaume, 227–235. Paris: Éditions Picard.

———. 2000. "All'ombra della cupola: Tradizione e innovazione nei cantieri fiorentini quattro e cinquecenteschi." *Annali di Architettura: Rivista del Centro internazionale di studi di architettura Andrea Palladio* 10–11: 276–287.

———. 2002. "Strategie difensive e politica territoriale di Cosimo I de' Medici nell'operato di un suo provveditore." In *Il principe architetto,* edited by A. Calzona, F. P. Fiore, A. Tenenti, and C. Vasoli, 125–152. Florence: Olschki.

Lamberti, Maria Mimita. 1977. "Artisti e mercato: Il giornale artistico (1872–1874)." *Annali della Scuola Normale Superiore di Pisa: Classe di Lettere e Filosofia* 7, no. 3: 1277–1301.

Lanaro Paola, Paola Marini, and Gian Maria Varanini, eds. 2000. *Edilizia privata nella Verona rinascimentale.* Milan: Electa.

Lanfranchi Strina, Bianca, ed. 2000. *Libretto dei conti del pittore Tiberio Tinelli (1618–1633).* Venice: Il comitato.

Landes, William. 2000. "Winning the Art Lottery: The Economic Returns to the Ganz Collection." *Recherches Économiques de Louvain* 66: 111–130.

Larner, John. 1969. "The Artists and the Intellectuals in Fourteenth Century Italy." *History* 54: 13–30.

Laureati, Laura. 2002. "Da Borgia a Este: Due vite in quarant'anni." In *Lucrezia Borgia,* edited by L. Laureati, 19–76. Ferrara: Sate.

Lee-Owen, Virginia, and William S. Hendon, eds. 1985. *Managerial Economics for the Arts.* Akron, Ohio: Association for Cultural Economics.

Lemme, Fabrizio. 2005. "I fedecommessi Romani: Una istituzione millenaria ma ancora valida." In *Capolavori da scoprire: Colonna, Doria Pamphilj, Pallavicini,* edited by G. Lepri, 23–27. Milan: Skira.

Lenman, Robin. 1992. "The Internationalization of the Berlin Art Market, 1910–1920, and the Role of Herwarth Walden." *Künstlerischer Austausch* 3: 535–542.

———. 1993. "Der deutsche Kunstmarkt, 1840–1923: Integration, Veränderung, Wachstum." In *Sammler, Stifter und Museen: Kunstförderung in Deutschland im 19. und 20. Jahrhundert,* edited by E. Mai and P. Paret, 135–152. Cologne: Böhlau.

———. 1996. "From 'Brown Sauce' to 'Plein Air': Taste and the Art Market in Germany, 1889–1910." In "Imagining Modern German Culture, 1889–1910," edited by F. Forster-Hahn, in *Studies in the History of Art* 53: 52–69.

Lerner-Lehmkuhl, Hanna. 1936. *Zur Struktur und Geschichte des florentineschen Kunstmarktes im 15. Jahrhundert.* Wattenscheid: Busch.

Leverotti, Franca. 1992. *Diplomazia e governo dello stato: I "famigli cavalcanti" di Francesco Sforza (1450–1466).* Pisa: Gisem ETS.

Levi, Donata. 1988. *Cavalcaselle, il pioniere della conservazione dell'arte italiana.* Turin: Einaudi.

———. 1989. "Mercanti, conoscitori, 'amateurs' nella Firenze di metà Ottocento: Spence, Cavalcaselle e Ruskin." In *L'idea di Firenze: Temi e interpretazioni nell'arte straniera dell'Ottocento,* edited by M. Bossi and L. Tonini, 105–116. Florence: Centro Di.

———. 1993a. "'Cosa venite a fare alla Minerva? Il mio dovere': Alcune note sull'attività di Adolfo Venturi presso il Ministero della Pubblica Istruzione." In Raimondi Ezio et al., *Gli anni modenesi di Adolfo Venturi.* Modena: Panini.

———. 1993b. "Carlo Lasinio, Curator, Collector and Dealer." *Burlington Magazine* 1079: 133–148.

Lippincott, Louise. 1995. "Expanding on Portraiture: The Market, the Public, and the Hierarchy of Genres in Eighteenth-Century Britain." In *Consumption of Culture, 1600–1800: Image, Object, Text,* edited by A. Berningham and J. Brewer, 75–88. London: Routledge.

Locatelli, Marilena, and Roberto Zanola. 1999. "Investment in Paintings: A Short-Run Price Index." *Journal of Cultural Economics* 23, no. 3: 211–222.

———. 2002. "The Sculpture Market: An Adjacent Year Regression Index." *Journal of Cultural Economics* 26: 65–78.

Lockwood, Lewis. [1984] 1987. *Music in Renaissance Ferrara 1400–1505.* Oxford: Oxford University Press. Translated as *La musica a Ferrara nel Rinascimento.* Bologna: Il Mulino.

Longo, Marina, and Nicola Michelassi. 2001. *Teatro e spettacolo nella Mirandola dei Pico (1468–1711).* Florence: Olschki.

Lopez, Roberto S. 1952. "Économie et architecture médievale. Cela aurait-il tué ceci?" *Annales* 7, no. 4: 433–438.

———. 1962. "Hard Times and Investment in Culture." In *The Renaissance: Six Essays,* edited by W. K. Ferguson, 29–54. New York: Harper & Row.

Lopez, Roberto S., and Harry A. Miskimin. 1962. "The Economic Depression of Renaissance." *Economic History Review* 14: 408–426.

Lorenzoni, Giovanni. 1939. *La storia economica d'Italia nel Medioevo.* Florence: Olschki.

Lorizzo, Loredana. 2003. "Il mercato dell'arte a Roma nel XVII secolo; 'pittori bottegari' e 'rivenditori di quadri' nei documenti dell'Archivio Storico dell'Accademia di San Luca." In *The Art Market in Italy, 15th–17th Centuries,* edited by Marcello Fantoni, Louisa Chevalier Matthew, and Sara F. Matthews-Grieco, 325–336. Modena: Panini.

Lubar, Steven D., and W. David Kingery, eds. 1993. *History from Things: Essays on Material Culture.* Washington, DC: Smithsonian Institution Press.

Lubbock, James. 1995. *Tyranny of Taste: The Politics of Architecture and Design in Britain, 1550–1960.* New Haven: Yale University Press.

Lugli, Adalgisa. 1990. *Naturalia et mirabilia: Il collezionismo enciclopedico nelle Wunderkammern d'Europa.* Milan: Mazzotta.

Luzzatto, Gino. 1932. *Storia economica dell'età moderna e contemporanea.* Vol. 1, *L'età moderna.* Padoa: Cedam.

———. 1949. *Storia economica d'Italia: Il medioevo.* Florence: Sansoni.

———. 1957. *Per una storia economica d'Italia: Progressi e lacune.* Bari: Laterza.

———. 1958. *Breve storia economica d'Italia: Dalla caduta dell'Impero Romano al principio del Cinquecento.* Turin: Einaudi.

———. 1963. *Storia economica d'Italia.* Florence: Sansoni.

Lyotard, Jean-François. 1974. *Économie libidinale.* Paris: Éditions de Minuit.

Maas, Harro. 1999. "Pacifying the Workman: Ruskin and Jevons on Labor and Popular Culture." In *Economic Engagements with Art,* edited by Neil De Marchi and Craufurd D. W. Goodwin, 85–120. Durham, NC: Duke University Press.

Maas, Jeremy. 1975. *Gambart, Prince of the Victorian Art World.* London: Barrie & Jenkins.

Maclaren, Sarah Fiona. 2003. *Magnificenza e mondo classico: Storia di un'idea estetica non politicamente corretta.* Rome: Meltemi.

Macleod, Diane S. 1987. "Art Collecting and Victorian Middle-Class Taste." *Art History* 10, no. 3: 328–350.

Maggio Serra, Rosanna. 1991. "I sistemi dell'arte nell'Ottocento." In *La pittura in Italia: L'Ottocento,* 2: 629–652. Milan: Electa.

Mainardi, Patricia. 1993. *The End of the Salon: Art and the State in the Early Third Republic.* Cambridge: Cambridge University Press.

———. 2000. "The 19th-Century Art Trade: Copies, Variations, Replicas." *Van Gogh Museum Journal* 62–73.

Mamone, Sara. 1980. "Feste e spettacoli per le nozze di Maria de' Medici." *Quaderni di teatro* 7: 206–213.

Mancini, Franco. 1985. "'L'immaginario di regime': Apparati e scenografie alla corte del viceré." In *Civiltà del Seicento a Napoli,* catalogo della mostra, 27–35. Naples: Electa.

Mandler, Peter. 2001. "Art, Death and Taxes: The Taxation of Works of Art in Britain, 1796–1914." *Historical Research* 74, no. 185: 271–297.

Manieri Elia, Giovanni. 1998. "Mercato dell'arte, connoisseurship e ambivalenze nella politica di tutela: La lunga vertenza sull'Antonello messinese oggi nella Pinacoteca di Spoleto, 1866–1894." *Spoletium* 39: 93–100.

Manning, Charles E. 1985. "Liberalitas: The Decline and Rehabilitation of a Virtue." *Greece & Rome* 32: 73–83.

Marchi, Piero. 1983. "Le feste fiorentine per le nozze di Maria de' Medici nell'anno 1600." In *Rubens e Firenze,* edited by M. Gregori, 85–101. Florence: La Nuova Italia Editrice.

Marcianò, Ada F. 1991. *L'età di Biagio Rossetti: Rinascimenti di Casa d'Este.* Ferrara: Corbo Editore.

Marconi, Nicoletta. 2000. "La cultura materiale del cantiere barocco Romano e il ruolo delle maestranze lombarde: Metodi, tecniche e apparati." *Arte lombarda* 130: 103–126.

———. 2001–2. "Cantiere e maestranze nel Seicento Romano: La facciata longhiana dei Santi Vincenzo e Anastasio in piazza di Trevi 1646–1660." *Bulletin-Association des Historiens de l'Art Italien* 8: 98–108.

———. 2004. *Edificando Roma Barocca: Macchine, apparati, maestranze e cantieri tra xvi e xviii secolo.* Città di Castello: Edimond.

Marillier, Henry Currie. 1926. *Christie's, 1766 to 1925.* Boston: Houghton Mifflin & Co.

Marshall, Christopher R. 2000. "'Senza il minimo scrupolo': Artists as Dealers in Seventeenth-Century Naples." *Journal of the History of Collections* 12, no. 1: 15–34.

Märten, Lu. 1914. *Die wirtschaftliche Lage der Künstler.* Munich: G. Müller.

Martin, Alfred von. 1932. *Soziologie der Renaissance.* Stuggart: Enke.

Martinelli, Paolo. 1978. "Il mercato dell'arte a Milano nella seconda metà dell'Ottocento." *Arte lombarda* 50: 126–130.

Martines, Lauro. 1998. "The Renaissance and the Birth of Consumer Society." *Renaissance Quarterly* 5, no. 1: 193–203.

Martini, Antonio, ed. 1970. *Cerimonie e feste di popolo nella Roma dei papi: Il Seicento.* Bologna: Cappelli.

Mattaliano, Emanuele. 1975. "La tutela delle cose di interesse artistico e storico dal 1861 al 1939." In *Ricerca sui beni culturali,* edited by G. Limiti, 2:1–68. Rome: Grafica Editrice.

Matteucci, Anna Maria. 1985. "La cultura dell'effimero a Bologna nel secolo xvii." In *Barocco romano e barocco italiano: Il teatro, l'effimero, l'allegoria,* edited by M. Fagiolo and M. L. Madonna, 159–173. Rome: Gangemi.

Matthews-Grieco, Sara F., and Gabriella Zarri. 2000. "Committenza Artistica Femminile." Preface in *Quaderni Storici* 104, no. 2: 283–294.

Mattioli Rossi, Laura. 1980. "Collezionismo e il mercato dei vedutisti nella Venezia del Settecento." *Ricerche di Storia dell'Arte* 11: 79–92.

Maule, Elita. 1980. "La 'Festa della porchetta' a Bologna nel Seicento: Indagine su di una festa barocca." *Il Carrobbio* 7, 252–262.

Mazzoni, Gianni, ed. 2004. *Falsi d'autore: Icilio Federico Joni e la cultura del falso tra Otto e Novecento.* Siena: Protagon.

McIver, Katherine. 2001. "Two Emilian Noblewomen and Patronage Networks in the Cinquecento." In *Beyond Isabella: Secular Women Patrons of Art in Renaissance Italy,* edited by S. E. Reiss, D. Wilkins, 159–176. Kirksville, MO: Truman State University Press.

Mckendrick, Neil, John Brewer, and John H. Plumb. 1982. *The Birth of a Consumer Society: The Commercialization of Eighteenth-Century England.* Bloomington: Indiana University Press.

McLellan, Andrew. 1996. "Watteau's Dealer: Gersaint and the Marketing of Art in Eighteenth-Century Paris." *Art Bulletin* 78, no. 3: 439–453.

McPhee, Sarah. 2003. *Bernini and the Bell Towers: Architecture and Politics at the Vatican.* New Haven: Yale University Press.

Meijer, Fik J. 1990. "De liberalitas principis en de problemen van de plebs urbana." *Lampas* 23: 74–88.

Melis, Federigo. 1962. *Aspetti della vita economica medievale: Studi nell'archivio Datini di Prato.* Florence: Olschki.

———. 1972a. *Documenti per la storia economica dei secoli* xiii–xvi: *Con una nota di paleografia commerciale.* Edited by Elena Cecchi. Florence: Olschki.

———. 1972b. "Fattori e strutture del costo del Perseo del Cellini." In *Problemi attuali di scienza e cultura.* Rome: Accademia Nazionale dei Lincei, Quaderno 177: 57–60.

Metcalf, William E. 1993. "Whose 'liberalitas'? Propaganda and Audience in the Early Roman Empire." *Rivista italiana di numismatica e scienze affini* 95: 337–346.

Miles, Devi. 1987. "Forbidden Pleasures: Sumptuary Laws and the Ideology of Moral Decline in Ancient Rome." Ph.D. diss., London.

Millar, Fergus. 1991. "Les congiaires à Rome et la monnaie." In *Nourrir la plèbe,* edited by A. Giovannini, 143–159. Basel: Reinhardt Verlag.

Miller, Angela. 1992. "The Mechanisms of the Market and the Invention of Western Regionalism: The Example of George Caleb Bingham." *Oxford Art Journal* 15, no. 1: 3–20.

Miller, Lilian B. 1989. "An Influence in the Air": Italian Art and American Taste in the Mid-Nineteenth Century." In *The Italian Presence in American Art, 1760–1860,* edited by B. Jaffe, 26–52. New York: Fordham University Press and Istituto della Enciclopedia Italiana.

Miller, Maureen C. 1995. "From Episcopal to Communal Palaces: Places and Power in Northern Italy (1000–1250)." *Journal of the Society of Architectural Historians* 54, no. 2: 175–185.

———. 2000. *The Bishop's Palace: Architecture and Authority in Medieval Italy.* Ithaca, NY: Cornell University Press.

Mills, Haaziane. 1984. "Greek Clothing Regulations: Sacred or Profane?" *Zeitswchrift für Papyrologie und Epigraphik* 57: 255–265.

Mireur, Hippolyte. 1900–1911. *Dictionnaire des ventes des tableaux, dessins, gravures.* 7 vols. Paris: Maison d'éditions d'œuvres artistiques.

Mitchell, Bonner. 1986. *The Majesty of the State: Triumphal Progresses of Foreign Sovereigns in Renaissance Italy (1494–1600).* Florence: Olschki.

Mitchell, Brian R. 1988. *British Historical Statistics.* Cambridge: Cambridge University Press.

Modesti, Adelina. 2003. "Patrons as Agents and Artists as Dealers in Seicento Bologna." In *The Art Market in Italy, 15th–17th Centuries,* edited by Marcello Fantoni, Louisa Chevalier Matthew, and Sara F. Matthews-Grieco, 367–388. Modena: Panini.

Mok, Henry M. K., Vivian W. K. Ko, Salina S. M. Woo, and Katherina Y. S. Kwok. 1993. "Modern Chinese Paintings: An Investment Alternative?" *Southern Economic Journal* 59: 808–816.

Molà, Luca. 2000. *The Silk Industry of Renaissance Venice.* Baltimore: Johns Hopkins University Press.

Molà, Luca, and Franco Franceschi. 2005. "L'economia del Rinascimento: Dalle teorie della crisi alla 'preistoria del consumismo.'" In *Il Rinascimento italiano e l'Europa,* vol. 1, *Storia e storiografia,* edited by Marcello Fantoni, 185–200. Treviso: Fondazione Cassamarca-Angelo Colla editore.

Moli Frigola, Montserrat. 1985. "Efimeras maquinas de fuegos artificiales napolitanos en Rome 1700–1737." In *I Borboni di Spagna e i Borboni di Napoli: Un bilancio storiografico,* edited by M. Pinto, 459–518. Naples: Edizioni Guida.

———. 1989. "Fuochi, teatri e macchine spagnole a Roma nel Settecento." In *Il teatro a Roma nel Settecento,* 1:215–258. Rome: Istituto della Enciclopedia italiana.

Mollat, Michel. 1958. "Y-a-t-il une économie de la Renaissance?" In *Actes du Colloque sur la Renaissance,* 37–54. Paris: J. Vrin.

Montecuccoli degli Erri, Federico. 2003. "I 'botegheri da quadri' e i 'poveri pittori famelici': Il mercato dei quadri a Venezia nel Settecento." In *Tra committenza e collezionismo: Studi sul mercato dell'arte nell'Italia settentrionale durante l'età moderna,* edited by Enrico Maria Dal Pozzolo and Leonida Tedoldi, 143–166. Vicenza: Terraferma.

Montias, John Michael. 1981. "Reflections on Historical Materialism, Economic Theory, and the History of Art in the Context of Renaissance and 17th Century Painting." *Journal of Cultural Economics* 5, no. 2: 19–38.

———. 1982. *Artists and Artisans in Delft: A Socio-economic Study of the Seventeenth Century.* Princeton: Princeton University Press.

———. 1987. "Cost and Value in Seventeenth-Century Dutch Art." *Art History* 10, no. 4: 455–466.

———. [1989] 1997. *Vermeer and His Milieu: A Web of Social History.* Princeton: Princeton University Press. Translated as *Vermeer: L'artista, la famiglia, la città.* Turin: Einaudi.

———. 1990. "Estimates of the Number of Dutch Master-Paintings, Their Earnings and Their Output in 1650." *Leidschrift* 6, no. 3: 59–74.

———. 1993. "Le marché de l'art aux Pays-Bas: xve et xvie siècles." *Annales* 6: 1541–1563.

———. 1996a. *Le marché de l'art aux Pays-Bas, xve–xviie siècles.* Paris: Flammarion.

———. 1996b. "A Secret Transaction in Seventeenth-Century Amsterdam." *Simiolus* 24, no. 1: 5–18.

———. 1999. "Auction Sales of Works of Art in Amsterdam (1597–1638)." *Nederlands Kunsthistorisch Jaarboek* 50: 144–193.

Moore, Gregory C. G. 2000. "Ruskin on Political Economy, or 'Being Preached to Death by a Mad Governess.'" *History of Economics Review* 31: 70–78.

Moore, John E. 1995. "Prints, Salami, and Cheese: Savoring the Roman Festival of the Chinea." *Art Bulletin* 77: 584–608.

Morselli, Raffaella. 1997. *Repertorio per lo studio del collezionismo bolognese del Seicento.* Bologna: Patron.

———. 1998. *Collezionisti e quadrerie nella Bologna del Seicento: Inventari 1640–1707.* Los Angeles: Provenance Index of the Getty Information Institute.

———. 2000. *Le collezioni Gonzaga: L'inventario dei beni del 1626–1627.* Milan: Silvana Editoriale.

Moses, Michael, and Jiangping Mei. 2002. "Art as an Investment and the Underperformance of Masterpieces." *American Economic Review* 92: 1656–1668.

Mottola Molfino, Alessandra. 1982. "Collezionismo e mercato artistico a Milano: Smembramenti, vendite, restauri." In *Zenale e Leonardo: Tradizione e rinnovamento della pittura lombarda,* catalogo della mostra, edited by Alessandra Mottola Molfino and Annalisa Zanni, 50–64. Milan: Electa.

Mottola Molfino, Alessandra, Mauro Natale, and Andrea Di Lorenzo. 1991. *Le Muse e il principe: Arte di corte nel Rinascimento padano.* Modena: Panini.

Moulin, Raymonde. 1967. *Le marché de la peinture en France.* Paris: Les Editions de Minuit.

Moureau, Nathalie, and Dominique Sagot-Duvaroux. 1992. "D'un Système à l'Autre: Les Mutations du Marché de l'Art depuis le xixeme siècle." *La Revue d'Économie Sociale* 29: 49–61.

Mrozek, Stanisław. 1984. "Munificentia Privata in Bauwesen und Lebensmittelverteilungen in Italien während des Prinzipates." *Zeitschrift für Papyrologie und Epigraphik* 57: 233–240.

Muensterberger, Werner. 1994. *Collecting: An Unruly Passion.* Princeton: Princeton University Press.

Mulryne, J. Ronnie, ed. 2002. *Court Festivals of the European Renaissance: Art, Politics and Performance.* Aldershot: Ashgate.

Mulryne, J. Ronnie, Helen Watanabe-O'Kelly, and Margaret Shewring. 2003. *Europa triumphans: Court and Civic Festivals in Early Modern Europe.* Aldershot: Ashgate.

Mundt, Barbara. 1993. "Mit Schützen beladen bin ich wieder hier: Berliner Museumsankäufezur Zeit der Weltausstellungen (1868–1900)." *Weltkunst* 63, no. 16: 1950–1953.

Munro, John H. 1983. "Economic Depression and the Arts in the Fifteenth-Century Low Countries." *Renaissance and Reformation* 19: 235–250.

Murphy, Caroline P. 2003. "The Market for Pictures in Post-Tridentine Bologna." In *The Art Market*

in Italy, 15th–17th Centuries, edited by Marcello Fantoni, Louisa Chevalier Matthew, and Sara F. Matthews-Grieco, 41–53. Modena: Panini.

Musacchio, Matteo. 1994. *L'archivio della Direzione Generale delle antichità e delle belle arti (1860–1890), Inventario,* I. Rome: Ministero per i beni culturali e ambientali.

Muzzarelli, Giuseppina M. 1996. *Gli inganni delle apparenze: Disciplina di vesti e ornamenti alla fine del Medioevo.* Turin: Paravia.

Myers, Fred R., ed. 2001. *The Empire of Things: Regimes of Value and Material Culture.* Oxford: James Currey.

Nadalini, Gianpaolo. 1993. "De Rome au Louvre: Les avatars du Musée Campana entre 1857 et 1862." *Histoire de l'Art* 21–22: 47–58.

Nagler, Alois Maria. 1964. *Theatre Festivals of the Medici (1539–1637).* New Haven: Yale University Press.

Nelson, Jonathan K., and Richard J. Zeckhauser. 2003. "A Renaissance Instrument to Support Non-profits: The Sale of Private Chapels in Florentine Churches." In *The Governance of Not-for-Profit Organizations,* edited by E. L. Glaeser, 143–180. Chicago: University of Chicago Press.

———. 2008. *The Patron's Payoff: The Economics of Information in Italian Renaissance Art.* Princeton: Princeton University Press.

Newcomb, Anthony. 1980. *The Madrigal at Ferrara 1579–1597.* Princeton: Princeton University Press.

Noldus, Badeloch. 2003. "Dealing in Politics and Art: Agents between Amsterdam, Stockholm and Copenhagen." *Scandinavian Journal of History* 28, nos. 3–4: 215–225.

North, Douglass. 1977. "Markets and Other Allocation Systems in History: The Challenge of Karl Polanyi." *Journal of European Economic History* 6, no. 3: 703–716.

North, Michael. 1992. *Kunst und Kommerz im Goldenen Zeitalter: Zur Sozialgeschichte der niederländischen Malerei des 17. Jahrhunderts.* Cologne: Böhlau.

———, ed. 1996. *Economic History and the Arts.* Cologne: Böhlau.

North, Michael, and David Ormrod, eds. 1998. *Art Markets in Europe, 1400–1800.* Aldershot: Ashgate.

Norton, Thomas E., and Douglas Dillon, eds. 1984. *100 Years of Collecting in America: The Story of Sotheby Parke Bernet.* New York: Harry N. Abrams.

O'Gorman, Francis. 2001. *Late Ruskin: New Contexts.* Aldershot: Ashgate.

O'Hagan, John W., and Christopher T. Duffy. 1987. *The Performing Arts and the Public Purse.* Dublin: Arts Council.

O'Malley, Michelle. 2003. "Commissioning Bodies, Allocation Decisions and Price Structures for Altarpieces in Fifteenth- and Early Sixteenth-Century Italy." In *The Art Market in Italy, 15th–17th Centuries,* edited by Marcello Fantoni, Louisa Chevalier Matthew, and Sara F. Matthews-Grieco, 163–180. Modena: Panini.

———. 2004. "Subject Matters: Contracts, Designs, and the Exchange of Ideas between Painters and Clients in Renaissance Italy." In *Artistic Exchange and Cultural Translation in the Italian Renaissance City,* edited by S. J. Campbell and S. Milner, 17–37. Cambridge: Cambridge University Press.

———. 2005. *The Business of Art: Contracts and the Commissioning Process in Renaissance Italy.* New Haven: Yale University Press.

Olivato, Loredana. 1974a. "Gli affari sono affari: Giovan Maria Sasso tratta con Tomaso degli Obizzi." in *Arte Veneta* 28: 298–304.

———. 1974b. "Provvedimenti della Repubblica Veneta per la Salvaguardia del patrimonio pittorico nei secoli XVII e XVIII." *Memorie dell'Istituto Veneto di Scienze, Lettere e Arti di Venezia* 37, no. 1: 12–45.

Ormrod, David. 1998. "The Origins of the London Art Market." In *Art Markets in Europe, 1400–1800,* edited by M. North and D. Ormrod, 167–186. Aldershot: Ashgate.

Ottani Cavina, Anna. 1979. "Le feste, gli apparati d'occasione." In *L'arte del Settecento emiliano: Architettura, scenografia, pittura di paesaggio,* exhibition catalog, edited by A. M. Matteucci, 209–242. Bologna: Alfa.

Pacciani, Riccardo. 1980. *Brunelleschi e la Magnificenza.* Florence: Centro Di.

Pade, Marianne, Lene Waage Petersen, and Daniela Quarta. 1987. *La corte di Ferrara e il suo mecenatismo 1441–1598.* Modena: Panini.

Pagliara, Pier Nicola. 2001. "'Destri' e cucine nell'abitazione del xv e xvi secolo, in specie a Roma." In *Aspetti dell'abitare in Italia tra* xv *e* xvi *secolo: Distribuzioni, funzioni, Impianti,* edited by A. Scotti Tusini, 39–99. Milan: Unicopli.

Pagnano, Giuseppe. 2001. *Le antichità del Regno di Sicilia: I plani di Biscari e Torremuzza per la Regia Custodia, 1779.* Siracusa: A. Lombardi.

Pallach, Ulrich-Christian. 1987. *Materielle Kultur und Mentalitäten im 18. Jahrundert: Wirtschafliche Entwicklung und politisch-sozialer Funktionswandel des Luxus in Frankreich und im Alten Reich am Ende des ancien régime.* Munich: Oldenbourg.

Papagno, Giuseppe, and Amedeo Quondam, eds. 1982. *La corte e lo spazio: Ferrara estense.* Rome: Bulzoni.

Papagno, Giuseppe, and Marzio A. Romani. 1982. "Una Cittadella e una città (il Castello Nuovo farnesiano di Parma, 1589–1597): Tensioni sociali e strategie politiche attorno alla costruzione di una fortezza urbana." *Annali dell'Istituto storico italo-germanico in Trento* 8: 141–209.

———. 1989. "Una cittadella e una città: Il castello Nuovo Farnesiano (1589–1597)." In *Investimenti e civiltà urbana, Secoli* xiii–xviii: *Settimana di Studi dell'Istituto Internazionale di Storia Economica "F. Datini" Prato 22 April–28 April 1977,* edited by A. Guarducci, 201–269. Florence: Le Monnier.

Parenti, Gabriele. 1959. "Il commercio estero del Granducato di Toscana dal 1851 al 1859." *Archivio Economico dell'Unificazione Italiana,* I, 8, 1.

Parkinson, Ronald. 1978. "The First Kings of Epithets: Early Picture Auctioneers and Their Auctions." *Connoisseur* 197, no. 794: 268–273.

Parpagliolo, Luigi. 1913. *Codice delle antichità e degli oggetti d'arte.* 2 vols. Rome: La Libreria dello Stato.

Pears, Iain. 1988. *The Discovery of Painting: The Growth of Interest in the Arts in England, 1680–1768.* New Haven: Yale University Press.

Pepper, D. Stephen. 1971. "Guido Reni's Roman Accounting Book-I: The Account Book." *Burlington Magazine* 819: 309–317.

Perini, Giovanna. 1993. "Dresden and the Italian Art Market in the Eighteenth Century: Ignazio Hugford and Giovanni Ludovico Bianconi." *Burlington Magazine* 1085: 550–559.

———. 1994. "'Perché desiderar senza chiedere?' Committenza e commercio di opere d'arte." In *La pittura in Emilia e in Romagna: Il Seicento,* edited by A. Emiliani, 383–403. Milan: Electa.

Pesando, James E. 1993. "Art as an Investment: The Market for Modern Prints." *American Economic Review* 83, no. 5: 1075–1089.

Pesando, James E., and Pauline M. Shum. 1999. "The Returns to Picasso's Prints and to Traditional Financial Assets, 1977 to 1996." *Journal of Cultural Economics* 23: 183–192.

Petrioli Tofani, Anna Maria. 1980. "Gli ingressi trionfali." In *Il potere e lo spazio: La scena del principe,* 343–354. Milan: Electa.

Petrioli Tofani, Anna Maria, and Giovanna Gaeta Bertelà, eds. 1969. *Feste e apparati medicei da Cosimo I a Cosimo II.* Exhibition catalog. Florence: Olschki.

Pevsner, Nikolaus. 1928. "Die italienische Malerei vom Ende der Renaissance bim zum ausgehenden Rokoko." In *Barokmalerei in den Romenischen Ländern,* 1–214. Potsdam: Akademische Verlagsgesellschaft Athenaion.

————. [1940] 1982. *Academies of Art: Past and Present*. Cambridge: Cambridge University Press. Translated as *Le Accademie d'arte*. Turin: Einaudi.

Piana, Mario. 1989. "Tecniche edificatorie cinquecentesche: Tradizione e novità in Laguna." In *D'une ville à l'autre: Structures matérielles et organisation de l'espace dans les villes européennes (xiiie–xvie siècles)*, edited by J.-C. Maire Vigueur, 631–639. Rome: École Française de Rome.

Piccialuti, Maura. 1999. *L'immortalità dei beni: Fedecommessi e primogeniture a Roma nei secoli* xvii *e* xviii. Rome: Viella.

Pietilä-Castrén, Leena. 1987. *Magnificentia publica: The Victory Monuments of the Roman Generals in the Era of the Punic Wars*. Helsinki: Societas Scientiarum Fennica.

Pigozzi, Marinella, ed. 1985. *In forma di Festa: Apparatori, decoratori, scenografi, impresari in Reggio Emilia dal 1600 al 1857*. Reggio Emilia: Comune di Reggio Emilia.

Pinchera, Valeria. 2002. "Arte e consumo della nobiltà fiorentina del Sei e Settecento." In *Economia ed Arte, Secc.* xiii–xviii*: Atti della* xxxiii *Settimana di Studi dell'Istituto Internazionale di Storia Economica "F. Datini" Prato 30 April–4 May*, edited by Simonetta Cavaciocchi, 635–648. Florence: Le Monnier.

Pinelli, Antonio. 1978–79. "Storia dell'arte e cultura della tutela: Le 'Lettres à Miranda' di Quatremère de Quincy." *Ricerche di Storia dell'Arte* 8: 43–62.

Pinto, Giuliano. 1983. "Qualche considerazione sull'attività edilizia nell'Italia medievale." *Annali della Facoltà di Lettere e Filosofia dell'Università di Siena* 4: 165–184.

————. 1984. "L'organizzazione del lavoro nei cantieri edili (Italia centro-settentrionale)." In *Artigiani e salariati: Il mondo del lavoro nell'Italia dei secoli*, 69–101. Centro Italiano di Studi di storia e d'arte. Pistoia.

Piola Caselli, Fausto. 1981. *La costruzione del palazzo dei papi di Avignone (1316–1367)*. Milan: Giuffrè.

————. 1996. "Public Finances and the Arts in Rome: The Fabbrica of St. Peter's in the 17th Century." In *Economic History and the Arts*, edited by M. North, 53–66. Cologne: Böhlau.

Plax, Julie-Anne. 1995–96. "Introduction to Work, Leisure, and Art." *Eighteenth-Century Studies* 29, no. 2: 211–213.

Pohlenz, Max. 1935. *Tò Prèpon: Ein Beitrag zur Geschichte des griechischen Geistes*. Göttingen: Nachrichten von der Gesellschaft der Wissenschaften zu Göttingen.

Pointon, Marcia. 1984. "Portrait-Painting as a Business Enterprise in London in the 1780s." *Art History* 7, no. 2: 187–205.

Polanyi, Karl. 1944. *The Great Transformation*. New York: Rinehart.

————. [1966] 1987. *Dahomey and the Slave Trade: An Analysis of an Archaic Economy*. Seattle: University of Washington Press. Translated as *Il Dahomey e la tratta degli schiavi: Analisi di un'economia arcaica*, edited by A. Salsano. Turin: Einaudi.

Pomian, Krzysztof. [1987] 1989. *Collectionneurs, amateurs et curieux: Paris-Venise*, xvie–xviiie *siècles*. Paris: Gallimard. Translated as *Collezionisti, amatori e curiosi*. Milan: Il Saggiatore.

————. 1993. "Collections et Musées." *Annales* 48, no. 6: 1381–1401.

Pommerehne, Werner W., and Lars Feld. 1997. "The Impact of Museum Purchase on the Auction Prices of Paintings." *Journal of Cultural Economics* 21, no. 3: 249–271.

Pommier, Eduard. 2000. *Più antichi della luna: Studi su Winckelmann e Quatremère de Quincy*. Bologna: Minerva.

Portier, François. 1996. "Prices Paid for Italian Pictures in the Stuart Age." *Journal of the History of Collections* 8: 53–69.

Pouillon, François. 1978. "Lusso." In *Enciclopedia Einaudi*, 8: 584–593. Turin: Einaudi.

Preti Hamard, Monica. 1999–2000. "Ferdinando Marescalchi, Leopoldo Cicognara et quel-ques notes sur le marché de l'art à Venise." *Bulletin-Association des Historiens de l'Art Italien* 6: 51–57.

———. 2000. "Collections et collectionneurs en Italie à l'époque napoléonienne." In *Antonio Canova e il suo ambiente artistico fra Venezia, Roma e Parigi,* edited by G. Pavanello, 523–553. Venice: Istituto Veneto di Scienze, Lettere ed Arti.

Previtali, Giovanni. 1964. *La fortuna dei primitivi.* Turin: Einaudi.

Prizer, William F. 1998. "Music in Ferrara and Mantua at the Time of Dosso Dossi: Interrelations and Influences." In *Dosso's Fate: Painting and Court Culture in Renaissance Italy,* edited by L. Ciammitti, S. F. Ostrow, and S. Settis, 290–308. Los Angeles: Getty Research Institute for the History of Art and the Humanities.

Puncuh, Dino. 1984. "Collezionismo e commercio di quadri nella Genova sei-settecentesca." *Rassegna degli Archivi di Stato* 44, no. 1: 164–218.

Puppi, Lionello. 2003. "Copie, falsi, pastiches: Riflessioni preliminari intorno al mercato dell'arte come economia del gusto." In *Tra committenza e collezionismo: Studi sul mercato dell'arte nell'Italia settentrionale durante l'età moderna,* edited by Enrico Maria Dal Pozzolo and Leonida Tedoldi, 23–34. Vicenza: Terraferma.

Quondam, Amedeo. 2004. "Pontano e le moderne virtù del dispendio." *Quaderni storici* 115, no 1: 11–43.

Quinterio, Francesco. 1980. "Note sul cantiere quattrocentesco: Le fabbriche tardo brunelleschiane." In *Filippo Brunelleschi: La sua opera e il suo tempo, Vol 2*: 645–654. Florence: Centro Di.

Racioppi, Pier Paolo. 2001. "La Repubblica Romana e le belle arti (1798–99): Dispersione e conservazione del patrimonio artistico." *Roma Moderna e Contemporanea* 9, nos. 1–3: 193–215.

Raggio, Osvaldo. 2000. *Storia di una passione: Cultura aristocratica e collezionismo alla fine dell'ancien régime.* Venice: Marsilio.

———. 2002. "Statue antiche e lettere di cambio: Gusto e credito a Genova nel Seicento." *Quaderni storici* 110, no. 2: 405–423.

Rebecchini, Guido. 2002. *Private Collectors in Mantua, 1500–1630.* Rome: Edizioni di Storia e Letteratura.

———. 2003. "Il mercato del dono: Forme dello scambio artistico a Mantova tra Quattro e Cinquecento." In *Tra committenza e collezionismo: Studi sul mercato dell'arte nell'Italia settentrionale durante l'età moderna,* edited by Enrico Maria Dal Pozzolo and Leonida Tedoldi, 113–122. Vicenza: Terraferma.

Rees, Leahy, H. 1999. "Art Exports and the Construction of National Heritage in Late-Victorian and Edwardian Great Britain." In *Economic Engagements with Art,* edited by Neil De Marchi and Craufurd D. W. Goodwin, 187–208. Durham, NC: Duke University Press.

Reinhardt, Volker. 1984. *Kardinal Scipione Borghese. 1605–1633, Vermögen: Finanzen undsozialer Aufstieg eines Papstnepoten.* Tübingen: Max Niemeyer Verlag.

Reitlinger, Gerald. 1961. *The Economics of Taste.* Vol. 1, *The Rise and Fall of Picture Prices 1760–1960.* London: Barries and Jenkins.

———. 1963. *The Economics of Taste.* Vol. 2, *The Rise and Fall of Objects d'art Prices since 1950.* London: Barries and Jenkins.

———. 1970. *The Economics of Taste.* Vol. 3, *The Art Market in the 1960's.* London: Barries and Jenkins.

Rengers, Merijn, and Olav Velthuis. 2002. "Determinants of Prices for Contemporary Art in Dutch Galleries, 1992–1998." *Journal of Cultural Economics* 26, no. 1: 1–28.

Renneboog, Luc, and van Tom Houtte. 2002. "The Monetary Appreciation of Paintings: From Realism to Magritte." *Cambridge Journal of Economics* 26: 331–357.

Riccetti, Lucio, ed. 1988. *Il duomo di Orvieto.* Rome: Laterza.

———. 1989. "La Banca Dati del Duomo di Orvieto: Considerazioni e prospettive." *Architettura: Storia e Documenti* 1–2: 35–54.

———. 1994. "'Per avere dell'acqua buona per bevere.' Orvieto: Città e cantiere del Duomo, secoli xiv–xv." *Nuova Rivista Storica* 78: 243–292.

———. 2003. "Ad perscrutandum et explorandum pro marmore: L'Opera del Duomo di Orvieto tra ricerca dei materiali e controllo del territorio (secoli xiii–xv)." In *Pouvoir et édilité: Les grands chantiers dans l'Italie communale et seigneuriale,* edited by E. Crouzet-Pavan, 245–373. Rome: École Française de Rome.

Rigoli, Paolo. 1988. "L'architettura effimera: Feste, teatri, apparati decorativi." In *L'architettura a Verona nell'età della Serenissima (sec. xv–sec. xviii),* edited by P. Brugnoli, A. Sandrini, 5–86. Verona: Banca Popolare di Verona.

Risch-Stolz, Marianne. 1988. "Strukturen des englischen Graphikmarkts um 1800." *Weltkunst* 58, no. 9: 1366–1369, and 58, no. 11: 1650–1653.

———. 1990. "'Auf jene Stücke, die ich wirklich nicht vorräthig habe, nehmeich Bestellungen an . . .'" in *Weltkunst* 60, no. 6: 825–827.

Robertson, David. 1978. *Sir Charles Eastlake and the Victorian Art World.* Princeton: Princeton University Press.

Robertson, Iain. 1992. "Shared Values, Then and Now: Lessons from the Seventeenth-Century Dutch Art Market." *Apollo* 136, no. 368: 247–250.

Roche, Daniel. 1986. "Modelli economici del mecenatismo." *Intersezioni* 6, no. 1: 5–14.

———. [1997] 1999. *Histoire des choses banales: Naissance de la consommation dans les sociétés traditionelles (xviie–xixe siècles).* Paris: Librairie Arthème Fayard. Translated as *Storia delle cose banali: La nascita del consumo in Occidente.* Rome: Editori Riuniti.

Roeck, Bernd. 1991. "La collocazione economica e sociale di artisti veneziani e della Germania meridionale attorno al 1600: Un confronto." In *Venedig und Oberdeutschland in der Renaissance: Beziehungen zwischen Kunst und Wirtschaft,* edited by K. Bergdolt, A. J. Martin, and B. Roeck. Sigmaringen: Centro Tedesco di Studi Veneziani.

———. 1999. "Kunstpatronage in der Frühen Neuzeit: Studien zu Kunstmarkt, Künstlern und ihren Auftraggebern." In *Italien und im Heiligen Römischen Reich (15–17 Jahrhundert).* Göttingen: Vandenhoeck & Ruprecht.

Romani, Marzio A. 1978. "Finanza pubblica e potere politico: Il caso dei Farnese (1545–1593)." In *Le corti farnesiane di Parma e Piacenza 1545–1622,* vol. 1, *Potere e società nello stato farnesiano,* edited by M. A. Romani, 3–85. Rome: Bulzoni.

Romano, Elisa. 1994. "Dal De Officiis a Vitruvio, da Vitruvio a Orazio: Il dibattito sul lusso edilizio." In *Le projet de Vitruve: Objet, destinataires et réception du De Architectura,* 63–73. Paris: De Boccard-Rome: L'"Erma" di Bretschneider.

Romano, Ruggero, ed. 1966. *I prezzi in Europa dal secolo xiii a oggi.* Turin: Einaudi.

———. 1971a. "Avvertimento." In *Tra due crisi: L'Italia del Rinascimento,* 7–10. Turin: Einaudi.

———. 1971b. "Arte e Società nell'Italia del Rinascimento." In *Tra due crisi: L'italia del Rinascimento,* 101–115. Turin: Einaudi.

———. 1974. "La storia economica: Dal secolo xiv al Seicento." In *Storia d'Italia,* vol. 2, *Dalla caduta dell'Impero romano al secolo* xviii, edited by R. Romano and C. Vivanti, 1811–1931. Turin: Einaudi.

———, ed. 1991. *Storia dell'economia italiana.* Vol. 2, *L'età moderna: Verso la crisi.* Turin: Einaudi.

Romano, Ruggero, and Ugo Tucci, eds. 1983. "Economia naturale, economia monetaria." In *Storia d'Italia,* vol. 6. Turin: Einaudi.

Rosenberg, Charles M. 1997. *The Este Monuments and Urban Development in Renaissance Ferrara.* Cambridge: Cambridge University Press.

Rossi Pinelli, Orietta. 1978–79. "Carlo Fea e il Chirografo del 1802: Cronaca, giudiziaria e non, delle prime battaglie per la tutela delle 'Belle Arti.'" *Ricerche di Storia dell'Arte* 8: 27–41.

Rotstein, Abraham. 1970. "Karl Polanyi's Concept of Non Market Trade." *Journal of Economic History* 30, no. 1: 117–126.

Roversi, Giancarlo. 1969. "I trafficanti d'arte bolognesi del secolo XVIII e le vendite della Madonna Sistina di Raffaello." *Culta Bononia* 1: 65–98.

Rubin, Patricia Lee. 1995. *Magnificence: Art of the Italian Renaissance Courts.* New York: Harry N. Abrams Hall.

Rush, Richard H. 1961. *Art as an Investment.* New Jersey: Prentice-Hall.

Saarinen, Aline B. [1958] 1977. *The Proud Possessors.* New York: Random House. Translated as *I grandi collezionisti americani.* Turin: Einaudi.

Sahlins, Marshall. 1974. *Stone Age Economics.* London: Tavistock Publications.

Salmons, June, and Walter Moretti, eds. 1984. *The Renaissance in Ferrara and Its European Horizons.* Cardiff: University of Wales Press; Ravenna: Edizioni del Girasole.

Salvalai, Raffaella. 1998. "Napoleone e i furti d'arte: I dipinti del Ducato di Parma, Piacenza e Guastalla requisiti e non più ritrovati." *Aurea Parma* 82, no. 1: 74–83.

Sangiovanni, Luigi. 1938. *La legislazione delle antichità e belle arti.* Milan: Albrighi e Segati.

Santi, Bruno. 1998. "Una bottega per il commercio: Repertori, vendite, esportazioni." In *I Della Robbia e l'arte nuova della scultura invetriata,* edited by G. Gentilini, 87–96. Florence: Giunti.

Sapori, Armando. 1940. *Studi di storia economica medievale.* Vol. 1, *Il Medioevo,* vol. 2, *L'epoca moderna.* Florence: Sansoni.

———. 1952. "Il rinascimento: Significati e limiti." Paper presented at the Third International Meeting on Renaissance Studies. Florence, Palazzo Strozzi, 25–28 September.

———. 1955. *Studi di storia economica (secoli xiii-xiv-xv).* 3rd ed. 3 vols. Florence: Sansoni.

Sargentson, Carolyn. 1996. *The Marchands Merciers of Eighteenth-Century Paris.* Oxford: Oxford University Press.

Sattel Bernardini, Ingrid. 1993. "Friedrich Müller, detto Maler Müller, e il commercio Romano d'antichità all'inizio dell'Ottocento." *Bollettino-Monumenti musei e gallerie pontificie* 13: 127–159.

Sauerwein, Ingo. 1970. "Die leges sumptuarie als römische Maßnahmegegen Sittenverfall." Diss. Phil., Hamburg.

Saunier, Charles. 1902. *Les conquêtes artistiques de la Révolution et de l'Empire, et les reprises des alliés en 1815.* Paris: Renouard.

Schiferl, Ellen. 1991. "Italian Confraternity Art Contracts: Group Consciousness and Corporate Patronage, 1400–1525." In *Crossing the Boundaries: Christian Piety and the Arts in Italian Medieval and Renaissance Confraternities,* edited by K. Eisenbichler, 121–140. Kalamazoo: Medieval Institute Publications, Western Michigan University.

Schnapper, Antoine. 1998. "Les inventaires après décès, les ventes publiques et le marché de l'art a Paris au XVIIe siècle." In *Markets for Art, 1400–1800,* edited by M. North and D. Ormrod, 119–129. Madrid: Secretariado de Publicaciones de la Universidad de Sevilla.

Schwartz, Leonard D. 1985. "The Standard of Living in the Long Run: London 1700–1860." *Economic History Review* 38: 24–41.

Schwartz, Gary. 2002. "The Structure of Patronage Networks in Rome, The Hague and Amsterdam in

xviith Century." In *Economia ed Arte, Secc.* xiii–xviii: *Atti della* xxxiii *Settimana di Studi dell'Istituto Internazionale di Storia Economica "F. Datini" Prato 30 April–4 May 2000,* edited by Simonetta Cavaciocchi, 567–574. Florence: Le Monnier.

Scott, John Beldon. 2003. *Architecture for the Shroud: Relic and Ritual in Turin.* Chicago: University of Chicago Press.

Scotti, Aurora. 1991. "Architetti e cantieri a Milano a metà del Cinquecento." In *Les Chantiers dela Renaissance,* edited by J. Guillaume, 239–246. Paris: Éditions Picard.

Segre, Arturo. 1923. *Storia del commercio.* Vol. 1, *Dalle origini alla Rivoluzione francese.* Turin: Lattes.

Sekora, John. 1977. *Luxury: The Concept in Western Thought, Eden to Smollett.* Baltimore: Johns Hopkins University Press.

Sella, Domenico. 1968. *Salari e lavoro nell'edilizia lombarda durante il secolo* xii. Pavia: Fusi.

———. 1979. "Le industrie europee (1500–1700)." In *Storia Economica d'Europa,* edited by C. M. Cipolla, vol. 2, *I secoli* xvi *e* xvii, 287–304. Turin: Einaudi.

Settis, Salvatore. 1981. "Artisti e committenti tra Quattro e Cinquecento." In *Storia d'Italia,* vol. 4, *Intellettuali e potere,* edited by C. Vivanti, 699–761. Turin: Einaudi.

———, ed. 1984. *La memoria dell'antico nell'arte italiana.* Vol. 1, *L'uso dei Classici.* Turin, Einaudi.

———, ed. 1985. *La memoria dell'antico nell'arte italiana.* Vol. 2, *I generi e i temi ritrovati.* Turin: Einaudi.

———, ed. 1986. *La memoria dell'antico nell'arte italiana.* Vol. 3, *Dalla tradizione all'archeologia.* Turin: Einaudi.

Shammas, Carol. 1990. *The Pre-industrial Consumer in England and America.* Oxford: Oxford University Press.

Shanahan, James L., and William S. Hendon, eds. 1983. *Economics of Cultural Decisions.* Cambridge: Abt Books.

Shanahan, James L., William S. Hendon, Izak Th. H. Hilhorst, and Jaap van Staalen, eds. 1983. *Economic Support for the Arts.* Akron, Ohio: Association for Cultural Economics.

Shapiro, Meyer. 1964. "On the Relation of Patron and Artist: Comments on a Proposed Model for the Scientist." *American Journal of Sociology* 70, no. 3: 363–369.

Shaw, Douglas V., William S. Hendon, and C. Richard Waits, eds. 1987. *Artists and Cultural Consumers.* Akron, Ohio: Association for Cultural Economics.

Sheard, Wendy Stedman, and John T. Paoletti, eds. 1978. *Collaboration in Italian Renaissance Art.* New Haven: Yale University Press.

Shell, Janice. 1995. *Pittori in Bottega: Milano nel Rinascimento.* Turin: Allemandi.

Shepherd, Rupert. 2002. "Giovanni Sabatino degli Arienti and a Practical Definition of Magnificence in the Context of Renaissance Architecture." In *Concepts of Beauty in Renaissance Art,* edited by F. Ames-Lewis and M. Rogers, 52–65. Aldershot: Ashgate.

Sherburne, James Clark. 1972. *John Ruskin, or The Ambiguities of Abundance: A Study in Social and Economic Criticism.* Cambridge: Harvard University Press.

Shiner, Larry. 2001. *The Invention of Art: A Cultural History.* Chicago: Chicago University Press.

Shovlin, John. 2000. "The Cultural Politics of Luxury in Eighteenth-Century France." *French Historical Studies* 23: 577–606.

Sicca, Cinzia, ed. 2000. *The Lustrous Trade: Material Culture and the History of Sculpture in England and Italy, c. 1700–c. 1860.* London: Leicester University Press.

———. 2002. "Consumption and Trade of Art between Italy and England in the First Half of the Sixteenth Century: The London House of the Bardi and Cavalcanti Company." *Renaissance Studies* 16, no. 2: 163–201.

Silver, Morris. 1983. "Karl Polanyi and Markets in the Ancient Near East: The Challenge of the Evidence." *Journal of Economic History* 4: 795–829.

Simi Varanelli, Emma. 1995. *Artisti e dottori nel Medioevo: Il campanile di Firenze e la rivalutazione delle "arti belle."* Rome: Istituto Poligrafico e Zecca dello Stato.

Simpson, Colin. 1986. *Artful Partners: Bernard Berenson and Joseph Duveen.* New York: Macmillan.

Sivori Porro, Gabriella. 1989. "Costi di costruzione e salari edili a Genova nel secolo XVII." *Atti della Società Ligure di Storia Patria* 29: 339–423.

———. 1994. "Note sull'edilizia genovese del Cinquecento." In *Atti della Società Ligure di Storia Patria* 34, no. 3: 261–284.

Slob, Ewoud. 1986. *Luxuria: Regelgeving en maatregelen van censoren ten tijde van de Romeinse Republiek.* Zutphen: De Walburg Press.

Smith, Carolyn. 1997. "An Instance of Feminine Patronage in the Medici Court of Sixteenth-Century Florence: The Chapel of Eleonora da Toledo in the Palazzo Vecchio." In *Women and Art in Early Modern Europe: Patrons, Collectors, and Connoisseurs*, edited by C. Lawrence, 72–110. University Park: Pennsylvania State University Press,.

Solkin, David H. 1993. *Painting for Money: The Visual Arts and the Public Sphere in Eighteenth-Century England.* New Haven: Yale University Press.

Sombart, Werner. [1902] 1925. *Der moderne Kapitalismus.* Munich: Duncker & Humblot. Translated and partially summarized from the second German edition by Gino Luzzatto as *Il capitalismo moderno: Esposizione storico-sistematica della vita economica di tutta l'Europa dai suoi inizi fino all'età contemporanea.* Florence: Vallecchi.

———. [1913] 1988. *Luxus und Kapitalismus.* Munich: Duncker & Humblot. Translated as *Lusso e capitalismo.* Milan: Unicopli, 1988. Also translated as *Dal lusso al capitalismo,* edited by R. Sassatelli (Rome: Armando, 2003).

Sosson, Jean-Pierre. 1984. "À propos des 'travaux publics' de quelques villes de Flandre aux aux XIVe et XVe siècles: Impact budgétaire, importance relative des investissements, technostructures, politiques économiques." In *L'initiative publique des communes en Belgique: Fondements historiques (Ancien Régime),* 379–380. Brussels: Crédit Communal de Belgique.

Soussloff, Catherine M. 1997. *The Absolute Artist: The Historiography of a Concept.* Minneapolis: University of Minnesota Press.

Southorn, Janet. 1988. *Power and Display in the Seventeenth Century: The Arts and Their Patrons in Modena and Ferrara.* Cambridge: Cambridge University Press.

Spallanzani, Marco, ed. 1996. *Inventari Medicei 1417–1465: Giovanni di Bicci, Cosimo e Lorenzo di Giovanni, Piero di Cosimo.* Florence: Spes.

———. 2002. "Maioliche Ispano-moresche a Firenze nei secoli XIV–XV." In *Economia ed Arte, Secc. xiii–xviii: Atti della XXXIII Settimana di Studi dell'Istituto Internazionale di Storia Economica "F. Datini" Prato 30 April–4 May 2000,* edited by Simonetta Cavaciocchi, 367–377. Florence: Le Monnier.

Spear, Jeffrey L. 1984. *Dreams of an English Eden: Ruskin and His Tradition in Social Criticism.* New York: Columbia University Press.

Spear, Richard E. 1994. "Guercino's 'Fix Price': Observations on Studio Practices and Art Marketing in Emilia." *Burlington Magazine* 1098: 592–602.

———. 1997. *The "Divine Guido": Religion, Sex, Money and Art in the World of Guido Reni.* New Haven: Yale University Press.

———. 2003. "Scrambling for Scudi: Note on Painters in Early Baroque Rome." *Art Bulletin* 85, no. 2: 310–320.

―――. 2004. "Claude and the Economics of Landscape Painting in Seicento Rome." *Konsthistorisk Tidskrift* 73, no. 3: 147–157.

Speroni, Mario. 1988. *La tutela dei beni culturali negli Stati italiani preunitari: L'età delle riforme.* Milan: Giuffrè.

Spezzaferro, Luigi. 1989. "Pier Francesco Mola e il mercato artistico Romano: Atteggiamenti e valutazioni." In *Pier Francesco Mola 1612–1666,* 40–59. Milan: Electa.

―――. 2001. "Problemi del collezionismo a Roma nel secolo xvii." In *Geografia del collezionismo: Italia e Francia tra il* xvi *e il* xviii *secolo,* edited by O. Bonfait, M. Hochmann, L. Spezzaferro, and B. Toscano, 1–23. Rome: École Française de Rome.

―――. 2004. "Le contraddizioni del pittore: Note sulla trasformazione del lavoro artistico nella prima metà del Seicento." *Quaderni storici* 116, no. 2: 329–351.

Spier, Jeffrey. 2000. "Sir Charles Frederick and the Forgery of Ancient Coins in Eighteenth-Century Rome." *Journal of the History of Collections* 12, no. 1: 35–90.

Spilner, Paula. 1993. "Giovanni di Lapo Ghini and a Magnificent New Addition to the Palazzo Vecchio Florence." *Journal of the Society of Architectural Historians* 52: 453–465.

Spiriti, Andrea. 2004. "Impegno finanziario e scelte strategiche: Costo e valore dell'arte nella Milano del secondo Seicento." *Quaderni storici* 116, no. 2: 403–420.

Stango, Cristina. 1987. "La corte di Emanuele Filiberto: Organizzazione e gruppi sociali." *Bollettino Storico-Bibliografico Subalpino* 85: 445–502.

Stein, John Picard. 1977. "The Monetary Appreciation of Paintings." *Journal of Political Economy* 85: 1021–1035.

Stockhausen, Tilmann Von. 2002. "The Courts and the Arts." In *Economia ed Arte, Secc.* xiii–xviii*: Atti della* xxxiii *Settimana di Studi dell'Istituto Internazionale di Storia Economica "F. Datini" Prato 30 April–4 May 2000,* edited by Simonetta Cavaciocchi, 419–429. Florence: Le Monnier.

Stoddart, Judith. 1990. "The Formation of the Working Classes: John's Ruskin 'Fors Clavigera' as a Manual of Cultural Literacy." *Bucknell Review* 34, no. 2: 43–58.

―――. 1998. *Ruskin's Culture Wars: "Fors Clavigera" and the Crisis of Victorian Liberalism.* Charlottesville: University Press of Virginia.

Stone, Lawrence. 1959. "The Market for Italian Art." *Past and Present* 15: 92–94.

―――. 1971. "Prosopography." *Daedalus* 100: 46–79.

Strong, Roy. 1973. *Splendour at Court: Renaissance Spectacle and Illusion.* London: Weidenfeld and Nicolson.

Stuard, Susan Mosher. 2005. *Gilding the Market: Luxury and Fashion in Fourteenth-Century Italy.* Philadelphia: University of Pennsylvania Press.

Stumpo, Enrico. 2003. "Per una storia del mercato dell'arte nell'Italia moderna, Aspetti teorici e problemi di ricerca." In *La storia e l'economia: Miscellanea di studi in onore di Giorgio Mori,* edited by A. M. Falchero, A. Giuntini, G. Nigro, and L. Segreto, 701–720. Varese: Lativa.

―――. 2005. "Per una storia del mercato dell'arte nell'Europa dell'Ottocento: Le esportazioni di antichità e oggetti d'arte in Italia dopo l'Unità." *Studi storici Luigi Simeoni* 55: 243–273.

Stürmer, Michael. 1983. "Die Preise des Luxus im 18. Jahrhundert." In *Studien zum europäischen Kunsthandwerk: Festschrift Yvonne Hackenbroch,* edited by J. Rasmussen, 205–215. Munich: Klinkhardt & Biermann.

Stylow, Armin U. 1972. "Libertas und Liberalitas Untersuchngen zur innenpolitischen Propaganda der Römer." Diss. Phil., Munich.

Subacchi, Paola. 1996. *La ruota della fortuna: Arricchimento e promozione sociale in una città padana in età moderna.* Milan: Franco Angeli.

Sutton, Denys. 1985. "Aspects of British Collecting, Part IV." *Apollo* 122, no. 282: 84–129.

Syson, Luke, and Dora Thornton. 2001. *Objects of Virtue: Art in Renaissance Italy.* London: British Museum Press.

Tabarrini, Marisa. 2000. "Il cantiere borrominiano di San Carlino alle Quattro Fontane: Le maestranze." In *Francesco Borromini,* edited by C. L. Frommel and E. Sladek, 419–424, Milan: Electa.

Tagliaferro, Laura. 1995. *La magnificienza privata: "Argenti, gioie, quadri e altri mobili della famiglia Brignole-Sale. Secoli* xvi–xix. Genoa: Marietti.

———. 2002. "Collezionismo, investimento e ricerca di fasto negli acquisti di opere d'arte dell'aristocrazia genovese." In *Economia ed Arte, Secc.* xiii–xviii: *Atti della* xxxiii *Settimana di Studi dell'Istituto Internazionale di Storia Economica "F. Datini" Prato 30 April–4 May 2000,* edited by Simonetta Cavaciocchi, 515–549. Florence: Le Monnier.

Talvacchia, Bette. 1996. "Notes for a Job Description to be Filed under 'Court Artist.'" In *The Search for a Patron in the Middle Ages and the Renaissance,* edited by D. G. Wilkins and R. L. Wilkins, 179–190. Lampeter: Edwin Mellen Press.

Tatarkiewicz, Wladyslaw. 1973. "Classification of the Arts." in *Dictionary of the History of Ideas: Studies of Selected Pivotal Ideas,* edited by P. P. Wiener, 1:456–462. New York: Charles Scribner's Sons.

Tateo, Francesco. 1965. "Le virtù sociali e l'immanità nella trattatistica Pontaniana." *Rinascimento* 5: 119–165.

———. 1999. "Introduzione." In *G. Pontano, I libri delle virtù sociali,* edited by F. Tateo, 9–38. Rome: Bulzoni.

Taylor, Francis Henry. [1948] 1954. *The Taste of Angels: A History of Art Collecting from Ramses to Napoleon.* Boston: Little, Brown. Translated as *Artisti, principi e mercanti: Storia del collezionismo da Ramsete a Napoleone.* Turin: Einaudi.

Tedoldi, Leonida. 2003. "Il mestiere del pittore a Brescia nel Cinquecento: Prime indagini." In *Tra committenza e collezionismo: Studi sul mercato dell'arte nell'Italia settentrionale durante l'età moderna,* edited by Enrico Maria Dal Pozzolo and Leonida Tedoldi, 67–75. Vicenza: Terraferma.

Teige, Karel. [1936] 1973. *Jarmarka umeni.* Praha: F. J. Müller. Translated as *Il mercato dell'arte: L'arte tra capitalismo e rivoluzione.* Turin: Einaudi.

Temin, Peter. 2002. "Price Behavior in Ancient Babylon." *Explorations in Economic History* 39: 46–60.

Thomas, Nicholas. 1991. *Entangled Objects: Exchange, Material Culture, and Colonialism in the Pacific.* Cambridge: Cambridge University Press.

Thomas, Anabel. 1995. *The Painter's Practice in Renaissance Tuscany.* Cambridge: Cambridge University Press.

Thompson, Noel. 1988. *The Market and Its Critics: Socialist Political Economy in Nineteenth Century Britain.* London: Routledge.

Thornton, Dora. 1997. *The Scholar in His Study: Ownership and Experience in Renaissance Italy.* New Haven: Yale University Press.

Throsby, C. David, and Glenn A. Withers. 1979. *The Economics of the Performing Arts.* London: Edward Arnold.

Todeschini, Giacomo. 1992. "Quantum valet? Alle origini di un'economia della povertà." *Bullettino dell'Istituto storico italiano per il Medioevo* 98: 173–234.

———. 1994. *Il prezzo della salvezza: Lessici medievali del pensiero economico.* Florence: La Nuova Italia Scientifica.

Tommasi, Anna Chiara, ed. 1998. *Giovanni Battista Cavalcaselle conoscitore e conservatore.* Venice: Marsilio.

Torelli, Pietro. 1920. *L'Archivio Gonzaga di Mantova.* Ostiglia: Mondadori.

Towner, Wesley. 1970. *The Elegant Auctioneers.* New York: Hill and Wang.

Trachtenberg, Marvin. 1997. *Dominion of the Eye: Urbanism, Art and Power in Early Modern Florence.* Cambridge: Cambridge University Press.

Travaglini, Carlo M. 1999. "'Ognuno per non pagare si fa povero': Il sistema delle corporazioni Romane agli inizi del Settecento." In *Corporazioni e gruppi professionali nell'Italia Moderna,* edited by A. Guenzi, P. Massa and A. Moioli, 277–305. Milan: Franco Angeli.

Trevor-Roper, Hugh Redwald. [1976] 1980. *Princes and Artists: Patronage and Ideology at Four Habsburg Courts, 1517–1633.* London: Thames and Hudson. Translated as *Principi e artisti: Mecenatismo e ideologia in quattro corti degli Asburgo (1517–1633).* Turin: Einaudi.

Trifone, Romualdo. 1914. *Il fedecommesso: Storia dell'istituto in Italia dal diritto Romano all'inizio del secolo* xvi. Naples: L. Pierro e Figlio.

Troilo, Simona. 2005. *La patria e la memoria: Tutela e patrimonio culturale nell'Italia unita.* Milan: Electa.

Tucci, Ugo. 1991. "Rinascimento ed economia." In *Economia e civiltà tra Medioevo ed età moderna,* edited by G. Fossati, 10–20. Bellinzona: Liceo di Bellinzona.

Tucker, Paul. 1998. "Charles Fairfax Murray as Agent to the National Gallery, 1877–1894." Paper presented at the conference "The Art Market in Europe and America in the Nineteenth and Twentieth Centuries," EUI. Fiesole, 8–9 May 1998.

Tuohy, Thomas Jason. 1982. "Studies in Domestic Expenditure at the Court of Ferrara: Artistic Patronage and Princely Magnificence." Ph.D. diss., Warburg Institute, London.

———. 1996. *Herculean Ferrara: Ercole I d'Este (1471–1505) and the Invention of a Ducal Capital.* Cambridge: Cambridge University Press.

Turrini, Patrizia. 1997. *Per honore e utile de la città di Siena: Il comune e l'edilizia nel Quattrocento.* Siena: Tipografia Senese.

Ufficio centale per i beni archivistici. 2000. *Ideologie e patrimonio storico-culturale nell'età rivoluzionaria e napoleonica: A proposito del trattato di Tolentino.* Rome: Ministero per i Beni e le Attività Culturali.

Urzì, Maria. 1933. *I pittori registrati negli statuti della fraglia padovana dell'anno 1441.* Venice: Ferrari.

Vaccaj, Giulio. 1923–24. "Quadri delle chiese di Pesaro asportati dai francesi nel 1797, 1798, 1811." *Rassegna Marchigiana* 2: 244–251.

Vaccari, Maria Grazia. 1998. "Tecniche e metodi di lavorazione." In *I Della Robbia e l'arte nuova della scultura invetriata,* edited by G. Gentilini, 97–116. Florence: Giunti.

Vale, J. Lawrence. 1992. *Architecture, Power, and National Identity.* New Haven: Yale University Press.

Van Der Woude, Ad M. 1991. "The Volume and Value of Paintings in Holland at the Time of the Dutch Republic." In *Art in History, History in Art: Studies in Seventeenth-Century Dutch Culture,* edited by D. Freedberg and J. De Vries, 285–329. Santa Monica, CA: Getty Center for the History of Art and the Humanities.

Van Houdt, Toon. 1999. "The Economics of Art in Early Modern Times: Some Humanist and Scholastic Approaches." In *Economic Engagements and the Art,* edited by Neil De Marchi and Craufurd D. W. Goodwin, 303–332. Durham, NC: Duke University Press.

Van Zanden, Jan L. 1999. "Wages and the Standard of Living in Europe, 1500–1800." *European Review of Economic History* 3: 175–197.

Vaquero Piñeiro, Manuel. 1996a. "L'università dei fornaciai e la produzione di laterizi a Roma tra la fine del '500 e la metà del '700." *Roma Moderna e Contemporanea* 4, no. 2: 471–494.

———. 1996b. "Ricerche sui salari nell'edilizia Romana (1500–1650)." *Rivista storica del Lazio* 5: 131–158.

———. 1999. "Compagnie di muratori e scalpellini lombardi nei cantieri edili Romani del XVII

secolo." In *Il giovane Borromini: Dagli esordi a San Carlo alle Quattro Fontane*, exhibition catalog, edited by M. Kahn-Rossi and M. Franciolli, 231–236. Milan: Skira.

Venturini, Lisa. 1992. "Modelli fortunati e produzioni di serie." In *Maestri e botteghe: Pittura a Firenze alla fine del Quattrocento*, edited by M. Gregori, A. Paolucci, and C. Acidini Luchinat, 147–163. Milan: Silvana Editoriale.

Vermeylen, Filip. 2003. *Painting for the Market: Commercialization of Art in Antwerp's Golden Age.* Turnhout: Brepols.

Veyne, Paul. [1976] 1984. *Le pain et le cirque: Sociologie historique d'un pluralisme politique.* Paris: Seuil. Translated as *Il pane e il circo: Sociologia storica e pluralismo politico.* Bologna: Il Mulino.

Vigezzi, Brunello, ed. 1983. *Federico Chabod e la "Nuova storiografia italiana 1919–1950."* Milan: Jaca Book.

Vigo, Giovanni. 1974. "Real Wages of the Working Class in Italy: Building Workers' Wages (14th to 18th Century)." *Journal of European Economic History* 3, no. 2: 378–399.

Vivenza, Gloria. 1995. "Origini classiche della benevolenza nel linguaggio economico. Dall'evergesia del mondo antico alla 'benevolence' della società commerciale." In *Tra storia ed economia: Studi in onore di Gino Barbieri*, edited by R. Molesti, 497–530. Pisa: Edizioni IPEM.

Volpe, Gioacchino. 1923. *Medio Evo Italiano.* Florence: Vallecchi.

Wackernagel, Martin. [1938] 1994. *Der Lebensraum des Künstlers in der florentinischen Renaissance: Aufgaben und Auftraggeber, Werkstatt und Kunstmarkt.* Leipzig: E. A. Seemann. Translated as *Il mondo degli artisti nel Rinascimento fiorentino: Committenti, botteghe e mercato dell'arte.* Rome: Nuova Italia Scientifica.

Warnke, Martin. 1970. *Das Kunstwerk zwischen Wissenschaft und Weltanschauung.* Gütersloh: Bertelsmann Kunstverlag.

———. [1985] 1991. *Hofkünstler: Zur Vorgeschichte des modernen Künstlers.* Cologne: DuMont. Translated as *Artisti di corte: Preistoria dell'artista moderno.* Rome: Istituto della Enciclopedia Italiana.

———. 1995. "Liberalitas principis." In *Arte, committenza ed economia a Roma e nelle corti del Rinascimento*, edited by A. Esch and C. L. Frommel, 83–92. Turin: Einaudi.

Warwick, Genevieve. 2000. *The Arts of Collecting: Padre Sebastiano Resta and the Market for Drawings in Early Modern Europe.* Cambridge: Cambridge University Press.

Watson, Katharine J. 1978. "Sugar Sculpture for Grand Ducal Weddings from the Giambologna workshop." *Connoisseur* 199: 20–26.

Weatherill, Lorna. 1988. *Consumer Behaviour and Material Culture in Britain, 1660–1760.* London: Routledge.

Weil, Mark S. 1974. "The Devotion of the Forty Hours and Roman Baroque Illusions." *Journal of the Warburg and Courtauld Institutes* 37: 218–248.

Weiner, Annette B. 1992. *Inalienable Possessions: The Paradox of Keeping-While-Giving.* Berkeley: University of California Press.

Weisberg, Gabriel P. 1990. "Antoine Vivenel, the Private Museum and the Entrepreneur under the July Monarchy." *Journal of the History of Collections* 2, no. 1: 21–39.

Welch, Evelyn. 1996. *Art and Authority in Renaissance Milan.* New Haven: Yale University Press.

———. 2000. "Women as Patrons and Clients in the Courts of Quattrocento Italy." In *Women in Italian Renaissance Culture and Society*, edited by L. Panizza, 18–34. Oxford: European Humanities Research Center.

———. 2002a. "Public Magnificence and Private Display: Giovanni Pontano's De Splendore (1498) and the Domestic Arts." *Journal of Design History* 15, no. 4: 211–221.

———. 2002b. "Art at Court and the Wider Urban Market: The Case of Milan, 1470–1500." In

Economia ed Arte, Secc. xiii–xviii*: Atti della* xxxiii *Settimana di Studi dell'Istituto Internazionale di Storia Economica "F. Datini" Prato 30 April–4 May 2000,* edited by Simonetta Cavaciocchi, 627–631. Florence: Le Monnier.

———. 2003. "From Retail to Resale: Artistic Value and the Second Hand Market in Italy (1400–1550)." In *The Art Market in Italy, 15th–17th Centuries,* edited by Marcello Fantoni, Louisa Chevalier Matthew, and Sara F. Matthews-Grieco, 283–299. Modena: Panini.

———. 2004. "Painting as Performance in the Italian Renaissance Court." In *Artists at Court,* edited by S. J. Campbell, 19–32. Chicago: University of Chicago Press.

———. 2005. *Shopping in the Renaissance: Consumer Cultures in Italy, 1400–1600.* New Haven: Yale University Press.

Werner, Karl Ferdinand. 1997. "L'apport de la prosopographie à l'histoire sociale des élites." In *Family Trees and the Roots of Politics: The Prosopography of Britain and France from the Tenth to the Twelfth Century,* edited by K. S. B. Keats Rohan, 1–22. Woodbrige: Boydell Press.

Wesch-Klein, Gabriele. 1990. *Liberalitas in Rem Publicam: Private Aufwendungen zugusten von Gemeinden in römischen Afrika bis 284 n. Chr.* Bonn: Habelt.

Wescher, Paul. [1976] 1988. *Kunstraub unter Napoleon.* Berlin: Mann. Translated as *I furti d'arte: Napoleone e la nascita del Louvre.* Turin: Einaudi.

White, Michael. 1999. "Obscure Objects of Desire? Nineteenth-Century British Economists and the Price(s) of 'Rare Art.'" In *Economic Engagements with Art,* edited by Neil De Marchi and Craufurd D. W. Goodwin, 57–84. Durham, NC: Duke University Press.

White, Harrison, and Cynthia White. 1965. *Canvases and Careers: Institutional Change in French Painting World.* New York: John Wiley & Sons.

Whitney, Elspeth. 1990. *Paradise Restored: The Mechanical Arts from Antiquity through the Thirteenth Century.* Philadelphia: American Philosophical Society.

Wilkins, David G., and Rebecca L. Wilkins, eds. 1996. *The Search for a Patron in the Middle Ages and the Renaissance.* Lampeter: Edwin Mellen Press.

Williams, Robert. 1995. "The Vocation of the Artists as Seen by Giovanni Battista Armenini." *Art History* 18, no. 4: 518–536.

———. 1997. *Art, Theory, and Culture in Sixteenth-Century Italy: From Techne to Metatechne.* Cambridge: Cambridge University Press.

Wilson, Richard, and Alan Mackley. 1999. "How Much Did the English Country House Cost to Build, 1660–1880?" *Economic History Review* 52: 436–440.

Winkler, Johnnes, ed. 1989. *La vendita di Dresda.* Modena: Panini.

Wisch, Barbara, and Susan Scott, eds. 1990. *"All the World's a Stage . . .": Art and Pageantry in the Renaissance and Baroque.* University Park: Pennsylvania State University Press.

Wittkower, Rudolph, and Margot Wittkower. [1963] 1968. *Born under Saturn: The Character and Conduct of Artists: A Documented History from Antiquity to the French Revolution.* London: Weidenfeld and Nicolson. Translated as *Nati sotto Saturno: La figura dell'artista dall'antichità alla rivoluzione francese.* Turin: Einaudi.

Woods-Marsden, Joanna. 1998. *Renaissance Self-Portraiture: The Visual Construction of Identity and the Social Status of the Artist.* New Haven: Yale University Press.

Worthington, Andrew C., and Helen Higgs. 2003. "Art as an Investment: Short and Long-Term Comovements in Major Painting Markets." *Empirical Economics* 28: 649–668.

Wyett, Jodi L. 2000. "The Lap of Luxury: Lapdogs, Literature, and Social Meaning in the 'Long' Eighteenth Century." *Literature Interpretation Theory* 10: 275–301.

Wyrobisz, Andrzé. 1965. "L'attività edilizia a Venezia nel xiv e xv secolo." *Studi Veneziani* 7: 307–343.

Yamey, Basil S. 1972. "Why £. 2,310,000 for a Velazquez? An Auction Bidding Rule." *Journal of Political Economy* 80: 27–40.

Zacour, Norman P. 1975. "Papal Regulation of Cardinals' Households in the Fourteenth Century." *Speculum* 50: 434–455.

Zanker, Paul. [1987] 1989. *Augustus und die Macht der Bilder*. Munich: Oscar Beck. Translated as *Augusto e il potere delle immagini*. Turin: Einaudi. Translated by Alan Shapiro as *The Power of Images in the Age of Augustus*. Ann Arbor: University of Michigan Press, 1990.

Zanoboni, Maria Paola. 1996. "Il commercio del legname e dei laterizi lungo il Naviglio Grande nella seconda metà del '400." *Nuova Rivista Storica* 80, no. 1: 75–118.

Zapperi, R. 1990. *Tiziano, Paolo III e i suoi nipoti: Nepotismo e ritratto di Stato*. Turin: Bollati Boringhieri.

Zevi, B. 1960. *Biagio Rossetti architetto ferrarese*. Turin: Einaudi.

———. 1971. *Saper vedere l'urbanistica: Ferrara di Biagio Rossetti*. Turin: Einaudi.

Zorzi, L. 1978. *Il teatro e la città*. Turin: Einaudi.

Acknowledgments

WITH THE PUBLICATION OF THE ENGLISH VERSION, I WOULD LIKE TO ONCE AGAIN thank the friends who contributed to the genesis of the original work, as well as this edition.

First and foremost, my thanks to Aldo De Maddalena, Marzio Romani, and Marco Cattini, for the patience, understanding, and affection they had always shown me, nourishing my passion for history and stories. For their useful advice and valuable suggestions I am grateful to Fabio Achilli, Marta Ajmar, Maurice Aymard, Stefano Baia Curioni, Malcolm Baker, Marina Bianchi, Philippe Braunstein, John Brewer, Suzy Butters, Gian Mario Cao, Joseph Connors, Laura Corti, Marisa Dalai, Neil De Marchi, Giovanni Luigi Fontana, Bruno Frey, Elena Fumagalli, Antonella Gioli, Allen Grieco, Michael Hutter, Daniele Jallà, Gérard Labrot, Daniela Lamberini, Donata Levi, Sandrino Mininno, Enrica Melossi, Luca Mocarelli, Angelo Moioli, Luca Molà, Giampiero Nigro, Michael North, David Ormrod, Katy Park, Francesco Poli, Guido Rebecchini, Patricia Rubin, Walter Santagata, Giuliano Segre, Marco Spallanzani, the late Enrico Stumpo, Gianni Toniolo, Paul Tucker, Roberto Valeriani, Angela Vettese, and Evelyn Welch.

For their continuing collaboration, my thanks to the staffs of Villa I Tatti, the Florenz Kunsthistorisches Institut, the Nederlands Interuniversitair Kunst Historisch Institut, and of the libraries and archives where I worked.

To Amanda George, Harriet Graham, and Jean McBain for their translations and painstaking editing work.

To Gabriel Dotto and the staff of the Michigan State University Press staff for their resolve in publishing the English edition and following its production with a level of attention and care that are rare these days in the publishing world.

My wife Noemi, my son Tommaso, my daughter Emma, and my sister Gioia read my writing and inspired, comforted, and benignly urged me on during the past decade of my Italian academic career.

To all of them goes my heartfelt gratitude.

Index